Hellenic Studies 28

# SAPPHO IN THE MAKING

# SAPPHO IN THE MAKING

## THE EARLY RECEPTION

Dimitrios Yatromanolakis

CENTER FOR HELLENIC STUDIES
Trustees for Harvard University
Washington, DC
Distributed by Harvard University Press
Cambridge, Massachusetts, and London, England
2007

Sappho in the Making: The Early Reception
by Dimitrios Yatromanolakis
Copyright © 2007 Center for Hellenic Studies, Trustees for Harvard University
All Rights Reserved.
Published by Center for Hellenic Studies, Trustees for Harvard University,
    Washington, D.C.
Distributed by Harvard University Press, Cambridge, Massachusetts, and
    London, England
Production: Kerri Sullivan
Printed in Ann Arbor, Michigan by Edwards Brothers, Inc.

LIBRARY OF CONGRESS CATALOGING-IN-PUBLICATION DATA
Yatromanolakis, Dimitrios.
    Sappho in the making : the early reception / by Dimitrios Yatromanolakis.
        p.   cm.
    Includes bibliographical references and index.
    ISBN 978-0-674-02686-5
    1. Sappho—Appreciation. 2. Sappho—Criticism and interpretation. 3. Sappho—
In art. 4. Greek poetry—History and criticism. 5. Oral interpretation of poetry.
6. Lesbians—Greece. 7. Women and literature—Greece—History—To 1500.
8. Lesbos Island (Greece)—Antiquities.   I. Title.

PA4409.Y38 2007
884'.01—dc22

                                                            2007037916

For
*Nikolaos and Maria Yatromanolakis*
and
*Elaine Scarry*

# Contents

# Contents

# Illustrations

# Preface

I WAS FIRST INTRODUCED to the dialects of Plato and Sappho in the last years of elementary school by an older friend who enjoyed reciting ancient Greek poetry and reading sections from Plato's *Symposion* at family gatherings. She taught me their dialects during three long summers in Greece. The work of both of those ancient composers of prose and song became scholarly preoccupations of mine later at college. It seemed to me then that their dialogues and songs displayed a comparable focus on the iconicity of language and on the articulation of the spatiality of *erôs*. Sokrates' reference in the *Phaidros* to the words and writings of the *palaioi sophoi andres kai gunaikes* ("ancient wise men and women") and his point that what he had in mind was probably Sappho (235b–c) echoed in my mind each time I tried to make sense of Diotima's inner voice. My approach to Plato changed during a cold winter in Oxford, when I started graduate studies and intensively read parts of the work of Gregory Vlastos.

Although in the twentieth century the scholarship on Sappho became vast and labyrinthine, researchers did not attempt to write a synthesis on the complexities of the formation of her figure. Scattered accounts of later sources and analyses of cases like [Ovid]'s *Epistula Sapphus* often (consciously or unconsciously) engage in a convenient and chronologically blurred narrativization of different aspects of her ancient reception: no distinctions are made with regard to ancient synchronic perspectives and especially to the diverse sociocultural mechanisms and practices conducive to the shaping of receptorial filters in different contexts and periods. More importantly, a widely sanctioned scholarly paradigm considers ancient reception as a clear reflection of biographical tradition. At the same time, researchers have advanced numerous ingenious reconstructions of the original sociocultural context of the songmaking of Sappho based, each time, on selected elements of the ancient reception itself, without investigating its cultural economies and synchronic structures. There is an urgent need for methodological theorizing on ancient reception and the anthropology of socioaesthetic idioms linked with reception in antiquity.

Despite sporadic scholarly remarks, the material related to the ancient shaping and reshaping of the figure and song-making of Sappho is considerably multilayered and extensive. The more I worked in the area, the more my investigations required significant expansion in different directions, lines of evidence, and sets of questions. Any time I deemed that a certain line of inquiry had been concluded, further intricate discursive idioms and practices, as well as metonymic and mythopractical webs of signification, shifted the boundaries and "imaginative horizons" of research.[1] It is my contention that the study of the ancient reception of archaic, classical, and Hellenistic socioaesthetic cultures involves many underexplored and unexplored areas and questions that future researches will need to tackle. Explorations of the cultural economies and sociopolitical discourses that conditioned the ancient receptions of Sappho may eventually reconfigure the way we reconstruct the context within which she composed her songs and our overall approaches to her fragments. This book, which focuses on a methodologically challenging area—the early reception—constitutes an anthropological investigation into the alterity of archaic, classical, and early Hellenistic discursive inflections and practices that contributed to the later Greek and Roman representations of the figure of Sappho. The lack of direct access to ancient socioaesthetic cultures—the impossibility of simple formulas—requires the advancement of interdisciplinary methodologies firmly based on the arresting technicalities of disciplines like archaeology, papyrology, and epigraphy. Therefore, the project undertaken here constitutes an attempt to write an archaeological ethnography of archaic and classical Greek socioaesthetic idiolects and sociolects;[2] its aim is to trace and recapture the interdiscursivity of the cultural textures that defined "Sappho."[3]

[1] For the notion of "imaginative horizons" from an anthropological perspective, see the pathfinding work of Crapanzano 2004.
[2] I employ the term "sociolect" in the sense of language "both as grammar and repository of the myths, traditions, ideological and esthetic stereotypes, commonplaces and themes" constructed by a social group (Riffaterre 1990:130 and passim).
[3] For the concept of "interdiscursivity" with regard to ritual textures, see Yatromanolakis and Roilos 2003; cf., further, Roilos and Yatromanolakis forth.

# Acknowledgments

THIS BOOK began taking shape in 2000 and was completed in June 2003. During the academic year 2003–2004 it was further revised, and I made some final bibliographical additions in January 2005.[1] The original 2003 manuscript was almost twice as large as the present book. This was partly due to the fact that in that manuscript there was a special focus on the Hellenistic and Roman reception of Sappho, while in the final version I shifted the focus to methodological and theoretical concerns that I have had since I started conducting research on archaic Greece and archaic and classical songmaking. My unpublished, but forthcoming, D.Phil. thesis represented a textual and interpretive commentary on major fragments of Sappho—a commentary that focused especially on sociocultural aspects of linguistic forms. Based on a reexamination of the original papyri and medieval manuscripts preserving fragments of songs of Sappho, my plan was to prepare a new critical edition and commentary. Denys Page's commentary in English (1955), despite its numerous merits, was idiosyncratic in scope and in the linguistic theories it adopted. Page was also vehemently criticized for his literary interpretations of the preserved texts, interpretations that to a certain extent influenced the critical edition that he along with Edgar Lobel produced in 1955. Eva-Maria Voigt's monumental edition of Sappho and Alkaios (1971) was considerably more wide-ranging and her instinct in textual criticism more flexible; one might also say that her critical apparatus was more learned in its consideration of papyrological readings and in the attribution of emendations to scholars. Voigt did not have access to numerous original papyri when she embarked on research for her edition and, therefore, for most of the fragments of Alkaios and Sappho she was based on the papyrological work of Schubart, Zuntz, Lobel, and other towering figures in Classics in the first half of the twentieth century, that is, when new poems of Sappho were discovered in Egypt. Since then little work has been done on the papyri and other manuscripts and no critical edition has appeared that would be based on a fresh examination of

---

[1] I have attempted to take into account 2004/2005 publications as much as possible.

the originals with the additional aid of modern microscopes and other technological devices.

That was my plan when I finished my D.Phil. thesis at Oxford. My ideas about fragments and editorial principles owe a great deal to the unparalleled papyrological acumen and critical eye of Peter J. Parsons, then Regius Professor of Ancient Greek at the University of Oxford. Although I know that I cannot reciprocate what Peter Parsons has offered in terms of my reexamination of papyri and manuscripts, as well as in elegantly insisting on the significance of interdisciplinary methods in editorial practice, I hope that my decision to publish this book first and slightly defer the publication of my commentary will not eventually disappoint him. For the numerous hours of recovering fragmentary *theasis* upon archaic modes of thought I shall always be indebted to him.

The years of my papyrological apprenticeship with Peter Parsons have been full of exposure to the intellectual and scholarly sagacity of other scholars too. The last decade (at least its second part that I mainly witnessed) of the twentieth century marked a special flourishing in papyrological, palaeographical, epigraphic, and text-critical activity and enterprises in Oxford. I was lucky enough to have as teachers Nigel G. Wilson, Gregory O. Hutchinson, Laetitia P. E. Parker, and Martin L. West. Revel Coles, John Rea, and Bruce Barker-Benfield kindly facilitated my research on Oxyrhynchus papyri in the Ashmolean Museum (the papyri having now been moved to the Sackler Library) and in the Bodleian Library. Further, Christiane Sourvinou-Inwood and Robert Parker fervently experimented in—and suggested new ways in approaching—ancient Greek religion in their lecture courses. To the former I also owe a special debt in guiding my research on vase-painting by providing unstinting support and her interdisciplinary insights into ancient Greek visual culture. These scholars' criticism in the development of my ideas and approaches remains lasting and decisive.

Panagiotis Roilos, collaborator for many years, improved the diverse aspects of the theoretical Problematik advanced in this book by discussing almost every detail with me. An eminent critical theorist in Hellenic Studies and Comparative Literature, he also read different drafts of each chapter and made incisive suggestions. I owe him profound gratitude. Another collaborator has offered me more than a colleague could expect. I met him in my first week at the Johns Hopkins University—standing and smiling next to an old departmental photograph of Basil L. Gildersleeve, a philologist who played a major role in shaping the discipline of Classics at Johns Hopkins and in the United States more broadly. Since our first meetings, Marcel Detienne has been commenting on and criticizing almost everything I have written, and his

comparative approaches to ancient Greek cultural and religious configurations and microfigurations are a constant source of inspiration in graduate courses and seminars I am still privileged to co-teach with him.

A number of scholars encouraged my decision to leave England after my doctoral studies and continue research in the United States. Margaret Alexiou and Gregory Nagy have been reading and commenting on drafts throughout the writing of this book. Both of them had previously read different parts of my D.Phil. commentary. With Albert Henrichs I discussed in detail certain parts and ideas at numerous meetings. From the very beginning of its conception, Gregory Nagy considerably encouraged me in advancing the methodological approaches and analyses included in this book and has provided me with decisive advice on issues historical and literary. I have further profited from discussions with Elizabeth Jeffreys, Michael Herzfeld, Henry Immerwahr, Michael Koukourakis, Stella Lianakis Yatromanolakis, Nikolaos Litinas, the late David Lewin, Richard P. Martin, David Mitten, Leonard Muellner, Gloria Pinney, Athanasios Roilos, Laura Slatkin, Stanley Tambiah, Richard Thomas, Katherine Thomson, and Irene Winter. The friendship of Evro Layton-Zeniou and John Shirley-Quirk has been invaluable throughout. In the final stages of revision the scholarly brilliance of Gregory Nagy has been significant; only those who have experienced his friendship know what this means. Michael Herzfeld has been instrumental in anthropological perspectives, which I have much appreciated; to him I owe a great deal that no words can depict. The singular efficiency of M. Zoie Lafis, as well as Emily Collinson, Jill Curry Robbins, and Kerri Sullivan, made the whole process of the production of the book smooth and rewarding. Joyce C. Nevis, a master in copyediting and a watchful (and critical) reader, sent me comments that improved the manuscript. Dr. Günter Poethke, Kustos of the Papyrussammlung on the Museumsinsel, Berlin, effectively facilitated my papyrological research in Berlin, and helped with the production of photographs of P. Berol. 9722. Dr. Nikolaos Kaltsas, Director of the National Archaeological Museum, Athens, and Eleni Morati helped with my research in Athens. Dr. Cornelia Weber-Lehmann, Curator at the Kunstsammlungen, Ruhr-Universität Bochum, offered me valuable help with archaeological material during my stay in Bochum.

This book would have not been written without the support and intellectual vigor of a particular institution. A three-year appointment at the Society of Fellows, Harvard University, provided me with the necessary time for research and further intensive training in social and cultural anthropology and ethnomusicology. More formative were the ideal academic environment and interdisciplinarity that the Society of Fellows fosters—among natural scientists,

humanists, and social scientists. Rosemarie Bernard, Diana Morse, and especially Nina Gurianova have been constant interlocutors and friends. To Peter Galison, Walter Gilbert, Martha Minow, the late Robert Nozick, Elaine Scarry, William Todd, and Helen Vendler I owe more than I can acknowledge here.

Thanks are owed to some other institutions that supported my work during and after my years at the Society. The William F. Milton Award that I received in 2001 generously funded my research on Attic vase-paintings in Germany, Greece, France, the Netherlands, and the United States. Upon my arrival at the Johns Hopkins University I realized that, leaving ideal surroundings, I found myself working in an equally inspiring research and teaching milieu that H. Alan Shapiro had established. To his scholarly incisiveness and wide-ranging expertise on ancient Greek visual and material culture I am most grateful. For their warm collegiality my thanks go to Stephen Campbell, Michael Fried, Hent de Vries, Neil Hertz, Herbert Kessler, and Richard Macksey. For valuable intellectual dialogue I should like to thank Veena Das of the Anthropology Department, Paola Marrati of the Humanities Center, and John Shirley-Quirk of the Peabody Institute. Finally during 2003 and 2004 I received two Dean's Research Grants of the School of Arts and Sciences that facilitated my research in Germany and Greece. Thanks are owed to Daniel Weiss and particularly Adam Falk.

My grandparents, Stephanos and Stella Tsainis of Konstantinoupole and Smyrne, taught me many stories and sociolects from their homeland—snapshots and narratives that left an imprint on my diasporic fieldwork on Greek antiquity. Ethnographic fieldwork that I conducted in Southern Italy and Crete showed me ways of describing. The insistence of Albert Henrichs, Panagiotis Roilos, and Alexandra Yatromanolakis that this book be written was invaluable. It is dedicated to my parents and to Elaine Scarry.

# Note on Transliteration

TRANSLITERATING ANCIENT GREEK WORDS of different periods—with all the phonetic and other changes that took place from the archaic to the Roman period and later—raises issues about consistency. Our knowledge of the precise pronunciation of ancient Greek consonants, vowels, and diphthongs in different dialects is limited. It is, therefore, problematic to adopt a transliteration system that assumes that archaic Greek dialects were pronounced in the same manner as the Greek of the early Roman period. In this book, most ancient Greek names of people and places retain their Greek terminations—Herodotos not Herodotus, Stesikhoros not Stesichorus. In spelling names like Poludeukes (Πολυδεύκης), I have opted for this form instead of the latinized Pollux. However, for only a few names widely familiar in their English form, I have employed that form—for example Homer not Homeros, Plato not Platon, Helen, Athens, Thrace, Oxyrhynchus, and so forth. In transliterations of ancient Greek words like *plêktron* and *kômos*, ê and ô represent the ancient Greek long vowels eta and omega. In archaeological terms—such as *amphora, oinochoe, kalyx-krater,* well established in this form—I have consistently retained the standard versions. The result is a compromise system, neither strictly hellenizing nor conventionally latinizing. An earlier version of pages 91 and 98–108 of this book appeared in *ZPE* 152 (2005), 16–30. All translations are my own except where otherwise indicated. Their aim is not literary elegance but an accurate rendering of the original texts. I have mainly attempted to convey the complex texture and stylistic idiosyncrasies of ancient Greek authors and orally transmitted songs and narratives.

# 1

## An Anthropology of Reception

Δεινὸν γάρ που, ὦ Φαῖδρε, τοῦτ' ἔχει γραφή, καὶ ὡς ἀληθῶς ὅμοιον ζωγραφίᾳ. καὶ γὰρ τὰ ἐκείνης ἔκγονα ἕστηκε μὲν ὡς ζῶντα, ἐὰν δ' ἀνέρῃ τι, σεμνῶς πάνυ σιγᾷ. ταὐτὸν δὲ καὶ οἱ λόγοι.

I think, Phaidros, that writing shares a strange feature with painting. The offspring of painting stand there as if they were alive, but if you ask them anything, they are solemnly silent. The same is true of written words.

—Plato, *Phaidros* 275d

> *Lesbia Illa*
> Memnon, Memnon, that lady
> Who used to walk about amongst us
> With such gracious uncertainty,
> Is now wedded
> To a British householder.
> *Lugete, Veneres! Lugete, Cupidinesque!*

—Ezra Pound, from "Ladies"

IN SCHOLARSHIP, more than in contemporary cultural politics and art, the problem of the historical presence of Sappho is complex. Not unlike the Homeric question that has provoked considerable debate over time,[1] a number of areas of contention have been present. Scholarly arguments and deliberations about the culture of Sappho in archaic Lesbos and elsewhere, the

---

[1] The problems involved in the research on Sappho have been lumped together under various rubrics. Among others, Russo (1973:721) opted for a close definitional comparison between Homer and Sappho and formulated the issue as follows: "the great Question of Sapphic studies," and the "*Sapphofrage*."

issue of what it meant to be a companion of Sappho's, and the question of the interpenetratedness of textuality and performative transmission (occupying also scholars working on the Homeric epics) have caused an unparalleled flourishing of research on the songs of Sappho and their original context over the last one and a half centuries. Theories about these and other scholarly concerns have been so numerous and of ever-increasing imaginative force-fulness that affording them full consideration within the covers of a single book would be impossible. Historical reconstructions advanced by different researchers and endorsed, even tacitly, by other historians and classicists have been intensely discussed to this day.

The problems involved in such debates are, as for the Homeric texts, mostly definitional: What is "tradition," "traditional style," and why should the latter be associated with formulaically based composition in perfor-mance? If all is attributed to tradition, could Sappho be viewed as a vehicle of a prearchaic and archaic tradition of women's poetry? And if tradition is at the center of scholarly endeavors to reconstruct the culture, or (as I prefer to put it in terms of her original context) the *cultures* of Sappho, should her songs be compared to the compositions of *partheneia* ("maiden songs") of Alkman, an almost coeval archaic poet who lived in Sparta? Is Sappho another Alkman, and does she converse in her songs with the Homeric epics in an attempt to (re)define a female poetic or performative perspective, as has often been argued? From such questions other central issues emerge. How can words like *erôs* and *erasthai*, or *gunê* and *pais* be glossed anthropologically in the frag-ments of Sappho? And, finally, how can the indigenous poetics—sociopolitical and textual—of Sappho be classified and *described*?

Again the case of the Homeric *Iliad* and *Odyssey* and their scholarly recep-tion can throw light on the problems surrounding the study of the fragments of Sappho. In the twentieth century, the Parry-Lord pathfinding theory of oral formulaic composition in performance has contributed considerably to the elucidation of a large number of issues related to traditional poetics and to an ethnography of what we might want to call traditional "vehicles of meaning."[2] Despite this pronounced advancement in the ways scholars look at Homer, the scholarly *discursivity*[3] of the different theories stemming from more tradi-

[2] For "vehicles of meaning," see Geertz 1983:118–119.
[3] "Discourse"—like "discursivity"—is employed here as elsewhere in this book not only in its general sense of verbal strategies but rather in its Foucauldian connotation of marked and situationally circumscribed utterance. Discourse is thus situated in specific contexts of power dynamics. The concept of discourse pervades Foucault's theory as a whole; see especially Foucault 1969, 1981. For an interesting problematization of established epistemological prem-ises in connection with the history of late antiquity, see Clark 2004.

tional approaches to archaic epic and from the Parry-Lord insights into the comparative workings of modern oral Serbo-Croatian epic and Homeric poetry has rarely been addressed within the disciplinary boundaries of Classics.[4] Survivalism, functionalism, and diffusionism are paradigms that have been, often unconsciously, promoted and remained almost unremarked in the study of the composition and transmission of the Homeric epics. Such paradigms have produced significant and wide-ranging results, but the assumptions on which they are based often remain insufficiently spelled out. As a result, there is no consensus on how to define traditionality, cohesion, inconsistency, Homeric textuality, and, more importantly for the archaic poetry that was composed (as we take it for granted) after the Homeric *Iliad* and *Odyssey*, the possible intertextual relations between archaic melic, elegiac, and iambic verses, on the one hand, and the Homeric epics, on the other.

It is not enough or even thought-provoking and promising, I argue, to point to the biographical tradition, as we call it, of the ancient reception of Homer or Sappho. In the case of Sappho, which, to be sure, is different from that of the Homeric epics, current research places almost exclusive emphasis on the biographical tradition stemming from comic texts of the fourth century BC. Everything, it is maintained, revolves around this late-fifth and fourth-century comic tradition. However, consideration of that tradition along with the later attested biographical tradition and the so-called testimonia related to Sappho have often led to a blurred and undifferentiated image of the activities of the song-maker—an image that is employed and read differently by diverse reconstructive attempts at reaching archaic realities as far back as the late seventh-century BC Lesbos.

Even in the case of the so-called biographical tradition, we may need to go far beyond maintaining that everything is fictional, since that would be a straightforward enterprise. The concept of fiction, as implicitly employed in older and current scholarship through the use of the term "biographical tradition," is rarely defined and often wedded to a somewhat narrow view of how *fictionalization* works and why it is generated within specific social contexts. At the same time, quite old or unsubstantiated views about Sappho still hold an overwhelming power over current historical reconstructions of archaic social actualities and ideological frameworks. The same is true for literary analyses that do not attempt to offer new, or to fine-tune already advanced reconstructions but presuppose them to a marked degree. Numerous translations in

[4] The studies of G. Nagy (1974; 1990; 1996a; 1999; 1996b; 2003; 2004a), J. M. Foley (1991 with references to his earlier work; 1995; 2002), L. C. Muellner (1976; 1996), and R. P. Martin (1989) provide an important exception.

different modern languages of textual reconstructions have established and promoted by-now naturalized poetic images that have entered the corpus of the fragments of Sappho. Very few scholars would question such images. The *editiones principes* of her fragmentary texts, although real treasure houses of insight and scholarly warnings, have ceased having appeal to most modern scholars working on historical or literary aspects; dots for uncertain letters, brackets, and risky reconstructive schemata tentatively entertained, but at the same time modestly undermined, by older papyrologists have often been altogether forgotten.[5] For all that, the tentative schemata have habitually been left intact and are taken for granted.

While the amount of research on Sappho has become almost intimidating and arguments and polemics continue to increase, the extant material—archaeological and textual—that would provide clues to our understanding of her work remains in surprisingly crucial cases underexplored. For example, partly adopting approaches current in the nineteenth century, twentieth-century scholarship attempted to see in the fragments of Sappho and the testimonia about her, references to the age of her companions and their role in the so-called Sapphic circle.[6] This use of late *sources* as conclusive *evidence* for archaic realities is not confined only to discussions of the age of her companions (or whatever we may want to call them); it extends also to the analysis of issues relating to the performance of her poetry.[7] Sources should not always be identified with the concept of evidence. The results of such and related inquiries are frequently based on late, post-Hellenistic sources.[8] Earlier representations of Sappho have been persistently underexplored or unexplored. More broadly, although the early modern and the nineteenth-/twentieth-century reception of Sappho has emerged as an autonomous field,[9] the ancient recep-

---

[5] I here do not refer to the detailed work of M. L. West and several other contemporary scholars who do pay particular attention to such central issues with regard to the text of Sappho.

[6] Starting with Welcker's *Sappho von einem herrschenden Vorurtheil befreyt* (Welcker 1816), see, especially, Merkelbach 1957; West 1970; Rösler 1992; and Calame 1997:210–214, 231–233, 249–252.

[7] Yatromanolakis 1999a:185n28 and 184–187. In Yatromanolakis 1999a, the concept of *sources* was deliberately distinguished from that of *evidence*.

[8] See above, n. 6; more recently, Lardinois 1994; cf. Lardinois 1996 and 2001.

[9] For the reception of Sappho in France between 1546 and 1937, see DeJean 1989; for a brief consideration of the period after 1937 and of samples of English scholarship, see her "epilogue." Cf. Prins's reservations (1999:14) about DeJean's attempt "to assimilate other traditions into a French model." For Germany, Greece, Italy, England, and the United States, see Robinson 1924; Rüdiger 1933; Marks 1978:353–377; Stein 1981; Rigolot 1983; Gubar 1984; Lipking 1988; Tomory 1989; Fornaro 1991; Wood 1994; Snyder 1995:101–123; Blank 1995; Most 1995:15–38; Snyder 1997b:123–159; Greene 1996 (articles by J. DeJean and others); Prins 1999; Dehler 1999; Collecott 1999; Reynolds 2000; Andreadis 2001; Yatromanolakis 2002; Écarnot 2002; Reynolds 2003; Yatromanolakis 2003b, 2006a; Prins 2005. Campbell 2004:191–204 is a thought-provoking and

tion of Sappho has not received proper attention and the ancient sources have been approached without systematic methodological apparatus that draws both on synchronic systems of signification and diachronic perspectives.[10]

The need to broaden our investigation is urgent. Sappho must be revisited from several different perspectives. One is her surviving textual corpus and its analysis. Contrary to what one might expect, given the amount of publications that appear every year, Sappho's texts preserved on papyri and parchments have recently suffered a relative lack of broad scholarly attention. Current critical editions do not incorporate new material and papyrological results that would facilitate literary analysis. More importantly, many parchments and papyri were transcribed and edited in the first half of the twentieth century. In their critical edition, Lobel and Page in certain cases did not reexamine the originals, but were based on previous papyrological and palaeographical work by Schubart, Zuntz, and several other scholars.[11] In her monumental edition, Voigt has regrettably adopted the same practice in numerous cases.[12] In their turn, cultural historians and literary critics have based their frequently influential analyses on puzzling or sometimes inaccurate texts.[13] Theories on Sappho have all too often rested upon further theories—linguistic, reconstructive, literary, cultural—all eventually based on the texts that Lobel-Page and Voigt offer. And, in a circular manner, literary testi-

---

insightful study. For collections of modern English and French poems translating, rewriting, or pertaining to Sappho, see Jay and Lewis 1996 and Brunet 1998. I examine different aspects of the modern scholarly reception of Sappho and of influential scholarly paradigms throughout this book; see further Yatromanolakis 2003a.

[10] For Sappho in medieval Greek literature there is no synthesis (the sources have not even been fully collected). For references to medieval Greek sources on Sappho, see Cataudella 1927; Ševčenko 1951 (cf. Gigante 1977); Browning 1960 (cf. Wirth 1963); Koster 1964; Moravcsik 1964; Cataudella 1965; Garzya 1971; Nickau 1974; Costanza 1976 and 1980; Christidis 1985; Pontani 2001. For a new medieval Greek source on Sappho in regard to her threnodic poems (Manganeios Prodromos 52.110–113), see Yatromanolakis 1999a:186. I would further add two intriguing sources: Manganeios Prodromos 5.192 and 49.162–165. Note that some (then) new medieval Greek sources were included in the corrected edition of Lobel and Page 1955 (1963):338; in Voigt 1971:addendum without page number after her page 506; and in Page 1974:155.

[11] To mention a few cases of recent treatments based on autopsy, and of the most recent material: Malnati 1993; Moretti 1995:23; Yatromanolakis 1999b; Steinrück 2000; Ferrari 2000; Ucciardello 2001; Gronewald and Daniel 2004a and 2004b.

[12] Lobel and Page 1955; Voigt 1971.

[13] Two significant examples of such texts are fragments 94 and 96 V: an examination of Voigt's detailed apparatus criticus for these fragments demonstrates the difficulty in determining which of the numerous different papyrological readings listed is the most accurate. Based on Voigt's (or Lobel-Page's) text, which often does not indicate the number of letters missing in lacunae, scholars have proceeded to propose different supplements and conjectures. See, e.g., Slings 1994.

monia related to Sappho are still widely used to ponder questions such as the role of *girls*—a marked category—in the "Sapphic circle" and in the society of archaic Lesbos.[14]

This book does not focus solely on the ancient reception of Sappho; it mainly aims to offer an anthropological *Problematik* and method for the investigation of ancient social dynamics and cultural idioms. The present study does not suggest that all the ancient reception is a series of cases of fictionalization. It attempts to create a dialogue with ancient sources and cultural economies and to approach them by means of conducting, as it were, historical fieldwork, while at the same time not suggesting that our "informants" are as unambiguous and always diachronically contaminated as we would hope. The fact that ancient representations are sometimes investigated between these covers in chronological sequence does not suggest any kind of stemmatic, unidirectional or evolutionary understanding of different synchronic indigenous ideas about Sappho across time.

I further propose that, in contrast to current sporadic outlines of *the* ancient reception of Sappho[15]—viewed as a unified conglomeration of miscellaneous images susceptible to modern *narrativization*—the preserved archival representations should be mapped out with regional differences fleshed out as much as possible. The divide between what we occasionally, commonsensically or retrospectively, seem to *expect* and to *have expected* from an investigation of reception, and the actual *practice* of contemporary analysis and reconstruction in Classics is, I want to stress, greater than one may wish to admit. The enterprise of challenging well-established concepts about Sappho may cause uneasiness or even retreat to the logic of the inclusion of such enterprises into the generic scheme of deconstructive historiography about the persona of such figures as Pythagoras and Erinna. What is at stake in this book is more intricate—and anthropologically more intriguing.

I do not attempt here a unified narrativization of different elements deriving from a marked choice of specific aspects reflected in the fragments and in ancient receptions—Roman and Greek—of the songs and the figure of Sappho. Although formative in the early stages, the *songs* were sometimes detached from synchronic modalities of scanning the *figure* of Sappho, which could lead an independent social life, as it were. This differentiation, even temporary or marked in ancient times, has been obliterated in modern eras.

---

[14] See, e.g., the otherwise wide-ranging book by Calame (1997:see above, n. 6).

[15] Dörrie 1975:13–29 (overly speculative); Lardinois 1989; Brooten 1996:32–39; cf. Nagy 1996a:219–221.

The early stages of the reception of Sappho provide a significant area within which current reconstructions and theories can be tested and new methodological paradigms can emerge.

## Paradigms and Filters

Sappho is a difficult author.[16] Unless the fragmentariness of her songs deceives us, they display, among other issues, a high degree of intricacy in terms of the pronounced use of pronouns, which, compared to patterns detectable in archaic male poets, are more enmeshed in almost contrapuntal exchanges.[17] Such dialogues make the work of a cultural historian even more complex in attempting to differentiate between, and define, the performative context and the descriptive context of the songs.[18] The singing voice converses with and addresses companions—female and male, directly or in embedded narratives[19]—as well as adversaries and Aphrodite. The goddess in turn replies to the poetic subject,[20] which in other songs is engaged in dialogue even with her *chelys* lyre:[21]

> ἄγι δὴ χέλυ δῖα †μοι λέγε†
> φωνάεσσα †δὲ γίνεο†

> come, noble *chelys*, speak to me
> take a voice

This fragment exemplifies a number of aspects of modern research on Sappho. For this reason, I shall pause here and focus on some marked methodological approaches to it.

The text was known to the late second century AD rhetorician Hermogenes and was widely read, even through Hermogenes' work, by medieval Greek writers. Hermogenes, who quotes the lines in his *On Types of Style (ideai)*,[22] claims that in this song Sappho addressed her lyre and the lyre replied to her.

---

[16] I here employ the word "author" only conventionally. In what follows, song-maker, composer, and poet are the preferred terms.

[17] With the editing of new papyrus fragments, this observation is confirmed.

[18] For the "performative context" and "descriptive context" of a song in the study of archaic melic poetry, viewed from a linguistic anthropological perspective and with regard to ritual, see Yatromanolakis 2003a:53–54.

[19] Sappho fr. 121 V.

[20] Sappho fr. 159 V.

[21] Sappho fr. 118 V.

[22] 2.4 (p. 334. 5–10 Rabe).

For him, the effect produced by assigning human capacities to objects like water was *glukutês* ("sweetness"), a feature often attributed to Sappho as well as to Herodotos in antiquity.[23] At the height of the Byzantine Renaissance in the twelfth century,[24] predating the Italian Renaissance in its cultural emphasis on Greek antiquity, medieval Greek authors like Eustathios of Thessalonike recast the lines in a more culturally reconstructive manner:

> Ὁμηρικῶς δέ πως καὶ ἡ λυρικὴ Σαπφὼ σχηματίζουσα τῇ κιθάρᾳ ἐγκελεύεται "ἄγε μοι, δῖα χέλυ, φωνάεσσα γένοιο."

The lyric poet Sappho too, in a somewhat Homeric figurative manner, urges her stringed instrument: "come, noble lyre, be eloquent for me."[25]

Eustathios preserves a different text for these two lines but, following a long tradition in textual criticism of ancient Greek literature, many editors have persistently trusted Hermogenes and his †μοι λέγε† without taking into account (this time respecting a similarly long tradition) the possibility that the unmetrical †... λέγε† is a marginal annotation that found its way into Hermogenes' text.[26] Even so, note that the meter of the two lines as they appear in Voigt's edition (fragment 118) is uncertain and has been assigned by Voigt to no book of the Alexandrian edition of Sappho.[27] Note also that the particle δή in line 1 is not found in Hermogenes and Eusthathios but, according to a 1814 report by C. J. Blomfield, a late manuscript of *On Types of Style* provides it.[28] Variant readings or new readings with poor support in the manuscript tradition of an author, but which seem appealing or superior to those preserved by the vast majority of witnesses, has been a phenomenon well attested and

---

[23] Hermogenes (*On Types of Style* 2.4, p. 334. 10–24 Rabe) provides an interesting discussion of *hêdonê* and *glukutês* in Herodotos 7.35.

[24] The most thorough and groundbreaking exploration of the revival of ancient Greek genres in twelfth-century Byzantium is provided in Roilos 2005.

[25] Eustathios on *Iliad* 1.1 (vol. 1, 16 van der Valk).

[26] The †δὲ in "line 2" would cause little problem to textual critics, who customarily excise particles and entire phrases from ancient Greek texts.

[27] Lobel and Page 1955 repeat verbatim the text and apparatus criticus printed earlier by Lobel (1925:51), but again they envisage two lines of uncertain meter—that is, a fragment considered by them impossible to assign to a certain book of the Alexandrian edition of Sappho. Lobel (1925:51), without any comment in his apparatus criticus, did not print λέγε in his text, but stated that "*post voc.* ἄγε (*sive* ἄγε δή, *Blomfield*) *neque* δὲ *neque optat. locum habet.*" Voigt (1971:127) remarked that "*cum a voc.* λέγε *aliquid dependere debeat, inter 1 et 2 fort. lac. statuenda.*" Both the tentative lacuna that Voigt points to and Lobel's contention have been forgotten in recent literary discussions of the fragment. The text that Voigt printed is taken for granted.

[28] Blomfield 1814:15.

insightfully discussed by Nigel Wilson.[29] Therefore, if correctly reported, δή causes no surprise and could be adopted—not, however, with unconditional certainty.

Despite the appearance of the editorial *cruces*, the situation is not as "tidy" as one might think when confronted with the text as printed by Voigt and other editors. In the early nineteenth century, Blomfield rendered the fragment as one line. He further substituted the transmitted χέλυ (*chelys* lyre) with χελύνη and added the annotation that according to the so-called "Etymologicum Magnum," a medieval Greek lexicon with an interesting history, the Aeolian name for χελώνη was χελύνη.[30] For the first part of his one-liner, Blomfield preferred the version transmitted by Eusthathios, δῖα χέλυ. He found no problem with Hermogenes' λέγε, but thought that μοι is most probably, but not certainly, a bogus reading. Therefore, the version he reconstructed was ἄγε, δῖα χελύνη, λέγε, φωνᾶσα δὲ γίνεο—despite the fact that sixth-century BC Lesbians, as we understand their dialect nowadays, would use the form χελύννα. Later in the nineteenth century, a highly influential critical editor, Theodor Bergk, adopted a different version in his printed text.[31] The fragment appeared in two lines and in the following configuration: ἄγε δὴ χέλυ δῖά μοι | φωνάεσσα γένοιο.

In this version, Hermogenes' λέγε is again undermined and Eustathios' version is almost unconditionally opted for. The only comment that Bergk added was that two German-speaking scholars, C. F. Neue and J. A. Hartung, had offered the versions ἄγε δῖα χέλυ μοι λέγε and ἄγε μοι χέλυ δῖα, respectively, for the first line. After the publication of other German anthologies, Bergk's Sappho fragment 45 eventually became Ernst Diehl's Sappho fragment 103.[32] Diehl actually suggested a change in a dialectal feature: ἄγι <δὴ>, χέλυ δῖά, μοι | φωνάεσσα γένοιο. And he kept Eustathios' version almost intact. Diehl's authoritative, impressive command of ancient Greek dialects and meter did not detect any metrical uncertainties in the text. Following earlier attempts, he assigned the two lines to the fifth book of the Alexandrian edition, presumably since he found in them a relative metrical affinity to Sappho fragment 101 V, which, according to Athenaios, was included in the fifth book of the

---

[29] Wilson 1987.
[30] See Etymologicum Magnum s.v. χελύνη (δηλοῖ καὶ τὴν κιθάραν παρ' Αἰολεῦσι). However, there are earlier sources for this: see Orion 28.15 s.v. ἀμύμων· ... τροπῇ δὲ τοῦ ω̄ εἰς ῡ. ὡς παρὰ Σαπφοῖ, χελώνη χελύνη; Etymologicum Genuinum s.v. ἀμύμων (based on a version of Orion's entry); and cf. Hesykhios s.v. χελύνη· τὰ χείλη, ἄλλοι τὴν κιθάραν. καὶ τὴν χελώνην. καὶ λύραν [...].
[31] Bergk 1882: 104 (fr. 45).
[32] Diehl 1925 (1923): 373 (fr. 103); Diehl 1936: 64 (fr. 103).

Alexandrian edition.[33] In the second edition of his *Anthologia Lyrica Graeca*, Diehl noted that Edgar Lobel (out of frustration or his customary overskepticism?) suspected that a number of readings transmitted by Hermogenes and Eustathios were not correct.[34] Yet, Diehl and Eva-Maria Voigt were not eventually convinced by Lobel's somewhat sweeping views.[35]

One could go on and defend a different version of the transmitted texts. However, another source, that of Mikhael Italikos, unearthed after Voigt's edition, confirmed a number of points and added new elements: ἄγε τοίνυν χέλυ δῖά μοι, λεγέσθω γὰρ ἐπικαίρως τὸ τῆς Σαπφοῦς, φωνητικωτέρα τε γίνου καὶ εὔφωνος καὶ πολύφωνος, καὶ τὰ βασιλέως ἐπαίνει καλά ("come, then, divine *chelys*—be the poem of Sappho (re)cited opportunely—become for me more resonant and sweet-toned and many-voiced, and praise the king's merits/benevolence").[36] What is noteworthy is that, probably some time before Eustathios, Mikhael Italikos, who was also familiar with Sappho's wedding songs,[37] located Sappho firmly in a praise context.

One might want to make four observations with regard to textual research on Sappho fragment 118V. The search for origins—the archaic song that Sappho composed and that was at a certain point written down—has been the most lasting and authoritative paradigm in scholarship on Sappho since

---

[33] Athenaios 9.410d–f.

[34] As a sample of learned and painstaking papyrological work, taking into account Lobel's editions of Alkaios and Sappho (1925 and 1927, much of which was reprinted, slightly revised, along with new material in Lobel and Page 1955) and his numerous *editiones principes* of papyrus fragments, one discerns that sometimes overskepticism may be the easy way out of a thorny textual problem. While methodologically important and often justifiable in the case of editing fragmentary texts, overskepticism, potentially operating as a boomerang, can be detrimental to research on ancient Greek cultural history or religion by scholars whose main methodological tools coincide with a desire to undermine everything the ancients (or medieval Greek sources) report. On this kind of scholarly overskepticism, see, from a different perspective, the sophisticated discussion by Sourvinou-Inwood 2002:176–177, 2003, and 2005.

[35] Treu 1984:82 and 219 accepted Diehl's version. Tzamali 1996:440 prints ἄγε, χέλυ δῖά, μοι λέγε | φωνάεσσα δὲ γίνεο and comments on ἄγε (arguing against Diehl's ἄγι).

[36] For another neglected but intriguing source that associates Sappho's songs with their performance by kings, see Chapter Three, p. 223. Moreover, Christidis 1985:4–5 adduces two more medieval Greek sources for Sappho fragment 118 V: Niketas Magistros *Epistles* 31.5–9 Westerink (εἰσάγουσί τε γάρ, γλυκαίνειν ἐθέλοντες τὸν λόγον, ἱστορίας καὶ μύθους καὶ τὸ πολλάκις προσομιλεῖν τοῖς ἀψύχοις· ἃ κηλοῦν μὲν οἶδε τὰς ἀκοάς, οὐ λυσιτελεῖν δὲ πρὸς σωτηρίαν ψυχῆς. οἷά που τὰ τῆς Σαπφοῦς ἐκεῖνα ῥήματα. "Ἄγε χέλυ δῖά μοι λέγε | φωνάεσσα δὲ γίνεο") and a poem attributed to Theodoros Prodromos ("Ἄγε μοι χέλυς παλαιὰ ῥητορικῶν [Christidis: ῥητόρων] χειλέων | ...). Niketas Magistros (tenth century) drew his quote from Hermogenes. As Christidis notes, Page 1974:155 referred to Mikhael Italikos' testimony as "*textum adhuc ineditum*" but the text had been edited by Fusco 1969/1970:153 and Gautier 1972:247.

[37] Sappho testimonium 194A V. Cf. also the text in Cramer, *An. Ox.* iii 169, attributed to Mikhael Italikos, where a reference to Σαπφικὴ χάρις.

at least the nineteenth century.[38] Even deconstructive attempts[39] or literary approaches that undermine the trustworthiness of a manuscript reading, without adducing additional evidence either from the poetics of the fragments of Sappho themselves or especially from different sociocultural aspects of the ancient reception of her songs,[40] aim at a reconstruction of the *original context* of a poem. I do not wish to suggest that this significant paradigm should not be embedded in research on textual criticism. On the contrary, wide-ranging approaches to the textual transmission of particular authors have often led to groundbreaking results. Also, my concern here is not whether or not there were different versions of Sappho fragment 118 V in Greek antiquity—a broader issue that will be investigated later in this book. What I point to is the effort to locate in such text-critical attempts *evidence* for the contextual—sociopolitical, cultural—webs of signification that, according to a number of scholars, lie behind the texts printed by critical editors. More specifically, emendations and prescriptive taxonomies of dialectal features have, in the case of Lobel and Page, contributed to an understanding of Sappho's poetry that promotes such distinctions as dialectally "normal" and "abnormal" poems—the latter assigned to a specific book of the Alexandrian edition of Sappho, the so-called book of the Epithalamians.[41] Lobel and Page's work on Sappho intended to be as objective as possible in terms of the linguistic observations and somewhat rigid classifications they advanced. However, their taxonomies were taken over by literary scholars to propose numerous ideas about poetic genre in Sappho, about how this issue was treated by the Alexandrians and what solution they gave in their Hellenistic editorial practice, and about several aspects of the performance and transmission of Sappho's songs in antiquity. I shall return to the issue of origins in the course of this book.

The second observation I would make is that the different critical editors considered above essentially *rewrote* the text of the original song of Sappho. In a fashion reminiscent of the early textual editing of versions of traditional songs by English and other collectors of oral poetry in an attempt to reach an *Ur*-version, textual critics in Classics have reconfigured the metrical structure and dialectal features of the so-called Rhodian "swallow-song" (*carmen popu-*

---

[38] This scholarly paradigm is earlier than the nineteenth century and is also exemplified in ancient sources.

[39] Deconstructive is here not employed in the sense associated with the work of Jacques Derrida.

[40] See, for example, Most 1995 and Lidov 1993; on Lidov 1993, see the criticism of Stehle 1997: 289n92 and Edmunds 2001:12–13.

[41] Lobel 1925 and 1927; Page 1955: (cf. his p. 338:"abnormal" dialect). On Lobel's linguistic theories about the Lesbian dialect, see Hooker 1977; cf. Bowie 1981. On the book of the epithalamian songs, see Yatromanolakis 1999a. See further Yatromanolakis 2007a.

*lare* 848 *PMG*) several times.[42] Although successive versions may well denote considerable progress based on scholarly results in linguistics and metrics, such renderings have been conducive to our current understanding of what an ancient Greek "folksong" is.[43] Similarly, but more markedly, the fragments of Sappho have been *rewritten* numerous times. I do not refer here to the more evident case of the papyrus fragments and the different supplements advanced by different hands. It is those fragments transmitted through indirect tradition—that is, those quoted in ancient treatises and literary texts and known to scholars long before the discovery of Greek papyri in Egypt in the late nineteenth century—that have often received *marked*[44] reconstructions, which place them in specific, again reconstructed, taxonomies. Such taxonomies have been necessary and most helpful, but in an attempt to *write* the history of diverse cultural phenomena in archaic Greece, cultural historians, especially more recently, tend to overlook the *discursivity* of textual reconstructions of quoted fragments. These quoted fragments have further determined to a significant degree the reconstructions of the language and cultural contexts of papyrus fragments of Sappho. Again, my objective is not to challenge the scholarly activities of modern editors, who have evidently made vast progress in constituting a text that represents, as faithfully as possible, the text critically produced in Hellenistic Alexandria. My emphasis is on representation and, more precisely, on the scholarly *discursivity* of such efforts that more often than not passes unnoticed. Ultimately my focus is on a more specific aspect: the *writing* and *rewriting* of modern historical narratives that reconstruct the original archaic Greek realities and idealities related to the *marked* case of a woman song-composer in Greek antiquity and, as a consequence, to

[42] Compare Page's text to Bergk's metrical analysis (1882:671–672) and to Diehl's text (1925:vol. 2, 201–202), not to mention Edmonds' edition (1940:526–529).

[43] On ancient Greek *carmina popularia*, see Yatromanolakis 2007b.

[44] The terms "marked" and "unmarked" are used in this book in their meaning in theoretical linguistics. The concept of "markedness" was developed by the theorists of the Prague School to describe the status/quality of a linguistic form as less neutral (see Battistella 1996; Tomić 1989; and Andrews 1990). My use of the notions of diachrony and synchrony also draws from theoretical linguistics, especially from Ferdinard de Saussure, without, however, their (sometimes) overly formalistic overtones in linguistics. I employ the term "synchrony" to refer to the study of a cultural phenomenon within its broader contemporary context. Here it is pertinent to clarify that my use of the concept of "imaginary" retains especially its marked theoretical associations in the work of Cornelios Castoriadis (notably in his discussion of *imaginaire social*, 'social imaginary'), which puts forward a sociological reworking of the notion as employed in Sartre and Lacan; in the latter's tripartite psychoanalytic schema, the imaginary occupies the middle position between the real and the symbolic. On the concept of social imaginary and its connections with Lacanian theory, see especially Castoriadis 1987.

other marked cases of male song-composers—choral and monodic at the same time—in different regions of what we call archaic Greece.

My third observation is related to the second: the choice between second-century Hermogenes and twelfth-century Eustathios by editors is determined by concerns not only strictly philological but also ideological. These concerns are related to ideas about the linguistic continuity between ancient Greece and medieval Greece. The main question here is whether the Byzantine Greek speakers understood ancient Greek and ancient Greek literature better than we do (that is, English, French, German, Greek speakers). Often the answer is negative—especially, but not exclusively, by British researchers; but striking cases occur of modern misunderstanding of the medieval Greek representation of ancient Greek. Even for earlier periods, the concept that our approach to ancient Greek texts is frequently more critical and nuanced than that of a perceptive author like the first-century BC Dionysios of Halikarnassos can put aside issues related to our discursivity. I shall consider one case of such a methodological perspective.

In the *Orestes*, Euripides presents Elektra urging the Chorus of Argive women, at their entrance into the orchestra, to move quietly, with a soft tread, lest they wake the sleeping Orestes. In his treatise *On Arrangement of Words* (Περὶ συνθέσεως ὀνομάτων), in the context of an analysis that places emphasis on aural dimensions and performative aspects of words and poetry, Dionysios of Halikarnassos provides an intriguing, relatively detailed discussion of the music of this part of the tragedy.[45] Dionysios' point is that, as was evident to him by numerous compositions and especially by choral songs of Euripides, music would require that words be subordinate to melody, and not melody to

---

[45] *On Arrangement of Words* 11 Usener and Radermacher (1929:40–43), 11.15–22 Aujac and Lebel (1981:94–96). Dionysios' analysis is embedded in a broader discussion of music and spoken language. On important issues related to Dionysios' discussion, see, especially, Koller 1956:25–27, Pöhlmann 1960:19–24, 39 and 1970:82, Usher 1985:78–79, Devine-Stephens 1991 and 1994:84, 120, 169–170, 215–223 (on the development of stress accentuation in ancient Greek), Parker 2001:37–38. I plan to examine elsewhere Chapter 11 of Dionysios' *On Arrangement of Words*. An ancient scholion on line 176 of the *Orestes* offers further information about the music and performative dimensions of the second strophe of this ἀμοιβαῖον, without commenting on the antiquity of the musical setting discussed there (note, however, that the *Orestes* was the most popular tragedy of Euripides in antiquity; on its popularity, see Willink 1986:lxii–lxiii): τοῦτο τὸ μέλος ἐπὶ ταῖς λεγομέναις νήταις ᾄδεται καί ἐστιν ὀξύτατον. ἀπίθανον οὖν τὴν Ἠλέκτραν ὀξείᾳ φωνῇ κεχρῆσθαι, καὶ ταῦτα ἐπιπλήσσουσαν τῷ χορῷ. ἀλλὰ κέχρηται μὲν τῷ ὀξεῖ ἀναγκαίως, οἰκεῖον γὰρ τῶν θρηνούντων, λεπτότατα δὲ ὡς ἔνι μάλιστα (text in Schwartz 1887:116; codex B, which preserves the scholion, provides the reading λεπτότερον, while Schwartz printed λεπτότατα). A new edition of scholia on Euripides in *all* preserved manuscripts is a scholarly *desideratum*.

words (τάς τε λέξεις τοῖς μέλεσιν ὑποτάττειν ἀξιοῖ καὶ οὐ τὰ μέλη ταῖς λέξεσιν). What Dionysios referred to was the relationship between the pitch accent that characterized ancient Greek of early periods and the musical movement of a composition. In this context, he quoted the introductory words of the Chorus and Elektra's admonition to them as they move/dance in the orchestra in *Orestes* 140–142. This is the text that Dionysios quotes and then analyzes musically:

σῖγα σῖγα, λεπτὸν ἴχνος ἀρβύλης
τίθετε, μὴ κτυπεῖτ᾽ ·
ἀποπρὸ βᾶτ᾽ ἐκεῖσ᾽, ἀποπρό μοι κοίτας.

Quietly, quietly, your shoe-tread place
lightly, make no stamping sound;
withdraw from there—that way—do withdraw from the bed.[46]

Even if we assume that Dionysios discussed a new, not the original Euripidean, musical setting of this section—certainly an attractive idea—[47] the first three words σῖγα σῖγα, λεπτὸν were sung, according to a score that he consulted or, more likely, I believe, according to his experience with reperformances of the song or of the play,[48] to the same musical note, despite the occurrence of the acute and grave modulations of the words' accents.[49] As for τίθετε, μὴ κτυπεῖτ᾽, Dionysios' close familiarity with both the music he had listened to and the copy of the text his papyrus scroll provided him with makes explicitly clear

[46] Usener and Radermacher 1929:42 more experimentally and, I believe, perceptively print σίγα σῖγα, while British editors of Euripides' *Orestes* normally opt for absolute consistency and print σῖγα σῖγα (cf. Euripides *Herakles* 1067 σῖγα σῖγα and *Orestes* 183–184). The manuscripts are divided between σίγα σίγα and σῖγα σῖγα (or σιγᾷ σιγᾷ in V, according to Diggle 1994:198). Cf. Aujac and Lebel 1981:95, who print σίγα σίγα and Biehl 1975:13, who prefers σῖγα σῖγα. In recent critical editions, lines 140–141 are attributed to the Chorus, while line 142 to Elektra; see, concisely, Willink 1986:10 and 105. Dionysios and certain manuscripts preserving the lines in question of Euripides' *Orestes* provide λευκόν instead of λεπτόν in line 140. See below, n. 53.

[47] Dionysios does not specify whether he discusses a new setting or the old one composed by Euripides and does not provide diachronic markers with regard to his analysis of music and tonal accent and pitch.

[48] In chapter 11 of his treatise, Dionysios refers to his first-hand familiarity with contemporary theater culture (note his emphasis on "the most popular theaters packed with crowds of men of all kinds and of no refinement"): ἤδη δ᾽ ἔγωγε καὶ ἐν τοῖς πολυανθρωποτάτοις θεάτροις, ἃ συμπληροῖ παντοδαπὸς καὶ ἄμουσος ὄχλος, ἔδοξα καταμαθεῖν […]. Cf. Dionysios' comparable claim in the same context: τὸ δ᾽ αὐτὸ καὶ ἐπὶ τῶν ῥυθμῶν γινόμενον ἐθεασάμην […].

[49] According to Dionysios, in (fifth-century BC?) spoken language, an acute accent denoted that the voice be raised no more than three tones and a semitone (οὔτε ἐπιτείνεται πέρα τῶν τριῶν τόνων καὶ ἡμιτονίου), that is, what was called διὰ πέντε.

that this is what Euripides' text looked like in the first century BC. Actually, a slightly fuller version of this reading—that is, τίθετε, μὴ κτυπεῖτε—is attested in almost all medieval manuscripts preserving the *Orestes*.[50] A late-twentieth-century critical editor, whose understanding of the manuscript tradition of the *Orestes* can hardly be challenged, chose to print the following version of the lines:

Χορός    σῖγα σῖγα, λεπτὸν ἴχνος ἀρβύλας
         τίθει, μὴ κτύπει [μηδ' ἔστω κτύπος].

'Ηλέκτρα   ἀποπρὸ βᾶτ' ἐκεῖσ' ἀποπρό μοι κοίτας.

Dionysios' account of τίθετε, μὴ κτυπεῖτ' cannot have been affected by scribal errors or defective transmission. The musical structure he describes necessitates the forms τίθετε, μὴ κτυπεῖτ'.[51] The modern editorial intervention is not as *marked* as those detectable in the "quoted" fragments of Sappho,[52] but the fact that other, possibly stylistic, considerations made James Diggle adopt or even propose the reading τίθει, μὴ κτύπει, when the medieval manuscripts almost unanimously point to τίθετε, μὴ κτυπεῖτ(ε), shows the extent of trust he had in either the ancient Greek critic Dionysios or the medieval Greek scribes and the cultural intricacies that often lie behind them.[53] When a modern English or Greek composer produces an *arrangement* of some so-called folksongs, should one assume that even the skeletal musical structure has not been exploited? In other words, arrangements of traditional songs (especially) by Nikos Skalkotas or Benjamin Britten retain this structure, and the work of a music analyst, if she or he decided to trace the "original" version of a specific song, would be to focus on the skeletal structure provided by Skalkotas and

---

[50] The manuscripts are split between τιθεῖτε and τίθεται. The same is true for the manuscripts preserving the text of Dionysios (see Usener and Radermacher 1929:42).

[51] *On Arrangement of Words* 11 Usener-Radermacher (1929:42) καὶ τοῦ 'τίθετε' βαρυτέρα μὲν ἡ πρώτη γίνεται, δύο δ'αἱ μετ'αὐτὴν ὀξύτονοί τε καὶ ὁμόφωνοι.

[52] For extensive analysis of marked editorial interventions in "quoted" fragments, see Yatromanolakis 2007a.

[53] On similar generalizing scholarly prejudices against medieval Greek scholars, see the account in Willink 1986:lix. Although Willink himself argues—with regard to the Hellenistic text of Euripides' *Orestes*—that "in some places it may appear that there was no single standard reading" (1986:lxi), he unreservedly considers Dionysios' λευκόν in line 140 an error (1986:106 and 107; cf. Diggle 1991:17, 31, 126). For the sources, including ancient scholia, preserving λευκόν, see Diggle 1994:198 (Diggle prints λεπτόν in line 140) and cf. Willink (1986:lxi): "that vulgate [of the select plays of Euripides] was never completely stable, and it needed the accompanying scholia in which variants (often better readings) were recorded." Dale 1968:205n1 had wondered "whether we are justified in assuming that Dionysios could not have read τίθεται," the version provided by a number of manuscripts.

Britten, or perhaps Ravel in his *Five Greek Folk Songs*, which present arresting similarities to Greek songs from Asia Minor collected at that time by French and German scholars. Such a type of research is considerably complicated; that is why overskepticism is perhaps not commendable. Unless one hypothesizes that the Byzantine Greek literati were almost always more "primitive" or idiosyncratic in their scholarly enterprises than, say, the English or the Greeks,[54] there is no serious reason to mistrust a priori their linguistic and literary insights. It might be intriguing to attempt to understand the linguistic and cultural context within which they worked, especially since their role in the preservation of ancient Greek literature was so central. If scholars in science studies are right in stressing that scientific facts in laboratories are expertly constructed by those who participate in experiments,[55] should historical and philological experimentation be more immune to possible scholarly fictionalization?

A fourth observation has already been adumbrated in my arguments so far. Authority and erudition—not easily assigned to critical editors in the history of the field of Classics—are features especially conducive to the establishment and general acceptance of a particular configuration of the fragmentary texts of an ancient author. As late as the year 2004, three early Ptolemaic papyrus fragments furnished the scholarly community with additional text for Sappho fragment 58 V—now an almost complete song—as well as a few other short fragments.[56] Since then a highly intensive scholarly endeavor has attempted to supplement the fragments[57] and, more importantly for the present book, to *rewrite* the original social context of the songs of a woman poet whose archaic Lesbian culture displays large gaps of indeterminacy.[58] The supplements that may prevail in the establishment of the text—and context—of the "new fragments" in a near-future critical edition of the textual corpus of Sappho could be partly associated with the distinctive authority of a textual expert in archaic melic poetry.[59]

[54] For a discussion of the modern tendency in classical archaeology to highlight the "primitiveness" of the ancient past, see Neer 2002:2.
[55] Latour and Woolgar 1979.
[56] See Chapter Three, pp. 203–204, and Chapter 4, p. 360 n. 341.
[57] See, among other hypothetical reconstructions, West 2005. West 2005 advances interesting arguments about different aspects of the text of the three Ptolemaic papyrus fragments.
[58] For "gaps of indeterminacy," a notion used by Iser with regard to the reception of texts (to be sure, not necessarily fragmentary like Sappho's), see Iser 1974 and 1978:24, 59–60, 172–175, 203–206.
[59] In view of the discussion thus far, it is noteworthy that even textual critics and editors of considerable learning and consummate command of ancient Greek like M. L. West prioritize certain scholarly traditions at the expense of both the actual situation with the texts of Sappho and of the early twentieth-century German tradition and the high standards set by such editors

In this context another, more pervasive, methodological approach to Sappho is appropriate for consideration. Scholarly authority is reflected in the multileveled use of generalizations in older and current scholarship on Sappho. A scholarly theory can often be considerably less detrimental to cultural historians focusing on archaic Greece and Sappho than scholarly generalization. Often presented in a more marked and authoritative manner than those found in literary-historical outlines in handbooks, statements that tend to generalize and provide information as something given and even substantiated constitute a scholarly modality especially applicable to such problematic figures as Sappho and Homer. A 1995 article holds that "we know for a fact that at least some of Sappho's poems continued to be sung enthusiastically in *symposia* and studied carefully in schools, in Athens and elsewhere in Greece, from the 5th century BC until the end of antiquity."[60] The marked, almost exaggerated discursivity of this scholarly statement is supported in a footnote by another sentence characterized by similar succinct brevity: it maintains that the evidence for the presence of the poetry of Sappho in fifth-century Athenian drinking-parties comes from the Attic vase-paintings listed by Gisela Richter in her 1965 catalogue of ancient Greek portraits.[61] It further notes that (the colossal philological figure of) Ulrich von Wilamowitz-Moellendorff is a good source of information provided about vase-paintings, and very late sources germane to such a sympotic, textual representation of Sappho

---

as W. Schubart and E. Diehl: "Since Edgar Lobel set new standards in the 1920s, the Lesbian poets have been fortunate in their editors. The *Poetarum Lesbiorum Fragmenta* of Lobel and Page (Oxford, 1955) still stands as a gaunt landmark with only slight signs of erosion" (review of Liberman 1999 in *Classical Review* 51 [2001]:4). That Lobel and Page in 1955 decided, unnecessarily to my mind, to break free from the overall numeration system established by Diehl, thus adding one more system (this time with two subdivisions, editorial numbers and book-numbers!) to the previous systems is indicative of this prioritization of traditions. Instead, Voigt (1971) retained Lobel and Page's system, but, in contrast to them, she cited in each case Diehl's established numeration system. Note that the same practice was adopted by Diehl (who cited the numeration of T. Bergk's important edition) and is currently being subscribed to by numerous critical editors, notably Rudolf Kassel in his and C. Austin's *Poetae Comici Graeci.*

[60] Most 1995:31. For footnotes in classical scholarship and the appeal to early authorities like Wilamowitz, see Nimis's interesting and amusing discussion (1984).

[61] Richter 1965 was aware of three vases: *hydria* in Warsaw, National Museum 142333 (formerly Goluchow 32; *ARV* 300; *Para.* 246); red-figure *kalathos-psykter* in Munich (2416; *ARV* 385.228, 1573, and 1649; *Add.* 228); and red-figure *hydria* in Athens, National Archaeological Museum (1260; *ARV* 1060.145; *Add.* 323). Wilamowitz (1913:40–42, which Most 1995 cites) did not examine the three vases but referred only to some of them in passing. Both Richter (1965:71) and Richter and Smith (1984:194–196) do not discuss the relevant vases, nor do they include in their lists the red-figure *kalyx-krater* Bochum, Ruhr-Universität, Kunstsammlungen Inv. S 508. As I show in Chapter Two, this *kalyx-krater* provides the only certain visual clues that we have about Sappho being performed in early fifth-century Athenian *symposia*. Cf. Yatromanolakis 2001a.

are listed.[62] This idea is cited in another article as "a conclusion" reached in 1995.[63] The complications stemming from such an approach to images and texts are multiple. In his brief report Wilamowitz actually did not comment on, or refer to, a possible sympotic use of the vases. More importantly, this approach assumes centuries of cultural continuity on the basis of late sources. This phenomenon is observable in a number of studies of the reception of ancient prose writers and poets: specifically, what our sources may suggest for a certain century or decade is taken as applicable to previous centuries; centuries are thus counted like years. Besides, as I argue in Chapter Two, the shape of only one out of the four vase-paintings depicting Sappho can be associated with the context of Attic *symposia*. The existence of the other vases does not entail that they were used at drinking-parties nor that Sappho was performed at fifth-century *symposia*.[64] No attempt at distinguishing between the shape of a vase and the visual signs employed in the image painted on it is made in the scholarly statement quoted above. The power of long and rigid cultural continuity within Greek antiquity is invoked as evidence for the uninterrupted performance of Sappho's songs in *symposia* (and their study at schools?) "in Athens and elsewhere in Greece."[65] In contrast to the current scholarly paradigm that intuitively envisages Sappho in the context of archaic and fifth-century *symposia* on the basis of very late literary sources, I argue that these sources do not validate the relevant claim. From a different perspective, another scholarly statement reads as follows: in the fifth century "Sappho appears to have become the paradigmatic *hetaira*."[66] This is observed while no synchronic evidence is cited to support the idea and in fact no explicit literary evidence from this period exists. Such generalizations, not substantiated through an investigation of the archaeological material or of the *poetics* and *discursivity* of the much later textual sources cited, have been part and

---

[62] These late representations are examined in Chapters Two and Three.

[63] Lidov 2002:228n58, referring to Most 1995:31.

[64] Note that Most 1995 is actually unaware of this *kalyx-krater*. Therefore, his statement is based on the other three vases—two *hydriai* and a kalathoid vase.

[65] On the same page (1995:31), Most further argues that *incerti auctoris* 25 C Voigt (= Aristophanes *Wasps* 1236–1237, according to Most) shows that "Aristophanes himself alludes to Aeolic poetry as being well known in Athens." But the fragment *incerti auctoris* 25 C in Voigt's edition does not suggest anything of the kind.

[66] Lidov 2002:229, in the context of his comment that it is "striking that Herodotus' only uses of *hetaira*—which are also the first surviving occurrences of the word in Greek in the sense of 'prostitute' or 'courtesan' —occur in a passage that connects the *hetaira* in question [Rhodopis] to Sappho. I conclude that Herodotus is reflecting a contemporary development whose popular expression would be found in comedy." For another case of constructing allegedly "paradigmatic" figures, cf. Yatromanolakis 2001b: 222–223.

parcel of recent research on Sappho.[67] An archaeological investigation may show that such modern generalizations can be culturally determined and constructed. What we expect or have expected may be somewhat ambiguous or impressionistic. The problem does not lie in the use of generalizations but rather in their tendency to be habitually internalized and become "ancient realities."

Such paradigms, in the sense introduced by Thomas Kuhn in the history of science and the sociology of knowledge,[68] have considerably determined the study of Sappho. Centuries of European voices engaging in creative, intertextual dialogue with her poetry and its fragmentation have been significant for the way in which scholars have viewed her poetry.[69] Artists have attempted to detect even the "original" sound symbolism of her words.[70] In this context, scholarly arguments have been particularly charged with culturally constructed ideas. As far as the issue of sexuality as reflected in Sappho's poetry is concerned, researchers tend to subscribe to either of two polar paradigms—homoerotic or heterosexual, the former being subdivided into different categories of formality or intensity. Sappho's songs are currently characterized as "frivolous,"[71] the name that biographical tradition provides for the

---

[67] The number of cases is large. I here refrain from citing examples, since this is not my main point.

[68] Kuhn 1962. Note that Kuhn's work was first published as a monograph in 1955 (in the *International Encyclopedia of Unified Science*, vol. 2, Chicago). On paradigms in the study of archaic Greek literature, cf. Yatromanolakis 2003a.

[69] Two examples will suffice: in the *Intermediate Greek-English Lexicon* (founded upon the seventh edition of Liddell and Scott's Greek-English Lexicon, reprint Oxford 1997), a dictionary widely used in university courses, the definition for the verb λεσβιάζω is still "to imitate Sappho (the Lesbian poetry)." In Ps.-Loukianos *Erôtes* 28, an intriguing passage related to female homoeroticism is translated by M.D. Macleod in the Loeb series (*Lucian*, vol. 8, Cambridge, Mass. 1967:195) as "Let wanton Lesbianism—that word seldom heard, which I feel ashamed even to utter—freely parade itself, and let our women's chambers emulate Philaenis, disgracing themselves with Sapphic amours." Macleod's "Sapphic amours" is a scholarly rendering of ἀνδρογύνους ἔρωτας. The fact that "Sapphic" has specific connotations in English does not make the case clearer. Note that LSJ (along with its revised 1996 supplement) has kept the definition "Sapphic" in the entry ἀνδρόγυνος (3b "of women"). For other cases where LSJ provides such definitions for complex words—and, more specifically, for the need to conduct, as much as possible, linguistic anthropological examinations in the study of archaic Greek and classical literature—see Chapter Three.

[70] Following a long tradition of theatrical and poetic works entitled *Psappha*, Iannis Xenakis's *Psappha* (1975) is perhaps the most sophisticated European musical text that attempts to reconstruct the "sonorities" of Sappho. The bibliography on Xenakis is vast (see Barthel-Calvet 2000 and Solomos 2001); on his *Psappha*, see Yoken 1985, and Flint 1989 and 2001.

[71] Lardinois 1989:24–25 ("Could it be that her frivolous songs praising the beauty of young girls gave rise to the assumption that she would also have been more than willing to sleep with numerous men, preferably in a shameless manner?").

husband of Sappho is unreservedly taken to have been a comic joke name,[72] and questions such as the following are posed: "If Sappho's poems, at least some of which were familiar to Athenian audiences, had directly contradicted the comedians' image of her, we might *expect* someone to have protested" (my emphasis).[73] One might wonder *who* would have reacted and in what contexts.

Comedy has been considered the exclusive evidence for the early reception of Sappho. Unfortunately we know nothing about the "old-comic," late-fifth or late early-fourth-century play *Sappho* attributed to Ameipsias, the first known comedy with Sappho as its main theme. All the other (fragmentary) plays are later. Comedy has become so much part of the current scholarly habitus that it is difficult to account, even briefly, for a specific reception of Sappho in antiquity without resorting to those fragmentary plays or to plays

---

[72] Categorically in Parker 1993:309–310: "he's Dick All-cock from the Isle of MAN." In the ancient Greek Κερκύλας, the emphatic "All-cock" can not be easily detected, while in modern American English, as native-speaking colleagues confirm, the name Dick (Richard) does not sound obscene when addressed to a man in all the contexts that do not involve a heated fight. Wilamowitz (1913:24) and Aly's views (1920:2361) were more flexible. See, further, Chapter Four, p. 294 and n. 36.

[73] Most 1995:31. In this article, Most argues (1995:31) that "the violence performed upon Sappho by reading ἐς σ' ἴδω in line 7 [of fragment 31 V], as English editors and those who have followed them have done throughout this century (...) is ... insidious," since, according to him, it distorts the ambiguous character of the fragment, and, more generally, the literary reception of Sappho's poetry. Most believes that "matters are in fact much more complicated" (1995:129). However, four observations on his views may be necessary: i) the evidence of Ploutarkhos cannot be readily dismissed as representing a simplification of the deliberate ambiguity of the passage. Instead, Ploutarkhos should be studied as an informant about the ancient reception of Sappho; ii) the wide application of the notion of ambiguity to fragmentary melic texts is arguably precarious: the distinction between ambiguity due to poetic intentionality and ambiguity due to poor textual transmission may not be so clear-cut; iii) one should agree with Most that Hermann was a great authority of nineteenth-century classical scholarship and his views should be duly taken into account by modern critical editions (Most holds that "no modern edition of Sappho mentions Hermann's conjecture, either in its text or in its apparatus or in its commentary" (1995:30); it is not clear what he means by "modern," but a critical edition still used and cited by a number of scholars, that of Diehl [1936] in the Teubner series, cites Hermann's emendation). However, although Hermann printed this emendation—without providing any further comments—in 1816, he changed his mind in an article of 1831, where he argued for a different emendation, ὡς ἴδω γάρ σε βροχέ'; iv) [G.] Most further attempts to turn his detection of gender ambiguity in certain poems of Sappho (frs. 1, 16, and 31 V) to advantage by suggesting (1995:33) that "we may even be able to distinguish in this regard between those poems of Sappho's that were read in schools and widely disseminated in ancient culture (and which are therefore transmitted as citations in the manuscripts of rhetoricians) and those which circulated only or primarily within collected editions of her works for a highly literate and specialized audience (and which have only survived on papyri)"; to my mind, such a subtle, hypothetical distinction goes too far.

that are reconstructed anew.[74] Going a step further, Kenneth Dover argues that "the patently lesbian character of some poems of Sappho did not damage her reputation as a poet, but in the classical period admiration for her art seems to have coexisted with something like a 'conspiracy of silence' about any sexual orientation which resembled hers."[75] Dover's belief in a "conspiracy of silence" is shared, implicitly or explicitly, by numerous scholars who attempt to understand why there seems to be no reference to homoeroticism with regard to Sappho in fifth- and fourth-century evidence.

If, instead of "evidence," we attempt to view sources as *informants* and to conduct archival, as it were, fieldwork in the context of ancient sociopolitical, cultural idioms, our methodological approaches to ancient communities and sociolects change. At the same time, close attention must be paid to the transmission of Sappho's songs—not only in antiquity, but also, if not more persistently, in modern times. It is more often than not overlooked that (some of) the longer papyrus fragments, as they stand in Voigt's important edition, may well comprise remains of two separate songs.[76] As far as the corpus of the fragments of Sappho allows us to see, many of her songs were relatively brief. Further, the issue of those Lesbian Aeolic fragments that have been categorized as "incertum utrius auctoris fragmenta," that is, those that may be attributed to either Alkaios or Sappho (or to neither of them), must be revisited, since they constitute sources of some significance.[77] Before I embark on an exploration of the earliest, late archaic, classical, and early Hellenistic informants, I shall develop the theoretical method that shapes the anthropological fieldwork on the ancient reception of Sappho undertaken in this book.

## Classics and Anthropology

The study of Greek and Roman antiquity has been often fruitfully crossfertilized with literary and critical theory. Formalism, structuralism, psychoanalytic approaches, deconstructionism, feminism have contributed useful insights to the study of ancient literatures and cultures. Despite the field's openness to theoretical critical discourses, classics as a whole still approaches

---

[74] See e.g. Lidov 2002. This approach is by no means confined to Lidov 2002, but is to be found in all relevant discussions.

[75] Dover 2002:226.

[76] See the papyrological arguments in Yatromanolakis 1999b, where it is shown that Sappho fr. 22 V actually consists of two separate fragments. Further confirmation of my argument here is provided by the early Ptolemaic papyri edited by Gronewald and Daniel (2004a and 2004b).

[77] The fragments are collected in Voigt 1971:359–376. A few more fragments may be added to those edited by Voigt. I investigate this issue in Yatromanolakis 2007a.

anthropology as the exotic, that is, intriguingly ambiguous "other." To be sure, anthropology is not a terra incognita for classicists. From James Frazer and the early twentieth-century Cambridge School to the principally structuralist anthropology of ancient Greece in Paris, to more recent concerns for cultural continuities and discontinuities in Mediterranean Europe and comparative approaches to ancient Greece through ethnographic explorations of Mediterranean countries, several scholars in the field like Jane Harrison, Louis Gernet, Marcel Detienne, Jean-Pierre Vernant, Christiane Sourvinou-Inwood, and John Winkler have opened insightful ways for a constructive interaction between classics and anthropology—or in the case of Gernet and a few other classicists, between classics and sociology.[78] Despite such enterprises, the dominant tendency in classics is to view anthropology and ethnographic accounts as repositories of possible parallels pertinent to typological comparisons with a view to bridging gaps in our knowledge of ancient Greek realities and to reconstructing such realities. Alternatively, focus on absolute differences, often themselves constructions of ideological essentialisms, becomes the main objective of an interest in anthropological accounts. Scholars who follow this approach, too, are mainly concerned with specific sociocultural phenomena but for opposite reasons: instead of parallels, they seek out dissimilarities. The following passage from an article on classical studies and anthropology, for instance, eloquently reveals this penchant for detecting what arguably may be self-evident differences among distinctive cultural periods, placing uncalled-for emphasis on contemporary Greece: "I conclude therefore with the nub of what I no doubt optimistically take to be my own objective observation of fundamental and irreconcilable differences between the mentality and ideology of the classical Greeks and those of modern Western society, including that of contemporary Greece."[79] Instead, epistemological and meth-

---

[78] According to his colleagues, Gernet was a sociologist of ancient Greece; see Detienne 2001:104 and Vernant's preface in Gernet 1968.

[79] Cartledge 1996:102. Being one of the few recent texts focusing on an interaction between classics and anthropology and published in a book outside the field of classics, it is odd that the largest part of Cartledge's entry discusses contemporary Greece. Albeit restrained by word limits, this modestly "objective" optimism at times manages to wane into a marked pessimistic subjective preference even to promote "foreign"—insightful, to be sure—analyses at the expense of purportedly inexistent "indigenous" self-reflexive studies (see, for example Kyriakidou-Nestoros 1978, a book that predates—and has been influential on—the books Cartledge cites): "to many modern Greeks, for example, their supposed classical ancestry is just one more facet of their perceived misfortune to be Greek; this challenged sense of national-ethnic pride has been sensitively analyzed by *foreign* scholars" (Cartledge 1996:101; my emphasis). Cartledge published some of his ethnographic observations even in the journal *Anthropology Today*, under the title "The Greeks and Anthropology" (Cartledge 1994). Both articles are apparently representative of what this particular "camp" (as Cartledge puts it) of British classicists thinks of

odological debates in anthropology have been in general kept out of the territory of classical studies. In this part of the book, I propose heuristic epistemological and methodological directions toward an anthropology of "reading" and, more importantly, "writing" ancient Greek cultures. My main focus is on the reception of the image and the song-making of Sappho and other archaic and classical poets. The theoretical method I put forward here is engaged in a critical dialogue with recent epistemological developments in anthropological cultural hermeneutics. Going beyond the prevailing practice and theory in the study of classical antiquity, the approach I develop is not concerned with parallel sociocultural systems or incidents across different societies—a practice that does not differ considerably from traditional diachronic or comparative folkloric studies. Instead of resorting to anthropological analyses as repositories of comparable instantiations of specific cultural phenomena, I propose that anthropology be viewed in terms of cultural hermeneutics that may contribute to a *Problematik* of the *interdiscursivity* defining the construction, circulation, and consumption of socioaesthetic meanings in Greek antiquity. As put forward in an earlier work, interdiscursivity involves a *textural* interplay among habitually or intentionally enacted systems of signification from various domains of experience and expression—"ordinary behavior, organization of time and space in everyday life, art (literature, music, dance, architecture, painting), sociopolitical processes, and cultural discourses."[80]

## The Persistence of Allegory: Expected Horizons and Textualized Cultures

In his discussion of Baudelaire's poem "Spleen," Jauss proposes a tripartite interpretive schema for the exploration of the paradigmatic reception of the poem. The theoretical formula that he develops is no doubt representative of his overall approach to the reception of literary texts. Drawing also on Gadamer's theoretical model, Jauss's idealized hermeneutic approach is orga-

---

anthropology and Greece. For what with De Certeau I call "pragmatic efficacy" of such devices of writing culture, see my discussion below in this chapter. More insightful are the following discussions of classics and anthropology: Hunter 1981; Winkler 1990:1–10; Loraux 1996; and Detienne 1979:1–19, 1991, 2000, 2001; for comparative approaches to ancient Greece through ethnographic explorations of Greece, Italy, and Spain, see Versnel 1987; Winkler 1990; and cf. Blok 2001; *contra*: Sourvinou-Inwood 1995; for histories of the interest of classicists in anthropology, see Marett 1908; Kluckhohn 1961; Finley 1975; Humphreys 1978:17–106; Redfield 1991; Sissa 1997.

[80] Yatromanolakis and Roilos 2003:37. See further Roilos and Yatromanolakis forth.

nized on three climactic levels. First, Jauss argues, comes the reader's original
encounter with the text. Next, a reverse hermeneutic approach to the poem
takes place, proceeding, as it were, from the end of the text to its beginning—
an approach aiming at the analeptic reconstruction of the initially undecipher-
able semantic and aesthetic correspondences among different thematic and
formal constituents of the whole poetic narrative. Jauss's analysis culminates
in the investigation of the original horizon of expectations that defined the
production of the poem in a specific period in literary history and determined
the connotations of its poetic discourse. For instance, the original associations
of "spleen," the principal mood that permeates the composition of Baudelaire's
homonymous poem, are deciphered through an exploration of representative
semantic and hermeneutic instantiations of the term in the mid-nineteenth
century. In this manner, Jauss proceeds to discuss the impact of Baudelaire's
poetry on the rearrangement of the aesthetic and poetic "horizon of expecta-
tions" of the time.[81]

One of Jauss's central interpretive points is the image of the enigmatic
Sphinx that appears toward the end of the poem. In an intriguing turn of his
hermeneutic focus, he places this and other figures of the poem at the center
of his analysis and views them in connection with Baudelaire's reevalua-
tion of allegory: the voice of the Sphinx is identified with that of the poetic
persona. However, Jauss neglects the semantic open-endedness associated
with this archetypal sign of discursive ambiguity and prefers to reconsti-
tute the "meaning" of the poem and the original context of its composition
and reception as a rather closed system of harmonious textual and extratex-
tual interactions. His insightful analysis is thus stalled by its theoretical and
methodological overdeterminism, and his hermeneutic desire for a complete
original meaning seems to succumb to the lures of the very discursive mode
(allegory) that he tries to elucidate. In the end, Jauss's approach becomes an
example of interpretive allegory wherein the discursive surface (the specific
literary text) stands for a unique semantic original that time has blurred but
the critic's mastery has reconstituted to its alleged authentic clarity.

It is significant that, loyal to his overall deconstructionist theory, Paul de
Man has commented on this drawback of Jauss's analysis while arguing for a
more flexible approach to the text that should foreground indeterminacy and
semantic elusiveness.[82] We might want to go a step further and argue that

[81] Jauss 1982:139–85.
[82] de Man 1982, especially xix–xxv. For a literature-oriented discussion of Jauss's approach to
reception, see Martindale 1993:9–10. It should be noted that Martindale's analysis, which does
not take into account Jauss's confinement within the methodological polarities of the allegor-

another problematic aspect of Jauss's methodological proposal in the specific essay cited is his insistence on polar temporal categories: the original authorial past, on the one hand, and the almost equally authoritative interpretive present, on the other. No doubt, such a distinction marks already a considerable progress from traditional philological interpretations tending to obliterate the second part of this notional polarity while privileging the former. At least, the recognition, no matter how inchoate, of the critic's hermeneutic present as a significant constituent of the whole interpretive process alerts us to the alterity of the cultural products of the past and the potential subjectivity of the terms of their reception in the present of the hermeneutic act.

However, texts, not unlike other cultural commodities, are subjected to a series of synchronic transactions that are not limited to this polar temporal schema. The gap between the past of the author and the present of the interpreter is mediated through a number of successive readings that a quasi-allegorical and historicizing reconstruction of the original moment of creation cannot recapture. A text and its author exist always *in the making*. Methodological or theoretical negligence of this process—which, I should stress from the outset, by no means adheres to evolutionary models of cultural and literary history that have dominated classical studies for so long—may result in a vicious hermeneutic circle where the critic's end (*telos*) seeks frustratingly to meet the authorial, historicized beginning.

If Jauss's method locates the text within its original horizon of broader cultural expectations, Clifford Geertz's approach to culture is famously constructed in terms of textual hermeneutics. Culture, Geertz, argues, should be viewed as an assemblage of texts that call for an explication on the part of the trained interpreter—the social anthropologist. Geertzian semiotics of culture has contributed a great deal to the interdisciplinary exchanges between anthropology and critical theory. However, if a comparison between the two fields may be ventured here, I would say that Geertz's emphasis on the "textual" configuration of culture has been constructed in terms comparable to traditional literary interpretation, the origins of which go as far back as ancient allegorizations. Instead of exploring the dynamic multilayeredness of cultural semantics, Geertz prefers to emphasize interpretive linearity and one-to-one symbolic correspondences, which, not rarely, are constructed by the privileged interpreter himself. Early on in his influential "Thick Description:

---

ical schema I point to here, is overly text-focused while at the same time it inevitably ignores the anthropological parameters of cultural rewriting explored in this chapter of the present book. These limitations of Martindale's discussion may be understandably due to the fact that his interest lies in the reception of ancient texts in modern times—not in antiquity.

Toward an Interpretive Theory of Culture," Geertz formulates his hermeneutics in terms of allegorical explication. Endorsing a Weberian approach to sociocultural phenomena, he defines culture in terms of "webs of significance" that he, as an anthropologist, is invited to decipher. "It is explication I am after, construing social expressions on their surface enigmatical," he stresses.[83] Both awareness and communication of one's methodological apparatus constitute an important step toward discursive and scholarly alertness. No doubt such alertness permeates Geertz's cultural semiotics but, at the same time, it is persistently downplayed by his recourse to the archetypal hermeneutic schema of allegorization. Inherent in such an approach to social and cultural phenomena is the premise of the interpreter's imposing authority: it is he or she who identifies, or even constructs, the "enigmatical" issue and he or she who offers the solution—more often than not a closed deciphering supposedly accessible not to the natives but only to the entitled "hierophant," the anthropologist, who appropriates the right to "read" the "ensemble of texts" that "the culture of a people is. . . over the shoulders of those to whom they properly belong."[84]

## Cultural Translations and Writing Practices

Arguably, any kind of interpretation proceeds more or less along the deep structural lines of allegorical hermeneutic schemata. This may be the inevitable risk of interpretive attempts in all fields of human and social sciences. However, this is not a detrimental impediment to scholarly enterprises in the humanities and social sciences if we keep in mind that "enigmatical" phenomena may be subjected to multilayered, successive readings and call for different interpretations according to the specific each time synchronic contextual data that the ethnographer/critic/philologist chooses or is able to collect.

In social anthropology such a tendency, and the urgency to acknowledge it, has been diagnosed since the 1980s—one of the welcome products of poststructuralist self-criticism, especially in American academic discourse. Classics, a field still closely adhering to traditional hermeneutic methods, even when engaged in discursive dalliances with methodologies subsequent to New Criticism, has a great deal to learn from such constructive self-referential and self-exposing epistemological adventures. In a well-balanced critical presentation of ethnographic discourses, Vincent Crapanzano points to the

---

[83] Geertz 1973:5.

[84] This formulation of Geertz's paradigmatic anthropological objective comes from his essay "Deep Play: Notes on the Balinese Cockfight" (Geertz 1973:452).

inherent paradoxical nature of mainstream anthropological interpretations, Geertz's included. On the one hand, anthropologists admit to the partiality of their analyses but, on the other, they claim definitive and final interpretations. Another paradox is that anthropologists—and, I would add, cultural historians, classicists included, too—need to make familiar what is foreign. Often their readings are constructed around overarching metaphorical schemata. Crapanzano, himself a master of metadiscursive allegory,[85] dismantles Geertz's penchant for imposing overstated allegories on his readings of whole cultures. A case in point is the latter's essay "Deep Play: Notes on the Balinese Cockfight." Cockfight is rather arbitrarily elevated to the status of an emblematic equivalent of Balinese cultural semantics as a whole. No doubt, rhetoric—especially the four master tropes of metaphor, metonymy, synecdoche, and irony—has always played and still plays a pivotal role in scholarly accounts.[86] What is at stake in anthropology and cultural history is that often such rhetorical strategies are foregrounded as innocent discursive mechanisms, which, however, often contribute to constructions of methodological and ideological stereotypes. The equation "cockfight=Balinese culture" is not just a playful or arbitrary rhetorical figure; it may involve, especially in the hands of readers or writers less alert than Geertz himself, further monolithic interpretive correspondences.

Crapanzano's discussion of Geertz's "deep" rhetorical "play" and "thick description" would have been even more nuanced if it had taken into account the latter's clear admittance to the affinities of interpretive anthropology (and of cultural history) with fictional writing. Already in the early seventies, Geertz was daring enough to develop a comparison between ethnographic analysis and fictional writing. Both, he argues, are based to a great degree on subjec-

[85] It is worth noting that in this particular essay, Crapanzano employs the mythological associations of Hermes in order to illustrate the discursive and ideological risks authoritative ethnographic discourse may entail. "The ethnographer," he says, "is a little like Hermes: a messenger who, given methodologies for uncovering the masked, the latent, the unconscious, may even obtain his message through stealth. He presents languages, cultures, and societies in all their opacity, their foreignness, their meaninglessness; then like the magician, the hermeneut, Hermes himself, he clarifies the opaque, renders the foreign familiar, and gives meaning to the meaningless. He decodes the message. He interprets" (Crapanzano 1986:51). Crapanzano's diction here is replete with allusions to established formulas of allegorical explication: the object of interpretation covers an encoded, "opaque," "latent," "masked" meaning that the anthropologist's "hierophantic" acuity is invited to decipher. What differentiates Crapanzano's analysis from hegemonic ethnographic allegorizations is the ironic and self-referential inflections of his discourse (cf. Crapanzano 1992).

[86] In this respect, valuable remains the work of Hayden White, who insightfully has exposed the figurative tropisms of historiographic discourses; see especially White 1978; also White 1987 and 1999:1–42.

tivity. "Anthropological writings," he maintains, "are themselves interpretations, and second and third order ones to boot. (By definition, only a "native" makes first order ones: it's *his* culture). They are, thus, fictions; fictions in the sense that they are 'something made,' 'something fashioned'—the original meaning of *fictio*—not that they are false, unfactual, or merely 'as if' thought experiments."[87] Geertz focuses primarily on the narrativity of anthropological discourse and its construction of a coherent account out of events that on a first level seem disparate or totally unrelated. It is this kind of fictionality that brings Flaubert's story of *Madame Bovary*, for instance, close to an interpretive ethnographic description. Geertz is right in pointing out the creativity involved in both discursive enterprises, the fictional writing of the novelist and the "thick description" of the anthropologist. On a theoretical level, this self-awareness is further enhanced by his distinction of different layers of descriptive and interpretive accounts, which emphatically or, rather, rhetorically, bestows priority on "native" perspectives. If I have insisted on Geertz's gallant self-reflexivity it is because I want to illustrate how even self-critical and alert approaches such as his semiotic interpretation of culture are not always impervious to fallacious ideological and methodological equations like the ones detected in his much-discussed study of the Balinese cockfight.

The ritualized performance of cockfights in Bali, their rules and manipulations by the players, are invested by Geertz with the interpretive potential of an overarching allegory standing for the semantics of the Balinese culture as a whole. On a metadiscursive epistemological level, this, in its turn, may be viewed as emblematic of the limitations inherent in any cultural hermeneutics aiming at the alleged (re)discovery of straightforward interpretive schemata.

The title of one chapter of Geertz's essay on this "paradigmatic" Balinese phenomenon indicates, I believe, the allegorizing deep notional structure of his argument: "Something for Something," which significantly alludes to the pattern of semantic equations privileged in traditional allegorical modes—allegory is the discourse in which something stands for something (else). When employed in broader sociocultural contexts, allegory may be viewed as an interpretive medium through which the alterity of a foreign, contemporary or past, discourse is transferred to the familiarity of the present. Fineman has nicely illustrated this potential of allegory, defining it as "that mode that makes up for the distance, or heals the gap, between the present and a disap-

[87] Geertz 1971:15.

pearing past, which, without interpretation, would be otherwise irretrievable and foreclosed."[88] Such hermeneutic tropisms, I argue, may be embedded in hegemonizing patterns of temporal organization promoting modern Western conceptions of past and present "others,"[89] thus activating a series of marked and potentially misleading ideological and cultural constructs: nostalgia, (ab)-original, exotic, "native," "primitive," "Oriental," "Western," "European," "Greek," and so forth. Fabian's critique of the manipulation of established temporal categories in modern anthropology may shed considerable light on the construction of such stereotypes. He discerns three main uses of time in anthropology: physical time ("objective" time measures), typological time (socio-culturally defined measures of time), and intersubjective time (time categories as enacted in interpersonal interplay). He criticizes the "distancing" strategy of denying the relations of "coevalness" between the ethnographer and his/her informants employed in the majority of ethnographic studies. This discursive mechanism works on the level of intersubjective time and establishes or perpetuates established concepts about the differences between the privileged observer (the anthropologist) and his/her informants—usually perceived as "exotic" objects of analysis. In the field of classical studies, a reverse tendency may often be discerned, which, however, reenacts comparable hegemonizing cultural stereotypes: often the distance between the present of the analyst's own culture and the classical past is reduced through a manipulation not of intersubjective time (by definition a temporal category not applicable to historical sciences) but of typological time. Not rarely, the "classical" age of the ancients and their achievements are compared to later epochs and sociocultural phenomena in order to validate them. For instance, the alleged ancient Greek rationalism (mainly a post-Renaissance construct) is paralleled to post-Enlightenment Western European orthologism. Analogously, political choices in Western societies are often legitimized through their comparison to the exemplum of Athenian democracy.

Schemata of this sort are more often than not symptomatic of the risks entailed by any attempt to render the experience of a foreign or past culture in terms more familiar to the translator and his/her readers. This is not an easy or innocent enterprise. Father Lafitau's perplexed and perplexing account of the customs of his contemporary eighteenth-century American Indians constitutes a representative case in point, albeit much less sophisticated than

---

[88] Fineman 1981:29.

[89] Fabian 1983:21–25; see also below my discussion of the idealization of "*the* (ancient) Greeks" at the expense of other peoples and periods.

Geertz's.[90] Any act of cultural translation is implicated in a nexus of ideological, cultural, or political power negotiations in which the most easily identifiable discursive forces are those of the "translator" and the producers of the original cultural discourse being transmitted. Such processes of transcultural hermeneutics are inscribed, consciously or imperceptibly, within broader webs of hierarchical relations. More often than not, the dynamics of these relations are determined by the translator's appropriation of the role of the hegemonic interpreter and the reduction of the "native" to the status of an unaware carrier of exotic knowledge.

The dynamics of cultural translation have been cogently commented upon by Talal Asad. Asad employs a parallelism between psychoanalysis and anthropology to delineate the anthropologist's retrieval of his informants' unconscious manifestations of their cultural semantics.[91] By definition, such an interaction establishes power relations between the cultural analyst and his/her analysand. The authority of the former derives from the latter's unconscious embeddedness within the complex nexuses of sociocultural signification. Asad rightly speaks of the "inequality of languages" activated in any attempt of cultural translation: "'Cultural translation' must accommodate itself to a different language not only in the sense of English as opposed to Dinka, or English as opposed to Kabashi Arabic, but also in the sense of a British, middle class, academic game as opposed to the modes of life of the 'tribal' Sudan."[92] Being institutionally more powerful, the translator's language tends to hegemonize the original discourse, thus transforming it. Asad's analysis provides several insights into the power relations articulated in the whole process of cultural translation. However, his understanding of linguistic and cultural discourse, which seems to owe a great deal to Saussaurian and Weberian approaches, downplays the *discursive* responsibility of the anthropologist. The cultural commentator is not or, rather, should not be, a passive agent in the hegemonic "games" reproduced by the institutions in which s/he and her/his language are intricately embedded. If we accept that the anthropologist has no other choice than being, as often is the case, uncritically conditioned by the alleged unconscious reenactment of broader established power relations in his/her own discourse, then we redeem him/her from the responsibility entailed by free choice to produce specific cultural "translation."

The metaphor of ethnographic or cultural historical commentary as a form of translation is pertinent to my discussion here, especially since it points

---

[90] Lafitau 1997. For a discussion of Lafitau's approach, see Yatromanolakis and Roilos 2003:25–26.
[91] Asad 1986:161–162.
[92] Asad 1986:159.

to the double discursive direction of any scholarly attempt to reconcile the foreignness of a locally or temporally distant culture with the knowledge current in the "translator's" own cultural community. In other words, the notion of cultural translation helps us supplement the Geertzian hermeneutic call for "reading" cultures with a more self-referential methodological awareness of the dynamics involved in "writing" cultures.[93] Writing about cultures inevitably entails constructing attitudes toward them. Anthropological and historical accounts alike are defined by discursive choices that tacitly or explicitly promote specific aspects of the culture under discussion and certain methodological possibilities.

Acknowledging the role of discursivity in the articulation of scholarly enterprise does not imply a deconstructionist, as it were, "death of the scholar" similar to Barthes's formulation of the "death of the author."[94] On the contrary, it underlies the urgency to recognize the subjectivity of the scholar as an active agent in the construction of cultural edifices.[95] The awareness of the culturally conditioned discursivity of "reading" and "writing" cultures does not result in a nihilistic epistemological *aporia*. Rather, it alerts us to the considerable degree of fragmentation inherent in any attempt at cultural, historical, or literary interpretation. What it questions is not the possibility of provable scholarly research but, rather, the *essentialization* of what I would call "hermeneutic metaphysics" that often prevails in cultural or literary history.

Such an elemental epistemological principle, which at first sight may seem a self-evident truism, only rarely comes to the fore in scholarly investiga-

---

[93] The concept of the supplement is employed here in its Derridean implications of a discourse that is involved in a critically dialogic or, rather, antiphonal relation to a previous sanctioned discourse. Recent studies in the field of classics have been intensely based on Geertzian hermeneutic analysis but without going beyond its emphasis on *reading* cultures (see, for instance, Dougherty and Kurke 1993:1–12 and 2003); the urgency of shifting our epistemological focus on strategies of *writing* culture is unfortunately not addressed in such scholarly enterprises. For a systematic exploration of the methodological and ideological implications of "writing culture" in anthropology, see the homonymous collection of essays edited by Clifford and Marcus (Clifford and Marcus 1986). Clifford further discusses this issue in Clifford 1988, where he problematizes established discursive authorizations of anthropological analysis. Parallel to Clifford's discussion is Marcus's and Fisher's investigation of past and current formative epistemological concepts in anthropology (Marcus and Fischer 1999). Marcus and Fisher focus on what they call "crisis of representation" in contemporary human sciences. This "crisis" is closely related to the awareness of the discursivity determining anthropological narratives and analyses.

[94] Barthes 1977a.

[95] Certain textual critics and critical editors, especially, but not exclusively, in Italy would not be willing to endorse such an idea.

tions of ancient Greek cultures. More often than not, such explorations, when eschewing the easy solution of indeterminacy, result in stereotypical or essentialized "reconstructions" of lost origins or fragmented evidence. Hermeneutic metaphysics, which by no means constitutes an exception to the rule in human sciences—certainly not in cultural and literary histories of archaic and classical antiquity—bespeaks a tendency to ignore the discursivity in which it is embedded. Instead, it often tacitly reproduces established strategies of constructing origins; it is enmeshed in the fallacy of a self-proclaimed "authentic" storytelling that ignores its own epistemological premises. I shall explore this tendency in some detail below in this chapter. The methodological risks lurking underneath such hermeneutic metaphysics become more insidious to the extent that they reinforce sanctioned methodological directions. Historicized—that is, a posteriori and monolithically constructed—origins rather than interacting textures of signification are thus elevated to the emblematic status of a promised scholarly holy land that needs to be rediscovered at any methodological cost, even at the expense of sensible discursive connections or available evidence. Inventing theories about "authentic" original truths—an enterprise by definition dependent upon an easy fusion of scholarly and fictionalizing strategies—should thus be viewed as a symptom of what Michel De Certeau describes as "storytelling" in historiography. "Storytelling," he aptly contends, "has a pragmatic efficacy. In pretending to recount the real, it manufactures it. It is performative. It makes believable what it says, and it generates appropriate action. In making believers, it produces an active body of practitioners."[96]

As I have argued, "reading" and "writing" cultures always presuppose a variable degree of pragmatic and symbolic efficacy of the kind De Certeau describes. Moreover, they both are processes implicated in the dialectics of agency and cultural determination. The reader as well as the writer of cultures is engaged in a dialogic interaction with the broader cultural context in which his/her discourse is produced and consumed: his/her broader synchronic cultural, national, linguistic, scholarly community.

Congenial to my understanding of cultural history is De Certeau's discussion of the "epic of the institution."[97] Every institutionally sanctioned discourse, De Certeau argues in a characteristically Foucauldian manner, derives its authority from its claim to reality. The principles according to which reality and the authority of the historiographic—and, I would add, the

[96] De Certeau 1986:207.
[97] De Certeau 1986:203.

anthropological—discourse that aims to recapture it are tested are dictated by the broader institutions to which this discourse is addressed. More often that not the validity of cultural hermeneutics is thus dependent upon traditional scholarly schemata and premises as well as dominant academic expectations and institutions. On the other hand, interpretations arguing for a redefinition of such established criteria or articulating a counterdiscourse questioning hegemonic methodological conceptualizations of reality are habitually faced in classical archaeology and history with an inflated skepticism that is conspicuously spared in cases of traditional reconstructions of reality, even when such reconstructions are obviously but not self-critically partial, subjective, or wildly speculative. Although addressing different scholarly and epistemological issues, De Certeau's problematization of the discourse and the "epic" of the institution is, I suggest, of considerable help in exploring the methodological principles dominating the field of classical studies.

Written from another perspective and with a different scholarly focus, De Certeau's critique complements the methodological self-referentiality informing poststructuralist anthropology of the last two decades or so and the shift of its epistemological emphasis from reading to writing cultures. "The 'real,'" he notes, "as represented by historiography does not correspond to the 'real' that determines its production. It hides behind the picture of a past the present that produces and organizes it. . . . The operation in question is sly; the discourse gives itself credibility in the name of the reality which it is supposed to represent, but this authorized appearance of the 'real' serves precisely to camouflage the practice which in fact determines it. Representation thus disguises the praxis that organizes it."[98]

In the socioaesthetic history of archaic and classical Greece—the principal focus of this book—the "real" more often than not is identified with the—always tacitly or explicitly glorified—"original." Albeit not by definition an unimportant enterprise, such an objective usually leads to circular arguments in which the "original" coincides with an ancient author's supposed intention behind which more often than not lurks the modern scholar's own covered subjectivity—as hegemonized by institutionally valorized "epics." Even today, the study of Greek antiquity remains haunted by the methodological Siren of intentional fallacy. "The artist wanted to express this idea," "the meaning of the poem or historical narrative is this," "the author could have never used such a word," etc., are formulaic expressions conveying our constructed (mis)conceptions rather than the ancient artist's unrecoverable

---

[98] De Certeau 1986:203.

state of mind at the very moment of the composition of his/her work.[99] These (mis)conceptions are habitually reenacted in the discourse often employed in literary and cultural histories of Greek antiquity. What I want to question here is not as much the significance or, to begin with, the possibility of origins as, rather, the epistemological premises and the discursive narcissism with which alleged origins are often constructed. The methodological self-satisfaction sometimes accompanying speculative recoveries of the "original" past has a great deal to do with a monolithic conceptualization of cultural phenomena in terms of one-to-one correspondences rather than systems of interacting webs of signification habitually or consciously reenacted, negotiated, or redefined. My intent in this work to put forward an anthropology of the reception of Sappho's poetry, rather than a reconstruction of the origins of its production, consumption, and meaning, is a methodological step in the process of reevaluating hegemonic hermeneutic premises about archaic and classical Greek patterns of producing and performing cultural capitals.

## Beyond Fictionalization: Agency, Collective Schemata, and Interdiscursivity

If culture as the elemental subject of anthropological analysis may be viewed as a continuous interplay between overarching habitual modes of signification and behavioral interaction, on the one hand, and individual agencies, on the other, aesthetic culture should be viewed in comparable terms. Since the first steps of its codified usage in the eighteenth century, "culture" connoted two different but ultimately complementary concepts: a collective system of symbolically communicated and shared discourses and a privileged and idealized production/possession/consumption of quintessentially humanistic values as expressed in intellectual and artistic achievements. If the former concept focused on the collective aspects of culture, the latter promoted a more individualistic understanding and evaluation of symbolically codified ideals.[100] In the English tradition, these two polar approaches to culture were characteristically represented by Tylor, on the one hand, and Matthew Arnold, on the other. Tylor advocated an approach to culture as a traditionally inher-

[99] Perry has memorably criticized the overwhelming longing to (re)construct origins even at the expense of provable data in his discussion of the ancient Greek novel. In a parodying formulaic narrative reenacting the discursive strategies of fictional writing, he recounts the origins of this genre as follows: "the first romance was deliberately planned and written by an individual author, its inventor. He conceived it on a Tuesday afternoon in July, or some other day or month of the year" (Perry 1967:175).
[100] Williams 1983.

ited, activated, and reproduced system of common values; Arnold stressed the differential distribution of cultural values among individuals and peoples.[101] In 1871 Tylor famously defined "culture or civilization taken in its wide ethnographic sense," as "that complex whole which includes knowledge, belief, art, morals, law, custom, and any other capabilities and habits acquired by man as a member of society."[102] Even more "modern" and anthropologically congenial, as acknowledged in recent discussions, was Herder's understanding of culture. Writing in 1774, almost a century before Tylor, Herder, the controversial patriarch of European *Volkskunde*, employed the term "culture" in the plural, thus underlining the idiosyncrasies of different cultures. In American anthropology, Franz Boas further developed Herder's emphasis on cultural differences among different peoples, opposing, at the same time, the universalistic, evolutionary model of human civilization.[103] Despite the reorientation of its focus from definitional issues to methodological problematics, from defining culture to reading and writing culture, contemporary anthropology is largely based on the approach of Boas.

Classics has in general suffered from an elitist adherence to a quasi-Arnoldian conceptualization of cultural accomplishments.[104] Traditionally, ancient Greeks, better known in the sanctioned jargon of the field as *the* Greeks—an idealized group of people whose alleged unrivaled glory has been forever secured by the apotropaic, as it were, discursive power of the intimidatingly definitive article "the"[105]—have marked the 'Olympos' of human and humanistic achievements, the absolute measure, the *metron* against which all other peoples and epochs are (mis)evaluated. Usually, artistic creations within that essentialized cultural *topos* are approached as the works of incomparable geniuses whose original intentions should be recovered from the traces of their often fragmented works of art—unless the analyst finds them trivial or frivolous.[106]

The concept of culture that I espouse and explore in this book views individual creation at the intersection of subjective agency and collectively produced, consumed, and transmitted symbolic discourses. Power dynamics and negotiations on all possible detectable scales—interpersonal, regional,

---

[101] Kroeber and Kluckhohn 1952; Stocking 1968:69–109.

[102] Tylor 1871:1.

[103] Kroeber and Kluckhohn 1952; Stocking 1968:195–233.

[104] Important exceptions include Detienne 1979, 2000, 2001, 2003; Winkler 1990.

[105] Even anthropologically oriented studies of ancient Greece are not always impervious to this kind of ideological essentialism; see, for instance, the otherwise interesting *Anthropology and the Greeks* (Humphreys 1973); cf. Humphreys 2004. See also Gentili and Pretagostini's *Musica in Grecia* (1988).

[106] See above, p. 19.

ethnic—and economics of symbolicity undertake a pivotal role in the interplay between individuals and collective modes of signification. In this interaction between subjective and collective agencies of culture, discursive boundaries are always in continuous flux.[107] The collective is penetrated and redefined by the individual, and vice versa. Moreover, such boundaries are never clear-cut; situated in a persistent blur where the subjective cannot always been discerned from the dynamics of traditional vehicles of meaning, they call for methods of exploration that should take into account the interpenetratedness of current modalities of traditional referentiality and more individualized discursive strategies.

An anthropological study of these discursive interactions should take into account the hermeneutic dynamics of habitus and practice. The practically oriented analysis of the reactivation of traditional vehicles of signification in archaic, classical, and early Hellenistic Greek artistic and ideological discourses that I put forward in this book goes beyond Bourdieu's rather static understanding of subjective agents' embeddedness within collective webs of symbolic or actual power relations.[108] Habitually internalized and activated organizing concepts and models of behavior are not impervious to redefinitions and reworkings by individuals. In an earlier study of the interpenetradness of ritual modes of signification and socio-cultural discourses in different, comparative Greek contexts, Panagiotis Roilos and I argue that a great deal of self-reflexivity is at times involved in the reenactment of inherited and practically reproduced ritual behavioral and semantic patterns. Flexibility and creativity is not excluded in ritual contexts—in the same way in which in oral literature individual singers may contribute their own innovative responses to the expectations dictated by tradition. A culture-bound sense of ritual-making, we contend, does not preclude manipulation of sanctioned forms of expression by individual or institutional agencies. Formality in ritual is thus to be understood as fluctuating along a spectrum, one end of which is marked by rigidity (Christian religious services, for instance), the other by a great degree of freedom and improvisation (e.g. carnival).[109] As participants in ritual practices who are not mere spectators but potentially active agents, individual carriers of cultural discourses, too, are not passive performers of overpowering structural forces. This holds all the more true for figures like Sappho, who enjoyed popularity in their local societies.

[107] See Chapter Four.
[108] Bourdieu 1977, 1990.
[109] Yatromanolakis and Roilos 2003:19.

The dynamic interplay between the two polar traditional approaches to culture (and history) is illustrated in Marshall Sahlins's study of the common epistemological grounds shared by historiography and anthropology. Sahlins calls rightly for an overcoming of the methodological boundaries between superorganic cultural system and individual agency.[110] He wittily describes the inflated emphasis on collectivity and hegemonic cultural order as a kind of "Leviathanology." In his critical reappraisal of Gramscian and poststructuralist, notably Foucauldian, versions of "Leviathanology," Sahlins contends that culture is not always a subjugating but often an empowering force. More incisively, he argues that currently exaggerated promotion in social sciences of "pancratic visions" of power and hegemony has ironically led to a new "subjectology," in which subject, as an abstracted entity, is "the only thing left standing." "The only object substantively remaining to historical and anthropological analysis is the subject into whom the cultural totality has been interpolated, the one summarily interpellated."[111] The "subject" has been thus transformed into an essentialized category devoid of any contextual specificity. As a result of this epistemological inversion, the same argument continues, "the univocal, atemporal, totalized system of categories and relationships, unwanted in culture, has been transposed to an ideal subject."[112] In place of such an abstracted subject Sahlins promotes the idea of the "biographical" individual. Admittedly, in anthropology as opposed to historiography, this sort of subjectivity has been rather neglected.

An interesting example that I want to bring into discussion, which considerably predates Sahlins's call for centering upon the individual agent as a biographical subject, is Marjorie Shostak's *Nisa*. The subtitle of her book clearly underlines the urgency for combining biographical writing with anthropological analysis: *The Life and Words of a !Kung Woman*. Published in 1981, *Nisa* offered an experimental alternative to established modes of ethnographic presentation. Indeed, Shostak's foregrounding of an indigenous woman's first-person narrative challenged sanctioned ways of ethnographic reports that until then had privileged interpretive accounts of mainly male informants. In Shostak's printed text, the voice and perspective of the woman ethnographer—an individual highly alerted to the discursivity of the written transcription of her informant's narrative—is marginalized in the introductory and concluding parts of the book, which is largely dominated by the

---

[110] Sahlins 2004:125–93.

[111] Sahlins 2004:148.

[112] Sahlins 2004:150. More concrete understandings and explorations of individual agency in a number of contemporary sociocultural contexts are found in Holland et. al. 1998.

!Kung woman's spoken autobiographical memoirs. Even though Nisa views her communication of aspects of her life to the American female anthropologist as a manifestation of a collaborative project, the whole enterprise is organized by expected discursive hierarchies. Despite its grammatical composition as free, direct speech, Nisa's narrative was not always produced as a voluntary response to her inner needs; rather, it was elicited and directed to a great extent by the Western ethnographer's carefully constructed questionnaire. Nisa is aware of this overpowering hierarchy and alludes to it from the very beginning of her autobiographical narrative: "Fix my voice on the machine so that my words come out clear. I am an old person who has experienced many things and I have much to talk about. I will tell my talk, of the things I have done and the things that my parents and others have done. But don't let the people I live with hear what I say."[113]

Some significant points emerge from the !Kung informant's initial invocation to the operator of the recording machine. First, Nisa is alert to the fact that her words will not remain in flux, *epea pteroenta*, as it were; they will be fixed by a recording machine that has the power to reproduce them at the will of its authoritative manipulator, the American female ethnographer. Second, Nisa differentiates herself both from her interviewer and from her own people: she is a mediator between the cultural "order" that she represents and that one of Shostak and her privileged audience. Nisa views and presents herself as an individual agent who conducts herself within a broader nexus of specific sociocultural relations that determine her speech while at the same time allow her to interpolate her own ideational and discursive autobiographical inflections. The boundaries between Nisa's self-reflexive story and the sociocultural constraints of her people, on the one hand, and Nisa's autobiography and the authorizing recording of her Western interlocutor, on the other, may be crossed over but never entirely abolished.

Though not expressing these discursive dynamics in such clear terms herself, Shostak is no doubt aware of the hierarchies inevitably activated in her interaction with Nisa. From the very beginning of her text, she exposes the ethnographic and political agenda that directed her fieldwork among the !Kung people as a whole and her reaction to Nisa's life and narrative in particular. In a pioneering attempt (for that period) to redeem indigenous female voices from their being muted in dominant anthropological accounts, and wishing at the same time to enhance her own understanding of "what it means" to be a woman in !Kung culture as compared with American society,

---

[113] Shostak 1981:51.

Shostak decided to publish the autobiographical account of Nisa rather than a study of any other aspects of the !Kung people.

Throughout her narrative, Nisa stands out as a self-aware agent and evaluator of broader sociocultural premises that she is supposed, or expected, to share with her people. Shostak herself comments that Nisa's emphasis on specific aspects of her life may not always be representative of the cultural values espoused by the majority of her people. Of special interest is her pointing to different degrees of sexual awareness among young girls in her culture. In some cases, the boundaries between homosocial and heuristic homoerotic modes of behavior are blurred:

> When girls are alone, they sometimes play sexually together. But when boys are there, they don't, because the boys are there to play that way with them. Girls can only touch genitals together; that's not really much help. Boys are the ones with hardness, with penises; boys have their spears. Girls have no spears, they have nothing; only softness. They don't have anything that moves around like a penis. So when girls are alone and take one another, they don't do it very well. No, a little boy is best; he does it right. When I was a small child, I played at nothing things. I had no understanding of things around me and didn't know about sexual play. Even if we were just girls playing, we played nicely. Because there is good play and bad play. Bad play is when you touch each other's genitals; good play is when you don't. But when I was older, I had some sense, and with that sense came the awareness of sex. That was still before the little girls actually knew what kind of play "playing sex" was; we just talked about it. The boys would ask each other, "When you play at sex, what do you do?" and they would ask us. We would say, "We don't know how to play that kind of play. You're the ones always talking about it. But we, we don't know. Anyway, however you play it, we won't do it. Why can't we just play?" That's when the boys would say, "Isn't having sex what playing is all about?" They would say, "You girls don't know anything, so look, first we'll play together, then we'll get married, and then we'll touch each other's genitals and have sex." The girls always refused, "Playing that way is very bad. Why do you keep saying we should do it when we don't want to?" Eventually my girlfriends started to play sexually with each other. They'd put saliva in their hands, rub onto their genitals, and touch genitals together. I didn't know how to do it and just sat, refusing. They'd

ask, "How come you don't play with us?" And I'd say, "If I did, my genitals would smell terrible. You put saliva and I don't like that." I'd wait around, and when they started to play nicely again, I'd join them and we'd play and play and play. Not long after, some of the girls started playing that kind of play with little boys. They learned about it long before I did. . . .[114]

In this account, patterns of habitual embodiments of culturally permissible, or, rather, definable, behavior may be detected. Homoerotic play among young girls is described as a practically reenacted preliminary phase to heterosexual encounters with boys. Ethical reaction to these practically internalized modes of sexual interaction among sexually aware girls differs from individual to individual, as Nisa's reservations indicate. She refers to her early memories of these sexual plays not as fetishized, idealized, or exotically distant experiences but, rather, as expected steps in most girls' gradual transition to later heterosexual relations.

Of special interest is also the subtle interweaving of Nisa's own discursive inflections with largely espoused discourses and practices of homosexual "play" among young girls. Her diction reflects her qualms toward this kind of behavior, which does not seem to be questioned by the majority of her girlfriends. "Softness" is the main trait of the female body that is juxtaposed to the hardness and aggressive potential of the male body. Male "spears" and female "softness" construct a metaphoric antithesis, which may be viewed as a proleptic inchoate narrativization of Nisa's own initially ambivalent reaction to her encounters with boys. A subtle questioning of hegemonic male discourses on sexuality may be detected in Nisa's description of the exchanges between girls and boys. Leaving aside the temptation to view her narrative in the light of Freudian, Lacanian, or, even better, post-Lacanian theoretical approaches, what emerges from Nisa's autobiographical response to the American ethnographer's invitation to recount her early sexual experiences is an inclusive interdiscursivity in which individual idioms negotiate, without abolishing or radically challenging, the authority of pervasive discourses about homosocial interaction.

Nisa's autobiography, as edited and published by the only person who had the ultimate authority over it—the female American ethnologist who recorded it—provides, I believe, an intriguing example of how sociocultural order and individual agency may be engaged in ever-redefined negotiations of boundaries, power relations, and discursive hierarchies. If, despite Shostak's self-reflexive ethnographic experiment, the "biographical" subject

[114] Shostak 1981:114–5.

still remains to be defined and explored in anthropology, in historiography, and certainly in classical studies, this discursive mode does not constitute the exception to established ways of literary and broader cultural interpretations. On the contrary, the tendency to reconstruct (or deconstruct) the "authentic" (or "fabricated") biographical truth about a poet's life (and work), has often led to a number of speculations and misconceptions. Not rarely, discussions of this sort are composed around a vicious circle of argumentation. For instance, recourse to the work of a song-maker (or to a posteriori reconstructions of it) is still thought to be the main step toward the recovery of some aspects of her/his life and ideology. On the other hand, the usually meager information about a poet's life is often—even implicitly and tacitly—employed as the principal context within which the semantic potential of a text is explored.

The desire to reconstruct the original context of an author's life and work is inevitably overpowering and not necessarily misleading. Methodological risks are rather implicated in attempts to present speculations about such issues as proved truths based on internal (more often than not philologically constructed) textual "evidence" or external indications. Institutional authoritative discourses (different schools, traditional, even if outdated, authorities in the field, dominant current ideological schemata—for instance the allegedly inherent affinities between the classical Athenian city-state and Western democracies) are often evoked to valorize such reconstructions.

The prevailing practice of exploring ancient receptions of poets and their works is directed by similar methodological choices. Priority has been given to proving what is "true" and what is "fictional" in ancient accounts of poets' lives. No doubt this is a highly useful enterprise, to the extent that it is based on good knowledge of the ancient sources and, whenever feasible, on an exploration of diachronic and synchronic developments. However, the mere identification of fictional elements in certain ancient accounts—which are sometimes conditioned by specific genre expectations—cannot go beyond certain corrective suggestions. This privileged methodological solution is characteristically encapsulated in the following passage: "I hope to show that virtually all the material in all the lives is fiction, and that only certain factual information is likely to have survived, and then usually because the poet himself provided it for a different purpose. If I have sometimes been too skeptical, it is in the hope of offering a corrective to the too eager credulity of the past."[115]

Instead, I argue, what is needed is first, a self-reflexive reevaluation of the tendency in modern scholarship to be itself allured by allegorizing fiction-

---

[115] Lefkowitz 1981:viii. This approach is by no means confined to Lefkowitz 1981, but it goes back to the nineteenth century (cf., e.g., Mure 1854:272–326). For criticism of Lefkowitz's method, see, from a different perspective, Graziosi 2002:3, 238.

alization. Discussions of archaic melic poetry often articulate unifying grand narratives with a view to offering linear, neatly organized historical reconstructions—or deconstructions. For instance, Sappho, it is assumed, must have been something exceptionally special. Or, if no agreement about a single nomenclature or identification can be established, then, so the argument goes, there is the solution of absolute deconstruction: Sappho was a mythical figure; she never existed.[116] If even in cases of highly self-reflexive ethnographic biographical accounts like Shostak's *Nisa*, the temptation of allegorical narrativization can hardly be eschewed,[117] in the field of classics biographical schemata are most frequently elicited from or imposed on the texts under investigation.

Second, instead of proposing simple corrections to ancient sources and reducing ancient narratives to the status of fictionalized and fictionalizing twaddle, the study of ancient receptions of the figures of song-makers and their compositions demands the synchronic and diachronic exploration of the complex discursive *textures* that interweave practically activated nexuses of signification. What kinds of notional patterns produced specific, even contradictory, receptions at a specific period? How did those patterns change over time and across different regional traditions and why? What were the culturally defined and perhaps individually each time activated receptorial filters through which specific images of a poet and his/her work were disseminated? How were local traditions different, and to what extent did they affect the regional perceptions of the poets and their works?

One of the aims of this book is to attempt to redirect the focus of current reception studies in classics to the interdiscursive mechanisms by means of which the representations of the poets were shaped and communicated in ancient times and in different regional contexts. Instead of demonizing ancient "fictions" and expelling them from the canon of respectable sources, such discursive scapegoats—along with information from broader sociocultural contexts—should be placed in the center of our investigation of synchronic practices of reception and their modulations across time and space.

## Mythopraxis and Traditions in Flux

Receptions of Sappho in classical and later Greece should be viewed, I propose, in terms of mythopractical performances of sociocultural archetypes. The concept of mythopraxis has been explored in cultural anthropology in connec-

---

[116] E.g., Lardinois 1994:62; Prins 1999:8.
[117] See Clifford's analysis of *Nisa* in Clifford 1986:98–109.

tion with the manipulation of the historical past in Polynesian societies to illustrate the reenactment of paradigmatic mythical scripts in local political arenas. The legitimizing dynamics of mythical archetypes is often open to negotiations since it cannot address unpredicted exigencies.[118] What makes this notion especially pertinent to my exploration of what I call practical performances of cultural meanings in archaic, classical, and early Hellenistic Greek societies is its capacity to encompass conceptually the two tradition-ally—at least in structuralist approaches—opposed categories of subjective agency and sociocultural collectivity. To go a step further, mythopraxis, as I employ it in connection with Greek antiquity, refers to the creative and at times questioning enactment not only of authoritative religious and cosmo-logical narratives but also of pervasive cultural values, ideas, or stereotypes[119] that at a given historical moment function as motivating forces of action on different levels—individual, interpersonal, regional, and so forth.

By encapsulating the dynamic dialogue between sanctioned discourses (*muthoi*) and their activation on different occasions and by different, indi-vidual, collective, or institutionally authorized agents (*praxis*), mythopraxis, as put forward in my investigation of the representations of Sappho in archaic, classical, and early Hellenistic Greek contexts, provides a novel method-ological framework within which the receptions of ancient song-makers and their compositions in antiquity can be explored. Often mythopractical perfor-mances of this sort would be activated, legitimized, or (con)tested in the context of established institutions such as the *symposion* and *mousikoi agônes*, and in idiomatic or more collectively codified artistic expressions (songs, vase-paintings, historiographic accounts, and so forth). The mythopractical approach to the reception of ancient poets that I propose places priority on the functions of cultural signs and capitals not as constituents of sterilized struc-tural systems but rather as semantic *textures* in action that are always open to changes. Such textures may respond to established cultural orders indif-ferently, approvingly, or critically. Sappho's image as a prototypical "lesbian," for instance, or her elevation to the status of a tenth Muse in the Hellenistic and later periods can be more holistically understood if viewed not as cases of

---

[118] Sahlins develops his understanding of the concept of mythopraxis mainly in Sahlins 1981 and 1985.

[119] In this regard, I find Tambiah's understanding of cosmology as any kind of firm, sanctioned sociopolitical and cultural principles that "compose the universe" of a particular society more congenial to my approach (Tambiah 1985:129–31; cf. Yatromanolakis and Roilos 2003:18, 20). Although he does not employ the concept of *mythopraxis*, Tambiah understands cosmology in a way largely corresponding to my use of the first notional constituent of *mythopraxis*. On the activation of cosmological principles in traditional Greek oral literature, see Roilos 1998.

mere fictionalizing fixations or intertextual (re)interpretations but as discursive constructs embedded in mythopractical performances of broader cultural meanings and stereotypes.

The concept of mythopraxis also alerts us to the intercrossing of temporal boundaries since it refers to synchronic reenactments of more often than not previously sanctioned sociocultural discourses. It presupposes, therefore, at least two temporal levels: the synchronic practical "now" of the specific moment in history under investigation and another chronological level that predates the first one. Furthermore, a mythopractical view of past cultural phenomena juxtaposes the scholarly present/modernity and the investigated past. The alterity of the latter needs to be negotiated by the mediating discourse of the former.

Such methodological and scholarly concerns can be effectively addressed, I argue, through a careful recourse to historical anthropology. The historical anthropological model I propose in this book questions the ideological premises tacitly informing the ethnohistorical version of historical anthropology. As a rule, ethnohistory follows in the traces of colonial ethnographic accounts since it tends to prioritize the study of the history of markedly "exotic" peoples, who in the early days of anthropology would be called "primitive."[120] It is as though the investigation into the past of less marginalized cultures, notably Western European and white American ones, should remain "untainted" by the insights of a discipline that has codified its epistemological and methodological apparatus primarily as a result of the study of cultural "others." The approach to archaic, classical, and Hellenistic Greek sociocultural discourses that I put forward builds upon comparative anthropological analyses. This approach should be engaged in a dialogue with current debates especially in the field of historical anthropology. Ethnohistory should not be excluded to the extent that it can provide comparative and methodological insights.

Leaving aside mainly the Cambridge ritualists and their followers in the middle of the twentieth century and later, the French School, which to a great extent has been shaped in a constructive dialogue with structuralist anthro-

---

[120] The original research scope of ethnohistory had been defined as follows in the front matter of the first volume of the homonymous journal of the newly founded discipline: "the documentary history of the culture and movements of primitive peoples, with special emphasis on the American Indian" (*Ethnohistory* 1[2], 1955). It should be stressed, however, that ethnohistory was developed as a critical response to the pervasive tendency in the ethnographic studies of that time to ignore the validity of oral history and of indigenous perceptions of historical past. For an overview of the epistemological principles and the systematization of ethnohistory as a particular research field, see Krech 1991.

pology, sporadic references in footnotes and introductory chapters of recent books, or entries in dictionaries, classics has more often than not preferred to keep its disciplinary "purity" from any essential epistemological contact with anthropology. Disciplinary isolation of this sort is not of course confined to classics, an historical discipline par excellence. The contest between alleged historiographic precision and anthropological theorization has notoriously challenged the relations between history and anthropology, at least until recently.[121] The following statement formulates this dogmatic opposition in characteristic clarity: "My studies of the symposion in Greek society of course begin from the activities engaged in by sympotic groups, rather than the composition or functions of such groups: that is the difference between the interests of the cultural historian, who wishes to enter the group and study it from the inside, and the anthropologist, whose concern is with structures."[122] Such methodological preferences are entirely legitimate and no doubt have often provided valuable insight into ancient cultural institutions. However, the supposed opposition between anthropological overgeneralizations, on the one hand, and historicizing empathy, on the other, is not as absolute as expressed in this passage. Anthropologists are not always interested in overarching structures whereas the ability to interact with a group of people, and therefore "study it from the inside," is a privilege inevitably left in the hands of the ethnographer rather than the historian. The informants of the former are agents engaged in present sociocultural interactions accessible to an in situ study; the case is unfortunately different with the historian's often fragmented sources. And there is no need to enumerate instances in which cultural historians of antiquity—or of later periods—have proposed imposing hermeneutic theories based on problematic reconstructions. Instead, exposure to anthropological methodologies may alert us more to the conditions of our reading and writing cultures and to the dynamics of the interaction of different discursive systems at a certain moment in history.

---

[121] The chasm between anthropology and history is characteristically echoed in Radcliffe-Brown's dogmatic assertion that history, as a whole, "does not really explain anything at all" (Radcliffe-Brown 1958:598). For an insightful reappraisal of the methodological and epistemological exchanges between history and anthropology, see Dirks 1996; Geertz 1995. Dirks 1987, Burke 1987, and Comaroff and Comaroff 1992 offer examples of intriguing historical anthropological approaches. For recent problematics of the relations between anthropology and history, see also Axel 2002, and Kalb and Tak 2005. Sahlins's works on Polynesian history explore in detail the potential of the interpenetratedness of anthropological and historical methods; see especially Sahlins 1981 and 1985. The reconciliation of the two disciplines is described as follows: "the problem now is to explode the concept of history by the anthropological experience of culture" (Sahlins 1985:72).

[122] Murray 1983:49.

An illuminating case in point is the study of the arrival of Captain Cook in Hawaii. Based on archival material as well as broader cosmological ideas pervasive in indigenous culture, Sahlins has attempted to retrace the reception of Captain Cook by the Hawaiians and the subsequent construction of his image. First hailed as the arrival of a god—a response instigated by traditional local religious associations—Cook's visit to the island was later subjected to a diametrically opposite interpretation that eventually led to his death. Sahlins explains this incident in terms of a dialogic interplay between indigenous cultural patterns of signification and the potential of historical events to activate and, as it were, to put them in test. The event of Captain Cook's arrival was assimilated by the islanders within the order of their dominant cosmological ideas by means of mythopractical processes.[123]

A different thread of interpretation of the same historical incident has been proposed by Obeyesekere. Although endorsing the hermeneutic potential of the concept of mythopraxis, Obeyesekere shifted the focus of his investigation from the traditional beliefs of the islanders to the hegemonic preconceptions of the British sailors about the indigenous people. The deification of Captain Cook, according to Obeyesekere, was a story fabricated by Cook's companions who felt superior to the indigenous people. Whatever side one may take, what remains important is that both studies illustrate how historical events interact with cultural patterns of signification and how historical study involves explorations of such patterns. Moreover, the debate between Sahlins's interpretation and Obeyesekere's counterdiscourse expose the ways in which both anthropological and historical scholarly discourses are embedded in wider discursive contexts. Characteristically, Obeyesekere explicitly bases the validity of his own version of the story not only on his study of archival material but also on his hermeneutic perspective, which is not that of an American scholar, but of a Sri Lankan—that is, an individual of colonial origins.[124]

One of the main objectives of my investigation of the receptions of the figure and the songs of Sappho in archaic, classical, and early Hellenistic Greece is not only to redraw, as it were, the itinerary of her presence in specific socioaesthetic or other synchronic (that is, archaic, classical, or Hellenistic) discourses, but also to map out the interplay of different mythopractical real-

---

[123] Sahlins 1981. Sahlins describes his main theoretical concern as follows: "the great challenge to an historical anthropology is not merely to know how events are ordered by culture, but how, in that process, the culture is reordered" (Sahlins 1981:8).

[124] Sahlins 1982; Obeyesekere's objections are systematically put forward in Obeyesekere 1992. Sahlins responded to Obeyesekere in Sahlins 1995. For a systematic discussion of their dialogue, see Borofsky 1997; cf. also Kuper 2000:190–200.

izations and constructions of her image.[125] This enterprise goes considerably beyond tracing intertextual references or proposing corrective suggestions to ancient Greek "fictions" about Sappho's life and work. Although not ignoring such established methodological directions in the field of reception studies, the main objective of my investigation is to propose methodological directions for the study of practices of shaping and negotiating textures of cultural signification in the specific periods I am interested in.[126] Ancient sources should be employed as informants situated within (and contributing to) broader

---

[125] Ethnomusicological as well as linguistic anthropological studies might contribute insights not so much in terms of crosscultural parallels of certain institutions but, rather in terms of methodological approaches to comparable phenomena of cultural interdiscursivities. An intriguing case in point is Steven Feld's study of the musical culture of the Kaluli people in New Guinea (Feld 1990). Although Feld himself does not employ the concept of mythopraxis, I read his ethnography as a telling illustration of practically performed broader cosmological ideas in Kaluli culture. Feld examines the complex ways in which music, poetry, sensorial and emotional categories, myths, and cosmological principles interact and shape each other in terms of what I call textural interdiscursivity. His principal point of departure is an indigenous tale about the metamorphosis of a young boy into a bird. Based on this well-known story among Kaluli people, Feld starts to trace its symbolic ramifications in broader discursive contexts. He shows how "becoming a bird" is not just a narrative element in the specific tale but a metaphor that pervades Kaluli's modes of perceiving and expressing fundamental aspects of life (and death). The basic semantic connotation of this particular image is the transposition from the world of the living to the world of the dead. In Kaluli culture, birds are often thought to be *ane mama* ("gone reflections") of dead people. Bird imagery is also employed to refer to human emotions and social categories (old, young, men, women). Using bird metaphors is a common practice of what Kaluli call "turned-over words"—figurative diction. For instance, adult women are described as "birds of paradise" while younger unmarried women as "little cassowaries" (Feld 1990:65). In aesthetic culture, ornithological metaphors are activated to describe or demarcate artistic expression. Songs are thus perceived as "bird sound and bird talk"; dancing is arranged and received homologically to bird movements. Weeping and lamenting are believed to be inspired by and modeled upon the voices of the birds. Evaluation of singing is often expressed in analogies with bird sounds. Feld's study shows how bird imagery functions as a kind of discursive texture that can be assimilated in mythical, cosmological, social, and aesthetic contexts. In Kaluli culture, "becoming a bird" constitutes, therefore, what I call a pervasive idiom—that is, an ideational and discursive formula that is reenacted in several contexts of mythopractical performances. Another intriguing case of what may be called homological systems of mythopractical signification is the ritually performed homosexuality among the Papua of New Guinea (Herdt 1981). Herdt shows that this marked sexual behavior is embedded in a number of practically reenacted symbolic orders. Of considerable interest are also the insights about the production of meaning in traditional societies provided by linguistic anthropology, a discipline with which my discussion throughout this book is engaged. For now suffice it to note that thought-provoking discussions of linguistic anthropological methods are found in Duranti 1997 and Duranti and Goodwin 1992.

[126] For the meaning of textural discursive interactions, see Yatromanolakis and Roilos 2003:13, 40 and Roilos and Yatromanolakis forth.; the concept of "texture" as defined in these books emphasizes the significance of sociocultural discourses in action rather than as static structures.

synchronic discourses. They may be envisaged as archival material that needs
to be mapped out, evaluated, questioned, and, whenever possible, contextual-
ized in all its interdiscursive implications. Individual sources—vase-paintings,
literary texts, inscriptions, and so forth—should not be approached as ossified
fossils pointing to a static, often retroactively constructed discursive order, but
as nexuses of cultural meanings engaged in a continuous dialogue with other
synchronic material and potentially subject to change and semantic inflec-
tions. These nexuses of meaning, I argue, do not necessarily circulate on paths
of evolutionary or deterministic developments. Different or even opposing
receptions of a poet and his/her work may coexist in the same synchronic
context.

## "Coining" Sappho and the Hermeneutics of *Vraisemblance*

My view of cultural phenomena as discourses produced at the intersection
of individual agency and collectively produced and consumed ideational and
behavioral schemata dictates a study of the receptions of Sappho in archaic,
classical, and Hellenistic Greece in terms of a continuous interplay between
artistic sociolects and broader idioms. How did individual aesthetic and ideo-
logical priorities (cor)respond to wider sociocultural discourses? How did
formations of reading in a specific period affect the reception of previous
artistic products and the creation of new ones?[127] To what extent was the rein-
scription of the image of Sappho in different discursive contexts at a particular
moment of the history of her reception conditioned by synchronic mytho-
practical models?

Such models were performed and received, I contend, in terms of
"naturalizing" processes—that is, perceptual and hermeneutic strategies of
*vraisemblance*. *Vraisemblance* has been employed mainly in critical theory in
connection with the process of "translating" the fictitious world of a literary
text to the principles of perceiving and evaluating reality prevailing in a given
culture.[128] Critics have also compared this reality to an authorizing (socio-
cultural) text—an interesting, independent literary theoretical equivalent of
Geertz's interpretive textualization of culture.

---

[127] The concept of "formations of reading" offers a more flexible and dynamic interpretive frame-
work than Jauss's "horizons of expectations." The former puts marked emphasis on the act
of reading as a creative process situated in a broader synchronic sociocultural reality (see
Bennett 1985); horizons of expectation are principally associated with textual, intertextual, or
genre structures.

[128] The French journal *Communications* dedicated an issue to this subject (*Le Vraisemblable, Com-
munications* 11, 1968).

*Vraisemblance* may thus refer to five climactic, closely interrelated levels of interpretive "naturalization." First, it has to do with the "text" of the "real world." Second, it operates on the plane of conceptual patterns particular to a specific culture. Third, it establishes connections between a given literary text and genre conventions. Fourth, it concerns the level of self-referentiality of the text that underlines the artificiality of its discourse. Finally, *vraisemblance* refers to concrete intertextual relations.[129] In parallel ways, the image of Sappho and her song-making were received and reinvented by means of mythopractical reworkings that each time were subjected to specific criteria of *vraisemblance*. Leaving aside the first level of *vraisemblance*, it may be argued that the discursive textures that Sappho's image and song-making constituted at different synchronic moments in the long history of her ancient reception were defined by a complex interaction among all possible different levels of hermeneutic *vraisemblance*: cultural idioms—differing from one ancient Greek region to another—; conventions of specific artistic and discursive media (vase-painting, historiography, melic poetry, comedy); marked self-referentiality employed in some of those media; explicit or implicit "intertextual" associations with the works and the images of other poets.

Sappho's figure and song-making—as circulated in different discursive contexts and subjected to several processes of naturalizing *vraisemblance* in late archaic, classical, and late Hellenistic periods—should be viewed as a kind of discursive texture, a cultural coinage, as it were, that was coined, manipulated, devalued, or inflated according to specific, culturally or individually marked, semantic filters. The reception of Sappho's image in those specific periods is to be understood in connection with broader contexts of cultural economy determined by synchronic socioaesthetic concerns as these were realized in specific discursive media or by specific cultural agents. Rather than indicating the specifics of the original performative settings of Sappho's songs, the variously determined values of the discursive currency of her image at different moments of her reception point—each time—to the dynamics of the synchronic cultural economies.

---

[129] Culler 1975:131–60; see especially 140.

# 2

# Ethnographic Archives of *Vraisemblance* in Attic Ceramics

κλίνη, ἐάντε ἐκ πλαγίου αὐτὴν θεᾷ ἐάντε καταντικρὺ ἢ ὁπῃοῦν, μή
τι διαφέρει αὐτὴ ἑαυτῆς, ἢ διαφέρει μὲν οὐδέν, φαίνεται δὲ ἀλλοία;

If you look at a bed from the side or from the front or from any
angle, does the bed itself become different? Or does it appear dif-
ferent, without being different?

—Plato, *Republic* 598a

IN CHAPTER ONE, I EXPLORED the complex dynamics of conducting histor-
ical fieldwork in ancient eras that have few, if any, similarities to modern
European perspectives on socioreligious and ideological nexuses of *seman-
sis*. Unavoidably, the scholarly discourses and the various types of method-
ological apparatus we employ can hardly capture the multilayered social
fabric of different societies of ancient Greece as these are reflected in archaic,
classical, Hellenistic, Roman, and medieval Greek sources. The act of scan-
ning ancient ideologies through the linear perspective of an informant's or an
analyst's language is in itself a precarious enterprise, and establishing even
(regrettably) partial contact with a fraction of ancient actualities and cultural
communicative systems confounds the consistencies or discontinuities often
imposed by the bifurcation of contemporary scholarly approaches, i.e., histor-
ical, literary, and archaeological as opposed to theoretical and anthropolog-
ical. Methodological problems arise when all, especially the earliest, available
informants are not taken into account in investigations of the sources assumed
to reflect something of the sociocultural milieu of an archaic poet, or of what I
prefer to call the anthropology of the ancient sociocultural reception of a song-
maker.

# A Syntax of Image and Representation

The frequent relegation of pictorial representations and visual culture, that is, archaeological remains, to footnotes (or, at best, to mere descriptions) by literary and cultural historians may be due to a number of reasons.[1] For the purpose of this discussion, I shall single out an epistemological factor that lies behind some current methodologies, more or less explicitly or implicitly spelled out, in the fields of classics and classical archaeology. In the latter field, a tendency still exists among a number of its practitioners to consider pictorial images as something that can be described and analyzed more or less objectively. Premises of scientific methods have often been applied to the examination of images as if, in natural sciences, observation and experiments were immune to theoretical axioms or counterinduction. Even in sophisticated iconologic analyses, let alone in more technical iconographic studies, pictorial signs are more often than not construed as devices that assume the role of granting a fixed meaning to the whole image under investigation. In more interdisciplinary approaches, where literature and visual culture are more integrated, texts and images are still often considered tacitly as distinct sources of information that should be either investigated separately or employed to confirm the evidentiary validity of one another.

For a long time, vase-paintings were examined as material for the application of influential connoisseurial methods. Such investigations led to invaluable (even if sometimes questionable)[2] distinctions of pictorial "marks" eventually to be ascribed to specific named or anonymous ancient painters. They also contributed decisively to the current classification and understanding of a vast corpus of painted pots, their relative chronology, and diverse iconographic themes. At the same time, painted vases (as a means of ostensibly *realistic depiction*) were deemed somewhat contrary in nature to literary texts, which can be polysemic and complex. The structural opposition between "nature" and "culture," a highly problematic distinction in its own right,[3] has steadily, perhaps unconsciously and certainly tacitly, been adopted in approaching the so-called scenes of reality, scenes of myth, and scenes of fantasy depicted, as the reasoning goes, on vases. I would hold that behind such approaches lies a conceptual paradigm according to which, as has been

---

[1] For example, in historical reconstructions of diverse aspects of ancient Greek religion, archaeological evidence is often not integrated into the examination of textual, historical evidence—a fact widely acknowledged by classical archaeologists and historians.

[2] The Sotades Painter is a notable case: see Hoffmann's insightful discussion (1997:147–148). Cf. Robertson 1992:186.

[3] Derrida 1978a:278–293 ("Structure, Sign and Play in the Discourse of Human Sciences").

noted with regard to broader theoretical issues of iconology, "the image is the sign that pretends not to be a sign, masquerading as (or, for the believer, actually achieving) natural immediacy and presence. The word is its 'other,' the artificial, arbitrary production of human will that disrupts natural presence by introducing unnatural elements into the world—time, consciousness, history, and the alienating intervention of symbolic mediation."[4]

The intrinsic value of such "empiricist" approaches to vase-paintings has been epigrammatically advocated by John Boadman: "Keat's urn was an 'unravish'd bride of quietness,' but she was of stone; her sisters of clay have lost their innocence and found their voices."[5] This vivid metaphor comes from an ironic critique of approaches that follow a different line of inquiry—approaches that see a cultural and "symbolic"[6] system functioning behind and in the images. The impetus for such an understanding of vase-paintings came principally from the work of Christiane Sourvinou-Inwood and Herbert Hoffmann.[7] Adopting scholarly tools from structural anthropology, Hoffmann attempted to demonstrate the inner, systemic coherence of the iconography of vases. Around the same time, Sourvinou-Inwood placed emphasis on the role of the viewer and put forward penetrating methods of analysis of vase-painting that have had a significant impact in the field. And with the "City of Images" exhibition and project organized by scholars in Paris and the University of Lausanne, a culturally contextual approach to images started to become prominent.[8]

One of the concerns of these methods was to reconstruct the conceptual and symbolic universe of vase-paintings by a shift of emphasis on the image rather than the painter as well as on the identification of specific semiotic schemata that point to specific associations, cultural ideologies, and contexts. Distinctions between scenes of real life and scenes of myth were significantly

---

[4] Mitchell 1994:43.

[5] In *Common Knowledge* 10.2 (2004):353.

[6] Goodman 1976; Nelson Goodman explores the term "symbolic" in its broadest and most neutral sense.

[7] Hoffmann 1977; later work in Hoffmann 1997; Sourvinou-Inwood 1979; earlier work collected in Sourvinou-Inwood 1991.

[8] Bérard et al. 1989 (originally published in 1984) and Bérard et al. 1987. Bérard's *Anodoi* (1974) also contributed to a more context-oriented study of ancient Greek visual imagery. This is not the place to discuss the methodological essays of scholars like Alain Schnapp and Christiane Bron, associated as they are with the "City of Images" project; see, e.g., Bérard 1983; Durand and Lissarrague 1980; Lissarrague and Schnapp 1981; Schmitt-Pantel and Thelamon 1983. It is interesting to compare Schnapp 1988 and Hoffmann 1988, articles that appeared in the same year and have almost identical titles, despite the different methodological approaches and style of research they reflect. The very thought-provoking work of Burkhardt Fehr should also be mentioned in this context.

challenged and ceased to be part of the methodological program of many researchers.[9] What is interesting for my approach here is the new emphasis on contexts and social imaginary and on the significance of the interaction of pictorial signs in the study of images.

The crucial question in any attempt to decode ancient images remains the definition that we are inclined to give to, or that implicitly informs our use of, the concept of image. At the same time, in a dialogically complementary process, our reconstruction of the historical specificity of the function of ancient Greek painted pots will determine the way we decodify their images. In this chapter, I shall first focus on archaeological and theoretical issues closely related to my analyses of vase-paintings throughout this book.

My understanding of images depicting Sappho starts from the premise that pictures belong to the conceptual spectrum of *representations*. Being one of the possible modes of signification, a pictorial image, like a musical text or performance, is a "non-linguistic" system that shares, however, a number of key aspects of a linguistic system. The main difference lies in the lack of always easily identifiable semantic demarcations in a pictorial image of its minimal or compound "units"—granted that by "units" we denote elements always in interaction with, and hardly detachable from, one another. Attempting to trace diverse forms of this interaction in the context of and against cultural paradigms and modes of social imaginary is one of the main aims of this chapter.

Although epistemological distinctions can be made between a picture and an image, the former often associated with "a constructed concrete object or ensemble," the latter with "the virtual, phenomenal appearance that [the former] provides for a beholder,"[10] in this chapter I use both words interchangeably. I shall also not enter into discussion of whether an *oinochoe* should be considered a "vase," with the diverse artistic connotations this word has, or a "pot" produced by a craftsman. For this reason, I use the term "vase-paintings" in a conventional manner. My premise is that *many* of these pictures or images belonged to the realm of ancient Athenian popular culture that was, however, shared and endorsed by wealthy and prominent Athenians in their domestic and social milieus. Further, it seems certain that not all vases were of equal value—aesthetic or other, although it is hard to determine with accuracy the diverse ancient aesthetic currency of specific vases unless we refer to the

---

[9] See, among other studies, Bažant 1981 and Harvey 1988.

[10] Mitchell 1994:4n5. For further significant distinctions, see Mitchell 1994:loc. cit., and Bryson 1983:131. On diverse concepts of images, see Mitchell 1986:7–46. For an incisive discussion of Nelson Goodman's influential semiotic approach to images and texts as symbol systems, see Mitchell 1986:53–74.

all-inclusive category of *types* of vases viewed outside their varied or possible original contexts.

Acting as representations, pictorial images or vase-paintings can be approached as ethnographic informants only through the medium of linguistic signs, a medium of representation that, like pictorial images, constructs actualities and what is being looked at. Whereas language is linear, and despite the fact that as viewers or hasty observers we often scan a picture linearly in different directions, images do not directly or straightforwardly articulate a linear nexus of recognition patterns (or meaning). This further suggests that we do not expect, nor is it possible, to uncover the original intentions of the "informant" since we approach pictorial signs with the additional complications that a modern description through linguistic signs may entail. The task is complex but rewarding, especially because in archaic and classical vase-paintings there are a number of identifiable semantic "idioms," conventions, and markers pointing to contextual considerations. If carefully explored, these can lead to more historically grounded analyses of socially constructed images.

Before embarking on a systematic investigation of the pictorial images of Sappho in the late archaic and classical periods, a crucial question arises again: How does an image circulate within social and cultural systems of communication? From a semiotic perspective, in contrast to analytic frameworks advanced or endorsed by the schools of the psychology of perception and the sociology of knowledge, Norman Bryson has incisively suggested that we need to think of an image neither, respectively, as a record of perceptions related to the mental fields of an artist and a viewer (the perceptualist approach), nor as a reflection of the milieu of a coherently and habitually constructed and naturalized reality shared by a visual community.[11] The problem with such kinds of understanding of a picture lies in the attempt either to analyze an image in isolation from the dynamic flow of its exterior, social world or to see it as a unidirectional reflection of the social construction of reality.[12] Rather, we should view an image in its dynamic *interaction* with other cultural discourses. If we approach a representation as a sign interacting with, responding to, refracting, and redrawing ancient realities, idealities, and patterns of thought, then pictures may be construed as discourses that gradually and subtly contribute to the articulation of those realities and idealities. This dynamic process

[11] For rigorous criticism of such influential approaches, see Bryson 1983:13–66.

[12] Bryson 1983 and 1991. On questions of painting and iconology I find the following studies congenial: Baxandall 1985; Bryson 1983; Derrida 1978b; Foucault 1966; Fried 1980; Maquet 1986; and Mitchell 1986.

operates, undoubtedly, on a different, considerably less "drastic" level than, say, changes in the social and political formation of a community. If the complexity of such changes can be sensed limpidly or passed unnoticed by the members of a community, the impact of images on the formation of cultural ideologies, even in a society as infused and galvanized in images as ancient Athens, is certainly less tangible and more diffuse or elusive. Yet the cultural dynamism of—an ever accumulating and ideologically freighted corpus of— images provides a conceptual window into the social constructions of the figure of Sappho in the earliest phase of its history, a few generations after the original performances of her songs in Mytilene.

It is true that vase-paintings have been traditionally construed as somewhat marginalized, inexpensive pictures drawn by craftsmen on pots in great, and thus culturally meaningless, quantities. However, apart from other widely accepted reconstructions of the superfluous value of painted pots in relation to "real" works of art in Greek antiquity (an idea that may have not been shared by ancient artisans and their customers), such an approach, I suggest, presupposes an understanding of vase-paintings similar or identical to a current, overly culturally determined view of popular pictures as only an insignificant part of the immense totality and multidimensional variability of images that people are exposed to in modern societies, in an era partly characterized by what has been termed "a pictorial turn."[13] My premise is that, despite their number and variability, pictorial images in ancient Athenian society interacted differently with their viewers. Many of them, repeating iconographic schemata with minimal semantic differentiation, must have passed unnoticed or were construed as more or less identical to other paintings with which the viewers were familiar.[14] Nonetheless, others, especially those used in the leisured context of *symposia* or in domestic and public spaces related to daily and ritual aspects of Athenian life, must have often attracted some interest on the part of their spectators, who sometimes also happened to be their commissioning patrons or standard purchasers. Before I proceed to an exploration of late archaic and classical representations of Sappho, I shall pause to consider some aspects essential for my attempt to "describe" modes of signification in Attic vase-paintings.

[13] On the "pictorial turn," see Mitchell 1994:11–34. Cf., from a different perspective, Debord 1994 [1967] and 1988.

[14] Even those images that repeated verbatim certain iconographic schemata contributed to the shaping of ideas about reality and fantasy. By repeating over and over similar or identical images, vase-paintings gradually and subtly established ways of viewing and understanding actuality, reverie, spectatorship, myth, fantasy, and diverse social constructs.

## The Social Life of Attic Vases

Ancient Greek painted pots were mostly functional: apart from vases employed as votive offerings in sanctuaries or buried in graves with the dead, painted pots were used as containers for diverse practical purposes in *symposia*, domestic contexts,[15] and related social milieus. In current discussions, the context of the *aristocratic symposion* has often been overemphasized. As a result, classicists and social and cultural historians take it for granted that almost all vases were intended for *symposia*.[16] Painted pots were produced in workshops specializing in elaborate pottery, more unrefined ware and tiles, and sometimes terracotta statuettes. Artisans (potters and painters) were men, but an image on a red-figure *hydria* found in a woman's grave in Ruvo includes in the craftsmen's company a woman working on a volute-*krater*.[17] Although the archaeological evidence about pottery workshops is scant and most of the available reconstructions are inevitably somewhat speculative, it seems that archaic workshops were often rather small, with working staff of three to ten people, and possibly fully operative on a seasonal basis.[18] The picture we have of the social and economic status of potters and painters in Athens or in Korinthos is vague, and related sources often contradict one another.[19] This observation does not suggest that we cannot reconstruct some *basic* aspects of the status of the Athenian potters and painters (a notable example is the widely accepted view that most of them were lower-class artisans, who, however, produced luxury pots for elite customers). Even so, the fact remains that any such reconstructions may perhaps not contribute considerably to an understanding of the actual cultural reception of painted pots and their images by customers and users in the classical period. The whole process of production and overall reception of vases must have been more complex than some current hypothetical accounts suggest, especially since available evidence is sometimes inconclusive. Furthermore, what is often underesti-

[15] The available archaeological record suggests that finds in houses are rarer; see Stissi 1999:96.
[16] See Chapter One, pp. 17–19, and discussion in this chapter.
[17] Milan, Torno collection, C 278 (formerly in the Caputi collection; hence "Caputi *hydria*" after its original collector), attributed to the Leningrad Painter (*ARV* 571.73 and 1659; *Add.* 261; Boardman 2001:147, fig. 178). The identification of the nature of the workshop (painters or metalworkers) on the Caputi *hydria* is problematic: see Green 1961; Kehrberg 1982; Thompson 1984:9–10; Venit 1988a. Rabinowitz 2002:152n15 adds further hypotheses. See the more cautious and interesting discussion of Douris' name (ΔΟΡΙΣ) by Buitron-Oliver 1995:1.
[18] Stissi 1999:86–88. On workshops in Athens, see Scheibler 1983:107–109 (1992:133–138); Arafat and Morgan 1989:321–323; Zachariadou, Kyriakou and Baziotopoulou 1992; Baziotopoulou-Valavani 1994; and Papadopoulos 1996:115–124.
[19] Shapiro 1995a; Stissi 1999:88–89; Williams, D. 1995; Kilmer and Develin 2001.

mated in archaeological reconstructions of the social and economic status of potters and painters is that for ancient viewers there could have been little or no interdependence of the status of a potter (or the modest price of a pot) and the aesthetic value and effectiveness of a vase-painting. Varied local and class-related aesthetics, as well as possible changes of such aesthetic criteria through time (late sixth to late fifth centuries), render a number of attempts to correlate pottery production and its cultural value somewhat speculative. The whole picture is multilayered, involving such currently controversial aspects as pottery trade and the distribution, reception, and aesthetic value of ancient Greek pottery in Etruria and other areas.[20]

The intricate elusiveness of these and related issues should not be closely associated with the often alleged simplicity and straightforwardness of the images depicted on vases and their reputed (relatively) minor contribution to the elucidation of ancient complexities related to visual culture and social imaginary. Lack of information about historical and local archaeological contexts for each vase (such as uses of different vases, functions of individual shapes, excavation details) does not entail that Attic images on pots should not be taken as cultural "texts"—that is, images that circulated within and interacted with broader discursive elements of ancient Athenian society. These representations were not produced to provide historical information about Athenian life. Instead, in their sheer abundance they often reflect archaic and classical Athenian thought patterns rendered as visual configurations and aesthetic microcosms. They point more to ancient inflections of representing society—to specific, more or less clearly delineated, or broader, sometimes even vast, landscapes of cultural discourses and social fabric that interacted with one another and were often subject to modifications. My investigation in this chapter is archival. It looks at images not in terms of whether they were always meaningful to the buyers of the pots but from the vantage point of the images as ethnographic archives—socioaesthetic spaces inscribed with visually codified idealities, constructs, and especially metonymic sets of significa-

[20] A critical overview of the related problems and complications arising from the available archaeological evidence is provided by Stissi 1999. For the Etruscan reception, see de la Genière 1987, 1988, 1999; Spivey 1991; Arafat and Morgan 1994; Sparkes 1996:158–164 (overview of earlier studies); Lewis 1997 and 2002:8–9; and especially Shapiro 2000, Reusser 2002, Bentz and Reusser 2004. The issue of whether the thematics and iconographical configuration of Attic vase-paintings were intended for Etruscan buyers and viewers is highly intriguing (since many vases were deposited in Etruscan tombs and used in other, non-funerary contexts in Etruscan cities), but still controversial. Sian Lewis has also attempted to take into account the aspect of slaves as viewers of Attic vases (1998/1999). On workshops and distribution of Attic red-figure pottery, see also Osborne 2004.

tion that are important in our attempt to explore ancient cultural informants about Sappho.

## Visualizing Idealized Cognitive Models

The iconographic schemata and the broader representational system of Attic painted pots are characterized by marked conventionality and economy. Signification is pictorially articulated through almost codified (albeit dynamic) schemata, but this process of semantic codification involved polyvalent signs that achieved their specificity only in the context of syntagmatic association and culturally discursive inflections of representation. By syntagmatic association I refer to the process by which a basic semantic unit is placed next to or combined with another, thus creating "minimal syntagms"—that is, combinations of smaller semantic units such as woman, lyre, and book roll—and more "complex syntagms"—that is, the articulation of marked meanings through the combination of "minimal syntagms" and the concomitant manipulation of conventionalized but often flexible iconographic schemata.[21] An emphasis on syntagmatic association—on the syntax of images—should not overlook the significance of the paradigmatic axis of the signifying system of Attic vase-painting.[22] In the large repertoire of basic semantic units, certain pictorial details were, and could be, substituted for others, which modified, even slightly, the articulation of visual discourse. Such substitutions may (or may not) have been entirely haphazard on the part of the painter. However, since we are not interested in what a painter had in his mind but in how an image was read in the context of specific sociocultural discourses and how it contributed to the construction of such discourses, the exclusion of certain pictorial details from an iconographic schema, the elimination of semantically marked elements, and the formation of pictorial divergences within a schema might have been of some importance for the reception of an image by its contemporary ancient viewers, especially in an artistic medium as conventionalized as ancient Greek vase-painting.[23] Iconographic microconfigurations should be seen in the light of closely related pictorial and cultural macroconfigurations and vice versa.

In my exploration of ancient images as ethnographic archives, I attempt to reconstruct their historical and anthropological specificity by focusing on

---

[21] On schemata, see Sourvinou-Inwood 1991:9–13 and 29–143; on "minimal syntagms," see Bérard 1983.

[22] For paradigmatic and syntagmatic axes of language, see Jakobson 1987:71.

[23] Cf. Sourvinou-Inwood 1991:12–13.

both micro- and macroconfigurations. Tracing discursive practices in pictorial archives may be the best way to define the "archaeology" of this project.[24] Although it is often impossible to capture most of—let alone all—the semantic (contextual, political, conceptual, and other) nexuses that ancient images could activate, it is necessary to decodify and remap all their pictorial elements— especially to view them in the light of patterns of recognition embedded in the culture that produced them. The difficulty of such an enterprise lies mainly in two aspects of the analytical process. First, "non-mythological" figural representations are sometimes marked by contextual polyvalence, since they draw on diverse "actualities." Second, if we attempt to see in vase-paintings an illustration of everyday realities or ideologies corresponding to such realities, we run the risk of over-reading the images—of reading in them discourses that are alien to the discursive contexts of pictures.

Instead of approaching representations with a view either to locating in them complementary evidence about specific cultural ideologies reflected in literary texts or to validating a one-to-one representational relationship between texts and images, we should view them, I suggest, in terms of what Lakoff, in the context of cognitive linguistics, has defined as "idealized cognitive models." Idealized cognitive models are categorical structures that help the members of a given society organize and understand their pragmatic and conceptual universe. They correspond to the diverse ways in which social groups make sense of the world around them and communicate their conceptualizations of reality/realities by constructing, employing, and sometimes redefining an infinitely large number of categories such as "neighbor," "greeting," "a lie," "enemy," "festival," "politics," or "womanhood." Each idealized cognitive model is not static; it is a complex and dynamic nexus of "nodes and links," associating it with, and dissociating it from, other idealized cognitive models. Among the structuring principles of an idealized cognitive model are metaphoric as well as *metonymic* mappings.[25] Involved in the formation of cognitive models, metonymy is also a fundamental process in the understanding of images by viewers. In the context of the often conventionalized and formulaic language of Attic vase-paintings, idealized cognitive models emerge, I argue, at the intersection of representational formalism and culturally conditioned artistic agency. To some extent, pictorial schemata presupposed cognitive models and metonymically reflected parts of them. Therefore, a cognitive model such as "non-Greek otherness" could be visually represented by a number of schemata in Athenian vase-painting. Alternatively, clusters of

[24] See Foucault 1969.
[25] Lakoff 1987:68–135, in the context of cognitive science and, especially, cognitive linguistics.

cognitive models were embedded in a single schema, which was repeated—often with marked modifications—over and over, became part of, and shaped late sixth- and fifth-century Athenian societies.

By attempting to trace pragmatic and conceptual categories through pictorial schemata in the context of this investigation of images representing Sappho, I shall be engaged not in reconstructing and extracting evidence about historicized ancient realities but in tracing the ways in which schemata contributed to the visual crystallization and even expansion of cognitive frames and mental spaces.[26] It is the almost rhetorical—due to the use of schemata—and aestheticized *vraisemblance* of such visually articulated frames and spaces that lies as a central question behind the more technical discussion of ancient images that follows.

## Connotation and Denotation

Placing late archaic and classical Attic vase-paintings in the context of pictorial schemata is potentially of some significance for our inquiry. As we have seen, a pictorial schema points to cultural representational frames and conventions. However, being part of and in interaction with sociocultural contexts, an image produces a pictorial discourse that can involve a certain nuanced positioning (not always identifiable by an observer not sharing the perceptual filters of a specific ancient visual community). Even if considered a minimal semantic marker, a visual sign such as "a woman standing alone and playing a musical instrument"[27] may have had specific cultural connotations in the late archaic and classical Greece, depending on the identification of the status of this female figure by ancient viewers. To elucidate my point, I refer to a story related by Dostoevsky in his *Diary of a Writer*:

> One Sunday night, already getting on to the small hours, I chanced to find myself walking alongside a band of six tipsy artisans for a dozen paces or so, and there and then I became convinced that all thoughts, all feelings, and even whole trains of reasoning could be expressed merely by using a certain noun, a noun, moreover, of utmost simplicity in itself [Dostoevsky has in mind here a certain widely used obscenity]. Here is what happened. First, one of these

---

[26] On mental spaces, see especially Fauconnier 1984; cf. also Lakoff 1987:281–282, whose work is partly based on Fauconnier 1984. On mental spaces, see further Fauconnier and Sweetser 1996 and Fauconnier 1997.

[27] On such representations, see below.

fellows voices this noun shrilly and emphatically by way of express-
ing his utterly disdainful denial of some point that had been in
general contention just prior. A second fellow repeats this very
same noun in response to the first fellow, but now in an altogether
different tone and sense—to wit, in the sense that he fully doubted
the veracity of the first fellow's denial. A third fellow waxes indig-
nant at the first one, sharply and heatedly sallying into the conver-
sation and shouting at him that very same noun, but now in a
pejorative, abusive sense. The second fellow, indignant at the third
for being offensive, himself sallies back in and cuts the latter short
to the effect: "What the hell do you think you're doing, butting in
like that?! Me and Fil'ka were having a nice quiet talk and just like
that you come along and start cussing him out!" And in fact, this
whole train of thought he conveyed by emitting just that very same
time-honored word, that same extremely laconic designation of a
certain item, and nothing more, save only that he also raised his
hand and grabbed the second fellow by the shoulder. Thereupon,
all of a sudden a fourth fellow, the youngest in the crowd, who had
remained silent all this while, apparently having just struck upon
the solution to the problem that had originally occasioned the
dispute, in a tone of rapture, with one arm half-raised, shouts—
What do you think: "Eureka!"? "I found it, I found it!"? No, nothing
at all like "Eureka," nothing like "I found it." He merely repeats that
very same unprintable noun, just that one single word, just that one
word alone, but with rapture, with a squeal of ecstasy, and appar-
ently somewhat excessively so, because the sixth fellow, a surly
character and the oldest in the bunch, didn't think it seemly and
in a trice stops the young fellow's rapture cold by turning on him
and repeating in a gruff and expostulatory bass—yes, that very same
noun whose usage is forbidden in the company of ladies, which,
however, in this case clearly and precisely denoted: "What the hell
are you shouting for, you'll burst a blood vessel!" And so, without
having uttered one other word, they repeated just this one, but
obviously beloved, little word of theirs six times in a row, one after
the other, and they understood one another perfectly.[28]

Not unlike this playful manipulation of the semantic potential of a linguistic
sign exemplified in the conversation among the Russian symposiasts in Dosto-

[28] Vološinov 1973:103–104 (also in Bryson 1983:82–83).

evsky's story, pictorial texts too—especially those used to decorate pots for ancient sympotic contexts or daily domestic use by women—can employ, to a *different* degree and through different means, marked connotations that need to be carefully deciphered by a modern viewer. This consideration does not entail that all pictorial connotations were perceived by all ancient Athenian viewers each time they may have had the leisure or curiosity to look at a representation on a vase. However, since pictorial connotations must have often been related to culturally generated and socially constructed modes of recognition, broadly shared by a community, Athenian viewers had access to such "codification" of seeing. Therefore, an attempt should be made to analyze each minimal semantic element and detail on a visual representation in their wider discursive contexts, despite the fact that a number of ancient connotations will inevitably be viewed only on the level of minimal denotation by the modern analyst.

## [Sappho] in the Image

It is time to draw into my discussion the late archaic and classical vase-paintings depicting Sappho. Although they are chronologically closer to Sappho's cultural milieu, the visual discourses of these vase-paintings have not been explored in older or current reconstructions and debates in the scholarship on Sappho; only fleeting references or brief descriptions of some of them have been occasionally made by classicists and literary historians.[29] Since hardly any textual sources exist for her reception in the period before the second or third quarter of the fifth century, I argue that these images throw significant light on the beginnings of the ancient attempts to contextualize Sappho—to locate her in different, distinctive situational frames that reflect successive stages in the earliest reception of her songs in the late sixth and fifth centuries. These successive stages were, I suggest, formative in fifth-century and later understandings of Sappho, although we cannot expect a linear, unidirectional development in the reception of her figure. Rather, Sappho's earliest reception should be viewed as multileveled and multidirectional. These painted pots suggest ideas

[29] See Chapter One, pp. 17–19, with reference to Most 1995. Lardinois 2001 (and Lardinois 1989, 1994, 1996) does not examine the vases, because "the relevance of these representations for our reconstruction of the 'real' Sappho is probably very limited" (2001:81). Snyder 1997a provides a brief and very general discussion of the images, without substantiating her views. Philologists like Ferrari (2003:45) do not tackle the representations ("poco o per nulla ci illumina in proposito la documentazione iconografica") or are not familiar with the complexities of ancient visual modes of representation.

that should constitute an integral part of any investigation into the early performative and more broadly sociocultural reception of Sappho's song-making.

The visual representations cover a period of some seventy years, from *c.* 510 to *c.* 440 BC.[30] It is significant that in about the same period, the late sixth century, images of Anakreon start appearing on vases,[31] while, as far as the available evidence permits us to see, no other archaic lyricists enjoyed any popularity among vase-painters.[32] During this period the figures and songs of Anakreon and Sappho will be culturally juxtaposed, and a complex sympotic association will be generated from this metonymic interaction. At least at this stage, their parallel receptions as song-makers whose compositions excited symposiasts converge to a considerable degree. In later periods the name of Anakreon and his erotic poetry will be persistently associated with Sappho's. I shall return to this aspect of the reception of the two song-makers in the course of this chapter and in Chapter Three.

As for the vases inscribed with Anakreon's name, two of them, a drinking-cup and a *kalyx-krater*, a vessel used for mixing wine and water, were among those certainly employed in *symposia*. The third one is a red-figure *lekythos*, often used as a one-handled small container for oil and perfumed toilet oil, as well as for household/table ware.[33] Only one of the vases depicting Sappho is a similarly symposiastic vessel—a *kalyx-krater*— while two others are *hydriai*, vessels for carrying water and, sometimes, other liquids.[34] The fourth vase

---

[30] Concerning the relative dating of vase-paintings, I would evoke Martin Robertson's incisive view: "it worries me to say that a given work of art can be dated, on grounds of its style, to a given point in historical time. [...] it has become part of the way we think about the subject to say, for instance, that such and such a vase by Exekias is to be dated in the decade 540–530; but I retain a mental reservation that this is a metaphor rather than a factual truth" (Robertson 1987:14). Among others, Robertson has pointed to the problems in dating the work of later archaic Athenian vase-painters to specific decades (e.g., 520–510, 510–500, or 490–480 BC) and subsequently associating certain vase-paintings with very specific political changes (Robertson 1992:41–42).

[31] This argument was first put forward in my D.Phil. thesis and in Yatromanolakis 2001a:160–161. The vases with Anakreon's name inscribed include a red-figure cup by Oltos in London (British Museum E 18; *ARV* 62.86, 1600.20, 1700; *Add.* 165); a red-figure *lekythos* by the Gales Painter in Syracuse (Museo Arch. Regionale Paolo Orsi 26967; *ARV* 36.2, 1621; *Add.* 158); and fragments of a red-figure *kalyx-krater* by the Kleophrades Painter (Copenhagen, National Museum 13365; *ARV* 185.32; *Add.* 187).

[32] The red-figure *kalathos-psykter* in Munich examined below (Antikensammlungen 2416; *ARV* 385.228, 1573, and 1649; *Add.* 228) also shows Alkaios next to Sappho.

[33] The Attic white-ground *lekythoi* were larger vessels used at the grave and as offerings for the dead.

[34] Cf., briefly, Boardman 1989:239 "The *hydria* is essentially for carriage and pouring (water) but the larger ones are probably mainly for display and the very small ones for any liquid."

with Sappho has a particular shape: it combines elements of a *psykter* (a kind of liquid- or wine-cooler) with features of a *kalathos*. I should here stress that it is not certain whether this kalathoid *psykter* is a *kalathos* proper or whether its function was related to the cooling of liquids.[35]

Three of the four vases inscribed with Sappho's name are rather well-known, albeit underexplored, representations of the poet.[36] The fourth one is less known[37] but deserves full attention for the image of Sappho it provides. Along with these four vases, in recent archaeological publications three more vases have been proposed as depicting Sappho.[38] It is these three images, and the methodological reasoning behind their identification, that I shall focus on first.

Although her name is not inscribed on it, a fragment from a belly-amphora in Stuttgart, perhaps by the Andokides Painter,[39] has been interpre-

---

For different uses of the *hydria*, see Richter and Milne 1935:11–12 and Kanowski 1984:39–42. Concerning the painters of the vases inscribed with Sappho's or Anakreon's name, although it has been remarked that a number of them—the Brygos Painter, Oltos, the Gales Painter, and the Kleophrades Painter—are closely associated with the red-figure Pioneers (Neer 2002:223n93: "the Brygos Painter began his career in the Euphronian shop; the Gales Painter is a Pioneer proper; Oltos is near Euphronios; and the Kleophrades Painter is a pupil of Euthymides"), hardly any firm conclusions can be drawn about these painters' preferences in depicting Sappho and Anakreon. The attribution of at least one vase is not certain, and our reconstructions of the artistic debts of each of these painters may not lead us far. The Munich *kalathos-psykter*, attributed by Furtwängler to the Brygos Painter and viewed by Beazley as a very late work by that painter, has more recently been attributed to the Dokimasia Painter (see below). For the Brygos Painter, it has been observed that with this vase-painter "we seem for the first time to be out of direct contact with the Pioneers" (Robertson 1992:94).

[35] Here and elsewhere the statements of Most (1995) and other classicists about vases clearly suggesting sympotic use (see Chapter One) become vulnerable to serious objections, since they are not based on a systematic study of the available sources. Detailed discussion follows in this chapter.

[36] *Hydria* in Warsaw, National Museum 142333 (formerly Goluchow 32; *ARV* 300; *Para.* 246); red-figure *kalathos-psykter* in Munich (Antikensammlungen 2416; *ARV* 385.228, 1573, and 1649; *Add.* 228); red-figure *hydria* in Athens (National Archaeological Museum 1260; *ARV* 1060.145; *Add.* 323).

[37] On this vase, see Yatromanolakis 2001a and 2005; red-figure *kalyx-krater* in Bochum (Ruhr-Universität, Kunstsammlungen Inv. S 508, formerly in Wuppertal [Kunisch 1971, no. 49]; Stähler 1984:122; not in Beazley). It is not listed in reference books on ancient Greek portraits (Richter 1965, Richter and Smith 1984), but Schefold 1997 has taken it into account and provided a brief and general report on the vase. The information provided in the Beazley Archive database is not accurate.

[38] Many other vase-paintings with women musicians but with no inscriptions identifying them have been thought as portraying Sappho. On this scholarly paradigm, see below in this chapter. One further vase, a bell-*krater* (*c.* 420 BC) formerly in the Middleton collection and now lost, has been reported as showing Sappho seated on a stool before a winged Eros who is bringing her a wreath. On this vase, see Immerwahr 1964:27 and Yatromanolakis 2001a:161n15.

[39] Landesmuseum 4.692; Schefold 1997:74 and 75, fig. 11.

ted as showing Sappho. Dated to about 525 BC, the fragment depicts a female figure playing a *kithara*. Iconographically similar is an image on a *lekythos* in Hamburg attributed to the Diosphos Painter and dated to about 500 BC.[40] However, here the female figure holding a *kithara* is flanked by two lions.[41] This vase is decorated in Six's technique, a combination of incised lines on an all-black surface with white paint added for the depiction of flesh parts. Mainly because the Diosphos Painter and the Sappho Painter—that is, the painter of the earliest vase that certainly depicts Sappho—specialized in this technique and, as C. H. Emilie Haspels has shown, should be grouped together as "partners" working side by side,[42] the female singer holding a *kithara* on the Hamburg *lekythos* has been identified as Sappho.[43] A *kylix* in Paris attributed to the Hesiod Painter and dated to about 460 BC[44] depicts a female musician seated on a *diphros*. The setting must be domestic, as suggested by the *diphros* as well as the mirror and the wreath that hang in the background, in front of and behind the seated figure. Besides the *phorminx* the musician holds in her left hand, she has a second stringed instrument on her lap. *This* female figure might have been perceived as a professional musician, given the juxtaposition of the two instruments in her hands. And since the context is domestic, it has been suggested that this poet/musician represents Sappho.[45]

These three, as well as numerous other identifications, are not based on vase-inscriptions. If we search for a common methodological denominator in such tentative suggestions, it is the underlying notion that Sappho must have represented a model of the female singer/poet par excellence in late archaic and classical Attic vase-painting.[46] Especially in those images where a domestic setting eliminates the possibility that a woman "poet" with a stringed instrument represents a Muse, to a very large number of archaeologists it seems plausible to propose that she is Sappho. Even (often traditional) images that Sappho employed in her wedding songs have been associated with specific vase-paintings. For example, a white-ground cup by the Sotades Painter[47] showing

---

[40] Museum für Kunst und Gewerbe 1984.497; Hornbostel et al. 1977:298, no. 258; Hornbostel et al. 1980:112, no. 66.

[41] Haspels (1936:97) pointed out that both the Diosphos Painter and the Sappho Painter were fond of depicting animals in connection with human and divine figures. Cf. Hornbostel et al. 1980:112.

[42] Haspels 1936:94–130 and 225–241; cf. Beazley 1963:300–301.

[43] Hornbostel et al. 1980:112.

[44] Louvre CA 482; *ARV* 774.2 and 1669; Bélis 1992: 55, fig. 1; Kauffmann-Samara 1997:287, fig. 4.

[45] Kauffmann-Samara 1997:286–290.

[46] See further below, pp. 67–68, 152–153 n. 336; Chapter Three, p. 272 n. 428, 272–275.

[47] London, British Museum D6; *ARV* 763.1 and 772; Hoffmann 1997:128–129, figs. 71–72, and 133, fig. 73.

a barefoot young woman standing on tiptoe to the right of a tree and reaching for its highest apple, has been viewed as a clear illustration of the following song by Sappho (fr. 105a V):[48]

οἶον τὸ γλυκύμαλον ἐρεύθεται ἄκρωι ἐπ' ὔσδωι,
ἄκρον ἐπ' ἀκροτάτωι, λελάθοντο δὲ μαλοδρόπηες·
οὐ μὰν ἐκλελάθοντ', ἀλλ' οὐκ ἐδύναντ' ἐπίκεσθαι

As the sweet-apple reddens on a quite high bough,
on the top of the highest bough; the apple-harvesters have
forgotten it;
no, they have not quite forgotten it; but they could not reach so
far.

Such an interpretation not only elides the afterlife associations of the imagery on the cup and all that we know about the excavation context—an Athenian tomb—in which this cup was found among other stemmed and stemless cups, *phialai*, and *mastoi*;[49] it also does not account for the name ΜΕΛΙΣ<Σ>A inscribed next to the (mostly damaged) crouching female figure to the left of the tree, as well as the last three letters of the apple-gatherer's name that are visible on the right-hand side of the image.[50]

This long-established scholarly paradigm is not confined to the case of Sappho. Other archaic poets have been identified in images of male figures holding stringed instruments in specific settings: it has been speculated that Arkhilokhos, too, is represented on vase-paintings,[51] although lack of vase-inscriptions cannot make such identifications compelling or even attractive. As regards Sappho, given her relative popularity in images on four painted pots with inscriptions attached to her figure, arguments have been advanced that her visual representations became "model images"[52] for the depiction of equally educated women practicing the art of music. Substantiation for this claim is sought from the widely accepted idea that Sappho must have been the only woman poet known in late archaic and classical Athens and thus possibly established as a paradigm of female musicianship. As I shall suggest

---

[48] Robinson 1924:107. Reflecting earlier archaeological hypotheses, Robinson's list of vases depicting Sappho (Robinson 1924:102–107) is overly speculative.

[49] Two of the other four cups have pictures evidently associated with themes of death and immortality (Hoffmann 1997:119–140; cf. Burn 1985 and Robertson 1992:186–188). For the imagery of this cup, see Hoffmann 1997:127–133. For the excavation context, see Burn 1985:100–102, Robertson 1992:185–186, and Hoffmann 1997:151 and 169–170.

[50] For these vase-inscriptions, see Robertson 1992:188 and Hoffmann 1997:127.

[51] See, more recently, Clay 2004:55–58.

[52] Bernard 1985:48.

later, such a conclusion is based on a slippery assumption: it presupposes that the *figure* of Sappho had acquired in mid-fifth century Athens a unidirectional, consistent identity—that of the paradigmatic woman poet. Instead, I argue that "Sappho," especially in the Athens *hydria* examined in this chapter, was located within the popular schema of gatherings of female musicians or of private poetic competitions. In an attempt to contextualize her songs that, as I shall show in succeeding chapters, were frequently performed in *symposia* of the classical period, such an assimilation of Sappho into contemporary pictorial schemata was one of the possible ways to naturalize her figure. "Female gatherings" constituted an idealized cognitive model that in the case of Sappho's poetry and image facilitated processes of visual and other discursive *vraisemblance*.

## Performing with a *Barbitos*

The earliest and most minimalist representation of Sappho is dated to about 510–500 BC (Fig. 1).[53] Produced almost two generations after her time, this *hydria* in Six's technique (formerly in Goluchow and now in Warsaw) has been attributed to the Sappho Painter, who actually got this name after the inscription ΦΣΑΦΟ placed next to the musical instrument that the female figure on this vase holds. The Sappho Painter, an artisan who, along with the Diosphos Painter, indulged in using Six's technique, was not as fond of vase-inscriptions as other painters: "real inscriptions are rare" and "on most of his vases, the Sappho painter puts mere senseless combinations of letters."[54] In this context, I argue that the inscription ΦΣΑΦΟ on the *hydria* in Warsaw indicates the intense excitement that Sappho's songs had caused outside Lesbos by *c.* 510 BC. Her early sixth-century musical activities had reached even the quarters of vase-painters.

Sappho is depicted wearing *chiton* and *himation* and as having struck the strings of a seven-stringed *barbitos*. A *barbitos* was a distinctively shaped, long-armed, and low-pitched lyre; to strike the *barbitos'* strings, musicians, professional or non-professional, used a *plēktron*, a small piece of ivory, bone, wood, or horn often attached by a cord to the instrument. Very often the *barbitos* is depicted as having seven strings, especially on vase-paintings between *c.* 500 and 475 BC, but *barbitoi* with five, six, and eight strings are also depicted.[55] As

---

[53] Dating: *c.* 510–500 (Richter 1965:71); *c.* 490 (Schefold 1997:74); "the date cannot be later than the last decade of the sixth century" (Beazley 1928:9); *c.* 500 (Haspels 1936:106).

[54] Haspels 1936:96.

[55] Cf. Maas and Snyder 1989:124. As far as stringed instruments are concerned, West 1992a (on

Figure 1. *Hydria* in Six's technique: Sappho playing the *barbitos*. Attributed to the Sappho Painter, *c*. 510–500 BC. Warsaw, National Museum, inv. no. 142333. Photo, National Museum in Warsaw.

is the case with Sappho on this *hydria*, most representations of figures playing the *barbitos* show the instrumentalist's left hand near the soundbox, finger-tips touching the strings, while their right hand with the *plêktron* is frequently depicted as having just completed an outward stroke.

The choice of the specific instrument in the image is not haphazard. This type of bowl lyre was associated with Sappho's cultural milieu. According to the cultural rhetoric of Pindar, the seventh-century Lesbian poet Terpandros was its inventor; both Sappho and Alkaios used the form *barmos* to refer to it in their songs.[56] In an evocative metaphor, Horace (*Carmina* 1.1.34) refers to *Lesboum...barbiton*, which stands for the lyric tradition of Lesbos that he

---

the *barbitos*, see West 1992a:57–58) follows to a considerable degree Maas and Snyder 1989. Cf. Roberts 1974. For the standard techniques in playing the *barbitos*, cf. Maas and Snyder 1989:121–123 and Roberts 1980. On the *barbitos* and the occasions for its use, see Snyder 1972 and Maas and Snyder 1989:113–138. Cf. Paquette 1984:173–185. For the *barbitos* in the context of *symposia* on vases, see also Bessi 1997:145 and 150–151.

[56] Pindar fr. 125 M; Sappho fr. 176 V (and see Voigt's *apparatus fontium* for the identification of the *barmos* with the *barbitos*); Alkaios fr. 70.4 V.

wishes to inherit and explore in his poetry.[57] And in the *Epistula ad Phaonem* attributed to Ovid (*Heroides* 15.8), Sappho calls to mind the *barbitos* as an instrument that cannot give voice to her sadness. Further, we are told that Anakreon mentioned the *barbitos* somewhere in his songs,[58] and, according to the third-century BC historian Neanthes of Kyzikos, this instrument was the invention of Anakreon, as the *sambykê* was purportedly the invention of Ibykos.[59] In the earliest visual reception of Anakreon, as well as of Sappho and Alkaios, the three lyricists are portrayed holding the *barbitos*.

Since this instrument is depicted both on the "context-free" image on the Warsaw *hydria* and in other, considerably marked representations, I focus here on the performance contexts in which it appears. On vase-paintings, the *barbitos* is most closely associated with the world of the *symposion* and *kômos*—including the *kômoi* of the "elaborately dressed revelers" that I examine later in this chapter; with Dionysos and satyrs and with representations of Eros.[60] Revelry, love and desire, leisure, mirth, and intoxication were among the dominant cultural connotations of the instrument in the sixth and fifth centuries—the period during which it was widely used before its gradual disappearance from art in the late fifth and the first half of the fourth centuries BC. Apart from its frequent depiction on Attic vases, the popularity of the *barbitos* in the first half of the fifth century is suggested by the comedy *Barbitistai* ("Barbitos-Players") by Magnes, who was active in Athens in the 480s and 470s.[61]

However, this popular musical instrument—which, according to Aristotle, was meant to provide pleasure and was thus, like the *aulos*, inappropriate in educational contexts—[62] was sometimes depicted in the hands of the Muses. More importantly, mainly in the second and third quarters of the fifth century, the *barbitos* was associated with women performing music in domestic settings.[63] These representations very often appear on red-figure *hydriai*, water

---

[57] Horace mentions the *barbitos* at the beginning of two other of his odes, *Carmina* 1.32.3–4 (*...age dic Latinum, / barbite, carmen*) and 3.26.3–4 (*nunc arma defunctumque bello / barbiton hic paries habebit*).

[58] Athenaios 4. 182f (= Anakreon fr. 472 PMG).

[59] Athenaios 4. 175d–e (= Neathes *FGrH* 84 F 5).

[60] For a discussion of vases depicting the *barbitos* in these contexts, cf. Maas and Snyder 1989:113–118. For the latest visual representations of the instrument in the late fifth century and (in Apulian and Etruscan art) in the first half of the fourth century, cf. Maas and Snyder 1989:127 and 170.

[61] Magnes testimonium 7 K-A and p. 628 in Kassel and Austin's fifth volume of *Poetae Comici Graeci* (= ancient scholia on Aristophanes *Knights* 522).

[62] Aristotle *Politics* 1341a. 39–41 ὁμοίως δὲ καὶ πολλὰ τῶν ὀργάνων τῶν ἀρχαίων, οἷον πηκτίδες καὶ βάρβιτοι καὶ τὰ πρὸς ἡδονὴν συντείνοντα τοῖς ἀκούουσι τῶν χρωμένων [...].

[63] I shall return to such representations in the course of this chapter.

containers that could easily accommodate paintings closely linked with the "domestic" world of women—as viewed by male pot-painters.[64]

On our late sixth-century *hydria* in Warsaw, the minimalist posture of Sappho pointing to her musicianship seems to have nothing in common with symposiastic and komastic images (often depicted on wine or *symposion* vessels) in which partygoers hold and play *barbitoi*. It would be tempting to associate this *hydria* with a female clientele rather than with the milieu of rowdy drinking parties. At the same time it should be observed that women playing the *barbitos* to accompany the activities of komasts are sometimes shown on red-figure vases of the first half of the fifth century,[65] and the schema of a komast with a *barbitos* in hand appears often on painted pots.[66] Further, I would draw attention to the fact that the Sappho Painter indulged in marked representations of female figures dancing and holding *krotala*. In all these cases the visual context defines the figures. Since scenes with small groups of women, let alone with a lone female figure, playing the *barbitos* are not popular on Attic black-figure vases,[67] I suggest that one of the best parallels to the image on the Warsaw *hydria* can be found on a red-figure *oinochoe* that depicts a woman with light brown hair playing an eight-stringed *barbitos* (Fig. 2). The vase, formerly in the Robinson Collection, Baltimore, and now housed in the Sackler Museum, Harvard University, can be dated to *c.* 490–480 BC.[68] This lone female musician wears *chiton* and a cloak thrown over her shoulders as well as an elegant headdress.[69] If this basic pictorial schema, painted as it is on an *oinochoe*, was viewed in a symposiastic context, its connotations were fittingly "recovered."

[64] Note that *hydriai* are often carried by women in fountain-house scenes depicted on *hydriai*. On these scenes, see Hannestad 1984, Manfrini-Aragno 1992, Manakidou 1992/1993, and Shapiro 2003.

[65] See, for example, the images in Frontisi-Ducroux and Lissarrague 1990:225, and Boardman 1986:49 (no. 24) and 60 (fig. 23).

[66] See, e.g., the obverse of a red-figure amphora, attributed to the Berlin Painter, in London, British Museum 266; *ARV* 198.21, 1633 (Paquette 1984:183, pl. B17); the reverse shows a youth with walking stick and holding out a cup.

[67] For another type of lyre (not a *barbitos*), see a black-figure, white ground *alabastron* in Leiden, Rijksmuseum van Oudheden I.1956.8.1 (*CVA* Leiden, Rijksmuseum van Oudheden vol. 2: 68 and pl. 104.4–7) and attributed to the Sappho Painter, which shows a dancing woman with *krotala* followed by a woman playing a standard bowl lyre, a *lyra*.

[68] Cambridge, Mass., Sackler Museum 1960.354. The vase-painting is unattributed. I hold that it should be related to the red-figure *oinochoe* Oxford, Ashmolean Museum 1927.66 (*ARV* 815.4 and 1583), attributed to the Painter of Philadelphia 2449, a follower of Makron, and dated to about 470 BC. The image on this *oinochoe*/mug shows a woman walking with a red flower in her left hand: the vase-inscription καλος ηικετες provides a *kalos*-name (on Hiketes as a *kalos*-name, see Beazley 1963:vol. 2, 1583–1584).

[69] Note that, like the Sappho on the *hydria* in Warsaw, the female figure on the oinochoe wears earrings; Sappho is also shown wearing a necklace.

Figure 2. Red-figure *oinochoe*: female figure with *barbitos*, *c.* 490–480 BC. Cambridge, MA, Harvard University Art Museums, Arthur M. Sackler Museum, Bequest of David M. Robinson, inv. no. 1960.354. Photo, Imaging Department, © President and Fellows of Harvard College.

To be sure, understanding Sappho on the Warsaw *hydria* depended on the context in which the image was seen. In view of the parallel appearance of Anakreon, also performing with a *barbitos*, on symposiastic vases and the pronounced popularity of the *barbitos* in komastic, symposiastic, and Dionysiac scenes in the late archaic period, the Warsaw Sappho might perhaps be viewed as an indication that her songs had not been unknown in symposiastic contexts too. Certainly her compositions had caused a sensation in Athenian (female? male?) gatherings by *c.* 510–500 BC, as the inscription ΦΣΑΦΟ in view of the Sappho Painter's regular use of nonsense inscriptions suggests. For all that, to find significantly marked representations of the poetess, we will need to turn now our attention to two intriguing vases painted in about 480–470 BC.

## Two Singers—Together

A rather large red-figure *kalathos-psykter* in Munich dated to *c.* 480–470 BC identifies a standing female figure holding a *barbitos* as ΣΑΦΟ ("Sappho").[70] The image on the vessel was long ago attributed to the Brygos Painter and considered a quite late piece of his, but Martin Robertson has cautiously preferred to see it as part of the work of the Dokimasia Painter, a pupil of the Brygos Painter.[71] This *kalathos-psykter* does not show "Sappho" as a lone *barbitos*-player (Fig. 3a). Another composer of songs from Lesbos is introduced into the scene: a standing bearded man named ΑΛΚΑΙΟΣ ("Alkaios"), who wears a flowing, transparent *chiton*, revealing his sex, a cloak, and a *tainia*. Having an elegant fillet around her head, "Sappho" is dressed in a similarly see-through *chiton*, but her *himation* covers the lower part of her body.

Turning to him, Sappho is looking at Alkaios, her face drawn in three-quarter view. "Sappho's" three-quarter view means that her gaze is not directed at the viewer. Intriguingly, preliminary sketches can be detected on the vase-painting.[72] Each of the two musicians holds a *barbitos* and a *plêktron*. While at first sight it is not certain whether Sappho is about to start or has just finished playing her eight-stringed *barbitos*, Alkaios clearly performs with his seven-stringed *barbitos*: five small circles spill out of his mouth. His head is shown bent down and not thrown back—as singers often position their heads

---

[70] Munich, Antikensammlungen 2416; ARV 385.228, 1573, and 1649; *Add.* 228. It was found in Agrigento, Sicily. The shape of the vase is kalathoid and has a spout at the bottom.

[71] Robertson 1992:100 and 118. I agree with Robertson's reservations and attribution.

[72] Drawing faces in three-quarter view is avoided by the Brygos Painter; see Robertson 1992:100. For a discussion of preliminary sketches on early-fifth century Attic red-figure vase-paintings and on this particular *kalathos-psykter*, see Boss 1997 (especially 350 and fig. 14).

Figure 3a. Red-figure kalathoid vase: obverse, Sappho and Alkaios with *bar-bitoi*. *C.* 480–470 BC. Munich, Staatliche Antikensammlungen, inv. no. 2416. Photo, Staatliche Antikensammlungen und Glyptothek München.

Figure 3b. Red-figure kalathoid vase: reverse, Dionysos and female figure. C. 480–470 BC. Munich, Staatliche Antikensammlungen, inv. no. 2416. Photo, Staatliche Antikensammlungen und Glyptothek München.

on Attic vase-paintings. Plucking individual strings with his left hand, he vocalizes: O O O O O.[73]

A methodological observation should be made at this point. The vase should not, a priori, be taken as a sympotic vessel. Its quite idiosyncratic shape—a combination of marked features of a *kalathos*[74] and features of a *psykter*—does not clearly suggest that this was a wine-cooler. It is a cylindrical and spouted kalathoid vase, the function of which can be a matter of speculation.[75] Therefore, in analyzing the *discursive contexts* of its images, we should not associate them with a hypothetical sympotic function of the vase itself. If the *images* on the vase may possibly place Alkaios and Sappho in a sympotic context, this is not corroborated with certainty by the shape of the kalathoid vessel.

The reverse of the vase reveals a parallel iconographic configuration, with a male and a female figure standing opposite each other (Fig. 3b). This time they are Dionysos and a female devotée, both wreathed with ivy leaves and dressed in *chiton* and *himation*. Instead of *barbitoi*, Dionysos holds a *kantharos* in his right hand and vine branches in his left, while his female companion carries an *oinochoe* and a sprig. Both vessels are sympotic. The *barbitoi* of Alkaios and Sappho are juxtaposed, as it were, to the vases held by Dionysos and his devotée. The *plêktra* that the performers hold are similarly juxtaposed to the branches that Dionysos and his female companion carry. Further, the two song-makers wear a ribbon and an elegant fillet, respectively, while Dionysos and his devotée are both wreathed with ivy leaves. Two inscriptions accentuate the relative symmetry and parallelism of the two sides. Between the two poets with the long-armed instruments is a vertical inscription that reads ΔΑΜΑ[Σ] ΚΑΛΟΣ ("Damas is beautiful"). On the reverse, to the right of Dionysos' mouth, lettering provides the word ΚΑΛΟΣ ("beautiful"), while to the left of the woman's mouth, another ΚΑΛΟΣ ("beautiful") appears, in retro-

[73] The five small circles come out of his mouth in two groups: OOO OO.

[74] On *kalathoi*, see Williams 1961.

[75] A few examples illustrate my point. First, a number of archaeological publications refer to it as a *kalathos*. For Schefold (1997:84) it is a "Mischgefäss (Kalathos)." Robertson (1990:100 and 118) calls it a cylindrical wine-cooler. Webster 1972:60 notes that "the shape is modelled on a woman's workbasket." Bell 1995:28 is critical of the identification of the vase as a wine vessel but provides further (wild) speculations. Simon (1981:113) describes it as a "kalathosförmiger krater." According to Boardman (1975:135), it is a big kalathoid jar with a spout (but cf. Boardman 2001:250 and 253). In Beazley (1963:vol. 1, 385) it is listed as a kalathoid vase with spout. Bell's article (1995) proposes a highly hypothetical scenario with regard to this vase: according to Bell, Pindar commissioned the vase to Brygos or someone near him, asked him "to add a spout at the base, because the krater would be used for honey and not for wine" (Bell 1995:25) and sent it along with his *Isthmian* 2 to Akragas.

grade. The two sides of a vase are often related with regard to the narrative they provide, and numerous cases exist where indirect associations between the images of the two sides are detectable. On this particular kalathoid vase, the symmetry of the figures on both sides is evident. Although Sappho's hair is drawn similarly to that of Dionysos, as well as of his female companion on the reverse, the body language of Sappho is different from that of Dionysos' female devotée: Dionysos' head leans slightly forward while Alkaios' head is bent down; Dionysos and his follower are fully dressed; Alkaios and Sappho's garments are lighter and partly diaphanous.[76] Speculation (even impressionistic) can be offered about the juxtaposition of the image of "Alkaios and Sappho" to that of "Dionysos and his female companion." For the sake of my methodological approach in this book, I refrain from indulging in such an enterprise.[77]

On the obverse side with the two poets from Lesbos, the image does not disclose what Alkaios is singing about, but the lowered position of his head has been viewed as an indication of "shame" on his part.[78] This vase-painting has thus been closely connected by a large number of scholars with a dialogic song between Sappho and Alkaios that Aristotle quotes in his *Rhetoric* (1367a.8–14 Kassel), a fragmentary poem attributed to Sappho.[79] Alkaios, Aristotle maintains, initiated the dialogue:

θέλω τί τ' εἴπην, ἀλλά με κωλύει
αἴδως...

---

[76] This feature might perhaps render some kind of eroticized dimension to the representation of Alkaios. The transparency of the upper part of Sappho's *chiton* could possibly reflect certain discursive idioms about her East Greek identity.

[77] Literary critics would wish to draw analogies between the two sides of the vase and to read Sappho as being closely associated with a maenadic figure and Alkaios with Dionysos himself. In numerous cases of Attic vases, representations on the two sides are indirectly associated when the viewer looks at both sides. Here, I believe, the possible associations are related to the broader realm of the *symposion* and its god, Dionysos. As I have noted, the *barbitos* of the two poets are juxtaposed to the *kantharos* and *oinochoe* that Dionysos and his female companion hold. Suggesting that there is a kind of narrative between the two sides corresponds to arguing that while Dionysos' female companion has her face directed toward him, Sappho turns her body away from Alkaios. Such an idea, based on a considerably marked adherence to the painter's "intentionality," would lead to further hypotheses, which cannot be easily substantiated if viewed in the context of other similarly symmetric representations on the two sides of Attic vases. The figure of Dionysos, as in other cases, is a metonymic reference to sympotic and komastic contexts and discourses. The image on the reverse potentially, but not certainly, places "Alkaios and Sappho" in the Dionysiac space of the *symposion* and *kômos*.

[78] See, e.g., Picard 1948:338–344, Webster 1972:60, Schefold 1997:84.

[79] Sappho fr. 137 V.

> I want to say something to you,
> but shame prevents me....

And, in response, we are told, Sappho sang: "but if you desired what is honorable or beautiful,... shame would not seize your eyes, but you would speak about what you claim [?]."[80] I shall return to this fragment attributed to Sappho in Chapter Four but for now I should point out that such dialogues between poets—belonging to the same era or even to chronologically distant periods—were often based on fabricated scenarios that amused the imagination of ancient performers, audiences, and writers.

Could Aristotle's claim have originated in earlier stories, possibly circulated in *symposia* or related venues, about a purported antiphonal exchange between Sappho and Alkaios in this dialogic song? Or could a vase-painting showing Alkaios singing to Sappho, such as the one under consideration, have contributed to the dissemination of fictionalized interpretations of a dialogic song of Sappho?

I argue that images such as the one on the Munich vase could have, to some extent, sparked off—or provided the basic narrative element regarding a "Lesbian poets' encounter" conducive to—fabricated stories eventually connected with specific songs by Sappho or Alkaios. Whether or not in the representation of Alkaios singing to Sappho the bent position of his head indicated "shame" on his part, can be only a matter of guesswork.[81] It is more likely, I

---

[80] The last sentence in the ancient text is corrupt. It is noteworthy that in a letter of 25 July 1907 to his wife, Rainer Maria Rilke made the same connection between the Munich kalathoid vase and Sappho fr. 137 V: "Alcaeus was a poet, who on an antique vase stands before Sappho with head lowered and lyre in hand, and one knows that he has said to her: 'Weaver of darkness, Sappho, you pure one with the honey-sweet smile, words throng to my lips, but shame holds me back'" (Rilke 1984:15, with E. Snow's editorial note). Should one wish to hear how the conversation continued, one might look at *Sappho an Alkaïos: Fragment*, a seemingly fragmentary poem by Rilke, in which he picks up where "Sappho" leaves off: "And what anyway could you have said to me, / and what concern has my soul for you, / if your eyes lower themselves timidly / when the not-said comes near? Man, / look, the saying of these things has / transported us, and even into fame. / When I think: beneath you our sweet / maidenhood would wretchedly perish, / which we, I who know and those who / know along with me, guarded by the god, / bore untouched, so that Mytilene / like an apple orchard in the night / grew fragrant with the swelling of our breasts. / Yes, these breasts too, which you did not select / as one intent on twining wreaths of fruit, / you suitor with the drooping face. / Go, leave me, that to my lyre may come / what you keep back: everything stands poised. / This god is no assistance to a pair, / but when he surges through the *one* /..." (Rilke 1984:14–15). Note that the German poem draws on the image of the Munich kalathoid vase, and the song that Rilke quotes in his letter is a conflation of (a version of) Alkaios fr. 384 V and Sappho fr. 137 V. For a discussion of Lawrence Alma Tadema's *Sappho and Alcaeus* (Walters Art Museum, Baltimore) and Theophilos' *The poetess of Lesbos Sappho and the kitharodos Alkaios* (Ἡ ποιήτρια τῆς Λέσβου Σαπφὼ καὶ ὁ κιθαρῳδὸς Ἀλκαῖος, Tériade Museum, Varia, Lesbos), cf. Yatromanolakis 2003b.

[81] "Concentration" to his singing can be an alternative idea; cf. Snyder 1997a:116.

believe, that the speakers of a dialogic song of Sappho were attributed histor-ical names some time before Aristotle and that the vase-painting itself did not represent anything but "Alkaios and Sappho in performance." In other words, if we gave this image a slightly more marked definition—"Alkaios singing to Sappho"—and added the adverbial perspective "bashfully," we would reenact the ancient fictionalizing procedure of attributing specific "plots" to poems, although such an enterprise would this time be associated with an image. Instead, I suggest that what we actually see on the obverse of this vase is the thematically diverse and often contextually dissimilar songs by Sappho and Alkaios located in the same performative space. The two poets with their *barbitoi* perform without their companions outside marked religious or polit-ical settings in the same visual context, and all possible differences in their songs are elided. Unlike later receptions of Sappho, no marked indications appear on this vase-painting that differentiate her figure as a performer from that of archaic male lyricists.

In this regard, the only recent, brief discussion of the vase-paintings depicting Sappho has attempted to see in all four of them a common pattern in the construction of gender on the part of the painters. According to this inter-pretation, these images constitute "instances of the 'muting' of a female figure by male artists" and at least three of them[82] "presented what was considered by Athenian standards an 'appropriate' model of a woman poet—subdued, passive, and in fact at least momentarily silent."[83] The idea behind such an approach is that Sappho, in contrast to Alkaios on the Munich kalathoid vase, is not depicted in a singing pose or in the act of singing. However attractive it perhaps appears, this view might not be easily borne out by the surviving images with Sappho. Given the rarity of representations of archaic poets or other celebrities on vase-paintings, the fact that Sappho—more than any other archaic lyricist—is depicted on four vases attests to the centrality of her performative voice and the popularity of her songs in the late archaic and classical periods. Should painters have wished to suppress or control Sappho's female voice, there would have been significantly marked indications of such an effort. On the contrary, on the Warsaw *hydria*, not unlike the Bochum *kalyx-krater* that I shall examine next, Sappho is shown with a *barbitos* and a *plêk-tron* in her hands: the *plêktron* itself indicates imminent or actual performance.

---

[82] The Warsaw *hydria*, the Munich vase, and the Athens *hydria*, which is examined below in this chapter.

[83] Snyder 1997a:114 and 115. Snyder confines herself to a general description of the vase-paint-ings, neglecting the reverse sides of the Munich kalathoid vase and the Bochum *kalyx-krater*, and draws parallels between the construction of gender in these four vases and "the conclu-sions drawn in a modern analysis of images of men and women in both art and advertising to the effect that '*men act and women appear*'" (1997a:114).

On the fourth vase, the Athens *hydria*, a scroll is held by the poetess before the eyes of the viewer: the scroll is not empty but contains a self-referential poem "by Sappho" juxtaposed to a distinctively marked epic formula. And on the Munich vase, Sappho is not "silent," waiting and listening.[84] Instead, Sappho is shown as a performer: I argue that the fact that the fingertips of her left hand touch the strings of her *barbitos* and are positioned in the same way as Alkaios' fingers[85] indicates that both musicians are not viewed from a different perspective in terms of their status. As for the manner in which she holds her *barbitos* (not in a straight position), there are a number of parallels of *barbitos*-players holding their lyres in a horizontal or even downward direction.[86] The five small circles that come from Alkaios' mouth do not add something marked to his status as a performer. Arguing that Sappho is muted, especially when the great majority of *barbitos*-players and, more broadly, lyre-players and singers on vase-paintings do not have melodic sounds spilling out of their mouths, is implicitly based on the assumption that other known poets are depicted as singing: however, as we will see in this chapter, Anakreon, the only other archaic poet appearing on vases, is not.[87] Like Anakreon, Sappho is represented as a musician who is not vocalizing. I suggest that "Alkaios," his head downcast, is the object of *her* gaze.

What we can infer from this image (not from the shape of the vase), but *especially* in connection with the Bochum *kalyx-krater* dated to the same decades, is that the figures of Sappho and Alkaios and their songs are now viewed in a more marked, symposiastic context. The Dionysiac imagery on the reverse of the vase supports this idea.[88] In addition, the *barbitoi* in the hands

[84] Snyder 1997a:114 and 116.

[85] This is the standard position of the fingers of *barbitos*-players on the strings of their long-armed lyres in vase-paintings; for the representation of the fingers of the left hand of *barbitos*-players, cf. also Maas and Snyder 1989:122 "fingers straight and usually separated."

[86] See, for example, a red-figure *pelike*, dated to c. 490 BC, in Florence, Museo Archeologico Etrusco 76895; *ARV* 280.17 (Peschel 1987:pl. 145); cf. London, British Museum E266; *ARV* 198.21, 1633 (Paquette 1984:183, pl. B17); Hamburg, Museum für Kunst und Gewerbe 1893.100; *ARV* 309.9, 1644 (Hoffmann and Hewicker 1961:22, nos. 66–67); Munich, Antikensammlungen 2311; *ARV* 197.9, 1633 (Dover 1989:R329).

[87] Snyder 1997a:114 oddly thinks that Anakreon, like such mythical singers as Orpheus, is shown singing. The cases of lyre-players and singers depicted along with poetic lines or just sounds coming out of their mouths are remarkably few, compared to the vast number of opposite cases.

[88] I do not agree with Webster's hypothesis that because of its kalathoid shape, the vase was intended as a present by Damas (ΔΑΜΑ[Σ] ΚΑΛΟΣ) to a woman, since *kalathoi* were women's work baskets (Webster 1972:60; note that Webster calls the vase a "wine-container" and attempts to associate the "poetic dialogue" between "Alkaios" and "Sappho" allegedly portrayed on it with a speculative scenario, according to which "in ordering this vase for his girl, Damas

of the poets, in view also of the ΔΑΜΑ[Σ] ΚΑΛΟΣ and the two "affirmative" ΚΑΛΟΣ next to the mouth of Dionysos and of his female companion, may similarly point to such a discourse. The images on the Munich kalathoid vase but, *more importantly*, the Bochum *kalyx-krater* indicate that Sappho's songs, for the first time in our record, were associated with the performative context of *symposia*. I argue that the Bochum *kalyx-krater* provides the only certain clues that we have about Sappho being performed in early fifth-century Athenian *symposia*. In contrast to the current scholarly paradigm that rather intuitively and anachronistically views Sappho in the context of *symposia* on the basis of very late literary sources, I further argue that these sources cannot substantiate the relevant claim. Against the background of the visual representation on the Bochum *kalyx-krater*, later informants, considered by scholars as evidence for the performance of Sappho in early *symposia*, need to be reexamined.

## The Grammar of Late Performances

Indeed, Sappho's poetry was represented in later antiquity as being sung in the context of dinner parties. Although these sources are very late, it has been thought that at least one of them reflects earlier practice. The sources that associate Sappho's songs with a sympotic context date from the first to the third centuries AD. The earliest one is Ploutarkhos and it is to his *Table-Talks* (*Symposiaka*) that I shall now turn.

The *symposiaka*, as Ploutarkhos explains in the introduction to the second book of his *Table-Talks*, are general topics and discussion suitable for the *symposion*, in contrast to the *sympotika*, the more specific talk about different aspects of the *symposion* itself.[89] The fifth *problêma*, or question, of the first book of Ploutarkhos' is of a more general character, a *symposiakon* proper: "why it is held that 'Eros instructs a poet.'"[90] This talk, Ploutarkhos points out at the very beginning of the fifth "question," started after the performance of some of Sappho's poems:

---

was surely making an apology for a too fervid approach as well as urging his suit"). According to Robertson 1992:100, this vase is double-walled, but I have not been able to verify this. It certainly has a spout at the bottom. For another general hypothesis that connects (without evidentiary substantiation) the image of the two poets (side A) with an *agôn* at a festival of Dionysos (side B), see Simon 1981:114. For discussion of a modern artistic attempt to imagine an ancient poetic contest between Sappho and Alkaios, cf. Yatromanolakis 2006a.

[89] *Symposiaka* 629d.
[90] *Symposiaka* 622c.

Πῶς εἴρηται τὸ

> 'ποιητὴν δ' ἄρα
> "Ερως διδάσκει, κἂν ἄμουσος ἦ τὸ πρίν,'
> ἐζητεῖτο παρὰ Σοσσίῳ Σαπφικῶν τινων ᾀσθέντων...

At a dinner hosted by Sossius, after the singing of some of
Sappho's compositions, the question arose as to why it is held
that "Eros then instructs [anyone to be] a poet, even if he was
unmusical before."[91]

At that dinner,[92] the performance of Sappho's songs seems to have been closely
related to the topic of the ensuing talk,[93] and, in the context of Ploutarkhos'
semi-imaginary and elaborately structured λόγοι παρὰ πότον ("after-dinner
talks over the wine"), a reference to those songs should be viewed as an apt
way to introduce the question of the discussion. The suitability of the songs of
Sappho as a prelude to an exploration of the idea that it is Eros that instructs a
poet is prominent. This passage, along with the story from the *Symposiaka* that
I shall examine next, suggest that for Ploutarkhos "the singing of Sappho's
lyrics at *symposia*" represents a standard thematic *topos* for Roman parties. The
performance of the love poetry composed by Sappho and Anakreon reflects
performative practices in *symposia* of his time.[94]

A further representation of the singing of Sappho's poems in first or early
second- century AD *symposia* is obtained from another *problêma* in the seventh
book of the *Symposiaka*: "what kinds of entertainment are most appropriate at
dinner."[95] The dramatic setting is now a dinner party hosted in Khaironeia,[96]

[91] These lines from Euripides' *Stheneboia* were particularly popular and widely quoted (starting with
Aristophanes *Wasps* 1074 and Plato *Symposion* 196e) in antiquity; see the sources collected in Euri-
pides fr. 663 *TrGF* (with Kannicht's apparatus) and Teodorsson 1989/1996:vol. 1, 107.

[92] For the meaning of παρὰ Σοσσίῳ, cf, e.g., *Symposiaka* 612e, 635e, and 645d. For Ploutarkhos'
Roman friend Sossius Senecio, see RE s.v. "Plutarchos," cols. 688–689 (K. Ziegler) and "Sossius,"
cols. 1180–1193; cf. the entry "Sosius Senecio, Quintus" in *Oxford Classical Dictionary* (third re-
vised ed., Oxford 2003), 1427.

[93] In other treatises, Ploutarkhos refers to a number of Sappho's songs related to *erôs*: see, for
example, *Erôtikos* 762f–763a; cf. Teodorsson 1989/1996:vol. 1, 108. Concerning the *problêma*
discussed here by Ploutarkhos, it is worth observing that Sappho had composed a poem about
a woman who did not share the roses of Pieria; see Sappho fr. 55 V and Yatromanolakis 2006b;
cf. fr. adesp. 1001 *PMG*.

[94] Even if one assumes that Ploutarkhos' reference to a performance of songs of Sappho reflects
an archaizing practice, this idea does not entail that, based on Ploutarkhos, one can take for
granted that such a practice goes back to the archaic period or the fifth century BC (why not
the fourth century?).

[95] *Symposiaka* 711a–713f: eighth question.

[96] See *Symposiaka* 710b περὶ ἀκροαμάτων ἐν Χαιρωνείᾳ λόγοι παρὰ πότον ἐγένοντο. The setting of
the eighth question of book 7 is the same as that of the seventh question.

Ploutarkhos' birthplace. The participants, we are told, included a Stoic sophist, Philippos of Prousa, Diogenianos of Pergamon, and, of course, Ploutarkhos himself. The Stoic sophist's argument was that all other kinds of entertainment should be banished from dinner parties. Instead, he would introduce a form of entertainment that had been recently launched at Roman parties: recitations of Plato's dramatic dialogues by slaves who learned by rote the most vivacious of such dialogues and performed them in a most "histrionic" manner. Philippos reacted strongly to the sophist's preference and maintained that he was one of the first to become annoyed when such symposiastic performances of Platonic works were introduced in Rome. His reverence for Plato would not allow him to hear such recitations, since:

ὅτε καὶ Σαπφοῦς ἂν ᾀδομένης καὶ τῶν Ἀνακρέοντος ἐγώ μοι
δοκῶ καταθέσθαι τὸ ποτήριον αἰδούμενος.

Even when Sappho's songs are performed, or Anakreon's, it
seems to me proper to put down my cup, out of respect.[97]

We are not told at *what* symposia Philippos used to hear Sappho's poems being sung—Roman or Greek. All the same, performances of lyric "classics," among other poetic and dramatic forms, farces, and dances, are here thought of as a type of entertainment at dinner parties of Ploutarkhos' era.[98]

For representations of Sappho at Roman *symposia* of the second century, we need to focus in some detail on a story related by Aulus Gellius in the nineteenth book of his *Attic Nights*.[99] In one of the numerous notes and stories that his twenty-book miscellany comprises, Gellius refers to a *cena* given by a talented and educated young man of equestrian rank from Asia on his birthday. Being well versed in music, the young host had invited his friends and teachers to a small estate near Rome. Antonius Julianus, Gellius' teacher of rhetoric, was also there, and his role at the dinner was to be crucial. The whole dramatization of this lighthearted anecdote seems fictitious; its main aim is to draw parallels between Greek and Roman erotic poetry, mostly to the advantage of the equally refined and charming verses of the latter. When eating and drinking were over and conversation was about to commence, it

---

[97] Note that ἂν ᾀδομένης is an emendation of the transmitted ἀναδεχομένης. In his critical edition, Hubert (1938:245) prints this emendation. Given the occurrence of Σαπφικῶν τινων ᾀσθέντων in *Symposiaka* 622c, ἂν ᾀδομένης is certainly the safest and best restoration of the problematic ἀναδεχομένης.

[98] It is only a hypothesis that such references can attest to the performance of Sappho's songs in archaic and classical *symposia*.

[99] *Attic Nights [Noctes Atticae]* 19.9.

was requested that young well-trained singers and musicians be brought in to perform:[100]

> *Ac posteaquam introducti pueri puellaeque sunt, iucundum in modum Ἀνακρεόντεια pleraque et Sapphica et poetarum quoque recentium ἐλεγεῖα quaedam erotica dulcia et venusta cecinerunt.*

> And when the boys and girls were presented, they sang in a delightful manner a number of Anakreontic and Sapphic songs, as well as some mellow and charming erotic elegiac verses of more recent poets.

The guests, including Gellius, were particularly elated by a poem by Anakreon, which is quoted by the miscellanist and happens to be not by Anakreon but from the *Anacreontea*, a shorter version of poem 4.[101] Greek words are employed for ἐλεγεῖα and Ἀνακρεόντεια, but not for Σαπφικά.[102] After becoming exasperated at the provocation and snobbishness of some Greek guests, who claimed that Latin love poets were inferior to "Anakreon and the other [Greek] poets of that kind,"[103] Antonius Julianus, as a good patriot (*pro lingua patria tamquam pro aris et focis*), melodiously intoned four early love epigrams, two by Valerius Aedituus and one each by Porcius Licinus and Quintus Catulus, all somewhat obscure poets.[104] An interesting aspect of the episode is that Gellius, as narrator, believes that, compared to the Latin poems that Julianus recited at that dinner, "nothing can be found in Greek or Latin that is more elegant, charming, polished, or concise,"[105] the songs of Anakreon and Sappho presumably included.

Further, it is also worth observing that elsewhere Gellius refers to specific "problems" from Ploutarkhos' *Table-Talks*,[106] which, as we have seen, envisage

---

[100] *Attic Nights* 19.9.4.

[101] *Anacreontea* 4 is preserved in three versions; see West 1993a:IX and 3–4; cf. Rosenmeyer 1992: 2n2.

[102] For bilingualism (and biculturalism) in Gellius and other Roman writers, see Swain 2004.

[103] *Attic Nights* 19.9.7.

[104] In the same century, Apuleius refers, in the same order, to these three poets (*apud nos vero Aedituus et Porcius et Catulus*), but, unlike Gellius, he does not quote them (*Apologia* 9 Helm). In this passage of his *Apologia*, Apuleius also mentions Anakreon, Sappho, and other archaic lyricists (on Cius in *Apologia* 9, see Yatromanolakis 2001b:209n6), to defend his writing of *amatorios versus*. Concerning Sappho (*mulier Lesbia*), he draws attention to the wantonness of her songs.

[105] *Attic Nights* 19.9.10.

[106] *Attic Nights* 17.11.6 (...*Plutarchus in libro* Symposiacorum; cf. 17.11.1), 3.6.1 (...*et Plutarchus in octavo Symposiacorum dicit*; cf. 3.6.3), and 4.11.13 (...*Plutarchus in* Symposiacis *dicit*). Gellius also makes other references to Ploutarkhos and starts his first book with Ploutarkhos' name; *Plutarchus* is the very first word of his *Attic Nights*.

the performance of Sappho in the context of dinner parties in his time. In the first story recounted by Ploutarkhos, the dinner at Sossius Senecio,[107] the conversation, as in Gellius' narrative, was triggered by the singing of some Sapphic songs (Σαπφικά τινα). I wonder whether *Sapphica* may refer to songs in the tradition of Sappho—that is, Sapphic compositions inspired by the *Musa Sapphica* to which Latin poets refer.[108] The singing of Sapphic and Anakreontic songs by skillful *pueri puellaeque* in Gellius is a notable feature that has escaped the notice of scholars: intriguingly, at the dinner hosted by a young man talented in music, the singers he brought in were boys and girls. I suggest that the dramatization of this incident, from the perspective of the ancient reception of Sappho, reflects the manner in which some of "Anakreon's and Sappho's" songs could have been performed in second-century AD banquets; this performative mode seems to break with the tradition of archaic and classical male *symposia* and to conflate monodic and choral modes of singing. Behind the theme of the "performance of Sappho's poems" occurring both in Ploutarkhos and in Aulus Gellius lie different first- and second-century traditions of the singing of Sappho's compositions, which had become an integral part of symposiastic entertainment and were, in such late eras, accompanied by ever newly set and improvised music, even when that setting might have been considered by some audiences "traditional."

A more complex and almost unexplored case of the performance of Sappho in *symposia* can be found in another Roman miscellanist, Aelian, who preferred, however, to write in Greek. While Gellius' *Attic Nights* was published about 180 AD, Aelian's *Historical Miscellany* (*Poikilê Historia*) was written some time in the first three decades or so of the third century. The story in which we are interested here is an excerpt preserved in Stobaios' fifth-century anthology, in a section with passages related to "industriousness" (περὶ φιλοπονίας). The fragment is ascribed to Aelian (Stobaios 3.19.58 = Aelian fr. 190 Domingo-Forasté), and in the same section, almost immediately after this excerpt, there occurs another passage from Aelian (Stobaios 3.19.60), probably excerpted this time from the seventh book of his *Historical Miscellany* (7.7).[109] Since in the latter work Aelian refers to stories about Solon,[110] it is not unlikely that the former fragment in Stobaios (3.19.58), a snapshot from the life of Solon, also

---

[107] *Symposiaka* 622c.

[108] Cf. Chapter Three, p. 213 n. 217.

[109] For the two versions of this passage, see Aelian *Historical Miscellany* 7.7a and 7.7b in Dilts's edition (1974:88).

[110] *Historical Miscellany* 5.7, 8.16. Note that one of these passages (*Historical Miscellany* 8.16) is about Solon, "the son of Exekestides," in his old age. References to Solon's legislation and political action include *Historical Miscellany* 3.17, 7.19, and 8.10.

comes from the *Historical Miscellany*.[111] Whatever the case, Aelian fragment 190 D.-F.[112] relates the following incident:

Σόλων ὁ Ἀθηναῖος Ἐξηκεστίδου παρὰ πότον τοῦ ἀδελφιδοῦ αὐτοῦ μέλος τι Σαπφοῦς ᾄσαντος, ἥσθη τῷ μέλει καὶ προσέταξε τῷ μειρακίῳ διδάξαι αὐτόν. ἐρωτήσαντος δέ τινος διὰ ποίαν αἰτίαν τοῦτο ἐσπού- δασεν, ὁ δὲ ἔφη 'ἵνα μαθὼν αὐτὸ ἀποθάνω.'

Solon of Athens, son of Exekestides, when his nephew sang a song by Sappho at a drinking party, was delighted with the song and asked the boy to teach it to him. When someone asked why he was so keen on this, [Solon] answered "So that I may learn it and then die."

This brings us back to early sixth-century Athens. But does the story provide any indications about the performance of Sappho's songs in *symposia* of the archaic period? Numerous scholars have assumed that the narrative reflects early practice or, more recently and at times rather impressionistically, that it can at least confirm indications provided by earlier sources.[113] The risks pursuant to such an inference can be numerous. Aelian is often not a reliable historical source, especially in cases when he mentions that Sokrates used to pose questions to people at Aristotle's Lyceum (*Historical Miscellany* 9.29). However, from the perspective of a broader, contextual exploration of the ancient reception of Sappho, it is not enough to assume simply that Aelian fragment 190 D.-F. is anecdotal, albeit indicative, as so often believed, of the realities of the archaic performances of Sappho. As we have seen, there are representations of the singing of Sappho at Roman dinner parties during

---

[111] Eight of the fragments of Aelian (frs. 1–8 Domingo-Forasté = frs. 1–8 Hercher) are attributed to the *Historical Miscellany* (see Domingo-Forasté 1994:18–20). These eight fragments, along with the fragment that concerns us here (fr. 190 Domingo-Forasté = 187 Hercher), have been included by Nigel Wilson in his Loeb edition of Aelian's *Historical Miscellany* (Wilson 1997:492–497; cf. Wilson 1997:23, who argues that "if such ascriptions are correct, it would appear to follow that the original text extended beyond 14.48 [i.e., the end of the *Historical Miscellany*] or that in the process of epitomisation some chapters were completely omitted"). For the process of "epitomization" or "abbreviation," see Wilson's concise discussion (1997:13–14 and 18).

[112] D.-F. will hereby refer to Domingo-Forasté's 1994 edition. Aelian fr. 190 D.-F. was fr. 187 in Hercher's older critical edition.

[113] From Mure 1854:273, to Robinson 1924:23 and 104, to Schefold 1997:24 and 74; cf. Nagy 1996:219. These scholars do not take into account, nor do they explore, the synchronic contexts of the late archaic and fifth-century reception of Sappho. More recently, for Lidov 2002:228 this late source can be juxtaposed with early images (themselves undifferentiated and blurred in Lidov) to confirm the sympotic reception of Sappho's songs *in general* and presumambly in all historical periods. By accumulating and putting the allegedly relevant "evidence" together, without attempting to investigate the cultural grammar of late sources, such approaches often construct "generalizing" and "diachronic" images of Sappho that contradict synchronic perspectives. Herington (1985:35–36) is more skeptical.

the late first and second centuries. We need to go beyond the unnecessary hypothesis that early and late representations suggest a linear continuity in the symposiastic performance of Sappho from early times to late antiquity.

I argue that such late sources—or as I would prefer to term them "informants"—if viewed within related sociocultural contexts, do not vouchsafe to disclose earlier cultural realities. If we search for informants that may throw some light on the story about Solon, we may come closer to the cultural practices involved in the construction of such anecdotes in later times. In this regard, Ammianus Marcellinus proves to be significant in providing *comparative* information about how basic plot structures could produce variations on specific themes. Writing in the fourth century, he recounts a similar story, but this time it is Sokrates and not Solon who becomes enchanted by a song of an archaic lyricist:[114]

> *Quidam detestantes ut venena doctrinas, Iuvenalem et Marium Maximum curatiore studio legunt, nulla volumina praeter haec in profundo otio contrectantes, quam ob causam non iudicioli est nostri. Cum multa et varia pro amplitudine gloriarum et generum lectitare deberent, audientes destinatum poenae Socraten coniectumque in carcerem rogasse quendam scite lyrici carmen Stesichori modulantem, ut doceretur id agere, dum liceret, interroganteque musico, quid ei poterit hoc prodesse morituro postridie, respondisse, ut aliquid sciens amplius e vita discedam.*

Some of them hate learning like poison, but read Juvenal and Marius Maximus with diligent care, in their unlimited idleness going through no other books than these; and why this is so is not for a man like me to judge. Given the greatness of their fame and ancestry, they ought to study many and various works; they ought to be aware that Sokrates, condemned to death and thrown into prison, asked someone who was skillfully performing a song of the lyric poet Stesikhoros to teach him to do this while there was still time. And when the musician asked what good this could be to him, when he was to die next day, [Sokrates] answered "So that I may learn something more before I depart from life."

In this section of book 28, Ammianus provides an account of the vices of Roman nobles around 370 AD. His reference to Sokrates may or may not conflate different versions of earlier stories.[115] However, what is worth pointing out is

---

[114] Ammianus Marcellinus 28.4.14–15 Seyfarth.

[115] See Cicero *On Old Age* [*Cato Maior de senectute*] 26 (cf. Plato *Euthydêmos* 272c), Valerius Maximus *Memorable Deeds and Sayings* 8.7.ext.8, and cf. Valerius Maximus 8.7.ext.14.

the basic narrative structure lying behind this story: "to learn something and die."[116] Solon is substituted for Sokrates but more importantly "Stesichorus," modified by "lyricus," has taken the place of "Sappho." As in the case of the *skillful* boys and girls in Gellius' narrative,[117] the musician in Ammianus skillfully performs, even in prison, a song that could have been by any of a number of poets. Viewed within this context, the story about the singing of Sappho in Aelian represents, I argue, an instance of the interchangeability of a number of possible poets in the discursive context of "the performance of a lyric song." The fragment of Aelian tells us more about the literary tastes and cultural practices of his time than about the performance of Sappho in the early sixth century BC.

To converse with fifth-century BC representations of "Sappho" in Athenian symposiastic contexts, we need to attempt to read the pictorial discourse of a *kalyx-krater*, a type of vessel that was certainly used at drinking-parties.

## Yes, in the Company of a Young Woman

The case I shall focus on here is an image of Sappho painted on a red-figure *kalyx-krater* attributed to the Tithonos Painter and dated to about 480–470 BC. The vase is housed in the Kunstsammlungen of the Ruhr-Universität Bochum.[118] On the obverse, Sappho is depicted holding a seven-stringed *barbitos* in her left hand, with a *plêktron* in her right hand (Fig. 4a). The fingertips of her left hand touching the strings of her *barbitos* are shown straight and separate, the standard position of the left hand of *barbitos*-players on Attic vase-paintings. Sappho stands with her body facing right, while her head is turned backward toward her outstretched right hand. It has been assumed that Sappho is shown here alone, as in the case of the Warsaw *hydria* on which she is depicted as a single figure striking the strings of a seven-stringed *barbitos*.[119]

However, the picture on the Bochum *kalyx-krater* becomes more complete if we investigate the vase closely and in the context of broader idealized cognitive models in Attic visual discourses. If we look at the reverse of the *kalyx-krater* (Fig. 4b), another female figure appears in similar pose, walking in the opposite direction from Sappho. Her clothes cover her body thoroughly. It is as

[116] See e.g. the story in Valerius Maximus' *Memorable Deeds and Sayings* 8.7.ext.14.
[117] Attic Nights 19.9.3 ...*scitissimos utriusque sexus.*
[118] Inv. S 508. I examined the vase with the permission of Dr. Cornelia Weber-Lehmann, Curator at the Kunstsammlungen. Dr. Weber-Lehmann informed me that the vase was donated to the Ruhr-Universität Bochum in 1972 from the private collection of Julius C. and Margot Funcke. For this collection, see Kunisch 1972 and 1980.
[119] Snyder 1997a:109; similarly in Snyder 1998:166.

Figure 4a. Red-figure *kalyx-krater*: obverse, Sappho with *barbitos*. Attributed to the Tithonos Painter, *c.* 480–470 BC. Bochum, Ruhr-Universität, Kunstsammlungen, inv. no. S 508. Photo, Ruhr-Universität Bochum.

if the second female figure were a mirror image of Sappho, although there are differences in the representation of the figures. That the images on the two sides of the *kalyx-krater* are related is an aspect I shall explore in the following section. Note that the painter chose to depict both women with their heads turned backward. While in the case of Sappho the position of her extended right arm and of her slightly outstretched right foot may account for the fact that her head is shown turned backward, the same is not true of the woman on the reverse. It is evident that some parallelism is achieved through the posture of the two female figures, although the fact that the second one is not represented as a *barbitos*-player invites closer inspection.

Figure 4b. Red-figure *kalyx-krater:* reverse, female figure. Attributed to the Tithonos Painter, *c.* 480–470 BC. Bochum, Ruhr-Universität, Kunstsammlungen, inv. no. S 508. Photo, Ruhr-Universität Bochum.

Upon rotating the vase and looking at—or comparing—both sides, the viewer realizes that the gaze of the two women will never interlock. While Sappho "looks" at the other female figure, that figure has her head turned in the opposite direction from Sappho, and vice versa. And as long as the two sides are perceived as a continuous "narrative,"[120] a snapshot placed in indefinite time—a sort of ritual time—the two figures will keep following one another, as in komastic scenes that I shall now explore.

---

[120] See Yatromanolakis 2001a. For the narrative connection of the different sides of vase-paintings, but mainly in mythological scenes, see Morgenthau 1886, Froning 1988, and Stansbury-O'Donnell 1999. Cf. Sourvinou-Inwood 1991:80–82.

## The Tithonos Painter and Modes of Representation

I have already suggested that the image of Sappho becomes more complete and complex upon viewing both sides of the vase. It should be stressed that this connectedness between obverse and reverse occurs often in late archaic and early classical vases and is a standard mode of representation for some painters during this period. Among numerous cases, I shall first discuss two culturally intriguing ones.

On the obverse of a red-figure neck-amphora attributed to the Brygos Painter and dated to *c.* 480 BC,[121] we see a *kitharôidos* wearing a *chiton* and a *chlamys* while striking the strings of his *kithara* with his *plêktron* (Fig. 5a). His head thrown back, as would be expected for a singer, he seems to be performing alone. However, on the reverse we see a young man holding a stick in his left hand and leaning his lowered head on his right hand (Fig. 5b). Whatever this gesture may suggest (frustration, concentration, or something similar), the young man appears to be a listener, the audience of the *kitharôidos* in the context of an (agonistic?) performance. The position of the figures—one placed opposite the other, as it were—the young man's face bent downward and looking in the direction of the *kitharôidos'* face that is thrown backward—is significant in this mode of representation, despite the fact that the gaze of the two figures does not interlock: each of them is focused on his represented role.

A second example is a red-figure *oinochoe* in the manner of the Triptolemos Painter and dated to the second quarter of the fifth century.[122] To the right of the handle of the *oinochoe* a Greek, wearing only a mantle that covers his back, grasps his erect penis and runs toward an archer who appears on the other side. Between the two male figures there is a good deal of black space, and the connection between the two sides can be made upon turning the *oinochoe*, as well as through an inscription. The second man, clad in non-Greek attire, with a *gôrytos* hanging from his left arm, bends forward. He is facing the same direction, thus allowing the aroused man to approach him from behind, despite the distance between them. With his face turned to the viewer, the archer raises his hands on either side of his head, his whole posture suggesting submissiveness or consent. An inscription running from the head of the naked, lightly bearded man to the archer's right foot helps us conceptualize the entire scene:

---

[121] Boston, Museum of Fine Arts 26. 61; ARV 383.199; Add. 228; Panvini and Giudice 2003:314, G52. On reactions of spectators in musical scenes on vase-paintings, see Seebass 1991.

[122] Hamburg, Museum für Kunst und Gewerbe 1981.173; Schauenburg 1975:pl. 25.1–3.

Figure 5a. Red-figure neck-amphora: obverse, *kitharôidos*. Attributed to the Brygos Painter, *c.* 480 BC. Boston, Museum of Fine Arts, John Michael Rodocanachi Fund, inv. no. 26.61. Photo, Museum of Fine Arts, Boston.

Figure 5b. Red-figure neck-amphora: reverse, draped youth with stick. Attributed to the Brygos Painter, *c.* 480 BC. Boston, Museum of Fine Arts, inv. no. 26.61. Photo, Museum of Fine Arts, Boston.

Εὐρυμέδων εἰμ[ὶ] κυβα[..] ἔστεκα ("I am Eurymedon. I stand bent over").[123] Both in the Hamburg *oinochoe* and in the Boston neck-amphora, the obverse side remains incomplete if the viewer does not look at the reverse. Even in cases where the association of the two sides is less palpable, their contiguity must have not left unaffected the horizons of expectations of ancient viewers, since a large number of scenes divided between the sides of certain types of vessels were part of their viewing experience.

More importantly, the Tithonos Painter himself aptly exploited in his work this kind of connectedness between the two sides of vases. All the vases attributed to him are red-figure neck-amphorae and *lekythoi*, except for a red-figure *stamnos* and two red-figure *kalyx-kraters*.[124] On one of the neck-amphorae that he decorated, the two sides show a youth offering a lyre and a youth apparently fleeing, respectively (Fig. 6).[125] Culturally the connection is palpable. On the reverse of a neck-amphora in Paris, the old Nestor holding a scepter in his left hand stands with his right hand outstretched, as if pointing to the other side—like Sappho on the Bochum *kalyx-krater*. On the obverse, a young male figure that has been identified as Nestor's handsome son Antilokhos (his name not inscribed) stands carrying lance and shield.[126] Like Nestor, Antilokhos has his head turned left. Coming out from the mouth of the near-naked young man is the inscription ΚΑΛΟΣ (retrograde). Note that, as in the case of the Bochum "Sappho," the inscription ΝΕΣΤΟΡ placed to the left of Nestor's mouth is also retrograde. On the two sides of another neck-amphora, a naked young athlete and his trainer, respectively, are depicted.[127] In the context of my overall argument, I should stress that such a visual division of a single thematic "episode" is characteristic of the Tithonos Painter. Among other examples in his work, two neck-amphorae are noteworthy. On one of them,[128] a *kômos* takes place: a near-naked youth with a *barbitos* strides forward

---

[123] On this *oinochoe*, see, among other discussions, Schauenburg 1975, Dover 1989:105, Davidson 1997:170–171, 180–182, Miller 1997:13, McNiven 2000:88–89. More recent analysis in Smith 1999 and, especially, Wannagat 2001 (with earlier bibliography).

[124] *Stamnos* fragments: Munich, Antikensammlungen SL480; *ARV* 310.20. Apart from the Bochum *kalyx-krater*, the second *kalyx-krater* attributed to him is New York, Market, Sotheby's (Sotheby-Parke-Bernet, New York, sale catalogue 12 June 2001:52, no. 59; information in the Beazley Archive Database [www.beazley.ox.ac.uk], no. 24504).

[125] Berlin, Antikensammlung F 2328; *ARV* 309.3.

[126] Paris, Louvre G 213; *ARV* 309.4; *CVA* Paris, Louvre 6, III.Ic. 31, pl. 40.1–2, 6, and 8.

[127] Naples, Museo Archeologico Nazionale H 3182; *ARV* 309.5; *Add.* 213; Patrucco 1972:179, fig. 88 (side A).

[128] Hamburg, Museum für Kunst und Gewerbe 1893.100; *ARV* 309.9, 1644; Hoffmann and Hewicker 1961: 22, nos. 66–67.

Figure 6. Red-figure neck-amphora: obverse, youth with lyre; reverse, youth. Attributed to the Tithonos Painter, *c.* 480–470 BC. Berlin, Staatliche Museen, Antikensammlung, inv. no. F 2328. Photo, Bildarchiv Preussischer Kulturbesitz / Art Resource, NY.

on the obverse; on the reverse, a second youth posed in the same direction turns his head backward to look at the *barbitos*-player. Figures facing right but with their heads turned backward is a recurrent feature in the Tithonos Painter (witness again the Bochum "Sappho").

Note that the right hand of the youth on the reverse is slightly outstretched toward the youth on the obverse. More significantly, the latter plays a *barbitos*, from the lower arm of which hangs an *aulos* bag. This visual sign, the *aulos* bag hanging from the musical instrument of a *komast*, will reappear on the Bochum "Sappho" painted by the same craftsman.[129] Further, on the

[129] This painter seems to have been fond of depicting figures playing a stringed instrument: apart from the vases already mentioned, see the red-figure *lekythos* Hillsborough (California), W.R.Hearst Collection 17 (*ARV* 310.18 youth with *chelys* lyre), the red-figure lekythos Khania, Archaeological Museum 2 (*ARV* 310.1, 1644 draped man with *kithara*), and the red-figure fragment Adria, Museo Archeologico Nazionale B 622 (*ARV* 310.2 youth with lyre and Eros).

reverse side of another neck-amphora,[130] Dionysos walks carrying a *thyrsos* in his right hand and a *kantharos* in his left. While his body is facing right, his head is turned backward—like the Bochum "Sappho." On the obverse, a maenad strides forward holding a *thyrsos* in her left hand and an *oinochoe* in her outstretched right hand, as if offering wine to Dionysos. The thematic connectedness between the two sides is further accentuated through the (almost rhetorical) repetition of visual signs, and the female figure's extended right hand invites the viewer to look at both sides and explore the connection. Because these were important modes of representation during the period I am interested in, ancient viewers must have been inclined to this way of viewing and understanding visual "micronarratives."

One final point remains to be examined. If one attempts to see the Tithonos Painter in a broader contemporary context, the best possible comparandum is the Berlin Painter, one of the major red-figure pot-painters influenced by the Pioneers Phintias and Euthymides. There is no doubt that Beazley was right in defining the Tithonos Painter as a craftsman "related to the Berlin Painter."[131] His figurework closely follows in the steps of the Berlin Painter,[132] whose favorite shapes of vases are amphorae (Types A and C, neck-amphorae, and Panathenaic-type amphorae) and *kraters*, among others. Such types of pots could accommodate the Berlin Painter's characteristic single-figure decoration on each side.[133] The numerous pots attributed to him provide a rich background against which the Bochum "Sappho" should be examined since the scheme of single-figure decoration—that is, the depiction of only one figure on either side of a pot—has been skillfully exploited on this *kalyx-krater* too. I here pay special attention to a synchronic consideration of the Tithonos Painter, whose work was evidently influenced by the Berlin Painter.

Among the Berlin Painter's mythological images, a bell-*krater* in Paris shows on one side Ganymedes, naked and blond-haired, with a hoop and a courting gift—a cock—in his hands. On the other side, gazing at Ganymedes, Zeus with his scepter held horizontally strides forward.[134] Similarly, Herakles holding out a *kantharos* appears on one side of an amphora Type A. Upon rotating the vase, the viewer sees on the other side Athena facing Herakles.

---

[130] Florence, Museo Archeologico Etrusco 4011; *ARV* 309.8; *CVA* Firenze, Regio Museo Archeologico 2, III.I.32, pls. 25.3 and 28.2–3.

[131] Beazley 1963:vol. 1, 309.

[132] Robertson 1992:130.

[133] This scheme of decoration is not confined to the Berlin Painter. The Kleophrades Painter and other contemporary painters used it, but the Berlin Painter was particularly attracted to this scheme, certainly more than others.

[134] Paris, Louvre G175; *ARV* 206.124, 1633; *Add.* 193 (Dover 1989:R348).

The *oinochoe* she holds in her right hand, as if offering a drink to Herakles who stands just "across from" her, corroborates the connection between the two sides that the viewer makes.[135]

However, if we leave these *mythological* pictures aside, a large number of others attributed to the Berlin Painter exemplify the single-figure decoration on each side in a more unmarked manner. In the latter cases, the connection between the two sides is somewhat less palpable but equally intriguing: it is articulated "thematically" by drawing on diverse schemata. On an amphora Type C attributed to the Berlin Painter, a young *kitharôidos* clad in elegant attire and singing is juxtaposed with a "judge" or "music coach" who stands opposite and looks at him: this figure is a bearded man with a long forked staff in his left hand, his right hand outstretched toward the singer—in an interesting gesture of fingers.[136] On one of the neck-amphorae also attributed to the Berlin Painter, a blond-haired, winged Eros with a hoop and a cockerel is placed "opposite" a youth who leans with extended hands on his walking stick and observes Eros.[137] An almost identical scene occurs on a neck-amphora attributed to the Tithonos Painter; the main difference is that the winged Eros is black-haired and holds a bird, while the youth extends his arms toward Eros.[138] The Berlin Painter's symposiastic and komastic scenes present similar snapshots: on one side, a near-naked old *komast* gazes at a near-naked youth with a *barbitos* who strides on the other side;[139] a single satyr playing a *barbitos* on one side turns his head backward to look at another satyr playing a *barbitos* on the other side.[140] A youth standing "across from" or "followed by" a man or another youth occurs time and again.[141] Further, in at least two vases attrib-

[135] Basel, Antikenmuseum und Sammlung Ludwig BS 456; *ARV* 1634.1 *bis*; *Add.* 190 (Kurtz 1989: pls. 46–47). Cf. the Panathenaic-type amphora Würzburg, Martin von Wagner Museum 500; *ARV* 197.8, 1633; *Add.* 190 (Kurtz 1989:pl. 40), and the *pelike* Vienna, Kunsthistorisches Museum 3726; *ARV* 205.113; *Add.* 193 (Kurtz 1983:51b–c).

[136] New York, Metropolitan Museum 56.171.38; *ARV* 197.3, 1633; *Add.* 190 (Kurtz 1989:pl. 42). Beazley (1922:72–73) suggested that the bearded man might be an instructor who "seems to be beating time to music."

[137] Boulogne, Musée Communal 656; *ARV* 200.48 (Beazley 1974b:pl. 16).

[138] London, British Museum E296; *ARV* 309.6, 1574; *CVA* London, British Museum 5, III.Ic.5, pl. 50.3a–b. For a similar, but elliptical, representation, see Shapiro 1992:66–67 and fig. 3.7.

[139] Frankfurt, Museum für Vor- und Frühgeschichte B409; *ARV* 202.82; *Add.* 192; *CVA* Frankfurt am Main 2, 27, pls. 69.3–4, 71.3–4.

[140] Munich, Antikensammlungen 2311; *ARV* 197.9, 1633; *Add.* 190 (Vierneisel and Kaeser 1990:338, 414, figs. 70.11, 74.7a–b).

[141] E.g., London, British Museum E266; *ARV* 198.21, 1633; *Add.* 191 (*CVA* London, British Museum 3, III.Ic.5, pls. 8.3a–b, 12.1a–b) and Madrid, Museo Arqueológico Nacional 11200; *ARV* 204.112; *Add.* 193 (Kurtz 1983:pls. 19 and 51a). Cf. Munich, Antikensammlungen 2319; *ARV* 198.22, 1633; *Add.* 191 (*CVA* Munich, Museum Antiker Kleinkunst 5, 8, pl. 210.3–4).

uted to the Berlin Painter, an *aulos* bag appears either in the hands of a lyre-player or hanging from the lower arm of a *barbitos* played by a woman[142]—the latter a striking parallel to the representation of Sappho and her *barbitos* on the Bochum *kalyx-krater*, as we will see in the course of this chapter.

To conclude, these and other cases clearly suggest that rotating and looking at both sides of a vase with such single-figure decoration was part of the viewing experience for contemporary Athenians. It is the anthropology of this viewing experience that we need to explore with regard to the Bochum vase. Seen in the context of other pots decorated by the Tithonos Painter and the Berlin Painter, the images on the Bochum *kalyx-krater* articulate a visual "text," the syntax of which invites further examination.

## The Rhetoric of Lettering

There is certainly more to the snapshot related by the vase; the story does not end here. The figure of Sappho is identified on the vase with a painted inscription. Her name is inscribed to the left of her head.

Inscriptions often constitute a significant element of the aesthetic and semantic whole of painted vases. In certain cases, a fusion of visual representation and verbal signification takes place, where the verbal sign not only supplements and defines but also lends intriguing complexity to the visual text.[143] But unlike such self-deconstructing "inscribed" modern images as René Magritte's *Ceci n'est pas une pipe*,[144] the kinds of associations and ideas on Athenian vase-paintings about the depicted figures provided by words in the form of dipinti and graffiti are of a more "definitional" nature. In his attempt to illustrate a psychoanalytic comparison of dreams and language, Freud aptly commented on the use of inscriptions in ancient vase-paintings as signifying markers circumventing the indeterminacy inherent in pictorial discourse:

> Before painting became acquainted with the laws of expression by which it is governed, it made attempts to get over this handicap. In ancient paintings small labels were hung from the mouths of the

---

[142] Naples, Museo Archeologico Nazionale RC163; *ARV* 198.18; *Add.* 191 (*LIMC* III, pl. 908); and Copenhagen, Ny Carlsberg Glyptothek 2701; *ARV* 211.196; *CVA* Copenhagen, Ny Carlsberg Glyptothek 1, 57–58, pl. 37.1–4.

[143] On word and image, among the most incisive discussions are Barthes 1977b, Alpers 1984:169–192, Butor 1969, Gombrich 1985, Pozzi 1981, Fisher 1986, Christin 1995.

[144] For a provocative and penetrating exploration of Magritte's painting of a pipe, across which lettering provides the words "This is not a pipe," see Foucault 1983.

persons represented, containing in written characters the speeches which the artist despaired of representing pictorially.[145]

And Aristotle had already pointed to the ancillary semantic function of inscriptions in ancient pictorial discourse: καθάπερ τὰ τῶν ἀρχαίων γραφέων, εἰ μή τις ἐπέγραψεν, οὐκ ἐγνωρίζετο τί ἐστιν ἕκαστον ("…just as in the compositions of the early painters, if they were not inscribed, it was not feasible to comprehend what each figure represented").[146]

The most ubiquitous and simple type of vase inscription is the signature inscription.[147] Hundreds of black-figure and red-figure vases bear such inscriptions, in which the name of the painter or the potter or of the owner of the workshop in which they were produced appears usually in the form "[Exekias] egrapsen" and "[Exekias] epoiêsen," or "[Sophilos] m' egrapsen" and "[Sophilos] m' epoiêsen"—in the latter case, as if the vase were speaking to the viewer.[148] Such instances of what I would term "vocality" in vases occur in sympotic[149] and other inscriptions: here "instructions" to the viewer—"greetings and drink well" or "greetings and drink me"—are given,[150] and the idea of a

---

[145] Freud 1965:347.

[146] *Topica* 6.2.140a.21–22. Note that much later, Aelian (*Historical Miscellany* 10.10) will offer an ironic view about the use of inscriptions on early paintings.

[147] On vase inscriptions, see Kretschmer 1894, Beazley 1932, Ferri 1938, Burzachechi 1962, Moret 1979, Cohen 1991, and the books by Immerwahr 1990 and Wachter 2001, where a large number of vase-inscriptions are collected and discussed. Cf. also Detienne 1988:537–538 and Bérard et al. 2000:184. For the interplay of image and text in early Greek art, see Hurwitt 1990; Kauffmann-Samara 1982; Lissarrague 1985, 1992a, and 1994; and, more recently and from a different perspective, Snodgrass 2000.

[148] In the case of Exekias, Sophilos, and Nearkhos, there are vases on which they sign as potter and painter at the same time: Sophilos in Athens, National Archaeological Museum 15499 (*ABV* 39–40.16; according to Beazley); Nearkhos in Athens, Akropolis 611 (*ABV* 82.1); Exekias in Berlin, Staatliche Museen 1720 (*ABV* 143–144.1). For Exekias' inscriptions, see Rebillard 1991. For a thought-provoking discussion of Sophilos' inscriptions, see Kilmer and Develin 2001. For Douris' literacy, see Guy 1987. On signature inscriptions, see also Williams 1995. For owners' inscriptions, see Steinhart 2003.

[149] For sympotic inscriptions, see Immerwahr 1990:48 and *passim*, and Vierneisel and Kaeser 1990:90–95 and *passim*. On a cup in Brussels (R260; *ARV* 97.10 and 103.4; here a standing youth is masturbating in front of a bell-*krater* and semen comes out of his penis while the exclamation "I greet" encircles him) and on another cup in the Louvre (G82; *ARV* 98.18 and 103.6; two youths holding a cup and a *barbitos*, respectively, in komastic mood), we see the verb προσαγορεύω inscribed; for other cases of προσαγορεύω, see Beazley 1963:97–104. On Munich 2307 (*ARV* 26.1, 1620), we read the playful comment—as if in a capping game—ℎος ουδεποτε Ευφρονιος ("as never Euphronios"), Euphronios here probably being the well-known painter.

[150] For New York 10.210.18; *ARV* 54.7, a red-figure *psykter*, and its inscriptions πομε ("drink me," according to Beazley) and perhaps χασϙο ("I open my mouth wide"), see Immerwahr 1990:61, no. 342; note that χασϙο is not certain (Immerwahr 1990:61, n. 16). For χαῖρε καὶ πρίου ἐμέ on Little Master cups, see Immerwahr 1990:48.

more pronounced involvement of the viewer/reader in the represented reality of the vase painting, or in the actual situational context in which the vase is used, is exploited.

The largest category is of course that of tag inscriptions in representational figure-scenes. These are captions—labels identifying figures, mythical scenes, athletic occasions, and even musical instruments.[151] *Kalos* and tag-*kalos* inscriptions, which start to appear on vases around 550 BC and decline in the third quarter of the fifth century (*c.* 430 BC), are also numerous.[152] While *kalos*-inscriptions are normally not attached to any depicted figure on the vase, the tag-*kalos* inscriptions have seemed to label the figures to which they are attached. However, the occurrence of floating *kalos* names in mythological scenes and elsewhere belies this idea.[153] Apart from the *kalos*-inscriptions, *kale*-inscriptions appear, a type that has received the least attention by scholars.[154]

Vase inscriptions do not always seem to make sense: "nonsense" inscriptions, common among sixth-century Athenian vase-inscriptions, often consist of strings of letters that are apparently incomprehensible or semi-incomprehensible[155] and may function as decorative signs of "literacy" on the part of the painter or the purchaser. "Mock" inscriptions, frequent on Little Master cups, may play upon words such as οἶνος and ἐποίεσεν.[156] Cases of vase inscriptions in the form of NENNENENENENENENENNEN are also attested.[157] Yet one of the most interesting kinds of vase-inscriptions is the "bubble" inscription, that is,

[151] For tag inscriptions, one may just point to the François Vase, where 130 inscriptions of names, even names of animals and objects such as the dogs in the Calydonian boar hunt and a fountain house and an altar, can be found (see Wachter 1991). Another, though less remarkable case, is an amphora by Exekias in the Vatican (344; *ABV* 145.13, 672.3, 686), which combines diverse kinds of vase inscriptions: ΑΧΙΛΕΟΣ and ΑΙΑΝΤΟΣ (sc., *eikôn*) are its tag inscriptions, while a *kalos* inscription, Exekias' signature as "potter," and 'bubble' inscriptions also occur. For *ton Athenethen athlon* ("one of the prizes from Athens") captions, see, recently, Hannah 2001. Even a *lyra* is labelled on a black-figure cup with numerous inscriptions (Munich, Antikensammlungen 2243; *ABV* 160.2 and 163.2).
[152] For *kalos*-inscriptions, see, among other studies, Lissarrague 1999 and Slater 1999. Kilmer 1993a provides a most interesting discussion of tag-*kalos* inscriptions. See also Boardman 1992, Shapiro 1983a and 1987. Cf. Frel 1996. For numerous cases of *kalos*-inscriptions, see Immerwahr 1990 and Wachter 2001. Immerwahr calls the tag-*kalos* inscriptions "caption-*kalos*."
[153] See Kilmer 1993a.
[154] Cf. p. 104 n. 176 below.
[155] See Immerwahr 1990:43–44 and 54–55: "Not all of them are meaningless: ...they can be classified as mock and near-sense inscriptions, meaningless inscriptions, imitation inscriptions or letters, and blots or dots" (44).
[156] For examples, see Immerwahr 1990:35, 54. Cf. also Beazley 1932.
[157] Brussels, Musées Royaux R 385A (black-figure lip cup dated to the third quarter of the sixth century); Baurain-Rebillard 1998 [2002]:fig. 4.

inscriptions reporting dialogues among depicted figures on the vase.[158] In an extensive example from a red-figure *pelike* in St. Petersburg, a youth, pointing to a *khelidôn* in the sky, states, "Look, a swallow," while a boy exclaims, "There it is," and a man confirms, "Yes, by Herakles, you are right." As the painter has written beside the boy, this scene suggests that "Spring is here."[159] In this group of inscriptions we should include poetic lines quoted or sung and recited by symposiasts or other figures on the vase.[160] Archaic and classical "lyric" songs are especially popular. On the tondo of a red-figure cup we see a young komast holding a *barbitos* and singing ΕΙΜΙΚΟ[ΜΑ]ΖΟΝΗΥΠΑΥ the last word of his song possibly being ΗΥΠΑΥ(ΛΟΥ) or something similar ("I go forward reveling in the accompaniment of the [reed pipe]").[161] Or, on a fragmentary *kalyx-krater* by Euphronios, we hear a reclining symposiast named Ekphantides singing the retrograde inscription ΟΠΟΛΛΟΝ ΣΕΓΕΚΑΙΜΑΚΑΙ[ΡΑΝ] (possibly a glyconic or hipponactean verse meaning "O Apollo, you and blessed…"), while an *aulos*-girl named Syko (Συκο) plays the double reed pipe.[162] Finally, we can even find possible "musical" inscriptions: the image on the Munich kalathoid vase,[163]

---

[158] On a black-figure *pelike* in Rome, Vatican 413 (not in *ABV*; Albizzati 1925/1939:183, pl. 61.413), we see a trade scene between men on both sides: ο ζευ πατερ αιθε πλουσιος γεν<οιμαν?> ("o Zeus, would that I might get rich") is written next to one of the figures and across the field on the obverse, while one of the male figures on the reverse exclaims: εδε μεν εδε πλεο<ν> παραβεβακεν ("it's full; it's already spilling over"). Boston, Museum of Fine Arts 1970. 233; *ARV* 444.241, a cup attributed to Douris, on which a sexual scene between a man and a woman is depicted, provides an erotic "bubble" inscription: "the girl is beautiful" is written on the cup, and the man who penetrates the woman says: "keep still" (hεχε hεσυχος). An inscription on the shoulder of a non-representational *oinochoe* in Munich (Antikensammlungen 2447; *ABV* 425, 666, 670, 671) reminds one of Platonic dialogic patterns: ΚΑΛΟΣ ΝΙΚΟΛΑ. ΔΟΡΟΘΕΟΣ ΚΑΛΟΣ "says" the first implied speaker; a second "speaker" replies: ΚΑΜΟΙ ΔΟΚΕΙ, ΝΑΙ; and the conversation continues: ΘΑΤΕΡΟΣ ΠΑΙΣ ΚΑΛΟΣ, ΜΕΜΝΟΝ ΚΑΜΟΙ ΚΑΛΟΣ ΦΙΛΟΣ (see Immerwahr 1990:75, no. 438, where he prints ΝΙΚΟΛΑ<Σ> instead of ΝΙΚΟΛΑ in the "first" phrase of the dialogue).

[159] St. Petersburg, Hermitage 615; *ARV* 1594.48; *Add.* 389 (obverse).

[160] For poetic inscriptions, see Hartwig 1893:255–258, Kretschmer 1894:90–93, Herzog 1912:17–21, Jacobsthal 1912:61–63, Herington 1985:195–198, Lissarrague 1990:123–135, and Csapo and Miller 1991. Cf. also Sifakis 1967, Ohly-Dumm 1985, Green and Handley 2001 (cf. Millis 2001). For poetic lines in book rolls often held by youths or women, see Beazley 1948 and Immerwahr 1964.

[161] Erlangen, Friedrich-Alexander-Universität 454; *ARV* 339.49; *Add.* 218. For alternative supplements, cf. Lissarrague 1990:134 and Csapo and Miller 1991:381. On such "lyric" inscriptions, see Yatromanolakis 2001a:165–166.

[162] Munich 8935; *ARV* 1619.3 *bis* and 1705; *Add.* 152. See Vermeule 1965 (Page, *SLG* fr. S317). Note that gamma after ΣΕ is uncertain (Τ seems to be possible; Page *SLG* fr. S317 does not dot this letter: ὤπολλον, σέ γε καὶ μάκαι[). Cf. Paris, Cabinet des Médailles 546 (*ARV* 372, 26; *Add.* 225), a fragmentary cup on which a symposiast sings the retrograde inscription ΟΠΟΛΟΝ (see Beazley 1953:74–76).

[163] Cf. Copenhagen, National Museum 13365; *ARV* 185.32; *Add.* 187 (a fragmentary *kalyx-krater*), on which we read in front of the mouth of a komast ΙΟΟΟ (see Immerwahr 1965).

with Alkaios standing next to Sappho, suggests that the five circles (OOO OO) coming out of his mouth represent a melodic line of his song, however minimalist or *vocalise*-like this string of sounds may now appear.[164] In a number of these cases we detect what I have elsewhere described as a pattern of visual performability of poetry.[165]

It is against this inscriptional and broader cultural background that we should examine the Bochum red-figure *kalyx-krater*. The inscription placed to the left of Sappho's head is retrograde and provides her name: ΣΑΦΦΟ. The first letter is a three-bar sigma, then alpha, followed by two phis, and an inelegantly drawn omicron. After omicron, the surface of the vase is somewhat damaged because of breakage in this area. The omicron is followed by two traces of uncertain letters; after this, a delta or lambda, and then the right-hand stroke of another letter. It is not clear what the letters after omicron mean. The inscription is retrograde, running from right to left, according well with the general pattern of retrograde inscriptions being placed normally to the left of the person or object to whom they refer.[166] The same pattern applies to vocalists on Attic vases, in cases when part of their song is "quoted" as coming out of their mouths: if the vocalist faces to the left, the phrase of his/her song emerges retrograde.[167]

If we compare this vase to the other vases depicting Sappho, we observe that her name is spelled in various ways: ΦΣΑΦΟ on the *hydria* (in Six's tech-

---

[164] For the black-figure *epinetron* Eleusis, Archaeological Museum 907 (Haspels 1936:228.54, pl. 34; attributed to the Sappho Painter and dated to *c.* 500 BC), which has been seen as providing traces of an early system of solmization in Greek antiquity, that is, earlier than the one described by Aristeides Quintilianos (*De musica* 2.13–14 Winnington-Ingram), see Bélis 1984. I would be reluctant to accept that the sounds represented in the inscription necessarily reflect a solmization system. See, further, Margherita Albertoni's discussion of the painted inscription ΝΕΤΕΝΑΡΕΝΕΤΕΝΕΤΟ on an Attic red-figure neck-amphora by Smikros (Σμικρος εγραφσεν), dated to the last quarter of the sixth century (Berlin, Antikensammlung 1966.19; *Para.* 323.3*bis*; *Add.* 154; Greifenhagen 1967:figs. 7–11)—an inscription interpreted by her as νήτην Ἄρει, νήτην ἔτω ("la *nete* per Ares, la *nete* emetta;" Albertoni 1977; cf. Greifenhagen 1967 for the repetition of νήτη). This string of letters appears near the ends of the reed pipes that a satyr plays, while, above his head, Τερπαυλος represents his name. More recently, see Polyxeni Adam Veleni's articles on an inscription from Brasna, Thessalonike (Adam Veleni 1999 and 2002).

[165] Yatromanolakis 2001a:165–166.

[166] Cf. Cook 1987:50 and Hurwit 1990:185.

[167] I would draw attention to Erlangen, Friedrich-Alexander-Universität 454; *ARV* 339.49; *Add.* 218, which is an exception to the consistency of this pattern, although in this red-figure cup (on the tondo), the inscription does come out of the mouth of the youth who walks forward holding a *barbitos* and a drinking-cup and has his head tilted up (incidentally marked as ho παις καλος with an inscription to his right, behind him), but it runs from his feet all the way to his open mouth.

nique) in Warsaw,[168] ΣΑΦΟ on the red-figure kalathoid vase in Munich,[169] and ΣΑΠΠΩΣ on the red-figure *hydria* in Athens. As for her name on papyrus and parchment fragments preserving her compositions and in the medieval manuscripts of indirect tradition quoting poems by Sappho, ΨΑΠΦΩ is normally preferred. Diverse spellings also occur on a coin from Mytilene (ΨΑΠΦΩ) and other coins from Eressos (ΣΑΠΦΩ and ΣΑΦΦΩ).[170] What is of importance for us is that on the *hydria* in the National Archaeological Museum, Athens, we read ΣΑΠΠΩΣ. The two pis are parallel to the two phis that we see on the Bochum vase. On the Athens *hydria*, instead of the geminate aspirate stop -πφ-, we find a "rendition of the sounds as a geminate stop without aspiration,"[171] but it is difficult to decide whether this is assimilation or some kind of graphic mistake. The point remains that the inscription on the Bochum *kalyx-krater* provides a form that can be closely compared to the inscription on the Athens *hydria*.

## Contextualizing Schemata

I now focus on the reverse of the Bochum vase. As we have seen, upon rotating and looking at the vase, the image of Sappho becomes more complex. On the reverse, a second female figure appears in similar pose, clad in an enveloping mantle and walking in the opposite direction from the figure representing Sappho on the obverse. The two female figures display a number of differences, despite the fact that their posture is similar. At first sight it is as if the two sides repeat each other. However, repetition often invites the viewer to associate images in separate fields. On this vase, we do not have a case of redundancy that attempts to convey its point through the emphasis of *exact repetition.*[172] Instead, slight variation invites the viewer to compare the two sides of the vase, revealing that the two sets of images form two parts of a single text. The first element of the narrative is Sappho represented as carrying her *barbitos*—a case of syntagmatic metonymy—and slightly swaying her right foot, possibly in some kind of dance step; a symmetry between her outstretched right hand

---

[168] The second phi in the name ΦΣΑΦΟ has been given an extra crossbar by mistake.

[169] The ΣΑΦΟ on this vase has been explained as possibly representing ΣΑΦ<Φ>Ο (Threatte 1980:542).

[170] See Wroth 1964:200 (Mytilene) and Head 1911:560 (Eressos) and 562 (Mytilene). Cf. the new epitaphs (*I.Lipara*) in *SEG* 51.1202–1372, especially *SEG* 51.1247 and 1248 (*I.Lipara* 273 and 274, stelai 'antiquiores,' *c.* fourth/third century BC), where Σαφφῶς (Epitaph of Saphpho) occurs.

[171] Threatte 1980:542.

[172] For repetition in Attic vase-painting, see Steiner 1993 and 1997.

and her outstretched right foot is evident.[173] The color of her hair is different from that of the second female figure. As in other cases of single-figure decoration favored by the Tithonos Painter and the Berlin Painter, Sappho's right hand and her gaze point to the reverse side of the *kalyx-krater*. The second element of the narrative (on the reverse) is the female figure wrapped in her clothes, a difference that may provide a contextualization cue in our attempt to understand the possible cultural recognition codes of this representation.[174] She is depicted walking and looking at the figure of Sappho on the obverse. As in the Hamburg *oinochoe* discussed above, their gaze does not interlock. In the *oinochoe*, the face of the Asiatic man was turned toward the viewer, while the aroused man, his left hand outstretched, looked in the direction of the man who was bent over. Here, the represented figures' gaze will never meet.

Again, to the left of Sappho's head her name is written. In all archaeological descriptions of the vase known to me, there is no discussion of a second painted inscription on the reverse. During an examination of the *kalyx-krater* in the Kunstsammlungen, Ruhr Universität Bochum, I was able to detect and read the inscription. This orthograde inscription runs from the front part of the *sakkos* of the woman to her left side. The first letter is eta, then we read epsilon, and after that, pi, alpha, iota, and sigma. The lettering is the same as that of the obverse, especially given the fact that this inscription is painted just under the rim, a typical challenge for the painter. ΗΕ ΠΑΙΣ is the "text" painted on the reverse (Fig. 7).

This "text" is a tag-inscription, one of the types of vase inscriptions discussed above. It would be perhaps possible to analyze it as a *kale*-inscription, if other considerations did not lead to different conclusions. Anonymous *kalos*-inscriptions can be found on hundreds of vases; the *kalos*-names, also frequent and praising the charms of a named individual (ΕΠΙΛΥΚΟΣ ΚΑΛΟΣ, etc.), constitute, in the words of Anthony Snodgrass, "direct communications to the user which may or may not relate to a primary visual communication."[175] *Kale*-inscriptions (without name) are by far less numerous,[176] and their possible func-

---

[173] The pose of Sappho is comparable to that of a youth with a *barbitos* on the reverse of a *pelike* attributed to the Berlin Painter (Madrid, Museo Arqueológico Nacional 11200; ARV 204.112; *Add.* 193 [Kurtz 1983:pls. 19 and 51a]). For the influence of the Berlin Painter on the Tithonos Painter, see above. Note that the female figure on the reverse of the Bochum *kalyx-krater* is walking. The position of Sappho's right foot is very similar to the overall posture of male and female singers often displayed on Attic vases.

[174] For contextualization cues with respect to archaic melic poetry, see Chapter Three and Yatromanolakis 2003a.

[175] Snodgrass 2000:24. For discussions of the *kalos*-inscriptions, see n. 152 above.

[176] Henry Immerwahr (pers. comm.) counts 44 examples under the heading hε παις καλε in his magisterial collection of vase inscriptions. He informs me that some of them may need to be

Figure 7. Detail of reverse of Bochum inv. no. S 508 (Fig. 4b), showing inscription.

tions have not been discussed systematically or synthetically.[177] I shall here focus on instances where hε παις occurs alone.

On the Boston red-figure *lekythos* 13.189, attributed to the Brygos Painter and dated to *c.* 480–470 BC, a woman working wool is depicted. She is seated on a *klismos* and pulls a strand of wool from the basket at her feet.[178] A mirror is hanging in the background, and "a small profile head is painted in outline on the disk, imitating an incised bronze mirror."[179] Starting above the head, a near-horizontal inscription reads: hε παις. It has been persuasively suggested that women working wool on Athenian vases function as a metaphor that both constructs and reflects ancient Greek conceptions of ideal maidens and women and their ideal social behavior.[180] The inscription, standing alone, is not part of a visual plot despite the fact that it may be part of a social narrative commentary.

---

vetted and eliminated, given that archaeological catalogues of vases do not always provide full descriptions of inscriptions.

[177] On some *kale*-inscriptions in the context of courtesans, see Frel 1996; also Robinson and Fluck 1937 and Frontisi-Ducroux's brief essay (1998 [2002]).

[178] *ARV* 384, 214; *Add.* 228.

[179] Truitt 1969:78. Photograph in Truitt 1969:82, fig. 10.

[180] Ferrari 2002.

On a red-figure cup attributed to the Antiphon Painter and dated to *c.* 480–470 BC, a naked girl appears, frontal, looking left and holding an *alabastron* and boots. At her left is a stool with clothes.[181] To the girl's upper left, hε παις is written. The context may be a preparation for bathing, but again the inscription does not seem to help contextualize the image further. A quite different case is a fragmentary cup in Florence that provides us with a partial image of a *symposion*: on side A, among naked women reclining, is a wineskin under the elbow of one of the figures, and hε παις is written on it.[182] hε παις here is not clearly defined by the very fragmentary context of the image; however, the overall symposiastic milieu of the representations on the vase point to a marked context.[183]

As in the case of the Boston *lekythos* mentioned above, another red-figure cup of around the same period (*c.* 470 BC) now in St. Petersburg[184] depicts on its interior a woman looking right and holding a mirror in her left hand. Behind her is a stool; around her, hε παις is written. The "function" of this image is possibly connected with the more marked image of a woman working wool, despite the fact that the unmarkedness of the St. Petersburg image is pronounced.[185] A similar reflection and cultural construction of women's lives can be detected on a red-figure cup attributed to the Brygos Painter and dated to the first quarter of the fifth century BC.[186] On the interior of the cup, we see a woman again looking right and holding a water bucket over a well. Around the scene hε παις is written. On the bucket we read the inscription καλε, while on the rim of the well, we read hε παις.

From the cases discussed so far, it becomes clear that the Bochum vase presents us with a different and more complex "text."[187] Its visual syntax is

[181] *Paralipomena* 361 (Cannes, private collection). Photograph in *Apollo* (London) July 1963:59, fig. 2.
[182] Florence 10 B 106 (dated to the first quarter of the fifth century) and Heidelberg 55; *ARV* 326. 91; 1645. Image of the outside surface of Florence 10 B 106 in Beazley 1933:pl. Y 15 (discussion of the different parts of this fragmentary vase, on p. 17, plate 10, no. 106). Image of the interior of Florence 10 B 106 in Beazley 1961:fig. 26, 3.
[183] On the interior of the cup, we see a middle-aged reveller being led by a naked girl. The inscription on the wineskin on side A is not mentioned by Beazley (see n. 182 above), but Henry Immerwahr drew my attention to it (per litt.).
[184] St. Petersburg B 1535; *ARV* 626, 107; *Para.* 513. Image in Peredolskaya 1967:plate 124 (inscriptions plate 177, 14 and 16).
[185] On side A, in center, a woman is looking right and playing with a ball; at her right, there is a column; on each side there is a youth holding a stick. On side B, we see a seated youth looking right and wearing a *sakkos*, a woman to right, holding a mirror, and a bearded man looking left.
[186] Vienna, University 502; *ARV* 377.109. Image in Philippart 1933:158, fig. 3.
[187] It should perhaps be pointed out that even if the inscription on the reverse was taken as a "conventional" *he pais kale* inscription, its juxtaposition with the image of Sappho on the obverse would have triggered off the associations explored here.

predicated by the two inscriptions, especially the hε παις inscription and the mode of representation of the second female figure. Represented discourses of music and gender further contribute to the construction of a visual metaphor that combines elements of artistic formalism, constructed "reality," and marked perceptual positioning. On this *kalyx-krater*, the visual element that first demands our attention is the enveloping mantle of the female figure on the reverse, a feature that evokes scenes where youthful figures are wrapped in their mantles. The connotation of this visual sign has been interpreted as a figure of *aidôs* (conventionally translated as "modesty," "shame," or "honor"). The figure of *aidôs* is a very common metaphor in Attic vase paintings of the late archaic and classical periods. The enveloping mantle, which encases an individual, leaving only head and feet uncovered, time and again appears in courtship scenes, where a mantle-covered young woman or boy constitutes the object of desire for other figures.[188] On the Bochum *kalyx-krater* the second female figure is wrapped in her mantle, in contrast to numerous dressed young women who listen to other women playing music, dance, or read from scrolls in Attic vase-paintings. The difference between the figure of Sappho on the obverse and the second female figure on the reverse is visually significant. That the female figure on the reverse is wrapped in her mantle should be seen as an indication that, in conjunction with the other indications investigated here, specific associations must have been evoked. As we have seen, the Tithonos Painter drew heavily on the Berlin Painter's figurework. The scheme of the single-figure decoration on each side of a vase allowed the Berlin Painter to depict a number of komastic scenes where a male youth with a *barbitos* stands "across from," or is followed by, a man or another youth. The Tithonos Painter has exploited this scheme on the Bochum *krater*, but has introduced the figure of Sappho—for the Athenian society, a marked, East Greek composer of songs about girls and women—in association with a young woman wrapped in her mantle.

Further, something that has been identified as an *aulos* bag hangs from the lower arm of the musical instrument that Sappho holds. We have already seen that on a red-figure *lekythos* attributed to the Berlin Painter—the exquisite draughtsman who considerably influenced the Tithonos Painter—an *aulos* bag hangs from the *barbitos* that a young woman plays.[189] After an examination

[188] Ferrari 2002:72–82. "It is most frequent in scenes painted on the 'backs' of vases, normally column kraters, showing standing figures, generally three, of which at least one is often wrapped in the mantle" (p. 72). See also Keith DeVries's similar observation (from his unpublished book draft *Homosexuality and the Athenian Democracy*, quoted in Rabinowitz 2002:158, n. 64).

[189] Copenhagen, Ny Carlsberg Glyptothek 2701; *ARV* 211.196; *CVA* Copenhagen, Ny Carlsberg Glyptothek 1, 57–58, pl. 37.1–4. The *aulos* bag on the Bochum *kalyx-krater* does not have the details of other depictions, but *aulos* bags are almost identically drawn on a number of vases.

of almost all known images of *aulos* bags, I have come to the conclusion that among contemporary painters who indulged in depicting *aulos* bags, Douris is the best representative; his cups provide a number of cases where an *aulos* case appears in sympotic or komastic contexts.[190] In some of Douris' depictions, the *aulos* bags are suspended near symposiasts and musicians or hang from the lower arm of *barbitoi* played by the represented figures. When no *aulos*-players are present, an *aulos* bag *stands* for them. *Barbitoi* and *auloi* (or *aulos* bags) are closely connected in such symposiastic and komastic scenes and become interchangeable.

The syntagmatic contiguity between an *aulos* bag and a *barbitos* in symposiastic images and contexts was an element with which Athenian viewers (and symposiasts!) were familiar. By means of marked metonymic associations, the specific representation of Sappho's *barbitos* on the Bochum *kalyx-krater* points, I argue, to symposiastic and komastic contexts on Attic vases, where the *aulos* and the *barbitos* are most often depicted. Moreover, in the fifth century BC, harps were associated by comic poets with sensual, erotic songs,[191] and Sappho referred in her songs to the *paktis* (a type of small harp played by women), among other musical instruments.[192] Finally, the two images of the Bochum *kalyx-krater* evoke the iconographic schema of "pursuit" fused with the idealized cognitive model of two walking komasts, one following or gazing at the

[190] Some of them appear on the so-called "Anakreontic" vases: see Munich, Antikensammlungen 2647; *ARV* 438.132, 1653; *Add.* 239 (Buitron-Oliver 1995:pl. 99, no. 177), and Paris, Louvre G 286; *ARV* 443.229; *Add.* 240 (Buitron-Oliver 1995:pl. 93, no. 157). For *aulos* bags in symposiastic contexts on his cups, see Paris, Louvre G 127 (+Cp 11962); *ARV* 427.1, 1569; *Add.*235 (Buitron-Oliver 1995:pl. 1, no. 1), Vatican, Museo Gregoriano Etrusco 16561; *ARV* 427.2; *Add.* 235 (Buitron-Oliver 1995:pl. 5, no. 8), Berlin, Antikensammlung F 3255; *ARV* 428.12 (Buitron-Oliver 1995: pl. 15, no. 24), Paris, Cabinet des Médailles 540; *ARV* 435.93 (Buitron-Oliver 1995: pl. 81, no. 139 interior), Munich, Antikensammlungen 2646; *ARV* 437.128, 1653; *Add.* 239 (Buitron-Oliver 1995: pl. 96, no. 173 interior), Athens, Agora Museum P 10271; *ARV* 442.213; *Para.* 375 (pl. 6, no. 10), and the *kantharos* Athens, National Archaeological Museum 205302; *ARV* 445.255 (Buitron-Oliver 1995:pl. 4, no. 7). An *aulos* bag can also hang from the arm of an *aulos*-player in komastic context or from the walking stick of a komast. See also Naples, Museo Archeologico Nazionale RC163; *ARV* 198.18; *Add.* 191 (*LIMC* III, pl. 908), a Panathenaic-type amphora attributed to the Berlin Painter, on the obverse side of which a winged Eros holds a lyre in his left hand and an *aulos* bag in his right hand.

[191] Eupolis fr. 148 K-A, Platon Komikos fr. 71. 14 K-A. Here the references are to *trigônon*, one kind of harp. Harps are most often shown in the hands of women in Attic vase-paintings. According to Menaikhmos (*c.* 300 BC), Sappho was the inventor of the *pêktis* (in Athenaios 14. 635b: Μέναιχμος δ' ἐν τοῖς περὶ τεχνιτῶν τὴν πηκτίδα, ἣν τὴν αὐτὴν εἶναι τῇ μαγάδιδι, Σαπφώ φησιν εὑρεῖν. On harps in art of the classical period, cf. Maas and Snyder 1989:147–155, 181–184; however, Maas and Snyder (1989:154) oddly remark that "there is no first inventor reported in the literature, as there is for many instruments (though a woman, Sappho, was proposed in Hellenistic times as the first player)."

[192] Sappho frs. 22.11 V., 156.1 V. Cf. the supplemented π]άκτιδι in Alkaios fr. 36.5 V.

other. I emphasize the word "evoke" since the schema of "pursuit" has diverse and often more marked configurations.[193] Here, as in komastic images by the Tithonos Painter and the Berlin Painter, Sappho follows the other female figure who follows Sappho. If the pose of Sappho's feet is viewed as suggesting dancing, this is another komastic discursive element in the representation.[194] Whatever meaning we attribute to the schemas exploited here, the inscription hε παις in the overall context I have delineated would trigger another image for the viewer. This time that idealized cognitive model is, I argue, the socio-cultural phenomenon of pederasty.[195] In the light of all the cultural elements I have detected on the Bochum *kalyx-krater,* its most central aspect on a pictorial discursive level is the assimilation of Sappho into a "pederastic" paradigm. In the course of the ancient reception of Sappho, such assimilation was exploited in a variety of complex ways.[196] It is the *combination* of the elements exploited on the vase that would have set off such associations. Further, I adduce here an image from Plato's *Phaidros* (241b) that provides a discursive modality familiar to classical symposiasts: φυγὰς δὴ γίγνεται ἐκ τούτων, καὶ ἀπεστερηκὼς ὑπ' ἀνάγκης ὁ πρὶν ἐραστής, ὀστράκου μεταπεσόντος, ἵεται φυγῇ μεταβαλών· ὁ δὲ ἀναγκάζεται διώκειν ἀγανακτῶν καὶ ἐπιθεάζων ("and so he becomes a fugitive from all of this and, constrained to become a defaulter, the former lover changes direction, from pursuit to flight—as the *ostrakon* flips on to its other side—whereas the former *erômenos* is compelled to pursue him with anger and invoking the gods"). In the context of performances and reper-formances of Sappho's songs at fifth-century Athenian *symposia*—songs that spoke about intimacy and companionship among women, but which, *especially* when performed at male drinking parties with female slave companions and women musicians present, could be interpreted diversely—the appearance of this visual representation on wine-mixing vessels like the Bochum *kalyx-krater*

[193] On various aspects of this schema, see especially Sourvinou-Inwood 1991:58–98. Note that Sourvinou-Inwood and, more recently, other scholars have focused on marked cases of mytho-logical pursuit, but there are also "milder" instances of "pursuit," where the "pursuing" figure does not assume an aggressive pose.

[194] See the examination of the so-called "Anakreontic" vase-paintings below. I here do not suggest that "Sappho" is, simplistically, a komast.

[195] On this phenomenon, see Dover 1989, Foucault 1984, Halperin 1990, De Vries 1997, Shapiro 2000b. On female homoeroticism, Dover 1989:171–184 is interesting but dated in terms of iconography (on which see Koch-Harnack 1989:143–158 and Kilmer 1993b:26–30; cf. Martos Montiel 1996:67–102, Petersen 1997:64–69, Rabinowitz 2002); see also Kroll 1925, Licht 1931:316–328, Hallett 1989 (an insightful study of Roman female homosexuality), Cantarella 1992:78–93, Halperin 2003:722–723, Brooten 1996.

[196] See, among other sources, Maximos of Tyros (18. 9 Koniaris), where "practices" espoused by Sokrates and Sappho are compared in detail.

is indicative of how the figure of Sappho began to be contextualized in the Athenian male imagination.

Such assimilation of Sappho and her songs into different pictorial and cultural schemata is fully displayed in the fourth vase depicting "Sappho." Before I proceed to an investigation of this representation, I shall draw into my discussion material related to the almost contemporary Athenian visual reception of another poet, whose symposiastic love songs about youths and young women became associated with Sappho's songs throughout antiquity. This association may have gradually developed when his and Sappho's compositions were performed together in Athenian *symposia*.

## Cultural Performance, Anakreon, and the "Elaborately Dressed Revelers"

In order to examine the pictorial figure of Sappho in an increasingly broader cultural context, I suggest turning to representations of other archaic melic poets on late archaic and classical vases. Except for a very tentative identification of Arkhilokhos on a white-ground pyxis attributed to the Hesiod Painter— "tentative" because the depicted man leaning on his staff in the company of Muses has alternatively been identified as Hesiod,[197] only images of Anakreon and Sappho enjoyed popularity in late archaic and classical vase painting.[198] Given that figures such as Ibykos and Simonides, as far as the evidence allows us to see, do not appear on vases, it is intriguing that Sappho becomes a celebrity, represented as an amalgam figure of the past who takes on features of the synchronic—each time—present and surrounded by an impending complex future.

In contrast to Sappho, Anakreon, a poet/composer from Ionia who traveled widely in his apparently long life—from Teos to Abdera in Thrace to Samos to Athens—[199] was a contemporary of the painters who depicted him on ce-

---

[197] Boston, Museum of Fine Arts 98.887; *ARV* 774.1; *Add.* 287 (Schefold 1997:111, figs. 40–41). There is no inscription to identify the male figure. Although Schefold 1997 supports such identifications, it is certain that they belong to the realm of hypothesis (see my examination above). In the case of this *pyxis*, both Schefold 1997:110 and Clay 2004:55–56 support tentative identifications.

[198] Alkaios appears in conjunction with Sappho on one vase. (Some of) Alkaios' and Anakreon's songs are viewed by Aristophanes as kindred in terms of their music: "think of the well-known Ibykos, and Anakreon of Teos, and Alkaios, who all put some spice into music..." (*Thesmophoriazousai* 161–162).

[199] For Anakreon's longevity, see [Loukianos] *Makrobioi* 26, but this information may be based on anecdotal traditions about Anakreon. Cf. also Schol. M Aiskhylos *Prometheus Bound* 128 (= fr. 412 *PMG*); note, however, that the relevant text has been emended by Weil (ἠρέσθη λίαν τοῖς

ramics. Several scholars believe that the obscure melic poet Kydias (*c.* 500 BC) is also represented on two contemporary Attic vases,[200] but this is far from certain.[201] Concerning Anakreon, apart from three representations on Attic vases with his name inscribed, his figure has also been connected with a series of images often referred to as "Anakreontic." As will become clear, only one painted pot as well as another with a similarly marked image is related to the so-called Anakreontic images.[202]

First, a note on terminology: "Anakreontic" is a tag that has implicitly been given to a specific series of vases by John Beazley.[203] These are some fifty vases that depict male figures dressed in *chiton* and elaborate *himation*, wearing turban-like headgear (often identified as *mitra*)[204] or cloth hats (*sakkoi*), boots, and, occasionally, earrings. The figures are bearded and often carry *skiadeia* (parasols) or *barbitoi* (long-armed bowl lyres). Since one of the three inscribed "portraits" of Anakreon bears images of men holding a parasol and a *barbitos* and dressed in the same manner, the whole series of vases was thought to depict Anakreon and his boon companions and to be associated with his stay in Athens, where he had been invited by Hipparkhos in the 520s.[205]

---

μέλεσιν αὐτοῦ ὁ τραγικός instead of the transmitted ἠρέσθη [sc. ὁ Ἀνακρέων) λίαν τοῖς μέλεσι τοῦ τραγικοῦ. This would make Anakreon a fan of Aiskhylos' choruses and music. But even if the transmitted text is correct, the information seems anecdotal. See also Valerius Maximus 9. 12 ext. 8, a reference to Anakreon's longevity in the context of a story about Anakreon's death by a grape pip stuck in his throat.

[200] Among others, Webster 1971:53–54; Rosenmeyer 1992:22.

[201] For Kydias (of Hermione?), see frs. 714–715 *PMG*. Almost nothing is known about this poet. Sokrates (in Plato *Kharmidês* 155d) who quotes Kydias fr. 714 *PMG*, calls him wisest in the matters of love (σοφώτατον... τὰ ἐρωτικά); the two lines that Sokrates quotes are from a love song speaking of a beautiful boy (...ἐπὶ καλοῦ λέγων παιδός) The two vases that allegedly depict this Kydias are Munich, Antikensammlungen 2614 and London, British Museum E 767 (for the vase-inscriptions on the red-figure *psykter* London E 767, see Immerwahr 1990:70).

[202] The image on the Syracuse *lekythos* (see n. 208 below) is close to the "Anakreontic" vases. On these vases, see Papaspyridi-Karouzou 1942/1943 (with earlier references), Beazley 1954:55–61 (with earlier references), Brandenburg 1966:77–81, Kenner 1970:113–116, De Vries 1973, Snyder 1974, Shapiro 1981:138–140, Boardman 1986, Frontisi-Ducroux and Lissarrague 1990 (originally published in 1983), Price 1990, Miller 1992:97–100, Delavaud-Roux 1995, Zanker 1995:24–26, Miller 1999 (with earlier references), Neer 2002:19–23; cf. also Cohen 2001:244–247.

[203] Beazley 1954:55–61. Beazley called the subject of the whole series "Anakreon and his boon companions" in the context of a "special komos" (Beazley 1954:57). Cf. Boardman (1975:219 and 222), who follows Beazley with a few adjustments ("transvestite men" 119 and 222, "Anakreon may have introduced this drag performance which remained fashionable for over fifty years" 219, "Anakreontic" 222); see also Boardman 1980:97–98 ("their dress must have seemed almost transvestite to Athenians"). Later, Boardman will modify his views (Boardman 1986).

[204] This type of headgear has been identified as *mitra* by Brandenburg 1966; cf. Boardman 1986:50.

[205] Beazley 1954. Beazley admits that the question whether the vases were intended to depict "more generally, revelers of the good old days" is not easy to settle (Beazley 1954:57; he takes the same qualification in Beazley 1974a:16: the images may "represent Anacreon and his boon-

The term "Anakreontic" boon companions and its archaizing version "booners" have been gradually avoided in more recent scholarship—and rightly so. We may prefer to attach to these male figures a more unmarked tag: "elaborately dressed revelers."[206] At the same time, the pictorial figure of Anakreon should be viewed in the context of the whole series of representations of elaborately dressed revelers, rather than vice versa.

As we have seen, the case of vase-paintings with Anakreon's name inscribed on them is different from those with Sappho, since Anakreon was alive when the images were produced. The earliest image of Anakreon comes from a red-figure cup by Oltos of about 520–510 BC.[207] Another representation of Anakreon appears on a *lekythos* by the Gales Painter of about 500 BC.[208] A third case of Anakreon's name inscribed on a vase is found in fragments of a red-figure *kalyx-krater* attributed to the Kleophrades Painter and dated to *c.* 500 BC.[209]

On one of the two sides of the Oltos cup, we see Anakreon in the company of two male figures standing before him (Fig. 8). The first male figure hastening toward Anakreon and closer to him is certainly a youth (one of Anakreon's feet crosses with the youth's right foot), while the figure walking behind the youth can be either another youth or a man (his shoulders and head are missing). Anakreon is bearded and wearing only a *himation* and a flower wreath. He holds a *barbitos* and a *plêktron*, the fingers of his left hand touching the strings, and walks forward toward the two male figures. The youth is also wreathed, with a cloak over his shoulders but, on the whole, his body is naked. To the right of the youth, his name is inscribed: ΝΥΦΕΣ (Ny[m]phes).[210] The second, fragmentary male figure is covered with a *himation*: no nakedness is depicted here. Behind Anakreon, on the left of the image, between the decoration

---

companions or old-fashioned revels in the times of the Peisistratids"). Semne Papaspyridi-Karouzou (1942–1943:251), as well as scholars earlier than her and Beazley, similarly thought that non-inscribed images of revelers of this specific type can represent Anakreon.

[206] Only rarely do we see symposiasts, instead of komasts, depicted on these vases: Kassel, Hessisches Landesmuseum A Lg 57 (Boardman 1986:47–48, no. 4 and fig. 12). See also, below, the Kleophrades Painter *kalyx-krater*, Copenhagen, National Museum 13365; *ARV* 185.32; *Add.* 187.

[207] London, British Museum E 18; *ARV* 62.86, 1600.20, 1700; *Add.* 165.

[208] Syracuse, Museo Arch. Regionale Paolo Orsi 26967; *ARV* 36.2, 1621; *Add.* 158. The *lekythos* is signed by the potter Gales. Relative dating: *c.* 500 BC (Beazley 1954:61); *c.* 510–500 (Boardman 1986:69); *c.* 500–490 (Richter 1965:77); *c.* 490 (Schefold 1997:76).

[209] Copenhagen, National Museum 13365; *ARV* 185.32; *Add.* 187.

[210] Could the name be read as "Servant of the Nymphs"? Cf. Schefold 1997:76: "der von Nymphen Begeisterte." Given the context, there can be no certainty in this hypothesis. On the Nymphs as employed in Anakreon's songs, see Anakreon frs. 357. 1–4 (Dionysos plays together with Eros, the Nymphs, and Aphrodite) and 448 *PMG* (Samos, an island on which Anakreon lived for a while as a poet at the court of the tyrant Polykrates, is described as "city of the Nymphs").

Figure 8. Red-figure cup: obverse, Anakreon with *barbitos*, two male figures. Attributed to Oltos, *c.* 520–510 BC. London, British Museum, inv. no. E 18. © Copyright, Trustees of the British Museum.

pattern and his figure, is a retrograde inscription ΚΑΛΟΣ, floating in the blank space.

On the other side of the cup, in a diametrically opposite movement to that of the two male figures on the Anakreon side, two armed Amazons running away from Herakles and toward the decoration patterns that frame the image defend themselves in a battle with the hero, who, sword in hand, hastens toward the Amazon on the right. Finally, on the tondo of the cup, we see a naked woman tying her sandal. Around her figure runs an inscription "Memnon is pretty."

This image of Anakreon, which was produced when he composed and performed new as well as older songs in Athens, fits well with the possible symposiastic use of the cup. Beautiful youths, wooing, wreaths, wine, and *barbitoi* were all essential elements in the composition of his songs, which in later periods began to be closely associated with the circulation of stories about his loves, homoerotic and heterosexual (he will be enamored of Sappho in the early third century BC).

Similar in compositional technique is the representation of Anakreon on the Gales Painter red-figure *lekythos* in Syracuse (Fig. 9). The surface of specific parts of the vase is damaged, but it is certain that Anakreon (his name in-

Figure 9. Red-figure *lekythos*: Anakreon with *barbitos*, two male figures. Attributed to the Gales Painter, c. 500 BC. Syracuse, Museo Archeologico Regionale Paolo Orsi, inv. no. 26967. Photo, Museo Archeologico Regionale Paolo Orsi.

scribed) wears both a long *chiton* and *himation* and moves to right, *barbitos* in hand. What he wears on his head is not clearly visible (possibly a fillet and a wreath, but the head is badly damaged).[211] Two youths surround him. The youth on the left, hastening toward him, holds a *skyphos* (a deep drinking-cup) different from the wide and shallow shaped drinking-cups, the *kylikes*.[212] No image seems to be drawn on the *skyphos*, which, in plain form, was one of the most common shapes of Athenian drinking cups for everyday use. Compared to Anakreon, the two youths are dressed sparingly: a cloak is thrown over the arm or the shoulders of the naked figures, respectively. The left-hand youth also holds a stick near his right knee, while the right-hand youth holds a similar wooden staff above his head (from the overall context no inference can be made about the possible signification of the pose of the right-hand youth). The figure of Anakreon resembles the "elaborately dressed revelers." This representation lies between the one on the Oltos cup and the fragmentary picture of the Kleophrades Painter *kalyx-krater*, although, since Anakreon is dressed in both *chiton* and *himation* and playing a *barbitos*, the Syracuse *lekythos* is closer to the Copenhagen *kalyx-krater*.

On the latter vase (Fig. 10),[213] the scenes depicted are semantically marked and more intriguing. On one of its (very fragmentary) sides, we see a male figure reclining on a couch and holding a lyre. The figure is in singing position. On this side are also traces of a second male figure reclining near a female figure playing the reed pipes. Above the reclining figure a *skyphos* and basket are hung; to the right of the female musician is a *kylix*, possibly held by a third (reclining?) figure. Above the lyre and the partly preserved right arm of the first reclining male figure is the inscription ]ΕΝΙΕΣ, possibly part of a song.[214] On the *kylix* that the third (missing) figure may have been holding, we read ΑΙΡΕ[ (starting from the left-hand side of the *kylix*).[215] The certainly sym-

---

[211] The original vase needs to be reexamined (cf. Beazley 1954:61), since, if the figure were bald (cf. Malibu, J. Paul Getty Museum 86.AE.296, *ARV* 837.10, a red-figure cup by the Sabouroff Painter with a representation of bald male figures wearing fillet), that would be an additional semantic detail in the image of Anakreon. However, from the drawing included in Schefold, Anakreon seems to be wearing a fillet and a wreath.

[212] See Kanowski (1984:139) for the apparent interchangeability of the names *skyphos* and *kylix* in inscriptions on vases.

[213] Copenhagen, National Museum 13365; *ARV* 185.32; *Add.* 187.

[214] Immerwahr (1965) discusses all the inscriptions of the vase and suggests that this specific one may be part of a poem of the *Theognidea* (1129 ἐμπίομαι· πενίης...). For a different explanation, see Beazley 1974a: 15.

[215] Its right-hand side is missing: hence ΑΙΡΕ[, which does not seem to represent *khaire*. On this inscription, see Immerwahr 1965:154, who considers the possibility of having *khaire* written here; cf. Beazley 1974a:15 ("probably for Χαιρε και πιει or the like, the chi perhaps thought of as on the other side of the cup").

115

Figure 10. Red-figure *kalyx-krater* fragments: obverse, *symposion*; reverse, *kômos* with Anakreon. Attributed to the Kleophrades Painter, *c.* 500 BC. Copenhagen, National Museum of Denmark, Department of Classical and Near Eastern Antiquities, inv. no. 13365. Photo, National Museum, Copenhagen.

posiastic image on this side is aptly juxtaposed with a representation of a group of four strolling revelers, a *kômos*, on the other side.[216] Of the three, now partly visible, elaborately dressed komasts,[217] two are preserved enough so that we may be able to draw some conclusions. One of them wears long *chiton* and shoes.[218] The other, preserved on a detached fragment, wears elegant *himation* and *chiton* as well as turban-like headgear and has a long, bushy beard. Head thrown back, he sings IOOO, a string of letters coming out of his open mouth. While he vocalizes, he carries—debonair—a parasol over his shoulder. Another separate fragment of this side of the vase shows the hands and part of the chest of one of the revelers, who holds a *barbitos* in the left hand and a *plêktron* in the right. He, like the other figures, moves to the right and is similarly dressed. To the right of his breast we see the beginning of a word: only an A[ survives, and we cannot be certain as to whether this is the beginning of a name. Along the preserved arm[219] of his *barbitos*, a clearly written inscription provides more focus: ANAKPE[ON].

In the context of all the elements employed in the visual rendition of these revelers, the name of the poet on the *barbitos* is significant. John Boardman has attempted to undermine its relevance to the scene by pointing out that it is uncommon for a figure to be named on appurtenances or objects s/he may be holding or is adjacent to; therefore, "[Anakreon's] name could have been prompted more by the *barbiton* on which it appears" than by his representational identity as intended by the painter, since the *barbitos* was especially associated with Anakreon in antiquity.[220] However, there are a few other similar cases[221] and even if we do not wish to take them fully into account, the point remains that an ancient viewer must have made a visual association between the figure with the *barbitos* and the inscription "Anakreon." The close contiguity of the instrument with the figure playing it clearly points to a direct association of the figure with the name, not only of the *barbitos* with

---

[216] The fourth figure, that is, the last one on the far right is dancing: we see one of his feet kicked up behind (cf. Beazley 1954:57).

[217] Of the fourth figure on the left, only one of his feet is preserved: see Beazley 1954:57, who discusses this side of the vase.

[218] Next to this figure is another figure wearing a long *chiton*. Beazley (1954:57 and 1974:15), followed by Immerwahr (1965:152), believed that the sigma inscribed next to this male figure is the end of his name (...Σ), but this is far from certain, as there are other possibilities (a καλός inscription?).

[219] The other arm of the instrument is missing.

[220] Boardman 1986:69. Cf. Frontisi-Ducroux and Lissarrague 1990:215, who make the same hypothesis.

[221] See Boardman 1986:68n48, where he refers to other cases of vase inscriptions on objects held by, or adjacent to, figures.

that name. The depicted singer-*barbitos*-name should, therefore, be viewed as constituents of a pictorial syntagmatic series in which the last element (the name) refers to the first one in the series (the singer) through the metonymic mediation of the marked musical instrument. In other words, Boardman's hypothesis has attempted to reconstruct the intentions of the painter, envisaging a highly attentive viewer who made over-subtle distinctions like the ones favored by Boardman. Since the cases of a figure's name written on an object he is holding or is adjacent to were few (as far as we can judge), a viewer must have proceeded to a more direct, almost metonymic, identification of the figure. Even if one decided to focus tentatively on the painter of the inscription, what could have made him draw this association? We should certainly not assume a priori that the later attested association of Anakreon with this instrument[222] was so pronounced in the late sixth century and, therefore, that "the name of the poet occurs here, on the *barbiton*, as a reference to Anakreontic poetry in general and not as an identification of a specific individual."[223] Even if one speculated that a marked, almost exclusive, connection between the instrument and the poet existed at the time, one could not help thinking that the *barbitos* was also associated strongly with Terpandros and Sappho,[224] and that numerous male and female[225] figures on vases, including Sappho, hold or play the *barbitos*. In view of these considerations, there could have been no clearcut equation of Anakreon's songs "in general" and *barbitos*.

Unless there was another indication in the missing parts of the scene with the komasts, Anakreon and his strolling cronies appear to have been assimilated into the visual schema of "elaborately dressed revelers" that emerged on Attic vases in the 520s, a period that coincides with the final years of the tyranny of the Peisistratids in Athens. The popularity of this image will recede before the mid-fifth century, with the "archaizing" Mannerists, and elaborately dressed komasts will cease appearing in about 450 BC.[226]

---

[222] See Kritias fr. 1 D-K (= *PMG* 500); Athenaios 4.175d and 4.182f. Cf. *Anthologia Palatina* 7.24.6 [= 'Simonides' 3.6 G-P and 'Simonides' 66.6 in Page 1981:287–288] τὴν φιλόπαιδα χέλυν.

[223] Frontisi-Ducroux and Lissarrague 1990:215. Boardman's hypothesis (1986:69) is more flexibly formulated.

[224] Pindar fr. 125 M. See above, p. 69.

[225] Frontisi-Ducroux and Lissarrague (1990:225n83) oddly refer, for the sake of their argument, to only a few examples of female *barbitos*-players (and *kithara*-players), but the cases are not so few. To those they cite add the three out of four vases depicting "Sappho"; see the vase in Boardman 1986:49, no. 39; and cf. Landesmuseum 4.692 (Schefold 1997:74 and 75, fig. 11), Museum für Kunst und Gewerbe 1984.497 (Hornbostel et al. 1977:298, no. 258) and Cambridge, Mass., Sackler Museum 1960.354 (my Fig. 2 above). Cf. the contextually different representation on the Polyxena sarcophagus in Sevinç 1996.

[226] Cf. Boardman 1986:65: "The series ends before the middle of the fifth century, and the late examples...may even be throwbacks to Archaic behavior rather than *portrayals of the contem-*

It is worth noting that similarly, but certainly not identically and as markedly, dressed male figures occurred earlier on vases.[227] As we have seen, the "elaborately dressed revelers" schema involves bearded male figures wearing the full-length *chiton* with *himation*, headdress (pleated turban or tied headcloth), boots or soft footwear, and occasionally earrings; they often carry parasols or a *barbitos*.[228] Sometimes female pipers are depicted along with the revelers.[229] The representation of these elaborately dressed figures is markedly different from the more traditional depiction of lightly clad or near-naked male figures of *symposia* and *kômoi* on vases (Fig. 11). The difference becomes intriguing if we compare the near-naked komasts on an Attic red-figure cup in Toledo, Ohio, and the elaborately dressed revelers on an Attic red-figure cup in Malibu.[230]

On the Toledo cup, the three male figures in the center are bearded and each has a cloak thrown over his shoulders covering only his back (Fig. 12). One of them is holding a wine container, and one is playing a *barbitos*. We see them strolling near naked and enjoying the intoxicating properties of wine. Let us focus on the third man, holding *krotala* and dancing on the right, before the naked boy holding a walking stick. The dancing position of his body and the elegance of his hand gestures are strikingly similar to the elaborately dressed, bearded man playing *krotala* and dancing on the Malibu cup (Fig. 13a). The difference lies in the emphasis on the elegance of the vestmental coding in the case of the men on the Malibu cup. At the same time, while the merrymaking komasts are accompanied, at least on the Toledo cup, by a naked young boy holding a walking stick, the elegantly dressed revelers are surrounded by similarly dressed, but not identically gesturing, young girls, who either hold para-

---

porary" (my emphasis). For this approach to vase-paintings, see below. Note that the dating is relative. Boardman's list of forty-six vases is supplemented by Miller (1999:230n27), who adds four vases (partly based on Price 1990:159–161), as well as the mid-fifth century *stamnos* that she publishes (Miller 1999:223–232). Miller considers a few more possible cases (1999:230n27). Price (1990:159–162; cf. also her n82 on p. 161) had added six vases, one of them being the red-figure *lekythos* with "Anakreon" by the Gales Painter (Syracuse, Museo Arch. Regionale Paolo Orsi 26967; *ARV* 36.2, 1621; *Add.* 158).

[227] Boardman 1986:51 and esp. 58; Price 1990:135 and 153–157 (but see the criticism of Delavaud-Roux 1995:248. 255).

[228] A red-figure *stamnos* (Madrid, Museo Arqueológico Nacional 11009) depicts one of the revelers, a *barbitos*-player, along with a parasol on his back. Cf. red-figure neck-amphora Berlin F 2351 (see Greifenhagen 1976:no. 12, figs. 19–20), on which an elaborately dressed komast carries a *barbitos* in his right hand and holds a parasol is his left hand.

[229] On a red-figure cup (side A, Malibu, J. Paul Getty Museum 86.AE.293; *Para.* 372. 8 *bis*) by the Briseis Painter, a shorter girl is holding a parasol for a heavily bearded reveler playing *krotala*; cf. side B of the same cup, where a fragmentary (probably female) figure is holding a parasol next to a bearded reveler.

[230] Toledo 64.126, Foundry Painter; Malibu, J. Paul Getty Museum 86.AE.293, side A, Briseis Painter.

Figure 11. Red-figure *stamnos*: obverse, *kômos*, youths, one with *barbitos*. Attributed to the Kleophon Painter, *c.* 440–430 BC. Brussels, Musées Royaux d'Art et d'Histoire, inv. no. A 3091. Photo, Musées Royaux d'Art et d'Histoire, Brussels.

sols for them or play reed pipes to accentuate, it seems, the pomp of the men's *cultural performance.*

It is this emphasis on vestmental extravagance that has caused considerable perplexity and debate among scholars who have been discussing the series of vases showing elaborately dressed komasts since the early nineteenth century. If we can decodify some aspects of the vestmental signification of these images, we will be able to contextualize the Kleophrades Painter *kalyx-krater* with more accuracy.

Figure 12. Red-figure cup: obverse, three komasts, one with *barbitos*, boy with stick, and *aulos* player. Attributed to the Foundry Painter, *c.* 490–480 BC. Toledo, OH Museum of Art, purchased with funds from the Libbey Endowment, Gift of Edward Drummond Libbey, inv. no. 64.126. Photo, Toledo Museum of Art.

Figure 13a and b. Red-figure cup: obverse (a: *above*), elaborately dressed revelers; reverse (b: *below*), elaborately dressed revelers. Attributed to the Briseis Painter, signed by Brygos as potter, *c.* 480–470 BC. Malibu, J. Paul Getty Museum, Villa Collection, inv. no. 86.AE.293. Photo, The J. Paul Getty Museum.

The least we can infer from the inscription "Anakre[on]" on the Kleo-
phrades Painter's *kalyx-krater* is that Anakreon's music has been assimilated
into the visual schema "elaborately dressed revelers."[231] This *barbitos* is per-
forming "Anakreon:" it does not merely represent a "quintessentially sym-
potic"[232] or komastic *barbitos*. The close contiguity of the *barbitos* with the
figure holding it leads, even momentarily and probably more firmly, to a direct
visual association of the name with the figure and not only with the musical
instrument. Certainly the association of the image with Anakreon was first
indicated by the painter of the inscription. The examination of some further
cultural elements will elucidate the patterns of signification embedded in the
image.

In order to decodify the Kleophrades Painter image, two pivotal issues
should be explored: Why was the name of Anakreon assimilated into the sche-
ma "elaborately dressed revelers"? And what did the series of vases depicting
these revelers denote and connote?

The attempts to account for the emergence of this iconographic schema
have been diverse. If one leaves aside the analysis by Françoise Frontisi-Ducroux
and François Lissarrague,[233] the common denominator in all approaches has
been the identification of the revelers of this series of vases with *specific* Athe-
nian realities and cultural phenomena current in late-sixth- and fifth-century
Athens. Nineteenth- and early-twentieth-century scholars thought that the
images on the vases represented rituals related to specific religious festi-
vals.[234] In the mid-twentieth century this hypothesis was undermined by an
equally early scholarly paradigm. It was suggested anew and more rigorously
that the figure of Anakreon must be connected with the proliferation of these
images; they all, to a certain degree, depicted Anakreon and his friends. Sem-
ne Karouzou had stressed the impact of Anakreon's poetic image of Ionian
elegance and luxury on Athenian circles of nobles.[235] The idea that the figure
of the Ionian Anakreon lies behind the representation of the revelers on these

[231] For the case of the Syracuse *lekythos*, see below.
[232] Quotation from Miller 1999:236, describing Frontisi-Ducroux and Lissarrague's (1990) view.
[233] In their discussion, the polyvalent figure of Dionysos has been viewed as a decisive element of
the apparent ambiguity and otherness of the revelers. See Frontisi-Ducroux and Lissarrague
1990:229 ("What the men of Athens, as they are represented on their drinking vessels, seem
to be searching for in the practice of communal drinking…is the chance to become other, to
become—just a little bit—woman, Eastern, or barbarian), and 1990:230 ("Dionysos…must lie
behind the "Anakreontic" *kômos*, just as he is implicitly present in the *kômos*, the symposium,
and every social and religious activity involving wine").
[234] For an overview of the history of interpretation of these vases, see Miller 1999:232–236.
[235] Papaspyridi-Karouzou 1942/1943.

vases has continued to flourish.[236] At the same time, two other historical approaches, some arguments of which partly overlap with those of the earlier studies, have been favored. The combination of elegant clothing (flowing *chiton, himation,* headgear) and appurtenances (*barbitos* and parasol) have been viewed as either Eastern or effeminate,[237] despite the fact that these two ancient cultural and conceptual categories are not mutually exclusive and thus very elusive in visual representations spanning sixty years. Further, these images have been placed within the context of *lydopatheia,*[238] a distinct form of Eastern elite lifestyle appropriated by Greek aristocrats, originally in East Greece, to promote their self-defining and differentiating ideologies.[239] According to these interpretations, in approaching these representations all eventually rests on how one outlines specific Athenian cultural actualities—on a pragmatic or a more ideological level.

It is admittedly hard to contextualize the "elaborately dressed revelers." As regards the view that the figure of Anakreon lies behind the images, it is not inconceivable that either Anakreon's early reputation or his arrival in Athens might have indeed titillated the imagination of Athenian society.[240] A more inclusive account would be that not only the image of Anakreon but also that of other East Greek poets like Alkaios or even the Westerner Ibykos, who settled on Samos,[241] are behind the turbaned and chitoned revelers.[242]

As for Anakreon, we do not know when exactly his songs reached Athens. If we can trust the basic nucleus of Pseudo-Plato's story in *Hipparkhos* (228b-c)

[236] For example, Price 1990 has seen in these revelers the figure of the Ionian lyric poet—and not of Anakreon alone—becoming a standard subject of Athenian popular burlesque, an early phase (according to Price) of the genre of comedy before it was formally established in 487/6 BC.

[237] Eastern: de Vries 1973 and Boardman 1986 (cf. Boardman 1976:283–284); effeminate: more recently, Miller 1999, who argues that the series depicts aspects of komastic or ritual tranvestism in antiquity.

[238] Anakreon fr. 481 *PMG* is a one-word fragment that provides the word λυδοπαθεῖς, glossed by the textual sources for this fragment (Schol. M Aiskhylos *Persians* 42; cf. the singular form λυδοπαθής attributed to Anakreon by Athenaios 15.690b-c and Eustathios *Iliad* 18.291, vol. 4, 180 van der Valk) as ἡδυπαθεῖς ("living in luxurious style"). Given the diverse contexts in which this epithet could have been employed, there can be little certainty as to whether the word is a positively charged or pejorative term. Neer's rendering "Lydia-mad" is somewhat sensational (Neer 2002:19).

[239] More recently, Neer 2002:19–20 (with references to earlier bibliography).

[240] In the second half of the fifth century, his reputation in Athens was strong: see Brown 1983:5; cf. Trypanis 1951, Aloni 2000, Ridgway 1998, and Wilson 2003:190–195 (based on an unconvincing reading of the Greek text of Kritias fr. 88, B1 D-K); also Labarbe 1982 on the ancient reception.

[241] Ibykos was not from East Greece, but he lived at the court of Polykrates in Samos.

[242] Cf. Price 1990 (above, n. 236).

about Anakreon's grand arrival in Athens after a prestigious invitation by the brother of the *turannos* Hippias, Hipparkhos, Anakreon must have taken up residence in Athens before the murder of Hipparkhos by Harmodios and Aristogeiton in 514 BC.[243] At the same time, dating Anakreon's arrival in terms of the end of the rule of the tyrant Polykrates in Samos, in whose "court" Anakreon also lived, involves evidentiary gaps, and it is best to accept that neat reconstructions of his career can be endorsed only as a very general framework, within which Anakreon's poetry was produced, and not as an absolute chronological sequence. If we are to trust the story about Hipparkhos' fetching him to Athens, Anakreon's songs must have been known in certain Athenian circles before the invitation was issued. His sojourn in a city incomparably smaller than modern Athens and, more importantly, his East Greek music might have given rise to some discussion in symposiastic and other musical and cultural milieus.

However, it is certain that we can only speculate about all this, *especially* about Anakreon's earliest impact on Athenian noble circles. The music of Sappho as well as of Alkaios might have also reached the ancient city by that time and it is not unlikely that Athenians became familiar with their songs some time during the last two decades of the sixth century, since the earliest visual representation of Sappho is dated to *c.* 510–500 BC. In discussions of the series of vases under investigation, it is often assumed that upon his arrival in Athens, Anakreon brought with him the East Greek musical flair and the *barbitos*. A question that needs to be posed, but which can hardly be resolved, is what the musical and poetic scene in Athens before the time of his arrival was. Was Athens immune to East Greek musical traditions before Anakreon performed his songs in Athenian *symposia* and related contexts? When "Anakreon" started being performed in Athens, was the cultural or actual sound of the *barbitos* unknown to the Athenians?

The earliest images of *barbitos* on Attic vases are dated to about 530–520 BC, but both Anakreon and Sappho hold the same musical instrument in their earliest representations.[244] The *barbitos* had an East Greek origin: Pindar (fragment 125 M) would imagine Terpandros, the famous musician from Lesbos, inventing it at Lydian banquets inspired by the sound of the *pêktis*, a many-

---

[243] Anakreon's Athenian sojourn may be corroborated by other sources: Aristotle *Constitution of the Athenians* 18, Aelian *Historical Miscellany* 8.2. Plato *Kharmidês* 157e refers to Anakreon's songs for the noble house of Kritias, the grandfather of the politician and poet Kritias of the second half of the fifth century. Schol. M on Aiskhylos *Prometheus Bound* 128 (see above, n. 199) refers to Anakreon falling in love with Kritias during his sojourn in Athens, but the information of the scholium seems anecdotal.

[244] An exception is the Athens *hydria* examined below.

stringed plucked instrument described by the late-fifth/early fourth-century dithyrambic poet Telestes as "high-pitched."[245] However, origins can often be blurred indicators of the date of the cultural dissemination of musical styles, instruments, or innovations. Almost a contemporary of Sappho, Alkman composed songs in Sparta with references to the allure of Lydian culture (fragment 1.67–68 *PMG*). And, earlier on, in the early seventh century, Terpandros, the legendary "inventor" of *barbitos*, moved from Lesbos to Sparta. The *barbitos* might well have reached Athens before Anakreon's songs were performed there. Any argument put forward on this front may be circular, and it is better not to make much of the supposed grand musical appearance of Anakreon in Athens but, rather, to think in terms of East Greek poets entering the musical circles of Athens.

The "Eastern elements" approach deserves more attention. It focuses on East Greek vestment coding by pointing out that each of the dress elements of the revelers was of Eastern origin. In the non-Greek East the parasol, for instance, was an indication of social status, "fit to be held over the Great King himself, symbolizing the way he cast the shadow of his protection over his people."[246] All the dress accessories of the revelers seem to have been worn by men in East Greece (and in Lydia and further eastward, as is evident from archaeological material),[247] and literary texts complement the archaeological record. Herodotos refers to the story of the Lydian Kroisos' recommendation to the Persian Kyros that in order for the Lydians never to rebel or become a threat to Kyros, they should be made to wear "tunics (*chitones*) under their cloaks (*himatia*) and high soft boots on their feet, and asked to take up the *kithara* and the harp and teach their sons to be retailers."[248] These were marks of luxury, as well as of departure from the male pursuit of warlike activities.[249] Therefore, according to De Vries, among several possibilities, "it might be that

[245] Telestes fr. 810. 4–5 *PMG* (= Athenaios 14. 626a). For the date of Telestes, see *Marmor Parium* Ep. 65 (Jacoby 1904:18), which records a victory of Telestes at Athens in 402/401 BC.

[246] Boardman 1986:64. For an excellent study of the parasol in late archaic and classical Athens, see Miller 1992. Miller (1992:100) challenges Boardman's conclusions that "its appearance in mainland Greece was at first in men's hands only and in the context of the komos" (Boardman 1986: 65).

[247] De Vries 1973 (see however below, n. 250) and Boardman 1986.

[248] Herodotos 1.155 κέλευε δέ σφεας κιθῶνάς τε ὑποδύνειν τοῖσι εἵμασι καὶ κοθόρνους ὑποδέεσθαι, πρόειπε δ' αὐτοῖσι κιθαρίζειν τε καὶ ψάλλειν καὶ καπηλεύειν παιδεύειν τοὺς παῖδας.

[249] Kroisos continues: καὶ ταχέως σφέας, ὦ βασιλεῦ, γυναῖκας ἀντ' ἀνδρῶν ὄψεαι γεγονότας, ὥστε οὐδὲν δεινοί τοι ἔσονται μὴ ἀποστέωσι. The line between men's luxurious and elaborate dressing and women's apparel (unless the latter consisted of the exclusively feminine *peplos*), was not *always* easy to draw. But apparently in East Greece wealthy men's elaborate clothes were not regarded feminine, unless they were too foppish and extravagant or viewed from a culturally marked perspective.

the figures are generally meant to be Athenians, but Athenians of a special set who were aping Eastern ways and dress."[250] It is this possibility that has shaped more recent views about the appearance of new habits in komast life in Athens as a result of East Greek *lydopatheia* in this city.[251]

If one focuses exclusively on each dress element of the revelers as a mark of East Greek or Lydian vestment coding, one may risk obscuring or essentializing the larger picture. This process of atomization[252] of a visual text in terms of the (real or constructed) origins of individual appurtenances the depicted figures sport presupposes or confirms an understanding of images as portraying scenes of real life, or, alternatively, aspects of *specific* Athenian political-cultural actualities. The vase-painter, according to this long-sanctioned approach,[253] depicts a reality with which he is familiar. And he is careful, again according to complementary interpretations, in representing clearcut ideologies that subscribe to the social demands of aristocratic audiences. These interpretative views attribute a specific, usually schematic, role to ancient Greek visual culture and can, in some cases, distort both ancient Greek realities and the Athenian social imaginary.

For a start, if one attempts to account for the emergence of the "elaborately dressed revelers" in the 520s (the final years of the rule of the Peisistratids in Athens), by correlating them closely with specific political developments, this can readily produce overhistoricizing interpretations that transfer vase-paintings from the world of representation to the world of documents. Given the uncertainties related to the relative dating of specific pots with images attributed to specific painters, any discussion of the period during which the vase-paintings under consideration were first produced should allow some chronological elasticity. If our first, marked depictions of dressed revelers are given an only slightly later dating—500 instead of 520 BC

[250] De Vries 1973:39. De Vries considers the possibility that the revelers might represent Anakreon and his friends as well as that the figures, alternatively, "are by and large meant to be Lydians, who somehow came into the real or artistic vision of the Attic craftsmen." For Boardman (1986:65) "the origin of every detail of their dress is found to be male" and "the origins of this special komast behavior must be sought…in an East Greek world heavily influenced by the behavior of their eastern neighbors," the Lydians. In this article, he rejects the idea of private komastic or ritual transvestism (but see his earlier views in n. 203 above). Cf. De Vries 1973:33–34.

[251] Cf. Boardman 1986:65 ("infiltration of East Greek habits into Athenian komast life") and 70 ("Lydopathic license of late Archaic Athenian komasts"). This approach to the dressed komasts is repeated by Kurke 1992:97–98, and, more recently, Neer 2002.

[252] For the atomization of ancient and modern commentaries on classical texts, see the interesting discussion in Most 1985:36–37.

[253] This approach or similar versions of it (ancient Greek vase-paintings representing either reality or myth) have rightly been criticized by some scholars: e.g., Bažant 1981:13–22.

—several possible interpretations that might account for the emergence of these images in the light of *specific* sociopolitical parameters allegedly lying behind the images can prove misleading. In other words, the earliest images could have been produced either during the rule of Hippias and his brother Hipparkhos,[254] who along with their father seem to have been open to things Ionian,[255] or during the years of the reforms of Kleisthenes, who, according to Herodotos, looked down on the Ionians.[256] Therefore, the cultural connotations of the images could be interpreted differently—as positive or ambivalent—on the basis of whether they reflect some "elitist" orientations of the Peisistratids and an emphatic appropriation of distinct forms of Eastern elite lifestyle by Athenian aristocrats, or alternative viewpoints.[257]

Such an approach to ancient Athenian images—one that presupposes an intense interest of vase-painters to represent a specific ideology of elitist social strata in positive terms—[258] lies behind a more recent understanding[259] of the "elaborately dressed revelers" as "archaeological evidence" for what has been called "the cult of *habrosunê*," a specific elite, luxurious lifestyle taken over by (especially seventh- and sixth-century) Greek aristocrats from the East, particularly from Lydia.[260] According to this view, the relevant vase-paintings, falling

[254] Hippias was *turannos* of Athens up to 511/510 BC. Hipparkhos, who was murdered a few years earlier, had brought (Aristotle *Constitution of Athens* 18.1) Anakreon, Simonides, and (Herodotos 7. 6) Lasos of Hermione to Athens.

[255] On this aspect of the Peisistratids, cf. Shapiro 1981:138. On the Peisistratids and cultural life in Athens, see Shapiro 1989 and 1995b, Angiolillo 1997, and Slings 2000a.

[256] We hear from Herodotos (5.69) that, to his mind, Kleisthenes had a low opinion of the Ionians, and that is why he decided that the Athenians should not have the same names of tribes as the Ionians and he made the necessary changes, when he won the support of the common people of Athens.

[257] Oddly, Neer (2002:22) suggests that "it is noteworthy that the 'Anakreontic' vases were produced under the Peisistratids and the Kleisthenic democracy—precisely the time at which the luxury-loving elite was at its weakest politically. The pictures seem to be compensating for the failings of political reality." Price (1990:172) interprets the elaborately dressed revelers as post-Peisistratid parody of the Peisistratid "sympathy towards the luxurious tastes and customs of Ionia."

[258] Although particularly attractive and—from a late-twentieth or early-twenty-first century post-Foucauldian perspective—inevitable, political readings of ancient visual representations can occasionally produce static or even essentializing narratives about the societies in which the images were produced.

[259] This view follows closely the interpretations offered by De Vries 1973 and Boardman 1986.

[260] Recently, Neer 2002:19–22. The expression "archaeological evidence" comes from Kurke 1992: 97 and 98. Kurke 1992:97 (and 1999:200) believes that the vases with elaborately dressed komasts are "sometimes called Anakreontic because the figure of Anakreon is labeled *on three of them*" (my emphasis). In Kurke 1999:200–201, the so-called "cult of *habrosunê*" is held to be reflected in scenes of *symposia* with *hetairai* and explicit sex scenes (popular on Attic vases between *c.* 530–470), which, according to Kurke, are related with the ideology of the so-called "Anakreontic" vases ("in two cases, both elements of representation occur on the same vessels"

"squarely on the side of the Panhellenic aristocracy" and "overlapping nicely with the period in which aristocratic luxury is celebrated in literary sources," constitute, like the contemporary literary evidence,[261] positive representations of the archaic *habrosunê*, which had nothing to do with the effeminate associations attributed to it in fifth-century perceptions of Eastern luxury culture.[262] Whatever one may think of the reconstructions put forward about this archaic aristocratic lifestyle,[263] it is hard to imagine—especially since the contemporary evidence is so scant and can be subjected to different interpretations—[264] that *habrosunê* was an "almost uniformly positive" ideology in the

---

1999:200 and n66, referring to two lovemaking scenes [discussed and labeled as "Anakreontic" by Sutton 1981:98; cf. Sutton 1981:126 "'Anacreontic' orgy" and Sutton 1981:131 "'Anacreontic' symposium"], named so because male participants wear *sakkos* and/or earrings).

[261] This tendency to view visual representations as "tangible" illustrations of reconstructed ideologies of archaic Greek poetic compositions ("vase painting shows us exactly what Λυδοπαθεῖς look like," Kurke 1992:97) is mainly based on a desire to fill the vast gaps in our knowledge of archaic Greek societies by finding exact correspondences between textual and visual representations and thus producing convergent evidence for reconstructed realities and ideologies.

[262] Neer 2002:22 (contrasting the "ideology" of a black-figure image by Kleiosophos dated to *c.* 530 BC, in which *mitra*-wearing "aristocrats" are portrayed in parodic manner); second quotation in Kurke 1992: 97; cf. Kurke 1992:97–99.

[263] Mazzarino 1947:191–246; Bowra 1970a and 1970b; Lombardo 1983. These scholars have collected and extensively analyzed the relevant sources and are closely followed by Kurke 1992.

[264] The form *habrosunê* occurs in Sappho fr. 58.25 V (*abrosuna*) and in Xenophanes fr. 3.1 W; for further occurrences of *habros* and *habrotês* in archaic Greece, see Lombardo 1983. In its highly fragmentary context, ἀβροσύνα in Sappho fr. 58d. 3 (= former fr. 58. 25 V; see the discussion of Sappho frs. 58a, b, c, and d in Chapter Four, p. 360 n. 314) is safer to be construed in the more unmarked meaning "delicacy" or "daintiness," and viewed as a kind of metapoetic phrase, comparable to that of Sappho fr. 16. 3–4 V ἔγω δὲ κῆν' ὄττω τις ἔραται (note the occurrence of δέ in ἔγω δὲ φίλημμ' ἀβροσύναν). West suggests that, given what little has survived, with ἀβροσύνα "Sappho does not mean 'elegance' or 'luxury'" (West 2005: 7n9). Martin West further draws my attention to *Theognidea* 474 and Solon 24.4 W (pers. comm.). A marked, political meaning ("luxury") is not borne out by the context. The following line (that is, Sappho fr. 58d. 4 τὸ λάμπρον †ἔρος ἀελίω† καὶ τὸ κάλον λέλογχε) is problematic (Page 1955:130n1: "I have no conception of the meaning" [of these two lines]). In view of the difficulties in interpreting the line (see, recently, West 2005:7–8), and even if we translated it (along with καί μοι of line 3) as either "and for me love has obtained the brightness and beauty of the sun" or "lust for the sun has won me brightness and beauty" (Nagy 1990:285), it would be misguided to see marked connotations in ἔγω δὲ φίλημμ' ἀβροσύναν and to read it unconditionally as "a programmatic political statement" in the sense of "I align myself with an aristocratic elite that has strong ties with the East," a declaration that is "[Sappho's] way of endorsing a particular style of aristocratic luxury" (Kurke 1992:96 and 99). Although at first sight interesting, this assumption remains unsubstantiated. Therefore, Lombardo's argument (Lombardo 1983:1088–1089) that—in view of Sappho's use of *habros*-words—in archaic Greece *habrosunê* was also associated with the world of women, is not undermined by the existing evidence (cf. ἀβρὰ παρθένος in Hesiod fr. 339 M-W and, especially, Alkaios fr. 42.8 V). Even if we were certain about the "standard" meaning of the word *habrosunê*, it would be difficult to maintain, I believe, that in performances of Sappho's songs original and subsequent archaic audiences could not make such complementary semantic associations.

societies of archaic Greece; therefore, the suggestion that a "radical reevaluation" or "dramatic shift in the valuation" of *habrosunê* took place between the sixth and fifth centuries[265] is schematic, if not exaggerated.[266] There is no way to support the assumption that Xenophanes of Kolophon's negative understanding of Kolophonian luxuries (fragment 3. 1 W ἀβροσύνας ἀνωφελέας παρὰ Λυδῶν, "useless luxuries from the Lydians")[267] represents a nonaristocratic, "middling" viewpoint allegedly related to the "genre" and performance occasions of archaic elegy.[268] This view rests on a hypothetical, superimposed ideological bifurcation that has been proposed for archaic Greek song culture. Should we assume that ambivalent valuations of, and responses to, *habrosunê* and *habrotês* had not been expressed on different levels ever since archaic aristocrats displayed their self-defining lifestyle,[269] which was imported from the East—a lifestyle that apparently is reflected in Xenophanes fragment 3.1 W and in Asios' poetic description of a Samian celebration of the Heraia festival?[270]

The Persian wars and other sociopolitical developments in the fifth century accentuated earlier ambivalent or negative responses, but all this happened gradually, not in a radical manner.[271] Margaret Miller has argued that "a luxury culture was maintained among the élite even in classical Athens, as a direct continuation of that which had prevailed in the period of aristocratic hegemony before the Persian Wars" and that "far from learning to despise luxury through contact with Persia, wealthy Athenians embraced Persian luxury and incorporated into their own world some of its symbols and practices."[272] Fur-

---

[265] Kurke 1992:92, 98.

[266] If, according to this schema, the very few available archaic literary sources taken to be privileging an elitist ideology provide a positive valuation of *habrosunê*, what is the point of arguing so emphatically that *habrosunê* was a uniformly positive aristocratic lifestyle in archaic Greece? The sources are so scant that it is somewhat pointless, I maintain, to reconstruct such a "radical" shift.

[267] Note that ἀβροσύνας is Schneider's correction of the reading ἀφροσύνας preserved in codex A of Athenaios (the fragment of Xenophanes is a quotation in Athenaios 12.526a–b). The earliest occurrences of ἀβροσύνη are in the singular (Sappho fr. 58d.3 [= fr. 58.25 V], Euripides *Orestes* 349), while ἀφροσύνη is often employed in the plural.

[268] Kurke 1992:96 and n18.

[269] Sixth-century social developments toward *isonomia* and against the elitist display of luxury within the city-state such as Solon's sumptuary laws (Kurke 1992:103) suggest this.

[270] Asios fr. 13 Bernabé. We can only conjecturally date Asios of Samos to the sixth or the fifth century. Bernabé 1987:127 and Gerber 1999:427 tentatively date him to the sixth century. Bowra 1970b: 125 argued that Asios did not write earlier than the fifth century.

[271] In this light, it is significant to take into account the fact that the Marathonomakhai were associated in the late fifth century with the old luxury fashion described by Thoukydides 1.6.3; see below, n. 275.

[272] Miller 1997:189; cf. Miller 1997:188–217.

ther, *habrotês* may have also been associated with more "indigenous" or long-assimilated and internalized forms of aristocratic differentiation.

This possibility is reflected in a passage from the "Archaeology" in the first book of Thoukydides' *Histories*. Athenian vestment coding of wealthy men in the sixth century could be elaborate, and writing toward the end of the fifth century, Thoukydides reports that "only recently" had elderly wealthy men ceased wearing linen *chitones* and fastening their hair with golden grasshoppers.[273] It is intriguing that Thoukydides claims that this fashion spread from Athens to Ionia.[274] At the same time, these golden fastenings in the shape of grasshoppers[275] suggest a symbolism of autochthony since grasshoppers are γηγενεῖς ("earth-born").[276] In the context of Athenian "myths," autochthony was, especially in the fifth century, ideologically fundamental for the promotion of the hegemonic discourses of Athens.[277] (Recall that the Athenian heroes of the glory days of the Persian wars were closely associated with the old Athenian luxury fashion [*habrodiaiton*] described by Thoukydides.[278]) It is certain that we do not know exactly what kind of luxurious articles of clothing and appur-

---

[273] Thoukydides 1.6.3. Gomme 1945:103 comments that "Thucydides in his youth will have known older men who remembered it" (cf. Hornblower 1991:26 "Th. implies that in the very recent past (Th.'s own lifetime?) Athenian men had changed from 'Ionic' to 'Doric'" [dress]). In the *Constitution of the Athenians* Pseudo-Xenophon (2.8) believes that "the Greeks prefer to use their own dialect, way of life, and type of attire, but the Athenians use a mixture from all the Greeks and the barbarians" (καὶ οἱ μὲν Ἕλληνες ἰδίᾳ μᾶλλον καὶ φωνῇ καὶ διαίτῃ καὶ σχήματι χρῶνται, Ἀθηναῖοι δὲ κεκραμένῃ ἐξ ἁπάντων τῶν Ἑλλήνων καὶ βαρβάρων).

[274] καὶ οἱ πρεσβύτεροι αὐτοῖς τῶν εὐδαιμόνων διὰ τὸ ἁβροδίαιτον οὐ πολὺς χρόνος ἐπειδὴ χιτῶνάς τε λινοῦς ἐπαύσαντο φοροῦντες καὶ χρυσῶν τεττίγων ἐνέρσει κρωβύλον ἀναδούμενοι τῶν ἐν τῇ κεφαλῇ τριχῶν· ἀφ' οὗ καὶ Ἰώνων τοὺς πρεσβυτέρους κατὰ τὸ ξυγγενὲς ἐπὶ πολὺ αὕτη ἡ σκευὴ κατέσχεν. Based on earlier scholarly views, Gomme speculated that Thoukydides may be wrong on this last point. However, it is not hard to question the validity of Gomme's idea by focusing on the broader Athenian ideological implications of Thoukydides' claim (see also Geddes 1987:307n6).

[275] Cf. Aristophanes *Knights* 1331 ὅδ' ἐκεῖνος ὁρᾶν τεττιγοφόρας, ἀρχαίῳ σχήματι λαμπρός (referring to the Athens of the days of Marathon) and *Clouds* 984 ἀρχαῖά γε ... καὶ τεττίγων ἀνάμεστα. Cf. Herakleides Pontikos fr. 55 Wehrli (ap. Athenaios 12. 512a–c) and Gomme 1945:101, who also quotes Loukianos *Ship or Wishes* 3 (Loukianos refers to Thoukydides' passage) and Eustathios *Iliad* 13.689, vol. 3, 537 van der Valk (Gomme 1945:102 and 106, respectively), comments on the association of this Athenian luxury fashion described by Thoukydides and Aristophanes with the celebrated Marathonomakhai (see, e.g., *Clouds* 985–86 ἀλλ' οὖν ταῦτ' ἐστὶν ἐκεῖνα, | ἐξ ὧν ἄνδρας Μαραθωνομάχας ἡμὴ παίδευσις ἔθρεψεν, following line 984 quoted above).

[276] Hornblower 1991:26. Asios fr. 13.5 Bernabé also refers to golden cricket brooches that the Samians wore. The date of Asios is not certain (see n. 270 above). Bernabé's transposition of lines 4 and 5 is not necessary (cf. O' Sullivan's hypothesis [O' Sullivan 1981] based on a 1817 proposal by A. F. Naeke). For the meaning of κορύμβη in Asios, see Gomme 1945:103–104 and Bowra 1970b.

[277] The studies on Athenian autochthony are numerous: see Parker 1987 (with references to earlier discussions) and Rosivach 1987 (somewhat optimistic); cf. also Hornblower 1991:12–13.

[278] For late fifth-century (424 onwards BC) sources, see n. 275 above.

tenances sixth-century Athenian aristocrats sported and especially how they thought about the origins of their self-defining dress. The possibility that some aristocratic vestmental accoutrements originating in the East had been assimilated into more "indigenous" (in the eyes of the Athenians) aristocratic clothing cannot be underestimated, especially when our reconstructions of archaic elitist lifestyle [*habrosunê*] as an overall cultural phenomenon in diverse *poleis* of archaic Greece can assume overgeneralized dimensions.

The "elaborately dressed revelers" should be seen in a wider context. The attire fashion displayed by the komasts is certainly more marked than anything else we see on other vase-paintings or on sculpture of the period. In some late sixth-century painted pots we see *mitra*-wearing, lightly clad bearded symposiasts reclining "outdoors" with other, ivy-wreathed companions or turbaned but naked and boisterous bearded revelers getting excessively drunk.[279] However, the combination of all the diverse accoutrements and articles of clothing of the elaborately dressed komasts points, I suggest, to their pictorially exaggerated "performance" of diverse cultural discourses about Eastern exoticism. Especially in the case of vase-painters, playful, inventive, and experimental as they often were with symposiastic and komastic images,[280] it would be simplistic and methodologically vulnerable to take pictures like the "elaborately dressed revelers" as documents of a specific reality or political-cultural ideology that corresponded to a specific Athenian reality.

First, this series of images with turbaned and chitoned bearded figures (accompanied sometimes by female figures—dancers, musicians, or parasol bearers) is, I argue, semantically not as homogeneous as it may at first appear. The Rhodes black-figure amphora that stands at the beginning of the whole

---

[279] Black-figure cup, Oxford 1974.344, dated to *c.* 520 BC (not known to Beazley): Boardman 1976 (among the three turbaned symposiasts one is beardless); comparable is an outdoors symposiastic scene on the frieze around the tondo of a cup dated to c. 520 BC (Essen A 169: Froning 1982:151–155; however, the symposiasts here do not wear mitra). Thanks to Alan Shapiro for drawing my attention to the latter vase. Boisterous revelers getting drunk: black-figure *oinochoe* signed by Kleisophos as painter and Xenokles as potter, Athens, National Archaeological Museum 1045, dated to *c.* 530 BC (*ABV* 186; *Add.* 51). For other related, contemporary vase-paintings, cf. Miller 1999:232n28.

[280] See Mitchell 2004 (with earlier bibliography; especially on her page 4, notes 3 and 4). See also Lissarrague 1998 and Cohen and Shapiro 2002. Neer (2002:23) admits that "it is entirely unjustified to assume that vase-painters would have shared the views of their clients. Rather, it is one of the chief dramas of vase-painting that it should be a site of negotiation between elites and artisans." On the serious problems involved in the often suggested relationship between craftsmen and elites, see Stissi 1999:88–89. Exclusive emphasis on the idea that almost all vases were intended for symposia—a concept that currently has a significant impact on classicists, who apply it to all vases—is misleading.

Figure 14. White-ground *kyathos*: bearded male figure with *barbitos*. Attributed to a contemporary of Psiax, *c.* 520–510 BC. Malibu, J. Paul Getty Museum, Villa Collection, inv. no. 77.AE.102. Photo, The J. Paul Getty Museum.

series as a forerunner depicts two naked youths with a *phorminx* and a drinking horn, respectively, along with a turbaned man wearing a sleeveless *chiton* and boots. This man, also holding a drinking horn, stands behind the muscular naked youth who occupies the center of the image. The man's position cannot be compared to that of later elaborately dressed komasts who "perform" their stroll often holding *barbitoi* and parasols.[281] Some two decades later a white-ground *kyathos* shows a turbaned man wearing a short, tight *chiton* with short sleeves (no *himation*) and holding a *barbitos* (Fig. 14).[282] This musician is not in the company of other male figures but is framed by two large eyes; behind each eye a cock is looking in the opposite direction, toward the handle of the *kyathos*. The male figure might be viewed as a singer/poet and not necessarily as a reveler. An elegantly moving, turbaned dancer holding as accessories an elaborate *barbitos* and a *kylix* is depicted on a white-ground plate by Psiax (dated to *c.* 510 BC).[283] This "komast," if we can call him so, dances to the music of a similarly stylish but motionless female piper (Fig. 15). These three black-figure pots, along with a red-figure *kalpis* with a dressed reclining symposiast and a lightly clad youth,[284] stand at the beginning of the series. The series of

---

[281] Rhodes, Archaeological Museum 12.200; *ABV* 115.3, dated to *c.* 540–530 BC; Boardman 1986:47, no. 1 and figs. 10a–b.

[282] Malibu, J. Paul Getty Museum 77.AE.102 and 78.AE.5, dated to *c.* 520–510 BC; Boardman 1986:47, no. 2 and figs. 11 and 1a–d.

[283] Basel, Antikenmuseum, Käppeli 421; *ABV* 294.21; Boardman 1986:47, no. 3 and fig. 9.

[284] Kassel, Hessisches Landesmuseum A Lg 57; Boardman 1986:47–48, no. 4 and fig. 12.

Figure 15. Black-figure plate: bearded reveler with female piper. Attributed to Psiax, *c.* 510 BC. Basel, Antikenmuseum, inv. no. Ka421. Photo, Andreas F. Voegelin, courtesy of the Antikenmuseum Basel und Sammlung Ludwig.

vases with the elaborately dressed komasts begins essentially in *c.* 500 BC, with an image on the Kleophrades Painter fragmentary *kalyx-krater* associating the strolling revelers with Anakreon. I shall focus here on certain cases and point to special semantic features rather than discussing the whole series.[285]

[285] However, I should point out that pictorial variations of setting or combinations of diverse elements and human figures (women or youths) raise the possibility that different vases in the same "series" were understood and "contextualized" in a different manner by contemporary viewers during the sixty or so years that such images were produced. To give an example: a pair of white-ground lekythoi (Paris, Musée du Petit Palais 336 and 335; *ARV* 305.1–2; Miller 1999: 238, figs. 18–19) dated to *c.* 500–480 BC, found in the same tomb, and painted by the same painter, show, respectively, an "elaborately dressed komast" and a woman dressed identically (cf. Miller 1999:240). The woman on the second *lekythos* holds a mirror not far from her face.

133

In the fragmentary image of the Kleophrades Painter, the komast with the bushy beard carries a parasol over his shoulder, for the first time in the series. Significantly, apart from its appearance in the hands of the elaborately dressed revelers, the parasol was associated with women in late-sixth- and fifth-century vase-paintings.[286] Unless we speculate that it was an element of the dress of those Athenian aristocrats who, as the argument goes, had adopted an East Greek or Lydian luxurious lifestyle, the use of parasol probably belongs to the sphere of pictorial imagination and inventiveness. On a number of these vases, the emphatic combination, or sometimes sheer accumulation, of diverse vestment elements of Eastern origin points to an attempt at stressing the exotic rather than the "real." In certain cases, as in a red-figure cup by the Briseis Painter and in a red-figure column-*krater* by the Pig Painter,[287] even *krotala* are added, an element that may have accentuated the construction of the marked "other," since they were a primarily female instrument (Fig. 16).[288] Although it has been proposed that some of the komasts' accoutrements might have been perceived synchronically as *potentially* or even *primarily* feminine,[289] it is mostly the invariable emphasis on the revelers' long, bushy beards that foregrounds the contrast between elaborate daintiness and masculinity. It has been further argued that this contrast or ambivalence in the representation of the komasts constructs conceptual "realities," an otherness, attainable in the context of the *symposion* and the *kômos* and the implicit (omni)"presence" of Dionysos in both.[290] Even if we assume that late archaic viewers did not perceive any gender ambivalence in the images, the symposiastic context of many of them accommodated the construction of imaginary "realities"—repre-

---

The parallelism evident in their garb, already around 500–480 BC, must have been a prominent element for their "interpretation" by contemporary viewers.

[286] Miller 1992 and 1997:193–198. Cf. above, n. 246.

[287] See also nos. 11, 23, 34 in Boardman 1986:48–49.

[288] Cf. Paquette 1984:205 and 209; Price 1990:144 and n32; Delavaud-Roux 1995:243. In visual representations, *krotala* are occasionally used by male figures like satyrs, naked and semi-naked komasts, and ephebes (cf. Delavaud-Roux 1995:243n22). Another name for *krotala* was *krembala*. Note also that in the late fourth century BC, Dikaiarkhos in his *Life of Greece* reported (fr. 60 Wehrli) that they were once extremely (ποτὲ καθ' ὑπερβολήν) popular in women's dances and songs.

[289] In some cases, the *sakkos*, often worn by women, replaces the mitra. Boardman 1986:65 notes that "it is likely enough that the feminine aspect became or even sought after, especially once the sakkos was adopted." From a literary point of view, Kurke sweepingly denies any synchronic feminine associations for the komasts (but see Miller's iconographical counterargument [Miller 1999:235n38]). Frontisi-Ducroux and Lissarrague 1990 stress the ambivalence in the representation of the revelers in the light of a male symposiastic interplay between the self and other. Miller 1999 finds a number of female features in their dress and appurtenances.

[290] See Frontisi-Ducroux and Lissarrague 1990.

Figure 16. Red-figure *pelike*: obverse *(left)*, elaborately dressed reveler with *barbitos*, female figure with *krotala*; reverse *(right)*, elaborately dressed revelers. Attributed to the Pig Painter, *c.* 475 BC. Rhodes, Archaeological Museum, inv. no. 13.129. Photo, Archaeological Museum of Rhodes.

sentations of Athenian cultural imaginings that should not be confused with actualities.

Such pictorial constructs are evident in the exaggerated accumulation of appurtenances in a number of the vases in the series, a fact that has led modern scholars to detect in the komasts even elements of ritual transvestism.[291] As soon as the exaggerated and accumulative display of luxurious accoutrements and Eastern clothing is recognized, we do not need to resort to interpretations that see behind the images realities or *specific* elite ideologies corresponding to such realities. In other words, bearded komasts garbed so elaborately and sometimes dancing to the sound of *barbitoi, auloi,* or *kithara* represented, I suggest, Athenian imaginings of the inhabitants of diverse Eastern lands (East Greeks, Lydians, and Persians) conflated as a single representative visual schema.[292] Further, being in interaction with other related

[291] For a critique of this view, see Neer 2002:222n84. See also n. 250 above.
[292] For example, as an Eastern headgear reflecting a broader Anatolian *koinê*, the turban ("perhaps [the] single most striking feature" [of the elaborately dressed komasts], Boardman 1986:50), "is well attested from India to Lydia, and in the period that we are studying, it is best shown on the Achaemenid monuments showing subject peoples" (Boardman 1986:51). For the use of parasol in the ancient Near East and Persia, see Miller 1992:93–95. Miller 1991:63–65 (with

configurations,[293] this visual schema is part of a broader idealized cognitive model in the representation of Eastern exotics and neighbors in late archaic Athens. Significantly, these images convey a broad range of exotic and cultural inflections and promote a kind of Panhellenic music culture, centered on Athens. The experimentation of vase-painters in rendering "foreignness" by drawing from a common pool of material and by combining diverse ethnic elements in clothing and accoutrements is documented in other cases.[294] The painted pots under consideration do not attest to changes in the komastic life of the Athenians of the late archaic and early classical periods, nor do they portray the possible *lydopatheia* of archaic Greek elites in its apparent grandeur. Rather, I argue, they capture instances of Athenian popular conceptual

---

bibliography on her pp. 73–74, n25) discusses the numerous problems in distinguishing foreigners (e.g. Scythians or Persians) in Attic painted pots of the late archaic and early classical periods. I should stress that individual garb and headgear styles linked with specific Western/Eastern Anatolian and Persian peoples are sometimes hard to distinguish in Attic vase-paintings. Apart from the fact that we cannot expect vase-painters to record faithfully the vestment elements of each people and to not experiment and blur the boundaries in the least, "from the second quarter to the end of the sixth century," for example, in Attic vase-paintings "the Phrygians ... are shown simply as if they were Greeks." In the fifth century, especially its second half, Phrygians are shown garbed in "Persian-type dress or at least what the vase-painters imagined such dress to be" (De Vries 2000:348 and 349, respectively). That the Persians associated the turban-like headdress with the Lydians (as De Vries 2000:359 argues) does not entail that late archaic and early classical Greek vase-painters and viewers did so too, since such a type of headgear was also worn by, e.g., East Greeks. I do not agree with De Vries's tentative identification of the drunken komasts in Athens National Archaeological Museum 1045 (see n. 279 above) with Lydians (De Vries 2000:360–363). This scholarly tendency to interpret Athenian vase-paintings as reflecting specific ancient (Athenian or foreign) realities is also evident in De Vries's discussion of the early-fifth-century Apadana reliefs in Persepolis (De Vries 1973): the identification of the "Lydian" subject delegation (men wearing an Eastern headdress, *chiton*, and *himation*) is based on the observation that on the façade reliefs on the tombs of the Persian kings at Naqsh-i Rustam the subject peoples of the Persian empire are labeled with the name of their ethnic group, and in the representation of at least one of the labeled Lydians, wearing only a short *chiton*, a short cloak, but no headdress, the Lydian has a braid coming down behind his ear. Since on the Apadana relief with the long-robed male figures wearing an Eastern headdress, these unidentified men have a long braid coming down behind their ears, they should, as the reasoning goes, be identified with the labeled Lydians of the façade reliefs on the tomb of a Persian king (for photographs of the reliefs see De Vries 1973:35, fig. 3 and 36, fig. 1). Although this is an attractive identification, it remains tentative and does not result in a secure identification of the specific "ethnic origins" of the garb, headdress, and other appurtenances of the "elaborately dressed komasts."

[293] See n. 279 above, for cases of the *mitra* also worn by lightly clad symposiasts or naked komasts. For the construction of the internal and external other in ancient Greek art, see, more recently, Cohen 2000.

[294] Regarding depictions of Amazons, see Shapiro 1983b:107 (and cf. 111) for the "conflation of two (or more) races which many Amazon vases share," that is, Thracian and Scythian.

Figure 17. Red-figure cup: tondo, elaborately dressed reveler with stick. Attributed to the Brygos Painter, *c.* 480–470 BC. Brussels, Musées Royaux d'Art et d'Histoire, inv. no. R332. Photo, Musées Royaux d'Art et d'Histoire, Brussels.

filters through which Eastern exoticism is represented—striding forward,[295] dancing,[296] or simply swaying to the music of strings and *krotala*. Such an exaggerated version of Eastern exoticism in Attic vase-paintings could be contrasted or juxtaposed to a sixth-century and early-fifth-century Athenian aristocratic lifestyle, and accordingly perceived—in positive, humorous, negative, or ambivalent terms—by viewers of diverse political takes.

However, were the diverse configurations of this visual schema conceived of or "read" in a one-dimensional manner by ancient Athenians in the span of some sixty years? Were all the revelers of this series—some in groups carrying parasols and *krotala*, others portrayed as lone dressed figures playing the *barbitos*—viewed in the light of a clearly defined and unified schema? Espe-

[295] In a red-figure cup by the Brygos Painter (Brussels, Musées Royaux R332; *ARV* 380.169; see Fig. 17), a komast wearing a broad tied headcloth (not a turban-like headgear) strides forward. His walking stick is floating in the background, only a small step far from the reach of his left hand. His face is frontal, looking at the viewer, but the almost tipsy posture of his head would evoke humorous overtones.

[296] In a red-figure cup by Oedipus Painter (German private collection: see Hornbostel and Stege 1986: 111–114, no. 53; Miller 1999:233, fig. 12), dated to *c.* 470 BC, the elaborately dressed revelers indulge in perhaps the most lively dancing in the whole series. Cf. the Psiax white-ground plate above, and the Kleophrades Painter fragmentary *kalyx-krater*, on which, as Beazley (1954:57) rightly remarks, one of the revelers dances "kicking up one foot behind."

cially in more recent debate, the whole series has been considered as a fixed semantic unit allegedly interpreted in the late sixth and the first half of the fifth century in an always *specific* and *consistent* way. Could other semantic elements have been assimilated into the idealized cognitive model of "exotic, elaborately dressed Easterner"?

As we have seen, two images associate Anakreon with bearded figures dressed in flowing *chiton* and *himation* and playing the *barbitos*. On the Gales Painter red-figure *lekythos* in Syracuse, the head of the represented poet is damaged, but it seems that he was wearing a fillet and a wreath.[297] The fact that Anakreon is accompanied by two naked youths with only cloaks thrown over their shoulders does not disqualify this image from being considered in the context of "the elaborately dressed komasts." Beardless young komasts, with or without *himatia*, are not infrequently juxtaposed with bearded "elaborately dressed revelers."[298] Whether or not the Gales Painter *lekythos* is to be included in the gradually expanding "corpus" of images with elaborately dressed komasts,[299] it is certain that it is at least associated with this broader iconologic pattern. As such, it can be examined mainly within this visual framework.

At the same time, I should draw attention to the fact that other elaborately dressed komasts are shown alone holding or performing with a *barbitos*.[300] Since both in the Gales Painter *lekythos* and in the Kleophrades Painter *kalyx-krater* in Copenhagen, a dressed komast with a *barbitos* is associated with the name of Anakreon, it is tempting to argue that vase-paintings of this kind

[297] See Beazley 1954:61, who reported that Anakreon wears a wreath, a fillet, and perhaps shoes, and that he once detected a *sakkos* on the poet's head, despite the fact that he was not certain whether he would wish to defend this early observation of his, since the head was damaged. Cf. Schefold 1997:76.

[298] For a collection of all the relevant painted pots, see Miller (1999: 237–239).

[299] The only reason to exclude it is the lack of headgear. See, however, n. 298 above, and cf. Berlin F 2351, a red-figure neck-amphora (Greifenhagen 1976:figs. 19–22; Boardman 1986:49, no. 25) on which an "elaborately dressed komast" is depicted wearing only a (not broad) band that does not cover his hair, but is tied around his head. Cf. also Paris, Louvre G 220; *ARV* 280.11; Boardman 1986:54, figs.15a, a red-figure amphora with an apparently balding, elaborately garbed komast wearing a tied headcloth. As I have argued, the whole series, with all the additions proposed by Boardman (1986) and Miller (1999), is not fully homogeneous. See, for example, the Tampa red-figure stamnos published by Miller (1999:224, fig. 1, 226–227, figs. 6–7) and included in the series, or the Dresden red-figure *pelike* included in Boardman 1986:50, no. 43 and considered problematic by Miller 1999:237n44. Such interesting variations are evident in other vases of the series.

[300] E.g., white-ground *kyathos*, Malibu, J. Paul Getty 77.AE.102 and 78.AE.5; Boardman 1986:36, fig. 1a–d. Red-figure *lekythos*, Boston, Museum of Fine Arts 13.199, *ARV* 588.73; Boardman 1975:fig. 334. Red-figure amphora, Paris, Louvre G 220; *ARV* 280.11; Boardman 1986:54, figs.15a–b (on the reverse we see an elaborately dressed komast with a parasol). See, further, red-figure column-*krater* Cambridge, MA, Sackler Museum 1959.125; *ARV* 566.3; see Fig. 18.

Figure 18. Red-figure column *krater*: obverse, elaborately dressed reveler with *barbitos*. Attributed to the Pig Painter, *c.* 475 BC. Cambridge, MA, Harvard University Art Museums, Arthur M. Sackler Museum, Bequest of David M. Robinson, inv. no. 1959.125. Photo, Imaging Department, © President and Fellows of Harvard College.

gradually initiated a close association of East Greek poets with the exaggerated fashion displayed by the "elaborately dressed komasts." Such images marked, I suggest, the invention of the cultural schema of "the elaborately dressed East Greek poets" in the minds of the Athenians of the late archaic and early classical eras. At a later period, Aristophanes portrayed Anakreon as one of those earlier poets, like Alkaios and Ibykos, who composed juicy music and used to wear particular headdresses and to move in Ionian fashion. As the Aristophanic version of the poet Agathon explains in the *Thesmophoriazousai* (159–163), it is inappropriate for a *poiêtês* to look shaggy and boorish:

σκέψαι δ' ὅτι
Ἴβυκος ἐκεῖνος κἀνακρέων ὁ Τήιος
κἀλκαῖος, οἵπερ ἁρμονίαν ἐχύμισαν,
ἐμιτροφόρουν τε καὶ διεκλῶντ' Ἰωνικῶς.[301]

think that
the renowned Ibykos and Anakreon of Teos
and Alkaios—composers who put some flavor into music—
used to wear headgears and mince in Ionian style.[302]

Agathon himself in the *Thesmophoriazousai* (137-139, 250-262) is "appropriately" depicted as adopting stylish manners similar to those of the old poet Anakreon: his poetic accoutrements include a *barbitos*, a girded elaborate *chiton*, a *himation* and shoes, a hairnet (*kekruphalos*) and a headdress (*mitra*).[303] The audience of Aristophanes' comedy did not need to be familiar with the elaborate garb of the Anakreon figures of the vase-paintings in order to understand the humorous effect of Agathon's stylish clothing.[304] The image of East Greek poets as elaborately dressed komasts had been firmly established in the horizons of expectations of the late-fifth-century Athenians despite the fact that the older representations had been forgotten. The cultural type of the aesthete East Greek poet could be applied, I argue, to any aesthete contemporary composer, especially the "New Music" practitioners and followers. And as in depictions of lone dressed komasts playing the distinctive long-armed lyre the parasol is absent, so Agathon, an avant-garde musician, appears on the Athenian stage singing with his *barbitos* both the solo and the choral parts of an elaborate, refined composition.

## Metonymic Webs of Signification

The assimilation of the figure of Anakreon into idealized cognitive models is parallel to the pictorial versions of the Athenian contextualization of the songs and the figure of Sappho. These versions indicate that Sappho was assimilated into different sociocultural discourses in the context of the performative transmission of her poetry. Given the hegemonizing male mentalities of Athenian society, Sappho's songs—products of a woman poet which had

[301] Alkaios, Ibykos, and Anakreon are listed together again in Schol. Pindar *Isthmian* 2.1b (iii 213 Drachmann), where reference is made to their common thematic attention to παιδικά.

[302] For this interpretation of the verb διακλῶμαι, see Sommerstein 1994:169.

[303] For the parallelism between Beazley's "Anakreontic" vases and Aristophanes' Agathon, see Snyder 1974. Cf. Webster 1972:55.

[304] So, apparently, Snyder 1974:246.

140

excited the interest of symposiasts and other Athenians—must have given rise to a great variety of interpretations. The highly marked figure of that Eastern female poet was subjected to a variety of naturalizing processes of *vraisemblance* or mythopractical associations. The multilayeredness of such receptorial practices—at times habitually enacted, at other times originating from and performed by localized discursive agencies—contributed to the trafficability of the image of Sappho in terms of a polyvalent socioaesthetic coinage. The value of her figure and poetry was thus constructed and assessed according to the different symbolic capitals privileged in specific discursive contexts.

The performance of Sappho's compositions in male symposia, and all that this entailed, was only one of the elements that shaped the early reception of her figure in Athens. I suggest that Anakreon and his songs, as well as their Athenian reception, further contributed to the broader discourses that informed the reception of Sappho. If we attempt to view her late-sixth- and early-fifth-century reception in a wider cultural context, at least one aspect of Anakreon's poetry requires particular consideration.

In his songs, Anakreon often presented sketches of certain types of people, sometimes named, other times unnamed in the extant fragments, the most well-known being a song about Artemon (fragment 388 *PMG*):

πρὶν μὲν ἔχων βερβέριον, καλύμματ' ἐσφηκωμένα,
καὶ ξυλίνους ἀστραγάλους ἐν ὠσὶ καὶ ψιλὸν περὶ
πλευρῆισι <-᷉-> βοός,                                                        3
νήπλυτον εἴλυμα κακῆς ἀσπίδος, ἀρτοπώλισιν
κἀθελοπόρνοισιν ὁμιλέων ὁ πονηρὸς Ἀρτέμων,
κίβδηλον εὑρίσκων βίον,                                                    6
πολλὰ μὲν ἐν δουρὶ τιθεὶς αὐχένα, πολλὰ δ' ἐν τροχῶι,
πολλὰ δὲ νῶτον σκυτίνηι μάστιγι θωμιχθείς, κόμην
πώγονά τ' ἐκτετιλμένος·                                                     9
νῦν δ' ἐπιβαίνει σατινέων χρύσεα φορέων καθέρματα
†παῖς Κύκης† καὶ σκιαδίσκην ἐλεφαντίνην φορεῖ
γυναιξὶν αὔτως <-᷉->                                                        12

In the old days he used to cover his hair with a wasped cap,[305] and to wear wooden dice in his ears, and round his ribs
a hairless ox-hide—
the unwashed covering of a poor shield—

---

[305] Note that the meaning of some words and expressions in this fragment is uncertain. For the problems involved, see Brown's concise discussion (1983:11–14).

that rascal Artemon, mixing with bread-selling women and
willing whores, seeking a living of fraud;
his neck was often in the stocks, often on the wheel,
his back often flogged with a leather lash,
and the hair of his head and his beard plucked out.
But nowadays he, the child of Kyke [?], rides in (ladies') carriages
wearing golden earrings and carries an ivory parasol
like women.

Artemon's previous way of life, fraught with poverty and fraud, is juxtaposed
to his current luxuries and riches: comfortable carriages, gold earrings, and
parasols—a combination of signs displaying effeminacy. The contrast between
the two lifestyles of Artemon is underscored by the way he is named in the
respective sections of the song: ὁ πονηρὸς Ἀρτέμων in line 5 and "the child
of Kyke," a reference to the name of his mother, and not of his father, in line
11.[306] Anakreon's songs about the nouveau riche Artemon became popular in
fifth-century Athens, and the phrases ὁ περιφόρητος Ἀρτέμων (fr. 372.2 *PMG*)
and ὁ πονηρὸς Ἀρτέμων seemed applicable to other cases.[307] Further, in frag-
ment 387 *PMG*, a story about a perfumer or a lyre-maker seems to have been
recounted in ambivalent or ironic manner, while in fragment 394b *PMG* one
bald Alexis was depicted as going wooing "once again" (δηῦτε); in other songs,
courtesans must have been similarly treated (fr. 347.11–18 *PMG*).[308]

Such songs provided Athenian symposiasts and other audiences with
images of specific social types and stereotypes.[309] Viewed in this light, a short
composition by Anakreon about a girl from Lesbos would have represented
an insider's East Greek perspective about "that island" (fr. 358 *PMG*). The song
relates an intriguing episode in which the performing "I," depicting himself
as white-haired, is invited by Eros to sport with a girl, who will eventually re-

---

[306] Cf. Brown 1983:14–15.

[307] In Anakreon fr. 372 *PMG*, quoted by Athenaios (12.533e–f) in the same context along with fr. 388
*PMG*, ὁ πονηρός Artemon is described as ὁ περιφόρητος Ἀρτέμων ("the notorious Artemon,"
or literally, "the litter-borne Artemon"; for the epithet περιφόρητος, cf. Gentili 1958:10 and
see Zenobios Ath. I 64 Miller, quoted in Diphilos fr. 35 K-A). In Aristophanes (*Akharnians* 850)
the comic poet Kratinos is called ὁ περιπόνηρος Ἀρτέμων. Later, Diphilos will also exploit the
expression ὁ περιφόρητος Ἀρτέμων in his *Emporos* (fr. 35 K-A). The phrase became proverbial:
the sources are collected in Anakreon fr. 372 *PMG* and Anakreon fr. 8 Gentili (Gentili 1958:9).

[308] Brown (1983:4) discusses fragments related to a possibly satiric portrayal of diverse types by
Anakreon.

[309] Compare also Anakreon fr. 426 *PMG* πάλαι ποτ' ἦσαν ἄλκιμοι Μιλήσιοι (and see Aristophanes
*Wealth* 1002 and 1075, Scholia on Aristophanes *Wealth* 1075, Timokreon fr. 733 *PMG* and
Timokreon fr. 7 W, Aristotle fr. 557 Rose, Demon *FGrH* 327 F 16, and Page's *apparatus fontium* in
Anakreon fr. 426 *PMG*).

ject him, because she gives her full attention elsewhere. I shall return to this song and its reception in the late fourth century in Chapters Three and Four. In the context of the present discussion, suffice it to observe that, despite the interpretive problems related to the final line of the fragment (πρὸς δ' ἄλλην τινὰ χάσκει, "she gapes at another" [girl? a young man?]), it seems certain that such a song would contribute to the creation of certain stereotypes about "girls from Lesbos." The emphatic position of ἐστὶν γὰρ ἀπ' εὐκτίτου Λέσβου ("for she is from well-built Lesbos") and the Lesbian lass' preference to "gape at" other things suggest that she was represented in this song as a "distinctive" case. In a spirit perhaps comparable to the modern English ditty "we don't like the girls from Birmingham, 'cause we know some things concerning th'm," Anakreon's composition was playfully conducive to the circulation of ideas about late-sixth-century young women from Lesbos. Be that as it may, what is of interest for us here is that the performance of a song like this in Athens[310] might have shaped some of the conceptual filters through which the images of Sappho painted on symposiastic vases were "contextualized" by contemporary viewers. The parallel singing of poems of Anakreon and Sappho in *symposia* and related venues had some impact on the way the visual representations of Sappho were understood, and these representations, in turn, reinforced the contemporary male perceptions of Sappho's songs.

## Recitals among Women

In the second half of the fifth century, changes in the themes that decorated Attic pottery are evident: of particular significance for my discussion here is that a heightened focus on representations of women by painters led to a marked increase of scenes with large or small groups of women in a domestic context. This emphasis on images of women in vase-painting was symptomatic of an overall contemporary social dynamic, especially hard to reconstruct in its multilayered texture—given the polyvalent character of visual representations, as well as the paucity and hegemonic male focus of literary sources.[311]

---

[310] The song seems to have been popular: in the late fourth century it was especially discussed by the Peripatetic writer Khamaileon and, as he tells us, "by others." Khamaileon, like others, was probably attracted to the idea that it was actually addressed to Sappho.

[311] The analyses and reconstructions of this change in emphasis are numerous and almost no scholarly consensus exists on what social factors contributed to it: see n. 312 below and Lewis 2002: 130–138. I agree with Osborne 1997 (who views the change in terms of "women's newly important place in citizen ideology"; 1997:4) and Lewis 2002 (who examines issues related to market and provenance) that the issue is more complex than has often been assumed.

As opposed to the sixth century BC, from about the mid-fifth century onward, women dominate the representations that commemorate the dead on Athenian funerary monuments and on white-ground *lekythoi*.[312] In this context of intense proliferation of vase-paintings depicting women adorning themselves or playing music with other women in domestic settings, a scene with four female figures—one reading from a scroll, another holding a lyre, and two standing around them—would have seemed common to contemporary ancient viewers.

Already in about 460 BC, representations of groups of women engaged in musical performance and in reading from scrolls in domestic interiors are favored by the Niobid Painter. Most often in depictions of such female gatherings, a seated woman playing an instrument or about to start her performance constitutes the central focus of the image; other women holding instruments, scrolls, or boxes stand around the seated figure, representing her audience or gazing at her.[313] On the obverse of an amphora attributed to the Niobid Painter and dated to about 460–450 BC,[314] a woman touching the strings of her *barbitos* is shown seated in right profile in the center of the composition, while another woman just holding reed pipes stands in front of her (Fig. 19). A *chelys* lyre is suspended over the seated figure. A third woman opening the lid of the chest that she carries on her left hand stands behind the *klismos* of the seated musician. A similar but slightly more marked representation of three women gathered to perform music appears on a *hydria* attributed to the Niobid Painter and dated to about the same decade (Fig. 20).[315] This time the chair of a frontally seated musician stands on a stepped *bêma*, a dais located in the center of an interior space, not far from an open door at the left of the whole composition. Near this door stands a woman who holds out an open book roll so that the seated woman on the *bêma* may be able to read from it. On the *bêma*, we see a chest with open lid, an indication, in this and other images, of imminent

---

[312] Osborne 1997 has associated this gradual change with Perikles' citizenship law of 451/450 BC, according to which citizenship was limited to those persons whose father *and* mother were Athenian. For this law and changes in wedding imagery in Athens during the fifth century, see Sutton 1992:24. For the increase of the so-called *gynaikonitis* scenes on Attic vases of the later fifth century, see, more recently, Lewis 2002:130–171 (for diverse interpretations of this change, see Lewis 2002:130–132); for statistics (with references to shapes and provenances) of the very large number of vase-paintings depicting women alone in the fifth century, see Webster 1972:226–228 and 241–243.

[313] For some of these images, see the discussion by Goulaki Voutira 1991 and Kauffmann-Samara 1997. Snyder 1998:167 provides a very brief account. For an archaeological examination of *mousikai gunaikes* on Attic vase-paintings, see Vazaki 2003.

[314] Baltimore, Walters Art Gallery 48.2712.

[315] New York, Solow Art and Architecture Foundation.

Figure 19. Red-figure amphora: obverse, seated woman with *barbitos*, woman with reed pipes, woman with chest. Attributed to the Niobid Painter, *c.* 460–450 BC. Baltimore, MD, Walters Art Museum, inv. no. 48.2712. Photo, The Walters Art Museum.

Figure 20. Red-figure *hydria*: three women, one seated with *barbitos*, one with scroll, one with lyre and chest. Attributed to the Niobid Painter, *c.* 460–450 BC. New York, Solow Art and Architecture Foundation. Photo courtesy of the Solow Art and Architecture Foundation.

Figure 21. Red-figure *hydria*: seated female figure with book roll, three female figures. In the manner of the Niobid Painter, *c.* 440 BC. London, British Museum, inv. no. E 190. Photo © Copyright, Trustees of the British Museum.

performance or recitation. On the right of the seated instrumentalist stands a third woman holding a *chelys* lyre and another chest. Finally, on a *hydria* in the manner of the Niobid Painter and dated to about 440 BC (Fig. 21),[316] the woman seated in right profile does not play or tune a lyre; instead, she recites from a book roll she holds, in the company of three other female figures: one stands behind her while the other two women in front of her hold a chest and a flower, respectively.

Against these almost contemporary pictorial scenes, *especially* the last one, the fourth vase-painting depicting Sappho (identified by inscription) and dated to *c.* 440–430 BC presents a strikingly similar composition (Fig. 22): Sappho is seated on a *klismos* reading from a book roll; a woman stands behind her; two other female figures stand in front of "Sappho," the first one holding a lyre. This red-figure *hydria* in the National Archaeological Museum, Athens,

[316] London, British Museum E 190; *ARV* 611.36; *Add.* 268.

Figure 22. Red-figure *hydria*: Sappho, seated, with three female figures. Attributed to the Group of Polygnotos, *c.* 440–430 BC. Athens, National Archaeological Museum, inv. no. 1260. Photo, courtesy of the Hellenic Ministry of Culture / Archaeological Receipts Fund.

is attributed to the Group of Polygnotos, vase-painters whose style is closely related to that of the Niobid Painter.[317] For the purpose of this discussion, it is noteworthy that, influenced by the Niobid Painter and his circle, the Polygnotans decorated a large number of *hydriai* with scenes of female gatherings[318] where musical performance is often but not always the pivotal element. At some of them, the seated woman in the center can hold a wreath or a box[319] instead of a *chelys* lyre, a *barbitos*, or an *aulos*; she can be juggling with balls or looking at a mirror.[320] The other women flanking the central figure carry elegant boxes, book rolls, lyres, *auloi*, or, in at least one case,[321] an *aulos* bag. Among the women, a winged Eros can also appear, occasionally holding a wreath and flying over the head of the seated figure (Fig. 23).[322] Even small ensembles of two seated women playing stringed instruments are depicted.[323] Sometimes a wreath hangs in the field above the central, seated musician (Fig. 24, center).[324]

[317] Athens, National Archaeological Museum 1260; *ARV* 1060.145; *Add.* 323; Tzachou-Alexandri 1989: no. 201; Matheson 1995:174, pl. 149. For the influence of the Niobid Painter on Polygnotos and his Group, see Matheson 1995:3–37 and *passim*. The *hydria* was found in Vari, Attica.

[318] I here focus on *hydriai* attributed to this Group. More generally, a considerable number of domestic scenes with female musical gatherings appear on *hydriai*. Other vase shapes that accommodate such scenes during the same period include amphorae, *lekythoi, pyxides, pelikai, stamnoi, oinochoai, lebetes gamikoi,* as well as certain types of kraters. On the correlation of subject and shape in the case of *pelike*, see Shapiro 1997. A scene painted on a bell-*krater* in the manner of the Kleophon Painter, a younger member of the Group of Polygnotos, is similar in its basic composition to the Athens *hydria* with Sappho: four women, one frontally seated, another standing on the left, and two more holding an open book roll and a *chelys* lyre, respectively, on the right (Nocera dei Pagani, Fienga no inventory number; my Fig. 33). Following a long tradition in identifying women musicians as "Sappho"—a scholarly methodology that I have questioned in this chapter—Metzler (1987:76) argues that the anonymous, frontally seated woman is Sappho.

[319] E.g., London, British Museum E 188; *ARV* 1048.42; *Add.* 321; Miller 1997:fig. 135.

[320] Playing with balls: red-figure *hydria* (not known to Matheson 1995) Avignon, Musée Calvet 106A (Cavalier 1996:185, fig. 71), attributed to the Christie Painter by M. Corso (in Cavalier 1996:182–186); holding a mirror: red-figure *hydria* Dresden, Staatliche Kunstsammlungen, Albertinum 213617 (*ARV* 1049.48), attributed to the Christie Painter.

[321] Gotha, Schlossmuseum 53; *ARV* 1049.49; *Add.* 321; *CVA* Gotha, Schlossmuseum 2, 12, pl. 55.1–3.

[322] London, British Museum E 189; *ARV* 1060.147; my Fig. 23. On the *hydria* Athens, Kerameikos 2698 (Pöhlmann 1976:pl. 2; my Fig. 32) Eros stands in front of a seated female musician and plays the *aulos*. This *hydria*, almost contemporary with the *hydriai* considered here, has not been attributed to a vase-painter.

[323] London, British Museum 1921.7-10.2; *ARV* 1060.138; *Add.* 323; *CVA* London, British Museum 6, III.I.C.3, pl. 83. One woman plays the *chelys* lyre and the other the *barbitos*.

[324] Athens, National Archaeological Museum 17918; *Para.* 443; my Fig. 24. Note that the connotations of wreaths hanging in the background depend each time on the broader context of the image. Cf. also below, n. 347. I should like to thank Dr. Giorgos Kavvadias of the National Archaeological Museum, Athens, for sending me a detailed description of the representation on the red-figure *hydria*, Athens, NAM 17918.

Figure 23. Red-figure *hydria*: four women, one seated with lyre, others standing around her, Eros flying above. Attributed to the Group of Polygnotos, *c.* 440–430 BC. London, British Museum, inv. no. E 189. Photo © Copyright, Trustees of the British Museum.

The Athens *hydria* is part of a large corpus of images with groups of women performing and reading book rolls in a domestic interior. That behind this corpus of images lies an idealized cognitive model—a cultural category associated with female gatherings, poetry recitations, and musicianship—is beyond doubt. The problem is that, as often with Attic vase-paintings, the "social status" ideologies (respectable citizen women or educated *hetairai*?) that we distinguish with regard to these domestic scenes seem schematic.

Even recently, Jennifer Neils has argued that the three women on the *hydria* attributed to the Niobid Painter discussed at the beginning of this section are *hetairai* and that the whole setting must represent a brothel.[325] Because non-mythological vase-paintings have all too frequently been viewed as depictions of daily life, it has seemed impossible to accept that such domestic scenes might represent fifth-century "respectable" Athenian women, since, according to this argumentation, no literary sources attest to the existence of musical education for them. On the contrary, the reasoning goes, *hetairai* and women hired as musicians in *symposia* and related occasions were well versed in different aspects of *mousikê*.[326] This idea has been questioned by a

[325] New York, Solow Art and Architecture Foundation. See Neils 2000:225.
[326] Williams 1993 illustrates this approach.

Figure 24. Red-figure *hydria*: women, one seated with *barbitos*. Attributed to the Peleus Painter, *c.* 430 BC. Athens, National Archaeological Museum, inv. no. 17918. Photo courtesy of the Hellenic Ministry of Culture / Archaeological Receipts Fund.

number of scholars,[327] but its rearticulation by Neils suggests a still lasting impact. Nonetheless, there seems to be no reason to maintain that the female musicians in such domestic scenes are educated *hetairai*.[328] At the same time, I believe that these images do not highlight the "respectability" of the depicted female figures; rather, they explore the latter's idealized musicianship, in the broadest sense. The "social status" (elite? generally respectable? "professional"?) of these women remains a historicizing and tantalizingly elusive question, which the images seem not to ponder.

Especially in this group of representations—if "group" is the proper word—the boundaries between mortal women and Muses are sometimes fluid. Similar scenes of musical gatherings with names of Muses inscribed next to the figures they identify can be found on diverse vases. On a *hydria* attributed to the Peleus Painter, a Polygnotan craftsman, three female figures engaged in musical performance are identified with inscriptions: Terpsikhore, Kalliope, and Thaleia.[329] Two more female figures are unnamed. Kalliope is seated on a *klismos* in the center of the composition and plays a *barbitos*, while Thaleia, holding a *chelys* lyre in her right hand, stands in front of her. Apart from the use of inscriptions, the main criterion for identifying Muses in this kind of all-female musical gathering is the appearance of pictorial signs like a rock (on which a Muse may be seated) and plants, indicating an outdoor setting.[330] It is noteworthy that even an outdoor setting can be mixed with a domestic setting on the very same image, as is the case of a *kalyx-krater* attributed to the Niobid Painter and dated to about 460 BC.[331] On the obverse of this vase a female figure holding reed pipes is shown seated on a rock on the right, while two more women on the left stand near a *klismos* and gaze at her; a *chelys* lyre

---

[327] See, among others, Götte 1957:48, Bérard 1989:91, Sourvinou-Inwood 1991:96n122, 137n143, Matheson 1995:288–289. Cf. Lissarrague 1992b:207.

[328] Matheson 1995:289–290 adduces archaeological arguments against this idea and compares these scenes to similar depictions of female musicians in domestic interiors on white-ground funerary *lekythoi*.

[329] Musée du Petit Palais 308; *ARV* 1040.22; *Add.* 319; Maas and Snyder 1989:136, fig. 16.

[330] Some scholars believe that the superabundance of instruments carried by large female ensembles is a criterion for the identification of these women as Muses (see, e.g., Snyder 1998:169). However, on a red-figure cup dated to about 450 BC (Bologna, Museo Civico Archeologico PU 271; *ARV* 825.19; *Add.* 294; Castaldo 1993: fig. 103) a large ensemble of ten women musicians (five with *chelys* lyres, four with *auloi*, and one with *barbitos*) does not represent Muses. On Muses in musical scenes, cf. also Queyrel 1988.

[331] London, British Museum E 461; *ARV* 601.20; Kauffmann-Samara 1997: 289, fig. 7; Vazaki 2003: 247, figs. 41–42 (sides A and B). For the problems in the analysis of the image on the obverse of this *kalyx-krater*, see Kauffmann-Samara 1997:290, where she also provides a discussion of all the other objects in the representation that suggest a domestic setting. For the identification of female figures in such scenes as Muses, see Queyrel 1992:659–660, 680.

hangs in the background, just above the head of the woman who sits on the rock.[332] The three women have been identified as Muses.[333] Although I would not hold that these female figures represent Muses, such a combination of outdoor and domestic elements suggests that the corpora of images that we attempt to categorize were conflated by the vase-painters.

It should be pointed out that the fact that female gatherings are sometimes strikingly similar to musical gatherings of the Muses does not mean that marked "divine" connotations are present in every image with female ensembles.[334] Rather than always viewing the gatherings of the Muses as the origins—"the models for the women we see portrayed playing instruments or reading from open scrolls"[335]—or, alternatively, the latter scenes as deliberately resembling those with the deities, we might prefer to think of a parallel and sometimes unmarked coexistence of such images, especially in the period under investigation (*c.* 440–420 BC). If we focus on the possible origins of a schema and attempt to see these origins as embedded connotations in all the images supposed to have been "modeled" on this schema, we run the risk of applying to these representations ideas that are often too generalized or impressionistic. In other words, each female mortal musician at such gatherings need not be metaphorically "associated" with a Muse.

More important, the Athens *hydria* with Sappho was modeled on the broader schema of all-female gatherings in domestic interiors. As we have seen, some of the women seated at the center of the composition hold or play a musical instrument, others have in their hands a small wreath or a chest, still others read a book roll; further versions can also be found. The widely adopted idea that many of the anonymous women musicians and those reading from a scroll in the numerous depictions and versions of this schema actually represented Sappho[336] is, I argue, schematic. If we speculate that these scenes

---

[332] On the reverse two women with musical instruments stand opposite each other: between them there is an open chest, which, as we have seen, is often associated with book rolls in musical scenes.

[333] See Kauffmann-Samara 1997:290 for this identification that has been proposed by a number of scholars. Instead, Kauffmann-Samara suggests that perhaps only the seated woman represents a Muse who "teaches," as it were, the standing mortal women.

[334] This approach has been favored, among other scholars, by Webster 1972:242. For a criticism of this tendency, see Lewis 2002:157.

[335] Lissarrague 1992b:206.

[336] Such identifications with Sappho have been proposed in numerous archaeological publications. See, for example, Metzler 1987:76, Simon 1972:421–422, Kauffmann-Samara 1997:289. Bernard 1985:48 has suggested that the representations of Sappho functioned as model images for other depictions of women. Williams 1993:100 maintains that "there are some [sc., groups of women] in which the painter no doubt had the legendary poetess, Sappho, and her pupils in mind." Simon 1972:421–422 believes that the lack of inscriptions does not go against the identi-

depicted "Sappho and her students," and since a very large number of such contemporary images have been preserved, at least a few more vase-paintings with Sappho's name inscribed on them should have come to light. I prefer to investigate the Athens *hydria* in the context of the diverse modalities of the fifth-century Athenian contextualization of the figure of Sappho. Around the same period (late fifth or early fourth century), Ameipsias apparently composed a play entitled *Sappho*.[337] Earlier in the fifth century, vase-paintings provided Athenian symposiastic versions of how Sappho had been received. The Athens *hydria* locates the songs and the figure of Sappho in the domesticated space of gatherings of female musicians and of private poetic recitations and competitions. It is this pictorial or cultural schema that "defines" Sappho, and not vice versa. Instead of attempting to see in the specific representation of a "domestic Sappho" a conflation of too-generalized connotations—that is, Sappho entering the realm of the Muses *and*, through the depiction of wreaths hanging in the background, becoming a metaphor for wedding songs (on a *hydria* intended for a bride) *and* being associated with female education—[338] I propose to shift the focus to those visual elements that differentiate it from other versions of this popular schema.

On the Athens *hydria*, Sappho is seated in right profile and flanked by three female figures.[339] One standing behind her, on the left, is about to put a wreath on Sappho's head;[340] lettering provides her name: ΝΙΚΟΠΟΛΙΣ. A woman standing on the right holds out a *chelys* lyre near Sappho and is named ΚΑΛΛΙΣ. Another woman (this time unidentified), at the far right of the compo-

---

fication of *Frauengemachbilder* as Sappho in her "circle," since the poetess was viewed in Athens as "eine mythische Gestalt wie Orpheus oder die Musen." This idea further reflects unexamined assumptions favored in current scholarship with regard to the presence of Sappho in fifth-century Athens. The unattributed red-figure *hydria* Berlin, Antikensammlung F2391 (Queyrel 1992:plate 385) was misleadingly thought of as having an inscription Σαπφυ (the inscription needs to be reexamined). A red-figure squat *lekythos* attributed to the Meidias Painter and dated to *c.* 420–415 BC (Ruvo, Museo Jatta 1538; *ARV* 13–14.16; *Add.* 362; Burn 1987:plates 38a–c) depicts Thamyris seated and playing a Thracian *kithara* in the company of Apollo, perhaps Muses (?), and winged Erotes: one of the female figures is named Σαο, which has been wrongly taken to represent Sappho; note that Σαὼ, along with forty-nine other women, is a daughter of Nereus and Doris in Hesiod *Theogony* 240–264 (even Burn 1987:55–56, following earlier identifications, argues that she is Sappho). See also above and Chapter Three, pp. 272–275.

[337] See, however, the discussion in Chapter Four, pp. 295–297.

[338] The coexistence of these associations has often been assumed in connection with this image. It has further been speculated that the *hydria* "portrays Sappho in what may be a female homoerotic setting" (Halperin 2003:722).

[339] I examined the vase and its inscriptions in the National Archaeological Museum, Athens, with the permission of the Director of the Museum, Dr. Nikolaos Kaltsas.

[340] The wreath is hardly visible nowadays. I agree with Anna Vazaki (2003:176n1067) about the traces of the wreath on the vase.

sition, rests her right hand on Kallis' shoulder. Two wreaths hang in the background. All dressed in *chiton* and *himation*, they look at each other, but not at the seated Sappho, whom they "frame." Sappho's gaze is directed toward the book roll she holds, which is at the center of the whole image.

The poet is identified by the inscription ΣΑΠΠΩΣ (Fig. 25). The omega is difficult to read both because of breakage in the area and since it has faded considerably; it has been reported and confirmed by scholars who examined the vase in earlier decades.[341] The genitive ΣΑΠΠΩΣ[342] appropriately defines the vase-painting: it is an εἰκών, an imaginary representation "of Sappho." Placed near the book roll, it is *as if* ΣΑΠΠΩΣ concurrently identifies the text written on it.

Nikopolis has been seen as a *redender Name* ("Victory-city"):[343] she is about to wreath Sappho, who reads from the book roll. Comparable "telling names" that could perhaps be considered here include the female names on a red-figure *hydria* attributed to another Polygnotan.[344] On this vase, a seated female piper is called Euphemia, a standing *barbitos*-player is given the name Kleodoxa, while the names Kleophonis, Kleodike, and Phanodike are attached to other women.[345] However, "Nikopolis" should be viewed, I suggest, in a wider context of images.

Nikopolis is the name of a woman depicted on the upper zone of another red-figure *hydria* attributed to the Polygnotan Group.[346] In this image, we have a markedly different scene: two female Pyrrhic dancers, a woman piper in front of them, and behind the piper, almost in the center of the composition, a seated woman watching them, called Nikopolis. Other women, some of them with lyres, a flying Eros holding a *phorminx*, and a youth leaning on his stick behind Nikopolis are also included in the scene. A wreath hangs in the field behind the woman piper and above Nikopolis' head.[347]

---

[341] Immerwahr 1964:26 (for further bibliography, see his n1 on p. 26).

[342] For the ending of this genitive, see Threatte 1996:259–260.

[343] Among others, Immerwahr 1964:26 and Vazaki 2003:176.

[344] Braunschweig, Herzog Anton Ulrich Museum 219; *ARV* 1037.2; *CVA* Braunschweig, Herzog Anton Ulrich Museum 30–32, pls. 23.1–6 and 24.1–3.

[345] Erotes (among them a winged youth named ["Ι]μερος) appear among the female figures. Cf. Immerwahr 1990:111. On the vase-painting, cf. Shapiro 1993:114–115.

[346] Florence, Museo Archeologico Etrusco 4014; *ARV* 1060.144; *Add.* 323; Liventhal 1985:44. fig. 4a and 45, figs. 4b–c. On this vase and other related representations, see, more recently, Scholz 2003 (with references to earlier discussions).

[347] Wreaths hanging in the background are relatively common in scenes of all-female musical gatherings in domestic settings. Furthermore, it is intriguing that on the lid of a red-figure *lekanis* attributed to the Meidias Painter and dated to the last quarter of the fifth century BC one of the female figures present, along with the heroes Pandion and Antiokhos in what appears to be a garden sanctuary, is called "Nikepolis" or "Nikopolis": Naples, Museo Archeologico Nazionale

Figure 25. Detail of red-figure *hydria* (Athens, National Archaeological Museum, inv. no. 1260; Fig. 22 above): inscription.

It is worth observing that despite differences in the complexity of the two images, Nikopolis is the name both of the seated woman on the Polygnotan *hydria* in Florence and of the figure standing behind Sappho on the Athens *hydria*, again the work of an unidentified painter of the Group of Polygnotos. Similarly, one of the performers on the Florence vase is named Kleodoxa. Apart from the *barbitos*-player Kleodoxa in the all-female gathering I have already considered, "Kleodoxa" reappears in a symposiastic scene depicted on a red-figure *stamnos* by Polygnotos: she is a piper playing for the bubbly company of three reclining male figures.[348] Although these names have been considered "telling names" or "professional names,"[349] I argue that since the vases are contemporary (*c.* 440–430 BC) and related to a specific group of painters, they are names used almost formulaically for different images by the Polygnotans.

---

Stg. 311; *ARV* 1314.17; *Add.* 362; Burn 1987:pl. 10a–b. For a discussion of the vase-painting in the context of representations of paradise gardens, see Burn 1987:15–19. "Nikepolis" (or "Niko-polis") holds a wreath in her left hand and approaches a *thumiatêrion*. On this *lekanis* lid and on the red-figure *hydria* under consideration, a number of female figures are named but the context is considerably different.

[348] London, British Museum E 454; *ARV* 1028.14; Matheson 1995:56, pl. 42.

[349] Webster 1972:71 and Liventhal 1985:42.

Viewed in this context, "Nikopolis" on the Athens *hydria* does not need to be taken too literally in terms of the receptorial filters through which the whole image with Sappho is constructed. The name does not convey an unusually marked connotation to the representation: as is the case with other images of all-female gatherings, it must have pointed to a kind of "victory" in musical performance or poetic recitation.

The idea of wreathing a *mousikê gunê* can be detected in a few earlier vase-paintings dated to 470–450 BC;[350] the closest example is provided by a contemporary red-figure *hydria* attributed to a Polygnotan painter, with a female figure wreathing a woman musician in a domestic interior.[351] An Eros holding a wreath in his hands can also hover over the head of a seated instrumentalist tuning her *chelys* lyre.[352] At the same time, as we have seen, the fact that Sappho is reading a book roll is not as unusual as has been assumed.[353] On the *hydria* in the manner of the Niobid Painter,[354] the woman seated in the center reads the book roll she holds; as in the case of the Athens *hydria* with Sappho, she is flanked by three other female figures, one standing behind her and two in front of her. A significant difference is the text written on her book roll; it consists of sixteen lines of almost *stoichêdon* written dots, which yield no sense. And on a red-figure *hydria*, possibly in the manner of the Shuvalov Painter and dated to about 430 BC, one of the two women depicted is seated on a stool and reads from a book roll, on which only some imitation letters are written.[355] On all these vases the women are unidentified.

I argue that the markedness of the Athens *hydria* rests principally on "Sappho" (ΣΑΠΠΩΣ) and the text on her book roll. "Kallis" and "Nikopolis" contribute to the specificity of the female space. As Sappho often did in her poetry, the painter has given the women names. Instead of performing a song, she is represented as reading from a book roll, despite the availability of a musical instrument. The *chelys* lyre that Kallis holds out near the seated Sap-

---

[350] Cf. Vazaki 2003:175–176.

[351] Athens, National Archaeological Museum 12883 (Peleus Painter); *ARV* 1040.21; see Vazaki 2003: 177 and 224, no. 94.

[352] London, British Museum E 189 (Group of Polygnotos); *ARV* 1060.147; Goulaki Voutira 1991:88, fig. 17. On the *hydria* London, British Museum 1921.7-10.2 (Group of Polygnotos); *ARV* 1060.138; *Add.* 323; *CVA* London, British Museum 6, III.I.C.3, pl. 83, an Eros with a wreath seems to be flying toward the women musicians.

[353] Matheson 1995: 287 finds the scene with Sappho reading unusual in the context of numerous similar compositions with a female figure seated in the center.

[354] London, British Museum E 190; *ARV* 611.36; *Add.* 268; Beck 1975:pl. 69. 351.

[355] London, British Museum E 209; *ARV* 1212.4; *Add.* 347; Beck 1975:pl. 69. 352. Cf. the earlier red-figure *pelike* Rome, Mus. Naz. Etrusco di Villa Giulia 50447; *ARV* 852.5 (in the manner of the Sabouroff Painter; Beck 1975:56.2).

Figure 26. Detail of red-figure *hydria* (Athens, National Archaeological Museum, inv. no. 1260; Fig. 22 above): scroll.

pho also appears in other related scenes of female gatherings. It is less marked than the *barbitos*, although on vase-paintings of the second half of the fifth century the *barbitos* is often depicted in the hands of a seated woman who plays music in the company of her friends in domestic settings.

What we see in this image is *a poet gazing at a poem* (Fig. 26). In contrast to other similar representations of women reading, Sappho's book roll is inscribed with an actual verse. Attic vase-paintings with boys and youths holding book rolls with texts written on them go back to c. 500–490 BC.[356] Scenes with women reading begin appearing in about 460–450 BC. One of the earliest, on a white-ground *lekythos* attributed to the Painter of Athens 1826, depicts a seated woman reading from a book roll to another woman standing in front of her on the left.[357] The text on the scroll is a "nonsense" inscription, three lines with

[356] On book rolls on vases, see Beazley 1948, Immerwahr 1964, Immerwahr 1973, and Pöhlmann 1976. Cf. also Immerwahr 1990:99.

[357] Basel, Market, Münzen und Medaillen, A.G., 51 (14–15 March 1975), pl. 46, no. 169. The representation and the text on the book roll are discussed in Immerwahr 1973: 146–147 (pl. 33.3–4).

four letters each. As we have seen, in related, almost contemporary images, the book rolls that women hold contain imitation letters or dots.[358] It should be observed that it is only on the earlier vases that the scrolls that male figures hold are inscribed with comprehensible strings of words.[359] These are mostly poetic texts. One of them possibly represents the beginning of a melic song;[360] and another includes an initial address to Μοῖσα ("Muse" in the Aeolic dialect) as well as the phrase ἄρχομ' ἀείδειν ("I begin to sing…").[361]

The text on the book roll that Sappho gazes at is written in twelve lines with four to two letters each, except for the final line:

ΘΕΟΙ
ΗΕΡΙ
ΩΝ
ΕΠΕ
ΩΝ     (5)
ΑΡΧ
ΟΜ
ΑΙΑ

This provides the phrase θεοί, ἠερίων ἐπέων ἄρχομαι ("gods, with airy words I begin…").[362] After "I begin" and the alpha that follows in line 8, more letters appear that produce no comprehensible word(s):[363]

İN.
NṬ     (10)
Τ.
Ν

Apart from this main text, ΠΤΕΡΟΕΤΑ̣ and ΕΠΕΑ are written vertically on the two "margins"—or the rolled parts—of the scroll, on the left-hand and right-hand sides, respectively. Since the name of the seated figure operated as a

---

[358] Cf. Immerwahr 1964:24–25 and 1973:144–145.

[359] For these inscriptions, see Beazley 1948. A Nike can also read from a scroll (Immerwahr 1964:35). For the book rolls that Muses carry, see Immerwahr 1964:28–33, 1973:145–146, and 1990:99n6; on these rolls, inscriptions that yield any sense are extremely rare.

[360] Oxford, Ashmolean Museum G 138.3; ARV 326.93; Add. 216; Hogarth et al. 1905: pl. 6. 5.

[361] Berlin, Antikensammlung F 2285; ARV 426, 431.48, 1653, and 1701; Add. 237; Buitron-Oliver 1995: pl. 58, no. 88. The inscription provides ἄρχομαι ἀεί{ν}δεν (no elision in ἄρχομαι).

[362] Something like "my song" is understood here.

[363] My reading of the letters in question differs slightly from that of Immewahr 1964:26. The last letters that he reads in lines 9 (after Ṇ) and 11 (after Τ) are very uncertain. On this scroll inscription, see Beazley 1928:9–10n2, and Immewahr 1964:26.

sign of her culturally marked popularity as a song-maker (ΣΑΠΠΩΣ) and, in contrast to images of other female readers (or even of Muses in the company of Apollo),[364] her book roll is inscribed with a "poetic line," this central, unexplored aspect of the image needs closer investigation in terms of the fifth-century receptions of Sappho.

From the viewpoint of the modern reception of the text on the book roll, John Maxwell Edmonds maintained that it represents part of the introductory poem to the first book of an early, pre-Alexandrian edition of Sappho—a collection possibly arranged by Sappho herself.[365] Especially in his edition *Sappho Revocata*, the line was made available again, in the original and in translation, to a nonspecialist public.[366] Edmonds did not discuss the text in view of the ancient reception of Sappho, despite the fact that it would have been interesting if he had commented on the highly hypothetical reconstruction and translation of the inscription that he proposed ("the words I begin are words of air, but, for all that, good to hear," that is, "beneficial"). Following Rudolf Herzog, Edmonds thought that ΘΕΟΙ was a dedicatory formula, like those occurring in stone inscriptions.[367] From this perspective, such a formula would indicate that this is the beginning of a book. Accordingly, πτερόε<ν>τα ἔπεα ("fledged words," "winged words") has been interpreted as a title written on the back of the book roll.[368] Despite the linguistic and textual remarks offered by Edmonds and Herzog, the line has not been included in critical editions of Sappho, and the whole idiosyncratic proposal has not found any defenders among scholars. The history of the modern aesthetic reception of this scroll inscription is rich, but this is not the place to explore it.[369] What is interesting

[364] For a highly problematic case, see Beazley 1948:339.

[365] Edmonds 1922 and Edmonds 1928a:180–181.

[366] Edmonds 1928b:5–5a.

[367] Herzog 1912:22–23. It should be observed, however, that the invocation Θεοί occurs incised twice along with *kalos*-names (like Τιμόξενος καλός and Χαρμίδης καλός) on the underside of a *krater* found, among other vases and household pots dated to the second quarter of the fifth century, in a well in the Athenian Agora (P 5164: Talcott 1936:350 and fig. 21). On the obverse of a red-figure neck-amphora attributed to the Painter of the Yale Lekythos and dated to the second quarter of the fifth century BC (London, British Museum E 291; *ARV* 662; *Add.* 277; Schefold and Jung 1989:27, fig. 12) the exclamation ΘΕΟΙ comes out from the mouth of elderly Phineus; it is interesting that on the same image Χαρμίδης καλός is written (cf. Talcott 1936:350; Kharmides is a popular *kalos*-name on Attic vases).

[368] Among others, Turner 1977:14–15. Cf. Edmonds 1922:9 "I will only add that 'Winged Words' would be particularly suitable as the title of a collection whose prologue began with 'Words of air'," and Edmonds 1928b:4 (notes in Latin).

[369] See, for example, the ingenious poetic reconstruction of the whole corpus of Sappho's fragments by Odysseas Elytis (1984), in which he has adopted the line as part of a longer poem. In France, Mora (1966: 414) will include the line in her translation of Sappho.

for the present investigation is that certain views about the function of θεοί and of "winged words" have remained somewhat influential.

That πτερόε<ν>τα ἔπεα represents a title is no more than a guess. As the image stands, the epic formula ἔπεα πτερόεντα is "visually" inverted and juxtaposed, as it were, to the phrase ἠέρια ἔπη—as if to provide a gloss on "airy words." Even if πτερόε<ν>τα ἔπεα were a title, I argue that its juxtaposition to ἠέρια ἔπη is culturally significant from the perspective of the ancient textual and visual representations of Sappho.

Similarly, θεοί has been accepted by several scholars as a dedicatory formula.[370] Given that the text on the book roll that Sappho holds can safely be considered an invention of the vase-painter or perhaps of another contemporary, there is no reason to expect an adherence to a metrical pattern. The painter, or whoever "composed/improvised" this line,[371] could have put θεοί together with ἠερίων ἐπέων ἄρχομαι as part of the same song, without thinking of the specific meter this would produce.[372] Sappho fragment 1 V begins with an address to a deity, and a number of her songs include similar invocations in their introductory lines.[373] More importantly, on a cup by Douris the poetic inscription on the book roll that the seated bearded man holds in the context of a school scene similarly starts with a vocative, which is not followed by a verbal form in the imperative or by a comparable phrase: Μοῖσά μοι ἀ<μ>φὶ Σκάμανδρον εὔρ<ρ>οον ἄρχομαι ἀείδειν ("Muse,...I begin to sing of fair-flowing Skamandros").[374] It seems likely that the vase-painter here fused two quotations, Μοῖσά μοι and ἀ<μ>φὶ Σκάμανδρον εὔρ<ρ>οον ἄρχομαι ἀείδειν.[375] Similarly, θεοί on Sappho's book roll may stand as the first word of the poem, an address to gods at the beginning of an improvised composition juxtaposed to the figure of Sappho.

---

[370] See Campbell 1993:358 (fr. 938d), who does not print θεοί along with the rest of the line; Page prints the word as a "separate" semantic unit in fr. 938d *PMG*. Cf. also Immerwahr 1964:46, who believes that θεοί is *extra metrum*.

[371] On improvisation, see Chapter Four.

[372] The meter of the lyric line στησιχόρων ὕμνων ἄγοισαι or στησίχορον ὕμνον ἄγοισαι on the fragmentary cup Oxford, Ashmolean Museum G 138.3 (see n. 360 above) is not easy to understand. Cf. Beazley 1948:338 and Immerwahr 1964:19. For the vocative θεοί, see, for example, Pindar fr. 75.2 M, Thoukydides 2.74.2, and Euripides *Helen* 1447. See also above, n. 367.

[373] See e.g. Sappho frs. 5 and 17 V.

[374] Berlin, Antikensammlung F 2285 (see n. 361 above).

[375] Cf. Immerwahr 1964:19.

## Visualizing Song-Making

Even so, the most significant part of the line is the phrase ἠερίων ἐπέων. This is the only instance that ἠέριος ("early," "at early morn") or ἀέριος ("of the air," "aerial," "in the air")[376] modifies the word ἔπος throughout ancient Greek literature. In all other cases of poetic lines written on the book rolls that *male figures* hold, the texts do not provide semantic difficulties. στησιχόρων ὕμνων ἄγοισαι or στησίχορον ὕμνον ἄγοισαι ("…bringing a chorus-establishing hymn") on a red-figure cup by Onesimos is a lyric line.[377] Ἑρμῆ<ν> ἀείδω ("I sing of Hermes") on a red-figure *lekythos* related to late Douris might perhaps be the beginning of the shorter Homeric *Hymn to Hermes* (18.1).[378] And we have already considered the line on the Douris cup.

What does ἠερίων ἐπέων ἄρχομαι mean? "I begin with air-like words"? "I begin with early words"—that is, words sung in the morning? More metaphorically, "I begin with lofty words"? Or perhaps, if one wishes to see a contrast between πτερόεντα ἔπεα and ἠέρια ἔπεα, "I begin with ἠέρια words" that are not epically πτερόεντα? Capturing the possible connotations is difficult, but it is important to pose the question: Why are the words of the poem that Sappho reads on the vase-painting ἠέρια and not πτερόεντα? The vase-painter has placed next to ἠέρια ἔπεα a formula with which he was familiar: ἔπεα πτερόεντα.[379] This might be an attempt to explain the occurrence and meaning

---

[376] Cf. LSJ, s.vv. ἀέριος and ἠέριος. In later periods, ἀέριος can have the meaning "vain, futile" (LSJ, s.v.). In Euripides *Phoinissai* 1534, it modifies σκότον, but the whole phrase is obelized in Diggle's edition (it is not obelized in Mastronarde's edition [1988:112]; see also Mastronarde 1994:577); cf. Euripides fr. 24b.3–4 *TrGF* and Kannicht's apparatus criticus; and *fragmentum adespotum* 1023.16 *PMG* (= *TrGF* adespotum F 692.16). In the Hellenistic period, ἠέριος can mean "misty, dimly seen" (LSJ, s.v). A search I conducted in the electronic database *Thesaurus Linguae Graecae* confirmed these broader meanings.

[377] Oxford, Ashmolean Museum G 138.3 (see n. 360 above)

[378] Collection H. Seyrig; *ARV* 452, 677.7; *Add.* 242; Beazley 1948:pl. 34. According to Beazley 1948 and Immerwahr 1964:21, the two words certainly come from *Homeric Hymn* 18.1; cf. Beazley 1950:318–319. The book roll that a seated youth holds on the red-figure cup Washington, DC, National Museum of Natural History 136373 (*ARV* 781.4; *Add.* 288; Beazley 1948:pl. 36) provides the text ὡς δή μοι καὶ μᾶλ<λ>ον επεσ, which Beazley (1948:339) supplemented as follows: ὡς δή μοι καὶ μᾶλ<λ>ον ἐπέσ(συτο θυμὸς ἀγήνωρ). Beazley compared the preserved part of the text to Homer *Iliad* 9.398 ἔνθα δέ μοι μάλα πολλὸν ἐπέσσυτο θυμὸς ἀγήνωρ. However, this is a conjectural supplement. The content of the text on the book roll that a seated, bearded man (ΛΙΝΟΣ) holds on the red-figure cup Paris, Louvre G 457 (*ARV* 1254.80, 1562; *Add.* 355; Beazley 1948:pl. 35B) is uncertain.

[379] The formula occurs very often in the Homeric epics; also, in Homeric Hymns and in [Hesiod] *Shield* 117, 326, and 445. For other epithets modifying ἔπεα in the Homeric epics, see Beck 1991:663. A ὕμνος can be πτερόεις in Pindar (*Isthmian* 5. 63 S-M καὶ πτερόεντα νέον σύμπεμψον ὕμνον). For the meaning of ἔπεα πτερόεντα, see Martin 1989:30–35.

of ἠέρια ἔπεα, or simply to juxtapose a familiar poetic phrase to the "less common"—metaphorical, literal, or even colloquial, but "poetically" formulated—ἠέρια ἔπεα that he chose for the line or that he had heard elsewhere. The meaning of ἠέρια ἔπεα was clear to him, but not *entirely* so to us. I suggest that since ἠέρια ἔπεα does not occur elsewhere in ancient Greek literature, it cannot be considered a "meaningless" choice on the part of the painter: it was either a phrase that he might have used almost colloquially, hastily, and playfully or a more "melic" expression that seemed fitting for the image of Sappho reading in the company of other women ("I begin with lofty words"), or part of a song he was familiar with.

Further, ἔπεα πτερόεντα is a marked formula traditionally associated with epic poetry and especially with the Homeric epics frequently performed in Athens by 440–430 BC. If the line ἠερίων ἐπέων ἄρχομαι was composed ad hoc by the painter, he certainly preferred not to employ this formula for the poem inscribed on the scroll. Although visually juxtaposed to πτερόε<ν>τα ἔπεα, it is ἠέρια ἔπεα that was written on the open sheet of the book roll: ἠερίων ἐπέων ἄρχομαι. This must have been viewed as a more suitable poem for "Sappho." Recall that other images with women reading do not have poetic lines inscribed on the book rolls.[380] Even if we assumed that πτερόε<ν>τα ἔπεα on the "margins" of her scroll represented a title written on the back, that would be a similarly marked element for the representation of Sappho. Why should the title of the book roll that an East Greek woman poet reads on an Attic *hydria* be ἔπεα πτερόεντα, while the poem on the open sheet starts with the line ἠερίων ἐπέων ἄρχομαι? Given the occurrence of ΣΑΠΠΩΣ on the vase and the inclusion of some female names that rendered apparent "specificity" to the image, the line ἠερίων ἐπέων ἄρχομαι would indicate some familiarity with the sort of songs that could aptly be juxtaposed to a representation of a female gathering in which Sappho is present.

Although the questions posed here resist definitive answers, it is certain that viewed as an ethnographic archival informant—in which visual and written signifiers interact and, in the absence of other signifiers that could have potentially been exploited, they provide contextualization cues—the text on the book roll in the context of the whole image on the Athens *hydria* represents a song markedly introduced with ἄρχομαι. It should be observed that compositions starting with a form of ἄρχομαι or with a verb prompting the beginning of the performance of a song circulated widely in the archaic and classical periods. First, poetic compositions like the Homeric Hymns

---

[380] Immerwahr 1964: has attempted to offer a too-generalizing interpretation for all the poetic inscriptions on book rolls: he has thus speculated that all the texts are epic.

(ἄρχομ' ἀείδειν in 2.1, 11.1, 13.1, 16.1, 22.1, 26.1, 28.1)[381] or the *Theogony* were introduced with "let us begin our singing" or a comparable phrase.[382] At the same time, songs were performed in the classical period as *skolia* that started with the verb "I sing" (ἀείδω).[383] "Sappho"'s song might have been used by the painter as a kind of *skolion*, a generic hymn, or as a more marked song: "with airy words I begin [...]." The inclusion of the inscription is based on individual agency, which reflected collective notional modalities but had more to do with its choice by a craftsman or one of his colleagues/informants. Such a composition appearing on the book roll that Sappho holds would be a marker of the popularity of her figure but not of her being established as a poet whose songs had a fixed textuality—an issue I shall explore in Chapters Three and Four.[384]

In this context, I want to emphasize that all the elements of the representation on the Athens *hydria* are culturally generated and should be viewed in their dynamic interactions with each other: the inscription on the book roll is not an insignificant element, even if we assumed that it could have been chosen hastily by its composer. Might one perhaps detect in ἠέρια ἔπεα and πτερόεντα ἔπεα signs of a metonymic juxtaposition of epic discourse to an *écriture féminine* associated with an East Greek song-maker like Sappho—especially since the whole image reflects an idealized cognitive model of female gatherings? The issue raised here defies a conclusive solution; numerous evidentiary gaps exist that do not allow us to understand the cultural and female alterity reflected in this vase-painting.

Whatever the case, the image on the Athens red-figure *hydria* represents a different discursive modality from those exploited on the other vases with Sappho. As I have argued, the minimalist representation on the *hydria* decorated in Six's technique might be decodified differently in diverse performative and cultural contexts. It can by no means be considered a clear indication that Sappho's songs were performed in *symposia*. Similarly, the kalathoid vase with Alkaios and Sappho marks an instantiation of the interdiscursivity of different performance contexts—that of Alkaios' political *hetaireia* and the performative-cultural modalities of Sappho's song-making—that meet in a common visual space, only to a certain degree modified by the appearance of Dionysos and his female companion on the reverse side. Even if the association between the sympotic territory of Dionysos and the visual, potentially multi-

[381] A number of the Homeric Hymns start with ἀείδω or a similar form denoting "I (shall) sing." Cf. [Stesikhoros] fr. 278 *PMG* and Simonides fr. eleg. 92 W (capped by Timokreon fr. 10 W).
[382] Hesiod *Theogony* 1.
[383] See *carmen conviviale* 885 *PMG*. For *skolia*, see Chapters Three, pp. 214–216, and Four, pp. 341–347.
[384] On the Athens *hydria*, see further Chapter Three, p. 312.

valent space occupied by Alkaios and Sappho is not certain, it might have been conducive to the gradual and fleeting expansion of the cognitive frames and mental spaces of ancient viewers. Such an association testifies to the performative resilience of Sappho's songs—an issue that I explore systematically in Chapters Three and Four—but the exact function and context-specific cultural and indexical markers of the kalathoid vase that bears the representation of the two singers cannot be definitely determined.

On the contrary, I contend that the Bochum *kalyx-krater* offers a solid basis on which any argument about a sympotic appropriation of the song-making of Sappho can be built. The deictic contextual cues that the *kalyx-krater* provides are considerably reinforced by its marked and complex representations. What these pictorial associations eventually achieve is an activation of cultural *vraisemblance* contributing to the naturalization of the figure of Sappho in the symposiastic and komastic spaces of male self-defining and reflexive gatherings. The sociopolitical dimensions of this kind of *vraisemblance* are related to a mythopractical negotiation of what might constitute Lesbian female companionship in the male Athenian imaginary of the early classical period. Time stands still.

# 3

# The Anthropology of Ancient Reception: The Late Archaic and Classical Periods

ΠΙΚΡΑΓΚΑΘΙ

Ἐνεφανίσθη καὶ χάθηκε ἡ δεσποινὶς ποὺ συνήντησα
μέσ' στὸ συρτάρι μου. Στὴ θέσι της μιὰ τολύπη
κρατεῖ τὸν φώσφορο τῆς ζωοφόρου της. Ἄποικοι
νέμονται τὶς ἐκτάσεις ποὺ ἐγκατέλειψε μὰ τὸ παιδὶ
τῶν ἀναμνήσεών μας κομίζει πλοκάμια ποὺ μοιάζουν
μὲ τὶς ἕξι διαφορετικὲς ἡδονὲς τῆς δεσποινίδος
ποὺ ὑπῆρξε βασικῶς μητέρα τοῦ παιδιοῦ της καὶ
μητέρα μου. Κάποτε ζῶ μέσ' στὸ συρτάρι. Μὰ
κάθε φορὰ ποὺ δὲν ὀνομάζονται μερικὲς περι-
πτώσεις ἀλλιῶς παρὰ χλαμύδες κάτω ἀπὸ τὶς ὁποῖες
ὑποσκάπτονται τὰ θεμέλια μιᾶς τραγικῆς κουρτίνας
παίρνω τὸ τελευταῖο μαντῆλι της καὶ παρακαλῶ
τὸ βάτραχό μου νὰ καταργήση κάθε οἰμωγὴ
ποὺ εἶναι δυνατὸν νὰ ὑπάρχῃ μέσα στοὺς θώκους
καὶ ἐπάνω ἀπὸ τὶς κουρτίνες.

The maiden whom I met in my drawer appeared
and disappeared. In her place a wisp is holding
the phosphorus of her zophoros. Settlers exploit
the regions that she left behind but the child
of our memories is bringing tentacles resembling
the six sensual pleasures of the maiden
who was basically the mother of her child and
my mother. Sometimes I live in the drawer.
But each time that certain cases are not named
otherwise but "chlamydes," under which
the foundations of a tragic curtain are
undermined, I take her last handkerchief
and beg my frog to cancel any wail
that there may be in the seats
and above the curtains.

—Andreas Embeirikos, "Bitter Thorn"

I N HIS DISCUSSION of the diverse rhetorical topics or elements of demonstrative syllogisms—rhetorical strategies of persuasion—Aristotle addresses the use of "induction" (*epagôgê*). It can be shown from a number of cases, he argues, that if the parentage of a child is at issue, mothers always discern the truth. This kind of syllogism draws conclusions from accepted premises. If, he continues, one aims to show that πάντες τοὺς σοφοὺς τιμῶσιν ("all honor the wise"), one may quote the rhetor Alkidamas of the late fifth and early fourth century, a pupil of Gorgias:[1]

> Πάριοι γοῦν Ἀρχίλοχον καίπερ βλάσφημον ὄντα τετιμήκασι, καὶ Χῖοι
> Ὅμηρον οὐκ ὄντα πολίτην, καὶ Μυτιληναῖοι Σαπφὼ καίπερ γυναῖκα
> οὖσαν, καὶ Λακεδαιμόνιοι Χείλωνα καὶ τῶν γερόντων ἐποίησαν
> ἥκιστα φιλόλογοι ὄντες, [καὶ Ἰταλιῶται Πυθαγόραν,] καὶ Λαμψακη-
> νοὶ Ἀναξαγόραν ξένον ὄντα ἔθαψαν καὶ τιμῶσιν ἔτι καὶ νῦν.

> The Parians, at any rate, have given Arkhilokhos honors, even though he was abusive; and the Khians Homer, even though he was not a fellow-citizen; and the Mytileneans Sappho, even though she was a woman; and the Spartans, although they are least fond of learning, made Kheilon a member of their council of elders; [and the Italiotes have honored Pythagoras;] and the people of Lampsakos honored Anaxagoras with a public burial, although he was a foreigner, and they honor him even nowadays.

In this long series of cases presented as intriguing paradoxes, Alkidamas has listed a female figure. The "paradox" here is related to a most pervasive and powerful paradigm in the cultural rhetoric and practice of fifth- and fourth-century Athens. The point that is made is that Sappho, who was from Lesbos and closely associated with the city of Mytilene, was honored by the people of Mytilene, despite the fact that she was a woman. Paros gave honors to a poet fond of insults, and Khios to a non-citizen poet.[2] Compared to the examples

---

[1] *Rhetoric* 1398b.10–16 Kassel (1976:130–131).
[2] Note that a variant reading for πολίτην is πολιτικόν.

of men "wise and skilled in art" offered by Alkidamas, the cultural paradox in the case of Sappho lies in her being a woman who conspicuously stood out as a poet in the long tradition of famous Lesbian male singers and poets/musicians that became proverbial in Greek antiquity.[3] By the standards of Athenian cultural politics, this feat was remarkable indeed.

The ideological paradigms and polarities that conditioned the reception of Sappho in antiquity (outside the island of Lesbos) were constantly different from those that shaped the ancient understanding of the poetry of Pindar, Arkhilokhos, Alkaios, and the Homeric epics. Although the songs and the figure of Sappho were often assimilated into sociocultural schemata pertaining to male archaic poets like Anakreon or even influential intellectuals and public figures like Sokrates, the anthropology of her reception was in each period and in different Greek and Roman societies filtered through culturally intricate politics of context, gender, and *écriture*. More than five centuries after Aristotle's reference, Athenaios in the *Learned Banqueters* succinctly pointed to two principal, complementary ideological categories that had defined the figure of Sappho the song-maker, especially in the earliest and, as I shall argue, the most decisive stages of the transmission of her poetry in Athens:

> ... Σαπφώ, γυνὴ μὲν πρὸς ἀλήθειαν οὖσα καὶ ποιήτρια, ...[4]
>
> Sappho, a woman—according to truth and nature—and a
> poetess...

The emphasis placed on the word "woman" in this passing reference to Sappho confirms that a complex cultural hermeneutics of gender was one of the primary prisms through which her poetry and, more importantly, its sociocultural contexts were perceived in societies where the categories "woman," "woman musician/poet," and "East Greek" were markedly loaded. As discussed in the course of this chapter, these categories were a formative *part* of the social economy of Athenian performance cultures throughout the early transmission and successive reperformances of Sappho's songs in that city. I shall argue that the second ideological concept, "woman poet/musician," in conjunction with broader and particularly intricate socioeconomic discourses related to East Greek societies, shaped the early making of the figure of Sappho, thus adumbrating the subsequent discursive configurations with which she was presented as conversing.

---

[3] On this proverbial pronouncement, see below, p. 200.
[4] Athenaios 15. 687a.

## On Lesbos

Sappho's poetic activity must have been well known in her own time[5] beyond the female community of Mytilene. Leaving aside those fragments that suggest some kind of competition with other women on the part of the poetic voice, it is hardly possible to trace the receptions of her songs by contemporary Mytilenean society as a whole. Although the view that Alkaios addressed Sappho encomiastically in one of his verses (Alkaios fragment 384 V) and that the two poets may have been involved in a poetic dialogue[6] is not as compelling as it may appear,[7] Alkaios and other members of his *hetaireia* are likely to have been acquainted with the figure of Sappho. Two poets of approximately the same age living in a cultural milieu where song-making and performance were deeply embedded in the broader social economy would have been aware of each other's presence within the confines of the archaic city of Mytilene.

More importantly, Sappho's "involvement" in the political dissensions of the turbulent Mytilenean society suggests such a mutual familiarity. Her possible exile to Sicily (as attested in *Marmor Parium* Ep. 36),[8] Sappho fragment 98b V (replete with allusions to political crises in Mytilene), and the derogatory or ironic references by both poets to influential families of Lesbian nobles,[9] reinforce this view.[10]

Before proceeding to a broader investigation of archaic and classical Greek discourses *about Lesbos*—discourses that, as I shall argue, were conducive to the early shaping of Sappho—it is worth examining Alkaios fragment 384 V, a one-liner in which a laudatory address to Sappho by a contemporary Lesbian has been detected and unanimously accepted as certain by numerous

---

[5] It is generally believed that Sappho was born toward the end of the seventh century and that her *floruit* coincides with at least the first three decades of the sixth century. It is highly uncertain whether she was older or younger than Alkaios (on this issue, see Saake 1972:37–50, who contends that Sappho was born *c.* 612 and died perhaps after 550, and thus on these premises that she was younger than Alkaios). For further discussion, see Page 1955:49, 152, 224–225.

[6] See Aristotle *Rhetoric* 1367a. 7ff. Kassel τὰ γὰρ αἰσχρὰ αἰσχύνονται καὶ λέγοντες καὶ ποιοῦντες καὶ μέλλοντες, ὥσπερ καὶ Σαπφὼ πεποίηκεν, εἰπόντος τοῦ Ἀλκαίου [...].

[7] For this dialogue and Sappho fr. 137 V, see below and Chapter Four.

[8] Jacoby 1904:12 ἀφ' οὗ Σαπφὼ ἐγ Μιτυλήνης εἰς Σικελίαν ἔπλευσε, φυγοῦσα [ ἄρχο]ντος Ἀθήνησιν μὲν Κριτίου τοῦ προτέρου, ἐν Συρακούσσαις δὲ τῶν γαμόρων κατεχόντων τὴν ἀρχήν.

[9] Polyanaktidai in Sappho fr. 155 V (perhaps also in fr. 213A d.7–8 V, but see Gronewald 1974:117 for other equally possible supplements with regard to Sappho S261 A, fr. 2, col. ii 9–10 *SLG*).

[10] The political dimensions in Sappho's poetry have been perceptively restressed by Stehle 1997:284–287. In connection with Alkaios' acquaintance with Sappho, such cases as Sappho fr. 16.7ff. V and Alkaios fr. 283.3ff. V, in which an evident divergence occurs regarding the responsibility of Helen in her elopement with Paris, do not constitute conclusive evidence of the mutual familiarity of the two poets, as has often been assumed in literary analyses.

scholars. This address has been considered the earliest marked instance of a reception of Sappho as "holy" by another song-maker from archaic Lesbos.

Lobel and Page, as well as other editors, printed Alkaios fragment 384 as follows:

ἰόπλοκ' ἄγνα μελλιχόμειδε Σάπφοι

violet-haired, holy, soft-smiling Sappho

For many literary critics and the majority of critical editors, the fragment clearly indicates that Alkaios was an admirer of Sappho.[11] And for those scholars who have attempted in the past to defend Sappho's "chastity," Alkaios' ἁγνὴ Σαπφώ has overtly or covertly become an enduring image.[12] It has often been suggested that in this greeting Sappho was duly portrayed by Alkaios as a sacred, decorous figure, similar to a goddess.[13]

The fragment is preserved by Hephaistion (14.4, p. 45 Consbruch), who quotes it to illustrate the so-called Alkaic dodecasyllable, without providing the name of its author. The manuscripts of Hephaistion are divided between -μειδε σαπφοι and -μειδες σαπφοι. Most scholars, including Lobel, Page, and Voigt,[14] have attributed it to Alkaios, but the ascription is not entirely safe. The fragment may well be attributed to Sappho. Voigt printed a different version, indicating that Hephaistion's quotation provides the first line of a poem:[15]

---

[11] The British dictionary LSJ (s.v. Σαπφώ) accepts Σάπφοι for Alkaios fr. 384 V = 55.1 Bergk (and the 1996 revised supplement does not contradict this, nor does it take into account Voigt's monumental critical edition). Bergk (Alkaios fr. 55.1) and Diehl (Alkaios fr. 63) printed Ἰόπλοκ' ἄγνα μελλιχόμειδε Σάπφοι in their influential editions. Bergk (1882:171) held that this fragment is an ἐρωτικόν, whereas Diehl (1936: 119) included it in Alkaios' possible ἐρωτικὰ μέλη (and added a question mark next to this category). Noteworthy in his apparatus criticus is Diehl's quote of Hesykhios' full entry under ἁγνή (καθαρὰ καὶ ἀμίαντος. ἢ παρθένος, "pure and undefiled, or maiden"), an unusual—and perhaps superfluous in the context of an apparatus criticus—lexicographical addition that reflected ideological paradigms related to the study of the social context of the poetry of Sappho current during the mid-1930s.

[12] See, for example, Bascoul 1911 and 1913, and cf. Gentili 1966; see, further, Ferrari 1940:38–53; Gentili 1988:89, 216–222, who maintains that Alkaios' "greeting presents itself as a reverent tribute to the sacral dignity of the poetess as ministrant of Aphrodite and to the grace and beauty that her role as love's priestess conferred upon her" (1988:222); Bowra 1961:238–239; and, earlier, the influential book of Welcker (1816:82). Numerous scholars have adopted this or a similar line of interpretation in recent publications and have accepted that in this fragment Alkaios certainly addresses Sappho (e.g. Lardinois 1994:62).

[13] In modern scholarship, Sappho's social role on Lesbos has often been deemed as that of a priestess of Aphrodite: see e.g. Murray 1993:327.

[14] Cf. Lobel 1927: Alkaios fr. 147 (= Alkaios fr. 384 V).

[15] On the fragment, cf. also Liberman 1988 (who argues for the emendation Ἄφροι, proposed by R. Pfeiffer), and Rodríguez Somolinos 1992:237–240, 1998:120–122, 164–165, 274. In his edition, Liberman (1999) prints Ἄφροι, a quite speculative rendering of the transmitted text.

* Ἰόπλοκ' ἄγνα μελλιχόμειδες ἄπφοι

violet-haired, holy, soft-smiling sister

Σάπφοι, according to this view,[16] cannot be sustained, since, in all other places in Lesbian poetry where Sappho's name is recorded, it is spelled Ψάπ-φω.[17] If we changed the initial letter of the name in fragment 384 V (μελ-λιχόμειδε Ψάπφοι), the line would not scan: the double consonant would lengthen the preceding short vowel.

The noun ἀπφῦς is attested in Theokritos 15.13–15,[18] whereas the medi-eval Greek lexicon Suda and Eustathios record the word ἀπφά or ἄπφα.[19] Since the fragment cannot be recontextualized, and the formation of the epithet μελ-λιχομείδης is more probable than that of μελλιχόμειδος (which is not attested elsewhere),[20] we may conclude that the evidence goes against the vocative Σάπ-φοι. It is obvious that if ἄπφοι is correct, the alternative reading must be ascribed either to fictionalizing proclivities of ancient audiences and readers or to erroneous word division. But the situation is not so straightforward as this.

The nominative of ἄπφοι must be ἄπφω,[21] but such a word is unattested.[22] It is also noteworthy that in all fragments of Sappho where the form "Psap-pho" occurs, it is always at the beginning of a line and thus in no way affects the meter.[23] It is likely that "Psappho" represents the way Sappho's name was pronounced in archaic Lesbos.[24]

---

[16] See Maas 1929:138; cf. Broger 1996:237–238.

[17] Sappho frs. 1.20, 65.5, 94.5, 133.2 V.

[18] See Gow's comment (1952, vol. II: 270) about the possible "fatherly" associations of its meaning.

[19] Suda A 3724 ἀπφά· ἀδελφῆς καὶ ἀδελφοῦ ὑποκόρισμα and Eustathios *Iliad* 5.408 (vol. 2, 111–112 van der Valk) ἄπφαν τὴν ἀδελφὴν Ἀττικῶς μόνη ἡ ἀδελφὴ εἴποι ἄν, καὶ πάππαν τὸν πατέρα μόνος ὁ παῖς, ὥσπερ καὶ μαμμίαν τὴν μητέρα... Ἰστέον δὲ ὅτι ἐκ τοῦ, ὡς ἐρρέθη, ἄπφα γίνεται καὶ τὸ ἄπφιον, ὑποκόρισμα ὂν ἐρωμένης (cf. Eustathios *Iliad* 14.118, vol. 3, 591 van der Valk). The last remark by Eustathios suggests that it was used also by lovers (in which case, we need to read "...soft-smiling darling" or something similar).

[20] Cf. μειλιχομε{τ}ιδής attested by Hesykhios M 602, and e.g. the adjectives φιλομμειδής and ἀμειδής.

[21] Hamm 1957:179, s. v.

[22] A possible, but not persuasive, explanation of its formation from ἄπφα or ἀπφά is given by Hamm (1957:53–54, § 113), who defends ἄπφοι in Alkaios fr. 384 V.

[23] The possibility that "Psappho" is a poetic variant of "Sappho" could be only *hesitantly* envis-aged. However, it would be odd to speculate that both forms are "metrical variants...typical of names which belong to an oral poetic tradition: cp. Ἀχιλλεύς/ Ἀχιλεύς, Ὀδυσσεύς/Ὀδυσεύς," as Lardinois (1994:62n24) does in his attempt to surmise that "we do not know for certain if Sappho as a person ever existed" and that "the fact that Alcaeus addressed Sappho in his poetry and spelled her name differently from the way it is spelled in the poetry preserved in her name, could possibly be an indication that she was a poetic construct rather than a real life figure in sixth-century Lesbos" (1994:62).

[24] Cf. Ἄλκαος in Alkaios fr. 401B a.1 V and ΦΙΤΤΑΚΟΣ on a coin from Mytilene (Head 1911:562), as well as in Alkaios' fragments (Φίττακος); see e.g. Alkaios fr. 70.13 V. See also the discussion of the diverse spellings of the name of Sappho in Chapter Two. Zuntz's (1951) theory of the

On the basis of the existing evidence, the fragment cannot be deemed as providing evidence for the alleged admiration that Alkaios had for his fellow citizen, Sappho. For all that, I would argue that if the fragment as printed by Voigt was actually composed by Alkaios and ἄπφοι is accepted as an unattested archaic form, ancient audiences could have still perceived ἄπφοι as a word play on Sappho's name (μελλιχόμειδες ἄπφοι).[25]

## The Politics of Lesbian Idioms

It is time to focus on archaic and classical cultural discourses related to the island of Lesbos. My objective is to explore the broader sociopolitical landscape of practices of stereotyping and the dynamic process of constructing chunks of attributed traits[26] for the people of Lesbos, thus mapping an identity rhetoric that became part of the cultural *habitus* of diverse ancient Greek social groups, especially Athenians of the classical period. This *habitus* should be viewed as an ever-expanding set of cultural dispositions, concepts, and structures lying behind the social practices of individuals—a set of cultural codes that is *not* detached, however, from individual agency. The present emphasis on Athens is predicated not only on the availability of cultural/textual discourses associated with that city but also on the markedness and intricate resilience that these discursive biases display. Such habitual conceptual patterns activated specific—each time—mythopractical processes that reinvented Sappho's image and negotiated the socioaesthetic value of her songs.[27] As I argued in Chapter Two, since the earliest sources for the reception of Sappho are visual and Attic and there are reasons to hold that a number of her songs were well known and performed in the context of late archaic and classical Athenian *symposia* and probably of female gatherings, the early textual discourses related to her figure should be viewed against the *dynamics of cultural stereotyping* that I shall explore. These dynamics, I suggest, mark the process of the formation of the cultural *habitus* that conditioned the politics of "reading" and eventual "writing" of the figure of Sappho in the early stages of its reception.

As soon as metonymic associations based on a specific cultural *habitus* are established, rehearsed, or even reformulated in diverse performative contexts, these associations function as matrices of ideologically marked signification

---

Asianic nature of Sappho's name, which would explain the existence of both variants in the manuscripts, is ingenious, but hardly provable.

[25] Σαπφώ is the form almost always used in later periods. See Chapter Two, pp. 102–103.

[26] On stereotypes as chunks of attributed traits and packaged *Gestalten*, see Pettigrew 1981:313–316.

[27] On mythopraxis, see Chapter One.

from which further marked associations will accrue. The process is multi-leveled and by no means confined to biographical "scanning" of Sappho's poetry by ancient audiences or to intertextual readings of varied complexity. I argue that "biographical" constructs, however interesting, form *only a part* of the broader ancient cultural practices of understanding and thinking about archaic Greek poets and socioaesthetic cultures. The current scholarly methodology of viewing representations of poets as biographical in nature is restrictive and often produces overschematic readings of ancient thought patterns because it engages primarily in identifying the fictionality of textual narratives without contextualizing them within their respective sociocultural economies. As the discussion of the case of the anthropological transcription of Nisa's life in Chapter One illustrates, biographical schemata, or even autobiographical discourses, are not produced in a formalistic vacuum. Rather, they are embedded within wider, often tantalizingly intricate, webs of signification. The issue is therefore not only or mainly to trace the anecdotal structure of a narrative but to investigate further—as far as ancient sources permit—the multilayered discursive idioms of the social *habitus* that conditioned a narrative. Instead of examining the reception of Sappho as a schematic and blurred series of fragmented representations and roles—Sappho as a heterosexual lover, or a homoerotic figure, or a Muse—that have been attached to her over time in antiquity, I propose to shift the scholarly focus to early contextualization mechanisms that may allow us to read textual/cultural narratives about Sappho anthropologically—by revisiting ancient ideological spaces and by employing ancient sources as indigenous cultural informants.

Some of the earliest cultural conceptions about Lesbos are related to its female population. When in the ninth book of the *Iliad* Agamemnon lists the gifts he proposes to offer Akhilleus with a view to appeasing his wrath, among the precious items he enumerates are Lesbian women:[28]

> δώσω δ' ἑπτὰ γυναῖκας ἀμύμονα ἔργα ἰδυίας,
> Λεσβίδας, ἃς ὅτε Λέσβον ἐϋκτιμένην ἕλεν αὐτὸς
> ἐξελόμην, αἳ κάλλει ἐνίκων φῦλα γυναικῶν.

> And I will give seven women skilled in flawless handiwork,
> women of Lesbos—whom when Akhilleus himself captured well-
> built Lesbos

---

[28] *Iliad* 9.128–130; cf. *Iliad* 9.270–272 and 19.245–256. Note that ἀμύμονα ἔργα ἰδυῖαι recurs in Hesiod *Theogony* 264, in a description of the fifty attractive (some exceptionally so) daughters of Nereus and Doris.

I chose out from the booty—who in beauty surpassed all the tribes of women.

Along with seven tripods, ten talents of gold, twenty cauldrons, and twelve superb, prizewinning horses, the seven women offered to Akhilleus function as objects of exchange in a social economy where gift exchange was essential in establishing and promoting relationships among individuals. The provenance of women is significant for the rhetoric of Agamemnon's kingly offer because as alluring gifts or even commodities, they surpass all the races of women. If, with Jean Baudrillard, we attempt to detect a dynamic relationship between gift exchange and seduction (in the broadest sense of the term),[29] Agamemnon's list of most valuable gifts is rhetorically displayed as an incomparably seductive deal[30]—especially if compared to other lists of gifts offered in critical moments in the *Iliad*.[31] The seven women—*Lesbian* and obtained on *Lesbos* (both references introduced emphatically in line 129)—are presented as unrivaled in two fundamental aspects of the socioeconomic *marketability* of women in ancient Greek societies: they are supremely skilled in handiwork and their allure can be emulated by no other groups of women. This kind of perception about the female inhabitants of a specific island, when embedded in poetry so widely performed and of such Panhellenic impact, reactivates the construction of traditions. As Ionian men are labeled ἑλκεχίτωνες ("with trailing tunics") in the *Iliad*, especially on an occasion that suggests that this idea was traditional,[32] so Lesbian women are singled out as potentially unique in beauty among all women.

Being East Greek and standing out among others, a young woman from Lesbos could cause as much admiration as ambivalent uneasiness when her presence is envisaged in the context of male drinking parties. More specifically, when a singer or, in the case of group performance, several participants

---

[29] Baudrillard 1979:58. On gift, see from a different perspective Derrida's most thought-provoking approach (Derrida 1991).

[30] See also *Iliad* 9.139–156 for other privileges and gifts that Akhilleus will be given by Agamemnon.

[31] Cf. Priamos' gifts to Akhilleus to ransom the dead body of his son in *Iliad* 24.228–235: luxurious clothing (robes, fine cloaks, coverlets, white mantles, and tunics, twelve items from each), ten talents of gold, two tripods, four cauldrons, and a beautiful precious cup from Thrace. Other lists are not as impressive: cf. *Iliad* 8.290–291 ("either a tripod or two horses…or a woman…"), *Odyssey* 4.128–132, and 24.274–279.

[32] *Iliad* 13.685 Ἰάονες ἑλκεχίτωνες in the (unexpected) context of battle. The same formulaic image occurs in the *Hymn to Apollo* 147 in the context of celebratory singing, dancing, and boxing: ἑλκεχίτωνες Ἰάονες.

perform a poem composed by an East Greek, the connotations of a Lesbian girl's beauty may become as polyvalent as the sympotic space allows. Anakreon fragment 358 *PMG* provides us with a masterly image of the elegance of such a girl:

σφαίρῃ δηὖτέ με πορφυρῇ
βάλλων χρυσοκόμης Ἔρως
νήνι ποικιλοσαμβάλῳ
συμπαίζειν προκαλεῖται ·
ἡ δ', ἐστὶν γὰρ ἀπ' εὐκτίτου          5
Λέσβου, τὴν μὲν ἐμὴν κόμην,
λευκὴ γάρ, καταμέμφεται,
πρὸς δ' ἄλλην τινὰ χάσκει.

Once again golden-haired Eros,
striking me with a purple ball,
challenges me to play with
a girl with embroidered sandals.[33]
But she, for she is from
well-built Lesbos, blames
my hair, because it is white,
and she is gaping at another.

That the word "another" (feminine) refers to an object of interest or desire seems beyond doubt, since the young girl χάσκει and the amatory tone of the song is conspicuous—at least in its opening phrasing.[34] Similarly central is the emphasis placed on the marked agency of the girl, who can strongly blame (καταμέμφεται) the singing voice's "white hair" and prefers to gape at other seductive personae. The gaze of the singing "I" is male,[35] "once again" in search

---

[33] "Elaborate sandals" or "fancy sandals"; cf. Sappho fr. 39.1–2 V πόδα<ς> δὲ | ποίκιλος μάσλης ἐκάλυπτε, a Lydian kind of sandal or slipper (certainly footwear, according to Poludeukes 7.93 Bethe).

[34] West's interpretation of χάσκω in this context as "[to be] foolishly preoccupied," or to give "one's whole attention to one thing when other more important issues are at hand" (1970b:209) is overly commonsensical (cf. his view of other scholars' suggestions about Anakreon fr. 358 *PMG* as lacking "commonsense," West 1970b:209n3). West's analysis pays no attention to the verb καταμέμφεται ("the girl is deep in trivial conversation with her [female] friend") and his assertion that "the implication is that Lesbian girls can afford to be choosy, they have young admirers enough to pick from," if taken commonsensically, implies that girls from other places would not be "choosy" when approached by an elderly man. Cf. Dover's criticism (1989:183n38). For χάσκω, see the concise discussion and bibliographical survey in Pfeijffer 2000:177n52.

[35] Unless we make the unnecessary assumption that it can be female too (Davison 1968:248 and Peliccia 1995:24n3).

of an eroticized female companion, a playmate or συμπαίστρια.[36] Through the construction of an almost triangular performative space, Eros, presiding over the reenactment of the song, incites the singer to gaze at a girl who gazes at some other object of desire. Everything else in the song seems, or is, ambivalent,[37] and has caused a lively and extensive scholarly debate in which partisans of one or another view have applied themselves to a fetishization of the female gaze, as well as of the object of the gaze of the Lesbian lass.

For a number of decades, at least in the twentieth century as well as at the beginnings of the twenty-first century, scholars have argued that the phrase ἐστὶν γὰρ ἀπ' εὐκτίτου Λέσβου ("since she is from well-built Lesbos"), which, along with πρὸς δ' ἄλλην τινὰ χάσκει ("and she is gaping at another"), poses the main interpretative conundrums of the song for modern readers, is a clear reference to the sexual proclivities of Lesbian women. "Lesbos," D. L. Page believed, "was a byword for [female homoerotic] practices as early as the lifetime of Anacreon, in the generation after Sappho."[38] More recently and aggressively, its has been maintained that although ἐστὶν γὰρ ἀπ' εὐκτίτου Λέσβου conveys no immediately identifiable homoerotic connotation, the ancient audience of this song would have gradually realized after the completion of its performance, that since "famous Sappho of Lesbos famously liked girls," "ἄλλην here might be a girl, and the first girl is identified as Lesbian in the sense of being 'Sappho' in that respect."[39] The detailed scenarios advanced with regard to the "original" audience and connotative implications of the song match in their diversity and speculative forcefulness only those often proposed for the fragmentary songs of Sappho—probably because of the marked manipulation of a Lesbian woman's imaginary presence in the poem.[40] πρὸς

---

[36] Cf. συμπαίζειν in line 4. συμπαίστρια in Aristophanes *Frogs* 409–411 καὶ γὰρ παραβλέψας τι μειρακίσκης | νῦν δὴ κατεῖδον καὶ μάλ' εὐπροσώπου | συμπαιστρίας ("a playmate"). For the complexities of the meaning of παίζειν and συμπαίζειν in archaic Greek poetry, see Rosenmeyer 2004.

[37] For the problems arising from this short fragment, see Campbell 1973/1974, Easterling 1977, Woodbury 1979 (and his p. 277n1, for earlier bibliography), Giangrande 1981, Marcovich 1983 (with further bibliography), Renehan 1984, Davidson 1987, Goldhill 1987:16–18, Dover 1989:183, Pelliccia 1991, Renehan 1993, Urios-Aparisi 1993, Carbone 1993, Pelliccia 1995, Cyrino 1996:379–382, Pfeijffer 2000, and Hutchinson 2001:273–278.

[38] Page 1955:143.

[39] Pelliccia 1995:32–33 (cf. Pelliccia 1995:33n26, where in an attempt to illustrate his view about "the lack of immediate connotation in the ethnic γάρ-clause [that is, ἐστὶν γὰρ ἀπ' εὐκτίτου Λέσβου] with an example drawn from" an American film that he saw in Berkeley in the early 70s, Pelliccia sweepingly holds that "Anacreon's poem may have opportunistically put together an idea of general Lesbian lesbianism on the basis of Sappho's poetry.")

[40] See e.g. Wilamowitz 1913:116 ("Sie [i.e., the girl] sitzt auf dieser oder jener Kline, oder besser, sie ist noch als μουσουργός mit ihren Instrumenten beschäftigt"); Davison 1968; Davidson 1987; Urios-Aparisi 1993; Pfeijffer 2000:165–167, 170–171.

δ' ἄλλην τινὰ χάσκει, some scholars have argued, refers to the hair of a young man, not to a girl, since the word implied here is κόμην ("hair") and the parallelism between τὴν μὲν ἐμὴν κόμην . . . καταμέμφεται ("she blames my hair") in lines 6–7 and πρὸς δ' ἄλλην τινὰ χάσκει ("and she is gaping at another") in the closing line of the song is striking. Alternatively, the reasoning goes, the hair must be the pubic hair around the penis of a young man, or even the pubic hair of the elderly singing persona, thus alluding to Lesbian women's alleged sexual preference for fellatio.[41] Such analyses presuppose that the young girl with the elegant sandals is viewed—probably in the context of a male *symposion*—as one who would find the pubic hair of an elderly or younger man attractive.

More curiously, it has very often been assumed that in our reconstructions of the context in which this song might have been performed (no period is ever specified, though scholars imply a performance in late archaic Greece), we need to envisage either that Anakreon composed this poem ad hoc—on the occasion of an actual *symposion* or a *pannychis*—or that the singing voice performs the piece with a couple of courtesans or female musicians providing entertainment with a ball. As late as the year 2000, the advantage of finding "a clear description of the dramatic setting, in which all three elements of the opening strophe—the ball hitting the lyric 'I,' the girl and Eros—are functional and connected" has led to "the idea of a stray ball originating from a game of catch played by the sandaled girl with a few other girls."[42] The ingenuity and intense anxiety reflected in the explication of—and the fervent debate over[43]— even the tiniest details of syntactical construction of the song,[44] although

---

[41] Gentili 1973, Giangrande 1973, 1976, 1981. Cf. Wigodsky 1962.

[42] Pfeijffer 2000:166 and 171. Davison believed that "the essential facts of the situation seem to be that the speaker saw the girl's feet before the rest of her became visible, and that she did not see the speaker's hair until after line 4. The speaker then must be supposed to have been lying down with head concealed until roused by the ball"; "it is more likely that we should suppose the incident to have occurred at a *pannychis*, at which persons of free birth and respectable character could associate on equal . . . terms" (1968:249 and 251). Woodbury suggested that the setting of the song "may have been at the court of Polycrates of Samos, to which the Lesbian girl, who is prominent in it, might have found her way as a refugee from the Persian ascendancy on the mainland opposite, or it may have been at the court of the Peisistratids at Athens, where Anacreon later arrived, at an age that might be supposed to account for his mention of white hair in the poem" (1979:278). Wilamowitz 1913:116 thought that the girl was a symposiastic "companion," and, similarly, Fraenkel 1975:292 imagined a hired musician. For further hypotheses, see Pfeijffer 2000:170–171.

[43] See e.g. Giangrande 1973, 1976, and 1981.

[44] See especially Pelliccia 1991 and 1995. In these two and other discussions of Anakreon fr. 358 *PMG*, it is noteworthy that scholars vehemently and constantly stress (as a kind of argument?) that their understanding and interpretation of the ancient Greek and of the syntactical constructions in this late archaic, highly polyvalent fragment is the most correct, "natural," and "idiomatic."

particularly significant in plausibly decodifying its playful "joke" and "punch-line," obscure its central performative elements. One wonders whether, in the context of performance and reperformance, audiences of *different periods and geographical regions* might have made diverse associations, as constantly shifting sociocultural frames and ideologies would have affected the reception of the song.[45] Further, the attempts to identify the actual or dramatic setting of the piece have been related for the most part, I suggest, to a desire to uncover (or refute the existence of) an invaluable late archaic piece of evidence about the female sexuality of a particular region, which may in turn shed light on Sappho.

## Paradigms and Histories

In fact, Sappho and the sociocultural context of her poetry have explicitly or only implicitly been behind almost all of the scholarly discussions to date. The history of the scholarly reception of this archaic song and other archaic melic fragments has not been explored. This prevents us from understanding fully the modern ideological premises that have conditioned the hermeneutics of Anakreon fragment 358 *PMG* or how early scholarly paradigms have mapped out interpretive tendencies in the twentieth and early twenty-first centuries. For all that, in the context of this investigation, two intriguing attempts at "rewriting" the politics of the song might be worth considering—attempts that have been reactivated in different forms by later critics. I hope this discussion will illustrate some of the discursive mechanisms by means of which the song and its overall cultural hermeneutic significance have been "rewritten" in modern scholarship.

The first of these hypotheses concerns the transmitted πρὸς δ' ἄλλην τινὰ χάσκει ("she is gaping at another" [feminine]). At least as early as the eighteenth century, ἄλλην caused intense uneasiness to textual critics. Already in the sixteenth century, an ethical anxiety about this song emerged.[46] The emendation ἄλλον,[47] accepted later by some nineteenth- and twentieth-century editors, was the result of this kind of scholarly skepticism, based on the reasoning that the main manuscript preserving the text of Athenaios' *Deipnosophistai* in which the fragment is quoted displays a number of scribal

---

[45] See, for example, the Athenian representations of Lesbian women in the late-fifth century examined below.

[46] See the Latin translation of the fragment by Dalechamps in Casaubon and Dalechamps 1597, an edition reprinted several times in the seventeenth century. Cf. Marolles 1680.

[47] See Kaibel 1887/1890:vol. 3, 321, apparatus criticus; Barnes 1705:272–275 and Pauw 1732:273 (cf. Edmonds 1931:146).

errors. It is important to recall that Athenaios cites the Peripatetic writer Khamaileon, who, in his treatise *On Sappho*, reported that Anakreon's song was addressed to Sappho. If Sappho needs to be saved from the accusation of homoeroticism, the emendation ἄλλον provides a forceful and remarkably minimal scholarly intervention that points to "Sappho" gaping after another man, not "Anakreon."[48]

Among those who endorsed the emendation ἄλλον was the authoritative critical editor Theodor Bergk, whose *Poetae Lyrici Graeci* continued to be cited as the standard edition of archaic and classical Greek lyric poets even after the appearance of Ernst Diehl's *Anthologia Lyrica Graeca*.[49] Several decades before the publication of Bergk's edition, Friedrich Gottlieb Welcker, a most influential figure in Classics, especially in the study of Sappho, in the nineteenth and early twentieth centuries, suggested that the second stanza of the fragment (lines 5–8) is spurious—invented and added at a later stage in Greek antiquity.[50] This hypothesis marks a different but complementary interpretive practice: playing down the early authority of the second stanza frees archaic Lesbos from any possible, even imaginary, associations with female homoeroticism.

Although Weckler's idea is hardly mentioned in recent discussions of Anakreon fragment 358 *PMG*, the overall interpretive method that it foregrounded is still widely subscribed to. If Sappho's poetry is deemed homoerotic, Anakreon's song must refer or allude to certain marked sociocultural realities of Lesbos. Also, if it is shown that ἄλλην τινά refers to a girl, this would provide us with the earliest piece of evidence for the "homoerotic" complexity of Sappho's poetry.[51] Scholarly views about the existence or absence of female homoeroticism in archaic Lesbos have been implicitly or even explicitly depen-

---

[48] That the emendation was rejected by Wilamowitz (1913:116n1) was perhaps an adequate reason to be similarly dismissed by Diehl and other textual critics. Cf. Marcovich 1983:374n2. Woodbury's brief discussion of the change in the scholarly prejudices against the compatibility of "good [ancient] Greek poetry and [ancient] Greek homosexuality" (Woodbury 1979:281) is somewhat schematic: the scholarly paradigms and ideologies related to poetry, textual criticism, and homosexuality in the field of Classics in the eighteenth, nineteenth, and early twentieth centuries are by far more complex.

[49] Bergk 1882:259. Bergk's edition is cited in recent articles, too.

[50] Welcker 1857:230–233.

[51] See Marcovich (1983:374) who argues that the young girl "prefers a girl to a man because she is Lesbian. The representatives of the alternate interpretation have rightly objected that there is just no evidence for the assumption that 'coming from Lesbos' would imply 'being a Lesbian.' I feel, however, that such an assumption is utterly possible in the times of Anacreon in view of the *unmistakable* homosexual inclinations of Sappho from Lesbos, as expressed in her poetry" (my emphasis). Pelliccia (1991:32) maintains that "Marcovich [i.e, 1983:374, quoted here] states the case well." See also Renehan 1993:45 (and cf. Renehan 1984:30) and Pelliccia 1995:32–33 (see above, n. 39), among other scholars.

dent on the *evidence* of Anakreon's song. The (manipulation of the) methodological concept of *evidence* attesting to ancient *realities* has been one of the most enduring discursive principles in the field of Classics and has contributed to a number of theoretical/hermeneutic paradigms that have not often been adequately challenged.

Instead of attempting to consider the fragment as evidence for a specific reality—whatever this might be—it is preferable, I suggest, to focus on its mechanisms of stereotyping. Anakreon's song did not converse with Sappho. It was made to do so at a later period,[52] thus to some extent conditioning its modern scholarly reception. Although whether it represents a complete song is not clear, Anakreon 358 *PMG* certainly is "a miracle of construction."[53] Probably for this reason, it has most often been deemed complete.[54]

Especially lines 5–8 display a tightly woven construction,[55] which contributes to a discursive elusiveness. The song begins with a synthesis of intricately chosen colors, diffuse as they are in the epithets πορφυρῇ, χρυσοκόμης, and probably ποικιλοσαμβάλῳ.[56] Color textures and desire are further developed with λευκή (κόμη) in the second stanza. Singing of an Eros whose hair is golden is a highly marked discursive gesture.[57] It emphatically introduces associations ("once again golden-haired Eros strikes me") that in the context of performance may not be easily dismissed when ἄλλην τινά is being heard after κόμην. As for the purple color of the ball, it is worth observing that Aphrodite is πορφυρῇ in another song of Anakreon, and Eros is presented by Sappho as coming from heaven wrapped in a purple mantle.[58] Similarly, in other archaic melic compositions, the gait of a woman can be singled out as a quality of allure and admiration.[59] The focus on the elaborate sandals of the girl in this song makes her allure more ποικίλη.

---

[52] Cf. Chapter Four, pp. 355–359.

[53] Woodbury 1979:277.

[54] See Pfeijffer 2000:164n1. A few scholars believe that it may perhaps not be complete: Urios-Aparisi 1993:70 and Hutchinson 2001:273.

[55] Cf. Woodbury 1979:278 and 280n15.

[56] Note that ποικιλοσαμβάλῳ is Seidler's emendation.

[57] In other archaic contexts, χρυσοκόμης Διώνυσος is juxtaposed with ξανθὴν Ἀριάδνην (Hesiod *Theogony* 947); and εὐπέδιλος Ἶρις sleeps with χρυσοκόμα Ζεφύρῳ and gives birth to Eros (Alkaios fr. 327 V). See also Pindar *Olympian* 6.41 χρυσοκόμας (Apollo) and cf. Athenaios 13.604b. Emphasis on the beauty of female hair in performative contexts is given by Alkman fr. 1.50–56, 1.101, 3.9 and 3.71–72 *PMG*; cf. Aristophanes *Lysistratê* 1309–1311 and 1316–1319. On the gendered grammar of hair in ancient Greek and Jewish cultures, see Levine 1995.

[58] Anakreon fr. 357.3 *PMG* (on which see Goldhill 1987:13); Sappho fr. 54 V.

[59] See Sappho fr. 16.17 V: Anaktoria's walk. In a different context, Pindar fr. 94b.70 M, the detail singled out is the sandals of the young woman.

Another programmatic, albeit parenthetical, singing "gesture" sets the tone of the second stanza: "but she—for she is from well-built Lesbos." As soon as this phrasing is completed, a second parenthetical image introduced by γάρ emerges: she spurns his hair—"for it is white." And as the girl blames the singing voice's white hair, she prefers to gape at another—(feminine) object of desire. That πρὸς δ᾽ ἄλλην τινὰ χάσκει refers to "another girl" (νῆνιν or κού-ρην) is most likely.[60] However, as the song develops its condensed and allusive narrative, especially in the context of performance, other associations cannot be shunned. "Some other head of hair," the hair of another man, may be deemed as implied by the antithesis between τὴν μὲν ἐμὴν κόμην and πρὸς δ᾽ ἄλλην τινά. Even if archaic or later Greek audiences could idiomatically understand πρὸς δ᾽ ἄλλην τινά as referring exclusively to "another girl," the antithesis of "my hair" and "another" (κόμη?) is striking. The song itself plays on the idea of ambivalence: Eros challenges the singing "I" to play a "game," the outcome of which is not certain, at least at the outset of the composition. The girl's sandals are emphatically defined as ποικίλα; the ball is "iridescent;"[61] and the multilateral construction of the second stanza, as well as the emphatic χάσκει with no noun to refer to at the end of the second stanza, suggest an openendedness. The "game" being "played" among Eros, the girl, and the poetic voice is "varicolored." Simon Goldhill has rightly stressed that a most pivotal element in the poetics of Anakreon is the "manipulation of the doubleness and gaps in language."[62] Often intricate suggestiveness and ambivalence are poetic tropes exploited by Anakreon, even in cases where specific sociocultural representations, easily decipherable by ancient audiences, lie behind an erotic narrative or a metaphor.

[60] Cf. Pfeijffer 2000:176ns43–45 with earlier bibliography and Hutchinson 2001:276; *contra* Woodbury 1979:283. Pelliccia 1995:33–34 offers a generalizing view about three possible (archaic?) audiences who would understand the "joke" differently: "Everyone has observed that some people are very highly attuned to witticisms and wit generally, while others are defective in this respect, sometimes not understanding a joke even when it is explained to them…Three possible audiences correspond to the three character types described: (A) The ready wit—(B) The majority: They do not see the joke so quickly as A does" [but they understand that ἄλλην τινά refers to a girl]—"(C) The obtusely humorless: Insensitive to the implications of the anticipatory γάρ-clause, C takes the poem as…a simple lament that the girl prefers a younger partner." Dover 1989:183 has pointed out that "it is…possible both that Anakreon means to represent the girl as homosexually interested in another girl and also that 'Lesbian' did not, in his time or at any other time in antiquity, have a primary connotation of homosexuality."
[61] Woodbury 1979:280 appositely described the ball as "purple," or "many-hued," or "iridescent."
[62] Goldhill 1987:14. From a different perspective, Renehan 1984 and 1993 discusses the ambiguity of the song.

In the song about the girl from Lesbos, I suggest, such a masterly cultural performance of ambivalence could contribute even more effectively to stereotyping. What should have remained certain after the end of a performance is that *a girl from Lesbos represented a marked, idiosyncratic case*. The precise "decodifying" of why it represented such a case must have depended on the occasion in which this song could be performed. To go a step further, in the context of monodic or group performances, the members of a gathering could certainly have been familiar with broader archaic cultural representations of women from Lesbos. In fact, the phrase ἐστὶν γὰρ ἀπ' εὐκτίτου Λέσβου conjures up the Homeric formulaic image I considered earlier in this chapter: γυναῖκας... Λεσβίδας, ἃς ὅτε Λέσβον ἐϋκτιμένην ἕλεν αὐτὸς ἐξελόμην. As has been noted, the epithet for Lesbos in the Homeric epics is ἐϋκτιμένη,[63] and ἀπ' εὐκτίτου Λέσβου, by pointing to the Homeric Λέσβος ἐϋκτιμένη, carries a somewhat dignified overtone: "she *hails* from Lesbos."[64] If in the archaic period cultural imaginings of Lesbian women were invested with homoerotic connotations, synchronic archaic audiences would have made appropriate connections, despite the ambivalence of πρὸς δ' ἄλλην τινὰ χάσκει and the polyvalence of ἐστὶν γὰρ ἀπ' εὐκτίτου Λέσβου—Lesbos being known for its alluring women. Yet, at the same time, in a symposiastic context such connections could be broadened. In Athenian *symposia* of the classical period, where, as we shall see later in this chapter, Lesbian women were associated with a sexual preference for fellatio, participants would have activated different associations. And later, the culturally multivalent *Lesbides, Lesbides, Lesbides* would encourage Roman readers of the *Epistula Sapphus ad Phaonem* to view Anakreon's song— in the context of a recitation or on other occasions—in a loaded manner.[65] I would argue, therefore, that the dynamics of connotative openendedness in the performances and reperformances of this song in the archaic and classical periods contributed to the circulation and development of ideological idioms, whatever these might have been—idioms that reflected practices of cultural stereotyping.

Such practices should be seen in a broader sociopolitical context, as part of familiar archaic and classical Greek discursive strategies related, among other factors, to intergroup identity formation. Associating specific geographical areas with certain cultural peculiarities and tendencies is a modality that goes back to the early archaic period. In the seventh century, iambic compo-

---

[63] *Iliad* 9.129, 9.271, *Odyssey* 4.342, 17.133. In *Iliad* 9.664, 24.544, and *Odyssey* 3.169, Lesbos is not modified by an epithet; εὔκτιτος is used for other places in the Homeric epics.

[64] Harvey 1957:213.

[65] [Ovid] *Heroides* 15.199–201.

sitions such as those of Arkhilokhos presented marked elements of—and thus effectively disseminated—regional stereotyping. In Arkhilokhos fragment 42 W, a female figure is described through a comparison with Thracians and Phrygians:

ὥσπερ αὐλῶι βρῦτον ἢ Θρέϊξ ἀνὴρ
ἢ Φρὺξ ἔμυζε· κύβδα δ' ἦν πονεομένη.

Like a Thracian or Phrygian sucking beer through the tube
she sucked; and she was stooped over—working hard.

While in the Homeric epics the Thracians are known as wearing their hair long at the top (Θρήϊκες ἀκρόκομοι, "the top-knotted Thracians") and Hipponax fragment 115.6 W repeats the same idea,[66] Arkhilokhos adopts or promotes a different image for them. This performative trafficability of stereotypes is evident in other songs of Arkhilokhos: in fragment 248 W, the inhabitants of the island of Karpathos are assigned a proverbial trait,[67] while in fragment 124 W the greediness and parsimony of the people of Mykonos (Μυκονίων δίκην) is juxtaposed with the behavior of a male figure who is criticized for going to *symposia* uninvited and drinking much wine without contributing to the expense.[68] Later, in a forceful composition, Pindar will attempt to reverse this practice of stereotyping by undermining the old idea that the Boiotians, his compatriots, were rustic and vulgar.[69]

Finally, an intriguing case that suggests how effectively special traits were attached to people of different geographical areas are the Sybarites. Although the archaic Greek city of Sybaris, in South Italy, was destroyed in 510 BC, its citizens remained in people's cultural rhetoric salient examples of luxuriousness and effeminacy—comparable only to Ionian luxurious living.[70] In a story about Kleisthenes of Sikyon and his daughter Agariste, Herodotos includes in the list of her suitors Smindyrides of Sybaris, "a man whose life-style reached the highest degree of luxuriousness and delicacy,"[71] and in later

[66] *Iliad* 4.533; Hipponax fr. 115 W is attributed by some scholars to Arkhilokhos instead. Note that Theokritos 14.46 (οὐδ' εἰ Θρακιστὶ κέκαρμαι) may reflect a similar idea about Thracian haircut.

[67] Καρπάθιος τὸν μάρτυρα; for the meaning of the phrase see Hesykhios s.v. (who preserves the fragment) and the sources cited in Arkhilokhos fr. 248 W.

[68] See Athenaios 1.7f–8b, who quotes the fragment, as well as Kratinos fr. 365 K-A (τὸν γοῦν γλίσχρον Ἰσχόμαχον Κρατῖνος Μυκόνιον καλεῖ...). On the Mykonians as avaricious, cf. the sources cited in Arkhilokhos fr. 124 W and Kratinos fr. 365 K-A, and see Göbel 1915:75–76.

[69] Pindar *Olympian* 6. 84–89; cf. Pindar fr. 83 M. For such stereotypes attached to the Boiotians, see Göbel 1915:57–63, and cf. Kratinos fr. 77 K-A and Alexis fr. 239 K-A with Arnott's comments (1996a:673–674).

[70] The sources are discussed by Dunbabin 1948:75–83. Cf. Presta 1959 and Rutter 1970.

[71] Herodotos 6.127: ὃς ἐπὶ πλεῖστον δὴ χλιδῆς εἷς ἀνὴρ ἀπίκετο.

tradition Smindyrides will remain a Sybarite most famous for his voluptuousness and effeminacy. Not unlike East Greek people and their neighbors, the Sybarites became a byword for soft-living luxury: Sybaritan boys, Athenaios notes, used "to wear purple mantles and have the locks of their hair tied up with golden ornaments."[72] Again, Herodotos informs us of the very close ties that Sybaris and the Ionian city of Miletos had established, while Timaios confirms the friendship between the two cities and stresses that the Sybarites shared the devotion the Etruscans, among the people of Italy, and the Ionians showed toward luxury: the Sybarites, who loved—and were masters of the art of—banquets,[73] wore garments made of Milesian wool.[74] By the second half of the fifth century BC, the verb συβαρίζειν (or συβαριάζειν) was coined to express the practice of indulging in "Sybaritic" luxuriousness.[75]

In Anakreon's time no such verb had been invented for people of Lesbos, as far as available sources permit us to see. Compared to other archaic instances of poetic exploitation of cultural stereotyping, Anakreon fragment 358 *PMG* appears more subtly multivalent in the associations it attempts to establish. I suggest that Anakreon's song plays on such archaic discursive practices and ideological idioms, especially since his "story" is related to the imagined presence of an alluring young girl with fancy sandals in a convivial setting—that is, to the polyvalent performative manipulation of women's bodies in poetry predominantly sung in male symposiastic contexts.

## Libidinal Economies[76]

If Anakreon's archaic ἐστὶν γὰρ ἀπ' εὐκτίτου Λέσβου alludes to the Homeric Λέσβος ἐϋκτιμένη and its beautiful young women, a passage from a classical playwright explicitly introduces further marked dimensions to the Homeric image:[77]

(Α.) δώσει δέ σοι γυναῖκας ἑπτὰ Λεσβίδας.
(Β.) καλόν γε δῶρον, ἕπτ' ἔχειν λαικαστρίας

---

[72] Athenaios 12.518e, probably drawing on the fourth/third century BC historian Timaios, who was from Sicily.
[73] Aristophanes fr. 225.3 K-A Συβαρίτιδάς τ' εὐωχίας; Aristophanes *Peace* 344; see Göbel 1915:128–129 and cf. Dunbabin 1948:80–81.
[74] Herodotos 6.21 and Timaios *FGrH* 566 F 50 (= Athenaios 12.519b–c).
[75] Aristophanes *Peace* 344; cf. Phrynikhos fr. 67 K-A and the later sources cited in Göbel 1915:129.
[76] The title here is inspired by Lyotard's insightful book on erotics and economy (Lyotard 1993 [1974]). His chapter on trade includes an important discussion ("Lydian Eulogy") of Herodotos' report about the Lydians being the first people to mint and use gold and silver coinage and to introduce retail trade (Herodotos 1.94, part of his Lydian ethnography).
[77] *Iliad* 9.270–272. Cf. 9.128–130 and 19.245–256.

(A.) He will give you seven women, from Lesbos.
(B.) What a beautiful gift—to have seven cocksuckers

This is a fragment from Pherekrates' *Kheirôn* (159 K-A), a comedy that, as its title suggests, must have somehow employed in its overall thematics the mythological figure of the homonymous centaur. A date for the production of the comedy is difficult to posit, but the very late fifth century would be a suitable time for Pherekrates to have been able to criticize composers/ poets like Timotheos and Philoxenos (*Kheirôn* fr. 155 K-A).[78] Pherekrates won his first victory some time between 437 and 430 BC, and his *Savages* (*Agrioi*) was performed in 420 BC. Whether his *Kheirôn* was a kind of mythological burlesque remains unknown. For all that, among the few and indirectly transmitted fragments that we have from this comedy,[79] it is worth observing that the largest part of fragment 162 K-A is a parody of a passage from the *Greater Works* (*Megala Erga*) attributed to Hesiod. According to Athenaios (8.364b–c), who quotes fragment 162 K-A, contemporary men, when it came to banquets, did not follow the exhortations offered by a (unidentified) character from Pherekrates' *Kheirôn* (fr. 162.1–3 K-A); instead they memorized the lines that followed those excellent exhortations (fr. 162.4ff. K-A)—lines that described the graceless behavior of a host who has invited people to dinner after a sacrifice but looks forward to their leaving soon after their arrival. Athenaios points out that these lines from Pherekrates' *Kheirôn* parodied some lines, now lost, from the *Megala Erga*.[80] Moreover, in the same fragment from *Kheirôn*,

[78] There is scholarly consensus that *Kheirôn* is by Pherekrates (Pherekrates frs. 155–162 K-A). Probably under the influence of Eratosthenes of Kyrene (who attributed Pherekrates' *Metallês* to Nikomakhos ὁ ῥυθμικός, see Pherekrates Μεταλλῆς test. 1–2 K-A [p. 155] and Pherekrates test. 3 K-A [p. 103]), Athenaios expressed some doubts about the attribution of *Kheirôn* to Pherekrates: ...ἐπὶ νοῦν οὐ λαμβάνοντες τὰ εἰρημένα ὑπὸ τοῦ τὸν Χείρωνα πεποιηκότος, εἴτε Φερεκράτης ἐστὶν εἴτε Νικόμαχος ὁ ῥυθμικὸς ἢ ὅστις δή ποτε (8.364a); cf. also Athenaios 9.388f, 9.368b, 14.653e–f, and Schol. Aristophanes *Frogs* 1308 (Chantry 1999:147). In their *Poetae Comici Graeci*, Kassel and Austin attribute *Kheirôn* to Pherekrates, and most scholars find no reason to doubt this attribution (see Dobrov and Urios-Aparisi 1995:142–143, Henderson 2000:142, and Hall 2000:414).

[79] Only eight fragments are preserved (155–162 K-A). It has been thought that two more fragments (*incertarum fabularum* fr. 165 and 168 K-A) that cannot be attributed to a certain comedy by Pherekrates may belong to *Kheirôn* (cf. Kassel and Austin's note in Pherekrates fr. 162 K-A).

[80] See Merkelbach and West 1967:146 (also cited by Kassel and Austin). Note that Athenaios' text refers to ἐκ τῶν εἰς Ἡσίοδον ἀναφερομένων μεγάλων Ἠοίων καὶ μεγάλων Ἔργων; Merkelbach and West have suggested that μεγάλων Ἠοίων καὶ should be deleted, while Dindorf (not mentioned by Merkelbach and West, but cited by Kaibel) had preferred to delete καὶ μεγάλων Ἔργων. Here my reference to the *Megala Erga* accords with Merkelbach and West's idea only for the sake of brevity. I do not subscribe to this idea, since Dindorf's suggestion would be equally plausible.

lines 11–12 K-A (μηδένα μήτ' ἀέκοντα μένειν κατέρυκε παρ' ἡμῖν | μήθ' εὕδοντ' ἐπέγειρε, Σιμωνίδη, "do not detain anyone to stay with us against his will, nor wake up a man who is asleep, Simonides") constitute a quotation of *Theognidea* 467 and 469,[81] thus contributing further to the levels of intertextuality that the fragment must have displayed.

Comparably parodic, but this time more transparently so for us, is Pherekrates fragment 159 K-A, which draws on Homeric poetry. In *Iliad* 9.270–271, the speaker is Odysseus who addresses Akhilleus and lists the rich gifts that Agamemnon will give him to placate his *mênis* and to persuade him to help the Achaeans in this most critical moment of the war:

> δώσει δ' ἑπτὰ γυναῖκας ἀμύμονα ἔργα ἰδυίας,
> Λεσβίδας...

> And he will give seven women skilled in flawless handiwork,
> women of Lesbos...

According to a widely endorsed suggestion by August Meineke,[82] the two speakers in Pherekrates fr. 159 K-A may be Odysseus and Akhilleus. The fragmentary nature of this passage and of the whole play does not allow us to view the two lines as something more than an intertextual dialogue with the Homeric episode, an obscene banter related to the beautiful Lesbian women of *Iliad* 9. I should stress that the Homeric reference to their beauty (9.272 and cf. 9.130) and their superb skills in handiwork is not omitted but caricatured in the καλόν of the second line of Pherekrates fragment 159 K-A and amplified by further details about their dexterity. The particle γε in the second speaker's remark, "what a beautiful gift," may convey a kind of irony,[83] but what is intriguing here is the word λαικαστρίας and its association with women from Lesbos in the fifth century BC. It is in this respect that Pherekrates' fragment is of significance for my attempt to re-draw the cultural landscape of stereotyping against which the East Greek figure and poetry of Sappho could be viewed by male audiences in fifth- and fourth-century Athens.

The sources that preserve Pherekrates' two lines comment on a sexual proclivity of the Lesbians. One of these sources, an ancient scholium on Aristophanes *Frogs* 1308, explains that the denotation of the verb *lesbiazein* is "to consort with, to have sexual intercourse (with someone) unlawfully; for the

---

[81] In line 11 of *Kheirôn* fr. 162, instead of μηδένα τῶνδ' ἀέκοντα (*Theognidea* 467), the transmitted text provides the emphatic μηδένα μήτ' ἀέκοντα. On improvisation and the *Theognidea*, see Chapter Four.

[82] Meineke 1839:77–78.

[83] Cf. Jocelyn 1980:45n24.

Lesbians were slandered on this account."[84] The *scholia recentiora* on the same line of the *Frogs*, which do not quote Pherekrates fragment 159 K-A, provide a similar explanation: "*lesbiazein* is to do shameful things; for the Lesbians are notorious for shameful and unlawful [sexual] practices."[85] Interestingly, another source in which the Pherekratean fragment is quoted is a twelfth-century commentary on *Iliad* 9.129, one of the lines in which Agamemnon refers to the seven Lesbian women that he chose for himself when Akhilleus captured well-built Lesbos—that is, women that Agamemnon proposes to give him as gifts. In this medieval Greek commentary by Eustathios of Thessalonike, the two passages are (haphazardly?) juxtaposed without any comment on the intertext of Pherekrates fragment 159 K-A. In his commentary on this Homeric line, Eustathios focuses on several aspects of the island of Lesbos, which, as he says, was also called Mytilene at that time, and points out the following:

> ἰστέον δὲ καὶ ὅτι δοκεῖ οὐκ ἀγαθοὺς ἀνθρώπους ἡ Λέσβος ἐνεγκεῖν.
> Ὅθεν καὶ λεσβιάσαι τὸ αἰσχρῶς μολῦναι τὸ στόμα κατὰ Αἴλιον
> Διονύσιον,...

> one must know that it seems Lesbos did not produce [morally] good people; hence *lesbiasai* means "to defile the mouth shamelessly," according to [the second-century AD Atticist lexicographer] Ailios Dionysios.

To illuminate this remark, Eustathios refers to Aristophanes *Frogs* 1308 (αὕτη ποθ' ἡ Μοῦσ' οὐκ ἐλεσβίαζεν, οὔ).

If we now turn to the fifth-century AD lexicographer Hesykhios,[86] the definition of λεσβιάζειν ("to do like the Lesbian women") and its semantic association with λαικάζειν become even more focused: λεσβιάζειν· πρὸς ἄνδρα στοματεύειν. Λεσβιάδας γὰρ τὰς λαικαστρίας ἔλεγον ("*lesbiazein*: to mouth [the penis of] a man; for the *laikastriai* were called 'Lesbian women'"). These and other ancient commentators as well as lexicographers clearly suggest that "to

---

[84] Text in Chantry 1999:147 "λεσβιάζειν" τὸ παρανόμως πλησιάζειν. διεβάλλοντο γὰρ ἐπὶ τούτῳ οἱ Λέσβιοι. Meineke proposed the emendation αἱ Λεσβίαι, instead of the transmitted οἱ Λέσβιοι (cf. the *apparatus fontium* in Pherekrates fr. 159 K-A, but, since volume VII of their *Poetae Comici Graeci* appeared in 1989, Kassel and Austin could not consult Chantry's excellent edition).

[85] Text in Chantry 2001:218: "λεσβιάζειν" ἐστὶ τὸ αἰσχρὰ ποιεῖν. διαβάλλονται γὰρ οἱ Λέσβιοι ὡς αἰσχρὰ καὶ ἄθεσμα πράττοντες. Chantry reports that other manuscripts have ἀπὸ μεταφορᾶς τῶν Λεσβίων αἰσχρῶν ὄντων ("from a metaphor related to the Lesbians who were shameless"). Note that in *scholium vetus* 1308 quoted above (n. 84) Markos Mousouros—after παρανόμως πλησιάζειν—added καὶ μολύνειν τὸ στόμα ("and to defile the mouth"); see Chantry 2001:218. On Mousouros and some of his scholarly activities, see Cameron 1993:184–185 and especially the important work of Layton 1994:15, 21–22 and passim.

[86] Hesykhios is dated to the fifth or the sixth century AD.

do like the Lesbian women"—*lesbizein* or *lesbiazein*—meant "to perform fellatio upon." The ancient scholia on Aristophanes *Wasps* 1346 even provide the etiological explanation that the verb and the sexual practice it denotes took their name from the inhabitants of Lesbos because it was among them that this was experienced first by a woman.[87] The scholia on the same line from the *Wasps* quote three of the seven references to this Lesbian practice during the classical period.[88]

In fifth- and early fourth-century Attic comedy, from Aristophanes to Theopompos and Strattis,[89] the Lesbians were viewed as being idiosyncratic in providing and receiving sexual satisfaction. The verb λεσβίζειν/λεσβιάζειν appears to be equivalent to λαικάζειν—ancient Greek version of the Latin *fellare*.[90] Possibly in the context of a *paignion* (a mimetic entertainment of erotic character performed at *symposia*),[91] one of the three old women in the final part of the *Ekklesiazousai*, by referring to the Greek letter *labda* (δοκεῖς δέ μοι καὶ λάβδα κατὰ τοὺς Λεσβίους, "you seem to me that you also want to do the *labda* in the manner of the Lesbians"), would evoke the highly coarse tone of the verb λαικάζειν and, through histrionic suggestive gestures, the sexual position of one's legs which the shape of the letter *labda* (Λ) implied.[92] It should be observed that in a few of the comic passages where the practice is referred to, the meaning is not entirely clear and that the possible connotations of λεσβίζειν as a marked Lesbian sexual preference might originally have been somewhat

[87] παρὰ τὸ ἱστορούμενον, ὅτι παρὰ Λεσβίοις τοῦτο πρῶτον ἡ γυνὴ ἔπαθεν.

[88] Theopompos fr. 36 K-A (ἵνα μὴ τὸ παλαιὸν τοῦτο καὶ θρυλούμενον | δι' ἡμετέρων στομάτων ‹ › | εἴπω σόφισμ', ὅ φασι παῖδας Λεσβίων | εὑρεῖν), Strattis fr. 42 K-A, and Strattis fr. 41 K-A (with no explicit reference to Lesbos as it is transmitted, but see Dobree's supplement χοὶ Λέσβιοι).

[89] Aristophanes *Frogs* 1306–1308; *Wasps* 1345–1349; *Ekklesiazousai* 920; Pherekrates fr. 159 K-A. These passages are concerned with female figures. For references to male figures, see n. 88. The passages are discussed, among others, by Jocelyn 1980:31–34. Lenaiou [Charitonides] provided a learned discussion of the verb *lesbizein/lesbiazein* (Lenaiou 1935:84–87); more recently, see Taillardat 1965:105, 428–429 (on *Frogs* 1305–1308); and especially Henderson 1991:183–184.

[90] For λαικάζειν, see Jocelyn 1980; Bain 1991:74–77. Jocelyn 1980 adopted ideas put forward earlier by W. Heraeus and A. E. Housman, who had collected and examined the available sources; he also took into account some further evidence discussed by Shipp (1977). Although exhaustive, Jocelyn 1980 should be read with caution, especially in terms of his assertions about λαικάζειν in late antique and medieval Greek and about the possible sources of medieval Greek texts; cf. also Bain's criticism (1991:75n196, and 76n202). For *fellare*, see Adams 1982:130–134; for *irrumare*, see Adams 1982:125–130 (especially p. 126: "*irrumo* and *fello* describe the same type of sexual act, but from different points of view: *irrumo* from the viewpoint of the active violator [= *mentulam in os inserere*], *fello* from that of the passive participant"); for substitutes for *fellare* and *irrumare*, cf. Adams 1982:211–213.

[91] Davidson 2000:50–51.

[92] *Ekklesiazousai* 920. On this passage, see Ussher 1973:203–204; Henderson 1991:183–184; Pfeijffer 2000:173n34; *contra* Jocelyn 1980:33–34. For a similar reference to *lambda* in Anthologia Palatina 12.187 (Straton), see Lenaiou 1935:87; Jocelyn 1980:43–44.

broader. Note that some of the passages that allude to Lesbian *erotica* suggest that fellatio could be envisaged—on the comic stage—as being practiced by males on males.[93] The principal meaning of λεσβίζειν/λεσβιάζειν must, therefore, have been "to perform oral sex," possibly including cunnilingus.[94] In that regard, λεσβιάζειν and φοινικίζειν ("to do like the Phoenicians," "to perform cunnilingus") represented two ethnically distinguishable but not entirely dissimilar practices.[95]

Although in the Pherekrates fragment Λεσβίδας and λαικαστρίας are closely related, Λεσβίς in fifth-century Athens would not be exclusively taken as indicating a "cocksucker" but could more broadly denote a "prostitute."[96] In a much later period and in different sociocultural contexts, the marked noun Λεσβίδες will be employed by Dion Khrysostomos[97] in a more general sense and in conjunction with *hetairai* ("courtesans").

Coining words like λεσβίζω and λεσβιάζω that referred to specific addictions, practices, or idiosyncrasies were part of a broader discursive trope of ancient Greek cultural economy. The verbs λακωνίζειν, συβαρίζειν (συβαριάζειν), ἀττικίζειν, μεγαρίζειν, λακεδαιμονιάζειν, κορινθιάζεσθαι, σιφνιάζειν, χιάζειν, βοιωτιάζειν, χαλκιδίζειν, and αἰγυπτιάζειν all meant "to do like—to imitate—the people of a particular city, island, area, or ethnic group" and they all appeared in comedies, most of them in Attic plays of the classical period.[98] Among these, "imitating the Lakedaimonians," "the Khalkidians," "the

[93] See n. 88, the passages quoted in Scholia on Aristophanes *Wasps* 1346. Later lexicographers and commentators frequently refer to "the Lesbian practice" without making any distinction between women and men (for sources, see Jocelyn 1980:48n66).

[94] Cf. Pfeijffer 2000:173n34. Since Aristophanes *Ekklesiazousai* 918–923 is a problematic passage (for the attribution of lines to speakers, see Sommerstein 1998:217), Pfeijffer's conclusion that "these reputed Lesbian oral skills were not incompatible with female homosexuality" goes unnecessarily beyond the ancient evidence about the known Lesbian sexual practice.

[95] Loukianos *Pseudologistês* 28 mentions both verbs without making or providing a clear-cut distinction. Note that Galenos XII. 249 Kühn suggests that performing cunnilingus (*phoinikizein*) is worse than performing fellatio (*lesbiazein*), but the reason for his assertion is not entirely clear. For the "Phoenician sexual practice," see schol. Aristophanes *Peace* 885, Hesykhios s.v. σκύλαξ, Etymologicum Magnum s.v. γλωττοκομεῖον (Euboulos fr. 140 K-A), and cf. Lenaiou 1935:87–88, Henrichs 1972:19–23, Henderson 1991:186, and Roilos 2005:262.

[96] Cf. Aristophanes *Akharnians* 526–529 and *Wasps* 1346.

[97] Dion Khrysostomos 66.9 οὐ γὰρ ὀλίγοις λίνοις, φασίν, ἢ δυσὶν ἢ τρισὶν ἑταίραις οὐδὲ δέκα Λεσβίσι θηρεύεται δόξα καὶ δῆμος ὅλος εἰς πειθὼ καὶ φιλίαν ἄγεται [...].

[98] λακωνίζειν Aristophanes fr. 358 K-A and Eupolis fr. 385.1 K-A; συβαριάζειν Aristophanes *Peace* 344; ἀττικίζειν Platon fr. 183.1 K-A (and cf. Eupolis fr. 99.25 K-A); μεγαρίζειν Aristophanes *Akharnians* 822; λακεδαιμονιάζειν Aristophanes fr. 97 K-A; κορινθιάζεσθαι Aristophanes fr. 370 K-A; σιφνιάζειν and χιάζειν Aristophanes fr. 930 K-A and σιφνιάζειν *com. adesp.* 942 K-A; βοιωτιάζειν *com. adesp.* 875 K-A; χαλκιδίζειν Aristophon fr. 3 K-A; αἰγυπτιάζειν Aristophanes *Thesmophoriazousai* 922 and Kratinos fr. 406 K-A. For κρητίζειν and κιλικίζειν see Suetonius in Taillardat 1967:62–63 and 147.

Korinthians," "the Siphnians," or "the Lesbians" involved some kind of sexual proclivity.[99] In this context, I am not interested in undermining or supporting the trustworthiness of the evidence of classical comedy about Lesbian sexual proclivities. These comic references may perfectly reflect ideological constructs related to Athenian cultural politics. In the case of the Mytileneans, the prehistory of Athens' dispute with them over Sigeion could have reinforced the creation of such an image of their social attitudes.[100] What is more important is to explore such views about Lesbian women in an even wider framework. The broader the context we attempt to take into account, the safer the implications of our historical fieldwork.

## Cultural Theatrics

Classical and later Greek attitudes toward East Greek women can throw some further light on the complex ideological matrices through which the female worlds depicted in Sappho's poetry could have been read and eventually rewritten. Since my focus here is on the cultural history of the classical period, the discussion that follows attempts to be as synchronic as possible, although I shall also consider later sources as comparative material related to possible (but not a priori certain) reflections of earlier inflections of stereotyping. Such inflections seem to have been so deeply embedded in the social imaginary of classical Athens that later ideological idioms displaying significant overlap with earlier ones might possibly have been in some archaizing "dialogue" with the classical practices of stereotyping. At the same time, I place emphasis on *diffusion—through performance—*and the trafficability of classical Athenian discursive biases related to East Greek women as well as the interaction of such biases with non-Athenian attitudes.

It is in the plays of Aristophanes and other almost contemporary playwrights that such ideological matrices, often constructed metonymically through socioeconomic associations, are displayed and parade, as it were, side by side with other refractions of classical Athenian male modes of thought. Defin-

---

[99] For χαλκιδίζειν see Kassel and Austin's annotations in Aristophon fr. 3 (note that the evidence is late). For pederasty in Khalkis, see Dover 1989:187–188; for Boiotia, see Dover 1989:81–82, 190. In Sparta, pederasty was said to have been widespread. According to Ploutarkhos *Lykourgos* 18, pederastic love was so approved among males that even the maidens attracted good and noble women as their lovers (οὕτω δὲ τοῦ ἐρᾶν ἐγκεκριμένου παρ᾽ αὐτοῖς, ὥστε καὶ τῶν παρθένων ἐρᾶν τὰς καλὰς καὶ ἀγαθὰς γυναῖκας…). On Aelian *Historical Miscellany* 3.12 and Sparta, see Dover 1988a:123–124. For σιφνιάζειν, see *com. adesp.* 942 K-A and Kassel and Austin's annotations (cf. *com. adesp.* 284 K-A); Aristophanes fr. 930 K-A (χιάζειν and σιφνιάζειν) is possibly about musical eccentricity or experimentation.

[100] Cf. Dover 1989:183.

ing female sexual satisfaction through the use of dildos was not an uncommon practice in fifth-century Attic comedy. In Aristophanes *Lysistratê* 158, the comic poet Pherekrates is credited with the phrase "skin the skinned dog" (κύνα δέρειν δεδαρμένην),[101] which in this context denotes the use of dildos by women. If their husbands ignore them, the women, Lysistrate suggests to Kalonike, can resort to dildos, which, according to Kalonike however, are only c(r)ock bunkum imitations. Earlier in the play, these leather toys are identified as products made in Miletos,[102] one of the major East Greek cities in Asia Minor. Milesian dildos must have become well known in one way or another.[103] The ancient scholia on Aristophanes *Lysistratê* 109–110 state that the comic poet playfully associated dildos with Milesian women, and this clear association must have also been made by classical Attic audiences. The scholia also assert that it was widows who used leather dildos. The Suda entry on the word ὄλισβος defines a dildo as a leather penis used by Milesian women as well as by τριβάδες ("'masculine' lesbians")[104] and those who indulge in shameless sexual acts (αἰσχρουργοί).[105] Further, a fragment from another comedy by Aristophanes reiterates—this time through a unanimously endorsed supplement—the Milesian provenance of dildos.[106] And the contemporary comic poet Kratinos would humorously, but closely, associate dildos with promiscuous women.[107]

Not unlike Ionian music, East Greek women were viewed and constructed in fifth- and early-fourth-century Attic comedies as potentially sensual and even subversive.[108] In a long scene toward the end of *Ekklesiazousai*, the first of the three old women invokes the Muses to sit on her lips and to find a voluptuous Ionian ditty for her to sing (882–883):

…Μοῦσαι δεῦρ' ἴτ' ἐπὶ τοὐμὸν στόμα,
μελύδριον εὑροῦσαί τι τῶν Ἰωνικῶν.

[101] Pherekrates fr. 193 K-A.

[102] Aristophanes *Lysistratê* 108–110. For similar associations, see Sophron frs. 23 and 24 K-A (from *Women's Mimes*).

[103] Cf. Herodas' mimiambs 6 and 7; see below.

[104] On dildos used by *tribades*, see [Loukianos] *Erôtes* 28.

[105] In the Suda (s.v.), ἀρρητοποιΐα ("practicing unmentionable things," "practicing fellatio") is defined as ἀσέλγεια, αἰσχρουργία. In the Suda entry on ὄλισβος, widows are also listed among those who used the ὄλισβος (note the past tense "used" that the Suda compiler employs twice). In the same entry, Aristophanes *Lysistratê* 109–110 is quoted.

[106] Fr. 592.16–17 K-A: τί ἐστι τοῦθ' ὃ λέγουσι τ[ὰς Μιλησίας]] παίζειν ἐχούσας, ἀντιβολῶ, [τὸ σκύτινον;] , and see Kassel-Austin's apparatus criticus on fr. 592.17–18. The supplements are highly likely: cf. fr. 592.18–21 and 24–25 K-A.

[107] Fr. 354 K-A; for promiscuous women (μισηταὶ γυναῖκες) cf. Arkhilokhos fr. 206 W and see the testimonia quoted by West.

[108] For Ionian music, see Aristophanes *Thesmophoriazousai* 163, *Ekklesiazousai* 883 and the whole scene thereafter, and Platon fr. 71 K-A.

At the outset of the scene, this old woman, probably an Athenian citizen, is represented as restless; she is burning with the desire to exploit the new privileges that Praxagora's decree in the play now gives her: she can have the young girl's lover for a sexual encounter before he sleeps with the girl, since according to the newly established social order, this is the legal procedure in such matters (944–945). The wanton tone of the whole episode is already evident in the reference to the "Ionian tune" the old lady wishes to sing. In the context of an exchange of songs between herself and the young girl, the girl indirectly addresses the former and teasingly asks, as a matter of urgency, for Orthagoras, a comic personified version of a dildo, so that the old woman may satisfy herself sexually. The old woman's reply metonymically associates the Ionian women with the Lesbian women, thus providing, I suggest, the most marked and inclusive "definition" of East Greek female sexuality preserved in texts of the classical period (918–920):

ἤδη τὸν ἀπ' Ἰωνίας
τρόπον τάλαινα κνησιᾷς·
δοκεῖς δέ μοι καὶ λάβδα κατὰ τοὺς Λεσβίους.

Poor girl, you are already having an itch
for the Ionian pleasure.
You seem to me to also want to do the *labda* in the manner
of the Lesbians.[109]

Performative discourses of this kind, as well as other scripts and texts composed earlier than the early fourth century, effectively contributed to habitually internalized and reproduced ideological idioms related to the inhabitants of East Greek cities and of any other Greek areas—Sybaris in South Italy, for instance—that shared the luxuriousness and alleged profligacy of East Greece. Such modalities of thought were often adopted unquestioningly or further modified by later generations, which constructed their own cultural narratives based on comparably habitual processes.

It is therefore interesting that later authors refer to stories that suggest parallel ideas about the markedness of East Greek women—stories that have remained largely underexplored. My exploration here by no means suggests any kind of schematic continuity in ideological inflections of stereotyping, since considerably divergent views were advanced and constructed in the centuries after the classical period that is my focus.[110] I employ them only as comparative material that throws light on how the markedness of

---

[109] Cf. above, p. 187.
[110] See e.g. *Anthologia Palatina* 7.614, an epigram about two Lesbian women.

East Greek women could be perceived in later periods. These narratives are embedded mostly in historiographic or ethnographic discourses as well as in poetry and collections of *thaumasia* ("marvels"), legends, and other intriguing stories.

One of these narratives was reported by Theopompos of Khios, a major fourth-century BC East Greek historian, in his *Philippikai historiai* ("History of Philippos"). The *Philippikai historiai* was an ambitious project focused on Philippos II but covering diverse aspects of the history of "the deeds of Greeks and barbarians,"[111] a kind of universal history. In the fiftieth book of this work, Theopompos included the following story about the people of Methymna, one of the five chief cities on Lesbos:

> καὶ τὰ μὲν ἐπιτήδεια προσφερομένους πολυτελῶς, μετὰ τοῦ κατα-
> κεῖσθαι καὶ πίνειν, ἔργον δ᾽ οὐδὲν ἄξιον τῶν ἀναλωμάτων ποιοῦν-
> τας. ἔπαυσεν οὖν αὐτοὺς τούτων Κλεομένης ὁ τύραννος, ὁ καὶ τὰς
> μαστροποὺς τὰς εἰθισμένας προαγωγεύειν τὰς ἐλευθέρας γυναῖκας
> <καὶ> τρεῖς ἢ τέτταρας τὰς ἐπιφανέστατα πορνευομένας ἐνδήσας εἰς
> σάκκους καταποντίσαι τισὶν προστάξας.

> And they had their meals in sumptuous style, by reclining and drink-
> ing, but they did no estimable deed that would justify these ex-
> penses. So the tyrant Kleomenes stopped them from doing those
> lavish things—the tyrant who bound up in sacks the procuresses
> who were used to pandering women of the free class, as well as three
> or four of the most conspicuous prostitutes, and commanded them
> to be thrown into the sea.[112]

This quaint narrative, with Kleomenes or, rather, Kleomis,[113] a fourth-century ruler of Methymna, taking action over habits male and female, combines two pivotal elements often reflected in narratives about East Greece: the extravagant luxury of its different cities and the "otherness" of their women. This otherness, which here is only slightly alluded to, will become more explicit several centuries later in Ploutarkhos' *Aitia Hellênika* ("Greek Questions").[114] The question now is: "why, on Samos, people invoke the Aphrodite of Dexikreon"? Ploutarkhos' research led him to two alternative etiological stories; the first of them reads as follows:

[111] Theopompos *FGrH* 115 F 25.
[112] Theopompos *FGrH* 115 F 227.
[113] See Jacoby's note on Theopompos *FGrH* 115 F 227 in *FGrH* 2D:387.
[114] Ploutarkhos 303c–d.

πότερον ὅτι τὰς γυναῖκας αὐτῶν ὑπὸ τρυφῆς καὶ ὕβρεως ἀκόλαστα
ποιούσας Δεξικρέων ἀνὴρ ἀγύρτης καθαρμῷ χρησάμενος ἀπήλλα-
ξεν.

Is it because a mendicant, Dexikreon, by conducting a purification
rite, freed the Samian women from the dissoluteness they indulged
in because of their luxuriousness and lewdness?

Although often representing different local traditions and sociopolitical rhet-
oric, East Greek women and their histories were viewed and written in terms
of their potential licentiousness, their marked idiosyncrasies, or at least their
unquenchable and lovelorn fervor. Long before the Suda entry related to the
sex toys of Milesian women,[115] around the mid-third century BC Herodas, in
one of his mimiambs, presented two women, Koritto and Metro, chatting
about dildos somewhere on the coast of Asia Minor.[116] Kerdon, the craftsman
who stitched a flawless scarlet dildo for Koritto, came from Khios or Erythrai
(6.58), a city in Asia Minor almost opposite the island of Khios. The cobbler
Kerdon reappears in another mimiamb by Herodas,[117] this time displaying in
his shop the elegant shoes and, more indirectly, dildos he skillfully produced
for his lady customers. As for Samian women, in the early third century BC
Asklepiades of Samos composed an epigram about two of them with appar-
ently atypical erotic proclivities:

Αἱ Σάμιαι Βιττὼ καὶ Νάννιον εἰς Ἀφροδίτης
    φοιτᾶν τοῖς αὐτῆς οὐκ ἐθέλουσι νόμοις,
εἰς δ’ ἕτερ’ αὐτομολοῦσιν ἃ μὴ καλά. δεσπότι Κύπρι,
    μίσει τὰς κοίτης τῆς παρὰ σοὶ φυγάδας.

The Samians Bitto and Nannion do not wish to frequent
    the realms of Aphrodite in accordance with her laws,
but desert to other things that are not good. Mistress Kypris,
    abhor those who are fugitives from the love-making within
        your realm.[118]

According to an ancient commentator on this epigram, Asklepiades attacks
them for being "masculine" lesbians (ὡς τριβάδας διαβάλλει), but I agree with

[115] Suda s.v. ὄλισβος ; see above, p. 190.
[116] Herodas 6; for the dramatic setting of mimiambs 6 and 7, see Headlam 1922:xlvii and cf.
    Cunningham 1971:160 and Mandilaras 1986:246.
[117] Herodas 7.
[118] Asklepiades 7 G-P (= *Anthologia Palatina* 5.207).

Kenneth Dover that Asklepiades most likely speaks about a lesbian couple from Samos.[119] Samos was also an island closely associated in the late fourth/ early third centuries BC with unbridled wantonness as well as luxuriousness. Attracted to stories about East Greek curiosities and keen to assault any signs of Eastern *habrotês* ("luxury"), the Peripatetic Klearkhos of Soloi recounted the "profligate way of life" on Samos during the time of the *turannos* Polykrates, who was said to have conceived the construction of the impressive "Quarters" (λαύρα and Σαμίων ἄνθεα) in the city of Samos, where prostitutes and other luxurious commodities of all sorts were plentiful and at the disposal "of all Hellas."[120] Samos was also recorded as the birthplace of a "woman writer" of a famous handbook on seduction and *ars amatoria* mentioned by Klearkhos in another work of his and by his almost contemporary historian Timaios of Tauromenion.[121] The name given to her was Philainis of Samos, and a number of other women writers from Samos and Lesbos later became the authors of such erotic manuals.[122]

An intriguing archival narrative about East Greek women has been preserved by Ploutarkhos in his *Gunaikôn Aretai* ("Virtues of Women"). Popular tradition had it that the young women of Miletos were once possessed by a "terrible and odd," rather portentous and unbridled, passion.[123] At that time numerous people conjectured that the air of Miletos was suddenly infected in such a way as to cause young women mental derangement. The impulsive change in the behavior of all the young women involved a yearning for death, and many of them hung themselves, despite the appeals, objections, and en-

---

[119] Commentary on this epigram in Gow and Page 1965:vol. 2, 122 and Dover 2002.

[120] Klearkhos fr. 44 Wehrli (... ὄντως ἐνέπλησε τὴν Ἑλλάδα): note that diverse shades of irony are evident in Klearkhos' fragment. On this story, cf. also Ps.-Ploutarkhos *de proverbiis Alexandrinorum* 61 and Eustathios on *Iliad* 16.702 (vol. 3, 918 van der Valk). Eustathios refers to, and comments on, Klearkhos fr. 44 Wehrli quoted by Athenaios 12.540f–541a.

[121] Klearkhos fr. 63.I Wehrli (Athenaios 10.457d–e); Timaios *FGrH* 566 F 35 (Polybios 12.13).

[122] For Philainis and an intriguing papyrus fragment, P.Oxy. 2891, containing the beginning of a work attributed to Philainis, see Tsantsanoglou's important study (1973a). On this text, see also Merkelbach 1972, Cataudella 1973, Luppe 1974, Marcovich 1975, and Luppe 1998. On Philainis, cf. also Parker 1992. Leukas was alternatively provided as the birthplace of Philainis (Gow and Page 1965:vol. 2, 4 and Tsantsanoglou 1973a:191), but P.Oxy. 2891, the only available fragment from a work attributed to Philainis, specifies Samos as her native place. Niko of Samos and Kallistrate of Lesbos were associated with the writing of such erotic handbooks (see Athenaios 5.220e–f, who also refers to Philainis in the same context). For a certain Salpe the Lesbian, allegedly a writer of *paignia*, see Athenaios 7.322a (= Nymphodoros *FGrH* 572 F 5). For the names Philinnis, Sappho, and other women who were their companions in a playful arithmetical epigram of Metrodoros, see *Anthologia Palatina* 14. 138. For *Philaenis* in Martial, see Martial 2.33, 4.65, 7.67 (*pedicat pueros tribas Philaenis*), 7.70 (*ipsarum tribadum tribas, Philaeni*)—an epigram following epigram 7.69, which mentions Sappho—, 9.29, 9.40, 9.62, and 10.22.

[123] Ploutarkhos 249b–d.

treaties of parents and friends. The only concern for the women of Miletos was to satisfy their obsession for death, and they would contrive any means for hanging themselves—one after the other. The oddity and markedness of the malady panicked the city of Miletos, which, devastated by the death of so many young women, took urgent measures: those who hung themselves were carried naked through the *agora* in the middle of the city. The "order of things" was bound to be restored through the wise agency of a man who proposed this measure, but the sheer lack of shame and the eccentricity that that legendary act of hanging themselves suggested were remembered—even in the version that Ploutarkhos heard and transmitted.[124]

Similar signs of uncontrollable passion were displayed in other stories of a rather different nature. Girls from the city of Methymna developed rampant and unconditional desire for Akhilleus when the hero was sacking and plundering Lesbos and other islands.[125] One of these girls, a certain Peisidike, contrived a plan and handed over Methymna to Akhilleus, in spite of the ardent resistance of the Methymnaian men, who defended their city in battle. Akhilleus' promise to the girl was that after the sack of Methymna he would become her husband, but when the city came into his possession, he ordered his soldiers to stone her instead—for reasons it would be interesting to know. This violent execution, extremely rare in this type of plots,[126] was not recorded in a different version in which a girl from Pedasos—a city in the southern Troas and geographically close to Lesbos—fell in love with Akhilleus and threw an apple inscribed with a message that helped Akhilleus conquer her city.[127]

Even in one version of the myth of Phaon of Mytilene it is not only Sappho or Aphrodite that are distraughtly enamored of him, but the women of the city in general. As a result of this collective passion, again according to this

[124] For the story, see also Aulus Gellius 15.10 and Polyainos *Stratêgêmata* (*Stratêgika*) 8.63 Woelfflin-Melber (note that in this version it is a Milesian woman who proposed the measure).
[125] See Hesiod fr. 214 M-W; Parthenios *Erôtika Pathêmata* 21 = anonymous on Lesbos *FGrH* 479 F 1 (according to Jacoby, "4th century BC?"; on Parthenios, see Lightfoot 1999:496–504). Lightfoot 1999:497 postulates that the version recorded in Hesiod fr. 214 M-W (= Scholia AbT on Homer *Iliad* 6.35) "hardly goes back to Hesiod; the inscription in iambic trimeters seems to point to a source in tragedy rather than to the influence of Callimachus' *Acontius and Cydippe*." That this remains a surmise needs hardly to be stressed. Parthenios *Erôtika Pathêmata* 26 (ἱστορεῖ Εὐφορίων Θρᾳκί [the third century BC poet "Euphorion tells the story in his *Thrax*"]) provides a different narrative about a girl from Lesbos who, according to a tradition, threw herself into the sea to avoid the pursuit of a man, who will be eventually killed by Akhilleus when the latter was plundering Lesbos. This seems to be an inversion of the story that Sappho threw herself into the sea from the cliff of Leukatas because of her unrequited love for Phaon (see below).
[126] Cf. Lightfoot 1999:496.
[127] Hesiod fr. 214 M-W.

version, Phaon is slain when one day he is caught (on Lesbos, presumably) in the very act of adultery.[128]

All these narratives and the wider cultural discourses they may reflect are much later than the ideological idioms conducive to the formation of a marked cultural *habitus* in the fifth and early fourth centuries BC. It is against the trafficability of these early habitually crystallized, internalized, and reproduced discursive filters—that, however, were also susceptible to modifications and revisions—as well as a number of other related conceptions, that I propose to examine the modalities of the late-sixth- and fifth-century receptions of Sappho.

I conclude this section by exploring a further discursive element, the antiquity of which cannot be determined. In an extensive fragment from Pherekrates' *Mettalês* ("Miners"),[129] a woman recounts to another character of the play the wealth of most delicious food of every sort as well as fancy sauces that the dead enjoy in *banquets* in the underworld. When her interlocutor, astounded at the coveted pleasures the dead indulge in, rhetorically asks her to stop providing further information, she continues:

> ...    κόραι δ' ἐν ἀμπεχόναις τριχάπτοις, ἀρτίως
> ἡβυλλιῶσαι καὶ τὰ ῥόδα κεκαρμέναι,
> πλήρεις κύλικας οἴνου μέλανος ἀνθοσμίου
> ἤντλουν διὰ χώνης τοῖσι βουλομένοις πιεῖν.

And girls in [fine] coverings woven of hair,
having newly reached the bloom of youth and with their roses trimmed,
drew with a funnel cups full of dark wine with exquisite bouquet for those who wished to drink.[130]

Although ῥόδα ("roses") in the sense of "bush" also occurs—in a modified version (ῥοδωνιά, "rose-garden," "rose-bed")—in the *Nemesis* of Kratinos (fr. 116.2 K-A),[131] and the expression ῥόδα κεκαρμέναι becomes easily intelligible in view of the practice of depilation of women's pubic hair in Greek antiqui-

---

[128] Aelian *Historical Miscellany* 12.18. Cf. Suda s.v. Φάων.

[129] See above, n. 78.

[130] Pherekrates fr. 113. 28–31 K-A.

[131] Hesykhios s.v. ῥοδωνιά· ὁ τόπος ἔνθα φύεται τὰ ῥόδα. καθάπερ καὶ ἰωνιά, ὅπου τὰ ἴα φύεται καὶ κρινωνιά, ἔνθα τὰ κρίνα. δηλοῖ δὲ καὶ τὸ ἀναιδές. See also Schol. (K) on Theokritos 10.11, 242.19 Wendel, which quotes the fragment. For the possible context of Kratinos fr. 116 K-A, see Kassel and Austin's annotations. On ῥόδον and ῥοδωνιά, cf. Lenaiou 1935:26–27 and Henderson 1991:135. On σέλινα in the sense of "vulva" in the same fragment of Kratinos (fr. 116.3 K-A), see Lenaiou 1935:27 and 34, and Henderson 1991:136 and 144.

ty,[132] an entry on ῥόδον in Hesykhios' lexicon of rare words intrigues with its specificity: ῥόδον· Μιτυληναῖοι τὸ τῆς γυναικός ("rose: the people of Mytilene call so the vulva"). How far back in time does this information go? Is it based on "local knowledge" stemming from texts of Lesbian authors[133] that Hesykhios had in mind? Or was "rose" in its sexually charged meaning a loan word from the Lesbians that became well known throughout Greece? What is of interest here is the (even faded and diversely represented) resilience of the marked associations of women from Lesbos with carnal pleasure, potentially obtainable in symposiastic contexts. As I have shown, these marked idioms were foregrounded in Athens during the fifth century.

## Early Performative Poetics

Before proceeding to a broader examination of the reception of Sappho in Attic *symposia* in the light of both the vase-paintings and the fifth-century perceptual filters explored in Chapter Two and earlier in this chapter, it is time to pause and focus on the possible channels of the early dissemination of Sappho's song-making. Closely interrelated with these channels is the issue of the extent of the oral substratum in the composition of her songs. If Sappho's poetry was characterized by structural features potentially susceptible to (even minimal) transmutations in the course of its performative transmission, such an aspect of her songs would be essential for an understanding of the earliest stages of her reception. We thus need to spell out all possible parameters that might have been conducive to such transmutations. Alternatively, if the transmission of her songs was characterized by a stable textual fixation, this might function as a decisive, "corrective" index in the gradual shaping of her figure.

As I shall argue later in this chapter, her poetry was only one of the elements in the wider, complex dynamics of the shaping of her figure in the early stages of her reception. The other crucial element was the relatively independent formation of her image after her poetry became popular in *symposia*. I suggest that when the *songs* of a poet become detached from the cultural economy that conditions the shaping of the *figure* of that poet, the practices and discursive *metonymies* that become operative in the politics of reception are conducive to an even more pronounced distancing of the figure from her poetry. The result is that, when necessary, it was specific elements of

---

[132] On this practice, see Kilmer 1982 and Bain 1982.

[133] Alternatively, non-Lesbian writers or sources might have associated this word with Lesbian linguistic practice.

the poetry that were gradually selected and applied to the trafficability of her *figure*. The early reception of Sappho constituted the principal factor in the selection and preservation of the songs that were also to determine eventually the receptions of her poetry in the Roman and later eras. The early formation of the figure of Sappho in Athens—and in other areas of the ancient Greek world for which there are only a few informants—should not be approached as a unified corpus of attempts at writing biographies about Sappho. The current, widely sanctioned paradigm of tracing, or taking for granted the existence of, fixed early biographies for each archaic melic poet goes against the inherent fragmentariness of any historicizing linear narrativization.

At the dawn of the sixth century, Lesbos was presumably no different from other Greek societies that were still emerging from their oral milieu.[134] The extent of literacy was arguably limited,[135] but the most affluent families of the island must have received some kind of education through early participation in choruses as well as in related civic institutions. Even so, song-making was deeply embedded in the social fabric of villages and cities: melic and epic, as well as a large spectrum of other songs, were constantly composed, performed, and reperformed. Mytilenean society, one might argue, was developing with that acquaintance with aesthetic modes of thought frequently characteristic of societies reliant on oral communication.

It is not certain whether the island had produced long epic poems of its own,[136] but positing epic bards who drew on and contributed to a broader tradition of epic song-making would not be precarious—as long as this idea does not interfere with the construction of further hypotheses that attempt to "reconstruct" historicized archaic realities. Poetry that shares some structural features with the Homeric epics is attested in the surviving fragments of Sappho: fragment 44 V, which is generally attributed to her and is composed

[134] The verb "to emerge" is here used conventionally: knowledge about archaic societies before the seventh century is scanty.

[135] Cf. Harris 1989:48.

[136] Among others, West 1973—based on ideas proposed earlier by German-speaking scholars—has argued for the early existence of Aeolic epic mainly on the basis of a piece of linguistic evidence from the fragments of Sappho and Alkaios (1973:191). In a later article, he expanded his theory (West 1988:162–165). Since then, however, some of his views have been challenged by Chadwick (1990) and, more to the point, by Wyatt (1992; for linguistic arguments against the existence of Aeolic epic, see the studies cited by Wyatt 1992:167n2). West 1992b virtually defends the same arguments propounded in West 1988, concluding that "Thessalian mythology, reference to Lesbos in the context of the Trojan War, and interest in Troy itself are not merely contingent phenomena that encouraged an Ionian epic tradition to sprout a few Aeolisms: they themselves point to prior Aeolic epic, and the linguistic Aeolisms point with them" (1992b: 175); cf. also West 2002. I see no way of proving or disproving such a view.

in glyconics internally expanded by two dactyls,[137] constitutes an unusual example of epically colored narrative. After the swift messenger Idaios announces the arrival of the bridegroom and his companions bringing the charming Andromakhe to Ilion, the wedding procession of Hektor and Andromakhe is set out in refined, epico-lyric detail.[138] In relation to this fragment and in view of the preservation of archaisms in its meter (glyconic expanded with two dactyls) such as isosyllabism and the Aeolic base,[139] it has been argued that the meter that Sappho employs here seems to be more archaic in structure than the Homeric hexameter, which frequently makes use of spondees instead of dactyls in the first four feet and refrains from adopting the pattern (short followed by long vowel) in the first foot: "The rigid phraseological correspondences between her pentameter and the epic hexameter are due to parallel inheritance of related formulas from related meters;" therefore, "by a fluke of history, structurally primitive material like the pentameter inherited by Sappho is attested at a relatively late phase, while structurally more developed material like the Homeric epic itself had become a Panhellenic fixed text at so early a period that it was already prehistoric from the standpoint of the classical period."[140]

Such a view has far-reaching implications for melic poetry in general and the Lesbian poetic tradition in particular. Specifically, as some related studies have stressed,[141] a Lesbian tradition of song must have existed some time before that inherited by Alkaios and Sappho,[142] and the possibility that various linguistic relics of this old tradition may have been functional at the time when these two poets composed their songs cannot be overlooked. Artistic manifestations do not come into being in a vacuum, as some sources for the case of Lesbos testify.

Arkhilokhos of Paros, whose *floruit* is usually placed about a generation earlier than that of Alkaios and Sappho, shows some familiarity with the poetic tradition of Lesbos: he refers to the performance of a paean associated with the

---

[137] See also Sappho fr. 44A V, which resembles fr. 44 V in its metrical structure.

[138] On this fragment, see especially the important studies of Kakridis 1966 and Rösler 1975. Cf. Rissman 1983: 119–148 and Schrenk 1994.

[139] For metrical archaisms in Indo-European poetic traditions, one should consult Meillet's seminal book (Meillet 1923). Nagy 1974, along with related work by scholars such as Roman Jakobson (1952) and Calvert Watkins (1995, with references to his early work), belongs to the tradition in linguistic analysis of metrics emanating from Meillet's theory of Indo-European meter.

[140] Nagy 1974:134–135. Cf. Nagy 1974:118–139, who focuses particularly on the "epic contacts" in Sappho fr. 44 V.

[141] Hooker 1977 and Bowie 1981.

[142] See also the rather intuitive conclusion that Wilamowitz reached in 1921: "wir beobachten die lesbische Poesie erst in ihrer letzten Stunde" (1921:98).

name of the island.[143] The superiority of the Lesbian minstrel became prover-
bial[144]—a pronouncement thought by Aristotle to allude to Terpandros,[145] the
first-known influential Lesbian poet after the possibly earlier shadowy figure
of Leskhes of Pyrrha or Mytilene. Terpandros of Antissa[146] along with Arion of
Methymna were highly talented *kitharôidoi* who left Lesbos and took up resi-
dence in Peloponnesos. Terpandros and Arion were credited in later periods
with significant innovations in music and choral dancing, respectively. If we
can trust late sources, another poet from archaic Lesbos whose compositions
did not escape time was Perikleitos (possibly around the end of the seventh
century), the last Lesbian winner in the musical competition held at the Spar-
tan Karneia.[147]

The songs composed by the earlier poets were for the most part trans-
mitted orally. Early traditional compositions lay behind the art of the two
poets, but interaction with the poetic traditions of other places such as Ionia
could have been no less important. At the same time, a certain tradition in wo-
men's poetry must have existed, anonymous or by individual—now unknown—
poets.

The invention of the Greek alphabet is dated, according to most research-
ers, to the first half of the eighth century, although some Semitic epigraphers
argue for an earlier date.[148] As has been noted, early short inscriptions and graf-
fiti from Euboian Lefkandi and the Euboian colony of Pithekoussai in Ischia
show that "Greek writing was in popular use in the farflung Euboian–Pithe-
koussan circuit before 750 BC."[149] The so-called Dipylon *oinochoe*, dated to *c.*
740–730,[150] and the cup of Nestor from Pithekoussai, perhaps contemporary
with or a little later than the former,[151] constitute the earliest known long me-

---

[143] Arkhilokhos fr. 121 W αὐτὸς ἐξάρχων πρὸς αὐλὸν Λέσβιον παιήονα.

[144] First attested in Sappho fr. 106 V. See also Aristotle fr. 545 Rose (and the sources quoted there), Ze-
nobios 5. 9, Hesykhios M1004, Suda M 701, Eustathios *Iliad* 9.129–130 (vol. 2, 677 van der Valk).

[145] See Aristotle fr. 545 Rose (= Eustathios *Iliad* 9.129–130, vol. 2, 677 van der Valk) Ἀριστοτέλης δὲ
…τὸ ʽμετὰ Λέσβιον ᾠδόν' τὸν Τέρπανδρόν φησι δηλοῦν.

[146] Other places—Methymna and the Aeolian Kyme—also are said to have been the birthplace of
Terpandros: see Suda s.v. Τέρπανδρος and Diodoros 8. 28 (in Tzetzes *Khiliades* 1.388–395 Κιθα-
ρῳδὸς ὁ Τέρπανδρος τῷ γένει Μηθυμναῖος·|…Διόδωρος ὡς γράφει…[lines 388 and 393]).

[147] Ps.-Ploutarkhos *On Music* 1133c-d.

[148] For bibliographical references, see Thomas 1992:53n4, and Morris 1993:73n8. For objections to
such an early dating, see Burkert 1992:27–28.

[149] Powell 1991:129. For a survey of "short" early Greek inscriptions, see Powell 1991:123–158.

[150] *IG* I² 919; Coldstream 1968:32–33, 358–359; cf. Jeffery 1990:68 and 76, no. 1 and Immerwahr
1990:7; *SEG* 43.10, *SEG* 48.89.

[151] *c.* 730–720, according to Jeffery 1990:235, no. 1. Powell (1991:163) rightly considers both alter-
natives possible. See also Immerwahr's excellent discussion (1990:18–19) and *SEG* 46.1327. For
the text of the inscription, cf. *CEG* vol. 1, no. 454. Note that the dating of the earliest Greek
inscriptions on pottery is more often than not relative.

trical inscriptions (partly in hexameters). For the *skyphos* or cup of Nestor, a number of interpretations have been put forward but the idea that this represents one of the earliest "songs" composed specifically for sympotic settings is attractive.[152] The surviving pieces of early inscriptions and graffiti[153] are witnesses to the existence of early literacy. It should, nevertheless, be emphasized that its breadth cannot have been extensive.[154] New findings might change the picture we have about eighth-century Greek writing and literacy,[155] but even if it eventually turns out that alphabetic writing was used from the very beginning of the eighth century or the last quarter of the ninth century, what is significant is that it was unquestionably employed, perhaps after some time during which it spread all over Greece, for marking of property and for recording metrical lines (notwithstanding the fact that the number of lines recorded was normally small, to judge from what evidence we have). The latter use of writing as performance art should be given proper attention in discussions of orality and literacy in early Greece. Inscribed tombstones from the late seventh century show that the idea of commemoration and perpetuation of the name of the deceased through written material was already at work. Therefore, the gradual interaction between spoken and written word had started to produce a new technology of communication that was to take over from the apparently old, long established one.[156]

Cultural changes, however, cannot be adequately evaluated on the basis of the number of graffiti, dipinti, and inscriptions that may be found either in Greece or in several of its first *apoikiai*. The advent of the alphabet, however revolutionary its implications might have been, could not have brought with it a cultural amnesia of traditional communicative structures. From an anthropological, comparative perspective, it has persuasively been held that what we term orality and literacy "are not two separate and independent things; nor (to put it more concretely) are oral and written modes two mutually exclusive and opposed processes for representing and communicating information. On

---

[152] Murray 1994:51.

[153] For a survey, see Powell 1991:123–186.

[154] Cf. Harris 1989:46.

[155] See Lambrinoudakis 1981:294 (plate 201a) and *Bulletin de Correspondance Hellénique* 106 (1982): 604 fig. 132 and 605 for a Geometric *krater* sherd from Naxos dated to c. 770–750 BC; cf. Jeffery 1990: 466 A. See, further, Peruzzi 1992 for an inscription on a globular one-handled flask from Gabii dated to c. 770 BC; cf. Bietti Sestieri 1992:184–185, *SEG* 43.646, *SEG* 47.1478, *SEG* 48.1266 and 2101, and Rösler 2004:ii. For a late Geometric bird-bowl from Eretria with a graffito that probably provides (very fragmentary) metrical lines, see Johnston and Andriomenou 1989 (they date it to c. 735–725; contemporary with the cup of Nestor).

[156] For orality and literacy in early Greece, see, apart from the studies cited in this section and in Chapter Two ("The Rhetoric of Lettering"), Andersen 1987, 1989, Detienne 1988, Stoddart and Whitley 1988, Baurain et al. 1991, Rösler 1997, Whitley 1997, Powell 2002, Yunis 2003.

the contrary they take diverse forms in differing cultures and periods, are used differently in different social contexts and, insofar as they can be distinguished at all as separate modes rather than a continuum, they mutually interact and affect each other, and *the relations between them are problematic rather than self-evident*" (my emphasis).[157] Determining the extent of the influence of the written word on a culture like that of early Greece, which for several centuries relied predominantly on oral mental structures, is hardly possible, given the scarcity of the available information about archaic Greece.

For early archaic Greece, the most decisive evidence for the reconstruction of any modes of thought comes from poetry. In tracing the formulaic elements in the language and thematic composition of the Homeric epics and comparing them to epic songs of different cultures,[158] we need to be attentive to the comparative observation based on ethnographic research that formulaic composition is not necessarily tantamount to oral composition.[159] However, even when writing has established itself as a medium of aesthetic expression in a society predominantly reliant on oral communication, we cannot—and should not—dismiss the idea that the recurrent lexical and thematic building blocks of a song/poem, attributed by some scholars "to the literary and stylistic tradition…dominant"[160] in a specific cultural milieu, still functioned as manifestations of oral modes of thought during the process of the composition of a specific song. Traces of formulaic composition can also be found in archaic melic and elegiac poetry,[161] while some scholars have even taken the view that the "Homeric" formulae that occur in the elegiac fragments of Arkhilokhos are indications of his being an oral poet.[162] This view is questionable[163] and the characterization "oral poet" seems hardly possible, if

---

[157] Finnegan 1988:175.

[158] The decisive impetus for that direction of analysis was provided by the researches of Parry (from 1928 up to the date of his early death in 1935) and Lord (see Lord 1960, and some of his earlier and later papers collected in Lord 1991 and 1995). For an account of the importance of the contributions of these two scholars, see Foley 1988:19–56. Lord's research has been extended in a number of different directions by Nagy (1979, 1990, 1996). Parry 1971b:347–350 and 1971c suggested that Sappho's language and compositions were oral-traditional.

[159] See, concisely, Zumthor 1990:97 (and the studies cited there). Cf., further, Finnegan 1988 and Smith 1977 and 1991.

[160] Thomas 1992:102.

[161] For a recent survey of the contributions to the issue, see M. L. Lord's Addendum to chapter 2 of A. B. Lord's posthumous volume (1995:62–68).

[162] Page 1963; Notopoulos 1966. For formulae in archaic elegy, see Giannini 1973.

[163] For criticism of Page's view, see Fowler 1987:10–11, 14–16 (and the bibliography he cites in his n35 [p. 109]). Thomas (1992:44) maintains that "a seventh-century poet like Archilochus went on composing partly in Homeric language and Homeric expressions adapted to the new metre, not so much because he was still an oral poet, or still belonged to a 'partly oral' culture…, but rather because the poetic tradition was dominated by the Homeric cycle."

not anachronistic, to apply unconditionally to any of the archaic melic poets. But it is evident that formulaic expressions fueled by the rhythmic patterns of meter—distinctive marks of the art of oral bards and singers—contributed to the composition of Arkhilokhos' poems. The formulaic overtones of those poems would sound familiar to people accustomed to the techniques of oral poetry and would provide some help for easier memorization of a song by its potential performer and audience.

In the case of Sappho,[164] apart from the patterns of alliteration and assonance that her songs demonstrate,[165] it is worth observing that repetitions of phrases[166] or short thematic blocks occur: κ.ώττι ιμοι μάλιστα θέλω γένεσθαι |...θύμωι and ὄσσα δέ μοι τέλεσσαι | θῦμος ἰμέρρει, τέλεσον (fr. 1.17–18, 26–27 V) compared to κώσσα ϝ]οι θύμω<ι> κε θέλη γένεσθαι | [πάντα τε]λέσθην (fr. 5.3–4 V);[167] οὐ δύνατον γένεσθαι (fr. 16.21 V) compared to οὐ δύνατον γένεσθαι (fr. 58.18 V); χρόα γῆρας ἤδη (fr. 21.6 V) compared to χρόα γῆρας ἤδη (fr. 58.13 V); τὰν εὔποδα νύμφαν (fr. 103.2 V) compared to εὔποδα νύμφαν (fr. 103B.2 V); λιγύραν ἀοίδαν (fr. 101A.2 V) possibly compared to λιγύραν [ἀοί]δαν (fr. 103.7 V);[168] χρυσοπέδιλος Αὔως (fr. 123 V) compared to χρυσοπέδιλ[ο]ς Αὔως (fr. 103.10 V). With the publication of three early Ptolemaic papyrus fragments that provide additional text for Sappho fragment 58 V,[169] thematic motifs repeated almost formulaically can be detected. The fragment now reads as follows:

> \* ἰ]οκ[ό]λπων κάλα δῶρα, παῖδες,
> ]. φιλάοιδον λιγύραν χελύνναν.    2

---

[164] I explore elsewhere (Yatromanolakis 2007d) the composition of Sappho's songs in the light of comparative and ethnographic material of women's songs from the Balkans, Portugal, and India (see Coote 1977, 1992, and Vidan 2003, Lord 1995:22–62 on Latvian *dainas*, and Cohen 2003 on *cantigas d'amigo*).

[165] See Dionysios of Halikarnassos *On Arrangement of Words* 23 (6.114–117 Usener-Radermacher); cf. Segal 1974:146–151.

[166] Another example is provided by Svenbro (in Lord 1995:64): περὶ γᾶς μελαίνας (fr. 1.10 V), ἐπ[ὶ] γᾶν μέλαι[ν]αν (fr. 16.2 V), γ]ᾶς μελαίνας (fr. 20.6 V). However, the case of frs. 5.5 V and 15.5 V that is cited in Svenbro (1984b:77n59) is most uncertain (see Voigt's apparatus criticus in Sappho fr. 15.5).

[167] Cf. Sappho fr. 60.6 V.

[168] The context here does not determine whether [ἀοί]δαν is the accusative singular or the genitive plural. Sappho fr. 101A V is attributed to Alkaios by Lobel and Page (fr. 347b L-P). Note that Bergk had joined Sappho fr. 101A V and Alkaios fr. 347 V (= Alkaios fr. 347a L-P) and reconstructed an eight-line poem (Alkaios fr. 39 Bergk in Bergk 1882:163–164); cf. an almost identical reconstruction in Lobel 1927:52 and in Page 1955:303–305. I agree with Voigt's attribution (for earlier defenders of this attribution, see Voigt's apparatus criticus; to those, add now Liberman 1999). Even if the fragment was assigned to Alkaios, the relevant phrase remains the same.

[169] Gronewald and Daniel 2004a and 2004b. See also Gronewald and Daniel 2005.

] ποτ᾽ [ἔ]οντα χρόα γῆρας ἤδη
ἐγ]ένοντο τρίχες ἐκ μελαίναν,                                              4
βάρυς δέ μ᾽ ὁ [θ]ῦμ̣ος πεπόηται, γόνα δ᾽οὐ φέροισι,
τὰ δή ποτα λαίψηρ᾽ ἔον ὄρχησθ᾽ ἴσα νεβρίοισιν.              6
†τα† στεναχίσδω θαμέως. ἀλλὰ τί κεν ποείην;
ἀγήραον ἄνθρωπον ἔοντ᾽ οὐ δύνατον γένεσθαι.           8
καὶ γάρ π̣[ο]τ̣α Τίθωνον ἔφαντο βροδόπαχυν Αὔων
ἔρωι…α̣.εισαν βάμεν᾽ εἰς ἔσχατα γᾶς φέροισα[ν       10
ἔοντα [κ]άλον καὶ νέον, ἀλλ᾽ αὖτον ὔμως ἔμαρψε
χρόνωι πόλ̣ι̣ο̣ν γῆρας, ἔχ[ο]ν̣τ̣᾽ ἀθανάταν ἄκοιτιν.     ✳?   12[170]

] children, the lovely gifts of violet-bosomed [Muses]
] clear-sounding song-loving lyre.
] once being… my body [is taken] now by old age
] my hair has turned [white] from black
and my heart has weighed down, my knees that once were
nimble to dance as fawns do not support me.
I often groan for this. But what could I do?
It is impossible for a human being not to grow old.
The story was that Tithonos once, loved by rose-armed Dawn,
was carried off by her to the ends of earth,
when he was handsome and young; yet grey old age in time
overtook him, the husband of an immortal wife.

Starting with lines 1 and 2, the occurrence of ἰόκολπος and λίγυρος suggests that the epithets were employed in a number of songs to describe either a bride (fr. 30.5 V) and divinities (fr. 103.3 V and 58.11 V)[171] or singing (fr. 101A.2 and 103.7 V) and musical instruments (fr. 58.2 V).[172] The image in line 5 γόνα δ᾽ οὐ φέροισι ("my knees do not support me") finds a close parallel in Alkman fragment 26.1–2 PMG οὔ μ᾽ ἔτι… γυῖα φέρην δύναται ("no longer can my limbs

---

[170] It is perhaps tempting to see line 12 as the end of the composition, but, to my mind, the editorial siglum indicating *initium* or *finis carminis* could be here endorsed only with qualifications.

[171] "Muses" [Μοίσαν] in fr. 58c.1 (= fr. 58.11 V) is most likely: cf. Sappho fr. 44A b.5 V (and see Voigt's apparatus criticus). The context of Sappho fr. 103.4 V is unknown. For Sappho fr. 21.13 V Treu (1984: 189) argued that τὰν ἰόκολπον referred to Aphrodite.

[172] The early Ptolemaic papyrus fragments provide us with some new fragmentary lines (see Gronewald and Daniel 2004a:5) that include the epithet λιγύραν (perhaps modifying singing or an instrument). In Sappho fr. 71.7 V, the sound of "breezes" (Lobel's ἄη[ται]) may perhaps be "clear" (λίγυραι); cf. Sappho fr. 2.10–11 V.

support me"), a fragment addressed to "honey-voiced girls." More striking is the similarity between Sappho's evocative, almost staccato †ται στεναχίσδω θα-μέως ("for these I groan often") and Anakreon's διὰ ταῦτ' ἀνασταλύζω θαμά ("for these I sob often...") in fragment 395.7–8 *PMG*. These[173] may not be viewed as fortuitous elements in Sappho's poetry. They should rather be construed as constituent parts of songs influenced both by compositional elements of oral tradition and by the conditions of their own oral performance. Although repetition of phrases, motifs, images, story patterns, and so forth in early archaic poetry was a feature of the poetics of individual poets, this poetics was considerably influenced by modes of communication generated by a predominantly oral society. That the use of writing might have determined the character of a composition and have entailed the formation of a somewhat different horizon of expectations on the part of the audience is possible.[174] However, one must pose the question whether archaic audiences (even some of the original ones that belonged to the social elite, if we may use such an overgeneralized term) were more familiar with written than oral modes of communication.

Even if eventually written down, poems achieved their communicative realization through the process of performance, by reaching their audiences and securing their wider popularity through public and private recitation and singing.[175] The availability of the technology of writing and the importance attached to the process of performance as a means for the dissemination of

---

[173] A further example of repetition of thematic block deserves separate consideration. Hephaistion (9. 2, p. 29f. Consbruch) and some other sources (all in Voigt's testimonia) quote the first line of a song by Sappho, where the Graces and the Muses are being called to appear: Δεῦτέ νυν ἄββραι Χάριτες καλλίκομοί τε Μοῖσαι (fr. 128 V) [note that δεῦτε and δεῦρο frequently introduce a Lesbian poem: cf. Sappho fr. 53 V, Alkaios fr. 34.1 V, and Sappho fr. 127 V, Alkaios fr. 33a.3 V, respectively]. Likewise, in another fragment the Graces are summoned (Sappho fr. 53 V: Βροδοπάχεες ἄγναι Χάριτες, δεῦτε Δίος κόραι). But in Sappho fr. 103 V, one of the ten *incipits* of Sapphic poems that are cited (]. δὲ (δέκα) κ(αὶ) ἑκάστης ὁ (πρῶτος) [, line 3 in Lobel and Page's edition) reads as follows: ]..ἄγναι Χάριτες Πιέριδέ[ς τε] Μοῖσ[αι (103. 8 L-P = 103. 5 V). In view of the traces of the two letters before ἄγναι, Lobel suggested δεῦτε ν]ῦν as a possible supplement for this line (ν]ῦν is possible, but, of course, not entirely certain; I have examined the papyrus fragment and agree with Lobel and Page's annotation: "secundae litt. vestigia in ν quadrant, sed solito latiorem, si eo quod praecedit signo ramus litt. υ extremus dext. repraesentatur"). What we observe is that Sappho repeated the same thematic block in the very first line of two metrically identical poems (for the metrical scheme [three choriambs and a baccheios] of fr. 103.5 V, cf., apart from Sappho fr. 128 V, Sappho fr. 114 V, evidently a wedding song). For another interesting case, see Treu 1984:205 and Aloni 2001:35.

[174] Latacz 1990:238–239.

[175] The studies on this aspect are numerous. It will suffice to refer to the following extensive investigations: Rösler 1980, Herington 1985, and Nagy 1990 and 1996; cf. also Thomas 1992:101–108 and 117–127, and Thomas 1995:106–113.

poetry[176] point to the multilaterality of communication in archaic Greek culture.[177] Pindar's comparison of sculpture with poetry is a case in point. According to Pindar, in contrast to sculpture engraved on stone, poetry has the capacity to transmit the fame of an athlete more widely, since it can spread fame through oral performance: οὐκ ἀνδριαντοποιός εἰμ', ὥστ' ἐλι-νύσοντα ἐργάζεσθαι ἀγάλματ' ἐπ' αὐτᾶς βαθμίδος | ἑσταότ·· ἀλλ' ἐπὶ πάσας ὁλκάδος ἔν τ' ἀκάτωι, γλυκεῖ' ἀοιδά,| στεῖχ' ἀπ' Αἰγίνας διαγγέλλοισ', ὅτι... (*Nemean* 5.1–3). More explicitly, Theognis describes the dissemination of Kyrnos' name through images of winged journeys, songs in *symposia* and, more broadly, oral modes of communication: σοὶ μὲν ἐγὼ πτέρ' ἔδωκα, σὺν οἷς ἐπ' ἀπείρονα πόντον | πωτήσηι καὶ γῆν πᾶσαν ἀειρόμενος | ῥηϊδίως· θοίνηις δὲ καὶ εἰλαπίνηισι παρέσσηι | ἐν πάσαις, πολλῶν κείμενος ἐν στόμασιν,| καί σε σὺν αὐλίσκοισι λιγυφθόγγοις νέοι ἄνδρες | εὐκόσμως ἐρατοὶ καλά τε καὶ λιγέα | ἄισονται (237–243).[178] These archaic discourses, among numerous others, do not imply that the only means of transmission in archaic Greece was performance. They place special emphasis on it, however, showing that even though Pindar[179] may have experienced the writing down of his verses, he thought of them in terms of their oral transmission. It is hardly possible to underestimate the workings of a vibrant oral tradition behind the composition and performance of the songs and poems of archaic lyricists.

[176] Finnegan (1977:16–24) stresses that oral poetry is connected with at least one of the following three parameters: oral composition, oral performance, and oral transmission. Finnegan's scheme is adopted by both Gentili (1988:4–5) and Thomas (1992:6) in their discussions of the oral aspects of archaic Greek culture.

[177] This is also true of much later periods, when reperformances of earlier poetry did not cease; but from the second half of the fifth century onward, it seems that the book trade and the establishment of writing as an important means of retaining and preserving knowledge of the past somewhat changed the balance between spoken and written word.

[178] Thomas's view that Simonides fr. 581 *PMG* suggests that "the late sixth-century poet Simonides implied with scorn that his poetry would last far longer than a mere inscription" and that "writing here could only be thought of as a mnemonic aid for what was to be communicated orally" (Thomas 1992:62; cf. 1992:115) is seriously undermined by Simonides' statement in line 5 (ἅπαντα γάρ ἐστι θεῶν ἥσσω), which precedes his allegation that whoever believes that μένος στάλας can be set against nature is a fool, since λίθον δὲ | καὶ βρότεοι παλάμαι θραύοντι (fr. 581.5–6 *PMG*). The fragment in question does not necessarily contrast the performance and circulation of poetry with its written stability.

[179] For evidence that Pindar's compositions were probably set down in writing during his life-time, see Herington 1985:202. See also Herington's discussion of "the various ways in which literary texts can be shown to have been preserved in the period that ends with the late fifth century" (1985:45–47). Rösler (1980:78–91) discusses the case of the *Theognidea*; he concludes that Theognis' poetry and some other parameters (e.g. the emergence of early philosophical prose writing) suggest that from the second half of the sixth century the first indications of the creation of a book culture in the fifth century appear. In regard to Theognis, Pratt interprets the "seal poem" as referring to the possible protection of Theognis' poetry by means of writing (1995:173–177).

## Music and Words: Transmission in Performance

In the fragmentary songs of Sappho that have survived, one can count more than thirty references to song as performing art and to all three categories of musical instruments (stringed, wind, and percussion). Characteristically, in one of her fragments Sappho conversed with her lyre (*khelus*)—by asking it initially to speak and find a voice.[180] That it was Sappho herself who composed the melodies of her poetic compositions should be beyond doubt.

Although no music has survived from archaic Greece, what may be said with relative confidence about Sappho's songs is that the original musical settings were performed (rather than composed) in a higher register than those of the male poets. How much higher that register was we can only speculate. As far as the evidence goes, Sappho's songs were not intended to be sung originally by male performers. Some of her fellow women were apparently musical (particularly the female figures addressed in fragments 22 and 96.5 V).[181] The sound of singing is more often than not described as λίγυρος, once as γλύκερος.[182] This coincides with a broader tendency in ancient Greek literary discourses to think of a fine singing voice as clear and pure. We hear that the Mixolydian was Sappho's preferred mode;[183] its emotional and mournful character[184] probably suited some of her threnodic songs and laments. Contacts with Lydia must have resulted in diverse cross-cultural interaction in music and singing.[185] Some echoes of Eastern tropes of singing and rhythmical (antiphonal) mannerisms may well have accompanied the adoption of the Adonis cult by Greek populations from Syria and Phrygia. Furthermore, Sappho's wedding and threnodic songs would perhaps have drawn—at least in modes of delivery (for example, antiphony)—on traditional songs. In a *carmen populare* said to originate from Lokroi, we observe similar dramatic tension to that detected in some songs of Sappho.[186] However, our intuitive notion that Sappho's songs, which were mainly stanzaic and short, were similar to (modern) "folk songs" or medieval European compositions

---

[180] Fr. 118 V (quoted by Hermogenes in *On Types of Style* 2. 4, p. 334 Rabe; Hermogenes also provides information about the content of the song).

[181] Cf. *incerti auctoris* 35.8 V (with an address to Abanthis).

[182] For a discussion of such features of sound, see Kaimio 1977:129–132.

[183] Aristoxenos fr. 81 Wehrli.

[184] Plato (*Republic* 398e) mentions that the Mixolydian, the Syntonolydian and some other modes of that sort were lamentatory and used by women. Cf. Aristotle *Politics* 1340a. 40ff., Poludeukes 4.78 Bethe.

[185] Terpandros may have played an important role in this. See Chapter Two, pp. 69, 118, 124–125.

[186] *carm. pop.* fr. 853 PMG. See Klearkhos fr. Wehrli. Compare Sappho fr. 94 V.

in terms of the repetition of music from stanza to stanza lacks supporting evidence.

Projections of our cultural categories on ancient material are often presented as almost certain, as in the following reconstructive account of melody in Sappho's songs: "they were songs, in recurring stanzas, which implies a recurrent tune. It is a reasonable supposition that all songs in the same metre were sung to the same tune. [...] The tunes do not seem to have been elaborate, since the stanzas are clearly articulated in two, three or four lines."[187] However, we must allow that even when they employed a recurrent metrical scheme, ancient song-makers might well have been more inventive and improvisational in the musical design of their compositions. Ethnomusicological and comparative fieldwork on musical cultures of Africa, Asia, notably China, and other continents places emphasis on improvisation even in cases where a song follows a metrical pattern.[188] Even so, ethnomusicological familiarity with non-Western European traditional music suggests that recurrent stanzas may not imply a recurrent tune. Note that the two metrical positions of indifferent quantity at the beginning of a glyconic, or in middle of such metric structures as – ‿ – × × – ‿ ‿ – ‿ – (cretic and glyconic) in Sappho fragment 98 V, might not have left the melodic line of a song unaffected. The same holds true for the cases where *synecphonesis* is introduced.[189] Especially in light of fieldwork currently conducted in diverse traditional societies, caution in advancing, and especially in endorsing, assumptions like the ones quoted above is urgently necessary.

This brings us to a related point. It has been suggested that since the origins of both an instrumental and a vocal system of musical notation probably cannot be traced back earlier than the middle of the fifth and the fourth centuries BC, respectively,[190] the musical settings of archaic melic poetry could

---

[187] West 1970a:307–308. For further, albeit more restrained, speculation on the subject, see West 1992a:210–211. For similar assumptions about repetition and monotony in Stesikhoros' music and how in the triadic system the melody of the third stanza "stove off monotony," cf. West 1992a:339. Cf. also his comparisons of "primitive" and "folk music" with early or archaic Greek music (about which fragmented information comes from late sources): West 1992a:328, 163–164. West 1992a based such hypotheses on older reconstructive musicological work that goes back to the time of C. Sachs and M. Schneider.

[188] The work of Simha Arom on central African polyrhythm (Arom 1991) can provide an insightful comparative corrective to classicists' hypotheses.

[189] Sappho frs. 1.11 (ὠράνω αἴθεορς); 16.11 (ἐμνάσθ<η> ἀλλὰ); and 55.1 V (κείσηι οὐδὲ). Cf. fr. 1.1 V; see further Yatromanolakis 2007a.

[190] See West 1992a:259–263; West mainly adopts Westphal's 1867 theory that ancient Greek musical notation comes from an early Greek (probably the Argive) script. For details, see West in *ZPE* 92 (1992), 38–41 (quoted also in West 1992a:261n15). M. K. Cerny has defended Westphal's theory as well (*Listy filologické* 113 [1990]:9–18).

not have been written down before then; hence, they were allegedly passed down orally (by means of continuous reperformances).[191] This is not an unreasonable idea[192] but it needs to be somewhat modified and articulated differently. How accurately can we assume Sappho's original musical settings to have been maintained through the process of oral transmission? The whole issue depends on how one envisages the role of music in melic songs and the vehicles of their transmission. Even if the music of a song by Sappho was not complex and sophisticated—but there is no reason, let alone evidence, to suppose so—the difference in register noted above may be an indication that some adaptation was inevitable when that song was performed by a male singer or a male group. This was the minimal possible change, which would hardly affect the song, especially when the singer was (say) a professional *kitharôidos*. However, non-professional singers did sing Sappho in *symposia*. More importantly, since the words themselves could occasionally not resist "transmutations" in the process of oral transmission,[193] why believe that the music was always disseminated accurately? It can be argued that arrangements and diversifications, caused by the different environments and regions in which Sappho's songs circulated, were inevitable. Perhaps indeed a composition by Sappho was, on occasion, set to a new musical accompaniment in cases and places where access to the original music was not entirely possible. We hear that in primary oral cultures new settings for the same song are sometimes composed.[194] Later Greek practice shows that composition of a new musical setting for specific lyric parts of a tragedy may also have taken place.[195] Even if the skeletal structure of the original music remained stable for some time, improvisational changes must have been inevitable. We may not take for granted that Sappho's melodies were preserved unadulterated in the process of their transmission. I would therefore suggest that music may have not been a secure mnemotechnic aid for the preservation of the words of a song, as has been frequently argued in connection with archaic melic poetry.[196]

[191] E.g. Rösler 1984:190, and Herington 1985:43–44.
[192] Accepted by several scholars, e.g. West 1992:270.
[193] See below in this chapter and Chapter Four.
[194] Nettl 1964:230–231.
[195] See the musical fragment from a dramatic lament on the death of Ajax preserved in Pap. Berol. 6870 (ll. 16–19), in Pöhlmann 1970:100–103 (Nr. 32); cf. Pöhlmann and West 2001:56–59 (no. 17). In regard to this fragment, cf. also West 1992a:320–321: "It seems therefore that in the Imperial period a new setting of an emotional lament from an older tragedy was made for a woman concert singer...".
[196] See, among other scholars, Rösler 1984:189. For music as mnemotechnic device, see Vansina 1965:36–39 and 1985:46–47.

My overview of musical elements has focused on aspects of Sappho's poetry that may shed some light on the processes of the early stages of its transmission and reception—processes I shall explore further in this chapter and in Chapter Four. What were the possible routes through which Sappho's poetry reached its audiences? Performance in the case of archaic melic songs coincides with transmission.[197] In the context of the oral dissemination of Sappho's songs, changes of the original "text" might have occurred. As has been insightfully analyzed by Wolfgang Rösler,[198] an Attic four-line *skolion* quoted by Athenaios,[199] originally extracted from a more extensive song of Alkaios (fragment 249 V), was being transmitted as an independent composition in (probably) classical Athenian symposia. Certain divergences of dialect and text/semantics between the *skolion* and the fragment of Alkaios, as it has been preserved in a papyrus from Oxyrhynchus,[200] may be viewed as "a reflex of a persistent symposiastic overuse, a product of a tradition that was perpetuated through the process of an oral, that is, uncontrollable, reproduction."[201] Based on the two versions, scholars have attempted to trace the original, genuine readings in Alkaios' song.[202] However, we might prefer to suggest that the two versions represent different stages of the early transmission of the song.

Along with oral transmission, the technology of writing could have helped with the first rudimentary written form of Sappho's songs. Whether Sappho herself wrote down (some or most of) her poems is bound to be a controversial issue. Did she ever put down in writing some of her ritual songs (mainly wedding songs and laments)? Were her poems transferred into written form only posthumously, when the people of Mytilene firmly realized that Sappho along with Alkaios were to become the most influential of their poets?[203]

---

[197] See Jack Goody's comments on the equation of performance with transmission in oral societies (Goody 1992:15).

[198] Rösler 1984.

[199] Athenaios 15.695a (= *carm. conviv.* 891 PMG).

[200] P.Oxy. 2298 fr. 1 (= Alkaios fr. 249 V).

[201] Rösler 1984:189 "Reflex einer anhaltenden sympotischen Abnutzung, Produkt einer sich immer wieder auch in mündlicher und das heißt zugleich unkontrollierter Reproduktion fortpflanzenden Tradition."

[202] See also Fabbro 1992 and Rossi 1993; cf. Pardini 1991:555–558 and Fabbro 1995:120–130. Rossi 1993 believes that in line 1 κατίδην (*carm. conviv.* 891 PMG), as transmitted in Athenaios' Attic collection of *skolia*, is the original version of the song, while προΐδην is a *lectio difficilior* provided by the papyrus that preserves the fragment (P.Oxy. 2298 fr. 1).

[203] We hear from Aristotle *Rhetoric* 1398b Kassel (1976:130–131) that the sophist Alkidamas (*floruit* around 390 BC) thought that wise people are honored by all: "The Parians, at any rate, have given Arkhilokhos honors, even though he was abusive; and the Khians Homer, even though he was not a fellow-citizen; and the Mytileneans Sappho, even though she was a woman." Note also that Isokrates in a letter addressed Τοῖς Μυτιληναίων ἄρχουσιν, defends a certain exile Agenor from Mytilene—at present the music teacher of Isokrates' grandsons in Athens—and

The transmission of Sappho's poetry should be envisaged as following two parallel channels, at least from the fifth century onward: oral performances and written versions. Nevertheless, the preponderance and importance of the former in the case of Sappho must be stressed, and it is to this that I shall now turn.

## The Strategies of Traveling

How did the poetry of Sappho embark on its varied trips—from Lesbos to Athens to Alexandria and other regions? For Sappho's audiences on Lesbos, participants in women's gatherings and wedding rituals should be considered as the most likely candidates for the dissemination of her poetry. In addition, if the cult of Adonis had some associations with Lesbos,[204] a large number of women from the island would have had the opportunity to listen to Sappho's composition about Adonis (fr. 140 V).[205] People in Sicily may also have had some early acquaintance with Sappho's songs, when she was apparently there some time before 595/594.[206]

To go a step further, professional singers from Mytilene should have helped in the diffusion of the wedding songs: initially they would have spread them all over the island and its cities, and later in neighboring islands and mainlands.[207] Sappho's *epithalamians* could be sung in other city-states, far from and near Lesbos. The coastline of Asia Minor is in such close proximity to Lesbos that Sappho's songs might have been performed in Greek city-states

---

refers to Mytilene's celebrated past: αἰσχρὸν γὰρ τὴν μὲν πόλιν ὑμῶν ὑπὸ πάντων ὁμολογεῖσθαι μουσικωτάτην εἶναι καὶ τοὺς ὀνομαστοτάτους ἐν αὐτῇ παρ' ὑμῖν τυγχάνειν γεγονότας, τὸν δὲ προέχοντα τῶν νῦν ὄντων περὶ τὴν ἱστορίαν τῆς παιδείας ταύτης φεύγειν ἐκ τῆς τοιαύτης πόλεως (8.4, Mandilaras 2003: vol. 3, 230–231). Sappho had a long time ago sung about the superiority of the Lesbian ἀοιδός to those of other lands (fr. 106 V), and now (around 350 BC) her poetic fame seems to be implicitly included in the long Lesbian musical tradition.

[204] On this issue, see Shields 1917:34–35.

[205] Such songs could be performed in the cult of Adonis in other Greek city-states as well. In the case that institutionalized segregation of young women on Lesbos had partly provided Sappho with the subject matter of her songs—that is, that some of Sappho's poetry was intended to be performed at young women's festivals—then one might think of such ritual songs as being transmitted by being adapted to ritual contexts outside Lesbos. However, there is no evidence to support this idea.

[206] Jacoby 1904:12. This is a well-established way of dissemination of poetry; see Finnegan's discussion (1977:153) regarding oral poetry: "Emigrants sometimes take their songs with them when they travel and sing them with varying degrees of adaptation and new composition in the countries to which they go [...]."

[207] The stories and different versions about the *kitharôidos* Terpandros' travels and origins (the sources are collected in Gostoli 1990) are indicative of musical interaction between Lesbos and other Eastern and Western regions.

of Ionia.[208] Thus the route of dissemination is not to be viewed as moving only from Lesbos to western parts of Greece, but also from Lesbos to the Ionian mainland and other Eastern islands.

Trade in Lesbos was well established already in the seventh century BC.[209] Cross-culturally, trade routes are a possible means of diffusion. People from places all over Greece traveled to and from Lesbos. It would not have been hard for some of them to hear Sappho's songs—after they had already become part of the heritage of the island and were probably sung at banquets and other gatherings—and, more importantly, to bring these songs to their own cities and communities. From that moment onward, the songs embarked on long-distance journeys and reached varied audiences. People from different social milieus must have started to become familiar with them. Women (including the more educated) in Thessaly or Attica or even further afield were among the first to perform them. In Chapter Two, I argued that the representation on the Athens red-figure *hydria* assimilates Sappho into the idealized cognitive model of female musical gatherings.[210] I should add here that although it has been thought that the scroll that Sappho holds on this vase-painting indicates that by 440–420 BC Sappho's poetry was transmitted in book form rather than through performance, this view cannot be substantiated, if the vase is investigated in the context of numerous other related representations.[211] Moreover, in the fourth century BC, Aristoxenos, in book four of his treatise *On Music,* reported the following: ἦιδον...αἱ ἀρχαῖαι γυναῖκες Καλύκην τινὰ ὠιδήν. Στησιχόρου δ' ἦν ποίημα ("in ancient times women sang a song called *Kalyke;* that was a poem of Stesikhoros").[212] It is significant that, again according to Aristoxenos, *Kalyke* was the name of a girl in the song who fell in love with a youth named Euathlos and used to pray to Aphrodite that she wed this youth. But Euathlos did not reciprocate her love and chaste Kalyke threw herself from a cliff near Leukas (ἐγένετο δὲ τὸ πάθος περὶ Λευκάδα).[213] The interconnections

[208] According to the Suda (s.v. "Sappho"), Anaktoria was from Miletos and Gongyla from Kolophon. Cf. Sappho fr. S261A.7–11 *SLG* (P.Colon. 5860), where it is said that Sappho was the educator of noble young women who came from Lesbos *and* Ionia. These sources are late and I do not assume any kind of validity in the realities they refer to.

[209] Cf. Spencer 1995:301 and Spencer 2000. See also Shields 1917: xii–xiii (not known to Spencer).

[210] Athens, National Archaeological Museum 1260; *ARV* 1060.145; *Add.* 323.

[211] See Chapter Two, pp. 143–163. To the question "By when are Sappho's songs viewed as written texts?" I would point to Aristoxenos fr. 71b Wehrli. However, see discussion below. Based on the image on the Athens *hydria,* Powell 2002:30 oddly holds that "the memorization of written poetry for musical performance...is attested on Greek pots of the fifth century."

[212] Stesikhoros fr. 277 *PMG.* This fragment is included in the *spuria* of Stesikhoros by both Page (1962: 136–137) and Davies (1991:232–233). The Stesikhorean authorship of *Kalykê* has been occasionally defended by some scholars.

[213] Stesikhoros fr. 277 *PMG.* For other stories about young women and men in songs attributed to Stesikhoros, see Stesikhoros frs. 278 and 279 *PMG* (*spuria*).

between this ancient song and the Phaon narratives related to Sappho and Aphrodite requires investigation in the light of broader cultural discourses.[214] For purposes of the present argument, I would place emphasis on Aristoxenos' fourth-century BC reference to the performance by early Greek women of a traditional song attributed to Stesikhoros.[215] Late sources include an epigram by Philodemos about an extraordinarily attractive Oscan young woman whose negligible imperfections include the fact that she is *unable to sing the songs of Sappho* (εἰ δ' Ὀπικὴ καὶ Φλῶρα καὶ οὐκ ἄιδουσα τὰ Σαπφοῦς).[216] Although this might have been employed as a variant of a cultural topos,[217] we can infer that—in the Hellenistic period and according to male writers—Sappho's poetry was widely sung by women.

## Economies of Symposia and Taverns

It is now time to bring together the diverse cultural nexuses and idioms that conditioned the earliest stages of the reception of Sappho in Athens. The Attic images investigated in Chapter Two do not suggest the emergence of a fixed and well-defined figure in the case of Sappho. No closely knit, unitary narrative can be reconstructed, and this, I suggest, is symptomatic of the overall cultural economy that defined the trafficability of the figure of Sappho in classical Athens. In other words, the reception of her figure in the classical period—that is, some generations after she composed her songs—appears more inherently fragmented and multileveled than that of male melic poets like Simonides and Anakreon. As I argue later in this chapter, the visual representations should be viewed in their fuller and more dynamic anthropological dimensions in the context of other broader cultural discourses, which were considerably more crystallized and habitually assimilated.

The aim of this section is to expand our investigation in order to trace and remap as many cultural idioms that defined the figure of Sappho as possible.

---

[214] See the argumentation in Chapter Four, p. 293. The significance of this song has not been explored in connection with other songs and ancient discursive idioms as well as with the Phaon narratives related to Sappho.

[215] Ploutarkhos' mention in the *Banquet of the Seven Sages* 14 of a woman in Eresos singing *carmen populare* 869 PMG is very late.

[216] *Anthologia Palatina* 5. 132. 7 (= Philodemos 12. 7 Gow-Page [1968]). On this epigram, see Gow and Page 1968:vol. 2, 381–382 and cf. Sider 1997:108–109. Gow and Page considered also the possibility that the phrase οὐκ ἄιδουσα τὰ Σαπφοῦς "may mean merely that she does not know Greek" (1968:vol. 2, 382); even if one accepts this somewhat overskeptical view, this does not exclude that, although the Oscan woman did not speak Greek and thus could not sing Sappho's songs, Greek women did.

[217] See especially Catullus 35.16–17 *ignosco tibi, Sapphica puella / Musa doctior [...]* and Martial 7.69.7–10 and 10.35.15–18.

The discourses I shall explore are widely scattered in our sources and have not been analyzed together. It is my contention that the textures of each discourse overlap with those of others, and what I shall attempt to reconstruct is the interdiscursivity of cultural economies that affected the shaping of the figure of Sappho throughout the fifth century BC. The idioms and cultural textures that will be examined have mostly passed unnoticed or certain of them have been viewed in a contextual vacuum and in a somewhat schematic manner. As a result, metonymic and metaphoric associations that were gradually attached to Sappho have remained vague or unexplored.

That "Sappho" was performed at *symposia* is suggested by one red-figure vase inscribed with her name—the Bochum *kalyx-krater*.[218] That the compositions of her fellow citizen Alkaios were sung at Attic symposia throughout the fifth century is indicated by the performative versions of Alkaios fragment 249 V as well as a fragment from the *Daitalês* ("Banqueters") of Aristophanes:[219]

ἆισον δή μοι σκόλιόν τι λαβὼν Ἀλκαίου κἀνακρέοντος

Take ... and sing for me some drinking song of Alkaios and
Anakreon.

It has persuasively been suggested that the twenty-five Attic *skolia* (drinking songs) transmitted by Athenaios in the fifteenth book of his *Learned Banqueters* were part of a collection of *skolia* that took shape in mid-fifth century BC.[220] As we have seen, the *skolion* 891 PMG was part of Alkaios fragment 249 V that was presumably transmitted even as an anonymous composition in classical Attic *symposia*. The different versions of the *Harmodios skolion* in honor of the *turannoktonoi* Harmodios and Aristogeiton[221] were well known to audiences of fifth-century comedies to the extent that characters in plays of Aristophanes constantly refer to, or quote their multiforms of, this song.[222] In the fourth century BC, Antiphanes will reconfirm the old popularity of the *Harmodios*.[223] Further, the *Telamon* and the *Admetos* songs—also specimens in Athenaios' Attic collection—are recalled by playwrights, especially in the context of staged

---

[218] See Chapter Two, pp. 88–110.

[219] Fr. 235 K-A. For the object of "take," see Kassel and Austin's annotations. Note that in *Politics* 1285a.35ss., Aristotle calls Alkaios fr. 348 V (an abusive song against Pittakos) *skolion* (...ἔν τινι τῶν σκολίων μελῶν).

[220] Reitzenstein 1893:13–17; *skolia* in Athenaios 15.693f–695f = *carmina convivialia* frs. 884–908 PMG.

[221] *Carmina convivialia* frs. 893–896 PMG.

[222] See *Acharnians* 980 and 1093; *Wasps* 1225; *Lysistratê* 632; *Pelargoi* fr. 444.2 K-A. According to Hesykhios' report (s.v. Ἁρμοδίου μέλος), some claimed that the song was composed by a certain Kallistratos. For the term *multiform*, see Lord 1991:76 and 1995:23.

[223] *Diplasioi* fr. 85.5 K-A and *Agroikos* fr. 3.1 K-A.

*symposia.*[224] In a reenactment of a banquet in the *Wasps*, another, explicitly political song by Alkaios is improvised.[225] Among the *skolia* that Athenaios preserves one is ascribed to the fifth-century Praxilla of Sikyon, a poet famous for her rococo-like hymn to Adonis.[226] I should like to stress that between Praxilla fragment 749 *PMG* and the *skolion* 897 *PMG* differences occur in the text as transmitted by the ancient sources.[227] I shall return to this issue in Chapter Four. On the tondo of a red-figure cup, replete as it is with images of symposiasts making music, drinking, and playing *kottabos*, an Atticized rendering of the opening phrase of a song generally assigned to Praxilla comes out of the mouth of a singer who reclines on a couch along with an *aulos*-player: ὦ διὰ τῆς θυρίδος ("oh you...through the window").[228] Attic *symposia* facilitated the creation of song repertoires, which could constantly absorb new compositions and subject them to metonymic "genre" associations.[229]

In this fifth-century context of fervent interest in the composition of drinking songs,[230] Sappho's poetry, as I shall argue in more detail in Chapter Four, did not remain unaffected. A neglected, albeit significant, late source attributes Praxilla fragment 749 *PMG*—a version of the *Admetos* song—to Sappho:

[224] Telamon song: Aristophanes *Lysistratê* 1237, Theopompos [inc. fab.] fr. 65.3 K-A, Antiphanes *Diplasioi* fr. 85.4 K-A. Admetos song: Kratinos *Kheirônes* fr. 254 K-A, Aristophanes *Wasps* 1238 and *Pelargoi* fr. 444.1 K-A. A *skolion* by the early fifth-century poet Timokreon of Rhodos (fr. 731 *PMG*) is "cited" in Aristophanes *Akharnians* 532–534.

[225] Aristophanes *Wasps* 1232–1235; Alkaios fr. 141 V (the restoration of Alkaios' fragment as is printed in Voigt or Lobel and Page is primarily based on Aristophanes' passage and on ancient scholia on that passage and on *Thesmophoriazousai* 162; if its aim is taken to be the reconstruction of the "original" song, this restoration may be considered tentative). On line 4 of this fragment, see Page 1955:237.

[226] Praxilla fr. 749 *PMG* and cf. *carmina convivialia* 897 *PMG*. Cf. also Praxilla fr. 750 and *carmina convivialia* 903 *PMG*. According to Athenaios 15.694a, Praxilla was admired for her *skolia*. See also Chapter Four, pp. 343–344

[227] For Praxilla 749.2 *PMG* γνοὺς ὅτι δειλῶν ὀλίγα χάρις is provided by the scholia on Aristophanes *Wasps* 1238 and Eustathios *Iliad* 2.711–715 (vol. 1, 509 van der Valk), while for carm. conv. 897 *PMG* γνοὺς ὅτι δειλοῖς ὀλίγη χάρις is preserved in the manuscript tradition of Athenaios (see Page's annotations in fr. 749 *PMG*). *Theognidea* 854 = 1038b W is a slightly different version of the same idea (ἤιδεα...| οὔνεκα τοῖς δειλοῖς οὐδεμί' ἐστὶ χάρις). It is of significance that the *skolion* attributed to Praxilla includes the address ὦ ἑταῖρε.

[228] London, British Museum 95.10–27.2 [1895.10–22.2], tentatively dated to *c.* 470–460 BC (Csapo and Miller 1991:370) and preserving part of Praxilla fr. 754.1 *PMG* (according to Eusebios Chronicle Ol. 82.2, Praxilla's *floruit* is 451–450 BC). On this vase, see Csapo and Miller 1991—with illustrations of the two sides and the tondo. The whole issue of the graffito inscriptions on this vase is complex.

[229] Yatromanolakis 2007b.

[230] *Skolia* are attributed to Stesikhoros (scholia on Aristophanes *Wasps* 1222), Simonides (scholia on Ar. *Wasps* 1222, Simonides fr. 651 *PMG* and *carmina convivialia* 890 *PMG*), and Pindar (see testimonia in *carmina convivialia* 912 *PMG* and cf. testimonia in Pindar frs. 122 and 125 M). Symposiastic encomia were hard to distinguish from *skolia* (cf. Harvey 1955).

τοῦτο οἱ μὲν ᾽Αλκαίου, οἱ δὲ Σαπφοῦς· οὐκ ἔστι δέ, ἀλλ᾽ ἐν τοῖς Πρα-
ξίλλης φέρεται παροινίοις.

Some ascribe it to Alkaios, some to Sappho; it is not by either of
these two, but it is transmitted in Praxilla's *drinking-songs*.[231]

Eustathios reports that the Atticist lexicographer Pausanias in the second
century AD wrote that the song was attributed either to Sappho or to Alkaios
or to Praxilla.[232] Although these are not fifth-century BC sources and we do not
know whether such attributions can be dated back to the Hellenistic period,
when editorial activities toward a textual fixation of Sappho's songs led to the
first Alexandrian scholarly collection of her poetry,[233] they certainly reflect
late discourses about the reception of Sappho. These lexicographic informants
suggest that "Sappho" could well be viewed as being sung at Attic *symposia*.[234]
Also, the performative rhythms of metrical structures—an aspect sometimes
neglected by modern analysts of the cultural history of the classical period—
must have played a role in the association of her songs composed in Aeolic
meters with Attic fifth-century *skolia*, which were usually short compositions
comprised of four lines or a couplet in meters of Aeolic type.[235]

As the visual representations of Sappho and Anakreon indicate, their songs
must have arrived in Athens around the same time. Alkaios' and Sappho's com-

---

[231] Scholia on Aristophanes *Wasps* 1238.

[232] Eustathios *Iliad* 2.711–715 (vol. 1, 509 van der Valk). See *incerti auctoris* fr. 25C V and Praxilla fr.
749 PMG. For modern attributions of the *skolion* to Alkaios and Sappho, see Voigt's apparatus
(*inc. auct.* fr. 25C V). Photios *Lexicon* A 370 (Theodoridis) provides similar information (᾽Αδμήτου
λόγον· ἀρχὴ σκολίου, ὃ οἱ μὲν ᾽Αλκαίου, οἱ δὲ Σαπφοῦς φασιν). The metonymic association
between Sappho and Praxilla is of importance.

[233] For the editorial reception of Sappho, see Yatromanolakis 1999a.

[234] A further intriguing source, Dioskorides 18 G-P (= *Anthologia Palatina* 7.407), should be discussed
in this context. Line 3 of this late third-century BC epigram addressed to Sappho reads:
[Sappho, with the Muses surely Pieria honors you] ἢ Ἑλικὼν εὔκισσος ἴσα πνείουσαν ἐκείναις
("or ivied Helikon, [you Sappho] whose breath is equal to theirs"). Gow and Page (1965:vol.
2, 250) comment: "parts of Helicon are very fertile (*RE* 8.5), but ivy, appropriate to Dionysus
and therefore to dramatists...and symposiac poets such as Anacreon (e.g. Antipater 246,
279), is less so to Sappho. The adjective does not occur elsewhere." I would suggest that the
epithet εὔκισσος is highly apt for Sappho, especially in an epigram that focuses on the diverse
aspects and repertoire of her poetry. "Ivied" bears traces of a symposiastic understanding
of Sappho that is embedded in one of the several Hellenistic epigrams about her. Note that
these epigrams generally outlined and disseminated a deeroticized version of Sappho's poetry.
Moreover, I would like to draw attention to the use of μαινόλαι θύμωι in Sappho 1.18 V and the
later attestation of μαινόλης as a ritual epithet of Dionysos (see Kornoutos *On the nature of gods*
60; Ploutarkhos *On Restraining Anger* 462B, Philon *De plantatione* 148, Origenes *Against Kelsos* 3.23,
Klemes of Alexandria *Protreptikos* 2.12.2, *Anthologia Palatina* 9.524.13 [an anonymous hymn to
Dionysos], Eustathios *Oration* 10.177, *Iliad* vol. 2, 259, vol. 4, 225, Maximos Planoudes *Epistle* 22;
cf. Arkhilokhos fr. 196a. 30 W μαινόλις γυνή and Hesykhios s.v. μαινόλης).

[235] Cf. Chapter Four, pp. 357–358. The same applies to the association of Sappho with Anakreon.

positions might have perhaps reached Athens slightly earlier, but none of our few early informants offer conclusive confirmation of this. As Terpandros apparently left Lesbos in the early seventh century and brought with him, to Sparta and to Delphoi, Aeolian and East Greek traditions in music and song-making—including the composition of *skolia*—so might Anakreon have contributed to the dissemination of Sappho's poetry in Athens.[236] That Anakreon must have been familiar with Sappho's songs is firmly established, as I have shown, by the parallel existence of their visual representations on Attic vases—which further suggests parallel performances and reperformances of their songs in the context of Athenian symposia. Since Sappho's songs were known in Athens already by 510–500 BC, Anakreon, who performed his songs there around the same decades, must have heard some of her compositions being sung on different occasions—if he had not heard them long before during his trips from Teos to Samos and other Greek areas. Either way, Anakreon composed a song about a girl from Lesbos with elegant, jazzy sandals, thus contributing to the shaping of ambivalent cultural discourses about young women from this island. To go a step further, fragments of Anakreon indicate some kind of performative "dialogue" with the songs of Sappho or, rather, with their themes and broader cultural tradition. There is no way for us to trace the ancient receptions of Anakreon fragment 376 *PMG*, but it is tempting to think that it could be viewed, especially after the figures of Sappho and Anakreon began to be closely associated,[237] as "intertextually" alluding to Sappho's songs about Phaon—compositions that were to be construed as indications of the idea that she herself leapt from the cliff of Leukatas because of her love for that exceptionally handsome man:

ἀρθεὶς δηὖτ' ἀπὸ Λευκάδος
πέτρης ἐς πολιὸν κῦμα κολυμβῶ μεθύων ἔρωτι.

Once again I leap up from the Leukadian cliff
and dive into the grey, surging waves, drunk with love.[238]

---

[236] A reference in Ps.-Ploutarkhos to an "invention" of σκολιὰ μέλη by this esteemed *kitharôidos* (καθάπερ Πίνδαρός φησι, "as Pindar says"; *On Music* 28) points to an ancient perception of the possible antiquity of this form. Cf. also Athenaios 15.693f.

[237] See Yatromanolakis 2001a:161.

[238] Anakreon 376 *PMG*. Even the catchword "once again" employed by Sappho and Anakreon (as well as by Alkman and Ibykos, poets whose compositions suggest some contact with East Greek or neighboring foreign cultures) might have been perceived as a sign of a common song-making tradition. On δηὖτε in these poets, see Wells 1973, Carson 1986:118–119, and especially Nagy 1996:99–102. Mace's assertion (1993) that the use of "once again" reflects the existence of a distinct and clearly defined subgenre of erotic archaic melic poetry, is overly schematic and anachronistic to the extent that it is based on modern categorical principles. See Yatromanolakis 2003a, 2007b, 2007e on the interdiscurivity of archaic genre discourses and modern taxonomic concepts.

Sappho's †ται† στεναχίσδω θαμέως ("for these I groan often") in the almost complete poem considered above[239] recalls Anakreon's διὰ ταῦτ' ἀνασταλύζω θαμά ("for these I sob often…") in fragment 395.7–8 *PMG*.[240] In Sappho fragment 94 V, the image καὶ πόλλαις ὑπαθύμιδας πλέκταις ἀμφ' ἀπάλαι δέραι ἀνθέων [ ] πεποημέναις ("and around your tender neck [you placed] many woven garlands made from flowers") and especially the occurrence of ὑπο-θυμίς in line 15 are reminiscent of Anakreon fragment 397 *PMG* πλεκτὰς δ' ὑποθυμίδας περὶ στήθεσι λωτίνας ἔθεντο ("they put over their chests woven garlands of lotus").[241] The ὑποθυμίς[242] was the indigenous word of the Aeolians and the Ionians for a garland, which used to be worn around the neck.[243] Athenaios remarks that the fourth-century BC scholar and poet Philetas of Kos mentions that the Lesbians called a myrtle spray *hupothumis*, around which they wove violets and various other flowers.[244]

On the level of poetics, both Sappho and Anakreon, as far as the evidence allows us to see, placed special emphasis on metapoetic pronouncements in their compositions. The singing voice of Anakreon fragment 402c *PMG* declares:[245]

> ἐμὲ γὰρ †λόγων εἵνεκα παῖδες ἂν φιλέοιεν·
> χαρίεντα μὲν γὰρ ἄιδω, χαρίεντα δ' οἶδα λέξαι.

> For young lads might love me for my words;[246]
> for I sing graceful songs and I know how to speak charming
> words.

---

[239] For clarity's sake, I shall henceforth call the song quoted above, pp. 203–204, Sappho fr. 58c (= Sappho fr. 58.11–22 V along with the text provided by P.Colon. 21351 and 21376). See Chapter Four, n. 341.

[240] Compare Sappho fragment 1.2 and 25–28 V with Anakreon fragment 357.6 and 9–11 *PMG*.

[241] Cf. Alkaios fr. 362.1–2 V, quoted along with Sappho fr. 94.15–16 V and Anakreon fr. 397 *PMG* by Athenaios 15.674c–d. Compare also Sappho fr. 120 V and Anakreon fr. 416 *PMG*, both songs quoted together in the *Etymologicum Magnum* 2.45–48.

[242] Or ἐπιθυμίς according to Ploutarkhos *Symposiaka* 3.1, 647F.

[243] Athenaios 15.678d and 15.674c.

[244] Athenaios 15.678d; Philetas fr. 42 Kuchenmüller. *hupothumis* was also the name of a type of bird in Greece: Dunbar's excellent discussion of this bird is based on extensive ornithological research on birds in contemporary Greece (Dunbar 1995:249–250, commenting on Aristophanes *Birds* 302).

[245] See also scholia on Pindar *Isthmian* 2.1b (3.213 Drachmann).

[246] There is a lacuna before or after the word λόγων (see Page's apparatus criticus in 402c *PMG*). Among the conjectural restorations quoted in *PMG*, Blass's λόγων <μελέων τ'> is the most unmarked and least repetitive (cf. Bergk's λόγων <ἐμῶν>); note the chiastic correspondence between λόγων and λέξαι and between the supplemented <μελέων τ'> and ἄιδω.

The speaking subject in Sappho fragment 147 *PMG* stresses "her" future reception:

μνάσεσθαί τινα φα<ῖ>μι †καὶ ἕτερον† ἀμμέων

Someone will remember us, I say, in the future.

In another song, according to Ailios Aristeides, the singing subject ("Sappho") boasted that Muses had made her really blessed, even enviable, and that she would be remembered even after her death.[247]

Further correspondences and commonly shared resonances can be detected in Sappho's and Anakreon's use of musical instruments that had an Eastern Greek aura. In their songs they referred frequently to the *paktis* and the *barbitos*, both stringed instruments of Eastern origin, as well as to neighboring Lydia and its lifestyle.[248] Such similarities bespeak the sharing of a common cultural milieu, but at the same time help us understand how Sappho's songs could be associated with Anakreon's East Greek compositions. In other words, these correspondences were conducive to the formation of the broader and more complex horizons of expectations that shaped the reception of both Anakreon and Sappho by late archaic and classical Athenians.

Since Anakreon's poems were sung in Attic *symposia*, some of these short compositions were perceived and performed as sympotic *skolia*.[249] In this respect, it is intriguing that Teos, the birthplace of Anakreon, was associated with the composition of the *skolia* of the sixth-century BC Teian poet Pythermos, who was mentioned by Hipponax in one of his iambic verses.[250] According

---

[247] *Orations* 28.51 (2.158 Keil). See Yatromanolakis 2006b for discussion of other fragments; cf. also Sappho fr. 58b (P.Colon. 21351).

[248] Anakreon frs. 373.3, 386 (*pêktis*); 472 *PMG* (*barbitos*); Sappho frs. 22.11, 156.1 (*paktis*); 176 V (*barbitos*). The same applies to Alkaios: see Alkaios frs. 36.5 and 70.4 V.

[249] For a fifth-century BC source that explicitly calls *skolion* a composition of Anakreon's, see Aristophanes *Daitalês* fr. 235 K-A (quoted above). See also Anakreon fr. 500 *PMG* (=Athenaios 13. 600d-e), where the fifth-century BC politician and poet Kritias calls Anakreon συμποσίων ἐρέθισμα ("the excitement/arousal of drinking parties"). For his image as symposiastic poet in later periods, see Loukianos *Symposion* 17 (for a performance of a sympotic centum of "Anakreon," "Pindar" and "Hesiod"), *True Story* 2. 15 (Anakreon in the company of Eunomos of Lokris, Arion of Lesbos, and Stesikhoros—all in the context of a *symposion* in the Elysian fields), and cf. Aulus Gellius *Attic Nights* 19. 9. 3f. (for the *Anacreontea*). See also Suda's συνέγραψε παροίνιά τε μέλη ("he composed drinking songs," s.v. Ἀνακρέων) and compare the παροίνια attributed to Praxilla (fr. 749 *PMG*).

[250] *Carm. conv.* 910 *PMG* (= Athenaios 14.625c). Athenaios reports that Pythermos of Teos was mentioned by Ananios or Hipponax. In antiquity Ananios' poems were sometimes confused with Hipponax's (see sources in Ananios frs. 1 and 3 W).

to Athenaios, some thought that Pythermos employed the "voluptuous" Ionian mode for the music of his *skolia*.[251] However, what was of considerable significance for the early reception of Sappho is the gradual and persistent association of her poetry and figure with Anakreon's songs, full as they were of sympotic images.

The performative association of Anakreon's erotic songs[252]—many of which were explicitly pederastic—with Sappho's compositions increasingly and implicitly contributed, I argue, to the notion that those of Sappho could potentially have some "pederastic" dimensions. To be sure, the expression of passion (conventional or not) for young men in song was not confined to Anakreon. Among other archaic poets—for example, Ibykos and Stesikhoros—[253] Alkaios too composed pederastic songs.[254] Why then should Anakreon in particular be connected with Sappho's poetry? I have already pointed to some of the broader discourses—visual, textual, cultural—that led to such a metonymic connection of Sappho and Anakreon. I further argue that this association, as reflected in the discourse of heterogeneous cultural informants, steadily shaped and placed into circulation an implicit definition of those songs that were received as *marked* "erotic songs" of Sappho. As soon as this association was established in the public imagination, it rendered Sappho's songs open to diverse performative and interpretive "scannings," especially by Athenian symposiasts. Probably the same performative context gradually facilitated the configuration of clusters of names of melic song-makers—clusters that were to endure for several centuries despite occasional modifications conditioned by their use in diverse discursive contexts.

[251] Athenaios 14.625c–d. Plato considered the Ionian mode soft and sympotic (*Republic* 398e …μαλακαί τε καὶ συμποτικαὶ…).

[252] Apart from the relevant style of his fragments, several Roman and Greek authors acknowledge that his poetry was predominantly erotic; see, especially, Cicero *Tusculan Disputations* 4.71 and Klemes of Alexandria *Stromateis* 1.78.

[253] See Ibykos fr. 288 *PMG*, his "ode to Gorgias" (fr. 289 *PMG*), and the testimonies *de nostri puerorum amore* in Davies's edition (TB1–TB5 [1991:240]), to which add *Anthologia Palatina* 7. 714. 3 (quoted as TA10). For Stesikhoros, see Athenaios 13.601a. It has been cogently suggested by Hägg (1985:96) that in the fragmentary novel *Metiokhos and Parthenope* (c. first century AD), Ibykos was present at a banquet in the court of the sixth-century Samian *turannos* Polykrates and sang of the young couple; for the fragments of the novel, see Reardon 1989:813–815 and cf. Stephens and Winkler 1995:72–94 (on Ibykos especially pp. 73 and 75). Hägg and Utas 2003 provide an authoritative and insightful exploration, with critical editions, of *Metiokhos and Parthenope* and *Vâmiq and 'Adhrâ*, an eleventh-century AD Persian epic poem by 'Unsurîî that is based on the ancient Greek novel. For Ibykos, see their discussion in Hägg and Utas 2003:43–44, 104–105, 139–140, 167–168, 230–231. Ibykos is called *\*îfuqûs* (as restored by Iranists) in the fragmentary Persian epic and is presented as playing the *barbat* and performing songs of Diyânûs, that is, Dionysos (see further Hägg and Utas 2003:230–231).

[254] For Alkaios' pederastic poetry, see Vetta 1982; cf. also Buffière 1980:246–249, Cantarella 1992: 12–13.

## Clusters

I shall examine here two such clusters, since they are related to each other in terms of their sympotic resonances. The first focuses on the association between Sappho and Anakreon; the second comprises the names Alkaios, Anakreon, and Ibykos. I begin with the latter.

I have already considered the image of old "Ionian" poets that the poet Agathon conjures up in the *Thesmophoriazousai*.[255] Sporting elegant headgears and mincing in Ionian style, Ibykos, Anakreon, and Alkaios[256] are viewed as composers of spicy, juicy music. As I argued in Chapter Two, the cultural schema of East Greek poets as elaborately dressed komasts was firmly established in the horizons of expectations of late fifth-century Athenians and had started being applied to any contemporary aesthete composer. Into that idealized cognitive model the names of Alkaios, Anakreon, and Ibykos had been assimilated—each one independently or even all of them as a musically and culturally coherent triad. The three names were placed together again by later sources, in a way suggesting an established configuration of a cluster of sympotic melic poets. Thus, in his *Tusculan Disputations*, Cicero derogatorily speaks about the statements and disclosures that *homines doctissimi* and the most distinguished poets make in their verses, illustrating his remark by citing the most extravagant cases of song-makers—all, significantly, from archaic Greece: Alkaios, a political man of great recognition in his city, who, yet, focused on love for youths; Anakreon, whose poetry, according to Cicero, is all erotic; and above all, Ibykos, who was burning from desire. As evinced in their writings, Cicero claims, the *erôs* of all of these poets was lustful.[257] A contemporary of Cicero, Philodemos, in his treatise *On Music*, constructs an

---

[255] Aristophanes *Thesmophoriazousai* 159–163. See Chapter Two, pp. 139–140.

[256] The case of the reading "Alkaios" is more complex, since an ancient scholiast mentions that the variant reading "Akhaios" occurred in the older copies of the play (162 ἐν ἐνίοις δὲ Ἀχαιὸς γέγραπται, καὶ τὰ παλαιότερα ἀντίγραφα οὕτως εἶχεν). See all the discussion and reasoning in the ancient scholion on *Thesmophoriazousai* 162 (the scholiast rejects any argument against the reading "Alkaios the Lesbian poet"). Almost all modern editors retain (rightly, I believe) the reading κἀλκαῖος ("and Alkaios") provided by codex Ravennas 429 and supported by Aristophanes of Byzantion (who, according to the scholiast, proposed it as an emendation) and the Suda (s.vv. ἐμιτρώσατο and ἐχύμισαν). There is scholarly consensus that Agathon refers here to the Lesbian poet, who, as I have discussed, is also "quoted" in other plays by Aristophanes. Cf. *Birds* 1410–1411 and see scholia on *Birds* 1410 and on *Thesmophoriazousai* 162, where it is reported that *Birds* 1410 parodies Alkaios fr. 345 V. It is significant that in *Birds* 1416 Peisetairos' comment (εἰς θοἰμάτιον τὸ σκόλιον ᾄδειν μοι δοκεῖ) on the Informer's "quotation" (1410–1411; cf. Voigt's apparatus criticus) may suggest that Alkaios fr. 345 V was viewed as a *skolion* (or "drinking song").

[257] Cicero, *Tusculan Disputations* 4.71.

argument against the Stoic philosopher Diogenes of Babylon and similarly refers to almost the entire marked triad of archaic pederastic poets:

οὐδὲ τοὺς νέους τοῖς μέλεσι διαφθ[ε]ίροντας παρέδειξεν τὸν Ἴβυκον καὶ τὸν Ἀνακρέοντα καὶ τοὺς ὁμοίους, ἀλλὰ τοῖς διανοήμασι.

And [Diogenes] did not [manage to] show that Ibykos and Anakreon and the like corrupted the young men by their music—rather this happened through their ideas.[258]

Even a scholiast on Pindar's opening strophe in the second *Isthmian* ode—an introductory praise of those notable poets who shot their hymns of love at any handsome boy at the apex of his bloom—points out that these lines refer to Alkaios, Ibykos, and Anakreon (or any other poets) who paid special attention to the pursuit of their favorite boys.[259]

A definitional complementarity is more pervasive in the case of the cluster "Sappho and Anakreon." This association is echoed already in Plato. Khamaileon has Sappho replying to a song addressed to her by Anakreon. Hermesianax, in the early third century BC, has Anakreon visiting Lesbos to pursue his love for Sappho, who must have been quite old, if not dead, when Anakreon was a boy.[260] In the late fourth/early third century BC, Klearkhos of Soloi also felt inclined to juxtapose the songs of Sappho and Anakreon.[261] The markedness of the juxtaposition takes diverse configurations, all of which, however, result in a habitually internalized assimilation of the figure and poetry of Sappho into the sympotic songs and persona of Anakreon. Writers who endorse—for a variety of purposes—the same associative schema range from the third century BC to the Roman period to medieval Greece:[262] in his treatise *On the Isthmian Games*, the scholar-poet Euphorion attesting that

---

[258] *On Music* 4.14.8–13 (p. 57 Neubecker [1986]). In this context it is intriguing that in the sentence that follows the passage discussed here, von Arnim in *SVF* 3.229 (Diogenes fr. 76 SVF) printed καὶ γὰρ ἅπερ Σαπ[φὼ] ὀνόματ' ἔλεγε, τούτοις ἔθρυπτον, εἴπερ ἄρα (Neubecker 1986:57 prints καὶ γὰρ ἃ Περσαῖ[ο]ς ὀνόματ' ἔλεγε, τούτοις ἔθρυπτον, εἴπερ ἄρα; cf. Kemke 1884:79, fr. 14.13–14). I intend to examine the whole text in detail elsewhere.

[259] Scholia on Pindar *Isthmian* 2. 1b (iii 213 Drachmann).

[260] Plato *Phaidros* 235b–c; Khamaileon fr. 26 Wehrli; Hermesianax fr. 7. 47–52 CA. The Neo-Platonic philosopher Hermeias, in his commentary on Plato's *Phaidros*, often refers to and discusses Plato's associative juxtaposition of the two melic composers (2.18, 42.12, 42.17, 42.32, 43.1, 43.18, and 88.21 Couvreur). See also discussion below.

[261] In his *Erôtika*, fr. 33 Wehrli.

[262] Dionysios of Halikarnassos *Demosthenes* 40 (5.214ff. Usener-Radermacher), where Hesiod, Sappho and Anakreon are used as characteristic examples of the elegant style, is not relevant to the issue. Menandros Rhetor 333.8–10, 334.26–335.4 refers to the many κλητικοὶ ὕμνοι of Sappho and Anakreon ("or the other poets") but also juxtaposes Sappho's kletic hymns to those of Alkman (for the problems arising from the transmitted text in 334.29–31, see the comments of

Anakreon and Sappho made mention of the instrument *barbitos* or *barmos* in their songs;[263] Ovid in his *Tristia*;[264] Ploutarkhos;[265] Dion Khrysostomos in an intriguing envisaging of the inappropriateness of the erotic songs of Sappho and Anakreon being sung by kings;[266] the anonymous *Anacreontea*;[267] Aulus Gellius;[268] Pausanias in his periegetic guide to Greece;[269] Maximos of Tyros;[270]

---

Russell and Wilson 1981:232–233). Horace *Carmina* 4.9.9–12 (see below, n. 264) is similarly not relevant to my discussion. In his brief reference to the fact that Sappho sang of love and was counted "simply as one of the nine lyric poets," Parker (1993:340) notes that she was compared to Anakreon (he also cites Winkler 1990:163 as a confirmation, but Winkler actually did not comment on this). Parker has taken into account the selected testimonia printed in Campbell 1982, and thus fails to see that several of the examples he cites are not relevant. The tendency to read testimonia out of their broader textual (let alone cultural) context is not confined to Parker, who does not go beyond noting the comparison.

[263] Athenaios 4.182e–f. On the variant form *barômos* attested in Athenaios 4.182f, as well as the "Aeolic" form *barmitos*, see, briefly, West 1992a:58n43. Note that the historian Menaikhmos of Sikyon (c. 300 BC), in his treatise *On Artists* (Athenaios 14.635e), mentioned that Sappho, "who was older than Anakreon, was the first to use the *pêktis*." In the same work, Menaikhmos argued (Athenaios 14.635b) that the *pêktis*, which according to Menaikhmos was the same as the *magadis*, was invented by Sappho. Both Aristoxenos and Menaikhmos (Aristoxenos fr. 98 Wehrli) maintained that the *pêktis* and the *magadis* were the same instrument.

[264] *Tristia* 2.363–365. Ovid compares the "instructions" that Anakreon and Sappho gave to their addressees and companions. Horace *Carmina* 4.9.9–12 places the two figures in the context of other poets.

[265] *Gunaikôn Aretai* ("Virtues of Women") 243b. Ploutarkhos explores the arbitrariness of the taxonomic concept according to which poetic art is categorized as male and female: in doing so he employs as a case in point and places side by side the songs of Sappho and Anakreon. For a performative sympotic association of the poets in Ploutarkhos' *Sympotic Questions* 711d, see discussion in Chapter Two, pp. 82–83.

[266] *Orations* 2.28 (*On Kingship II*). This passage has remained unexplored in current scholarship on Sappho. The dramatic setting of Dion's second oration on kingship is a discussion that Alexandros the Great had with his father Philippos. The theme of this discussion is Alexandros' admiration of the Homeric epics and Philippos asks his son to give him reasons why he is infatuated with these poems. Alexandros reflects on what readings and intellectual exercises rulers should focus on, and when it comes to music (*mousikê*), he points out that he would not be willing to learn all existing music but only enough to perform hymns to gods with the *kithara* or the *lyra* and to sing the praises of brave men. As an example of those compositions that are not befitting to be sung by kings, he mentions the most obvious (γε): the *erôtika melê* of Sappho and Anakreon's. Intriguingly, the whole discussion also focuses on how Alexandros envisages the *musical* performance of the Homeric epics (see *Orations* 2.29).

[267] *Anacreontea* 20.1–2. Anakreon and Sappho are here modified with the same epithet (*hêdumelês*, "sweet-singing"). The poetic subject claims that if the two of them are mixed with a song of Pindar and poured in his cup, they would all be an exquisite drink for Dionysos, Aphrodite, and Eros.

[268] *Attic Nights* 19.9.4. See discussion in Chapter Two, pp. 83–85.

[269] Pausanias 1.125.1 (1.55 Rocha-Pereira). Anakreon is represented by Pausanias as the first poet after Sappho to write mostly erotic poetry.

[270] Maximos 18. 9 l–m Koniaris (1995: 234–235). Ἡ δὲ τοῦ Τηΐου σοφιστοῦ τέχνη τοῦ αὐτοῦ ἤθους καὶ τρόπου [this passage follows Maximos' discussion of the τέχνη ἐρωτική of Sokrates and Sappho]· καὶ γὰρ πάντων ἐρᾷ τῶν καλῶν, καὶ ἐπαινεῖ πάντας... (= Anakreon fr. 402 *PMG*).

Themistios;[271] Himerios;[272] and even Gregorios of Korinthos.[273] All these informants consciously or unconsciously define Sappho's poetry through suggested analogies (subject, addressees, occasional context) with that of Anakreon. And there is no doubt that such parallelisms in turn exercised influence on early and later writers who attempted to reconstruct Sappho's life.[274] Anakreon— who, according to Klemes of Alexandria, was the inventor of erotic poetry just as Lasos of Hermione, as Klemes claims in the same context, invented the dithyramb[275]—functioned as a fixed cultural idiom against which "Sappho" could be molded or even coined each time other central aspects of her songs and her figure were deemed irrelevant to a discursive strategy.

The trafficability of the cultural coinage "Anakreon and Sappho" was so extensive that their names could appear interchangeably in certain cases. Apart from ascribing the invention of the Mixolydian mode to her, the fourth-century BC music theorist Aristoxenos, we hear, reported that Sappho and Alkaios deemed their book rolls (*volumina*) as comrades.[276] But at the same time, according to another informant, Aristoxenos claimed that Anakreon and Alkaios thought of their *libri* as friends.[277] The two reports (possibly) unconsciously alter the names and provide different versions, but they further display, I suggest, some kind of fluidity in the applicability of similar concepts to the two song-makers.

## Fluidities

A different kind of fluidity, more central to this investigation, can be detected in the representation of the figure of Sappho throughout fifth century BC. As suggested in Chapter Two, the Athens *hydria* bespeaks a discourse altogether

---

[271] *Orations* 13.170d–171a Schenkl and Downey (1965: 245; Ἐρωτικὸς ἢ περὶ κάλλους βασιλικοῦ). The two poets are excused for being exuberant and immoderate in the admiration of their beloved youths (*paidika*). Themistios goes on and accounts for his statement.

[272] *Orations* 17.4 (p. 105 Colonna). In this oration on the Cypriots, Himerios observes that Sappho and Anakreon never cease to invoke Cyprian Aphrodite as an overture to their songs.

[273] Also known as Gregorios Pardos, *Commentary [Exêgêsis] on Hermogenes'* Περὶ μεθόδου δεινότητος ap. *Rhetores Graeci* 7. 1236 Walz. It is observed here that the ear is shamefully buttered up and cajoled by erotic phrases such as those of Anakreon and Sappho.

[274] For example, Sappho is γυναικεράστρια in P.Oxy. 1800 fr. 1, which alludes to the pederastic model that applies to the male poets, since it may imply that she was believed to have played the *erastês* to a female counterpart of the male *erômenos*.

[275] *Stromateis* 1.78.

[276] Aristoxenos fr. 71a Wehrli (Ps.-Acro on Horace *Sermones* 2.1.30).

[277] Aristoxenos fr. 71b Wehrli (Porphyrio on Horace *Sermones* 2.1.30).

dissimilar from that reflected in the Munich *kalathos-psykter* and especially the Bochum *kalyx-krater*. These three vase-paintings show an external receptivity of Sappho in both female and male performative contexts. I shall now argue that Sappho's songs were characterized by a multilayered flexibility in terms of their potential assimilation into diverse performative contexts and cultural idioms. Especially in the classical period, which mainly concerns me here, Sappho was not seen as an established poetic figure whose songs could not have been subject to alterations that fitted the often independent shaping of her image. The poetry and the figure of a song-maker can be inextricably bound and move side by side. However, given the adaptability of Sappho's songs to diverse sociocultural contexts, her figure was also and gradually, I suggest, delineated independently and in a variety of ideological modalities in the fifth century BC. In contrast to the Hellenistic discourses reflected in the epigrams that made her a Muse—a deeroticized, almost neutral *eikôn*—her figure in the fifth century resisted a unified narrativization—a definition that would fix her in the imagination of people as the representative par excellence of a specific cultural type. In other words, Sappho could receive diverse or complementary definitions that went beyond clear-cut taxonomic principles applied to the more easily and habitually contextualizable songs of male poets. The case of Simonides, which I choose among other similarly marked cases of male archaic lyricists, provides the backdrop against which the shaping of the figure of Sappho can be evaluated. In this respect, as I argue in Chapter One, Sappho should rather be viewed as a kind of discursive coinage, as it were, whose socioaesthetic value and trafficability were differently determined and estimated according to the diverse contexts of its circulation.

In one of the earliest dated plays (424 BC) of Aristophanes, the chorus of Athenian Knights express their hostility to Paphlagon—a fictional embodiment of the politician Kleon—by wishing that if his shamelessness is prevented in some way they will then, and only then, sing "drink, drink for good fortune"—the opening phrase of a "four-horse chariot" epinician ode of Simonides.[278] The archaic poet was regularly quoted and his image exploited in fifth-century comedy.[279] In his *Helots*, perhaps almost contemporary with Aristophanes' *Banqueters* (427 BC),[280] Eupolis has one of the characters or the chorus of the play say that, compared to the songs of Gnesippos, performing

---

[278] *Knights* 405–406; Simonides fr. 512 *PMG*.

[279] See e.g. Aristophanes *Wasps* 1410–1411, Simonides fr. 597 *PMG*, and Simonides fr. eleg. 86 W.

[280] Storey 2003:66 dates the play to the early 420s (*c.* 428), but the dates he proposes are tentative. Cf. Storey's somewhat tentative observations on Eupolis' *Helots* (2003:176–179).

the compositions of Stesikhoros, Alkman, and Simonides was old-fashioned those days.[281] Pheidippides seconds this idea in the quarrel he has with his father Strepsiades in the *Clouds*.[282] In the context of a banquet, Strepsiades asks his son to take a lyre and perform a song by Simonides, an epinician ode that included the image of the wrestler Krios of Aigina getting shorn when he went to "the glorious sanctuary of Zeus."[283] Having recently graduated from Sokrates' *phrontistêrion*, Pheidippides at once makes it clear that playing the lyre and singing at a drinking-party are old-fashioned practices and that Simonides is simply a bad poet. Comparable to this attitude is the view reflected in Eupolis fr. 398 K-A, where Pindar's poems are said to have been "silenced" by the contemporary lack of love for beauty and honor on the part of the masses. More definitive, however, is the representation of Simonides as avaricious in Aristophanes' *Peace*.[284] This fixed attribute for Simonides seems to go back to Xenophanes of Kolophon, who, according to tradition, called him a niggard (κίμβιξ).[285] It is evident that both Simonides and other archaic poets like Anakreon and Alkaios acquired a specific, somewhat unified "identity" in the imagination of fifth-century Athenians.[286]

With Sappho, I contend, the issue is more complex. What is detected in the surviving sources is a multiplicity of discourses revolving around her figure and lack of a unified narrativization. At the early stages of the reception

---

[281] Eupolis fr. 148 K-A. Stesikhoros' compositions might possibly have been viewed as traditional and as belonging to the older types of poetry in Aristophanes *Clouds* 967; see Page's discussion in Lamprokles fr. 735 *PMG* and Stesikhoros fr. 274 *PMG*. In Eupolis fr. 395 K-A, Sokrates is represented as stealing an *oinochoe* while singing a piece by Stesikhoros to the lyre.

[282] Aristophanes *Clouds* 1355–1362.

[283] Simonides fr. 507 *PMG*.

[284] *Peace* 697–699 and see ancient scholia on these lines. For the reference by the poor, patronage-seeking Poet to καὶ κατὰ τὰ Σιμωνίδου in Aristophanes *Birds* 919, see Dunbar 1995:521 (with bibliography) and 531.

[285] Xenophanes fr. 21 B 21 D-K (= Xenophanes fr. 21 W; cf. Khamaileon fr. 33 Wehrli, and Giordano 1990: 82 [fr. 33] and 169–171). West 1989/1992:vol. 2, 189–190 places the fragment of Xenophanes in the category "haec ex elegis esse possunt"; see also Giordano 1990:171. The most thorough study of Simonides as a skinflint in ancient traditions is Bell 1978. For Xenophanes and Simonides as κίμβιξ, see Bell 1978:34–37, who concludes that "the comment ascribed to Xenophanes seems to be genuine." The sources related to this established representation of Simonides include, apart from Xenophanes and Aristophanes, Khamaileon fr. 33 Wehrli, Ps.-Plato *Hipparkhos* 229b–c, Aristotle *Êthika Nikomakheia* 1121a.7, *Rhetoric* 1391a, 1405b.23–28 (= Simonides fr. 515 *PMG*), Theophrastos fr. 516 Fortenbaugh et. al. (1992:vol. 2, 338), Kallimakhos fr. 222 Pfeiffer, P. Oxy. 1800 fr. 1.40 (late second or early third century AD), P. Hibeh 17 (third century AD), and Stobaios 3.10.61. See further Bell 1978, especially his discussion of the later ancient representations of Simonides as wise.

[286] For Anakreon, see Chapter Two and above; cf. the image provided by the fifth-century Athenian poet Kritias (Anakreon fr. 500 *PMG* = Kritias fr. 1 D-K).

of her poetry and her figure, this multiplicity and fluidity are accounted for, I argue, by their inherent dynamic tendency to be assimilated into idealized cognitive models and by complex gender politics. When images of Sappho and Anakreon painted on vases circulated in Attic *symposia*, the initial associations between the two figures began to develop—long before Plato's juxtaposition.

## A Politics of Music

I shall embark here on an examination of how broader cultural idioms may have conditioned the gradual shaping of the figure of Sappho by focusing first on discourses related to music. When her songs traveled to Athens, they went through a regional "translation," in the sense that male participants at banquets and other performative venues had to "make sense" of them by relying on indigenous concepts and perceptual filters. Through such receptorial processes of discursive *vraisemblance*, the figure and songs of Sappho were naturalized and accommodated in different sociocultural environments. It is these filters we need to reconstruct in order to conduct historical-anthropological fieldwork on late archaic and classical cultural Athenian dynamics related to the reception of East Greek songs composed by a woman poet.

A fragment from an encomiastic *skolion* by Pindar provides us with a discursive framework highly pertinent to East Greek musical cultures:

τόν ῥα Τέρπανδρός ποθ' ὁ Λέσβιος εὗρεν
πρῶτος, ἐν δείπνοισι Λυδῶν
ψαλμὸν ἀντίφθογγον ὑψηλᾶς ἀκούων πακτίδος

[the *barbitos*] which once was invented first by Terpandros,
the Lesbian, when he heard at banquets of the Lydians
the concordant, octave-doubling plucking of the tall *pêktis*.[287]

Archaic Lesbian communities were imagined (in later sociocultural spaces) as having their music infiltrated by the Lydian musical tradition.[288] "Lydian" in

---

[287] Fr. 125 M. Cf. Aristoxenos fr. 99 Wehrli. The meaning of ὑψηλᾶς πηκτίδος ("tall *pêktis*," "lofty *pêktis*," or "high-pitched *pêktis*"?) is not entirely clear.

[288] On "Phrygian and Lydian elements" in the music of Peloponnesos, see e.g. Athenaios 13.625e–626a (= Telestes fr. 810 *PMG*). Strabon 10.3.17 provides an interesting discussion of the ancient discourses about the Asiatic—for, example, Phrygian or Thracian—character of ancient Greek music (see his introductory proposition: ἀπὸ δὲ τοῦ μέλους καὶ τοῦ ῥυθμοῦ καὶ τῶν ὀργάνων καὶ ἡ μουσικὴ πᾶσα Θρᾳκία καὶ Ἀσιᾶτις νενόμισται). A comparative, ethnomusicological study of the different discourses related to the "literary" appropriation of Lydian and Phrygian musical structures in ancient Greece is a *desideratum*.

many such references should be understood, I suggest, as an inclusive term metonymically standing for a wider Near Eastern area, since Lydian music or culture were often thought of by diverse ancient Greek communities as an "idealized," albeit profligate, effeminate, or decadent, *topos*. To take for granted poetic claims that a musical instrument originated in a specific Near Eastern context is somewhat precarious, since such ideas are frequently contradicted by other similarly constructed pronouncements.[289] Adopting a "foreign" musical instrument and adjusting it to more indigenous musical practices and tastes or "re-inventing" it altogether must have been a common modality in the ancient Near East and Greece. Especially the contiguity, geographical or cultural, of Lesbos and such areas as Lydia or Phrygia would suggest the sharing of a broader Anatolian musical *koinê*, despite regional, even marked, differences as well as related ideologies encoded in performative discourses. Attempting to ascertain the *specific* derivation of an instrument on the basis of chronologically and ideologically heterogeneous ancient informants is, therefore, an almost futile exercise.[290] What is certain is that a number of cordophones or idiophones were of East Greek or Eastern, non-Greek origin.[291] In the case of the *pêktis* (or in Dorian and Lesbian dialects *paktis*), a many-stringed

---

[289] A very similar, almost identical, type of harp, the *magadis*, was considered either Lydian or Thracian in origin (see Michaelides 1981:199, Barker 1988, and Mathiesen 1999:274). The *trigônos*, also a harp, was viewed as either Phrygian or Syrian or possibly Lydian (cf. Michaelides 1981:322, West 1992a:72n105, and Maas and Synder 1989:150–151). For differences among these types of harp, see Maas and Snyder 1989: 147–154 (closely followed by West 1992a:70–75, where also earlier bibliography). For the identification of the almost spindle-shaped *trigônos* or *trigônon*, see Maas and Snyder 1989:151 (overlooked in West 1997:50). For the *magadis*, see Barker 1988.

[290] It is not easy to infer from Pindar fr. 125 M that the Eastern poets "borrowed it from the Lydians" (see, among other classicists and music historians, Maas and Snyder 1989:40). Similarly, Barker 1984:49. According to myth, when Thracian women killed Orpheus—Thracian in origin—his head and lyre were thrown into the river by them and flowing into the sea were washed onto the shore at the city of Antissa on Lesbos; his lyre was found by fishermen and brought to Terpandros (Nikomakhos Excerpta 266.2–12 Jan).

[291] We read, for example, that "if the exact nature of the *pektis* (or *magadis*) is uncertain, at least the Lydian origin of the instrument is confirmed" by fifth-century literary sources (Maas and Snyder 1989: 40), an older idea also adopted by West 1992:71 (cf. West 1997, which rehearses almost the same evidence) as well as by numerous scholars. Note that LSJ and its new supplement (in the writing of which West was involved) state that the *pêktis* was "said to have been introduced (from Lydia) by Sappho" (LSJ s.v.), and cite Menaikhmos F 4 *FGH*, despite the fact that the fragment does not support this speculation. Similar assumptions pervade the section on harps in West 1992:70–75 (e.g. on p. 72 we read that the type of harp "without the pillar is closer to oriental models and no doubt the earlier"). The overly speculative assertions in Beaton 1980 and especially Sultan 1988 are made from a similar, but far-fetched and anachronistic, perspective. Concerning the origins of the *barbitos*, Maas and Snyder are cautious (1989: 39).

plucked instrument, it is interesting that, as opposed to the non-Greek roots of numerous names of ancient Greek instruments, but similarly to the *trigônos* or *trigônon*, it stems from the Greek adjective *pêktos* or the verb *pêgnumi* ("to join or fasten together"). The *pêktis*, a high-pitched instrument[292] compared to the relatively low-pitched *barbitos*, was referred to by Sappho in her songs—once probably as being played by a female companion.[293] If Sappho's archaic and East Greek *paktis* had any resemblance to the *pêktides* of the classical period, high-pitchedness would suit the higher register of the music of her songs in their reperformances by contemporary women in Lesbos.

To understand the broader associations that the *pêktis* and Lydian music—or music in dialogue with and potentially influenced by the Lydian tradition—had in Athenian contexts and how such cultural textures could permeate closely related performative discourses, we need to focus on a number of fifth-century discourses that establish a firm basis for the present investigation.

In an intriguing exhortation from his *Seasons*, Kratinos appears to have been one of the first playwrights to foreground the connections between sensual love songs, the Lydian musical fashion or mode, and women musicians—all in conjunction with and defining the work of an artistic male figure whose identity and apparent versatility have perplexed researchers to a considerable degree. Gnesippos was mentioned and parodied in other plays by Kratinos as well as by Khionides, Eupolis, and Telekleides.[294] The problem lies in the likelihood, ingeniously raised by Paul Maas and more recently supported by Ioannes Stephanis, that there were two Gnesippoi, one *kith-arôidos* or melic poet, the other a tragedian or producer of tragedies, "the son of Kleomakhos."[295]

> ἴτω δὲ καὶ τραγωιδίας
> ὁ Κλεομάχου διδάσκαλος
> †μετὰ τῶν† παρατιλτριῶν
> ἔχων χορὸν Λυδιστὶ τιλ-
> λουσῶν μέλη πονηρά

---

[292] Telestes fr. 810.4–5 *PMG* calls it "shrill-voiced."

[293] Sappho frs. 22 and 156 V.

[294] Kratinos *Herdsmen* fr. 17 K-A; *Malthakoi* ("Delicate/Indolent Men," "Mollycoddles") fr. 104 K-A; Khionides *Beggars* fr. 4 K-A; Eupolis *Helots* fr. 148 K-A; Telekleides *Sterroi* ("Tough Men," "Hard-Boiled") fr. 36 K-A. It is of some significance that in Khionides fr. 4 K-A the songs of Gnesippos are associated with those of Kleomenes (on Kleomenes, see the sources in *PMG* 838, especially Epikrates fr. 4 K-A). See further discussion in Chapter Four, pp. 288–291.

[295] Maas 1912; Stephanis no. 556 (pp. 117–118). For testimonia on Gnessipos, see *TrGF* vol. 1: 144–145 (and cf. the individual fragments, cited above, n. 292, in Kassel and Austin).

Let the son of Kleomakhos,
the *didaskalos* of tragedies,
go, taking with him a chorus of hair-plucking
female slaves, pulling the hair/textures/strains of their
    knavish limbs/songs in the Lydian style/mode.[296]

Even if Gnesippos is viewed as a *paigniagraphos* or, rather, *paigniographos*, as Athenaios labels him,[297] the point remains that through a lighthearted manipulation of the ambiguity of such words as *tillein* ("to pluck"), *Ludisti*, and *melê*,[298] Kratinos reflects an intricate web of signification, segments of which and further fine-tuning will recur throughout the fifth and fourth centuries.[299] Gnesippos is imagined here and in other instances as a producer of popular but decadent and frivolous art, and we should be especially attentive to such discourses about "noncanonical," lowly forms and practices as they constitute, through their power of labeling, a key element in our tracing of habitually internalized idioms that shaped the understanding of cultural and artistic phenomena in fifth-century Athens.[300] The art and versatility of Gnessipos accommodate even more diverse ideological inflections than, for instance, those of the established Euripides in the *Frogs*, and they function as a heterologic locus on which fluidity, ambiguity, and exoticism are projected. Eupolis, for example, specifies more clearly the musical instruments—*iambukai* and *trigôna*—plucked by adulterers when they lasciviously perform Gnesippos' songs at night:

τὰ Στησιχόρου τε καὶ Ἀλκμᾶνος Σιμωνίδου τε
ἀρχαῖον ἀείδειν, ὁ δὲ Γνήσιππος ἔστ' ἀκούειν.
κεῖνος νυκτερίν' ηὗρε μοιχοῖς ἀείσματ' ἐκκαλεῖσθαι
γυναῖκας ἔχοντας ἰαμβύκην τε καὶ τρίγωνον

[296] Kratinos *Seasons* fr. 276 K-A. Kaibel has restored the corrupt text of line 3 as follows: μετ' αὐτὸν ὁ παρατιλτριῶν, see Kassel and Austin's apparatus criticus.

[297] This is how he introduces Gnesippos' name in 14.638d (Γνησίππου τινὸς μνημονεύει παιγνιαγράφου τῆς ἱλαρᾶς μούσης). *paigniographos* is an emendation by Causabon, to my mind rightly defended by Maas (cf. Kassel and Austin's annotation in Khionides fr. 4). Davidson 2000 sees Gnesippos literally as a writer of *paignia*, a composer of erotic poetry for adulterers, that is, "a dim reminder of a private theatre which from an early date rivaled the dramatic production of the *polis* and stood in contradistinction to it" (2000:58). More literally, and less convincingly, Cummings 2001:53 argues that Gnesippos might have been "the founder of the literary paraclausithyron as a distinct and developed genre of content."

[298] Cf. Kassel and Austin's annotation on lines 3-5 (with reference to Meineke's view).

[299] For the *trigônon* (and *tumpana*) in a probably obscene context, see Eupolis *Baptai* ("Dyers") fr. 88 K-A.

[300] See Bourdieu's analysis of analogous shapings of *habitus* in Bourdieu 1977:72-158 and 1990:52-111.

The compositions of Stesikhoros and Alkman and Simonides
are old-fashioned to sing, but we can hear Gnesippos [every-
where, yes.]
That man has invented nocturnal ditties, serenades for
adulterers
to sing to the *iambukê* and the *trigônon* and to call out chicks.[301]

Instruments such as the *iambukê* and the *trigônon* seem to have been high in register[302] and thus suitable for the performance of songs by women. In effect, "ditties sung by women," "popular and folk song," "adultery," "high-pitchedness," even "otherness" were metonymically correlated in male hegemonic discourses. The permutations that such connections developed, along with the traditional, archaic and classical Greek concept[303] that songs of mourning, antiphonal wailing, and women were inseparably interrelated, as if *by nature*, were grafted onto the Athenian social imaginary to the extent that musical modes high in register were thought of as "feminine," "slack," or "soft"—with all the broader, multifaceted cultural and semantic extensions that these terms might have involved in the classical period.

Thus Sophokles will categorize and label the alleged "ethnicity" of predominantly female stringed instruments by stressing the antiphonal sonority of two harps:

πολὺς δὲ Φρὺξ τρίγωνος ἀντίσπαστά τε
Λυδῆς ἐφυμνεῖ πηκτίδος συγχορδία

Often the Phrygian *trigônos* ... and the concord
of the Lydian *pêktis* resounds in answering strains.[304]

Another fifth-century Athenian playwright, Diogenes, explores the associations between these two instruments and maidens, but this time the *aulos* and further Eastern ethnicities are introduced:

---

[301] Eupolis *Helots* fr. 148 K-A.

[302] On the *iambukê* and *sambukê*, see Michaelides 1981:279 (with earlier bibliography) and 146; Higgins and Winnington-Ingram 1965:67n34; Paquette 1984:290–292; West 1992a:75–77. Cf. Mathiesen 1999:278–280.

[303] See, especially, Alexiou 2002a:4–23 and for further studies Roilos and Yatromanolakis 2002:261–272; anthropological, comparative, and ethnomusicological material: 270–272. See also Alexiou 2002b. Loraux 1990 and 2002 are subtle, somewhat schematic analyses. Relying heavily on earlier bibliography, Kowerski 2005 provides a general, uneven survey of the evidence about Simonides' threnodic songs, including fragment 22 W. See further and from different perspectives Martin 2001:71; Nagy 2005:408–409; and Aloni's insightful article (forth.). Among recent studies, see Derderian 2001; Huber 2001; Oakley 2004; and Sourvinou-Inwood 2005:119–146.

[304] Sophokles *Mysians* fr. 412 *TrGF*.

κλύω δὲ Λυδὰς Βακτρίας τε παρθένους
ποταμῷ παροίκους Ἅλυϊ Τμωλίαν θεόν
δαφνόσκιον κατ' ἄλσος Ἄρτεμιν σέβειν
ψαλμοῖς τριγώνων πηκτίδων ἀντιζύγοις
ὁλκοῖς κρεκούσας μάγαδιν, ἔνθα Περσικῷ
νόμῳ ξενωθεὶς αὐλὸς ὁμονοεῖ χοροῖς

And I hear that the Lydian and Baktrian maidens
living by the river Halys worship the Tmolian goddess
Artemis in a laurel-shaded grove
while they thrum the *magadis* with concordant pluckings
of *trigônoi* (and) with counterbalancing pluckings of *pêktides*,
where the *aulos*, in Persian tune/style, sounds in welcome
concord to the choruses.[305]

Toward the end of the fifth century, the avant-garde dithyrambist Telestes composed a piece in which the companions of Pelops were presented as the first to introduce the Phrygian *nomos* of the mountain Mother in Greek banquets:

πρῶτοι παρὰ κρατῆρας Ἑλλάνων ἐν αὐλοῖς
συνοπαδοὶ Πέλοπος Ματρὸς ὀρείας
Φρύγιον ἄεισαν νόμον·
τοὶ δ' ὀξυφώνοις πηκτίδων ψαλμοῖς κρέκον
Λύδιον ὕμνον.

The first to sing to the reed pipes the Phrygian
*nomos* of the Mountain Mother by the mixing-bowls
of the Greeks were the followers of Pelops;
and they thrummed the Lydian hymn with the high-pitched
pluckings of the *pêktis*.[306]

As in other cases, collocation of "Phrygian" and "Lydian" in terms of the origins of instruments suggests a traditionally or conventionally demarcated complementarity of Eastern musical traditions rather than cultural realities,

---

[305] Diogenes *Semelê* fr. 1.6–11 *TrGF*. The meaning of lines 9–10 is hard to translate adequately; for different renderings and the semantic problems of the lines, see Barker 1984:297n187 (neglected in West 1997:49). Casaubon suggested the emendation ψαλμοῖς τριγώνων πηκτίδων <τ'> ἀντιζύγοις ὁλκοῖς (see the apparatus criticus in Diogenes fr. 1 *TrGF*), an addition that produces more easily comprehensible sense, but not necessarily cogent in view of the scant evidence about possible ancient techniques of having three (or two) stringed instruments playing together.

[306] Telestes fr. 810 *PMG*; cf. 806 *PMG*. In the latter fragment it is probably Olympos, a legendary Phrygian or Mysian reed-pipe player, who is viewed as the inventor of the Lydian mode. *Aulos* music was thought of as being imported into Greece by Olympos.

despite the fact that, as we have seen, certain instruments were represented as more closely related to specific regions. Further, an East Greek poet who took up residence in Athens toward the end of the first part of the fifth century, Ion of Khios, in his satiric *Omphalê* (the name of a mythical queen of Lydia) referred to Lydian *psaltriai* or female harpists, to Lydian ointments and perfumes that are "better to know than the life-style in the island of Pelops," and to a Lydian *magadis aulos*.[307] The comic poet Platon further elucidates the connotative force that *psaltriai* will acquire, especially in the context of male symposia, for which they were often hired to entertain the guests:

σπονδὴ μὲν ἤδη γέγονε καὶ πίνοντές εἰσι πόρρω,
καὶ σκόλιον ᾖσται, κότταβος δ' ἐξοίχεται θύραζε.
αὐλοὺς δ' ἔχουσά τις κορίσκη Καρικὸν μέλος <τι>
μελίζεται τοῖς συμπόταις, κἄλλην τρίγωνον εἶδον
ἔχουσαν, εἶτ' ᾖδεν πρὸς αὐτὸ μέλος Ἰωνικόν τι

Libation has already been poured and they are far along in
    drinking
and they have sung a *skolion*, and the *kottabos* has come out.
Some little lass with reed pipes is playing a Karian tune
for the banqueters, and I saw another lassie playing
a *trigônon* and she was singing an Ionian song to its accompani-
    ment.[308]

Here, amidst the tossing of wine drops from *kylikes* onto a certain material and amatory object/subject (*kottabos*) and the singing of mirthful *skolia*,[309] Karian strains—elsewhere attested as charged with sympotic and sensual or threnodic associations[310]—are performed in the jolly space of a staged drinking-party

[307] Ion frs. 22, 24, and 23 *TrGF*, respectively. In Ion fr. 23 *TrGF*, a problematic one-liner, the meaning of *magadis aulos* (cf. the apparatus criticus in *TrGF*) is usually determined by the fuller discussion and alternatives provided by Athenaios 14.634c–e, in which the fragment is quoted.

[308] Platon Komikos *Lakonians or Poets* fr. 71.10–14 K-A. For the authorship of the play, see Kassel and Austin's note before the first fragment (fr. 69 K-A) of the play.

[309] On the *kottabos*-game, see especially Sartori 1893; Schneider 1922; Mingazzini 1950/1951; Sparkes 1960; Hoesch 1990a; Csapo and Miller 1991.

[310] Aristophanes *Frogs* 1301–1303 οὗτος δ' ἀπὸ πάντων μὲν φέρει, πορνῳδιῶν,| σκολίων Μελήτου, Καρικῶν αὐλημάτων, | θρήνων, χορειῶν (all three nouns modified by "Karian," cf. Dover 1993:350). For other, erotic perceptions about being Karian, see the interesting but mid-third-century BC case of Makhon and his *Khreiai*, anecdotes about Athenian courtesans: 16.310 Gow (on the courtesan Gnathaina) and cf. Gow's comments (1965:114). In these anecdotes about Gnathaina, it is striking that the comic discourses of the playwright Diphilos, a lover of the famous courtesan, are embedded in sympotic discourses that had been widely and previously appropriated by classical and postclassical comedy. Staged *symposia* are a common feature of ancient Greek comedy. In the *Laws* 800e, Plato refers to Karian women singers as hired mourners at funerals; for discussion and further evidence, see Alexiou 2002a:10 and 107.

while, using her female register, a young harp-player vocalizes a song, significantly described as Ionian. Having examined the marked idioms concerning Ionian ditties, female sexual pleasure, and voluptuous Ionian Muses,[311] I shall now place emphasis on the discursive convergence related to female things Ionian and Lesbian—a convergence that extends to imaginings of diverse webs of cultural practices. Further, it is worth bearing in mind that, as far as sources allow us to see, in the classical period the technical profession of sympotic *psaltriai*, *kitharistriai*, *aulêtrides*, and *orkhêstrides*—all female entertainers who could often be lumped together under the broader rubric *pornê* or *hetaira*—was both well established and regulated, at least in the fourth century, by legislation.[312]

Related but later representations are detected in philosophical and music-historical treatises. However, the ideological modalities are now ramified in the social discursive space of musical technicalities. In the third book of his *Republic*, Plato describes the Ionian and Lydian musical modes, the slack *harmoniai*, as soft and sympotic[313] and rejects the use of *trigôna*, *pêktides* as well as other such many-stringed and polyharmonic instruments "in songs and melodies."[314] And in his *Lakhês*, the "genuine" musical man is represented as the one who is in tune, as it were, with the "only Hellenic" mode, the Dorian, but not with the Ionian, the Phrygian, or the Lydian.[315] More interestingly, Aristotle labels instruments like *barbitoi, pêktides, trigôna, sambukai* and all those that require technical manual expertise (*kheirourgikê epistêmê*) as ancient *organa* rejected by earlier Greeks because they did not contribute to education or to virtue but, instead, prioritized the pleasure (*hêdonê*) of audiences.[316] Similarly, the music theorist Aristoxenos called the *pêktis*, the *sambukê*

---

[311] See above, pp. 190–191.

[312] See Kemp 1966:220–221; Starr 1978; Maas and Snyder 1989:184–185; Davidson 1997:81–82, 197–198; Lewis 2002:94–97, 157–159.

[313] *Republic* 398e Τίνες οὖν μαλακαί τε καὶ συμποτικαὶ τῶν ἁρμονιῶν; Ἰαστί, ἦ δ' ὅς, καὶ λυδιστὶ αὖ τινες χαλαραὶ καλοῦνται.

[314] *Republic* 399c–d.

[315] *Lakhês* 188d.

[316] Aristotle *Politics* 1341a39–b1. In the same context, Aristotle also refers to *heptagôna*, an otherwise unknown stringed instrument (cf. Michaelides 1981:124). *Skindapsos* or *kindapsos*, another stringed instrument, perhaps a type of lute (like the *pandoura*), mentioned by Anaxilas *Lyremaker* fr. 15 K-A along with the *barbitos*, the *pêktis*, the *kithara*, and the *lyra*, was in the late fourth century represented as an entertainment item for "the woman who does not know the distaff" (Matron of Pitane fr. 539 *SH* and cf. Lloyd-Jones and Parsons' apparatus criticus, "ἀνηλακάτοιο: id est, meretriculae?"). Cf. Timon of Phlious fr. 812.3 *SH* (...νοῦν δ' εἶχεν ἐλάσσονα κινδαψοῖο) for the alleged stupidity of the instrument. On the *skindapsos*, see Higgins and Winnington-Ingram's excellent discussion (1965:66–67; West 1992:60 thinks that *skindapsos* is a kind of lyre.); Michaelides 1981:166; Maas-Snyder 1989:185–186.

and other such instruments *ekphula* ("foreign"), presumably pointing to the exotic, by his time, musical aura they conveyed.[317] In the late fourth and third century BC, the shrewd parodist Sopatros returned to the idea that the *pêktis* boasts a barbaric Muse.[318] In the context of these convergent, if heterogeneous, discourses it is intriguing that the pioneer seventh-century BC musician Polymnestos of Kolophon, cited in their songs by Alkman and Pindar, was credited with the invention of the "Hypolydian" *tonos*, while concurrently the Phrygian or Mysian Olympos, a legendary piper and composer, was viewed as the inventor of the Lydian mode.[319] Poseidonios, a Hellenistic polymath and scientist, confirmed his expertise in historical matters, including banquet customs and Western and Eastern luxury cultures, by discussing in one of his treatises the kinds of musical modes Anakreon employed in his songs. Possibly relying on earlier theoretical or historical music treatises, he reported that Anakreon made use of only three modes: significantly, the Phrygian, the Lydian, and the Dorian.[320] As has been transmitted, the text of this fragment of Poseidonios does not mention the Dorian mode but explicitly discusses "three modes." The [Dorian] is based on a supplement suggested by Markos Mousouros and is widely endorsed in subsequent critical editions. What is certain is Poseidonios' reference to the Phrygian and the Lydian, two modes heavily charged both from music-historical and cultural perspectives.

In this regard and in the context of the earlier comic and other discourses related to diverse types of harps, Euphorion, in his *On the Isthmian Games*, discussed the instrumentalists "now called *nabla*-players, *pandoura*-players,

---

[317] Aristoxenos fr. 97 Wehrli.

[318] Sopatros fr. 12 K-A. Note that here *pêktis* may perhaps allude to a lute, but this is far from certain. See the insightful discussion in Higgins and Winnington-Ingram 1965:66n30 (overlooked in West 1997:52, "[t]he reference must be to a two-stringed lute"). Higgins and Winnington-Ingram (with earlier bibliography) are right in arguing that "the reference may be to stringing in 'double courses.'"

[319] Polymnestos: Alkman fr. 145 *PMG* and Pindar fr. 188 M; cf. Kratinos fr. 338 K-A. On Polymnestos and the so-called Hypolydian *tonos*, see Ps.-Ploutarkhos *On Music* 1141b. For Olympos, see Telestes fr. 806 *PMG* ("Olympos" likely as the subject); Aristoxenos fr. 80 Wehrli; Klemes *Stromateis* 1.76.4–6 (περί τε μουσικὴν Ὄλυμπος ὁ Μυσὸς τὴν Λύδιον ἁρμονίαν ἐφιλοτέχνησεν [in the context of other *heuretai*]; cf. Aristoxenos fr. 83 Wehrli; Poludeukes 4.78 Bethe (on Olympos' and Marsyas' Phrygian and Lydian modes). The Aeolian *harmonia* is described by Pratinas fr. 712 *PMG* as suitable to all boasters in song while, again according to Pratinas (fr. 712a), the Ionian mode represents the "relaxed" Muse compared to the tense Muse (note that the word Ἰαστί is considered a *glossêma* and deleted by Page in fr. 712a *PMG* and ἀοιδολαβράκταις is an emendation by Bergk in fr. 712b *PMG*; cf. Pratinas fr. 5 *TrGF* and Snell's apparatus criticus). On the influential *topos* of πρῶτος εὑρετής, see especially Kleingünther 1933.

[320] Poseidonios fr. 292 Edelstein and Kidd (1989:254–255). See also Kidd 1988:983–986. Discussion of the whole context of Poseidonios' account of musical modes and the *magadis* in Anakreon would take us too far from the most salient issues here.

and *sambukê*-players." The *barbitos*, he explained, was mentioned by Sappho and Anakreon, and the *magadis*, the *trigônon*, and the *sambukê* were actually old instruments, by the standards of the third century BC and the "archaeological" interests of the erudite poet. Is it not compelling testimony for the antiquity of the instruments, he stated, that in Mytilene the *sambukê*, a harp like the *magadis* or the *pêktis* used by Sappho and Anakreon, was portrayed in the hands of one of the Muses by the ancient sculptor Lesbothemis? In all events, Euphorion observed, that instrument, differing only in nomenclature from the other old many-stringed instruments, bore the trademark of Mytilene, as it was so commonly employed in that city.[321]

Comparable insights into the cultural-rhetorical question "what is gendered music?" can be gained from considering one musician and one song. Kharixene, "an *aulos*-player and a composer of musical airs," a "song-maker" too, whom Kratinos and Aristophanes described in their plays as proverbially ancient and old-fashioned, was at least later viewed as a "composer of erotic songs."[322] And "Kleitagora," a kind of drinking song, cited as early as the days of Kratinos and performed in the same contexts as the Admetos *skolion*, was later thought of as the name of a poet Lesbian in origin.[323]

By conducting archival fieldwork on fifth-century Athenian cultural economies related to Eastern and East Greek indigenous musical language—styles, modes, instruments—my objective is to redraw the intricacies of the recognition mechanisms that Athenians put into practice or, at least, had actively at their disposal, in their constant dialogues with diverse musical traditions. In a musical culture like that of fifth-century BC Greece, the linguistic properties of music were considerably more marked and pervasive than any musical experience we may be able to conceive of in the twentieth-first century—unless we attempt to read the *alterity* of ancient musical languages through the comparative perspectives of ethnomusicology and linguistic anthropology. Late archaic

---

[321] Athenaios 4.182e-f, 14.635a-b, and 14.635e-f.

[322] See Kratinos *Odysseuses* fr. 153 K-A; Aristophanes *Ekklesiazousai* 943; Theopompos *Sirens* fr. 51 K-A; Hesykhios, Photios, and other lexicographers in Kratinos 153 K-A and in Campbell 1992:98–99. In Theopompos *Sirens* fr. 51 K-A, a similar conception may be detected, if viewed in the broader cultural idioms I investigated above: a woman instrumentalist "plays putrid/unsound melodies on her pipes, like those that belong to the era of Kharixene" (αὐλεῖ γὰρ σαπρὰ αὕτη γε κρούμαθ' οἷα τἀπὶ Χαριξένης).

[323] See Kratinos *Kheirônes* fr. 254 K-A; Aristophanes *Danaides* fr. 271 K-A; *Wasps* 1245–1247; *Lysistratê* 1236–1238, and later sources in Kratinos fr. 254 K-A and *PMG* 912. Kleitagora was alternatively considered "Spartan" or "Thessalian." Cartledge (1981:92–93) refers to Kleitagora as a Spartan poetess. Cf. Athenaios 13.600f–601a on Megalostrate, "a Spartan poetess" at the time of Alkman (= Khamaileon fr. 25 Wehrli). In his *Periploi* ("Asiatic Voyage"), Nymphodoros of Syracuse reported that Salpe, an author of *paignia*, was from Lesbos (*FGrH* 572 F 5).

and early classical Athens constituted a cultural space immersed, on a number of levels, in preoccupations and sociopolitical anxieties about the communicative efficacy and linguistic properties of music.[324] I shall here confine my discussion to two underexplored discursive modalities that reflect a broader concern with "what is music" and how its language produces antithetical but frequently complementary discourses.[325]

On the fifth-century Athenian stage, Eupolis presented a character musing—not without some traces of irony—over the depth and "curvedness" (καμπύλον) of music:

καὶ μουσικὴ πρᾶγμ' ἐστὶ βαθύ τι † καὶ καμπύλον

and music is a thing deep and intricate.[326]

Although the context of this apparently reflective "pronouncement" is lost, it seems certain that it mirrors a more general preoccupation with the political, ethical, and performative potential of musical idioms. If, as John Blacking has observed, music is humanly organized sound,[327] often reflecting and, one might add, interfering with social structuration and practice, archaic and classical musical cultures may be seen—each in its own synchronic complexity and social particularity—as vast arenas of dynamic poetic and musical forms that evolved or regressed, intersected and mutated, resulting in constantly cross-fertilized "genres."[328] Music—however it was perceived by different social groups in the classical period—constituted a vital communicative discourse that interfered with matters both linguistic and socioeconomic.

Later in the fourth century, after diverse changes in styles and tastes, the playwright Anaxilas will redefine music and point to its potentially self-reproductive, even transgressive, properties and its propensity for almost grotesque idioms. It is worth noting that the fragment that follows may also be read as a question, thus conveying a more pressing sense of comic unease:

ἡ μουσικὴ δ' ὥσπερ Λιβύη, πρὸς τῶν θεῶν,
ἀεί τι καινὸν κατ' ἐνιαυτὸν θηρίον
τίκτει

---

[324] For music as language I find congenial the comparative ideas and methods developed in Feld 1974; 1984a and 1984b; Feld and Fox 1994; Feld and Schieffelin 1996 (orig. publ. 1982); cf. Feld and Brenneis 2004.

[325] I do not here touch on the more specific investigation into what has been termed "New Music"; see especially Martin 2003 and, for an earlier period, cf. Wallace 2003.

[326] Eupolis fr. 366 K-A with Kassel and Austin's apparatus criticus.

[327] Blacking 1973.

[328] Yatromanolakis 2007b.

> and music is like Libya, which, by the gods,
> gives birth to some new creature/beast
> every year.[329]

The Athenian discursive practices explored throughout this and the previous chapter constituted, I argue, the most fundamental elements of the cultural economy that conditioned the early processes of "scanning" the figure and the poetry of Sappho in male performative contexts. The analysis of situated discourses can be even further widened, but I shall now pause to consider a methodological issue that has a significant impact on current research on Sappho. In Chapter Four, I shall further discuss aspects of comparable methodological paradigms that have dominated the study of the sociocultural context of the poetry of Sappho since the nineteenth century.

## *Saxa loquuntur*: Alterities

The majority of scholars have so far attempted to unearth sociohistorical realities that may possibly lie behind the fragmentary *theasis* that the remains of the poetry of Sappho as well as the sources related to her allow us. This is a valuable and time-honored paradigm, which has provided the scholarly community, and those interested in Sappho outside this community, with a wide-ranging treasury of insights into possibilities and reconstructive alternatives. Based on these alternatives, critics have advanced literary interpretations that endeavor to confirm the "alternatives." These literary and cultural interpretations have often been ingenious and can occasionally hardly be challenged in terms of their imaginative forcefulness. A number of models have vigorously reconstructed the *original* context of Sappho's poetry, and literary critics, including structuralists and feminists, have endorsed, explicitly or more tacitly, one or another of these models. Challenges to such reconstructions have been launched and new reconstructive syntheses have replaced the older ones.

An eminent critic and influential critical editor, Denys Page, in 1955 disagreed with those researchers who supported the view that Sappho was involved in a cult association or in teaching responsibilities, and "with feigned solemnity" he "exorcize[d] these melancholy modern ghosts." Similar rites of interpretation that apply the same discourse to an outright rejection of earlier

---

[329] Anaxilas *Hyakinthos* fr. 27 K-A. For the expression πρὸς θεῶν in entreaties, "either in asking another to act (with imperatives etc.) or in urgent questions (when one entreats the other to reply," see Barrett 1964:202 (quoted also by Kassel and Austin). That "Libya always brought forth and nurtured something new" was proverbial (see sources in Anaxilas fr. 27 K-A).

scholarly views have been performed recently.[330] Reconstructions have been so copious and labyrinthine—even in cases where no explicit attempt is made to decipher the original social setting of Sappho but only to advance aesthetic analyses—that no historiographic synthesis of the scholarly paradigms that have permeated the study of Sappho would find an adequate parallel in the research on any other archaic poet.

In the case of Sappho, scholarly discursivity is complicated by issues related to gender and *l'écriture féminine*,[331] the frequent impenetrability of Sappho's linguistic medium, the truncated, elusive state of archaic sociocultural discourses, and the symbolic stature of her figure in European contexts for a number of centuries—a kind of political hydrocephalism that has been attached to the few "archaeological" remains of Sappho's songs. Interpretation and reconstruction are not always identical processes, and researchers have more often than not been involved in unearthing the social, political, and aesthetic discourses that lie behind the corpus of Sappho:

> Imagine that an explorer arrives in a little-known region where his interest is aroused by an expanse of ruins, with remains of walls, fragments of columns, and tablets with half-effaced and unreadable inscriptions. He may content himself with inspecting what lies exposed to view, with questioning the inhabitants—perhaps *semi-barbaric* people—*who live in the vicinity*, about what tradition tells them of the history and meaning of these archaeological remains, and with noting down what they tell him—and he may then proceed on his journey. But he may act differently. He may have brought picks, shovels and spades with him, and he may set *the inhabitants to work with these implements*. Together with them he may start upon the ruins, clear away the rubbish, and, beginning from the visible remains, uncover what is buried. If his work is *crowned with success*, the discoveries are self-explanatory: the ruined walls are part of the ramparts of a palace or a treasure-house; the fragments of columns

---

[330] Page 1955:140; following closely Page's discursivity, Parker 1993:339: "I am officially announcing its death" [i.e., of an approach]. For the connections between Page and Parker, see Parker 2005:19n8. For an absolute dismissal (based on no further investigation) of Calame's reconstruction of the "circle" of Sappho (Calame 1977, 1997), see Helen Morales 1998 ("This is risible speculation"). Equally idiosyncratic language is displayed in numerous publications, attesting to the persistent, unfeigned desire to reconstruct the *original* context. On M. Williamson's handbook *Sappho's Immortal Daughters* (Cambridge, MA 1995) and recent insightful work on Sappho, see Yatromanolakis 2004a. On methodological paradigms, see Yatromanolakis 2007a.

[331] I am aware that the cultural construction of categories like gender, ethnicity, and religion has been the focus of intense debate and criticism in a number of fields in the social sciences. For gender, see Gal 1992 and 1995.

can be filled out into a temple; the numerous inscriptions, which, by good luck, may be bilingual, reveal an alphabet and a language, and, when they have been deciphered and translated, yield *undreamed-of* information about the events of the remote past, to commemorate which the monuments were built. *Saxa loquuntur.*[332]

This metaphor was employed in 1896 by Sigmund Freud to describe the methods of the discipline of psychoanalysis. For Freud, archaeology and psychoanalysis intersect in their attempt to reconstruct, not just interpret, objects of the past, with a view to gaining access to—and making sense of—ruins and ima-ges and to translating the past into a historical narrative. It is not coincidental that Freud conceived of this analogy when he conducted investigations into female hysteria. The passage quoted comes from "The Aetiology of Hysteria," based on a lecture Freud gave at the *Verein für Psychiatrie und Neurologie* in Vienna in 1896[333] that attempted to throw light on the process of reconstructing continuous narratives and filling in lacunae. Female discourses and the female body become an exoticized locus where diverse interpretive negotiations take place, and when some of the latter are "crowned with success, the discoveries" can sometimes be self-explanatory. Anthropological metonymies—interviewing the inhabitants who live in the vicinity, the informants who come from different eras and can be strange to us, and setting these people to work with our implements—constitute central aspects of the process.

However, in contrast to Freud's sophistication and interpretive flexibility in psychoanalytic methods, researchers in classical studies and ancient history have often shown a reluctance to investigate their own discursivity in the historical reconstructions they advance.[334] A self-examining methodolog-

---

[332] Freud 1962:192 (my emphases). In a later publication, as well as others in between, Freud explores further the analogy: "Constructions in Analysis" in Freud 1964:257–269, originally published in 1937. More specifically, Freud stresses the process of *constructing* in a reconstruction: "His work of construction, or, if it is preferred, of reconstruction, resembles to a great extent an archaeologist's excavation of some dwelling-place that has been destroyed and buried or of some ancient edifice. The two processes are in fact identical, except that the analyst works under better conditions and has more material at his command to assist him, since what he is dealing with is not something destroyed but something that is still alive—and perhaps for another reason as well. [...] Both of them have an undisputed right to reconstruct by means of supplementing and combining the surviving remains. Both of them, moreover, are subject to many of the same difficulties and sources of error." On historical anthropology and the complexities of reconstruction, see Yatromanolakis 2007d.

[333] For discussion of the date, see Strachey in Freud 1962:189–190.

[334] This is particularly relevant to textual reconstructions and supplements recently proposed by some textual critics (especially in Italy) who occasionally employ Latin as their scholarly language, even in publications at the beginning of the twenty-first century, and reject the reconstructions of others *ex cathedra*.

ical interrogation—as social sciences, most notably social and cultural anthropology, have often illustrated—is significant for understanding the limitations, narrative mechanisms, and discursive politics that one's writing about culture(s) involves. "Writing" *about* culture entails "*writing*"—that is, constructing—culture(s).

Interpretations of fragments of Sappho have thrown considerable light on linguistic and textual aspects as well as on the broader poetics of her songs. Even wide-ranging linguistic investigations like those of Edgar Lobel and Denys Page presuppose a *specific*, unusually marked reconstruction of the language idioms that Sappho might have employed in her poems. Such studies have prescribed the exact features of a "pure" archaic Lesbian dialect and have further determined restorations of the fragments of Alkaios and Sappho.[335] Literary analyses have more often than not envisaged a specific social setting for Sappho's songs and have proceeded to decodify the exact *meaning* of specific words, which, as the argument goes, reflect certain reconstructed archaic realities and ideological frames closely related to the "homoerotic" or "broadly educational and initiatory" character of the poetic corpus of Sappho. The situation is considerably more marked than can be analyzed in one book.[336] The discursivity of reconstructive attempts has rarely been acknowledged in the field, while futile polemics about *specific* details of imaginative restorations increase and acknowledgment of the broader contribution of each reconstruction to the construction of the immediate next is often only implicitly made or hidden in rhetorical tropisms.[337]

---

[335] For Lobel's (1925 and 1927) and earlier reconstructions of a "pure Lesbian dialect" or "vernacular" in the fragments of Alkaios and Sappho, see the pathfinding studies of Hooker (1977). Page 1955 followed Lobel's ideas almost to the letter. For an insightful criticism, see Gomme 1957, who, however, vehemently accused Lobel and Page of insensitivity to poetry (of Sappho fr. 168B V "both Lobel and Page have such a hate that they have banished it not only from Sappho, but from Lesbian," Gomme 1957:265). For further related British polemics, see Page 1958 and Gomme 1958. Lobel's authority has not ceased influencing more recent textual reconstructions and emendations. On Sappho's poetic dialect, cf. Bowie's monograph (1981). On Lesbian dialect, see the thorough, important work by Blümel 1982 and Hodot 1990 and 1997.

[336] Cf. Yatromanolakis 2001a:159 and 166; 2003:43–46; 2005:16–17; 2007a.

[337] Notably and more recently in Kowersky 2005. In this regard, it is interesting that in a review (*Hermathena* 171 [2001]:73) of D. Boedeker and D. Sider (eds.), *The New Simonides*, Oxford 2001, we read that "speculation can be exciting, but...the practice of *ars nesciendi* seems more prudent." However, we then see its author, G.L. Huxley, proceeding to wild speculations about the possible historical identity of Ekhekratidas, a Thessalian ruler in the late archaic period. Cf. Kowerski's characterization of this review as "excellent" (2005:47). On reconstruction of the fragments ingeniously edited by Peter J. Parsons in 1992 as P.Oxy. 3965, see Yatromanolakis 2001b:220–221 and 224–225. On the male representations of female voices, see the study by Richard Martin (2001). Martin is right in stressing the intricacy of the performance of women's voices by male poets. On cultural determination and schematization in literary and archaeo-

In what follows, I shall put forward a different line of investigation. While it is almost not feasible to reconstruct in any detail the original context in which Sappho composed her songs and poems—so many synchronic links, discourses, and interdiscursivities are missing—whereas, as I have argued, the earliest, late archaic, classical, and still later archival representations do not readily disclose archaic realities, I shall attempt to show that these representations are, from an anthropological point of view, more important than modern constructions and restorations of the gaps of indeterminacy that the texts and locally marked cultural discourses of Sappho display.[338] Although further research on the texts and possibly new fragments of Sappho and other archaic song-makers, as well as later writers, may throw some light on the social dynamics within which such archaic utterances and cultural practices were shaped and reproduced, I propose that only through a plurality of investigations into the linguistic and sociocultural anthropology of (especially early)[339] sources—sometimes neglected in archives—and their broader political and musical discursive textures, can scholarly advances be made in regard to how Sappho and her archaic world of social action are to be viewed and written about in modern times. What remains of her are these representations offered by ancient informants and, as in most contemporary ethnographies, we need to trace both the interdiscursivity of these informants and the historian's or ethnographer's own involvement in the construction of an interactive dialogue with the informants. A major part of this scholarly enterprise lies in the *questions* that an ethnographer decides to pose. Historical contextualizing acquires meaning on the basis of what she/he is asking, and statistical data, when it comes to an aesthetic, musical culture, can sometimes be deceptive.

---

logical analysis, see Sourvinou-Inwood 1991, esp. 3–23. On the tendency to consider hypotheses about historical events as more valid than reconstructions of ideologies, see Kurke 1994:69n6: "there is no justification for this naïve criticism—in fact, just the opposite: given that all we have in many cases are textual traces, we are in a better position to reconstruct the ideological or symbolic systems at work than the 'realities' of events." On collecting ancient Greek fragments, see the interesting volume by Most (1997). On ethnomusicological consideration of ancient Greek "popular song," see Yatromanolakis 2007b. On the "new," by now "old," Simonides fragments, see Nagy 2005.

[338] For the notion of gaps of indeterminacy, see Iser 1974 and 1978:204–206.

[339] I do not wish, however, to prioritize only early informants, since I do not share possible concerns for a markedly evolutionary scanning of ancient discourses. The focus of this book is mainly, but not exclusively, on the early stages, which in one way or another had impact on later discourses, despite the occurrence in later periods of divergent, sometimes ad hoc, definitions or representational multiforms. The first rehearsals toward the writing of biographical accounts of Sappho in later times were conducive to the formation of more established traditions, which were characterized by *centrifugal tendencies* in the construction of variant representations related to Sappho.

The methodological *Problematik* proposed in this book seeks to eschew polar, quasi-allegorical, interpretive schemata—presented in Chapter One in connection with Jauss's influential line of literary analysis. Rather than a linear hermeneutic continuum on which the interpreter's authoritative discourse is believed or forced to correspond directly to the historicized *origins* of a sanctioned literary figure of the past—in our case, Sappho—my research here promotes and focuses on the processes through which the figure of Sappho was made at different stages of her reception, especially the most formative ones of late archaic, classical, and early Hellenistic periods.

Therefore, while especially attentive to the (transmission of the) fragments of Sappho and to what apparently marked *words* might have meant for the cultural economies in her contemporary Lesbos or in archaic Sparta, as well as to the intersubjectivities embedded in her songs, and to comparative ethnographic frameworks that would somewhat hone the formulation of questions, I argue that the early—late archaic, classical, and Hellenistic—informants need to be credited with the significant role of throwing light on what Sappho meant culturally rather on how she was perceived in archaic Mytilene. The enterprise is complex and does not aim to suggest that the picture we may want to draw about the historical Sappho—however she might be defined—should be blank due to lack of reliable sources. Just the opposite: the informants and related sociocultural discourses—the one fueling, forging, or undermining the other—are more numerous than usually assumed, so brimful of insights and microconfigurations that it is sometimes hard to see what lies beneath and what circulates sideward, as if metonymically.

The diverse discursive strategies explored in this chapter were, I argue, reactivated and reenacted in the process of making sense of the songs of Sappho, a woman poet from East Greece, with all the idiomatic inflections this held in late archaic and classical Athenian *symposia*, taverns,[340] and comparable venues of male sociability. These venues operated as notional markers of the bonding of the members of a group and helped release or heighten the tension caused by interpersonal communication, political and economic affairs, and the vulnerability of male societies in terms of corporeal and intellectual pleasure; time; and death. By fostering solidarity and sociability—the

---

[340] On taverns, see Davidson 1997:53–61. The study of the institution of the *symposion* was pioneered in Germany by a number of scholars: the history of scholarship is carefully discussed and represented in Vetta 1983a. On the *symposion* in all its attested varieties, see Reitzenstein 1893; Philaretos 1907; Martin 1931; Rösler 1980; Vetta 1980, 1992, 1996; Peschel 1987; Latacz 1990; Murray 1990; Slater 1991; Schmitt-Pantel 1992; Murray and Tecuşan 1995; Schäfer 1997; Slings 2000b; Fehr 1971, 2003. Vierneisel and Kaeser 1990 is an interesting volume exploring different aspects of the *symposion*. On *kômos*, cf. Smith 1998 and 2000; Bierl 2001; Pütz 2003.

basis of reciprocity—*symposia* in all their attested variety infiltrated the overall social theory of diverse groups and regulated their shifting positions about society.[341] Through the singing of topical songs and the musical ritualization of drinking, the exchange of smiles and sexual innuendos or favors with women performers, the endorsement of the social phenomenon of pederasty (depending on the economic rank of each group), symposiasts and tavern frequenters had formed marked sociolects—the key element of this investigation so far.

These sociolects were part of classical Athenian language socialization. Participants in singing (in the case of group performance) and members of the audience, an active element of ancient performative spaces—either through the hovering presence of hegemonic sociopolitical status or by means of receptorial interaction[342]—shared, I suggest, common but not necessarily tautosemous sets of interpretive strategies, nor always isomorphic with the widely established and habitually internalized communicative filters. However, the discourses explored in previous sections were sufficiently marked and interrelated to allow possible individuation to move within their performative efficacy and range.

It may be opportune to note here that all these discursive idioms, despite their markedness, should be viewed as unobtrusive, almost naturalized, cultural currencies in the process of receptorial scanning of musical performances by male audiences:

> ...the beings we encounter in the everyday commerce have in a preeminent way the character of *unobtrusiveness*. We do not always and continually have explicit perception of the things surrounding us in a familiar environment, certainly not in such a way that we would be aware of them expressly as handy. It is precisely because an explicit awareness and assurance of their being at hand does not occur that we have them around us in a peculiar way, just as they are in themselves. In the indifferent imperturbability of our customary commerce with them, they become accessible precisely with regard to their unobtrusive presence.[343]

[341] For drinking and mutual commensality as a reflection of social contradictions and a mechanism for constructing social ideologies, see Karp 1980.

[342] I prefer to speak of "audiences," and not of "listeners" as Lord (1995:1–2) suggested, since "listeners" has marked associations of relative passivity on the part of the informants and pronounced, almost exclusive involvement on the part of the singer or even the ethnographer's voice that interprets. "Audience" is not taken here as implying "a more formal type of event."

[343] Heidegger 1988:309.

Martin Heidegger's idea of unobtrusiveness, which is significantly resonant with the theory of practice in social sciences, has far-reaching implications for the following discussion of the ways Athenian male audiences scanned "Sappho" in the context of *symposia* and similar venues. It is through the language of her songs that such discursive idioms shaped the earliest perceptions about her and engendered oral narratives that are confirmed by archival narratives—in the sense "archive" is employed in this book.

## Trafficability of Palimpsests

One of the most neglected aspects of Sappho's songs is their use of semantic units with immanent, by the classical period, double-layered meaning. I shall here confine the discussion to three case studies.

In a papyrus fragment dated by Edgar Lobel to the second half of the second century AD, we witness the emergence of two previously unknown female names in the fragments of Sappho: Arkheanassa and Pleistodike.[344] The fragment seems to provide three words from a Sapphic stanza, an indication that they were part of a song included in the first book of the Alexandrian edition:

    ].̣.[.].̣τ...[
...[..].σε εμα κ'Αρχεάνα[σ-
σα Γόργω<.> σύνδυγο(ς)· ἀγτὶ τοῦ
ς̣[ύν]ζυξ· ἡ Πλειστοδίκη
τ]ῆ̣ι Γ[ο]ργοῖ σύνζυξ με-        5
τὰ τ[ῆς] Γογγύλης ὀν[ο]μασθή-
σετ[αι· κ]οινὸν γὰρ τὸ ὄγο-
μ[α δ]έδοται ἢ κατὰ τῆς [.]...
α̣[...] Πλ[ε]ιστοδίκη[..]ν
    ὀνομ]ασθήσετ[αι] κυ-     10
]η[      ].̣ατ̣ετουτ
    ].̣ νο̣ αν

...my...and Arkheanassa
yoke-fellow of Gorgo: "yoke-fellow" instead of
*sunzux*; Pleistodike
will be named mate to Gorgo

---

[344] Lobel 1951 (Sappho fr. 213 V). Treu (1984:165–166) suggested that Pleistodike is the same as Arkheanassa, the latter coinciding with the name of the Lesbian clan of Arkheanaktidai, on which see Alkaios fr. 112.24 and 444 V.

along with Gongyla;
for the name that has been given [?]
is her usual one or on the basis of her...
...Pleistodike
will be named...[345]

Gorgo, we are told by Maximos of Tyros,[346] was represented in some songs as being in a competitive interaction with the poetic "I." In fragment 29c.9 V, the reading Γόργοι seems plausible, but no context is provided; and in fragment 103 A a col. II. 9 V, not included in Lobel and Page's edition,[347] Γόργ[ —if articulated so—is the first word of a song.[348] Maximos' idea is confirmed by fragment 144 V. In the context of a grammatical discussion of the declension of such nouns as Σαπφώ, an ancient grammarian (possibly Herodianos) observed that—compared to the Attic Σαπφοῦς—the Aeolic genitive was Σαπφῶς, as it is in contemporary Greek,[349] and he quoted *fragmentum adespotum* 979 PMG

---

[345] As far as I can see on the papyrus, [δ]έδοται in line 8 is far from certain. Voigt does not indicate this in her apparatus criticus. Note that Lobel 1951 commented: "[p]ossibly "[δ]εδοται, but o not suggested by the trace on the line after δ]..., the feet of two uprights followed by the lower part of an upright descending well below the line." I agree with Lobel that what is readable is μ[..].δ.ται, at the beginning of the line.

[346] Maximos of Tyros 18.9 Koniaris. Maximos refers to Gorgo and Andromeda and quotes Sappho fr. 155 V, where the addressee is called Polyanaktid (Πωλυανάκτιδα παῖδα). Cf. Treu's suggestion in n. 344 above. For the formation of Arkheanassa in Sappho fragment 213 V and possible associations it could evoke in later times, cf. Suda s.v. Ἀστυάνασσα· Ἑλένης τῆς Μενελάου θεράπαινα· ἥτις πρώτη τὰς ἐν τῇ συνουσίᾳ κατακλίσεις εὗρε καὶ ἔγραψε περὶ σχημάτων συνουσιαστικῶν. In this respect, more important is an epigram ascribed to Plato (IX in Page 1975:49 and in Page 1981:167–169), as well as a similar version of the same epigram attributed to Asklepiades (41 G-P), where Arkheanassa is the name of a *hetaira* from Kolophon: Ἀρχεάνασσαν ἔχω, τὴν ἐκ Κολοφῶνος ἑταίραν (...). On Asklepiades 41 G-P, see Gow and Page 1965:vol. 2, 144–145; on "Plato" IX, cf. Page 1981:167–169. According to Athenaios 13.589c, who attributes the epigram to Plato, ὁ δὲ καλὸς ἡμῶν Πλάτων οὐκ Ἀρχεάνασσαν τὴν Κολοφωνίαν ἑταίραν ἠγάπα· ὡς καὶ ᾄδειν εἰς αὐτὴν τάδε. Gow and Page persuasively suggest that "the lines were originally written as a fictitious grave-inscription by Asclepiades, with whose style they well agree, and were appropriated or misunderstood, and consequently tampered with, by those who ascribed them to Plato or wished to make them seem his" (Gow and Page 1965:vol. 2, 145). The version of the epigram attributed to Plato is indicative of the mechanisms involved in the textual transmission of a literary composition, which at a certain historical point becomes associated with the reception of the "personal life" of a philosopher like Plato. On Plato and ancient anecdotes about his lifestyle, see Riginos 1976; on Plato's erotic affairs, cf. Riginos 1976:162–163.

[347] Lobel and Page 1955 (1963). For this reason, it does not appear in Campbell 1982 either. Treu 1984:175 provides excellent brief comments. Lobel and Page believed that there was nothing to suggest an Aeolic poet, but this is true for other small fragments too, normally found among more extensive fragments copied by the same hand.

[348] See Voigt's apparatus criticus: "marg. sin. ad (a) col. II 9 coronis."

[349] Both genitives are used today: the one in -ως seems to be more frequent, but the use of the genitive in -ους or in -ως often depends on social communicative contexts.

(ἐκ Σαπφῶς τόδ' ἀμελγόμενος μέλι τοι φέρω)[350] and Sappho fragment 144 V: μάλα δὴ κεκορημένοις | Γόργως ("those who have been quite glutted with [the misbehavior, company, unmusicality of] Gorgo").[351] In fragment 213 V, κ' Αρχεάνα[σ]|σα Γόργω <.> σύνδυγο(ς)—considering "Gorgo" as either genitive or dative—suggests two things: that Arkheanassa is called the partner or yoke-mate of Gorgo, or that she is referred to as the wife of Gorgo. Both meanings were available in fifth-century Athens.[352] Scholars have so far attempted to elucidate the original meaning of the word in archaic Lesbos by resorting to arguments about possible institutional, homoerotic, or initiatory/educational structures—all hypothetical or somewhat corroborated by very late informants, who are not approached by scholars from the vantage point of the informants' own cultural economies. For instance, it has been held that "within the women's communities of archaic Lesbos there were liaisons of an 'official' character, which could involve a genuinely matrimonial type of relationship, as is shown by Sappho's use (fr. 213.3 V.) of the term *yokemate*. The word…is a specific, not generic, way of referring to the actual bond of marriage."[353] Marked sexual connotations have been further detected by Claude Calame, who has seen the word σύνδυγος in Sappho fragment 213 V as an element of the representation of actual homoerotic relationships between lover and beloved in the context of initiatory rituals associated with choruses of young girls.[354] Other related analyses have stressed the initiatory (and homoerotic) character of such choruses, thus attesting to the influential presence of Arnold van Gennep's old paradigm of rites of passage in Classical Studies.[355]

---

[350] *Fragmentum adespotum* 979 PMG = 1001 *SH* (Lloyd-Jones and Parsons prefer ἐκ Σάπφως… [cf. Bergk 1882:706, *fragmentum adespotum* 62, and see Bergk's apparatus criticus—for some of the early reconstructive approaches to Sappho, Alkaios, and the specific fragment—and Edmonds 1940:439], while Page and other critical editors print ἐκ Σαπφῶς…).

[351] Toup's emendation Γοργῶς can hardly be challenged (κεκορημένου στόργος in ms.).

[352] Euripides *Alkestis* 921 (σύζυγες; Admetos lamenting), 314 and 342; Aiskhylos *Libation-Bearers* 599 (ξύζυγοι ὁμαυλίαι). In the sense of "brother" in Euripides *Trôiades* 1001 (for Polydeukes and Kastor); in the sense of "yokemate" in Euripides *Iphigeneia in Tauris* 250 (for Orestes and Pylades) and in Aristophanes *Wealth* 945; cf. *Herakles* 675 for the ἡδίσταν συζυγίαν of the Muses and the Kharites.

[353] Gentili 1988:76. Gentili continues: "we learn that Pleistodice, along with Gongyla,…is the 'wife' (*sýzyx*) of Gorgo, the woman who presided over a rival community. This means that the directress of the *thíasos* could be paired with two girls simultaneously." Ritual marriage is a marked aspect in Gentili's reconstruction of the original context of Sappho's songs.

[354] Calame 1997:212–213, 240. For Calame's interest in initiation, see Calame 1999 and 2001:xi–xiv.

[355] See e.g. Bremmer 1980:292–293 and Rösler 1992. Along with earlier German studies, Merkelbach 1957 and Brelich 1969 have had a significant impact on modern understanding of ancient Greek initiation. On initiation in Classics, cf. also Bremmer 1996, Graf 2003; and see especially the perceptive study by Lincoln (2003). On ancient terms denoting "ritual," see Yatromanolakis and Roilos 2003:13–20.

Instead of searching for the "original," particularly elusive, context of Sappho's poetry, it is significant to shift the scholarly focus to how her songs could be scanned in the early phase of her reception. Analyzing such double-tiered denotational units in Sappho throws light on the mechanisms and potential politics of her reception and, if juxtaposed with the cultural idioms explored earlier in this chapter and in Chapter Two, provides key contextualization cues that ground the advanced argument on a firm axis of ancient horizons of expectations. In the context of performances of her poetry, words—unmarked or marked—such as σύνδυγος, possibly employed more than once in Sappho's songs, facilitated the transmission of a marked cultural economy associated with matters Lesbian and female.[356]

In this regard, the indigenous denotation of the word ἕταιρα in archaic Lesbos offers further insights into the ideological idioms that fifth-century Athenians could have effectively applied to the performative trafficability of Sappho. While examining the case of *hetaira*, I invite the reader to juxtapose here the visual signs explored in Chapter Two: the *barbitoi* held by Sappho on the Warsaw *hydria*; the Munich *kalathos-psykter*; and especially the Bochum *kalyx-krater*, where the inscription *he pais* ("the girl") is placed above the head of the female figure on the reverse. I argued that the latter visual image was intended for sympotic contexts, whereas the representation on the Athens *hydria*, where one of the female standing figures—ΚΑΛΛΙΣ—extends a *chelys* lyre to the seated Sappho, stands in striking contrast to the discourses exploited on the Munich *kalathos-psykter* and, more significantly, the Bochum *kalyx-krater*. At the same time, representations related to Anakreon provided frameworks within which comparable East Greek aesthetic discourses could be placed. I would further ask the reader to recall the definitional complementarity discussed earlier in this chapter in terms of the cluster "Sappho and Anakreon."

It is only in the context of these interrelated and intricate discursive practices that the images on the vase-paintings can be more fully explored and understood. Since, as I suggested in Chapter Two, a visual representation circulates within dynamic cultural matrices and sociolects, and is in turn conducive to further social configurations, such diverse idioms need to be viewed concurrently or in terms of metonymic multiforms where elements are combined and reperformed on a number of sociopolitical axes.

ἕταιρα is a polyvalent term to which Athenaios devoted a considerable part in the thirteenth book of his *Deipnosophistai*, or *Learned Banqueters*.[357] Dur-

---

[356] Note that at least at a later period Arkheanassa was the name of a courtesan who, interestingly, came from Kolophon (see above, n. 346).

[357] The book bears the title ΠΕΡΙ ΓΥΝΑΙΚΩΝ (at the colophon), although the other books of the *Learned Banqueters* are not modified by titles.

ing a heated debate about women and courtesans conducted by Myrtilos (a Thessalian grammarian) and Theodoros (nicknamed Kynoulkos, a stern Cynic philosopher who reprimands Myrtilos for actually being a *pornographos* and for indulging in wineshops, in books about concubines, and in the company not of male companions but of courtesans),[358] Myrtilos caps the speech of his interlocutor by offering extensive counterargumentation: his ideas, Myrtilos claims, concerned real "companions" (*hetairai*), "those who are able to maintain a friendship" with men without resorting to monetary wiles.[359] It is only these women, according to Myrtilos, that are "called by the name of friendship" (τῷ τῆς φιλίας ὀνόματι προσηγορευμένας) and whose designation *hetairai* is associated with the Aphrodite known among Athenians as "the Companion Aphrodite."[360] We also hear that sanctuaries dedicated to the Companion (*Hetaira*) Aphrodite existed in Ephesos and in Athens, while there was also a shrine of Prostitute Aphrodite (*Pornê*) in Abydos on the Asiatic coast of the Hellespont.[361] The Hetaira Aphrodite, according to Apollodoros of Athens, brought male and female companions—*hetairoi* and *hetairai* in the sense of "female friends"—together in the same religious space.[362] Myrtilos, learned in such matters, reports that at his time freeborn women and maidens still called their near-and-dear friends *hetairai* and points to a linguistic continuity between Sappho's era and his contemporary reality—a span of some eight centuries and crossing dialectal semantic nuances. Two of the three fragments of Sappho that back Myrtilos' contention are quoted in this context of his speech:[363]

Λάτω καὶ Νιόβα μάλα μὲν φίλαι ἦσαν ἔταιραι
Lêtô and Niobê were much beloved companions

and

---

[358] Athenaios 13.566f–567b, and, especially, 13.567a.

[359] His rebuttal starts at 13.571a and comes to an end at 13.610b. In the context of this argumentation, Myrtilos refers a number of times to Sappho: 13.571d, 596b–e, 599c–d, 605e; cf. 598b–c. Strategically Myrtilos' speech starts with Sappho (13.571d).

[360] Athenaios 13.571c. See further 13.559a, where a fragment from the *Korinthiastês* ("Playing the Whoremonger") of the early fourth-century BC playwright Philetairos is quoted: Philetairos fr. 5 K–A; see Apollodoros of Athens *FGrH* 244 F112 (a fragment from his treatise *On the Gods*); Hesykhios s.v. Ἑταίρας ἱερόν· τῆς Ἀφροδίτης Ἀθήνησιν. ἀπὸ τοῦ τὰς ἑταίρας καὶ τοὺς ἑταίρους συνάγειν (cf. Photios s.v. Ἑταίρας· Ἀφροδίτης ἱερὸν Ἀθήνησιν· ἀπὸ τοῦ συνάγειν ἑταίρους καὶ ἑταίρας); Klemes *Protreptikos* 2.39.2 οὐχὶ δὲ Ἀφροδίτη περιβασοῖ μὲν Ἀργεῖοι, ἑταίρᾳ δὲ Ἀθηναῖοι καὶ καλλιπύγῳ θύουσιν Συρακούσσιοι; and Macrobius *Saturnalia* 3.8.3). On the Aphrodite Hetaira, see Pirenne-Delforge 1994:428–430.

[361] Athenaios 13.573a and 572e–f, respectively.

[362] Apollodoros *FGrH* 244 F112.

[363] Athenaios 13.571d.

249

τάδε νῦν ἑταίραις
ταὶς ἔμαις †τέρπνα† κάλως ἀείσω

these pleasant [songs] now
I shall sing beautifully for my companions.[364]

Myrtilos does not provide a date for the Athenian Hetaira Aphrodite, but the fragment from the fourth-century BC Philetairos quoted earlier in book thirteen of Athenaios offers a *terminus ante quem*: "how melting, oh Zeus, and soft is her gaze; no wonder there is a sanctuary to the Hetaira everywhere, but in no place in Greece is there one to the wife" (5 K-A).[365] As for the sanctuary of Hetaira Aphrodite in Ephesos, Athenaios does not cite more specific sources,[366] but loyal to his method of free association, quotes a passage from the *Erôtika* of the fourth/third-century Peripatetic writer Klearkhos.[367] I shall return to Klearkhos' *Erôtika* in Chapter Four. For now, suffice it to note that in this particular narrative, he recounted a story about the king of Lydia, Gyges, which is related to this discussion. The ruler was notorious (*periboêtos*) for his special attachment to his concubine, for whom, after her death, he erected a monument still named at Klearkhos' time the "*Hetaira* monument," a high edifice that caused sensation and was visible to all the denizens of Lydia. Contacts between Ephesos and Lydia are attested,[368] and the associations were further validated in fifth- and early-fourth century Athens by oral traditions, historical memories and accounts, as well as performative exploitations of relevant themes. In his *Clouds*, Aristophanes refers to the cult of Artemis in a "house of gold" at Ephesos, where the young daughters of the Lydians participate in the worship of the goddess; and in his *Tumpana-Players*, Autokrates indulges in a synaesthetic description of the nimble movements of the Lydian maidens' dancing at a festival of the Ephesian Artemis.[369]

Like the σύνδυγοι in fragment 213 V, Sappho's discourses about her or other women's ἕταιραι could be scanned in the fifth century, and were eventually read in later periods, as contextual allusions to performative exchanges

---

[364] Sappho frs. 142 and 160 V. Lobel and Page (1955) print fragment 160 as one line, without obelizing the word τέρπνα, since it is not certain that the fragment comes from a Sapphic stanza. Lobel 1925 wondered whether a question mark should be placed after ἀείσω ("shall I now sing these songs…?"). For the textual problems of fragment 160 V, see Voigt's apparatus criticus, where Treu's concise but incisive comments are cited (Treu 1984:182).

[365] Philetairos was thought by some in antiquity to be the son of Aristophanes (see Dikaiarkhos fr. 83 Wehrli and Suda s.v. "Philetairos").

[366] Except for Eualkes of Ephesos *FGrH* 418 F 2.

[367] Klearkhos fr. 29 Wehrli.

[368] See Sakellariou 1958:427–430.

[369] Aristophanes *Clouds* 599–600; Autokrates fr. 1 K-A.

among courtesans, especially when songs such as fragment 126 V were sung in the context of male gatherings: δαύοισ(') ἀπάλας ἐτα<ί>ρας ἐν στήθεσιν ("may you sleep" or "sleeping on her delicate companion's bosom")—whatever the intradiegetic setting (mythological or not) of the song might have been. *Hetaira* in the sense of "courtesan" gained wide currency in Athens in the fifth century, as references in Herodotos, Metagenes, and Aristophanes confirm.[370] It is not only the use of the word ἔταιρα by Sappho in the context of singing about her friends that could trigger marked associations but, rather, the accumulative dynamics of the double-layered semantic textures embedded in a number of her songs.

A third intriguing case is a fragment that alludes to possible erotic practices of aristocratic (?) women in Mytilene, variously attributed to Sappho or Alkaios. This is Alkaios fragment 303Aa in Voigt's edition that Lobel and Page had previously attributed to Sappho (fragment 99 L-P). Treu and Liberman have assigned it to Sappho.[371] I would attribute the fragment to her. In this mutilated fragment, after a reference to Polyanaktidai ("descendants of Polyanax") and the "peculiar" plucking of the strings of an instrument,[372] the papyrus preserves the word ὀλισβ.δόκοισ<ι>, meaning "receiving (-ers of) the *olisbos*."[373]

---

[370] Herodotos 2.134.1, 2.135.5; Metagenes *Breezes* or *The One Who Hides in His Mother's Skirts* fr. 4.1 K-A (note that LSJ mistakenly translates μαμμάκυθος as "blockhead," while its 1996 revised supplement provides the definition "one who hides in his mother's skirts;" μαμμάκυθος is employed in the same sense or in the meaning of μαλθακός ["mollycoddle"] in present-day dialects of Crete); Aristophanes *Peace* 440; *Thesmophoriazousai* 346; *Wealth* 149. The Homeric Hymn to Hermes, usually dated to the fifth century BC, also attests to the meaning "dinner companion" for the word *hetaira* (4.31 on which see Càssola 1975: 518). Lidov (2002:228–229) refers to this meaning of *hetaira*, but accumulates late—even medieval Greek—and earlier sources without distinction in his attempt to speculate that Sappho was presented as a courtesan in comedy (cf. Chapter One, p. 18). On Attic comedy and Sappho, see Chapter Four. Lidov seems to posit a seamless *cultural* continuity in the performance of Sappho that is not warranted by the sources and, as a result, his account assumes topsy-turvy dimensions. The problem with such ideas is not that they are speculative but that they neglect crucial methodological issues about synchronic cultural practices: often centuries are counted like years. For a similarly argued, somewhat impressionistic, connection between Sappho and the word *hetaira*, see Walker 2000:352n5. On the intricate—visual, textual, cultural—meanings of *hetaira* in archaic, classical, and early Hellenistic Greece, see Herter 1957 and 1960; Peschel 1987; Calame 1989; Halperin 1990:88–112; Reinsberg 1993; Davidson 1997:109–136; Kapparis 1999:4–8, 214–215, 311–313, 408–409, 422–424; Kurke 1999:175–219; Miner 2003; cf. Henry 1985.

[371] Treu 1984:164–165; Liberman 1999:xcii–xciv.

[372] I agree with Lobel's suggestion (1951b:13) that in line 4 χορδαισιδιακρεκην probably represents χόρδαισ(') ἴδια κρέκην. Cf. Voigt's apparatus criticus, and Rodríguez Somolinos 1994:118.

[373] For the fragment, see Page 1955:144–145n1; Giangrande 1980; Galiano 1984:142; Giangrande 1983; Rodríguez Somolinos 1994:117–118 and 1998:166–167 (cf. the discussion in Rodríguez Somolinos 1992:287–288 and Stephens 2002:78–80 [to be read with caution]; for *hapax legomena* in Alkaios and Sappho, see Rodríguez Somolinos 1997). West's view that *olisbos*—only in this frag-

Concerning the decipherment, the traces, as far as I can see on the papyrus with the aid of microscope, confirm this reading. If the tattered nature of the fragment does not deceive us, the original song was a kind of invective against Polyanaktidai, probably "the female descendants of Polyanax."[374] Artificial copulation of women is depicted in Athenian vase-paintings of the classical period, and it has been suggested that homoerotic connotations in such depictions cannot be excluded.[375] Nevertheless, there is no reason to argue that the invective here is not against heterosexual women—whatever "heterosexual" might mean for early sixth-century Greece. It should be emphasized that despite the difficulties in reconstructing the broad outline of the fragment, its most thought-provoking aspect is its explicitness and what that explicitness suggests about the original audience(s) in Mytilene.

However, even if we accepted the assumption that ὀλισβ.δόκοισ‹ι› referred to a *plêktron*—the piece of horn with which the strings of a *barbitos* or related instrument were struck and "slid"—or that ὄλισβος was coined in southwest Asia Minor from the Ionian word ἀλίσβη ("deceit") through a hypothetically reconstructed, intermediary form *ἄλισβος[376]—and thus that its original meaning was "deceiver" or, if from ὀλισθεῖν/ὀλισθάνειν, "slider"[377]—a *plêktron* in an invective such as fragment "303A"[378] could have well been scanned, I argue, as an *olisbos* in late archaic and classical Athens, since this is the only attested meaning of *olisbos* for that and later eras ("dildo"). The revised 1996 supplement to LSJ renders ὀλισβοδόκος as "receiving the ὄλισβος, perhaps in

---

ment—has the meaning of *plêktron* (West 1970a:324, followed by Guarino 1981) mainly indicates misapplied moralizing reflected in the modern study of Sappho. Without examining the papyrus, Snyder (1997:114–115) is somewhat skeptical about the decipherment of ὀλισβ.δόκοισ‹ι› in line 5.

[374] The gender of this name cannot be determined with absolute certainty. The point is generally disregarded that the association of *olisbos* with Polyanaktidai may apply either to female descendants of the house of Polyanax, or to male ones, since Πωλυανακτ[ίδ]αις in line 2 can be the accusative plural of both a feminine and a masculine adjective (unless, surprisingly, it represents the nominative masculine singular [for the ending -αις in this grammatical case, see, briefly, Page 1955:84–85n1]). Modalities of male homoeroticism must have been as common in Lesbos as in other Greek areas, and Alkaios composed pederastic songs. In my discussion, I refer to Polyanaktidai as females.

[375] See Kilmer 1993b:27, 29–30, 98–99 (and 100–102 for the involvement of male fantasy in depicting female sexual self-satisfaction).

[376] Tibiletti Bruno 1969. See Hesykhios s.v. ἀλίσβη· ἀπάτη.

[377] Nelson 2000 [2002], supporting West's hypothesis through etymological views advanced by, among others, Frisk 1960/1972 (with earlier bibliography) and Chantraine 1968/1980.

[378] Without suggesting that the issue of attribution is entirely settled, I would place this fragment back in the "Sappho fragment 99" slot that Lobel-Page and other critical editors reserved for it.

sense 'plectrum,'" [379] but this, for the most part, indicates how authority influences current "translations" of possible archaic cultural and aesthetic phenomena. To go a step further, the *plêktron* often used by women musicians in their recitals was associated with the *olisbos* around mid-third century BC. As we have seen, in his sixth mimiamb, Herodas represented a lively dialogue between Koritto and Metro, who chat fervently about leather dildos and female masturbation somewhere on the coast of Asia Minor. [380] In the context of Metro's search for the name of the craftsman who stitched a scarlet *baubôn*—an *olisbos*—for her friend Koritto, the former refers to a Kerdon, not the actual cobbler who came from Khios or Erythrai, but one who "could not even stitch a *plêktron* for a lyre." [381] As A. D. Know argued on the basis of the material collected by Walter Headlam, the association was triggered by the similarity in shape between a *plêktron* with its cord attached to a lyre and the dildo with its little straps (*himantiskoi*). [382] Two more late cases draw similar associations: Juvenal imagines a woman music-lover who employs the *plectrum* of her lyre as a consolatory, pleasing object to which she generously offers kisses and caresses; and Akhilleus Tatios conjures up an image of a man called Ther-

---

[379] This phenomenon might be termed "scholarly warning," but it is more than that. M. L. West was the chairman of the British committee that oversaw the project of producing a new supplement to LSJ, after the publication of the 1968 supplement (see pages v–vii of the new 1996 supplement). According to the preface of this supplement, "the Greek-English Lexicon of Liddell and Scott was first published in 1843," and "in the 150 years which have passed since then its has gone through nine editions, the last being augmented by a Supplement published in 1968." The ninth edition was published in 1940. After the publication of the 1968 supplement, M. L. West "kept custody of the slips from which it was printed and a collection of material that had been excluded from it" (p. v). West put forward his idea about the early meaning of ὀλισβοδόκος in a 1970 article (1970a). Since then he has proposed the same idea in other of his writings (West 1990:1–2). Cf. West 1992a: 65, where he speculates that "Homer's failure to mention the plectrum encouraged the fallacious theory (*Suda* iv.323.10) that it was invented by Sappho, who does refer to it (fr. 99.5 L.-P.)." For the overall, somewhat politically charged, methodology adopted for the compilation of LSJ in the nineteenth and, especially, early twentieth centuries, see the "Preface 1925" in LSJ: iii–xi. The problems with the current LSJ are several and scholars have pointed to inaccuracies, methodological inconsistencies or obsolete linguistic approaches, and definitional/ideological preconceptions; most researchers are by now accustomed to thinking about definitions of ancient Greek words in terms of considerably marked *evolutionary* paradigms current in lexicography (as well as in social sciences) in the nineteenth and early twentieth centuries.

[380] Headlam 1922: xlvii and cf., among other commentators, Cunningham 1971:160 and Mandilaras 1986: 246.

[381] Herodas 6.51. On this line, see Headlam 1922:301–302 (cf. Cunningham 1971:168). Nelson 2000:78 takes this association as possible supporting evidence for the meaning "plectrum" that West contended for the use of the word ὀλισβ.δόκοισ<ι> in Sappho.

[382] On the *himantiskoi* in line 71 of Herodas' sixth mime, see Headlam 1922:307–308.

sandros who, as a youth, apparently used to lubricate himself in gymnasiums, to straddle a *plêktron*, and to wrestle with those boys whose looks were more masculine.[383] The association of the *plêktron* with the *olisbos* may go back, I suggest, to the time (already in the fifth century BC) when female musicians, often oscillating in male definitional rhetoric between *hetairai* and *pornai*, performed their songs to the accompaniment of a stringed instrument that was struck with a "pick."

These case studies, which throw some light on the immanently double-layered semantic textures of Sappho's songs, can be corroborated by other cases that have been the subject of intense (and sometimes circular) scholarly debate. If viewed from the perspective of a reconstructed, principally hypothetical, original context of Sappho's poetry, such cases remain controversial. I shall here explore the most central of them, closely related as it is to the overall poetics of Sappho.

In her celebrated fragment 16 V, the singing voice starts with a traditional discursive mode, the so-called *Priamel*:

* O]ἰ μὲν ἰππήων στρότον, οἱ δὲ πέσδων,
 οἱ δὲ νάων φαῖσ' ἐπ[ὶ] γᾶν μέλαι[ν]αν
 ἔ]μμεναι κάλλιστον, ἔγω δὲ κῆν' ὅτ-
 τω τις ἔραται·

 πά]γχυ δ' εὔμαρες σύνετον πόησαι
 π]άντι τ[ο]ῦτ',...

Some [men?] say a troop of horse and some a host of infantry
and some say an army of vessels is the most beautiful thing
on the black earth, but I say it is whatever one loves.
Quite easy to make this understood by everyone...

Although there is no evidence in the papyrus that line 1 is the beginning of a new poem, it has been assumed so from the context.[384] The definitions that have been given of the priamel since the first systematic usage of the term in Classics[385] are diverse in perspective.[386] Ἄλλοι ἄλλα, but Bundy's account seems the most comprehensive one to consider: "the priamel is a focusing

[383] Juvenal *Satires* 6.383–384; Akhilleus Tatios *Leukippê and Kleitophôn* 8.9.4. These two well-known passages are cited in Headlam 1922:301–302. Nelson 2000 adduces them and states that they were cited by Otto Crusius (1926:142). These cases indicate that the *plêktron*, literally a "striker," was assimilated into the semantic frame of *olisbos* rather than that both words, as Nelson maintains (2000:79), "originally used to designate musical implements" and were only later used euphemistically to denote a leather penis.

[384] Hunt 1914a:20–21.

[385] Dornseiff 1921:97–102.

[386] For a survey and criticism of the most important of them, see Race 1982:8ff.

or selecting device in which one or more terms serve as foil for the point of particular interest."[387] In this fragment, the list foil of lines 1–3a is capped by the gnomic climax of lines 3b–4 (ἔγω δέ...), which, in turn, is made specific by a concrete climax introduced in line 15 with the reappearance (?) of the poetic voice (..]με), the temporal νῦν, and the name of the person who seems to be the focus of the song (Ἀνακτορί[ας]). Between the two climaxes, a mythological exemplum appears that illustrates the gnomic climax (3b–4) and the statement of general comprehensibility which that (τοῦτ᾽) climax carries with it (5–6a). All the items of the list foil are dependent on the word στρότον, and virtually constitute *one* notion—that of military display—which is contrasted with or listed next to the idea that ἔγω puts forward.

Scholars have recognized two basic, mutually exclusive, functions of the climax to this priamel: the poetic ἔγω δὲ κῆν᾽ ὄττω τις ἔραται can denote *either* a contrast *or* a personal preference standing side by side with other people's preferences. In other words, this priamel may have the function of either of the subdivisions of the *kontrastierende* or *antithetische* priamel type, as Krischer has well defined them: it can be identified with the form of the *verabsolutierende* priamel, in which a contrast between the choice of the singing voice and the choices of others is conspicuous; or it might fit the schema of a *relativierende* priamel, where a balanced presentation of all choices is adopted, without any hint of contrast or wish for rejection or correction.[388]

In a number of diverse, nuanced interpretations proposed so far, the verb ἔραται is translated as "(one) loves." This rendering is suggested by the mythological exemplum that follows and the concrete climax of lines 15–20. If we accept this erotic sense, the notion of contrast here becomes very likely. But ambivalence is ubiquitous in words like ἔρασθαι and, as has been maintained, we cannot be entirely certain whether the meaning that ἔρασθαι conveys here is "to love" (erotic) or "to long for" (generic). One could cite expressions such as πολέμου ἔραται (*Iliad* 9.64) or μεγάλης δ᾽ οὐκ ἐρέω τυραννίδος (Arkhilokhos 19.3 W), where an erotic interpretation of the verb in question would not be admissible. Hence, some adherents of what might be called *relativity* theory argue that no firm conclusion can be drawn as to whether the particle δέ in line 3 is adversative or continuative,[389] since the meaning of ἔραται—in the general sense "(one) longs for, wishes for"—does not require a contrast between οἱ μὲν...οἱ δέ...οἱ δέ and ἔγω. Rather, it indicates an attempt on the part of the poetic persona to incorporate into one sentence and render in a

[387] Bundy 1986:5.
[388] Here I employ Krischer's terms (Krischer 1974) only to describe the two basic interpretive approaches that scholarship on this fragment has propounded.
[389] For the terms, see Denniston 1954:162ff. and 165ff.

255

relative and unspecific manner the desire for the different kinds of κάλλιστον that people might generally experience.

In the extant fragments of Sappho and Alkaios, the words ἔρασθαι and ἔρος (or ἔρως) *may* possibly refer to erotic love,[390] but the evidence is not adequate to demonstrate a single clear-cut usage.[391] Therefore, ἔραται cannot by itself prove that it carries in fragment 16 an erotic sense, and it should not by itself determine the interpretation of the opening stanza. Only if we lend it the amorous character of the myth—which itself contains a kind of priamel in κωὐδ[ὲ πα]ῖδος οὐδὲ φίλων το[κ]ήων |…ἀλλὰ παράγαγ'.…—and possibly of the final priamel (with the reference to ἔρατον βᾶμα) does the statement of the poetic persona read *verabsolutierende*.[392]

[390] ἔρασθαι: once more in Sappho 49.1 V ἠράμαν μὲν ἔγω σέθεν…, where the meaning fluctuates between erotic and friendly love. ἔρος: in Sappho fr. 15.12 V the reference to "sexual love" that Page (1955:10) assumes, based on the text produced by Lobel and himself, is not so certain (see Voigt's apparatus criticus); the context of fr. 23.1 V is irrecoverable; fr. 58.26 V seems to refer to "love" generally; in fr. 112 V, if it is correctly reconstructed, erotic content in the expression ἔρος δ' ἐπ' ἰμέρτωι κέχυται προσώπωι can be convincingly argued in view of line 5. Cf. perhaps Sappho frs. 44Aa.11 and 67b.8 V, where, however, the context is uncertain (ἔρος or Ἔρος?) or unknown, respectively. In Alkaios fr. 283.9 V, the word ἔρω<ι> denotes physical passion; in Alkaios frs. 296a.2 and 297.4 V, the context is lost.

[391] Similarly, other words from the same stem do not show an explicitly erotic sense, except in a few cases: Sappho fr. 132 V ἀντὶ τᾶς ἔγωὐδὲ Λυδίαν παῖσαν οὐδ' ἐράνναν…does not support such a meaning; ἔρατος modifies Anaktoria's walk in our fragment, garlands in Sappho fr. 81. 4 V (in these two cases it could have amorous connotations), and, perhaps, the word "island" or Lesbos in Alkaios fr. 296b. 12 V (νάσ]ω or Λέσβ]ω δ' [ἐ]ράτας supplied by Barner [1967:172 and 174] and Lobel, respectively); the adjective ἐρόεις is applied to olive trees (Alkaios fr. 296b.2 V) and an altar (*inc. auct.* 16.2 V), but ἐρό]εσσ' Ἄβανθι (*inc. auct.* 35.8 V) may perhaps be an address with amorous overtones.

[392] Among the many parallels to this specific priamel that one can adduce, the following are striking: οὗτοι ἐν ἅρμασιν καὶ οὗτοι ἐν ἵπποις,| ἡμεῖς δὲ ἐν ὀνόματι κυρίου θεοῦ ἡμῶν μεγαλυνθησόμεθα (Psalms 19 [m 20]. 8 Rahlfs), and ὁ μὲν ἵππον εὖ διώκοι,| ὁ δὲ τόξον εὖ τιταίνοι,| ὁ δὲ θημῶνα φυλάσσοι| κτεάνων, χρύσεον ὄλβον·|…ἐμὲ δ' ἀψόφητον εἴη| βιοτὰν ἄσημον ἕλκειν…(Synesios *Hymns* 9.20–24, 29–30 Lacombrade; see Pesenti 1922:50 and 53, and, especially, Terzaghi 1939:275 for similarities and differences between Sappho's poem and Synesios' hymn). Synesios may well look back to Sappho. But little or no influence could have occurred between Sappho and the Psalmist. Is this a Near Eastern or traditional motif that they exploited independently? Similarly important are Plato *Lysis* 211d–e ὁ μὲν γάρ τις ἵππους ἐπιθυμεῖ κτᾶσθαι, ὁ δὲ κύνας, ὁ δὲ χρυσίον, ὁ δὲ τιμάς· ἐγὼ δὲ…βουλοίμην ἄν μοι φίλον ἀγαθὸν γενέσθαι, and *Anacreontea* 26 σὺ μὲν λέγεις τὰ Θήβης,| ὁ δ' αὖ Φρυγῶν ἀυτάς,| ἐγὼ δ' ἐμὰς ἁλώσεις.| οὐχ ἵππος ὤλεσέν με,| οὐ πεζός, οὐχὶ νῆες,| στρατὸς δὲ καινὸς ἄλλος | ἀπ' ὀμμάτων με βάλλων. The frequently quoted Delian epigram (κάλλιστον τὸ δικαιότατον· λῷιστον ιδ' ὑγιαίνειν·| πρᾶγμα δὲ τερπνότατο.ιν, τοῦ τις ἐ.ρᾶι, τὸ τυχεῖν, *Theognidea* 255–256; cf. also its variations in Aristotle *Ēthika Nikomakheia* 1.9.14 [1099a.27], *Ēthika Eudēmia* 1.1 [1214a.5], and see the version of Sophokles fr. 356 *TrGF*: κάλλιστόν ἐστι τοὐνδικον πεφυκέναι, | λῷστον δὲ τὸ ζῆν ἄνοσον, ἥδιστον δ' ὅτῳ | πάρεστι λῆψις ὧν ἐρᾷ καθ' ἡμέραν), which has been thought to prove that ἔραται refers to "wanting" in a general sense, is rather different in thought and composition from Sappho fr. 16 V, since the epigram both expresses three categories of values (κάλλιστον, λῷστον, τερπνότατον) and lacks any contrasting dramatis personae.

Yet some other considerations suggest that a kind of contrast is indeed present in the first stanza, without excluding the possibility of some reservation on the part of the poetic voice. First, in the fifth stanza, we hear that Anaktoria's walk and the sparkle of her face is preferable to the Lydian chariots and armed infantry. The poetic subject expresses an obvious contrast in this stanza, and maintaining that because of the difference in the modality (verb and mood) of the initial and the final priamel (φαῖσ'...ἔμμεναι as opposed to <κ>ε βολλοίμαν) "the opening preamble...asserts a certain *truth*, while the final...states a *preference*,"[393] represents an attempt to recontextualize the sense of the whole song by undermining the statement of the final priamel.[394] If the κάλλιστον for the poetic voice is Anaktoria, then the contrast of the fifth stanza is likely to be reflected in the first stanza. Besides, if the statement ἔγω δὲ κῆν' ὄττω τις ἔραται is equivalent to the Latin *de gustibus non est disputandum*, as has often been held, then "Anaktoria" would have been perceived by ancient audiences as receiving, through the song, only a general and reserved compliment.[395] Second, the list foil consists of thematically associated images: they refer exclusively to "military" aspects of social discourse and not to various spheres of action.[396] To my mind, if the *relativity* theory were valid, the initial priamel should have contained representations of the preferences of more than one group of people—that is, we should have a formulation along the following lines: Some people consider the glittering parades of various military units as the finest thing in the world, others wealth, others the weaving of extravagant tapestries, others political power. On the contrary, what we have here is: People hold that the finest thing in the world is the splendid spectacles connected with the various armed forces, let us say the cavalry, the infantry, and the navy, but I hold [...]. That the focus is on a specific sphere of objects is confirmed by the list foil of the final priamel. Third, if οἰ μὲν...οἰ δὲ...οἰ δέ contend that the finest thing is X, this does not necessarily mean that they long for it.[397] This might be the most beautiful thing for them, and so they will say if they are asked, but their longing may be for wealth, wine, sexual encounters, and so on. Therefore, even the notion of an abstract "definition" of what people love that some scholars recognize in the initial priamel cannot be unconditionally valid.

---

[393] Barkhuizen and Els 1983:27.

[394] The original audience(s) of the song in Sappho's time could more readily "decipher" the meaning of ἔραται and thus would not need to wait for the final priamel so that they might make sense of the opening one. In our own effort to understand the function of the first stanza, the case seems to be the opposite.

[395] Koniaris 1967:258–259. For more recent discussion of Sappho fr. 16 V, see Bierl 2003.

[396] Cf. Race 1982:63.

[397] Des Bouvrie Thorsen 1978:10.

Finally, what the poetic subject seems to stress here is her preference for small, concrete but fleeting, beloved things: the ἔρατον βᾶμα and the λάμπρον ἀμάρυχμα of Anaktoria. She does not long for spectacular objects but for a few ethereal, albeit evanescent, manifestations of her companion's beauty—simply the occasional sight of her gait or the bright movement of her face. She virtually dissociates herself from the *theasis*, in the modern sense, of other people, and for that reason the notion of dissociation may qualify and supplement the notion of contrast. The speaking voice admires a kind of sight not comparable to that of armies and fleets; this preference constitutes, I suggest, one of the most intriguing features of Sappho's poetics—and not simply of her female perspective—a poetics that might be defined as "poetics of *theasis*."[398]

If ἔραται in fragment 16 V, as well as other instances of *erôs* words in Sappho, are viewed as expressions of homosocial—not institutionally/educationally or homoerotically "amorous"—intimacy developed in female gatherings, then the best context in which to place such an understanding is to be found in classical Athenian visual representations of women musicians' gatherings and recitals.[399] I place emphasis on the *alterity* of such refracted female discourses—even though they were apparently represented by male artists—[400] and on a methodological approach that, instead of conglomerating all diverse discourses into one modern historicizing narrative, attempts to differentiate the significance of each discourse and then explore the possible interdiscursivity of their interaction. In other words, since the original, late seventh-/early sixth-century context is almost impossible to reconstruct with some certainty, it is equally, if more, significant to explore the anthropology of the early contexts in which Sappho's songs were performed. Such contexts, in turn, help us conceive of possible archaic contexts, which, however, will ultimately remain conjectural.[401]

However, if ἔραται was placed in the context of Athenian male *symposia* and related venues, the erotic overtones must have been pronounced and the ἔγω δέ—performed by either a male group or a female musician who entertained them—should have been seen only as contrastive/adversative.

This immanent doublelayered *semansis* in the songs of a woman poet was, I argue, the most crucial element in the earliest stages of the reception of her figure and her compositions. Further, it was the broader cultural idioms

[398] On the gaze in Sappho's songs, see the discussion in Stehle 1990.
[399] For these visual discourses see below.
[400] See Chapter Two, p. 57.
[401] If, following current paradigms in scholarship, we attempt to "read" ἔραται in the context of choruses of young girls against the background of religious festivals, we remain uncertain as to what overtones we hypothetically attach to the word and the whole song.

explored throughout this chapter that were conducive to the different coinages of her figure, and not only her poetry *per se*. In the classical period her songs were characterized, as we will see in Chapter Four, by *textual plasticity*; as a result, "Sappho" should be seen more as a discursive *texture* in dialogue in the fifth century with other broader and often more influential synchronic cultural *textures*. The idea that in the late sixth and fifth centuries BC Sappho was a coherent paradigmatic poetic figure whose text was comparable to the fixed type exemplified, for instance, by the ancient Indian epics *Mahābhārata* or *Rāmāyaṇa* needs to be reconsidered.[402]

## Contextual Plasticity

Before I proceed to discussing this issue, I shall investigate some further performative elements of Sappho's songs. If we look at some of the fragments carefully, we can detect an embeddedness of thematic units related to the songs' immanent *resilience* to different social contexts. This resilience, I argue, facilitated the transmission of Sappho's songs in different city-states and in diverse cultural spaces. The most significant of those units, whatever its broader context may be, is the exhortation to "take a musical instrument and sing:"

<div align="center">

]ς πέταται διώκων

]                                      9

]τας ἀγαύας

]εα, λάβοισα

].ἄεισον ἄμμι

ιτὰν ἰόκολπονɹ     ]                     13

]ρων μάλιστα

]ας π[λ]άναται

]flies in pursuit

]                                      9

]glorious

] taking

] sing to us

</div>

[402] For these epics and Indian oral regional epics, see especially Blackburn et al. 1989 and Smith 1991. As Blackburn and Flueckiger stress in Blackburn et al. 1989:7, "on one level are the regional retellings of the Sanskrit epics. Although the *Mahābhārata* and the *Rāmāyaṇa* have become classical, literary texts, with standard editions, they also live in contemporary performance traditions."

of the violet-bosomed one                    13
     ] mostly (especially?)
     ] wanders.[403]

In his critical edition, Ernst Diehl, following Wilamowitz, reconstructed his text of line 12 in such a way as to provide the image "taking [the sweet-voiced *paktis*] sing to us...."[404] For line 8 he quoted in his apparatus Wilamowitz's suggestion that "[Ero]s" or "[Imero]s" is the subject of "flies," an image that partly recurs in Sappho fragment 22 V. Avoiding the old, Eros flies pursuing the youth—according to Wilamowitz, an altogether "archaic" concept. The transition to the exhortation to sing was detected in ἔα in line 11. The papyrus does have a stop (·) after ]ε̣α, and the comma before λάβοισα appears necessary: with λάβοισα a new idea is introduced. In line 14, [ἐτά]ρων ("of companions") was hesitantly entertained and duly relegated to Diehl's apparatus criticus. Finally, in line 13, Max Treu, who also adopted Wilamowitz's "taking [the sweet-voiced *paktis*]" in his edition, saw in "the violet-bosomed" a reference to Aphrodite.[405]

To be sure, the context of the song is far from certain and no coronis exists to indicate whether a new song started somewhere in the middle of the whole fragment or whether it represents a single composition. However, the exhortation "take an object and sing of someone" is, I suggest, a thematic unit that in fifth-century Athenian *symposia* evoked a certain performative idiom— the idea that a *skolion* is being sung or is "somewhere around."[406] It should be recalled that both in the *Banqueters* and in the *Clouds*, Aristophanes presented some of his actors urging others to "take a lyre or a myrtle sprig and sing a song or a drinking song (*skolion*)"[407]—and this appears to have been a standard practice in the performance of compositions in *symposia* and similar male gatherings. Such thematic units in Sappho operated, I argue, as *contextualization cues* in milieus different from her original one.

---

[403] Sappho fr. 21.8–15 V. For aspects of the history of attribution of lines 12–13, before the first edition of P.Oxy. 1231 in 1914, see Voigt's *apparatus fontium* in fr. 21 (Voigt 1971:48).

[404] Diehl 1936:26 (his fragment 32 = fr. 21 V), where [δ' ἀδύφωνον πᾶκτιν] ἄεισον ἄμμι is printed. In his 1925 edition, Diehl did not adopt a supplement (1925:343). In line 10, Diehl 1936 printed his [ἀλλὰ νῦν μέμνασθ'~] τᾶς ἀγαύας—with its reference to the "memory of a companion" theme often adopted speculatively in textual restorations of the text of Sappho—and he noted in his apparatus criticus (1936:26) that Ἀτθίδος might alternatively be entertained—as another way of reconstructing the transition to λάβοισα in line 11.

[405] Treu 1984:189.

[406] See further Yatromanolakis 2007a (a suggestion I first put forward in my D.Phil. thesis).

[407] *Banqueters* fr. 235 K-A ("Taking...sing for me some drinking song of Alkaios and Anakreon"); *Clouds* 1355 (*lyra*); and 1364 (myrtle branch). λαμβάνω is the verb used in all three cases.

Sappho fragment "22B," as we might call the largest part of fragment 22 V,[408] constitutes a more interesting case. In what appears to be a multiform of the broader thematic idea exploited in other fragments,[409] the singing "I" invites a female figure to take up a stringed instrument and to sing of a companion. What I shall explore is the different levels of reception that the contextualization cues embedded in the song offered to audiences (fr. 22.9–19 V):

.].ε̣.[....].[...κ]έλομαι σ.[
..].γυλα.[...]α̣νθι λάβοισα.α.[
πᾶ]κτιν, ἄς σε δηὖτε πόθος τ.[
    ἀμφιπόταται
τὰν κάλαν· ἀ γὰρ κατάγωγις αὔτα[
ἐπτόαισ' ἴδοισαν, ἔγω δὲ χαίρω,
καὶ γὰρ αὔτα δή πο[τ'] ἐμεμφ[
Κ]υπρογέν[ηα
ὠς ἄραμα̣[ι
τοῦτο τῶ[
β]όλλομα̣[ι

]  I bid you [sing?]
[of] Gongyla, [Ab?]anthis, taking the [ ]
h]arp as yearning now again flies
    around you,
you beautiful one; for that dress [ ]
[you] when you saw it; and I rejoice;
for once the Cyprian herself
    blamed [me?]
for praying [
this [
I wish [want.

The translation I provide here is to be taken as tentative. The song, which has in recent scholarship been granted a canonized status among the more substantial fragments of Sappho, has been viewed as significant for the light it may shed on such issues as the configuration of longing and the construction of the gaze in her poetics. The singing "I" is asking, in a self-referential manner, the song's addressee to take a small harp and perform a song about another female figure; *pothos* is once more (*dêute*) involved in the setting, while the sing-

[408] Yatromanolakis 1999b.
[409] See e.g. 21 and 58c (= 58.11–22 V). For the concept of *multiform*, see Lord 1991:76 and 1995:23.

261

ing voice seems to suggest that the cause of the excitement of one of the two female figures is the [seductively elegant] dress worn by the other. The general outline of the rest of the text is difficult to grasp: we hear something about the Kypros-born goddess and there is an obscure reference to a prayer.

Most recent analyses of the fragment tend to adhere to the following marked scenario:[410] the speaker commands Abanthis to sing of *her desire* for the beautiful Gongyla, whose dress thrilled Abanthis. However, there is nothing in the textual remains to make this reconstruction compelling, since it would be possible to have at least three different scenarios leading to different conclusions about the plot of the fragment. The main questions to pose are: Whose desire is fluttering around the female figure addressed to by the singing voice? Who does the dress, referred to in line 13, belong to? How many figures, including the speaking "I," are involved in the plot of the song? If we accept that they are three and that the names of the addressee and the other female figure are Abanthis and Gongyla, respectively, the flying desire can be either Abanthis's for Gongyla, or Gongyla's for Abanthis. A third possibility is, I suggest, that only two figures are involved in the fragment as it stands: that is, the poetic subject and the addressee, since [...]ανθι after ..].γυλα. may well be an epithet modifying the addressee.[411]

The history of restorations endorsed throughout the twentieth century (since 1914) cannot be investigated in detail here but a reference only to Jurenka's reconstruction would suffice to illustrate some of the relevant interpretive practices:[412] according to this reconstruction, the fragment is a wedding song—an overpowerful paradigm in the scholarship on Sappho in the last two centuries. Instead, I prefer to explore the contextualization cue "take a harp and perform a song" discussed above and to view it in the context of two central discursive modalities. The first—male symposiastic—will not be extensively discussed here but elaborated below. The second one needs to be fleshed out at this stage, for it represented an antithetical, but complementary, aspect of the performative transmission of Sappho's songs.

On a red-figure Athenian *chous* housed in the National Archaeological Museum in Athens, we see an elegantly produced, serene scene of a *symposion* (Fig. 27).[413] On the body of this fine *chous*—attributed to the Eretria Painter and dated to *c.* 425–420 BC—a draped youth with a wreath on his hair reclines

---

[410] Skinner 1991:84–85, Snyder 1997b:38–42; among other analyses.

[411] In Yatromanolakis 2007a, I examine the papyrus text of fr. 22 V (= fr. 22B) and different restorations that have been advanced and rigorously defended, as well as the one suggested here.

[412] Jurenka 1902.

[413] Athens, NAM 15308; *ARV* 1249.17; Lezzi-Hafter 1988:pl. 138a–c and frontispiece in her plates volume.

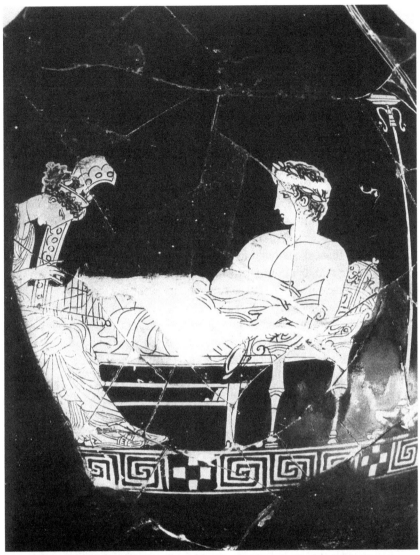

Figure 27. Red-figure *chous*: draped youth reclining with cup, female figure seated, playing harp. Attributed to the Eretria Painter, *c.* 425–420 BC. Athens, National Archaeological Museum, inv. no. 15308. Photo courtesy of the Hellenic Ministry of Culture / Archaeological Receipts Fund.

on a lush *klinê*, drawn in three-quarter view. His muscular chest and arms are shown naked, but a *himation* covers the remaining part of his body. From a finger of his left hand a drinking cup is floating while his right hand is placed

near his chest. In front of the couch a low table is set with fruit, but apparently no other food, for this is the time for the consumption of wine. Behind his couch a stylish standing lamp is drawn, with no fire blazing—an indication that allows us to think that the setting is nocturnal and dimly lit. Near his feet a female musician—a *psaltria*—is seated, plucking a ten-stringed harp with an arched soundbox and pillar to connect its two ends. This is the type of harp to which *paktis* (or *pêktis*), frequently mentioned in Sappho, may refer. The musician wears *chiton* and *himation* and decorated sandals, and has a diadem on her hair. Her head is tilted down, her eyes fastened on the fingers of her right hand as well as on the strings of the harp. Virtuosity is not necessarily an issue here, since the context is symposiastic. The youth gazes at the harpist and listens to her melic pluckings. On the left-hand side, the image is broken.[414] The vase was found in the theater of Dionysos in Athens and its shape may be plausibly connected with the festival of the Anthesteria,[415] celebrated in the month Anthesterion toward the end of February. The festival's second day—called *Choes*—centered on drinking-parties of a special type, with *choes*, larger and miniature, used by and given to the participants in the festival.

Even so, the image on this *chous* rarely recurs on other vases.[416] Harps are in most cases plucked by women musicians in contexts where no men participate: that is, in female gatherings defined and differentiated by specific visual signs as well as the appearance of these images on shapes of vases associated with marked occasions. What one may detect in this corpus of representations of female harpists—including the image on the Athens *chous*—is an *interdiscursivity* of different sociolects: on the one hand, a male, symposiastic sociolect

---

[414] It has been suggested that a standing listener might be missing (Lezzi-Hafter 1988:203)—an attractive idea, given the three-figure decoration exploited in other vases (*oinochoai* and *choes*) attributed to the Eretria Painter.

[415] See Lezzi-Hafter 1988:339, no. 216, and 203.

[416] See a terracotta relief in Heidelberg with a comparable representation (Maas and Snyder 1989:214, *Münchener Jahrbuch* 3 [1926]:267, pl. 8). The red-figure neck amphora London, British Museum E 271 (*ARV* 1039.13; *Add.* 319; Robertson 1992:215, fig. 224), attributed to the Peleus Painter, who was associated with the Group of Polygnotos (see Chapter Two), and dated to *c.* 440–430 BC, constitutes one of the earliest (perhaps the earliest, depending on dating) cases of representation of a harp in Attic vase-painting. On the obverse, Terpsikhore (ΤΕΡΨΙΧΟΡΑ), Mousaios (ΜΟΣΑΙΟΣ), and Melousa (ΜΕΛΕΛΟΣΑ) are depicted while on the reverse is an image of a woman standing between two draped youths with walking sticks. In this representation, the harp with arched soundbox and no pillar is plucked by the seated Terpsikhore. It is interesting that harps are not represented earlier on Athenian pottery. Note that Athens, National Archaeological Museum 19636 (*Para.* 479.91*bis*; Tsiaphaki 1998:357, fig. 35a), a *pyxis* (?) fragment, perhaps in the manner of the Meidias Painter and dated to around the last quarter of the fifth century, depicts a male figure, Mousaios, playing a harp and Thamyras with a lyre; Apollo and named Muses (one female figure is called Sophia, others are labeled Kalliope, Ourania, Polyhymnia) also appear. For Cycladic marble figurines of musicians playing harps, see Younger 1998:10–13, 71–73. On harps in ancient Greece, see Herbig 1929.

much more pronounced in textual sources; on the other, a female sociolect refracted in a marked manner in visual images.

On a *lebes gamikos* in the National Archaeological Museum, Athens (Fig. 28),[417] a scene occurs that can be closely associated with the broader context of weddings. The representation is attributed to the Washing Painter, a craftsman known for his indulgence in an overall feminine thematic in his work: both the *loutrophoroi* and the *lebetes gamikoi* assigned to this vase-painter are brimful of marriage images.[418] Note that thematic and draughtsmanship affinities are detectable in the work of the Eretria Painter—that is, the craftsman of the Athens *chous*—and in the representations of the Washing Painter as well as those of the Meidias Painter, despite the fact that each of these three painters of the second half of the fifth century is distinct and displays different levels of skill and originality. The Athens nuptial *lebes*, dated to *c.* 430–420 BC, shows a domestic gathering of women along with a winged Nike on the right. A female figure is represented seated in the middle and flanked by a standing woman holding boxes on the right and three other women standing on the left, one of them plucking a frame harp next to the seated figure.[419] The seated young

---

[417] Athens 14791; *ARV* 1126.5. On representations of marriage in vase-painting, see Lissarrague 1992b:142–163; Oakley and Sinos 1993 (with earlier bibliography); Sutton 1997/1998 (with earlier studies); Sabetai 1997; Vérilhac and Vial 1998; and especially the excellent volume by Cavalier 1996, with ethnographic material and contributions by Kauffmann-Samara 1996 and Lissarrague 1996; see also Kauffmann-Samara 2003. On wedding songs, see Hague 1983 and especially Contiades-Tsitsoni 1990. On related aspects of marriage, see Avagianou 1991 and Parisinou 2000. I should note that Eros and Himeros flying or standing near female figures appear in different contexts and visual configurations and sometimes with different connotations in a large number of representations with personifications and goddesses (see the images in Shapiro 1993:63–64, 66, 68, 75, 105, 118–124, 196–199, 203, 205) and with scenes related to *cultural performances* of wedding and femininity (see images in Oakley and Sinos 1993:53, 62, 66, 67, 76, 83, 90–91, 95, 97, 99, 109–111, 116–119; and a number of cases in Burn's monograph on the Meidias Painter [1987:plates 22–25, 27–29, 30, 42, 44–45, 48–51] and in articles on women and marriage in Cavalier 1996; cf. Kauffmann-Samara 1988:294, fig. 8).

[418] On the Washing Painter, see Robertson 1992:223–227 and Sabetai 1993 (to which I did not have access). See Rabinowitz 2002:152n15 for the argument advanced by Mihalopoulos 2001 that the Washing Painter and the Eretria Painter were women vase-painters (I have not had access to the latter dissertation either). On *lebes-gamikos*, cf. Sgourou 1997.

[419] For other representations of standing (not seated) harpists, see volute *krater* Ferrara, Museo Nazionale di Spina 3033 (*ARV* 1171.1, 1685; *Add.* 338; Kurtz 1989:plates 33–35), attributed to Polion: on the reverse we see Apollo, Thamyris playing the kithara, and Muses seated and standing with musical instruments; red-figure *hydria* Berlin, Antikensammlung F2391 (unattributed, found in Ampelokepoi, Athens; Queyrel 1992:plate 385): an image of Muses, one seated on a hill and playing a lyre, another seated behind her (under the *hydria*'s right handle) playing the reed pipes, two others, one standing plucking a harp and the second standing and gazing at the Muse who plays the lyre seated on a hill; behind her and in front of the seated *aulos*-player an *aulos*-bag is hung in the field; in the scene there is also a fifth Muse. On the latter vase, see Chapter Two, n. 336.

Figure 28. Red-figure *lebes*. *Above:* Nike, women, one playing harp, one seated on chair. *Opposite page:* Views of all sides. Attributed to the Washing Painter, *c.* 430–420 BC. Athens, National Archaeological Museum, inv. no. 14791. Photos courtesy of the Hellenic Ministry of Culture / Archaeological Receipts Fund.

woman looks up through the hole of a single reed pipe that she has in her right hand and holds the other single *aulos* in her left hand; her left arm leans on the back of her *klismos*. In this and related representations, no marked meaning is detectable in the pose. Instead, female gaze and perspective are, I argue, especially foregrounded, indicated by the figure looking through the pipe and her companion gazing at the standing harpist and leaning on the latter's shoulders.

This image constitutes part of a broader corpus that shares specific visual signs (a marked presence of hovering or standing/seated winged Erotes, wreaths, female jewelry, boxes, and torches) with an even wider set of representations. A related, but somewhat more marked, depiction by the Washing Painter occurs on another *lebes gamikos* (Fig. 29).[420] The seated young woman here looks up at a fluttering Eros. She does not play her frame harp but the fingers of her left hand are on the strings; the arm of her right hand leans comfortably on the back of her elegant chair. Eros holds fruit in his hands and is seized by the leg by a female figure standing on the right. Behind her a young girl carries a chest and a basket while behind the seated figure stand two companions, one holding a fillet near the head of the harpist and another carrying an unlit and a lit torch in her hands. With such images on marked shapes of vases, one is tempted to generalize and argue unreservedly that they all depict actual wedding preparations. We may need to distinguish between the function of a vase and the image it bears. A female gathering with one of the companions playing a harp might not represent a wedding preparation, but marriage connotations are attached to it by the shape of the vase and the possible context of its use. Often the seated figures, when adorned by the other companions, may well be categorized as "brides," but in other cases "bride" should be taken only as a metaphoric label, since aspects of the life of young women before or after marriage might correlate interdiscursively on the same image intended for a wedding. Further, the fact that *named* Muses—or figures so labeled in archaeological discussions—are shown as playing harps[421] and other stringed instruments on vases of more generic use does not necessarily suggest that brides in wedding scenes were indirectly compared to Muses by ancient Athenian viewers. The idea that such a visual connection functions as a compliment to the bride or the seated female figures represented on marked

[420] New York, Metropolitan Museum 16.73; *ARV* 1126.6; *Add.* 332.

[421] See e.g. *pelike* New York, Metropolitan Museum 37.11.23; *ARV* 1313.7; *Add.* 362 (Burn 1987: plates 35–37), attributed to the Meidias Painter. On the obverse, Mousaios is seated playing a Thracian *kithara* flanked by a female figure named Deiope, a child named Eumolpos, and Muses (Melpomene playing the harp, Erato drumming a *tympanon*, Kalliope, Terpsikhore), Harmonia, Aphrodite, Pothos, and Peitho.

Figure 29. Red-figure *lebes*: women, one with torches, one seated with harp. Attributed to the Washing Painter, *c.* 430–420 BC. New York, Metropolitan Museum, Rogers Fund, 1916, inv. no. 16.73. Photo © The Metropolitan Museum of Art.

wedding shapes is favored in recent analyses and more often than not taken for granted. I do not here wish to undermine this notion since comparisons of mortals with mythological figures are well attested. Instead, I wish to point to the precariousness of reconstructing ancient sociolects by basing arguments about specific images on such (often hypothetical) connections.[422]

When we return to the Washing Painter and his *lebetes* and *loutrophoroi*, we find another marked representation: a seated female figure plucking the strings of a frame harp and concentrating on her performance, as well as a companion standing behind her and carrying a *loutrophoros-hydria* decorated with ribbons (Fig. 30).[423] Two other female figures with chests and baskets flank the seated harpist from the right. On other parts of the *lebes*, young women appear carrying *kalathoi* and a Nike holding sprigs is flying.[424] The *loutrophoros-hydria* is here an especially marked sign. Finally, on a *pyxis*, a round cosmetic container, attributed to the Washing Painter and dated to *c.* 430–420 BC,[425]

---

[422] Cf. Chapter Two, p. 152.
[423] New York, Metropolitan Museum 07.286.35; *ARV* 1126.1; *Add.* 332.
[424] Cf. also New York, Metropolitan Museum 16.73 (Fig. 29).
[425] Würzburg, Universität, Martin von Wagner Museum H4455; *ARV* 1133.196; 1684; *Add.* 333 .

Figure 30. Red-figure *lebes*: women, one seated playing harp. Attributed to the Washing Painter, *c.* 430–420 BC. New York, Metropolitan Museum, Rogers Fund, 1907, inv. no. 07.286.35. Photo © The Metropolitan Museum of Art.

a young woman sits on a lush couch and adorns her hair with the help of a winged Eros (Fig. 31). Behind the couch and the seated figure stands a female companion holding again a *loutrophoros-hydria*. On the other side of the couch, behind Eros, another companion appears lifting her drapery from the shoulders. Behind her a wreath hangs in the field and a wool basket is on the floor. Next to them a seated woman, looking in the opposite direction, plays a frame harp. Before her, two more female figures—one seated and holding a scepter, the other standing and carrying a box—gaze at a wrestling *agôn* between two Erotes flanked from the left by another female figure holding a scepter.[426] The presence of the wrestling Erotes may be somewhat connected with the two female figures presiding over the *agôn* and the songs performed by the seated harpist.

The fragments of Sappho I examined above should be viewed in the context of three visual discursive idioms: a male symposiastic discourse that, as the

---

[426] Different tentative identifications of the figures have been proposed: see e.g. Robertson 1992: 227 and Kauffmann-Samaras 1996:436 and 442. Most scholars see the presence of Aphrodite in one or two of the represented figures as certain.

Figure 31. Red-figure *pyxis*: women, one seated on *klinē* with Eros, one with *loutrophoros*, Erotes wrestling, one woman seated on chair, one seated with harp. Attributed to the Washing Painter, c. 430–420 BC. Würzburg, Martin von Wagner Museum, inv. no. H 4455 (L 541). Photo, K. Oehrlein, Martin von Wagner Museum der Universität Würzburg.

available sources suggest, was the predominant one in fifth-century Athens; a discourse related to female musical gatherings as these are refracted in Attic representations produced by diverse craftsmen; and a discourse closely associated with the institution of marriage and wedding rituals, even if some of the vases reflecting this discourse might have been used in different contexts or buried along with the dead. Songs composed by Sappho and performed in late archaic and classical Athens were, I argue, scanned on the basis of these three discourses. Some of these songs should be viewed as *multiforms* with a common thematic focus. That focus—introduced or reactivated by exhortations like "take a harp," "take a *barbitos*" or a wreath "and sing of a beautiful companion"—was further assimilated into habitually internalized (but liable to individual agency) cultural idioms that were conducive to the shaping of cultural spaces within which the original context of different songs by Sappho was located. This process was replicated in the performative contexts and modalities of other city-states and ancient Greek communities, the idioms and sociolects of which are now unavailable.

Concerning the second discourse—female gatherings where musical performances were the central focus—I have already explored some relevant vase-paintings in Chapter Two. On a somewhat neglected late fifth-century *hydria* found in the Kerameikos in Athens—an offering comparable to nuptial *lebetes* and white-ground *lekythoi* lying in a tomb near the dead—we find a young woman musician playing a tall *barbitos* and seated not in the center of the scene, as usual, but at far left (Fig. 32).[427] Not using his particularly long wings, an Eros stands in front of her and plays the *aulos*. Behind him, on the right, another young female figure unrolls a scroll near a low table while an onlooker stands behind her. The image on this *hydria*, almost contemporary with the *hydriai* by the Group of Polygnotos, has not been attributed to a painter. The *sakkos* worn by the *barbitos*-player does not indicate her possible status. But the addition of the book roll held by the second woman, who also wears a *sakkos*, might convey the inclusion of poetry recitation as part of the whole musical performance. Another type of vase, a bell *krater* in the manner of the Kleophon Painter, provides us with a more standard configuration, probably because it promotes the designs established by the Group of Polygnotos:[428] a little Eros, neither holding a wreath in his hands nor floating above the head of the frontally and centrally seated woman musician, sits on the floor almost

[427] Athens, Kerameikos 8070 (Knigge 1990:148, fig. 143 right). Note that the *hydria* was part of vase offerings (*lebetes gamikoi*, *chytrai*, cups, and other shapes) deposited in Athenian graves (see Boardman and Kurtz 1971:22).

[428] Once Nocera, Fienga [no inventory number]. Metzler (1987:76) suggests that the anonymous seated woman represents "Sappho," but see Chapter Two on this methodological paradigm.

Figure 32. Red-figure *hydria*: seated woman playing the *barbitos*, Eros, woman with book roll, onlooker. Athens, Kerameikos Museum, inv. no. 2698. Photo Deutsches Archäologisches Institut, Athens, neg. no. 8070; courtesy of Kerameikos Museum, Athens.

cross-legged (Fig. 33). On the left side of the image, the two female figures' gazes interlock—and Eros lies between them. The instruments that three of the four women hold are all *chelys* lyres. As in the Kerameikos *hydria*, here the female spectator at far right is clad in an enveloping mantle. And similarly, the obverse of a *kalyx-krater* in Würzburg—attributed to the Christie Painter and dated to around 440–430 BC—recomposes the scene by varying the stringed instruments held by the two women and by showing a chest lying open on the floor (Fig. 34).[429]

The idealized cognitive model reflected in these representations can be supplemented by two intriguing cases. They both suggest fifth-century BC contexts—even imaginary—within which Sappho's songs might have been, I argue, located by both female and male viewers, because such images were conducive to the shaping of cultural idioms and horizons of expectations. On a bell *krater* attributed to the Danae Painter and dated to *c.* 460–450 BC, the image on the obverse is framed by two columns pointing to a domestic space (Fig. 35a).[430] Although the Metropolitan Museum's descriptive label for

[429] Würzburg, Martin von Wagner Museum 521; *ARV* 1046.7; *Add.* 320. The reverse depicts draped youths.
[430] New York, Metropolitan Museum 23.160.80; *ARV* 1075.10, 1703; *Add.* 326.

Figure 33. Red-figure bell *krater*: obverse, four women, one seated with lyre, two standing with lyres, one with book roll. In the manner of the Kleophon Painter, *c.* 420 BC. Once Nocera, Fienga, no inv. no. Photo, Alexandra Goulaki Voutira.

Figure 34. Red-figure *kalyx-krater*: seated woman with *barbitos*, two standing women, Eros flying above. Attributed to the Christie Painter, *c.* 440–430 BC. Würzburg, Martin von Wagner Museum, inv. no. 521. Photo, K. Oehrlein, Martin von Wagner Museum der Universität Würzburg.

Figure 35a. Red-figure bell *krater*, obverse three women, one seated with *barbitos*. Attributed to the Danae Painter, *c.* 460–450 BC. New York, Metropolitan Museum, Rogers Fund, 1923, inv. no. 23.160.80. Photo © The Metropolitan Museum of Art.

this vase indicates that the seated woman musician on the right may be Sappho—or that it has been maintained that the three women might be Muses—I have suggested in Chapter Two that this archaeological paradigm is based on a hardly substantiated but widely endorsed theory that should be considered far from certain or attractive. The seated musician on the right strikes her *barbitos* with a *plêktron* while on the left two other women observe the performer intensely. This aspect of spectatorship is exploited in a large number of archaic and classical vase-paintings, thus suggesting and reflecting ways of ancient viewing. But here, if the painter's drawing of the eyes of the female figure standing in front of the seated figure does not deceive us, the intensity is pronounced.[431] The Metropolitan Museum's description sees in this repre-

[431] For contemporary male spectators, see the bell *krater* New York, Metropolitan Museum 21.88.73; *ARV* 1029.20, 1602; *Add.* 317 (Matheson 1995:pl. 47). The spectators often frame an image. Here, not unlike the cases considered in pp. 146–149, 153–154, and above, p. 272, the spectator stands across from the main performative event; he holds a staff behind a seated bearded man and

sentation "an intimacy that is exceptional in Greek vase-painting," and this idea has led scholars to detect "signs of a connection between music and female [same-sex] desire."[432] Rather, it is the notion of focused spectatorship that may have been conveyed through the gaze of the woman. The gaze of the second standing woman is more reflective as she places her chin and hands on the right shoulder of the other. The seated musician's face is drawn in three-quarter view. Although not entirely triangular, the perspective of the gaze of the three women is highly complex. On the reverse, we see three standing women, one of whom, motionless, is fully wrapped in her mantle and looking at the others (Fig. 35b).

The image on the obverse of this bell *krater* is not exceptional in its focus on intense female spectatorship in the context of a musical performance. A *kalyx-krater* attributed to the Niobid Painter and dated to about 460 BC displays a comparable manner of gaze.[433] On the obverse, we see a female figure holding reed pipes in both hands and seated on a rock, indicating an outdoor setting; a *chelys* lyre hangs in the field above her head. In a position similar to that of the two women on the bell *krater* in the Metropolitan Museum in New York, the two female figures here stand in front of, and gaze at, the seated musician, who does not perform. Next to the second young woman, who embraces the other, is a *klismos*, suggesting a domestic context. On the reverse, the Niobid Painter added a related representation of two female figures standing opposite each other. One of them plays the *aulos* while the other holds a *chelys* lyre near an open chest.[434] Further, around the body of a pointed *amphoriskos*—attributed to the Heimarmene Painter and dated to *c.* 430 BC—an intricate scene of the Helen myth unfolds: nine painted figures, among which Aphrodite with [Helen] on her lap stands out.[435] Not far from them, Himeros leans on

---

makes a hand gesture. As in the case of the *kitharôidos* discussed in Chapter Two, pp. 91–93, the *kitharôidos* here is young and his clothing elaborate. This image, attributed to Polygnotos and dated to *c.* 450–440 BC, is the obverse of the vase; the reverse shows three draped youths. Behind the *kitharôidos'* head occurs the inscription καλος, while near the standing spectator's face Beazley read Νικομα<χο>ς κ<α>λος (Νικομας κ<α>λος). Note that the first καλος is near the face of the standing bearded man on the left. I suggest that καλος could sometimes be read as καλῶς by ancient contemporary viewers: cf. red-figure amphora Paris, Musée du Louvre G 213 (*ARV* 309.4; Schefold and Jung 1989:216, fig. 191), attributed to the Tithonos Painter; red-figure *kalathos-psykter* Munich, Antikensammlungen 2416 (*ARV* 385.228, 1573, and 1649; *Add.* 228; see Chapter Two, p. 76); red-figure *oinochoe* Cambridge, Mass., Harvard University, Sackler Museum 1960.354 (for an attribution, see Chapter Two, p. 71).

[432] Rabinowitz 2002:117.

[433] London, British Museum E 461; *ARV* 601.20; Kauffmann-Samara 1997:289, fig. 7; Vazaki 2003:247, figs. 41–42 (sides A and B). For a discussion of the obverse of this *kalyx-krater*, see Kauffmann-Samara 1997:290.

[434] See Chapter Two, p. 151.

[435] Berlin, Antikensammlung 30036; *ARV* 1173.1; *Add.* 339 (Shapiro 1993:193, figs. 151–154, and

Figure 35b. Red-figure bell *krater*, reverse (*right*): three standing women. Attributed to the Danae Painter, *c.* 460–450 BC. New York, Metropolitan Museum, Rogers Fund, 1923, inv. no. 23.160.80. Photo © The Metropolitan Museum of Art.

the naked [Paris] and reenacts the rhetorical power that Aphrodite exercises over [Helen]. Next to [Paris], two young female figures, one with a bird on her fingers, stand opposite each other. To the right of the seated Aphrodite stands a woman named ΠΕ[Ι]Θ[Ω] (Persuasion). Finally, in front of her, two young women gaze intensely at the [whole] scene.[436] The woman on the left embraces and leans on the other and has her right hand outstretched, pointing to the "performance" of the myth.[437]

The two representations of female musical gatherings considered here adumbrate the ways in which Sappho's images in songs like frs. 21 and 22 V

---

228, fig. 186). For the inscriptions on the *amphoriskos*, see Lezzi-Hafter 1988:346, no. 251 (Lezzi-Hafter provides the date 430–425 BC); compare the drawing in Boardman 1989:fig. 308, where the names provided by the inscriptions are indicated (how accurately I cannot tell).

[436] For representations of two women of whom one leans on the shoulder of the other, see Speier 1932:9–12.

[437] Around the shoulder of the *amphoriskos* there are two Erotes, who confirm, as it were, the aspects of *erôs* highlighted on the main image.

could be—or were— scanned by both male and female Athenian viewers in the fifth century. Each community must have laid stress on different aspects of the "intimacy" shown between women. Such an intimacy would be difficult to label "sensual" or "erotic," from a modern scholarly perspective. Except for the multilayered and elusive case of the original context of the songs of Sappho, we lack unambiguous and non-"literary" female sources about the manner in which women friends interacted with each other in domestic, non-ritual female gatherings in the archaic or the classical period. We may infer, in the absence of marked visual signs or textual counterindications, that such visual representations conveyed a sense of companionship often observable among women in present-day Mediterranean Europe. However, if compositions like Sappho fragment 22 V were performed in the context of a male *symposion*—especially since their thematic resilience could be easily accommodated in such a venue—any reference to female intimacy, familiar also from a large number of vase-paintings, was subject, I suggest, to a male scanning and understanding in the light of the marked discursive idioms about Lesbos and Ionia as well as about Lesbian and Ionian women, music, songs, and the instruments employed by them. The doublelayered semantic fluidity of other songs by Sappho should have further contributed to different male scannings.

I argue that the three discursive practices detected and explored so far—or rather an amalgamation of them through metonymic mappings and sets of signification—led at the earliest and most decisive stages of the receptorial dynamics related to the figure of Sappho to negotiations of its original semantic specificity and to a representational, textual or visual, plasticity that accommodated all the *aspects* of the later shapings of her poetry and figure: a pronounced focus on wedding and ritual imagery; a symposiastic "translation" that ranged from the *hetaira* schema to more pederastic and even female homoerotic contexts; and a more neutral configuration that placed emphasis on domestic and ritual gatherings of women. At the same time, the earliest stages marked the process of, and might have contributed to, the textual transmission of Sappho's songs until their editorial reception by the Alexandrian scholars in the third and second centuries BC.[438] The anthropological herme-

---

[438] For the Alexandrian receptorial activities related to the poetry of Sappho, see Yatromanolakis 1999a. The publication of three early Ptolemaic papyrus fragments of poems of Sappho (Gronewald and Daniel 2004a, 2004b, and 2005) and their juxtaposition with a fragment of a song that does not seem to belong to Sappho support the ideas advanced in Yatromanolakis 1999a:180 and n5, and 191. Cf. P.Oxy. X. 1232 and Hunt's comments on col. iii, fr. 1, line 8: "That the number of the book was added is not very likely; and hence the possibility remains that the roll contained a selection from Sappho's works and that a poem in different metre preceded the *Marriage of Andromache*" [i.e., fr. 44 V] (Hunt 1914b:50 and cf. Hunt 1914b:45). For further analysis, see Yatromanolakis 2007a. For S286 *SLG* (P.Mich. inv. 3498ʳ), see Chapter Four, p. 360.

neutics advanced here does not point to an evolutionary conceptualization of the reception of Sappho. Instead, it unpacks the multileveled synchronic dynamics of late archaic and classical receptorial textures and highlights the *interdiscursivity* of related practices.[439] These dynamics articulate discourses that we can trace in later, diverse and heterogeneous, regional traditions.

To substantiate these arguments further I shall investigate the semantic, contextual plasticity and doublelayeredness of one of the most extensive fragments:

τεθνάκην δ' ἀδόλως θέλω·
ἄ με ψισδομένα κατελίμπανεν              2
<—>
πόλλα καὶ τόδ' ἔειπέ [μοι·
ὤιμ' ὡς δεῖνα πεπ[όνθ]αμεν,
Ψάπφ', ἦ μάν σ' ἀέκοισ' ἀπυλιμπάνω.       5

τὰν δ' ἔγω τάδ' ἀμειβόμαν·
χαίροισ' ἔρχεο κἄμεθεν
μέμναισ', οἶσθα γὰρ ὥς ‹σ›ε πεδήπομεν·      8

αἰ δὲ μή, ἀλλά σ' ἔγω θέλω
ὄμναισαι [...(.)].[..(.)].ϝαι
ὀσ[  –10–  ] καὶ κάλ' ἐπάσχομεν·          11

πό[λλοις γὰρ στεφάν]οις ἴων
καὶ βρ[όδων ...]κιων τ' ὔμοι
κα..[  –7–  ] πὰρ ἔμοι π‹ε›ρεθήκα‹ο›       14

καὶ πόλλαις ὑπαθύμιδας
πλέκταις ἀμφ' ἀπάλαι δέραι
ἀνθέων ἐ[  –6–  ] πεποημέναις.            17
<—>
καὶ π.....[     ]. μύρωι
βρενθείωι .[     ]ρυ[..]ν
ἐξαλ‹ε›ίψαο κα[ὶ ιβασ. ]ιληίωι            20
<—>
καὶ στρώμν[αν ἐ]πὶ μολθάκαν

---

[439] On the interdiscursivity of ritual patterns of signification and the concept of *texture* examined here, see Yatromanolakis and Roilos 2003; 2005a:15–18. See further Roilos and Yatromanolakis forth.

ἀπάλαν παρ[     ]ο̣γων
ἐξίης πόθο̣[ν    ].νίδων           23
<—>
κωὔτε τις[    οὔ]τε̣ τι
ἶρον οὐδ' ὐ[     ]
ἔπλετ' ὄππ[οθεν ἄμ]μες ἀπέσκομεν,     26
<—>
οὐκ ἄλσος .[       ].ρος
                  ]ψοφος
                  ]…οιδιαι     29

and I honestly wish I were dead.
Weeping she left me
with many tears and said *this*:[440]
Alas, what sufferings have been ours,[441]
Psapph(o), I swear, I leave you against my will.
And these [are the words] I answered her:
Rejoice, go, and
remember me, for you know how we cared for you.
But if not, I shall
remind you…

              …and beautiful times we had.
[For ma]ny [wrea]ths of violets
and [of] roses and…together
     ] by my side you put on,
and many woven garlands
made of flowers
             around your soft neck
and with [ ] flowery
choice unguent with which
you anointed yourself;
and on soft couches

---

[440] That πόλλα καὶ τόδ' ἔειπε can be analyzed differently ("she said much and *this*"), especially in view of the "contrast" between τόδ' in line 3 and τάδ' in line 6, has interesting implications, which space does not allow me to examine (on this issue and the asyndeta in these lines, see Yatromanolakis 2007a).

[441] Carson 2002:185 renders the line in modern English as follows: "Oh how badly things have turned out for us," while West 1993b:42 translates: "Oh, it's too bad! How unlucky we are!" It is admittedly difficult to render the meaning of the ancient Greek here. A Cretan song (that I recorded during fieldwork in the summer of 1999) includes the phrasing "τί δεινά ἐπάθαμε," which captures the sense more succinctly.

[of?] tender [    ]
you satisfied your longing.
And neither any [  no]r any
holy [space] nor [   ]
was there from which we were absent,
nor grove [     d]ance
                ]sound
                ]…oidiai

Along with fragment 96 V, preserved on the same sixth/seventh-century AD parchment,[442] Sappho fragment 94 V[443] presents problems closely related to the methodological and ethnographic concerns of linguistic anthropology. How to render πεδήπομεν ("pursue," "follow after," "look after," or "cherish," as in LSJ?) in line 8, or the plural number of πεδήπομεν? Citing a scholium on *Iliad* 13. 257 that suggests that the use of first person plural verb instead of the first person singular is characteristic of Aeolic, Blass argued that behind this first person plural is the persona of Sappho.[444] The scholium reads (Erbse III, p. 448): κατεάξαμεν ὃ πρὶν ἔχεσκον] πληθυντικῷ ἑνικὸν ἐπήγαγεν Αἰολικῶς. Αἰολικῶς appears only in the manuscripts grouped as b and is omitted by A and T. Although the evidence may not appear compelling,[445] Blass's argument needs more wide-ranging investigation. If one attempts to view it in a reconstructed original sociocultural context or especially in terms of fifth-century Athenian idioms, the sense of πεδήπομεν may again throw some light on the immanent doublelayeredness of Sappho's discourse for late archaic and classical Greek societies.

My focus here is on the recollections that "Psappho" conjures up in the dialogic utterances exploited in the song. I have argued elsewhere that these

[442] For the date, cf. the discussion in Cavallo and Maehler 1987:86 ("second half of vi").

[443] The fragment has been preserved in P.Berol. 9722, initially edited by W. Schubart with the assistance of U. von Wilamowitz-Moellendorff in 1902 (Schubart 1902:195–197), and republished by Schubart in 1907 in the *Berliner Klassikertexte* (Heft 5, Zweite Hälfte; Schubart 1907:12–14). The end of the fragment (18–29) was published again in a more complete form, due to the discovery of an additional piece in the Berlin Aegyptisches Museum (on the Museumsinsel) by Lobel (1925:79). Zuntz reedited fragment 94 in 1939 (Zuntz 1939:83–92). The same parchment also contains fragments 95 and 96 V and some other smaller but highly interesting scraps. These fragments have been placed by modern editors in the fifth book of the Alexandrian edition of Sappho's songs on the basis of their metrical similarity to Sappho fragment 101 V, which, according to Athenaios 9.410d–f, was included ἐν τῷ πέμπτῳ τῶν μελῶν.

[444] Blass 1902:468. This passage is also quoted in Bergk [1882] fr. adesp. 54 (see Bergk's comment: "Aeolenses igitur poetae hanc structurae varietatem videntur frequentavisse. nunc exempla desiderantur").

[445] Erbse notes (p. 448 in his apparatus criticus): "neque…inveni hanc figuram usquam Aeolicam appellatam esse." Cf. Sappho fr. 121 V and see further Yatromanolakis 2007a.

recollections are represented in this fragment as snapshots of the past, deprived of specific time—a kind of ritual time.[446] What is pertinent to the present discussion is that by standards of fifth-century dominant Athenian contextual frames for which we have secure informants, the song reenacts a ritualized sequence of male symposiastic discursive modalities. The phrase πὰρ ἔμοι in line 14 points to the physical contiguity between "Psappho" and the departing female figure rather than to a specific space (the occasionally entertained idea that "at my house" is implied here, based rather on linguistic expressions in modern languages). In lines 12–23, where snapshots from a female gathering are envisaged, the subject of "Psappho" is nowhere so emphasized as in line 14. The snapshots trace the agency of the departing female figure, and only in line 26 does "Psappho" reappear by means of the plural ἀπέσκομεν. After πὰρ ἔμοι she remains alone and acts without the interference of others in the presence of passive figures (lines 14 and perhaps 23). The singular and plural are metonymically intermingled in the fragment. After the so-called climax of her actions (lines 21–23), ἀπέσκομεν may place her and "Psappho" in a broader circle of people (as possibly is the case with πεδήπομεν), but this is not certain. As the fragment stands, each of the first three stanzas of snapshots seems to be introduced with the adjective πόλυς,[447] and, if so, this reiteration is conducive to the abstractness and timelessness of the description.

Each snapshot progressively represents a different stage in sympotic rituals. The wreaths in the first snapshot appear in many of the visual representations of female gatherings but also on Attic black-figure paintings of the second half of the sixth century, in the so-called "courtship scenes" where, among the gifts of the lovers to their beloveds, garlands are often included. Garlands were deemed the sign par excellence for the beginning of a *symposion*.[448] I have already made mention of the ὑπαθύμιδες of the second snapshot and the indigenous use of the word by the Aeolians and the Ionians.[449] Encircling the neck of komasts and symposiasts, ὑποθυμίδες also adorn their chests in related sympotic scenes on vase-paintings. According to Athenaios, the ὑποθυμίδες gave out a pleasant, seductive smell as their name suggests (ἀπὸ τῆς τῶν ἀνθῶν ἀναθυμιάσεως).[450] Like the unguents of the third snapshot, they were a means of erotic provocation. Further, perfumed oils were widely

[446] Yatromanolakis 2003a:57.
[447] For line 19 see Voigt's apparatus criticus. Although in line 12 the supplement πό[λλοις is not absolutely certain, πό.λλαις in line 15 is safe, given that it is attested by Athenaios 15.674d.
[448] Cf. Blech 1982:64–72.
[449] See above in this chapter, p. 218.
[450] Athenaios 15.688c. Cf. 15.669c–d.

used in sympotic contexts, after or along with the wearing of garlands.[451] More specifically, the discursive connotations of μύρωι βρενθείωι in lines 18–19, an intriguing kind of unguent but unremarked by commentators, can be elucidated by a tragic fragment that labels βρένθειον as Lydian (κεχριμένη[ν οἶ]μαί σε β[ακκάρει ⏑–] | ἢ Λυδικὸν β[ρ]ένθει[ο]ν...), in a context where a female figure is involved.[452] References of Alkaios and Sappho to (often luxurious) things Eastern and Western are not necessary to be discussed here.[453] The pouring of fragrant oils on—or the anointing with scented ointments of—the head and the chest of symposiasts was a standard practice. And men reclining on couches, in the company of youths or female companions and entertainers, was for many a climactic feature of a drinking-party.[454]

To conclude, the performative contextual discourses embedded in the song can help us redefine the conditions of the reception and transmission of Sappho's poetry especially during the late archaic and classical periods. And in a similar receptorial context, Sappho fragment 92 V should, I believe, also be placed. Although badly mutilated, this song too presents contextualization cues that could have contributed to such a scanning:

```
[
[
πε[
κρ[.........]περ[
πέπλον[...]πυσχ[            5
καὶ κλε[..]σαω[
κροκοεντα[
πέπλον πορφυ[ρ........]δεξω[.]
χλαιναι περσ[
στέφανοι περ[              10
καλ[.]οσσαμ[
```

---

[451] On perfumed unguents and Sappho fr. 94.18–20 V, see Yatromanolakis 2007a. For references to unguents in archaic literature, see Lilja 1972:58–64 and Grillet 1975:90–92. In Greece they were produced already in Mycenaean period (cf. the word a-re-<pa> found in tablets from Pylos; see Jorro 1985/1993, s.v., and Probonas 1978, s.vv. ἄλειφαρ, ἄλειφα, and ἀλείφω).

[452] *Fragmentum adespotum* 656. 30–1 *TrGF*. See the annotations and apparatus criticus in *fragmentum adespotum* 656 *TrGF* (also for the possible situational context of line 27; cf. line 35 ἐν τάπητι Σαρδ[ιανικῶι]).

[453] For Alkaios, see especially fragment 322 V, with a reference to wine drops flying from Teian cups, and test. 462 V (Δικαίαρχος ὁ Μεσσήνιος, Ἀριστοτέλους μαθητής, ἐν τῷ Περὶ Ἀλκαίου καὶ τὴν λατάγην φησὶν εἶναι Σικελικὸν ὄνομα [Dikaiarkhos fr. 95 Wehrli] καὶ ὅτι δὲ ἐσπούδαστο παρὰ τοῖς Σικελιώταις ὁ κότταβος δῆλον ἐκ τοῦ καὶ οἰκήματα ἐπιτήδεια τῇ παιδιᾷ κατασκευάζεσθαι, ὡς ἱστορεῖ Δικαίαρχος ἐν τῷ Περὶ Ἀλκαίου [Dikaiarkhos fr. 94 Wehrli]).

[454] For the fourth snapshot of lines 21–23, see Yatromanolakis 2007a.

φρυ[
πορφ[υρ
τ̣α̣π̣α̣[
[                                          15
π[

robe                              5
and
saffron-colored
purple robe
cloak(s) Pers[ian?]
garlands                          10
[beauty ?]
Phry[gian?][455]
purple
[rugs?][456]

Within this anthropological hermeneutics and in the light of the discussion about the doublelayered semantic fluidity of the word *hetaira*, a further discursive idiom might be investigated.

Propping himself on his elbow on a symposiastic *klinê* in Agathon's house, the comic poet Aristophanes, in the narrative of Plato's *Symposion*, advances an imaginative theory about the "ancient," primordial nature of the sexes (γένη) and the involvement of Eros in their development.[457] Once upon a time human beings were two-bodied, and the sexes represented three combinations: male-male, female-female, and male-female (ἀνδρόγυνον). Because of their arrogance toward the gods, they were by Zeus' will split into halves, in order to become weaker and more numerous. When this bodily split was achieved, the population was soon threatened with extinction; desiring their other half, each person entwined his/her hands round the other half's body and eventually died of famine and inertia. But by the intervention of merciful Zeus, the human race was saved. For all that, each human being's desire for its other half did not cease to spur it on to search for what it had lost.[458] Since then, people strive to be united with their other halves and reach their pri-

---

[455] The capitalized P here and in line 9 [Persian] is not certain. For these two supplements, see Schubart 1907.
[456] Cf. above, n. 452, and see Bakkhylides fr. 21.2 Maehler (οὔτε πορφύρεοι τάπητες), the latter parallel adduced by Crusius 1907:1309 and Voigt (1971:102, in her apparatus criticus on fr. 92).
[457] *Symposion* 189c2–193d5.
[458] *Symposion* 191d5: ζητεῖ δὴ ἀεὶ τὸ αὑτοῦ ἕκαστος σύμβολον.

mordial wholeness.[459] The power that forces and encourages them to do so is Eros.

Aristophanes' speech is highly pertinent to an exploration of Sappho's songs in their receptorial contexts, where *erôs* in its broadest sense was a prevalent aspect. It is also in this speech that we first encounter the notion of female homoeroticism.[460] Aristophanes' explanation of this species of "sexual" orientation is clear: ὅσαι δὲ τῶν γυναικῶν γυναικὸς τμῆμά εἰσιν, οὐ πάνυ αὗται τοῖς ἀνδράσι τὸν νοῦν προσέχουσιν, ἀλλὰ μᾶλλον πρὸς τὰς γυναῖκας τετραμμέναι εἰσί, καὶ αἱ ἑταιρίστριαι ἐκ τούτου τοῦ γένους γίγνονται (191e.2–5). The syntactical construction employed here (οὐ πάνυ […] ἀλλὰ μᾶλλον…) is not without importance but has remained underexplored. In the case of the other two sexes that Aristophanes mentions in this context[461]—that is, those who are φιλογύναικες (ἄνδρες) or φίλανδροι (γυναῖκες) and those (men) who τὰ ἄρρενα διώκουσι—sexual orientation is generally clear-cut and well defined. However, as Plato presents it, female same-sex nature is not characterized by exclusiveness in its potential realizations. It seems plausible to argue that this view did not diverge greatly from that of a number of male educated Athenians in the classical period—especially those familiar with and sympathetic to Plato's work—and, if so, related social constraints were implicitly but effectively imposed on Athenian women inclined to have other than heterosexual desires.[462] However, for some of those well known to have had indulged in female homoeroticism, the label *hetaira* might have been considered particularly apt.

Although Athenian informants of the classical period (or rather the surviving texts of contemporary, fifth-century literature) do not provide any sources pointing to a metonymic association of *hetairistria* and *hetaira*,[463]

[459] *Symposion* 192d10–193a1: τοῦ ὅλου οὖν τῇ ἐπιθυμίᾳ καὶ διώξει ἔρως ὄνομα.
[460] Cf. Chapter Five, n. 3.
[461] *Symposion* 191d6–192b3.
[462] Cf. the conditions of the homosexual men, as depicted in Aristophanes' speech (*Symposion* 192a7–b2): ἐπειδὰν…ἀνδρωθῶσι, παιδεραστοῦσι καὶ πρὸς γάμους καὶ παιδοποιίας οὐ προσέχουσι τὸν νοῦν φύσει, ἀλλ᾽ ὑπὸ τοῦ νόμου ἀναγκάζονται (my emphasis).
[463] In her insightful study, Politou-Marmarinou 1982:20 [226] stresses the significance of semantic contiguity based on similarity in sound; she aptly cites Levi-Strauss's argument that "les mots sont contaminés par leurs homophones en dépit des différences de sens." On ἑταιρίστρια and ἑταίρα, cf. the much later sources in Hesykhios s.v. διεταρίστριαι and Photios s.v. ἑταιρίστριαι. See also the inventive and rather obscene depiction of the sexual activities of ἑταιρίστριαι in Lesbos by Loukianos, who envisages the sexual behavior of a certain Lesbian Megilla, τὴν Λεσβίαν Μέγιλλαν τὴν πλουσίαν, as highly masculine (*Dialogues of Courtesans* 5.2): πότον τινὰ συγκροτοῦσα αὐτή τε καὶ Δημώνασσα ἡ Κορινθία, πλουσία δὲ καὶ αὐτὴ καὶ ὁμότεχνος οὖσα τῇ Μεγίλλῃ, παρειλήφει με κιθαρίζειν αὐταῖς· ἐπεὶ δὲ ἐκιθάρισα καὶ ἀωρία ἦν καὶ ἔδει

such a semantic contiguity, especially in the context of the diverse discursive idioms investigated in this chapter, would possibly add to a sympotic reception of a woman poet's songs about *hetairai* and "intimacy" between them.[464] Cultural metonymies in the case of Sappho formed from the earliest stages of her reception a dynamic modality that assimilated and shaped marked webs of signification.

---

καθεύδειν... Ἄγε δή, ἔφη, ὦ Λέαινα, ἡ Μέγιλλα, κοιμᾶσθαι γὰρ ἤδη καλόν (...) Ἐφίλουν με τὸ πρῶτον ὥσπερ οἱ ἄνδρες, οὐκ αὐτὸ μόνον προσαρμόζουσαι τὰ χείλη, ἀλλ' ὑπανοίγουσαι τὸ στόμα, καὶ περιέβαλλον καὶ τοὺς μαστοὺς ἔθλιβον (...). It is worth observing that in *Dialogues of Courtesans* 5. 1, the reading Λεσβίαν in the first sentence of the dialogue is provided by codex A, while codices γ, L, and Ψ (for the sigla see Macleod's critical edition) transmit ἀσεβῆ. On the use of vulgar forms in the *Dialogues of Courtesans*, see Deferrari 1969:80–81. The names of the two masculine lesbians, Megilla and Demonassa, recall Sappho's Gongyla and Arkheanassa; and the description that follows the entertainment with the *kithara*-playing (...καὶ ἀωρία ἦν καὶ ἔδει καθεύδειν) is perhaps reminiscent of Sappho fr. 168 B V (lines 3–4 ...παρὰ δ' ἔρχετ' ὥρα, ἔγω δὲ μόνα κατεύδω). However, I suggest that Loukianos here combines allusions to the by then current image of Sappho as a ἑταίρα and ἑταιρίστρια, the rumors about the immorality of Lesbian women (see Loukianos *Pseudologistês* 28), and, more importantly, certain social constructs that viewed lesbian women as masculine (cf. [Loukianos] *Erôtes* 28). Note that in the *Dialogues of Courtesans* 5.2, Klonarion claims the following about Lesbos: τοιαύτας γὰρ ἐν Λέσβῳ λέγουσι γυναῖκας ἀρρενωπούς, ὑπ' ἀνδρῶν μὲν οὐκ ἐθελούσας αὐτὸ πάσχειν, γυναιξὶ δὲ αὐτὰς πλησιαζούσας ὥσπερ ἄνδρας. On this dialogue in the context of other *hetairikoi dialogoi*, see Yatromanolakis 2007a.

[464] On fragments related to "intimacy"—whatever the original denotation of this concept might have been—see above, pp. 245–262, 277–283.

# 4

## Traditions in Flux

It is thanks to them
that I live in three dimensions,
in a space non-lyrical and non-rhetorical,
with a horizon real because movable.

They themselves do not know
how much they bring in empty hands.

"I owe them nothing,"
love would say
on this open question.

—Wisława Szymborska, from *Gratitude*
(trans. M. J. Krynski and R. A. Maguire)

I N THE PREVIOUS CHAPTERS, I explored the complexities of the discursive
practices and socioaesthetic idioms that shaped the receptorial filters
through which archaic melic poets, most notably Sappho, and their songs
were assimilated into different cultural economies of late archaic and classical
Greece. In this chapter, I focus on a number of underexplored fifth-century
and later informants who suggest intricate synchronic reactivation of aspects
of Sappho's figure and poetry in symposiastic contexts, and, more often than
not, in connection with forms of marked eroticism. How did the discursive
inflections and practices investigated in previous chapters condition the
performative trafficability of the songs and the figure of Sappho in the late
classical and early Hellenistic periods?

## Reception as Reenacted "Script"

In a study of the *reception* of a song-maker as *reenacted and reflected* in performa-
tive mediums like theater, performance—as a sociocultural form of agency—
should not be approached only in terms of a reflective practice but also, or

sometimes mainly, in terms of a reflexive macro- and micro-configuration of metonymic webs of signification. As has been argued, the double role of participants in a performative event "entails both their ontological involvement in the enacted 'script' and an epistemological distancing from the performed spectacle that invests their actions with a certain and varying, from occasion to occasion, reflexivity."[1] Such dynamic reflexivity informs also the activation of *mythopraxis* in the fragmentary theatrical and other discourses that will be examined in this section.[2] When Sappho is metonymically associated in ancient performative mediums with canonical and especially noncanonical figures, forms, and practices, the result is the activation of both reflective and reflexive discursive idioms on the part of a writer and his audiences—idioms that had a powerful impact on later representations, based in turn on renewed agency.

In the first half of the fifth century or possibly slightly later, one of the earliest Attic playwrights, Khionides, composed the *Beggars*, from which four fragments survive. In the first of those fragments,[3] a character seems to be reflecting on the sweetness or lack of sweetness of some unspecified objects. Significantly, the markedly sensual music of two poets is foregrounded as the absolute paragon of sugariness:

> ταῦτ' οὐ μὰ Δία Γνήσιππος οὐδ' ὁ Κλεομένης
> ἐν ἐννέ' ἂν χορδαῖς κατεγλυκάνατο

> these, by Zeus, neither Gnesippos nor Kleomenes
> could sweeten with nine strings.

Two other fragments refer to the possible consumption of (inexpensive) saltfish and to the habit of the Athenians (when they hold a meal in honor of the Dioskouroi in the *prutaneion*) to set upon the tables cheese and cakes made of coarse meal and wine, as well as ripe olives and leeks, as a reminder

[1] Yatromanolakis and Roilos 2003:16; cf. 2003:19.
[2] On *mythopraxis*, see the methodological Problematik formulated in Chapter One.
[3] According to Aristotle *Poetics* 1448a.33–34, Khionides and Magnes were the two earliest Athenian comic poets. The *Beggars* is attributed to Khionides by the Suda (see Khionides testimonium 1 in Kassel and Austin's edition), but Athenaios, who quotes all four fragments (Khionides frs. 4–7 K-A), casts doubt on its authenticity (14.638d and 4.137e = Khionides frs. 4 and 7 K-A). Dating fragmentary plays of comic poets is a notoriously precarious enterprise. According to the Suda s.v. Χιωνίδης (and modern scholars, see Khionides testimonium 1 K-A, with discussion in the apparatus criticus), Khionides was probably the first of the poets-victors at the City Dionysia in 486 BC (διδάσκειν δὲ ἔτεσιν ὀκτὼ πρὸ τῶν Περσικῶν; cf. Pickard-Cambridge 1988:132). For the dating of the work of the so-called old comic (mainly fifth-century) poets, see Geissler's important book (1969). For the problems and ideologies reflected in "Old," "Middle," and "New" comedy as ancient terms, see Nesselrath 2000, Sidwell 2000, and Csapo 2000.

of the ancient lifestyle.[4] Given the title and the remains of the play, banquets for beggars and the poor could have been envisaged or experienced on the Athenian stage during the performance of this play but any outline of the plot would be considerably speculative. Even if one questioned the attribution of the *Beggars* to Khionides,[5] it would not affect the present investigation. I have already considered the lascivious songs assigned to the figure of Gnesippos, the *paigniagraphos tês hilaras mousês,*[6] by fifth-century informants. Here he is juxtaposed with another musical figure—Kleomenes—and possibly associated with musical tendencies attributed to Phrynis.[7]

For Kleomenes little information exists on which to rely.[8] However, an early- or mid-fourth-century play about courtesans, *Antilais* by Epikrates, sheds some light on the socioaesthetic associations of Kleomenes' song-making. In this comedy, in which *aulêtrides* and their preferable musical *nomoi* in the context of drinking-parties and related affairs were discussed,[9] Epikrates presents a character who places emphasis on, or brags about, musical/poetic expertise in songs elsewhere connected with *symposia:*[10]

τἀρωτίκ' ἐκμεμάθηκα ταῦτα παντελῶς
Σαπφοῦς, Μελήτου, Κλεομένους, Λαμυνθίου

the *erôtika* songs I have learned thoroughly,
those of Sappho, Meletos, Kleomenes, Lamynthios.

Lais in Epikrates' *Antilais* was allegorically represented as a predatory eagle, when young, and as a *teras,* acting as portent, when old and wrinkled.[11] A famous late fifth-century *hetaira,* mentioned by the early middle-comic play-

---

[4] Khionides frs. 5 and 7 K-A.

[5] Athenaios questions the authorship of numerous comedies; his doubts are not confined to *Beggars.* Kassel and Austin include the fragments in the works of Khionides.

[6] See Chapter Three, pp. 229–231. Athenaios 14.638d: literally, "the writer of playful and cheerful songs," with connotations of lustfulness.

[7] Kleomenes fr. 838 *PMG.* In the ancient scholia on Aristophanes *Clouds,* Kleomenes is mentioned along with Kinesias and Philoxenos, in the context of *kuklioi khoroi.* On Phrynis, see, concisely, Neubecker 1994 [1977]:45–46. On Philoxenos, among other sources, see Antiphanes fr. 207 K-A. On Kinesias and Philoxenos, cf. also Barker 1984:94–95.

[8] The sources in Kleomenes fr. 838 *PMG* could not perhaps refer to the same musician but, in the absence of counterindications, we may want to associate the few sources we have with Kleomenes of Rhegion, the melic poet.

[9] Epikrates fr. 2 K-A, where a character claims that the *nomoi* of Apollo and Zeus are performed by all *aulos*-girls, but the girls referred to in this fragment perform only the Hawk's *nomos* (Hierax, according to a tradition, was an *aulos*-player who died young and who was Olympos' household slave, student, and beloved; Poludeukes 4.78ff. Bethe). For Olympos, see Chapter Three. For visual representations of *aulos*-girls, see Peschel 1987:figs. 189–244.

[10] Epikrates fr. 4 K-A.

[11] Epikrates fr. 3 K-A.

wright Philetairos as "having died while being fucked,"[12] Lais was thought of as being erotically associated with the philosophers Aristippos and Diogenes and even with the painter Apelles; the latter, gazing at her beauty, fell in love with her while she (still a virgin) carried water from the spring of Peirene in Korinthos; and Apelles soon requested her, though not a professional courtesan, to accompany him to a *symposion* that his *hetairoi* had prepared.[13] Interestingly, it was said about Lais that Aphrodite *Melainis* of Korinthos used to appear to her by night as the goddess of the dark and to give her signs about near-future affluent lovers[14]—an idea that would provide certain receptorial filters to those listening either to Sappho fragment 134 V (❋ Zὰ <.> ἐλεξάμαν ὄναρ Κυπρογενηα, "I conversed with you in a dream, Kypronegeia" or "I spoke in a dream with Kyprogeneia") in the context of the recurrent assimilation of the poetic "I" of Psappho into the speaking voice of Aphrodite, or to fragment 101 V, where the singing voice addresses Aphrodite:[15]

(πρὸς τὴν Ἀφροδίτην)
χερρόμακτρα δὲ †καγγόνωντ†
πορφύραι †καταυταμενά-[16]
τατιμάσεις† ἔπεμψ' ἀπὺ Φωκάας
δῶρα τίμια †καγγόνωντ†

handcloths...
purple...[fine?, perfumed?, floating with the breeze?]
...[she?] sent from Phokaia,
prized gifts...[17]

---

[12] Philetairos fr. 9.4 K-A. For Philetairos and his association with Aristophanes, see Chapter Three, n. 365.

[13] Athenaios 13.588c–d. For Lais, see Athenaios 13.588c–589b. She was considered by some as Korinthian (because she traveled to Korinthos), but others argued that she was from the Sicilian town of Hykkara.

[14] Athenaios 13.588c.

[15] Cf. fragments 1 and 63V.

[16] I would not be too reluctant to take into account here (at least in the context of an apparatus criticus) Ahrens's πόρφυρα (πορφύρα?) and Maas's καταΰτμενα (see Voigt's annotation "πόρφυρα...fort. recte, cf. S. 44.9," that is,...κάμματα | πορφύρ[α] καταΰτ[με]να), despite Page's doubts (1955:69 and 80). Unlike Voigt's text-critical sagacity, Lobel and Page (1955:83) were unnecessarily frugal in not referring to these restorations in their apparatus criticus.

[17] In line 3, Wilamowitz detected a reference to a certain Mnasis and emended the corrupt τατιμάσεις into τά τοι Μ<ν>ᾶσις (see Voigt's apparatus criticus); cf. fragment 82a V, where Μνασιδίκα, provided by the majority of the indirect sources that quote the fragment, was rendered as Μναΐς in one of those sources and was conjecturally emended as a form of Μνᾶσις by Bergk in 1867, followed by Lobel 1925 (cf. Lobel and Page 1955:57, who do not refer to Bergk 1867) and Theander 1943:154n1; see also Sappho fr. 81.4 V. As for line 4, Gallavotti 1962 speculated that †καγγόνωντ† represents Μαόνων ("of the Ionians"?).

Even so, in the *Antilais*, the juxtaposition of Sappho with the three "noncanonical" male poets suggests that Epikrates would classify her love songs with theirs—that is, the content of her songs would not prevent them from being considered purely and simply as *erôtika*, without any further contextual qualifications.[18] In principle, a love song by a male poet like Meletos could have been either pederastic in its perspective or addressed and referring to a seductive young woman or beloved.[19] It should be recalled here that the elusive figure of Meletos was known for his erotic *skolia* in the late fifth century.[20] For the fifth-century poet Lamynthios of Miletos, we hear that he composed an erotic *melos* called *Lydê*—a song that, like the late fifth/early fourth-century Kolophonian poet Antimakhos' *Lydê*, was about or addressed to his beloved *hetaira*, "the barbarian Lydê."[21] Therefore, the *erôtika* of Sappho, placed by Epikrates in the same cultural category as those of male poets, would have been conveniently assimilated in the socioaesthetic paradigm of pederastic poetry or otherwise marked erotic song culture.

A different fourth-century narrative in the second book of the *Erôtika* by Klearkhos, a learned student of Aristotle with a pronounced zeal for stories about the inhabitants of Eastern lands, suggested that the *erôtika aismata* (τὰ ἐρωτικὰ ᾄσματα) and the so-called Lokrian songs were no different from the compositions of Anakreon and Sappho.[22] From the vantage point of the reception of Sappho, it is significant that the Lokrian songs were held to be adulterous (μοιχικαί) in plot and perspective. Athenaios preserves one of them and claims that once in Phoinike, one could hear this type of popular song performed at every street and corner:[23]

[18] *Ta erôtika* may also be construed here as "the erotic ways of…" or "the erotic manners of…," in the sense of the erotic ideas, practices, or intensity displayed in the compositions of these poets. Certainly *ta erôtika* cannot mean "the erotic affairs" in this context, given the available sources about both Kleomenes and Meletos.

[19] As I argued in Chapter Two, such a connection between Sappho's poetry and male pederastic discourses was exploited in the Bochum *kalyx-krater* and made explicit later by Maximos of Tyros (18.9 Koniaris) and Themistios (*Orations* 13.170d–171a Schenkl-Downey). Cf. P.Oxy. 1800 fr. 1, a papyrus fragment dated to the late second or early third century (Hunt 1922b).

[20] See Aristophanes *Frogs* 1301–1302 [Hall-Geldart] οὗτος δ' ἀπὸ πάντων †μὲν φέρει, πορνιδίων†, | σκολίων Μελήτου, Καρικῶν αὐλημάτων, and cf. Dover's comments (1993:350), who prints οὗτος δ' ἀπὸ πάντων μὲν φέρει, πορνῳδιῶν, | σκολίων Μελήτου, Καρικῶν αὐλημάτων. Dover's hypothesis that "there is, however, a possibility that we should punctuate after σκολίων, thus introducing a deliberate ambiguity (maybe a near-pause but not quite a pause after σκολίων), and thus a swipe at the tragic poet," is perhaps overcautious and unnecessary.

[21] See Lamynthios fr. 839 *PMG* and Klearkhos *Erôtika* fr. 34 Wehrli.

[22] Klearkhos fr. 33 Wehrli.

[23] *Carmen populare* 853 *PMG*. On Lokrian songs, see Gigante 1977b:658–662. On popular songs, see Yatromanolakis 2007b.

291

ὦ τί πάσχεις; μὴ προδῶις ἄμμ', ἱκετεύω·
πρὶν καὶ μολεῖν κεῖνον, ἀνίστω,
μὴ κακόν <σε> μέγα ποιήσηι
 κἀμὲ τὰν δειλάκραν.
ἀμέρα καὶ ἤδη· τὸ φῶς
 διὰ τᾶς θυρίδος οὐκ εἰσορῆις;

Oh, what afflicts and aches you? Don't betray us, I beg you.
Get up before he [my husband] comes,
lest he do great harm to you
 and me, pitiable woman that I am.
The light of day is already come; don't you
 see it through the window?

The affinities of this song with other compositions are multiple and marked: Sappho in fragment 1 V presents Aphrodite asking Psappho, who was afflicted by anguish and pain, "*who* is wronging" her. In a song composed in the so-called Praxilleion meter and assigned to Praxilla of Sikyon—a *melos* possibly included in her *paroinia* or readily assimilated into sympotic *skolia*—we hear the speaking voice addressing a female figure as follows: ὦ διὰ τῶν θυρίδων, "you who look beautifully in through the window, a virgin by your face but a married woman in the lower part of your body."[24] A *skolion* transmitted in the edition of the *paroinia* of Praxilla was also attributed to Sappho and Alkaios.[25] The use of the plural ἄμμ' in line 1 of the Lokrian song that Athenaios transmits can shed some light on the intricate function of plurals and singulars in Sappho. The traditional symposiastic image δάκτυλος ἀμέρα in a song of Alkaios addressed to a companion (ἄϊτα)[26] is reversed in the Lokrian ode—both songs conveying a sense of performative urgency.[27] The question here is not whether this particular Lokrian song is old or not[28]—how can one be certain, in any case?—or whether Klearkhos in this passage had written Ἰωνικὰ ᾄσματα ("Ionic songs") instead of the transmitted ἐρωτικὰ ᾄσματα ("erotic songs") as

[24] Praxilla fr. 754 *PMG*. Carey 2003 thinks that the fragment may represent a wedding song (and he misidentifies Praxilla's fragments as nos. 388–90 *PMG*). For the early classical red-figure cup inscribed with part of this song, see Chapter Three, p. 215.

[25] Cf. Chapter Three, pp. 215–216.

[26] See Lobel 1927:51 (apparatus criticus); Page 1955:307.

[27] Cf. Sappho fr. 43.9 ἄγχι γὰρ ἀμέρα (end of the song, but the context is probably entirely different).

[28] See Bowra 1961:83 "This song is not likely to be old, but it looks as if it came from an ancient tradition…" and "[i]t is popular in nearly every sense and comes from an almost vulgar tradition" (84). Bowra has not been alone in advancing such ideas. He has been followed by numerous scholars; cf. e.g. Dover 1987:107.

Wilamowitz believed,[29] but rather why toward the end of the fourth century Anakreon's and Sappho's songs were so closely compared to Lokrian adulterous poetic idioms. Klearkhos' discussion points to cultural cognitive models and taxonomic discourses comparable to those explored earlier in this book.

In this regard, it is worth observing that in the first book of his *Erôtika*, Klearkhos discusses the case of another popular song, this time purportedly composed by a woman called Eriphanis.[30] This so-called pastoral song (νόμιον) was performed by Eriphanis, the lyric poetess, as Klearkhos claims, after she fell in fiery love with Menalkas during her hunting on mountains. Like the virgin goddess Artemis evoked by the singing "I" in Sappho fragment 44A V, Eriphanis now embarked on an interminable hunt and pursuit (but for different reasons), the result of which was that even utterly unaffectionate people and the wildest animals wept and commiserated with the young woman's predicament. It was then that Eriphanis decided to compose the *nomion*; after completing the composition in her mind, she wandered throughout mountainous waste lands, once again wailing and singing, as if in ritual lament, the refrain: "the oaks are tall, oh Menalkas."[31] The isomorphism of this popular story with the Phaon accounts related to Sappho and Aphrodite reflects, I argue, the dynamic, deep narrative structures lying behind traditions about ardent women song-makers and performers—deep structures that point to marked cultural mechanisms and modes of thought in the late classical and early Hellenistic periods.

## The Paradigm of Comedy

A research paradigm is an analytic practice and theory (or a set of ideas, theories, and analytic processes) based on a synthesis gradually produced by a group of scholars and largely endorsed by a research community. As Thomas Kuhn, who introduced the notion of scientific paradigms as "shared examples" in the history of science and sociology of knowledge, incisively formulated it, "close historical investigation of a given specialty at a given time discloses a set of recurrent and quasi-standard illustrations of various theories in their conceptual, observational, and instrumental applications. These are the

[29] Wilamowitz's emendation of the transmitted text is cited even by such a perceptive critical editor as Wehrli in Klearkhos fr. 33. Did not Anakreon compose Ionic songs?
[30] See, further, the discussion in Chapter Three (pp. 212–213) of the song *Kalykê* performed by ἀρχαῖαι γυναῖκες (Stesikhoros fr. 277 *PMG* = Aristoxenos fr. 89 Wehrli). For Kalykê as mother of Endymion, cf. Hesiod fr. 245 M-W (= Schol. Apollonios Rhodios 4.58, p. 264.8 Wendel). I investigate the significance of *Kalykê* for the case of Sappho in Yatromanolakis 2007a.
[31] Klearkhos fr. 32 Wehrli.

community's paradigms, revealed in its textbooks, lectures, and laboratory exercises."[32]

Among the scholarly paradigms that have dominated discussions of late classical and all later reception of Sappho is the belief that the most decisive stage in her reception was the exploitation of her figure in Attic comedy. This belief is currently deemed a "fact," and diverse aspects of the later reception of Sappho are most often attributed by scholars to the exclusive—as the theory goes—influence of comedy on the shaping of early traditions about her. This approach was developed and widely promoted by Friedrich Gottlieb Welcker in the early nineteenth century.[33] Using Epikharmos fragment 218 K-A νᾶφε καὶ μέμνασ' ἀπιστεῖν ("be warily sober and remember to distrust") as an epigraph to his *Sappho Freed from a Reigning Prejudice (Sappho von einem herrschenden Vorurtheil befreyt)*,[34] Welcker argued that Athenian comedy was responsible for almost all the early and later fabrications about Sappho. Welcker's influence is long-lasting, as is evident from numerous later and more recent scholarly reconstructions and suggestions. For instance, the idea that Sappho was short in height and dark in complexion ([Ovid] *Heroides* 15. 33–35) has been confidently attributed to an unknown play of the comic tradition.[35] The information provided by the Suda—a late-tenth-century medieval Greek lexicon—that Sappho had a wealthy husband whose name was Kerkulas has been taken for granted as coming "from one of the numerous comedies on Sappho."[36] More generally, it has been suggested (and widely accepted) that in Athenian comedy, "from Old comedy through Menander" Sappho was a stage figure "who exemplified insatiable heterosexual promiscuity."[37]

---

[32] Kuhn 1962 [1996]:43.

[33] For the vast influence of Welcker 1816 on later scholarship, see Calder 1986.

[34] Welcker 1816; later version published in his *Kleine Schriften*, vol. 2, Bonn 1845, 80–144. Welcker quoted the whole fragment: νᾶφε καὶ μέμνασ' ἀπιστεῖν· ἄρθρα ταῦτα τᾶν φρενῶν.

[35] See, among other scholars, Dörrie 1975:16–17. The Ovidian authorship of the *Epistula Sapphus ad Phaonem (Heroides 15)* has been questioned: see Tarrant 1981 and 1983:268–273, Knox 1995:12–14. Rosati 1996 favors the attribution of the poem's authorship to Ovid.

[36] Parker 1993:309 (with references to earlier scholars). Similarly, concerning Welcker's *Sappho Freed from a Reigning Prejudice*, Calder 1986:141 has observed that Welcker missed "the comic origin of Sappho's husband." The Suda (s.v. Σαπφώ) also claims that Kerkulas did business from Andros. Campbell 1982:5 renders the name "Kerkulas" (and his association with Andros) as "Prick from the Isle of Man" (cf. κέρκος). Compare Parker's "Dick All-cock from the Isle of MAN" (1993: 309), which is sensational. I should perhaps stress that Kerkulos is attested as a personal name from Euboia (see *LGPN* vol. 1 [The Aegean Islands, Cyprus, Cyrenaica]:254, s.v. Κερκύλος) and personal names like Kerkiôn and Kerkôn similarly occur in inscriptions: see *LGPN*, s.vv. in vol. 1, vol. 2 (Attica), vol. 3A (The Peloponnese, Western Greece, Sicily and Magna Graecia), vol. 3B (Central Greece), vol. 4 (Macedonia, Thrace, Northern Regions of the Black Sea). On Kerkulas, cf. Chapter One, p. 20.

[37] Most 1995:17.

More recently, an extensive study argues that one of the earliest sources about Sappho—Herodotos' discussion of Rhodopis and her relation with Sappho's brother Kharaxos—is based on an earlier, but unattested, comedy by Kratinos. According to this approach, no hints exist in the preserved fragments of Sappho that she composed a song in which she vehemently criticized her brother for spending a great amount of money to free Rhodopis; therefore, this idea must be the invention of a contemporary comic dramatist, more specifically of Kratinos.[38]

Herodotos' account deserves close examination, since if the aforementioned approach is correct, Herodotos and later sources related to Sappho's brother Kharaxos present an important aspect of the early, fifth-century reception of Sappho: the invention of a story about Sappho in a lost, unattested comedy. Before embarking on an investigation of this issue, it is worth considering extensively the Athenian comedies about Sappho and what they suggest about the reception of her figure in the late fifth and fourth centuries.

## An Anatomy of Representations

As far as the evidence permits us to see, the first comic dramatist who apparently included Sappho as one of the main characters in the plot of a play is Ameipsias, a late fifth- and early fourth-century poet. From Ameipsias' *Sappho* only one word survives. In his list of synonyms for "slothful" and "being slack," Poludeukes reports that the word νωθρότερον ("more sluggish") occurred in Ameipsias' play.[39] Nothing is known about the context of even this single word. A different kind of source seems to provide the title of *Sappho* by Ameipsias. A second-century AD papyrus fragment preserves a very fragmentary list of comic poets and some of their plays (P.Oxy. 2659). According to John Rea, its *editor princeps*, P.Oxy. 2659 comes from a "catalogue of some provincial library or a reading list."[40] The list is in alphabetical order and the authors' names are given in the genitive. In one fragment (P.Oxy. 2659 fr. 1, col. 1), the titles of two plays are preserved but without the name of their author:

Μοιχοί
Σ]απφώ

Note that the fragmentary list provides names and plays of poets of both the fifth and the fourth centuries. The two plays have been attributed to

[38] Lidov 2002.
[39] Poludeukes 9.138 Bethe ἐν δὲ τῇ Ἀμειψίου Σαπφοῖ καὶ νωθρότερον εὑρήκαμεν.
[40] Rea 1968:70.

Ameipsias, since "[o]nly Ameipsias is known to have written both a *Moichoi* and a *Sappho*."[41]

What is known about the plot of our possibly first *Sappho* amounts to almost nothing; even its attribution to Ameipsias has been questioned. Kaibel thought that the name Ἀμειψίου in Poludeukes' reference to the occurrence of the word νωθρότερον in *Sappho* should be rather emended to Ἄμφιδος ("in Amphis' *Sappho*").[42] Calder has endorsed Kaibel's skepticism and accepted his suggestion, since *Sappho* would be "a theme that differs considerably from Ameipsias' other titles."[43] If this approach is correct, then all the plays entitled *Sappho* would come from the fourth century. But even if it is not, the date of our first *Sappho* is unknown; it could have been composed either in the late fifth or in the early fourth century.

Even so, what has remained unnoticed is that the case of our second source about a *Sappho* by Ameipsias—the catalogue of comic poets and a number of their plays—is more complex. This source seems to defend the attribution of a *Sappho* to that poet and reinforces the antiquity of the paradigm of comedy. As we have seen, the list provides names of both fifth- and fourth-century poets. In fact, P.Oxy. 2659 fr. 1, col. 1 (the fragment that provides the titles *Moikhoi* and *Sappho* without the name of a poet) also includes the name of Araros, a fourth-century comic poet and son of Aristophanes.[44] Because many of the names in the fragmentary list belong to poets of the so-called Old Comedy,[45] Rea attempted to attribute the titles *Moikhoi* and *Sappho* to a late-fifth century or at least "Old-Comic" poet. According to Rea, it is only Ameipsias who is known to have produced both a *Moikhoi* and a *Sappho*. Kassel and Austin have followed Rea's argument and included the two titles of the Oxyrhynchus fragment in the testimonia about Ameipsias (test. 2 K-A). However, another major comic poet is known to have written both a *Moikhoi* and a *Sappho*: Antiphanes.[46] Antiphanes is considered a "Middle-Comic" poet and it is from his *Sappho* that

---

[41] Rea 1968:71.

[42] See the apparatus criticus in Bethe's edition of Poludeukes (9. 138); Bethe 1931:184. Amphis wrote a *Sappho* and all the other plays entitled *Sappho* come from the fourth century or possibly later.

[43] Calder 1986:141.

[44] Araros' first play was produced around 376–372 BC; see Araros testimonium 1 in Kassel and Austin's edition (and cf. Araros testimonium 3 K-A).

[45] The fragmentary list includes the name of an author unknown among comic playwrights—Apollonios—and of one of his plays (cf. Rea 1968:70–71 and Apollonios in Kassel and Austin's *Poetae Comici Graeci*). The date of Apollonios is uncertain but Rea (1968:71) notes that "Apollonios is not a known Athenian name in the fifth century and is at least very rare in the fourth."

[46] Antiphanes fr. 159 K-A (*Moikhoi*) and fr. 194–195 K-A (*Sappho*).

the most extensive fragment from any known comedy entitled *Sappho* has survived.[47] What is equally, or perhaps more, likely is that the author of the two plays mentioned in the Oxyrhynchus fragment was Antiphanes. I suggest that the evidence that the papyrus fragment provides is actually inconclusive and our information about a *Sappho* by Ameipsias rests solely on the brief reference in Poludeukes discussed above.

In the fourth century, plays entitled *Sappho* become something of a fashion.[48] Among others, poets who produced a *Sappho* include Ephippos, Amphis, and Timokles. From these plays we have only a few fragments, which are difficult to contextualize.[49] For Ephippos' *Sappho* we know that somewhere in the play there was a description of a male prostitute or at least of a young man who would be willing to have intimacies with other men in exchange for good-quality food:[50]

> ὅταν γὰρ ὢν νέος
> ἀλλότριον †εἰσελθὼν ὄψον ἐσθίειν μάθηι[51]
> ἀσύμβολόν τε χεῖρα προσβάληι βορᾶι,
> διδόναι νόμιζ᾽ αὐτὸν σὺ τῆς νυκτὸς λόγον

> For when a young man
> enters [another man's house without being seen?]
> and puts a hand to the food without contributing his share,
> you should believe that he pays his reckoning in the night.

It is thought-provoking that the only surviving fragment from the *Sappho* of Timokles similarly refers to men's attraction to young men:

> ὁ Μισγόλας οὐ προσιέναι σοι φαίνεται
> ἀνθοῦσι τοῖς νέοισιν ἠρεθισμένος

---

[47] For Antiphanes' *Sappho*, see below.

[48] I should like to emphasize that a title like *Sappho* cannot be indicative of the plot of a play or of whether "Sappho" was the name of an ordinary woman/protagonist who, through her action, reminded the audience of the figure and the poetry of Sappho; cf. n. 57 below.

[49] Ephippos fr. 20 K-A, Amphis fr. 32 K-A, and Timokles fr. 32 K-A.

[50] This is evidently suggested by the context in which the fragment is quoted (Athenaios 13.572b-c, who further reports that "the orator Aiskhines has said the same thing in his speech *Against Timarkhos*"; see Aiskhines *Against Timarkhos* 75 [*Orations* 1.75 Dilts]: "What is one to say when a youth, quite young and exceptionally handsome, leaves his father's house and spends his nights in other men's houses and has expensive dinners without paying his share (ἀσύμβολον)...?". For Ephippos and the dating of his plays, see Nesselrath 1990:196–197.

[51] As transmitted ("...learns to eat another man's fish"?), the line is problematic and diverse emendations have been put forward (cf. Kassel and Austin's apparatus criticus); Kaibel's ἀλλότριον εἰσελθών τις οἶκον διαλάθηι is interesting and is here only tentatively translated.

Misgolas does not seem to make approaches to you,
although he is inflamed by young men in their bloom.

Misgolas was an Athenian often thought to be characterized by an intense pas-
sion for homoerotic pursuit.[52] Contemporary poets like Alexis parodied him for
being especially attracted to young *kitharôidoi* ("singers to the accompaniment
of the *kithara*") or *kitharistai* ("*kithara*-players"):[53]

ὦ μῆτερ, ἱκετεύω σε, μὴ 'πίσειέ μοι
τὸν Μισγόλαν· οὐ γὰρ κιθαρωιδός εἰμ' ἐγώ

mother, I implore you, do not threaten me with Misgolas;
for I am not a *kitharôidos*.

Although the plots of both Ephippos' and Timokles' *Sappho* are tantalizingly
elusive, Diphilos' *Sappho* allows us a glimpse of some of the characters involved
in the play.[54] From this comedy, the date of which is not certain, a fragment
and an indirect reference to an intriguing aspect of the plot survive. Fragment
70 K-A probably shows Arkhilokhos in the context of a *symposion*,[55] while frag-
ment 71 K-A reports that Arkhilokhos and Hipponax were presented in the
play as lovers of Sappho. I would like to draw attention to the fact that, as the
broader context of this reference indicates (Athenaios 13.599c–d), Arkhilokhos
and Hipponax were "lovers" of Sappho in the sense of "suitors," since, as in the
case of Alkaios and Anakreon as suitors of Sappho in Hermesianax's *Leontion*,[56]
each poet would attempt to win her love independently. Note that in Diphilos'
*Sappho* the figures chosen to be "suitors" of Sappho are composers of invective
verses. Whether either of the two poets succeeded in attracting her interest
in this play remains unknown, given the scrappiness of the available sources.[57]

[52] For Misgolas, see Arnott 1996a:63 and Fisher 2001:170–183.
[53] Alexis fr. 3 K-A. Cf. Antiphanes fr. 27.14–18 K-A. Aeskhines' *Against Timarkhos* 41 describes
Misgolas as someone who used to have constantly around him *kitharôidoi* and *kitharistai*. For
these passages, see Athenaios 8.338e–339c.
[54] Diphilos fr. 70–71 K-A.
[55] Diphilos fr. 70 K-A Ἀρχίλοχε, δέξαι τήνδε τὴν μετανιπτρίδα | μεστὴν Διὸς σωτῆρος, Ἀγαθοῦ
Δαίμονος. The context in which the fragment is quoted (Athenaios 11.486f–487a) is an account
of a type of cup used in *symposia*; some other quotations included in this account in Athenaios
suggest that Diphilos fr. 70 K-A was part of some kind of symposiastic scene.
[56] On this poem by Hermesianax, see the discussion below. Note that the case of Alkaios and
Anakreon as "suitors" of Sappho in Hermesianax's *Leontion* is mentioned by Athenaios in the
same context (13.599c–d).
[57] Other comedies that are *alleged* to have been related to Sappho include *Phaôn* by Platon Komikos
(7. 188–198 K-A) and Antiphanes (2. 213 K-A), *Leukadia* by Menandros (P.Oxy. 4024 and other
sources, for which see Arnott 1996b:220–243), Diphilos (5. 52 K-A), Alexis (2. 135–137 K-A),
Amphis (2. 26 K-A), and *Leukadios* by Antiphanes (2. 139–140 K-A). Cf. Aly 1920:col. 2366. For all
that, Arnott (1996a:394–95) has argued that both Alexis' and Menandros' *Leukadia* at least were

My analysis of comic representations of "Sappho" so far has shown that the widely endorsed theory that comedy constituted the most decisive and influential stage in the early, fifth-century reception of the figure of Sappho is mainly based on our willingness to allow ourselves to imagine, or to *rewrite*, the possible plots of comedies entitled *Sappho*. The theory—currently viewed as a concrete "fact"—that "from Old comedy through Menander," Sappho was a stage figure "who exemplified insatiable heterosexual promiscuity" is interesting, but can be hardly substantiated. As far as our informants allow us to understand, Attic comedy—almost exclusively fourth-century plays[58]—must have contributed considerably to the creation of specific *marked* webs of signification attached to the figure of Sappho and creatively employed by later writers. However, except for Menandros' reference to Sappho leaping from the cliff of Cape Leukatas to cure her desire for Phaon (a mythological, exceptionally handsome ferryman from Lesbos)[59] no indication exists that she was represented in Attic comedy as promiscuous.

What should be explored in terms of fourth-century representations of the poet is Antiphanes' *Sappho*, a play to which I now turn.

---

not parodies of the myth of Phaon and Sappho: "such travesties are avoided by Menander...,  although Wilamowitz's suggestion that Menander may have transformed incidents of the myth into experiences of ordinary folk is appealing" (Arnott 1996a:395). For Antiphanes' *Phaôn*, see Kassel and Austin's concise annotations (they quote Kock's view about the plot of the comedy: "dubium utrum fabulosus ille Sapphus amator an famelicus quidam Pythagorista, de quo cf. Alex. fr. 223.15, comoediae nomen dederit").

[58] In the extant comedies of Aristophanes, Sappho is not mentioned by name; it has often been argued that there are some possible allusions to several fragments of Sappho, but such Aristophanean formulations, in the broader context of the various performance cultures in Athens, might have not been registered as markedly Sapphic by audiences: *Knights* 730 τίς ὦ Παφλαγὼν ἀδικεῖ σε; (cf. Sappho fr. 1.19–20 V), and, perhaps, *Ekklesiazousai* 954 πάνυ γάρ τις ἔρως με δονεῖ (cf. Sappho fr. 130.1 V), and *Clouds* 278 ὑψηλῶν ὀρέων κορυφὰς ἐπὶ (cf. Sappho fr. 44A a.6 V). Given its context, it would be risky to suggest that in *Frogs* 1308, Dionysos alludes to the "tradition" of the poetry of Sappho; even the idea that he might imply the early figures of Arion and Terpandros should not necessarily be taken for granted. In *Lysistratê* 142–145, a pun might possibly be detected (cf. Sappho fr. 168B V) but, again, the overall idea expressed in the lines of Aristophanes would not be uncommon (see line 592 of the same play).

[59] Menandros fr. 258 Körte-Thierfelder (1957/1959: vol. 2, 97; cf. Arnott 1996b:230–231). See, further, the passages collected by Voigt in Sappho testimonium 211. For Sappho's leap, see, apart from the studies cited by Voigt at the end of Sappho testimonium 211 (Voigt 1971:160), the thorough and wide-ranging article of Nagy (1973/1990b) and Stehle's most thought-provoking treatment of the function of male mythical young figures in the poetics of Sappho (1990). For an unnecessary emendation of Pseudo-Palaiphatos' passage related to this myth (*On Unbelievable Things* [περὶ ἀπίστων] 48, Festa 1902:69), see West 1990:2. Also, the text in Gallavotti of the last sentence of Pseudo-Palaiphatos' passage (οὗτος ὁ Φάων ἐστίν, ἐφ' ᾧ τὸν ἔρωτα αὐτῆς [not αὐτῆς] ἡ Σαπφὼ πολλάκις ἐμελοποίησεν [= Sappho test. 39 in Gallavotti's 1962 edition; cf. also fr. 181 in his edition]) is somewhat awkward in the wider context of the narrative (see the apparatus criticus of Festa 1902:69).

## Elective Affinities

In the first half of the fourth century, a complex representation of Sappho was in dialogue with fifth-century discursive idioms investigated in Chapters Two and Three. Some time during this period, Antiphanes, a playwright who begun staging his comedies slightly before or around 380 BC,[60] composed his *Sappho*, from which two fragments have survived.[61] One of these fragments consists only of one word quoted in Polydeukes' *Onomastikon*: βιβλιογράφος ("book writer") was used in an unknown context in *Sappho*.[62] This idea of "writing," also employed by Aristoxenos in connection with Sappho and comradeship,[63] is one of the most central elements of the extensive fragment that has been preserved from this play.[64]

Antiphanes fragment 194 K-A represents a dialogue between "Sappho" and another figure, whose identity the available text does not allow us to ascertain adequately. Sappho's address to him is "oh, father"—a thought-provoking indication for the almost unparalleled proliferation and transmission of names for the father of Sappho in classical antiquity.[65] The fragment is transmitted by Athenaios in the context of his inquiry into the definition of riddles (*griphoi*) and their exploitations by comic poets.[66] At the outset of this inquiry it is made clear that the issue of what the famous riddle composer

---

[60] See Antiphanes testimonium 2 in Kassel and Austin's edition. Cf. Antiphanes testimonia 1 and 4 K-A.

[61] Antiphanes fr. 194–195 K-A.

[62] Antiphanes fr. 195 K-A; however, cf. Kratinos fr. 267 K-A.

[63] See Chapter Three.

[64] Antiphanes fr. 194 K-A.

[65] Note that Athenaios 10.450f mentions that ταῦτά τις ἐπιλυόμενός φησιν; and cf. 10.450e ἐπιλυομένου (Meineke: ἀπολυομένου A) τινὸς οὕτως (my emphasis). The different names for Sappho's father enumerated in P. Oxy. 1800 fr. 1 and the lemma on Sappho in the Suda suggest the variety of biographies about her (seven names altogether, according to Treu 1984:234–35; Treu's view that the seven names may hint at the existence of seven different ancient biographies of Sappho is not likely, since it is equally possible that one or two different biographies referred to all these alternative names, which different oral or later written traditions alleged to be authentic). The total number of the attested names for Sappho's father seems to be ten (two in P.Oxy. 1800 fr. 1, seven in Suda [apart from *Skamandrônymos*, who occurs in P.Oxy. 1800 fr. 1 as well], and one in Scholia on Pindar, Drachmann 1.10.6 [Vitae et Varia]). Note that some of the names in question have a similar root, a fact that may partly be accounted for by the workings of oral tradition (Σκαμάνδρου – Σκαμανδρωνύμου, Ἡεριγυίου – Εὐρυγύου). The most frequent, and earliest attested, is Σκαμανδρώνυμος (P.Oxy 1800 fr. 1, Suda Σ 107, Scholia on Plato *Phaidros* 235c, Herodotos 2.135 (reference to Kharaxos' father), Aelian *Historical Miscellany* 12.19). I would emphasize here that even in the tradition of ancient Greek biography, such a large number of variants is unusual.

[66] Athenaios 10.448b (beginning of discussion).

Kleobouline of Lindos put forward in her *ainigmata* ("riddles")—explored adequately, it is maintained, by the discussants' friend Diotimos in a separate treatise—will not be touched upon. The broader examination of riddles is introduced by a reference to Klearkhos, whose fragments from his treatise *Erôtika* were considered above. In another treatise, *On Riddles (Peri griphôn)*, Klearkhos claimed that there were seven types of riddles.[67] It is significant that a different ancient source making a brief reference to Klearkhos' seven types of riddles adds that *griphoi* are enigmatic questions propounded in the context of *symposia*.[68] As a matter of fact, Klearkhos' own classification of riddles places comparable emphasis on the institution of the *symposion* as the context within which riddles were performed.[69] Indicative of such a close association between *symposia* and the performance of riddles is that at an earlier period Simonides, as an informant creatively relates, during a dinner "at the season of fierce heat" somewhere in Greece improvised (ἀπεσχεδίασε) an elegiac poem in the genre modulation of a riddle;[70] Aristophanes and Antiphanes placed *griphoi* in the context of drinking-parties;[71] and, in markedly different and considerably later sociocultural contexts, a fourth- or fifth-century "author" of a hundred riddles in Latin was assigned the name "Symphosius."[72] A number of other sources foreground the *symposion* as a central performative space for riddles.[73]

More succinctly than Klearkhos, Aristotle had explored the genre of riddles in his *Poetics*.[74] In the context of his discussion of the use of "exotic language" (ἡ τοῖς ξενικοῖς κεχρημένη)—a marked feature of which is metaphor—he observed that a composition that makes intensive use of metaphoric diction becomes a riddle, whereas a poem employing a great number of loan words is associated with barbarism. The hallmark of a riddle is the metonymic attachment of impossibilities to a linguistic visualization of real things. The

[67] Athenaios 10.448c.
[68] Klearkhos fr. 85 Wehrli (ancient scholia on Aristophanes *Wasps* 20). On riddles in Greek antiquity, see Schultz 1909/1912, Ohlert 1912, and Roilos 2005:139–144, 153–154.
[69] Fr. 86 Wehrli (Athenaios 10.448c-e), with references to asigmatism in an ode by Pindar, "a type of riddle propounded in melic poetry" (Pindar fr. 70b M). For asigmatism in ancient Greek poetry, see West 1976 and van der Weiden 1991:64–65.
[70] Simonides fr. eleg. 25 W (Kallistratos *FGrH* 348 F 3). For the concept of genre modulation, see Roilos's groundbreaking book (2005).
[71] Aristophanes *Wasps* 20–23; Antiphanes *Pot-Belly, or Knoithideus* fr. 122 K-A (Athenaios 10.448e–449b). For another "riddle" in Antiphanes, see *Ganymêdês* fr. 75 K-A (Athenaios 10.459a-b); cf. *Problêma* fr. 192 K-A. The *Theognidea* include compositions with discursive elements of riddles: see *Theognidea* 667–682, 949–954, and 1229–1230.
[72] See Ohl 1928 and Bergamin 2005. In his *Onomastikon*, Poludeukes also associates the performance of riddles with *symposia* (6.107–108 Bethe).
[73] E.g. Plato *Republic* 479b-c.
[74] *Poetics* 1458a.

linguistic properties of metaphor and metonymy, if blended repeatedly in a short composition, can lead to the creation of an *ainigma*.

Unfortunately, the context of the preserved scene from Antiphanes' *Sappho* is not known. In another play on Sappho, the "New-Comic" *Sappho* by Diphilos (fragments 70–71 K-A), Arkhilokhos was presented moving in the context of a dinner party and he along with Hipponax were suitors of Sappho.[75] However, the pronounced fragmentariness of both *Sapphos* does not help the recontextualization of the scene in Antiphanes. As Antiphanes fragment 194.1–5 K-A stands, Sappho initiates the dialogue and propounds a riddle:

> (Σαπφώ.) ἔστι φύσις θήλεια βρέφη σώιζουσ' ὑπὸ κόλποις
> αὐτῆς, ὄντα δ' ἄφωνα βοὴν ἵστησι γεγωνὸν
> καὶ διὰ πόντιον οἶδμα καὶ ἠπείρου διὰ πάσης
> οἷς ἐθέλει θνητῶν, τοῖς δ' οὐδὲ παροῦσιν ἀκούειν
> ἔξεστιν· κωφὴν δ' ἀκοῆς αἴσθησιν ἔχουσιν          5

> SAPPHO: There is a female being hiding under the folds
> of her garment[76]
> baby children,[77] and, although voiceless, they raise a
> sonorous, loud cry
> across both the swelling sea and over every land
> to whomever they wish; and for those not present it is
> possible
> to hear it; and those obtuse in their sense of hearing... [78]

From the outset it is intriguing that the riddle and the solutions offered—in a manner reminiscent of an epistemology of interpretation—are replete with ambiguities, linguistic and cultural. The wordings βρέφη ὑπὸ κόλποις (line 1), βοὴν γεγωνόν (line 2), as well as—in what follows the lines quoted here—the word ῥήτορας (line 7), the position of ἀεί in line 11, the almost technical sense of ἀκριβῶς in line 15, and the occurrence of λαλεῖ in line 19 are carefully exploited. This particular scene was impressive enough to stir the interest of medieval Greek authors. Sappho's *ainigma* is cited by Eustathios of Thessalonike in the twelfth century,[79] and lines 1–5 and 17–19 are quoted in the section on *problêmata* and *ainigmata* of the appendix to the Palatine An-

---

[75] See the discussion above, p. 298.
[76] Or, "under her bosom."
[77] Or, "fetuses in her womb."
[78] Alternatively, perhaps "they have a dull sense of hearing."
[79] Eustathios on *Iliad* 6.169 (vol. 2, 270 van der Valk).

thology by the thirteenth-century Greek monk Maximos Planoudes.[80] More importantly, the riddle was repropounded in a different version attributed to an eleventh-century Greek writer known for his *ainigmata*, Basileios Megalomitis.[81] Otto Mazal assigned this version of the riddle to the fragmentary twelfth-century novel *Aristandros and Kallithea* by Konstantinos Manasses,[82] but this is far from certain, given that what has been preserved from the novel is mainly quotations of gnomic character in Makarios Khrysokephalos' fourteenth-century anthology Ῥοδωνιά, in two other anonymous *florilegia*, and in Maximos Planoudes' *Collection from Diverse Books*.[83] This is not the place to consider extensively this version of Sappho's riddle but I should point out that attempts have been made to show that Basileios misread the ancient Greek lines of Antiphanes,[84] even though it is by far more likely that he created his own version of the *ainigma*.[85]

Despite the status she occupies on stage as a riddler, the elderly interlocutor of Sappho in Antiphanes replies confidently and pithily to the challenge posed since, as he asserts, he knew precisely what the riddle was about (fr. 194.6–16 K-A):

(B.) ἡ μὲν φύσις γὰρ ἦν λέγεις ἐστὶν πόλις,
βρέφη δ᾽ ἐν αὐτῆι διατρέφει τοὺς ῥήτορας.
οὗτοι κεκραγότες δὲ τὰ διαπόντια
τἀκ τῆς Ἀσίας καὶ τἀπὸ Θράικης λήμματα

---

[80] Antiphanes frs. 7 and 8 in Cougny 1890:565 and 580 (annotations). For Planoudes (*c.* 1255–*c.* 1305) and the early fourteenth-century Demetrios Triklinios, see Wilson 1996:230–241, 249–255, and the article on Planoudes by C. Wendel in *RE* (20:2202–2253); cf. Cameron 1993 (with several sweeping statements). On the transmission of excerpts of Menandros in medieval anthologies, see Easterling's insightful article (1995).

[81] Boissonade 1831:437–452. Boissonade suggested that Megalomitis might perhaps stand for Megalomytes ("Naso"?). The *ainigma* was printed in Boissonade 1831:450–451 and is entitled "Βίβλος." In Planoudes' Συναγωγὴ ἐκλεγεῖσα ἀπὸ διαφόρων βιβλίων, where it reoccurs, it is glossed as "αἴνιγμα, βίβλου" (for this title, see Mazal 1967:200).

[82] Mazal 1967:200 (fr. 142).

[83] See Tsolakis 1967:32–37. Tsolakis (1967:45–47), who does not include this fragment in his excellent edition of Manasses' novel, considers the possibility that other sections from Planoudes' Συναγωγὴ ἐκλεγεῖσα ἀπὸ διαφόρων βιβλίων, where Mazal found the lines, may be attributed to *Aristandros and Kallithea*.

[84] Meineke 1840:113; even by medievalists: Conca 1994:759. Note that line 5 of Antiphanes fr. 194 K-A has been transmitted and emended in different ways; see Meineke 1840:113 and 1847:547; Kassel and Austin in Antiphanes fr. 194.

[85] Different versions of Sappho's *griphos*, devoid of any pretense to imitate an "original" literary text, became at a certain point part of orally transmitted traditional riddles still performed in contemporary Greek villages in Arcadia and Crete. The parallel phraseology in these oral multiforms—composed in *dekapentasyllabos stikhos*—is intriguing.

ἕλκουσι δεῦρο. νεμομένων δὲ πλησίον        10
αὐτῶν κάθηται λοιδορουμένων τ' ἀεὶ
ὁ δῆμος οὐδὲν οὔτ' ἀκούων οὔθ' ὁρῶν.
(Σαπφώ.) ⏓ - ⏑ - πῶς γὰρ γένοιτ' ἄν, ὦ πάτερ,
ῥήτωρ ἄφωνος; (Β.) ἢν ἁλῶι τρὶς παρανόμων.
⏓ - ⏑ - καὶ μὴν ἀκριβῶς ὠιόμην        15
ἐγνωκέναι τὸ ῥηθέν. ἀλλὰ δὴ λέγε.

B: The (female) being of which you speak is a city,
and the babes she nourishes within her are the public
    speakers.
These, by their clamoring, draw here
profits across the sea from Asia
and from Thrace. But the people (*dêmos*), neither hearing
nor seeing anything, sit near them
while they share and consume, and rail at one another ever.
SAPPHO: ... For how, father,[86] could
a public speaker (*rhêtôr*) be voiceless?
B: If he is convicted three times of making illegal proposals.[87]
... I thought indeed that I understood
precisely what you were speaking about. But do tell me
    yourself.

His reaction is that of a classical Athenian citizen—legalism, corruption, public apathy, androcentrism, and complacency are fully exposed. At the center of the riddle, his response to it, and its final solution lies a ventriloquized feminine discourse. Both the *polis* and the epistle are female and, as such, they nourish within them discursive and performative *phuseis* of considerable significance and plasticity. The *writing* of the epistle, as well as that of the *polis*, is also represented as female, while the silent reading of the epistle's letters by people not present[88] is given a performative dynamic comparable to that of a song—a dynamic reminiscent of Poseidippos' later image of Sappho's "voice-giving pages" (φθεγγόμεναι σελίδες):[89]

(Σαπφώ.) θήλεια μέν νυν ἐστὶ φύσις ἐπιστολή,
βρέφη δ' ἐν αὐτῆι περιφέρει τὰ γράμματα·

---

[86] πάτερ could also function as a respectful address to an older person.
[87] On γραφὴ παρανόμων, see Hansen 1990:225, 237–239; cf. Wankel 1991.
[88] On silent reading, see especially Knox 1968; Svenbro 1993:163–186; Gavrilov 1997; Burnyeat 1997; cf. Johnson 2000.
[89] Poseidippos 17.5–6 Gow-Page. On this epigram, see below.

ἄφωνα δ' ὄντα <ταῦτα> τοῖς πόρρω λαλεῖ
οἷς βούλεθ'· ἕτερος δ' ἂν τύχηι τις πλησίον          20
ἑστὼς ἀναγιγνώσκοντος οὐκ ἀκούσεται

SAPPHO: The female being, then, is an epistle,
and the babes she carries around within her are the letters;
they, although voiceless, speak to those far away,
whom(ever) they wish; and if some other person happens to
stand near the one who is reading, he will not hear.

The *polis*, although grammatically feminine, represents the male public sphere
of sociopolitical exchanges while the masculine *dêmos* is seated voiceless and
deaf before the civic performance space of the *rhêtores*. Sappho's riddle was
also presented within a performance space almost exclusively dominated by
male and ventriloquized female discourses. The levels of the male hermeneutic
perspective in the fragment are more complex than a confidently straightfor-
ward "playing the other" analytical schema would capture.[90] Sappho's riddle
renders her an authoritative figure whose voice has a performative efficacy
(βοὴν γεγωνόν) comparable to her archaic, mostly orally transmitted songs.

Although the context of the scene is elusive, a comparative approach to
it is worth pursuing. I shall not attempt to reconstruct a hypothetical context;
instead, I examine the discursive idioms that might have informed a male
scanning of the dialogue. To be sure, whether this scene was part of a staged
*symposion* of any kind is uncertain. However, I would argue that even if the
scene with Sappho's riddle was part of a dialogue that took place in a generic
context (within the plot of the comedy), there are ways to explore what its
broader connotations might have been.

I shall first examine the context within which plays on Sappho were com-
posed. According to Aristotle's *Poetics*, for comedy "the composition of plots
(*muthoi*) originally came from Sicily, and among Athenian poets Krates was
the first to give up the iambic mode and to compose stories (*logoi*) and plots
of universal character."[91] Krates staged most of his plays in the 440s and 430s.
In the cultural milieu of these decades, comedies both markedly political—
in the sense usually associated with Aristophanes' political diatribes—and
more "universal," with mythological burlesque, fantastic and otherworldly
stories, and plots mirroring everyday life should be placed. Among the latter,
it is intriguing that the *Sappho* attributed by Polydeukes to Ameipsias was

---

[90] On the fragment, see Svenbro 1993:158–159; Steiner 1994:113–114; Prins 1999:25–26; Martin
2001:73–74.
[91] *Poetics* 1449b.5–9.

produced (if the attribution is correct) during a period pregnant with theatri-
cal experimentation on the cultural trafficability of archaic poets. The exact
date of this *Sappho* is unknown and it would be either a late fifth- or an early
fourth-century play.[92] His *Revellers* was produced—and won the first prize over
Aristophanes' *Birds*—in 414 BC,[93] and can provide a first clue to a much broader
contemporary social concern with performers, performative institutions like
the *symposion*, and archaic song-makers. It is, I suggest, within this broader
cultural tradition that the *Sappho* attributed to Ameipsias, the first play with
Sappho as one of its main figures, should be viewed.

Some of the titles that need to be considered in relative juxtaposition
to this *Sappho* are Telekleides' *Hesiodoi*, dated possibly to the early 420s,[94]
and Kratinos' *Arkhilokhoi*,[95] a play that associated this playwright firmly
with Arkhilokhean *psogos* in later tradition.[96] In the latter comedy, some
poets following the style of Homer and Hesiod were called *sophistai*,[97] as
"the wise men who happened to exist" at the time of Kroisos were labeled
*sophistai* by Herodotos.[98] Other plays germane to this discussion are Kratinos'
*Mollycoddles/Softies* (*Malthakoi*), Magnes' *Lydians*, and, especially, his *Barbitos-
Players* (*Barbitistai*), which, according to ancient scholiasts,[99] were alluded to
in Aristophanes *Knights* (522–523)—where Magnes, Kratinos, and Krates are
discussed by the Chorus leader in the same context.[100] More significant for my
investigation, however, is Kratinos' *Kleoboulinai*, the title of which was later
reemployed, slightly modified, by Alexis.[101]

[92] See the discussion above, pp. 295–297.

[93] Ameipsias *Komastai (Revellers)* K-A. No word survives from this play. Cf. Phrynikhos' *Komastai* frs.
14–18 K-A.

[94] *Hesiodoi* frs. 15–24 K-A. For the date, see Geissler 1969:16 and 24. Cf. the fourth-century comedy
*Hesiodos* by Nikostratos (fr. 11 K-A). Note that titles might be deceptive about the actual plot of
the comedies.

[95] Dating *Arkhilokhoi* (frs. 1–16 K-A) to *c.* 430 BC or even slightly later (see Kassel and Austin in
the annotations before Kratinos *Arkhilokhoi* fr. 1) is safer than a date "not long after 449 BC"
as Geissler (1969:18–19) somewhat optimistically assumed on the basis of a reference in *Arkhi-
lokhoi* fr. 1 K-A to the death of Kimon. On the fourth-century play *Arkhilokhos*, see Arnott
1996a:112–115; on the title *Arkhilokhoi*, cf. Arnott's comment (1996a:112): "Cratinus' Ἀρχίλοχοι
owed its plural title in all probability to a semi-chorus of Archilochus and his supporters
battling against a semi-chorus of epic poets in an Old-Comedy literary *agon*." Cf., earlier, Pieters
1946:133–135.

[96] See Kratinos testimonium 17 in Kassel and Austin's edition. Cf. Kratinos frs. 3 and 6 K-A.

[97] Fr. 2 K-A. The phrase Κρατῖνος...τοὺς περὶ Ὅμηρον καὶ Ἡσίοδον ἐπαινῶν οὕτως καλεῖ in Dio-
genes Laertios 1.12 (Marcovich) can be construed variously in terms of the possible plot of the
fragmentary comedy.

[98] Herodotos 1.29.

[99] Spyropoulos 1975 has questioned the information provided by the scholia.

[100] Cf. Antiphanes *Ludos (Lydian)* fr. 144 K-A.

[101] Alexis *Kleoboulinê* fr. 109 K-A.

The *Kleoboulinai* was produced on the Athenian stage some time around 430 BC.[102] Its title was a marker of the Kratinean predilection for the use of the plural in his *Dionysoi*, *Kheirônes*, and *Odussês*, the themes of which adumbrated comparable developments in the so-called "Middle Comedy." By the middle of the fifth century, Kleobouline of Lindos, an eastern city on Rhodes of which Kleoboulos was *turannos* in the early sixth century, was known as an accomplished riddler.[103] Only a few fragments from the *Kleoboulinai* have been preserved, one of which seems to come from an *ainigma* or a comparable pronouncement typically introduced with the word ἔστι.[104] Obscene connotations can be detected in this fragment (ἔστιν ἄκμων καὶ σφῦρα νεανίαι εὔτριχι πώλωι, "there is an anvil and hammer in a young foal with flowing mane"). Although the text is too fragmentary for such connotations to be ascertained, it is worth pointing out that πῶλος in Anakreon (fragment 417 *PMG*) refers to a seductive young woman, a "Thracian filly," while in Euboulos (fragment 82 K-A) to a *hetaira*, a companion of Aphrodite. "Kleobouline and her female friends"—the title of Kratinos' comedy—might have propounded in different disguises a number of riddles in gatherings vividly staged by the playwright. It has been convincingly argued that "her friends" comprised a chorus of women, as was the practice in contemporary tragedies and comedies, while the associations between the authoritative voice of riddlers, on the one hand, and the Sphinx, the mythical riddle performer, on the other, were marked in the fourth-century BC.[105] To go a step further, it is noteworthy that *griphoi* introduced with ἔστι were propounded in Euboulos' *Sphinx-Kariôn* (fragment 106 K-A).[106]

## Performance and Metonymy

The associations between the riddle performer Kleobouline and Antiphanes' *Sappho*—especially since Kratinos had staged in the fifth century his *Kleoboulinai* and Alexis, a younger contemporary of Antiphanes, composed a *Kleoboulinê* some time during his career—are not necessary to emphasize. What should be spelled out instead is a wider web of signification that somehow interconnected the figures of Kleobouline, Sappho, the Sphinx, and even Aisopos—all of them related to the cultural performance of metaphors in

[102] The date is not certain. See Geissler 1969:23 and 81. Cf. also Pieters 1946:144–146.
[103] On Kleobouline, riddles, and Indo-European and modern traditions of riddling, see Bader 1989:145–149 and Bryant 1983:26 and passim.
[104] Kratinos fr. 94 K-A and see Kassel and Austin's annotations.
[105] Meineke 1839:277–278.
[106] Cf. Aristophanes *Knights* 1059.

the fourth century BC. This web is to be understood in terms of a group of metaphoric associations interwoven into a *metonymically* configured nexus of varied discursive textures. Individual metaphoric connections were thus implicated in a process of signification that lacked the discursive certitude of a single signifying center to the extent that any attempt at a unifying identification was metonymically deferred by its more or less antagonistic discursive supplements. It is at the intersections of the "male," as is were, self-assertiveness of individual metaphoric connections and the "female," (re)generative discursive dynamic of metonymic deferrals of meaning that the reception and naturalization of Sappho's image and poetry in the classical period needs to be approached.[107]

I start with Alexis' *Kleoboulinê*. In the only preserved fragment from this comedy, a reference appears to a *hetaira*, Sinope, attacked, we hear, in comic plays for her indecent behavior.[108] A number of plays by Alexis were given names of seductive *hetairai*—among them *Agônis*, a name that appears on a funerary vase dated to the third century BC;[109] *Dorkis or The Girl Who Smacks Her Lips*, with all the connotations that ποππύζω may have;[110] *Opôra*; and *Polukleia*.[111] Allusions to *symposia* in some of these fragmentary comedies are safely detected. Alexis' *Aulêtris*, *Orkhêstris*, and perhaps *Poiêtria* point also to comparable associations. In the *Orkhêstris*, in the context of a reference to bibulous women, an old woman is called a Sphinx riddler.[112] In this regard, it is worth observing that in Anaxilas' *Neottis*, a comedy exploiting the nomenclature and traits of courtesans, it was claimed that "it is possible to call all the prostitutes a Theban Sphinx, those who prattle not in simple language," but, as Aristotle would say, in a diction strengthened by the metonymies of exotic metaphors, or, in Anaxilas' words, "in riddles."[113] Alexis' *Aulêtris* is only one of the numerous "Middle-Comic" plays that were in sustained dialogue with

---

[107] For an understanding of these two supplementary tropes in terms of flexible "male" and "female" discursive inflections, see the interesting discussion in Gallop 1985:114–132.

[108] Alexis fr. 109 K-A.

[109] Courby 1922:216 (for the inscription Ἀγωνὶς | κε Γορπιέου and its dating); cf. Kassel and Austin's annotation on *Agônis*.

[110] The title of the play in ancient Greek is *Dorkis or Poppuzousa*. Cf. the sense "tootle (on a reed-pipe)" in Theokritos 5.7 (on ποππύσδεν see Gomme 1952:vol. 2, 96) and Alexis' *Aulêtris* and *Orkhêstris*.

[111] Alexis *Agônis* or *Hippiskos* frs. 2–6 K-A and Kassel and Austin's annotations (for the two names of the comedy, see Arnott 1996a:51); *Dorkis or Poppuzousa* frs. 57–9 K-A; *Opôra* frs. 169–170 K-A; *Polukleia* fr. 190 K-A.

[112] Alexis fr. 172 K-A.

[113] Anaxilas fr. 22–23. In the same fragment, the voices of Sirens and other mythical female creatures are also related to courtesans.

the cultural politics related to *psaltriai, aulêtrides,* and *kitharistriai.* Antiphanes himself composed an *Aulêtris* and Euboulos' *Psaltria* probably presented several aspects of sympotic female entertainers. *Hetairai* propounding riddles in the context of male *symposia* and generally expert in repartée were made even more widely known by Makhon in the middle of the third century BC.[114] As has been persuasively shown, in the late fifth century, Pherekrates and other playwrights promoted the incipient appearance of female figures in "Old Attic Comedy."[115] Comedy's thematics was gradually expanded to include, in addition to legendary women, female figures in cultic contexts, in domestic settings, in the streets, in luxury sympotic couches, and in the market. As pointed out in Chapter Two with regard to visual representations, the trafficability of female characters in the Athenian social imaginary during the second part of the fifth century was certainly pronounced, and this chronological correspondence with the comic texts needs further consideration—an issue that goes beyond the scope of the present investigation. In Attic comedy, as in other discourses, the same phenomenon continues well into the fourth century.

What has remained unremarked is that by Herodotos' time the performance of songs of Sappho was *indirectly* associated with the storytelling of Aisopos through a narrative about him and an illustrious courtesan who moved to Egypt, whereas in a much later period, the late first/early second century AD, Aisopos was viewed in the company of the riddler Kleobouline.[116] I shall focus on the narrative about the courtesan Rhodopis in the next section of this chapter.[117] For now it should be noted that Alexis, the author of *Kleoboulinê,* had also composed another thought-provoking play, the *Aisôpos.*[118] Twelve consec-

[114] See Gow 1965.
[115] Henderson 2000.
[116] Ploutarkhos *The Dinner of the Seven Sages.* On this dialogue, the participation of Aisopos at the dinner, and the silent presence of Kleobouline (who was called Eumetis, in 148c τὴν σοφὴν …καὶ περιβόητον ἀγνοεῖς Εὔμητιν; οὕτω γὰρ ταύτην ὁ πατὴρ αὐτός, οἱ δὲ πολλοὶ πατρόθεν ὀνομάζουσι Κλεοβουλίνην), see Detienne and Vernant 1974:288–290 and Mossman 1997; on the Seven Sages, cf. Martin 1993. Russo 1997 discusses significant aspects of the performance of traditional wisdom. I examine Ploutarkhos' *Dinner of the Seven Sages* in Yatromanolakis 2007a.
[117] Herodotos 2.134–135. Among the fables attributed to Aisopos one is about two *hetairai* (see Hausrath and Hunger 1970: 45 and 217; cf. Adrados 2003:44–45).
[118] Concerning the possible dating of *Aisôpos,* Arnott (1996a:75) assumes that "to the Greeks of Alexis' time Solon (a character in Αἴσωπος: fr. 9.1) and Aesop were figures of their remoter past, *to be classed with the heroes of myth;* myth burlesque throve in Athenian comedy at the beginning of Alexis' career but not later" (my emphasis). According to Arnott's estimations (1996a:19, 293), the first half of Alexis' career should be dated to the period before *c.* 330–320 BC.

utive lines from a dialogic part of *Aisôpos* are quoted by Athenaios,[119] and it is evident that in this comedy the figure of the politician and poet Solon, whose refined verses were performed by boys in the festival of Apatouria in the mid-fifth century and who was also given a role in Kratinos' *Kheirônes*,[120] was juxtaposed on stage with the figure of Aisopos. In the preserved fragment from *Aisôpos*, the discussion between Solon and a non-Athenian, possibly Aisopos, is about the Hellenic (read here: Athenian) way of drinking at *symposia*—more specifically, the Ἑλληνικὸς πότος. This short dialogue cannot help us reconstruct the possible plot of the play, especially since numerous Attic comedies were brimful of scenes with staged symposia or, more often, with chats about and descriptions of drinking-parties.[121] It would also be difficult, however attractive it might seem, to posit any connections between *Aisôpos* and *Kleoboulinê* on the basis of the intriguing appearance of their homonymous characters, along with Solon, in the same symposion, in Ploutarkhos' Τῶν ἑπτὰ σοφῶν συμπόσιον (*The Dinner of the Seven Sages*).[122]

However, for the figure of Aisopos the earliest source is to be found in the ethnographic discourse of Herodotos. In the specific narrative from his *Histories* to which I have referred, Aisopos is represented as a slave to a certain Iadmon at Samos. The geographical regions associated with the origins of Aisopos are intriguing: Samos, Thrace, Phrygia, and Lydia.[123] His fellow slave in the story that Herodotos relates is Rhodopis, a courtesan of Thracian origin. In the last years of the fifth or in the early fourth century the comic playwright Platon in the *Lakonians* or *Poets* referred to the return of Aisopos'

[119] Alexis fr. 9 K-A.

[120] Kratinos fr. 246 K-A (= Diogenes Laertios 1.62 Marcovich). On the performance of Solon's poems in the Apatouria, see Plato *Timaios* 21a–c, where Kritias relates a story about his childhood and mentions the chanting of Solon's poems by boys. Note the words used by Plato for the recitation of the poems: Ἐγὼ φράσω παλαιὸν ἀκηκοὼς λόγον οὐ νέου ἀνδρός. ἦν μὲν γὰρ δὴ τότε Κριτίας, ὡς ἔφη, σχεδὸν ἐγγὺς ἤδη τῶν ἐνενήκοντα ἐτῶν, ἐγὼ δέ πη μάλιστα δεκέτης· ἡ δὲ Κουρεῶτις ἡμῖν οὖσα ἐτύγχανεν Ἀπατουρίων. τὸ δὴ τῆς ἑορτῆς σύνηθες ἑκάστοτε καὶ τότε συνέβη τοῖς παισίν· ἆθλα γὰρ ἡμῖν οἱ πατέρες ἔθεσαν ῥαψῳδίας. πολλῶν μὲν οὖν δὴ καὶ πολλὰ ἐλέχθη ποιητῶν ποιήματα, ἅτε δὲ νέα κατ' ἐκεῖνον τὸν χρόνον ὄντα τὰ Σόλωνος πολλοὶ τῶν παίδων ᾔσαμεν (my emphasis). For Eupolis' late fifth-century *Dêmoi* and the possible appearance in it of Solon as one of the four dead leaders (Miltiades, Aristeides, and Perikles) who returned to Athens, see Storey 2003:115–116. For Kratinos' *Kheirônes*, see Pieters 1946:112–116.

[121] On *symposia* in Attic comedy, see Bowie 1997; and especially Fisher 2000. Cf. Diggle 2004:347–348. Scenes of *symposia* were popular in fourth-century comedy.

[122] Arnott is somewhat overskeptical (while his reconstructions of the plots of fragmentary comedies by Alexis and Menandros are almost too tolerant): "It is perhaps unlikely that Plutarch borrowed anything directly from Alexis for his own dialogue of the sages' banquet, even though he placed Aesop next to Solon in it [...] and introduced the subject of drunkenness into the conversation" (1996a:76).

[123] See Perry 1952:215–216 (testimonia 3–7).

soul to earth after his death.[124] Aristophanes, too, discussed and incorporated
in his plays fables attributed to the storyteller a number of times. Moreover,
an account about Aisopos preserved in Herakleides Lembos' excerpts from
Aristotle's *Constitution of the Samians* may possibly come from the writings
of Euagon or Eugaion, a fifth-century historian from Samos.[125] Concerning
the fifth-century presence of the figure of Aisopos, an Attic red-figure cup,
attributed to the Painter of Bologna 417 and dated to *c.* 450–440 BC,[126] depicts
a caricature of a man with oversized, slightly bald head who is wrapped in
his mantle. With a large nose, wrinkled forehead, and disheveled beard, he
is seated on a rock holding a stick in his hand. Opposite him sits a fox—the
size of its body being almost as large as the man's head—markedly gesturing
with its right foreleg, possibly an indication of narrating a story to the seated
chap, who, though his mouth is open, seems meditative as if a participant in
an act of storytelling. The image has most often been labeled "Aisopos and
the fox,"[127] but I agree with Paul Zanker's suggestion that the man may be a
parodic representation of an intellectual in the context of an overall antip-
athy, as well as ambiguous admiration, toward influential thinkers in Periklean
Athens.[128] The seated man might further be viewed, I suggest, as a manipula-
tion of the cultural image of *logopoioi* of the time (among whom Aisopos was
included)[129] through the genre marker of *psogos* poetry as exemplified by
Hipponax.[130]

[124] Platon fr. 70 K-A. See Kassel and Austin's annotation for the attribution of the play.
[125] See Perry 1952:216 (testimonia 5 and 6). On Euagon of Samos, see *FGrH* 535. On this fragment
from Aristotle's Σαμίων Πολιτεία, see Aristotle fr. 573 Rose and his apparatus criticus; Aristotle
fr. 591.1 Gigon. Cf. Dilts 1971:24, fr. 33 and on Herakleides Lembos and his excerpts, see Dilts
1971:7–13.
[126] Vatican, Museo Gregoriano Etrusco 16552; *ARV* 916.183; *Add.* 304 (Zanker 1995:33, fig. 19).
[127] E.g. Schefold 1997:86.
[128] Zanker 1995:32–34. Lissarrague (2000:137–138) discusses this vase-painting but finds the tenta-
tive identification of the seated man with Aisopos plausible. This identification goes back
to the first half of the nineteenth century (Otto Jahn being its first proponent; Lissarrague
2000:137), and its acceptance by numerous archaeologists attests to the lasting influence of
the scholarly paradigm explored in Chapter Two. Lissarrague's argument that this "represen-
tation of Aesop...on a cup used at banquets is not surprising" since "[t]he symposium lends
itself perfectly to the dramatization of the fables re-enacted by the drinkers" (2000:138) is
interesting. On Aisopos and traditions associated with his figure, see Nagy 1999:280–290. Cf.
Wiechers 1961, Karadagli 1981 (with references to earlier studies), Papademetriou 1987, and
Adrados 1999. For different versions of the *Life of Aisôpos*, see Perry 1952, Papademetriou
1987, Papathomopoulos 1999a, and Grammatike Karla 2001. Cf. also Papademetriou 1997 and
Robertson 2003. On modern renderings and versions of the fables and of the *Life of Aisôpos*, see
Parassoglou 1993 and Papathomopoulos 1999b.
[129] See the discussion below.
[130] See also figure 20 in Zanker 1995:33.

The association of Aisopos with Kleobouline in Ploutarkhos' *Dinner of the Seven Sages*[131] along with the fifth-century BC appearance in a narrative of Herodotos of the fabulist and the songs of Sappho about the decadent life of her brother Kharaxos and Rhodopis in Egypt may constitute signs of a broader web of metonymic interactions. As I pointed out, the performance of compositions of Sappho was indirectly associated with the storytelling of Aisopos in the *Histories* of Herodotos. To go a step further, it is important for this discussion as well as for the investigation in the following section that Aisopos' fables were performed in the context of *symposia* in Aristophanes' plays.[132] Much later, Aisopos himself figures as a skillful performer of popular wisdom and a propounder and solver of *problêmata* in the context of dinners.[133] I argue that the *logoi* of Aisopos and the songs of Sappho were first "juxtaposed" in the context of performances of stories, riddles, and poetic compositions at *symposia*. Antiphanes' fourth-century scene of the riddling poet and its broader discursive associations explored in this section contributed to marked male scannings of the figure of Sappho.

## Herodotos, Oral Traditions, and Symposia

As we have seen, the first possible comedy entitled *Sappho* may be the late fifth- or early fourth-century *Sappho* attributed to Ameipsias by Poludeukes.[134] I suggested that in contrast to a widely endorsed paradigm, the available sources about fourth-century comedies related to Sappho do not provide indications about her being represented as promiscuous. Numerous arguments about the influence of late fifth-century comedy on early and later traditions about Sappho rest solely on a one-word fragment from a play attributed to Ameipsias, the precise date of which is actually unknown. This scholarly paradigm has informed the study of a number of later texts connected with the reception of Sappho. A notable and early case in point is Herodotos' reference to Sappho in his account of the story of Rhodopis and Sappho's brother

---

[131] Ploutarkos 150a–f, 154a–c. In this banquet, in which the participants πρὸς ἀλλήλους ἅμα δειπνοῦντες ἔπαιζον (150c), Aisopos speaks about *aulos*-makers and performs a riddle by Kleobouline (150e–f). At another point in the sympotic discussion (154b), he attempts to defend Kleobouline's riddles and quotes another *ainigma* which, as he mentions, she propounded to them some minutes before dinner. Kleoboulos also discusses a story (*logos*) that his daughter Kleobouline told her brother (157a–b). On Aisopos and Kleobouline in this *symposion* and, more broadly, on Aisopos and *symposia*, see Yatromanolakis 2007a.

[132] See, especially, *Wasps* and cf. van Dijk 1997:188–229, Adrados 1999:233, 378.

[133] Cf. *Life of Aisopos* (*Vita Aesopi G* and *W*) and Ploutarkos *Dinner of the Seven Sages*.

[134] See the discussion above, pp. 295–297.

Kharaxos. This narrative, one of our earliest sources about the poet, is intro-
duced by Herodotos in the context of his discussion of the three pyramids of
the Egyptian kings Kheops, Khephren, and Mukerinos:[135]

πυραμίδα δὲ καὶ οὗτος (Μυκερῖνος) κατελίπετο πολλὸν ἐλάσσω τοῦ
πατρός, εἴκοσι ποδῶν καταδέουσαν κῶλον ἕκαστον τριῶν πλέθρων,
ἐούσης τετραγώνου, λίθου δὲ ἐς τὸ ἥμισυ Αἰθιοπικοῦ· τὴν δὴ μετε-
ξέτεροί φασι Ἑλλήνων Ῥοδώπιος ἑταίρης γυναικὸς εἶναι, οὐκ ὀρθῶς
λέγοντες· οὐδὲ ὦν οὐδὲ εἰδότες μοι φαίνονται λέγειν οὗτοι ἥτις ἦν ἡ
Ῥοδῶπις (οὐ γὰρ ἄν οἱ πυραμίδα ἀνέθεσαν ποιήσασθαι τοιαύτην, ἐς
τὴν ταλάντων χιλιάδες ἀναρίθμητοι ὡς λόγῳ εἰπεῖν ἀναισίμωνται),
πρὸς δὲ ὅτι κατὰ Ἄμασιν βασιλεύοντα ἦν ἀκμάζουσα Ῥοδῶπις,
ἀλλ’ οὐ κατὰ τοῦτον· ἔτεσι γὰρ κάρτα πολλοῖσι ὕστερον τούτων
τῶν βασιλέων τῶν τὰς πυραμίδας ταύτας λιπομένων ἦν Ῥοδῶπις,
γενεὴν μὲν ἀπὸ Θρηίκης, δούλη δὲ ἦν Ἰάδμονος τοῦ Ἡφαιστοπό-
λιος ἀνδρὸς Σαμίου, σύνδουλος δὲ Αἰσώπου τοῦ λογοποιοῦ. καὶ γὰρ
οὗτος Ἰάδμονος ἐγένετο, ὡς διέδεξε τῇδε οὐκ ἥκιστα· ἐπείτε γὰρ
πολλάκις κηρυσσόντων Δελφῶν ἐκ θεοπροπίου ὃς βούλοιτο ποινὴν
τῆς Αἰσώπου ψυχῆς ἀνελέσθαι, ἄλλος μὲν οὐδεὶς ἐφάνη, Ἰάδμονος
δὲ παιδὸς παῖς ἄλλος Ἴαδμων ἀνείλετο, οὕτω καὶ Αἴσωπος Ἰάδμονος
ἐγένετο. Ῥοδῶπις δὲ ἐς Αἴγυπτον ἀπίκετο Ξάνθεω τοῦ Σαμίου
κομίσαντος [μιν], ἀπικομένη δὲ κατ’ ἐργασίην ἐλύθη χρημάτων
μεγάλων ὑπὸ ἀνδρὸς Μυτιληναίου Χαράξου τοῦ Σκαμανδρωνύμου
παιδός, ἀδελφεοῦ δὲ Σαπφοῦς τῆς μουσοποιοῦ. οὕτω δὴ ἡ Ῥοδῶπις
ἐλευθερώθη καὶ κατέμεινέ τε ἐν Αἰγύπτῳ καὶ κάρτα ἐπαφρόδιτος
γενομένη μεγάλα ἐκτήσατο χρήματα ὡς [ἂν] εἶναι Ῥοδῶπιν, ἀτὰρ
οὐκ ὥς γε ἐς πυραμίδα τοιαύτην ἐξικέσθαι. τῆς γὰρ τὴν δεκάτην τῶν
χρημάτων ἰδέσθαι ἔστι ἔτι καὶ ἐς τόδε παντὶ τῷ βουλομένῳ, οὐδὲν
δεῖ μεγάλα οἱ χρήματα ἀναθεῖναι. ἐπεθύμησε γὰρ Ῥοδῶπις μνημήιον
ἑωυτῆς ἐν τῇ Ἑλλάδι καταλιπέσθαι, ποίημα ποιησαμένη τοῦτο τὸ μὴ
τυγχάνει ἄλλῳ ἐξευρημένον καὶ ἀνακείμενον ἐν ἱρῷ, τοῦτο ἀναθεῖ-
ναι ἐς Δελφοὺς μνημόσυνον ἑωυτῆς. τῆς ὦν δεκάτης τῶν χρημάτων
ποιησαμένη ὀβελοὺς βουπόρους πολλοὺς σιδηρέους, ὅσον ἐνεχώρεε
ἡ δεκάτη οἱ, ἀπέπεμπε ἐς Δελφούς· οἳ καὶ νῦν ἔτι συννενέαται
ὄπισθε μὲν τοῦ βωμοῦ τὸν Χῖοι ἀνέθεσαν, ἀντίον δὲ αὐτοῦ τοῦ νηοῦ.

---

[135] Herodotos 2.134–135. The text quoted is from Karl Hude's Oxford edition of Herodotos' *Histories*
(third ed., Oxford 1927). The text as printed in H. B. Rosén's Teubner edition (vol. 1, Leipzig
1987) differs slightly from Hude's text, but their divergences do not affect the present discus-
sion.

φιλέουσι δέ κως ἐν τῇ Ναυκράτι ἐπαφρόδιτοι γίνεσθαι ἑταῖραι·
τοῦτο μὲν γὰρ αὕτη, τῆς πέρι λέγεται ὅδε [ὁ] λόγος, οὕτω δή τι κλεινὴ
ἐγένετο ὡς καὶ οἱ πάντες Ἕλληνες Ῥοδώπιος τὸ οὔνομα ἐξέμαθον,
τοῦτο δὲ ὕστερον ταύτης τῇ οὔνομα ἦν Ἀρχιδίκη ἀοίδιμος ἀνὰ τὴν
Ἑλλάδα ἐγένετο, ἧσσον δὲ τῆς ἑτέρης περιλεσχήνευτος. Χάραξος δὲ
ὡς λυσάμενος Ῥοδῶπιν ἀπενόστησε ἐς Μυτιλήνην, ἐν μέλεϊ Σαπφὼ
πολλὰ κατεκερτόμησέ μιν. Ῥοδώπιος μέν νυν πέρι πέπαυμαι.

He, too, left a pyramid—much smaller than his father's—quadran-
gular, each side of the base twenty feet short of three plethra, and
up to half made of Ethiopian stone. Some among the Greeks say
that this [pyramid] was Rhodopis', the courtesan's, but they are not
correct in saying this; they seem to me to speak not even knowing
who Rhodopis was (otherwise they would not have attributed to
her the building of such a pyramid, on which countless thousands
of talents, so to speak, must have been spent); besides, [they do
not know] that Rhodopis flourished during the reign of Amasis,
not during the reign of Mukerinos. For Rhodopis lived very many
years later than those kings who left behind these pyramids; she
was Thracian in origin, a slave of Iadmon of Samos, the son of He-
phaistopolis, and a fellow slave of Aisopos, the composer of [prose]
stories. That he [Aisopos], too, was a slave of Iadmon was clearly
proved in this way: for, when the Delphians, following the oracle's
command, proclaimed many times that whoever wished could
claim recompense for Aisopos' life, no one else appeared—but only
the son of Iadmon's son, also called Iadmon, claimed compensa-
tion; so Aisopos, too, was a slave of Iadmon. But Rhodopis went to
Egypt when she was brought there by Xanthos of Samos, and having
come for work, she was freed for a great amount of money by a man
from Mytilene, Kharaxos, son of Skamandronymos and brother of
Sappho the song-maker. Thus indeed Rhodopis was redeemed from
slavery and remained in Egypt, and, being very alluring, she earned
a fortune that was large for her—for a Rhodopis—but certainly not
large enough for acquiring such a pyramid; for it is possible, even
to this day, for everyone wishing to do so to see a tenth of her prop-
erty, and [thus] there is no need to attribute great wealth to her. For
Rhodopis desired to leave in Greece a memorial of herself and, by
having something made which does not happen to have been con-
trived and dedicated by any other in a temple [before], to dedicate

it at Delphi so that her memory may be preserved. So, spending a tenth of her property, she had as many iron roasting spits for oxen as that amount would allow made for her, and she sent them to Delphi. And even today these spits still lie heaped behind the altar that the Khians dedicated, opposite the temple itself. Somehow, the courtesans in Naukratis tend to be particularly alluring; for, on the one hand, this woman [Rhodopis], about whom this story is told, became so famous indeed that all the Greeks learned the name of Rhodopis; and on the other hand, at a later period, another one whose name was Arkhidike, became celebrated in song (ἀοίδιμος) all over Greece, although less talked about in meeting places (περι-λεσχήνευτος) than [Rhodopis]. As for Kharaxos, when he freed Rhodopis, he returned to Mytilene, and Sappho rebuked him a great deal in song. And now concerning Rhodopis I leave off.

The story of Rhodopis is skillfully juxtaposed with other narratives about women and prostitution in the context of Herodotos' account of the succession of Egyptian kings in the second book of his *Histories*. Proteus—the king who, according to a *logos* that Herodotos adduces (2.112), allowed Helen to stay with him till Menelaos came to Egypt to take her back to Sparta—was succeeded by Rhampsinitos (2.121). It is in the account of Rhampsinitos' reign that we hear of a story according to which the king, in his effort to catch a cunning thief, set his daughter in a room as a prostitute and commanded her, before she sleeps with any of the men who would come to her, to compel them to tell her the cleverest and worst thing they had ever done.

The idea of a king's daughter becoming a prostitute to help her father recurs in Herodotos' narrative about the successor to Rhampsinitos, Kheops (2. 126).[136] In the broader context of this narrative, Herodotos refers to the building of one of the great pyramids in Giza, Kheops' pyramid. In contrast to the prosperity of Egypt during the reign of Rhampsinitos, Kheops' rule was cruel and hated by the Egyptians, who later did not want even to mention the names of Kheops and his brother Khephren, calling Kheops' and Khephren's pyramids after a shepherd (2. 128). The building of Kheops' pyramid was a most laborious and costly project. This pharaoh was so wicked that, being in need of money, he set his daughter in a house and ordered her to charge customers a certain amount of money for her services.[137] It is intriguing that

[136] See Fehling 1989:199, who discusses "motif-repetitions in close proximity."
[137] For the building of a monumental tomb (that of Aluattes) and the important role of prostitutes, cf. Herodotos 1.93.

Herodotos concludes this narrative by reporting that Kheops' daughter obeyed her father's order but also got the idea of leaving behind a memorial of herself (μνημήιον καταλιπέσθαι) and asked each man with whom she slept to give her as an extra present a block of stone. It was said that it was from those stones that a small pyramid was built in front of her father's great pyramid (2.126).

Herodotos repeats the theme of a woman wishing to leave behind a memorial of her own in a narrative (2.134–135) that forms part of the account of the reign of Mukerinos, thus incorporating Rhodopis and her dedication at Delphi into the whole act of narration.[138] The kingdom had passed from Khephren, Kheops' brother, to Mukerinos, Kheops' son, whose rule was just and highly respected—in contrast to that of Kheops and Khephren. Like the latter two, Mukerinos too left behind a pyramid, which, however, was wrongly (οὐκ ὀρθῶς λέγοντες) attributed by some Greeks to the courtesan Rhodopis.[139] Herodotos employs the phrase μετεξέτεροι Ἑλλήνων to refer to a story that "some among the Greeks" circulated (2.134). At this point in his narrative he does not tell us anything more specific about those Greeks.

*Quellenforschung*—the search for sources, especially written sources—has been a most significant practice in the scholarship on Herodotos.[140] A recent extensive study of the narrative about Rhodopis maintains that the source lying behind Herodotos' references to Kharaxos' affair with Rhodopis and to Sappho's poetic rebuke of it is a lost comedy by Kratinos; therefore, according to this reconstruction, the narrative about Rhodopis constitutes another case where fifth-century Attic comedy seems to have invented stories about Sappho and to have contributed to the shaping of her figure at a very early stage of her reception. Although it is acknowledged that this argument "requires that we date her entry into [comedy] somewhat earlier than our explicit references provide"[141] (so that Herodotos might have been able to draw on it), it is suggested that he got the information he provides from a comic source of the third quarter of the fifth century—a play by Kratinos which must have been well-known and easily recognizable by Herodotos' audiences.[142]

[138] Cf. Fehling 1989:199.
[139] For Herodotos' frequent references to "correctness" in the context of his overall argumentative style, see Thomas 2000:228–235.
[140] Cf. Murray 1987:93. For a recent overview, see Hornblower 2002.
[141] Lidov 2002:227. Note that Lidov 2002:228 reports that "she [Sappho] became a figure in comedy known for her sexual involvement rather than, or as well as," her poetry.
[142] For comedies related to Sappho, see the discussion above. There is no evidence about an earlier comedy by Kratinos in which Rhodopis, Naukratis, Kharaxos, and Sappho were drawn together, as Lidov (2002:227 and 229) admits. He also provides the qualification that "there are no grounds for guessing whether Herodotus is using one or several contemporary comic sources" (2002:230).

This reconstruction is interesting indeed. However, before endorsing it, investigation of the available relevant sources within their broadest possible context as well as locating cultural associations and nuances that may prove instrumental in our approach to Herodotos' narrative would be significant. Herodotos is not our only informant in regard to Kharaxos' affair with a courtesan and Sappho's reaction and reference to it in song. The early third-century BC composer of epigrams Poseidippos writes about the affair and Sappho's "dear song." In the late first century BC/early first century AD, the geographer Strabon, and two centuries later, Athenaios further refer to the story and Sappho's poetic involvement.[143] I draw on these informants in the course of my argumentation about the composition of Herodotos' narrative.[144]

We have already seen how the story of Rhodopis has been juxtaposed with other narratives about women and prostitution in the specific section of the second book of the *Histories*. The narrative about Rhodopis displays similar skillfulness in the way it is composed. Herodotos refutes entirely the story circulated by some Greeks that the courtesan of Naukratis had a great pyramid built for her. For this reason, he adduces two arguments that he presents as incontestable. *Those Greeks who give currency to this story speak about the pyramid and Rhodopis without knowing who Rhodopis actually was.* First, the building of such a pyramid would practically presuppose spending innumerable thousands of talents, and, although Rhodopis became remarkably famous—a kind of cultural metaphor for the great name that a *hetaira* could achieve—she could have never gained the wealth necessary for the construction of a monument that would be appropriate for a pharaoh; and second, chronological considerations make it impossible for Rhodopis to have had this specific pyramid built for her since her heyday coincided with the reign of Amasis in the sixth century, not that of Mukerinos, who lived much earlier.

From this point onward, Herodotos focuses on what he had heard and the information he had collected about Rhodopis' life—that is, on what he presents as the "true stories" about her. Initially Rhodopis was a slave of a man from Samos. She was also a fellow slave of Aisopos, the composer of prose stories (λογοποιός). Herodotos makes this point in order to substantiate his previous statement about the chronology of Rhodopis.[145] In this narrative, Aisopos is represented as a "resident" of Samos. The geographical regions associated with the legendary storyteller are significant. His fellow slave in this narrative is of Thracian origin. Other informants present Aisopos as Thracian, Phrygian

---

[143] For other sources, see below.

[144] I shall further consider sources that Lidov and other researchers have not taken into account.

[145] Cf. Lloyd 1988:85, who refers to later sources about Aisopos' *floruit*.

or Lydian—an aspect of ancient Greek mentalities that supports the argument advanced in Chapter Two concerning the interdiscursivity of regional features displayed on the vase-paintings with the "elaborately dressed revelers and musicians." In his effort to substantiate his point about Aisopos and his Samian master, Herodotos refers to a legend associated with Aisopos and Delphi.[146] He will again use evidence from Delphi later in this narrative, when he will describe Rhodopis' dedication at the sacred space of the Delphic temple. Throughout the narrative (2.134–135), statements about the correctness of Herodotos' account and arguments supporting his statements are so subtly interwoven that the unfolding of the narrative may occasionally seem cluttered with digressions.[147] In fact, however, each element is connected with broader themes ingeniously exploited by Herodotos.

Since Rhodopis was a slave of a certain Iadmon from Samos, the idea that she was brought to Egypt by another Samian, Xanthos, comes as no surprise. It may not be a coincidence that in later traditions Xanthos was the Samian master of Aisopos.[148] Herodotos stresses that Rhodopis came to Egypt to ply her trade (κατ' ἐργασίην), which accounts for her erotic affair with Kharaxos, a native of Lesbos who spent a great sum of money to purchase her freedom. It is in this context that Sappho's name is first introduced, and the whole narrative ends with another reference to Kharaxos and Sappho, but especially to the poetry of the latter. It is significant that during the different stages of her career as presented in Herodotos, Rhodopis' name was associated with the name of a fable maker and eventually of a song-maker (μουσοποιός). While λογοποιός ("composer of stories") is also used by Herodotos to define the early Ionian logographer Hekataios of Miletos (2.143, 5.36, 5.125),[149] μουσοποιός occurs only in connection with Sappho (2.135). Elsewhere in the same book, the term employed for Homer and Aiskhylos is ποιητής (2.23 and 2.156, respectively).[150] Interestingly, although Sappho is a μουσοποιός, Alkaios is called a ποιητής (5.95), while Anakreon is mentioned as "Anakreon of Teos," without

---

[146] On this legend, see Lloyd 1988:85–86.

[147] For instance, Herodotos' discussion of the special charms of courtesans from Naukratis at the end of his narrative (2. 135. 5–6 "somehow, the courtesans in Naukratis...") has often been viewed as a digression to the broader digression that he allegedly makes with this narrative about Rhodopis.

[148] See *Vita Aesopi* 20–90 (*Vita G* and *Vita W*).

[149] On Hekataios as *logopoios* in Herodotos, see, among other discussions, Murray 1987:99–100; Hartog 1988:296; Thomas 2000:163, 167. Note that Hekataios is first called *logopoios* (2.143) only several chapters after Aisopos is so called.

[150] Cf. 2.53 (where Hesiod is also mentioned). Homer is called ἐποποιός elsewhere in the *Histories* (7.161); see also 2.116 (ἐς τὴν ἐποποιίην used in connection with Homer), and cf. 2.120 (...εἰ χρή τι τοῖσι ἐποποιοῖσι χρεώμενον λέγειν).

the tag ποιητής.[151] The feminine form ποιήτρια occurs at a later period,[152] and Sappho is called so by Strabon, Pausanias, Galenos, Aelian, and Athenaios—among other writers.[153] The term *mousopoios* employed here by Herodotos might perhaps be viewed as the earliest case in our written sources of a subtle differentiation between male poets and Sappho. Μουσοποιός may also be associated, on some level, with Sappho's use of μουσοπόλος in fragment 150 V:

 οὐ γὰρ θέμις ἐν μοισοπόλων <δόμωι>
θρῆνον ἔμμεν' <.......> οὔ κ' ἄμμι πρέποι τάδε

For it is not right in a house of those who serve the Muses
that there be lament...that would not befit us.

Be that as it may,[154] *mousopoios* should certainly be considered in the context of the intense, sudden popularization of terms for "making poetry" in the fifth century: ποιητής, ποίησις, μελοποιός ("maker of songs"), and a number of other compound words employing the suffix -ποιός.[155] In fact, in the fifth-

---

[151] Cf. "Simonides of Keos" (5.102); "Arkhilokhos of Paros" (1.12; but some scholars delete the reference to Arkhilokhos in this passage; see How and Wells 1928:vol. 1, 59 and Rosén 1987:9, who does not delete it); "Olen, a Lycian man" (4.35); "Solon of Athens" (5.113). For Pindar, see 3.38 (καὶ ὀρθῶς μοι δοκέει Πίνδαρος ποιῆσαι νόμον πάντων βασιλέα φήσας εἶναι); cf. Phrynikhos in 6.21 (...καὶ ποιήσαντι δρᾶμα Μιλήτου ἅλωσιν καὶ διδάξαντι...). Cf. also "Arion of Methymna...second to none of all the kitharodes of his time" in 1.23.

[152] See a third-century BC inscription (218/7 BC) from Lamia, *SIG* 532.3–5 ἐπειδὴ Ἀριστο[δ]άμα Ἀμύντα Ζμυρναία ἀπ' Ἰω[νίας] ποιήτρια ἐπ[έ]ω[μ] πα[ρα]γ[ε]νομ[έ]να ἐν τὰμ πόλιν πλείονας ἐ[πιδείξεις] ἐποιήσατο τῶν ἰδίωμ ποιημάτων, and another contemporary inscription (end of the third century BC) from Delphi, *SEG* 2.263.2–4 ἐπειδὴ [Ἀριστοδ]άμ[α Ἀμ]ύντα Ζμυρναί[α] ἀπ' Ἰωνί[ας] [ἐπέωμ] ποιήτρ[ια] παρα[γε]νομ[έν]α (a number of letters survive after the participle, but the text cannot be restored with any certainty). It is worth noting that the ποιήτρια Aristodama is from Ionia and that the first inscription (as it is restored) refers to the mode of her performances. See also *SEG* 49.556 and 49.618 (on *SEG* 2.263 and *SIG* 532) as well as the new inscription from Kos published by Bosnakis 2004 (...Κώιαν ποιήτριαν...); cf. *SEG* 30.1066.3–4 (for a hypothetical restoration of ποιήτρια). Alexis wrote a comedy entitled *Ποιήτρια* (fr. 189 K-A), but the precise meaning of the title is uncertain (see Arnott 1996a:555).

[153] Strabon 17.1.33 (ἡ τῶν μελῶν ποιήτρια); Pausanias 8.18.5; Galenos 4.771; Aelian *Historical Miscellany* 12.19; Athenaios 13.596e, 15.687a.

[154] It has been proposed (Svenbro 1984a:171 and 208n93) that the original reading in Herodotos 2.135 could have been *mousopolos* instead of *mousopoios*, and that *mousopoios* is the result of a scribal error. For Svenbro, if *mousopolos* was the original reading, it would constitute an example of Herodotos' tendency to assimilate epic and lyric phrases into his narratives. I agree with Ford (2002:134n6) that Svenbro's skepticism about *mousopoios* is not useful.

[155] On this fifth-century phenomenon, see especially Ford 2002:131–137 (with references to earlier approaches); on *poiein* in connection with "making poetry," cf. also Graziosi 2002:41–47 and, from a different, thought-provoking perspective, Nagy 2004b.

century, Euripides employs *mousopoios* twice:[156] in both cases it refers to the
future *memorialization* of heroes by performers and poets.

Herodotos' narrative concludes with a reference to Sappho and her song-
making (2.135.6). After the first occurrence of Sappho's name (2.135.2) the
emphasis is on how Rhodopis, having been redeemed, had the opportunity to
remain in Egypt and to gain a great fortune because of the outstanding art
of her seductiveness. The wealth she amassed was substantial for a courtesan
but not enough for the building of a pyramid like that of a king, Mukerinos,
the pharaoh with whom the whole narrative started. Although Rhodopis—
Herodotos emphasizes—could not have had such a grand monument built for
her, she felt *the desire* (ἐπεθύμησε) to leave behind a memorial of herself in
Greece. Herodotos' account here returns to the land of Rhodopis' initial career
and, more specifically, to Delphi, where evidence about her fortune could be
found.

It should be pointed out that what runs through the whole narrative is an
intricate emphasis on "making" (a monument or a song). Rhodopis desired to
make a *poiêma* (ποίημα ποιησαμένη), to commission artisans to make an arti-
fact that would function as a memorial of herself—an artifact that, emphati-
cally, no one else had thought of dedicating in a sanctuary.[157] It is significant,
I suggest, that Herodotos foregrounds Rhodopis' monument at Delphi by
describing it as a *poiêma*, a word denoting both a "made thing" and a "poem"
that eventually connects Rhodopis' and Sappho's *poiêmata* through an inter-
posed mention of other *poiêmata* composed for Rhodopis and another cour-
tesan, Arkhidike. *Poiêma* in the sense of "poem" occurs already in Kratinos
fragment 198.5 K-A (ἅπαντα ταῦτα κατακλύσει ποιήμασιν, "he will swamp
the whole place with his poems").[158] Rhodopis' desire for a *poiêma* is fulfilled
during her lifetime through the impressive, according to her, construction of
numerous ox-sized roasting spits made of iron, which she, a *hetaira*, sent to the
much-visited, sacred space of Delphi to stand as a memorial of herself.

---

[156] *Hippolutos* 1428–1430 ἀεὶ δὲ μουσοποιὸς ἐς σὲ παρθένων | ἔσται μέριμνα, κοὐκ ἀνώνυμος πεσὼν
| ἔρως ὁ Φαίδρας ἐς σὲ σιγηθήσεται and *Trojan Women* 1188–1189 τί καί ποτε | γράψειεν ἄν σοι
μουσοποιὸς ἐν τάφωι; (cf. Barrett 1964:413).

[157] On Rhodopis' dedication, see Ridgway 1987:406, Lloyd 1988:87, von Reden 1997:173, and
McClure 2003:151. Jeffery 1990:124 observes that "[Rhodopis] wished to make a memorable gift;
may it not have been the size and quantity which made it so?" (1990:124). Benardete 1969:56
and Steiner 1994:139 discuss the passage but do not pay attention to the double meaning of
*poiêma*. Kurke 1999:224–225 analyzes ironical aspects of Herodotos' presentation of Rhodopis
and her dedication.

[158] A fragment from his *Pytinê*, produced in 423 BC.

However, Rhodopis did not become famous only because of her memorial. Herodotos here hastens to add a crucial observation that he had inchoately introduced in 2.135.2 (κάρτα ἐπαφρόδιτος): being a courtesan in Naukratis somehow, almost metonymically, entails being invested with the distinctive aura of a particularly gifted expert in the art of allurement. In Rhodopis' profession, the name of Naukratis functioned as symbolic capital that contributed decisively to the fame and marketability of a seductive woman. Courtesans residing in Naukratis could somehow become exceptionally famous, and Rhodopis, being initially associated with Aisopos on Samos (characteristically, a place also known for its courtesans), had the fortune to be brought by a Samian to Egypt and, especially after meeting Sappho's brother Kharaxos, to launch as a freedwoman a notable business in Naukratis. Nuanced associations and ideas are masterfully interwoven in this narrative: Herodotos concludes it by reintroducing the names of the *mousopoios* and Kharaxos and by stressing that Rhodopis' career as an especially beguiling and wealthy sixth-century courtesan became so well known that people throughout Greece were able to say a great deal about her. To be sure, no section in the narrative can be called a "digression."

Several questions arise with regard to the whole story that Herodotos recounts. Does he provide any cues indicating specific contexts that facilitated or fostered the trafficability of the courtesan's name? In the context of this adroitly composed narrative, does he allow us to understand who the μετεξέτεροι Ἑλλήνων who gave currency to the false story about the pyramid might have been? Where could one hear the apparently more convincing, albeit somewhat ironically charged, stories about the life of Rhodopis? Do we need to posit the existence of one or more comedies about Rhodopis in which the names of Sappho and Kharaxos were involved so that we may be able to locate Herodotos' *Quellen* for this narrative? More specifically, who were his informants?

I argue that a significant marker pointing to a context within which stories about Rhodopis circulated is provided by περιλεσχήνευτος toward the end of the narrative. The adjective that Herodotos chose to use here does not occur elsewhere in ancient Greek literature.[159] περιλεσχήνευτος should be viewed in the light of cultural practices pervasive in archaic Greece, that is, practices conducive to the dissemination of traditions and orally transmitted

---

[159] It is used by medieval Greek writers in the eleventh and twelfth centuries. Cf. also Hesykhios, s.v.

stories related to different places. It refers to conversations and entertaining chats about courtesans in the context of drinking-parties, men's meeting places, taverns, and related venues. περιλεσχήνευτος should be glossed as "talked of in every club" or "talked about in the men's clubs."[160] That discussions about (real or purported) courtesans and prostitutes took place in the context of drinking-parties and related male gatherings is suggested by several fragments of archaic poetry.[161] At the same time, that *hetairai* were an integral element of early symposia is indicated by numerous representations that start appearing on Attic vases from the mid-sixth century onward.[162] A graffito on the underside of a Korinthian black-glazed *skyphos* (*c.* 475–450 BC) from a public dining place in the Athenian Agora reflects discussions favorable in male gatherings: Σικελε καλε τοι δοκει τοι μοιχοι ("the Sicilian woman, I tell you, seems beautiful to the adulterer").[163]

Furthermore, I would draw attention to the intriguing fact that on a red-figure sympotic cup attributed to Makron and dated to the first quarter of the fifth century (*c.* 490–480 BC) the inscription Ροδο[π]ις κ[α]λε ("Rhodopis is beautiful") occurs: on the interior we see a satyr playing an *aulos* and a female companion with flowing hair and a *thursos*, while the two sides of the cup depict a continuous scene of a *symposion* where reclining men and naked or half-naked women play the game of *kottabos* and listen to the music of a standing *aulos*-player.[164] According to a restoration proposed by Beazley, on a fragment from another contemporary cup attributed to Makron, the inscription [Ρ]οδο[πις] was placed near a woman performer holding an *aulos*; behind

[160] See LSJ, s.v. Cf. Kurke 1999:225, who persuasively renders it as "talked of in the men's clubs." Kurke deems περιλεσχήνευτος a "pedestrian" term and argues that there is an "abrupt shift in style" here (1999:225), but given the fact that the adjective occurs only once in Herodotos (2.135.5) and nowhere else in ancient Greek literary or historical texts (see above), it is difficult to ascertain the validity of this suggestion.

[161] See e.g. Arkhilokhos fr. 206–209, 302 W (the authenticity of the latter is defended by Casadio 1996: 33–34) and Anakreon fr. 346 *PMG* (with Kurke's analysis; 1999:191–195). Cf. *carmina convivialia* 905 *PMG*.

[162] See, among more recent studies, Peschel 1987 and Reinsberg 1993:104–112. Given the synchronic emphasis of my discussion, I refrain here from referring to the large number of later literary representations of the presence of *hetairai* and sex-workers at sympotic gatherings.

[163] See Rotroff and Oakley 1992:98, no. 148 (Σικελὴ καλή τοι δοκεῖ τῶι μοιχῶι, which is rendered as "Sikele [or the Sicilian girl] seems beautiful to the adulterer"); for the graffito, see their fig. 22 and pl. 53. For τοι (in the sense of "you know," "I tell you," "mark my words," "hark!"), see Denniston 1954:537 ("Its primary function is...to establish, in fact, a close rapport between the mind of the speaker and the mind of another person. [...] τοι implies, strictly speaking, an audience."

[164] New York, Metropolitan Museum 20.246; *ARV* 467.118, 1616, 1654; *Add.* 245; Kunisch 1997:pl. 130.377. The scene of the symposion on the drinking-cup includes, among other things, a standing woman holding the head of a man who is vomiting into a container.

her, *krotala* are hung in the field.[165] I should note that, except for its occurrence on few Attic vases, "Rhodopis" is extremely rare as a Greek personal name in any geographical region.[166] It is also worth pointing out that, at a much later period, Ῥοδόπη (not Ῥοδῶπις) will become the name of a *hetaira* or a young woman who, naked along with other exceptionally charming women, busied herself with beauty contests of an experimental character.[167] Fantasies and stories of similar beauty contests were exploited by Kerkidas and Alkiphron,[168] but what may perhaps be significant in the case of the two red-figure vase-paintings with "Rhodopis" is that the rarely attested name is again associated with a courtesan at a later period in Heliodoros' novel *Ethiopian Story*.[169] I argue that at least the nonfragmentary cup with the inscription "Rhodopis is beautiful" suggests that the *name* Rhodopis circulated within the sympotic visual culture of the late-archaic period.[170]

Herodotos stresses that the *hetaira* Rhodopis was περιλεσχήνευτος, certainly more so than another enthralling woman whose career was associated with Naukratis, Arkhidike. In this context, he employs two poetic terms which, as has been rightly observed, occur in epic and lyric compositions but are quite rare in prose texts: ἀοίδιμος ("celebrated in song") and κλεινή ("renowned").[171] Arkhidike "became celebrated in song all over Greece," an

---

[165] Rome, Mus. Naz. Etrusco di Villa Giulia [Kunisch 1997: no. 121]; *ARV* 477.305; Kunisch 1997: pl. 42.121. Even Αρχεδικε καλε appears on a red-figure lekythos attributed to the Sabouroff Painter and dated to *c.* 450 BC: the inscription is placed between a seated woman holding a mirror and a draped youth leaning on his stick and looking at her (New York, Metropolitan Museum 26.60.78; *ARV* 844.151, 1614; *Add.* 296). Further, on a fragment of an Attic black-figure cup-*skyphos* occurs the inscription [A]rkhedike: London, British Museum 1911.6–6.17; Hogarth et al. 1898/1899:56, no. 108.

[166] See *LGPN* vol. II (Attica): 391, s.v. Ῥοδῶπις and vol. IV (Macedonia, Thrace, Northern Regions of the Black Sea): 300, s.v. Ῥοδῶπις.

[167] *Anthologia Palatina* 5. 36. I want to adduce here another source on the name "Rhodope": a character in Loukianos' dialogue *On Dance* 2 claims: ἀνὴρ δὲ τίς ὤν … καὶ ταῦτα παιδείᾳ σύντροφος καὶ φιλοσοφίᾳ τὰ μέτρια ὡμιληκώς, ἀφέμενος … τοῦ περὶ τὰ βελτίω σπουδάζειν καὶ τοῖς παλαιοῖς συνεῖναι κάθηται καταυλούμενος, θηλυδρίαν ἄνθρωπον ὁρῶν ἐσθῆσι μαλακαῖς καὶ ᾄσμασιν ἀκολάστοις ἐναβρυνόμενον καὶ μιμούμενον ἐρωτικὰ γύναια, τῶν πάλαι τὰς μαχλοτάτας, Φαίδρας καὶ Παρθενόπας καὶ Ῥοδόπας τινάς, καὶ ταῦτα πάντα ὑπὸ κρούμασιν καὶ τερετίσμασι καὶ ποδῶν κτύπῳ […]. "Rhodope" is here employed as a marked example of the most lustful women of antiquity whose stories are mimetically performed by an effeminate fellow.

[168] Kerkidas fr. 14 *CA*; Alkiphron *Epistles* 4.14.4, a buttocks beauty contest between two *hetairai*.

[169] Heliodoros 2.25. In Akhilleus Tatios' *Leukippê and Kleitophôn* 8.12 another marked case of the name "Rhodopis" occurs.

[170] Note that "Rhodopis" could have been well used as a *redender Name*.

[171] Kurke 1999:224. Cf. LSJ s.vv. In line with her overall approach (cf. the same argument in Kurke 1994), Kurke believes that there is an "inconcinnity" in Herodotos' use of these terms in the context of "his determinedly practical account of Rhodopis." Instead, I argue that ἀοίδιμος and κλεινή signpost the broader context within which περιλεσχήνευτος should be understood.

idea that recurs in Herodotos only once more in the context of his discussion of a remarkable Egyptian song, the "Linos," an orally transmitted traditional composition that was ἀοίδιμος in Phoinike, Kypros, and elsewhere.[172] I suggest that especially ἀοίδιμος offers additional contextualization cues for the understanding of the semantic and wider sociocultural associations of περιλεσχήνευτος, as it foregrounds the discursive frames within which Arkhidike became a theme for song. The term points to sociocultural spaces that broaden the meaning of περιλεσχήνευτος. Songs about the courtesan Arkhidike should have been performed mostly in male gatherings. It also adumbrates the final reference to Sappho's song-making. As Herodotos constructs his argument, both Arkhidike and the "renowned" Rhodopis were περιλεσχήνευτοι and ἀοίδιμοι. The difference was only one of degree and impact.[173] For Rhodopis, "about whom this story (λόγος) is told," both stories and songs circulated in Hellas. Interestingly, her career as slave and courtesan brought her into contact with a *logopoios* and the brother of a *mousopoios*. Since the ethnographer's aim is to refute an exaggerated, albeit amusing, story that gained currency among some Greeks—a story that anachronistically associates Rhodopis with the pyramid of the Egyptian king he is discussing here—he adduces narratives that effectively support his argument; he does not discuss nor, in this context, does he need to prove their intrinsic "historicity."[174] For him, these stories are markers of "who Rhodopis actually was," while some of them are further supported by the evidence one could find at Delphi. Even though presented by Herodotos with touches of irony, the stories about Rhodopis make evident that she could not have had a pyramid built for herself. The courtesan was much "talked about in the men's clubs" and everyone in Hellas knew her name. For Herodotos, one needed to visit Delphi in order to view the actual *poiêma* of Rhodopis. As for chronologically plausible stories about her, the περιλεσχήνευτος ἑταίρη had made a widely known career in the context of male gatherings and sympotic occasions. Herodotos points to his "sources," and, therefore, postulating the existence of an unknown comedy as a possible poetic source for him would be a redundant

---

[172] Herodotos 2.79. This account is again part of Herodotos' Egyptian ethnography. Among other occurrences of ἀοίδιμος, in the Homeric Hymn to Apollo the god's Delphic temple is "to be a theme of song for ever" (3.299 ἀοίδιμον ἔμμεναι αἰεί), while in the Iliad Helen says to Hektor that Zeus has brought an evil doom upon them so that they may be a theme for song for men to come (6.357–358 ὡς καὶ ὀπίσσω | ἀνθρώποισι πελώμεθ᾽ ἀοίδιμοι ἐσσομένοισι). On ἀοίδιμος in Pindar, see Pfeijffer 1999:408, 548–549.
[173] According to the ethnographer, Rhodopis' relation with Kharaxos became the theme for song even for Sappho.
[174] Cf. n. 180 below.

speculation.[175] This latter approach bespeaks a preference for the authority of written, canonized forms of literary discourse at the expense of oral story-telling.[176] The marked denotation of ἀοίδιμος and περιλεσχήνευτος and the broader cultural connotations with which they invest Herodotos' narrative suggest, I argue, that his sources were stories orally transmitted in men's meeting-places and sympotic gatherings.

As we have seen, before he closes his narrative ("and now concerning Rhodopis I leave off") Herodotos returns to Kharaxos—in a form of ring composition:[177] "as for Kharaxos, when he freed Rhodopis, he returned to Mytilene, and Sappho rebuked him a great deal in song."[178] It should be observed that Kharaxos' name is reintroduced *just after* Herodotos' discussion of how much περιλεσχήνευτος Rhodopis was. I suggest that the syntagmatic contiguity of the final reference to Kharaxos with the emphatic περιλεσχήνευτος and its sociocultural associations indicates that the story about Kharaxos should be viewed as part of the chats and singing about the courtesan that took place in male gatherings. This accounts for the arresting transition of the narrative to Kharaxos and Sappho. Although most often taken (and rendered) as a further digression untidily appended at the very end of Herodotos' account, the reference to Sappho's brother and song-making substantiates not only the ethnographer's original point about the courtesans in Naukratis being partic-

---

[175] The reasoning behind Lidov's reconstruction of the *Quellen* in the narrative (2002:214) is that by "some Greeks" in the case of the incorrect attribution of the pyramid, Herodotos must have meant Hekataios and the Ionian geographers. Building on this hypothesis, Lidov argues that Hekataios could have only learned this story from the Greeks in Naukratis. This suggestion, the argument continues, would rule out Hekataios and the Greeks in Naukratis as the source of the correct story that Herodotos provides and contrasts to the one favored by "some Greeks." Lidov believes that "since it is probably a Naucratite version that he corrects, Herodotus would not have heard [the correct story] there" (2002:214), and he attempts to postulate that the literary source on which Herodotos was based was one or more plays belonging to a single genre: comedy. In Lidov's reconstruction, the scholarly paradigm of *Quellenforschung* is combined with the paradigm of "comedy as the original source of early and later traditions about Sappho." On Herodotos' sources in the Egyptian *logos*, see Hunter 1982:308–310. On his historical method, cf., among other studies, Lateiner 1989 and especially Darbo-Peschanski 1987; on narrative strategies in Herodotean storytelling, see Kazazis 1978. Thomas 1993 discusses Herodotos and oral performance. For the modern skepticism toward oral sources and the complex politics of oral history research, see Prins 2001. For oral sources in Herodotos, see, especially, Lang 1984, Murray 1987, Cobet 1988, Thomas 1989:95–154, Flower 1991, and Evans 1991:89–146.

[176] It reflects traces of judgment of taste not shared by the transmitters of such oral traditions. For the notion of "distinction" as a modern category of cultural judgment, see Bourdieu 1984.

[177] Mary Douglas is preparing a penetrating book on the anthropology of ring composition in diverse cultural performative and other traditions: Douglas forth.

[178] On the use of κερτομέω in the context of festivities of men, see below, n. 256. On the complex meaning of κερτομέω in Homer, see Clay 1999.

ularly alluring, but, more importantly, his discussion of how ἀοίδιμοι, κλειναί, and περιλεσχήνευτοι they can be. What Herodotos actually claims here can be formulated as follows: "in men's clubs and related venues there is a lot of conversation, common talk, and singing about Rhodopis; recall Kharaxos' relation with her, which is also sung of, since Sappho rebuked him in song (ἐν μέλεϊ)." Sappho's μέλος was part of the cultural performance and reperformance of Rhodopis' story in male gatherings. And that must have been known to Herodotos' audiences since Rhodopis "became so famous indeed that all the Greeks learned her name" and, on top of this, she was impressively περιλεσχήνευτος.[179]

Sappho's song-making is also further proof for the chronological argument Herodotos initially advanced against the wrong attribution of the building of a great pyramid to Rhodopis. His use of ἐν μέλεϊ ("in song") makes his first reference to Kharaxos as Sappho's brother chronologically more grounded. As is the case with ἀοίδιμος, the song(s) of Sappho further contribute to the elucidation and expansion of the meaning of περιλεσχήνευτος. In a dense network of signification, Herodotos provides markers pointing to contexts where stories and songs related to Rhodopis circulated and were reperformed. In line with his argumentative style, he chooses to focus on *poiêmata* that defined the name of the *hetaira*.[180]

That Sappho composed a song or songs about Kharaxos' relation with a Naucratite woman is confirmed by other sources. However, what these sources make evident is that Sappho did not use the name Rhodopis for Kharaxos' lover. She referred to that lover as Dorikha. Poseidippos composed an epigram about Dorikha and Kharaxos in which he also made mention of Sappho and her poetic contribution to the dissemination of the "fame" of Dorikha:[181]

> Δωρίχα, ὀστέα μὲν †σ' ἁπαλὰ κοιμήσατο δεσμῶν
> χαίτης ἥ τε μύρων ἔκπνοος ἀμπεχόνη,

---

[179] Describing Rhodopis here as "κλεινή throughout Greece" was not enough for Herodotos; he makes the additional point that she was noticeably περιλεσχήνευτος.

[180] It would be misleading to believe that Herodotos is here engaged in proving what we would nowadays call the "historicity" of each detail of his narrative. Rather, he refers to stories and general—not scientifically precise—chronological markers that refute the false story that "some Greeks" gave currency to (cf. οὐκ ὀρθῶς λέγοντες in 2.134.1).

[181] Poseidippos 17 G-P. For line 1 different emendations have been proposed (see Gow and Page 1965:vol. 2, 497). Austin and Bastianini 2002:158 print Δωρίχα, ὀστέα μὲν σὰ πάλαι κόνις ἦν ὅ τε δεσμός (see their apparatus criticus and Austin's translation "Doricha, your bones were dust long ago, and the ribbon [of your hair]"). Wilamowitz 1913:19–20n1 preferred to print Δωρίχα, ὀστέα μὲν σὰ πάλαι κόνις ἠδ' ἀναδεσμός. For another restoration, see Angiò 1999:153. Gow and Page 1965:vol. 2, 497 suggested that "σὰ πάλαι κοιμήσατο is highly plausible but there would seem to be a lacuna between [lines] 1 and 2." I agree that κοιμήσατο in the transmitted text should not be dismissed. On this line, cf. Schott 1905:36–38 and Fernández-Galiano 1987:114, 116.

ἦ ποτε τὸν χαρίεντα περιστέλλουσα Χάραξον
σύγχρους ὀρθρινῶν ἥψαο κισσυβίων·
Σαπφῷαι δὲ μένουσι φίλης ἔτι καὶ μενέουσιν
ᾠδῆς αἱ λευκαὶ φθεγγόμεναι σελίδες.
οὔνομα σὸν μακαριστόν, ὃ Ναύκρατις ὧδε φυλάξει
ἔστ' ἂν ἴῃ Νείλου ναῦς ἐφ' ἁλὸς πελάγη.

Dorikha, your bones fell asleep [long ago] and the band(s)
    of your hair and the perfume-emanating wrap
with which you once covered handsome Kharaxos,
and, skin to skin, you grasped the morning wine-cups.
But Sappho's white[182] phonating[183] columns
    of dear song still remain and will remain.
Blessed is your name, which Naukratis will thus preserve
    as long as a ship sails from the Nile on the open sea.

I want to focus here on two aspects of this complex epigram. First, it would be difficult to maintain that it is merely an unequivocal celebration of—a praise poem composed for—a seductive woman. In an intertextual response to Sappho, Poseidippos playfully exploits the discrepancy between his apparent eulogy and Sappho's negative poetic reaction to the affair between Kharaxos and Dorikha. Note that the epigram does not focus on other aspects of Dorikha's career but on this specific affair.[184] In lines 5 and 6, the learned epigrammatist constructs a multilayered representation of the "lucid," "resounding" columns of Sappho's "dear" song.[185] In his emphatic transition to

---

[182] Or "lucid" (cf. Gow and Page 1965:vol. 2, 498).

[183] Or "resounding."

[184] The reference to a ship that sails from the Nile to the salty sea has been aptly interpreted as alluding to Naukratite ships carrying papyri: Rosenmeyer 1997:132. One might go a step further and suggest that the whole image is about Dorikha's name that remains and will remain written and safely preserved on Egyptian papyri containing Sappho's song(s); this will secure the dissemination of Dorikha's name.

[185] Lidov (2002:223) takes the phrase "dear song" too literally ("friendly song") and believes that "the 'problem' here is that the epigram hardly makes sense unless the poem [of Sappho] praised Doricha: it contradicts Athenaeus' statement directly and Herodotus' by implication." Cf. his view (2002:226) that "together, the Posidippus epigram and [Sappho] fragment 5 could lead us to expect only friendly and affectionate relations." For Athenaios' discussion of Dorikha and Kharaxos, see below. Lidov also rejects Wilamowitz's suggestion that certain aspects of the epigram may be ironic (1913:19–20) and holds that there seems to be no reason to "make words mean their opposite as a source of humor *at the expense of the ignorant (the ones who know about Doricha but not Sappho)*" (2002:223n46; my emphasis). However, the epigram stresses the impact of Sappho's song, and not other aspects of Dorikha's life and career. This argument supposes, on no evidence, that Poseidippos' Hellenistic readers knew about Dorikha but not about Sappho's poetry.

the song-making of Sappho, he confirms that the papyrus roll containing the performative utterances of her odes will remain a speaking testimony to the story and to Dorikha's accomplishment to become a theme for a song or songs composed by Sappho.[186] Among other possible aspects, Poseidippos chooses to single out the "morning wine-cups" that Dorikha shared with Kharaxos, thus associating the couple with one of the most significant performative spaces within which their story circulated.

Second, Poseidippos' epigram attests that he was familiar with a song or songs by Sappho related to Kharaxos and Dorikha, a woman who lived in Naukratis. Such a song has been detected among the preserved fragments of Sappho, but more recently it has been proposed that the references in Herodotos, Poseidippos, and other texts[187] to Sappho's composition(s) rebuking her brother were not based on evidence in the songs of Sappho and that all these informants do not suggest "the existence of any such narrative or rebuke in poems known or lost to us."[188] However, if we return to Herodotos and examine other citations of archaic poetry in his work, we observe that the ethnographer does refer to actual poems. In 2.135.6, the phrase that he employs with regard to Sappho is ἐν μέλεϊ ("in song"), and it is with ἐν μέλεϊ that he again refers to a song by Alkaios in 5.95.2, a fragment of which is quoted by Strabon (Alkaios fragment 401B.a V). Among other cases, Pindar fragment 169a.1 M is mentioned by Herodotos in 3.38.5, while Solon fragment 19 W is used as a testimony in 5.113.2 (ἐν ἔπεσι). If the reference to Arkhilokhos as a chronological marker for the reign of Guges of Lydia is not taken as a possible marginal gloss,[189] Herodotos again exploits the testimony of an actual poem (1.12.2 ἐν ἰάμβῳ τριμέτρῳ).[190]

All this supports Poseidippos' intertextual reference to a song or songs by Sappho about Kharaxos and his lover Dorikha. Additional confirmation that Sappho composed a song in which the name Dorikha appeared is offered by Strabon in his discussion of Mukerinos' pyramid at Giza:[191]

λέγεται δὲ τῆς ἑταίρας τάφος γεγονὼς ὑπὸ τῶν ἐραστῶν, ἣν Σαπφὼ
μέν, ἡ τῶν μελῶν ποιήτρια, καλεῖ Δωρίχαν, ἐρωμένην τοῦ ἀδελφοῦ

---

[186] For the metaphor of φθεγγόμεναι σελίδες and "singing" or "talking books" in Hellenistic poetry, see Bing 1988:29–33. See also Page 1981:342 on *Anthologia Palatina* 9.184.5.

[187] For Strabon's account, see below.

[188] Lidov 2002:203.

[189] Both K. Hude his Oxford edition (1927) and Rosén 1987:9.do not delete it.

[190] Arkhilokhos fr. 19 W.

[191] Strabon 17.1.33 (=3.379 Kramer).

αὐτῆς Χαράξου γεγονυῖαν, οἶνον κατάγοντος εἰς Ναύκρατιν Λέσβιον κατ' ἐμπορίαν, ἄλλοι δ' ὀνομάζουσι Ῥοδῶπιν.

It is said to have been the tomb of the courtesan that was made by her lovers, the courtesan, whom Sappho the melic poetess calls Dorikha—the beloved of her brother Kharaxos, when he transported Lesbian wine to Naukratis for trade—but others name her Rhodopis.

Strabon makes explicit that such a song or songs existed and that Sappho called Kharaxos' lover Dorikha. He further provides some explanation for Kharaxos' activity in Naukratis: the trade of Lesbian wine, famous as it was in the context of drinking-parties throughout Greece.[192] A similar point (κατ' ἐμπορίαν) is made later by Athenaios in his discussion of famous courtesans from Naukratis (13.596b-d); he does not specify what kind of trade Kharaxos went to Naukratis for. Athenaios refers to Sappho's poetry against Dorikha, although in [Ovid] *Heroides* 15.63-70 Sappho is portrayed as giving faithfully much advice and warning to Kharaxos (*me quoque, quod monui bene multa fideliter, odit*) and in Herodotos' narrative it is Kharaxos who is rebuked by her.[193] Athenaios also comes into dialogue with Herodotos' discussion of the two Naucratite courtesans and quotes Poseidippos' epigram about Dorikha. He, however, adds the important observation that "Herodotos calls her [i.e., Dorikha] Rhodopis, being unaware (ἀγνοῶν) that she [Rhodopis] is different from Dorikha."[194]

What is certain from the sources investigated so far is that Sappho composed at least one song in which she included the name Dorikha. The latter was

[192] See Alexis fr. 276 K-A Λεσβίου <δὲ> πώματος | οὐκ ἔστιν ἄλλος οἶνος ἡδίων πιεῖν, Ephippos fr. 28 K-A, Arkhestratos fr. 190.19 *SH*, and see, for further references, Arnott 1996a:769, who also notes that, along with Khian and Thasian, Lesbian was deemed one of the three choicest wines. It is interesting that in the same context (17.1.33 = 3.379–380 Kramer), Strabon reports a fairy tale–like story that some recounted about Rhodopis. A different version of this tale is preserved by Aelian (*Historical Miscellany* 13.33), who also refers to a story about the Naucratite courtesan Arkhedike (*Historical Miscellany* 12.63). For stories about Rhodopis, see Biffi 1997.

[193] Lidov (2002:221) believes that Athenaios or his sources misunderstood the gender-neutral pronoun μιν in Herodotos' πολλὰ κατεκερτόμησέ μιν and took it as referring to Rhodopis. He does not examine the likelihood, which may be supported by the relevant sources, that there was more than one song related to Dorikha and Kharaxos. Note that elsewhere (10.425a) Athenaios says that Sappho praised her brother Larikhos in many places (πολλαχοῦ). On Sappho in Athenaios, see Brunet's brief discussion (2003). Cf. also Athenaios 9.391f, where he makes reference to a song by Sappho (Sappho fr. 1.9–12 V) without quoting it.

[194] He also reports here that Rhodopis' spits dedicated at Delphi were mentioned by Kratinos (fr. 269 K-A; Kratinos' reference to the spits is not preserved; see Kassel and Austin's annotation about the textual transmission of ὧν μέμνηται Κρατῖνος διὰ τούτων).

presented as the lover of Kharaxos; his traveling and affair became a theme for Sappho's song-making.

Let us now focus on a fragment of Sappho that has been viewed as an allusion to this affair:[195]

]α μάκαι[ρ
]ευπλο.·[
].ατοσκα[
]                4

]οσθ'[   ]βροτεκη[
]αταισ[   ]γεμ[
].ύχαι λι.[  ]ενος κλ[
].[      ]        8

Κύ]πρι κα[ί σ]ε πι[κροτ´..]αν ἐπεύρ[οι
μη]δὲ καυχάσ[α]ιτο τόδ' ἐννέ[ποισα
Δ]ωρίχα τὸ δεύ[τ]ερον ὡς ποθε[
]ερον ἦλθε.         ❋

Kypris, may [she/he] also find you bi[tter ]   9
and may [she?], telling of this, not boast…
Dorikha how [ ] a second time
[ ] came.

This is the text as printed by Voigt. Lobel and Page's text presents some crucial differences, including the restoration ὡς πόθε[ννον | εἰς] ἔρον ἦλθε in lines 11 and 12, which can be rendered as "how [he] came a second time [to longed-for] eros."[196] For line 5 it has been thought that the text might be restored on the basis of Sappho fragment 5.5 V (ὄσσα δὲ πρ]όσθ' [ ἄμ]βροτε κῆ[να…, "and all the mistakes [he] did before…"),[197] but this is highly uncertain, since the left-hand part of lines 5–8 (]οσθ'[, ]αταισ[, etc.) comes from a separate papyrus scrap that has been tentatively attached to the main fragment. Similarly problematic is λί[μ]ενος ("harbor") for line 7.[198]

---

[195] Sappho fr. 15 V. In the translation of lines 9–12, I have not opted for a marked scenario for the possible plot of the song. The most widely endorsed scenario is that of Page 1955:46: "Cyprian, and may she find you harsher; and grant that she, Doricha, be not proud to tell how he came the second time to her longed-for love." Cf. Lobel 1925:3; Lobel and Page 1955:13.

[196] Or, "[to] love['s longing]."

[197] See Voigt's apparatus criticus for different restorations of the second part of the line. Cf. also Hunt 1914a:40 for lines 1–6.

[198] For the papyrological problems that such a restoration would involve, see Lobel and Page's apparatus criticus (1955:13). For the separate papyrus scrap (P.Oxy. 1231 fr. 3), see also Lobel 1925:3.

Different scenarios have been proposed for the plot of lines 9–12. This part of the song has been boldly, even self-confidently, "rewritten" several times by modern scholars.[199] What remains evident is that the poem included a reference to "boasting" and, most probably, to "desire" (ποθε[).[200] At the same time, the name Dorikha was mentioned in the vague context of "boasting," "desire," and "a second time." That Δ]ωρίχα is a probable reading in line 11 has recently been doubted, but on no good grounds.[201] After a reexamination of the papyrus, I have come to the conclusion that so little is preserved from the letter before ρίχα in line 11 (Δ]ωρίχα)—and the position of the dot of ink preserved is so ambiguous[202]—that it would be quite difficult to maintain that it is incompatible with an omega.[203] The first editor of the papyrus, Arthur Hunt, was duly cautious in his decision to print Δω]ρίχα.[204] Lobel, who reexamined the papyrus for his 1925 edition, printed Δ]ωρίχα.[205] It should be stressed that personal names or words ending in – ρίχα are extremely rare. The meter requires a long syllable before ρίχα. In order to dismiss "Dorikha" as a probable reading, we would need to suggest another attested ancient Greek word or personal name that would fit the space.[206] Even if we consider the possibility that ρίχα is perhaps the genitive singular of a masculine name, a name such as that of Sappho's brother Larikhos should be excluded because of its attested ending (–ος). Furthermore, if we assume that omega is ruled out as a possible letter before ρίχα, other similar papyrological cases suggest that we cannot easily reject a most likely or almost certain restoration of a syllable in a word (at the beginning of a line) because of an ambiguous trace on the papyrus.

---

[199] See Wilamowitz's suggestions already in Hunt 1914:23. Cf. Voigt's apparatus criticus. For Wilamowitz's supplements, see Lobel 1925:4.

[200] One syllable is missing after ποθε[ and the syllable of θε[ must be long (or lengthened by two consonants following it).

[201] Lidov 2002:224.

[202] The right upright of an omega in P.Oxy. 1231 does not always "curve in towards the left" (Lidov holds that this happens "quite consistently;" 2002:224).

[203] I reexamined P.Oxy. 1231 (Ms.Gr. Class c. 76 (P)/1, 2) in the Bodleian Library in July 2004. I am grateful to Dr. Bruce Barker-Benfield for allowing me to use an ultra violet inspection lamp as well as to examine a considerably enlarged digital image of the papyrus fragment in question (P.Oxy. 1231 fr. 1 col. I. 1–12).

[204] Hunt 1914a:23.

[205] Lobel 1925:3.

[206] There is space for two letters before ρίχα (P.Oxy. 1231 fr. 1 col. I. 11). It would be hard to accommodate three letters here: see, most importantly, the spacing and size of letters in τω τις ερατ αι (only a few lines below the line in question) in P.Oxy. 1231 fr. 1 col. I. 16 (photograph in *The Oxyrhynchus Papyri*, vol. X, pl. 2 [London 1914]). Cf. also the spacing and size of letters at the beginning of lines in P.Oxy. 1231 fr. 1 col. II.

A case in point has been aptly discussed by Gregory Hutchinson.[207] In line 4 of an extensive fragment attributed to Ibykos (S151 *SLG*),[208] the papyrus provides the following text: ..].ος μεγάλοιο βουλαῖς, unanimously restored as Ζη]νὸς μεγάλοιο βουλαῖς and sometimes printed, without the sublinear dot, as Ζη]νὸς μεγάλοιο βουλαῖς ("by the plans of great Zeus"). The composition is brimful of epic formulas and images. In the context of the first two stanzas highlighting aspects of the Trojan war and in view of *Iliad* 1.5, 12.241, or *Odyssey* 8.82—among other relevant passages—the restoration Ζη]νὸς μεγάλοιο βουλαῖς might be considered most probable, not least because two letters are missing before ]νός. However, as Hutchinson observes, "one would certainly expect Ζη]νός; but one would also expect the serif at the top right hand of ν to face the other way." Since the traces on the papyrus are not compatible with the letter nu, Hutchinson prints ..].ος μεγάλοιο βουλαῖς,[209] although in his commentary he duly discusses parallels that evidently support Ζη]νὸς μεγάλοιο βουλαῖς.

Given the marked rarity of names or words that would end in –ρίχα, "Dorikha" must be deemed as a most probable restoration of .].ρίχα. Recall that Poseidippos refers to Sappho's "dear song" related to Dorikha and Kharaxos. It is not unlikely that there was more than one song about them or at least about Kharaxos.[210] Athenaios (10.425a = Sappho fragment 203a) stresses that Sappho praised another of her brothers, Larikhos, πολλαχοῦ ("in many places"). Also, in an intriguing fragment previously ascribed to Alkaios, but attributed to Sappho by the most recent critical editor of the fragments of Alkaios,[211] the following image occurs after a possible address to a female figure:[212]

]ται· πόρναι δ' ὅ κέ τις δίδ[ωι
ἴ]σα κἀ[ς] πολίας κῦμ' ἄλ[ο]ς ἐσβ[ά]λην.
.]πε[..]ε.ις τοῦτ' οὐκ οἶδεν, ἔμοι π[ί]θην,
ὅ]ς π[όρν]αισιν ὁμίλλει, τάδε γίνε[τ]ᾳ[ι·

[207] Hutchinson 2001:238.
[208] 282 *PMG*; S151 in Davies' edition (1991).
[209] Hutchinson 2001:40. Cf. his comments: "the traces, however, do not much resemble any letter in the hand" (2001:238).
[210] See Sappho fr. 5 V. I believe that it would be methodologically unnecessary to attempt to associate closely Sappho fr. 15 V with Herodotos' account.
[211] Liberman 1999:lxxxvii–xci and 60 (on fr. 117b, see lxxxvii–lxxxviii). The attribution of the fragment to Alkaios had been questioned by Fränkel 1928:274–275; cf. also Campbell 1982:287 and Kurke 1999:226n10. Fränkel proposed that this fragment should be ascribed to Sappho. Liberman's arguments seem to be in the right direction.
[212] Alkaios fr. 117b.23 V: ἐ]πόνησας κατα[ρ]αμένα. This fragment (preserved on P.Oxy. 1788) is now attributed to Sappho by Liberman 1999 (see n. 211 above). The lines discussed here are 26–32.

δεύξ[ι] μα[.] αὔτω τ̣ὼ χρήματος [ἄψερο]ν
α̣]ῖ̣σχος κα̣[ὶ κα]κ̣ό[τα]τ' ὠλο̣μέν̣[αν
πόλλαν.[....]΄[.]των, ψεύδη δε[.....]σ̣αι

> what one gives to a prostitute
> is the same as thrown into the waves of the grey sea.
> [...one?] does not know this, I can persuade him;
> if one consorts with prostitutes, these things happen to him:
> after the business itself he must [suffer]
> dishonor and much accursed distress...

Such a trenchant or admonitory style would not be inconsistent with other fragments, including Sappho 99 L-P explored in Chapter Three.[213] The poetic subject in fragment 55 V is acerbic in its prediction of an ominous future for the addressee:

κατθάνοισα δὲ κείσηι οὐδέ ποτα μναμοσύνα σέθεν
ἔσσετ' οὐδ' ἔπος <εἰς> ὔστερον· οὐ γὰρ πεδέχηις βρόδων
τὼν ἐκ Πιερίας, ἀλλ' ἀφάνης κἀν Ἀίδα δόμωι
φοιτάσηις πεδ' ἀμαύρων νεκύων ἐκπεποταμένα.

> when you are dead you will lie there and never any memory
>     of you
> or any verse for you will there be in the future; for you have
> no share in the roses of Pieria, but unnoticed in the house of
>     Hades too
> your soul will wander among the faded corpses.[214]

This song may reflect aspects of social competition in the turbulent political milieu of late-seventh- and early-sixth-century Mytilene. Even so, reciprocally antagonistic language was part of Sappho's poetic discourse, as can be inferred from fragment 37 V, in which the singing voice directly—or as an intradiegetic speaker within a broader narrative—[215] expresses the wish: "may winds and worries carry off the one who rebukes me."[216] The occurrence of discursive fea-

---

[213] Cf. pp. 251–254.

[214] On this fragment, see, more recently, Yatromanolakis 2006b.

[215] For intradiegetic speakers within a poetic narrative, see Sappho fr. 94 V. Cf. frs. 1, 44, 44A a, and 109 V. Note that initially Sappho fr. 44A was tentatively thought of as belonging to Alkaios, but later persuasively attributed to Sappho and included among her fragments in the editions of Voigt (see Voigt's *apparatus fontium*) and of Campbell (1982:90–92).

[216] See also Sappho fr. 120 V.

tures of blame poetry in Sappho has been perceptively analyzed by Antonio Aloni,[217] and Herodotos' point about Sappho rebuking Kharaxos intensely in song should be viewed in this context.

It seems that the song(s) related to Kharaxos became known and caused sensation and discussion in men's meeting places, as is inferred from the fact that Kharaxos and Sappho appear twice in Herodotos' account. περιλεσχή-νευτος and its juxtaposition with the marked poetic adjectives ἀοίδιμος and κλεινή further show that *at the same time* entertaining chats and singing about Rhodopis had become the most significant element in the cultural traf-ficability of her name. The courtesan Rhodopis had entered the realm of orally transmitted songs and stories. As observed above, the rarely attested name "Rhodopis" is even inscribed on at least one Attic sympotic cup dated to around 490–480 BC. Sappho's song(s) about Kharaxos and Dorikha became part of those widely circulated traditions. Although it has been thought that Rhodo-pis was Dorikha's nickname, her working name,[218] both names have the ring of *redender Namen*.[219] If we accepted such an idea, it would be difficult to speculate which was her original name and which a nickname.[220] There are also no indi-cations about why Sappho would have chosen to use the name Dorikha, instead of Rhodopis. I would suggest that the available sources point to a different direction concerning the occurrence of the two different names in Sappho and Herodotos.[221]

It should be pointed out that what we know about Sappho's Dorikha is very little compared to what we hear about Rhodopis. Dorikha might have been *re-presented* in Sappho's poetry mainly as an alluring lover of Kharaxos, one that he met during his travels. To contextualize the reference in Herodotos to Kha-raxos' stay in Egypt we need to take into account a central aspect of the history

---

[217] Aloni 1997:lxvi–lxxv. Philodemos (*On Poems* B fr. 20 col. i. 10–11, Sbordone 1976:155; fr. 117, Janko 2000:330) refers to the "iambic manner" of some of Sappho's songs: see Yatromanolakis 1999a:186.

[218] See Lloyd 1988:86.

[219] Cf. Aloni 1983, who, in contrast to earlier views (e.g. Page 1955:49), suggests that, since Herodotos mentions that Rhodopis flourished during the reign of Amasis, there is a chrono-logical difficulty in identifying Dorikha with Rhodopis (see also Lidov 2002:218). Aloni 1983 believes that Kharaxos' affair with Dorikha belongs to a specific genre of story and song related to rebukes of merchants who spent their property on a whore. Cf., from a different perspec-tive, Kopidakis 1995.

[220] Using the argument of "common sense," Page (1955:49) assumes that Rhodopis was Dorikha's nickname, which Sappho avoided using. One could easily suspect the opposite.

[221] On the occurrence of the name Dorikha in Sappho, see Poseidippos' epigram and Strabon's reference discussed above. My argument is not only dependent on Sappho fr. 15 V.

of archaic Mytilene. That Lesbians traveled to and had a strong interest in the city of Naukratis is well substantiated archaeologically.[222] Mytilene was an important trade center in the seventh and sixth centuries.[223] Perhaps in the course of the seventh century it succeeded in establishing itself as a preeminent maritime power, which probably overshadowed the other major cities of Lesbos.[224] The trade dynamics of Lesbos, which ranged from Gordion to Egypt to the Black Sea, is reflected in archaeological evidence: sixth-century Lesbian grey ware amphorae have been found, among other sites, in Egypt.[225] Early in its history, Mytilene was credited with the establishment of settlements in the Troad and Thrace.[226] In the archaic period, this city-state developed in a way distinct from the other *poleis* of Lesbos. As has been shown, during this period

[222] On Naukratis and trade, see Coulson 1996, Möller 2000, Höckmann and Kreikenbom 2001. On Greek painted pottery (and inscriptions on Greek vases) found in Naukratis, see Petrie et al. 1886:46–63, Gardner 1888:62–75, Venit 1988b, and Möller 2000:166–181.

[223] There is no recent major synthesis of the history of Lesbos and, particularly, Mytilene in the archaic and classical periods. The scattered bibliography (from 1940 onward) includes Mazzarino 1943, Gallavotti 1948:7–30, Page 1955:149–243, Treu 1980:95–96 (references to earlier studies), Bauer 1963, Charitonides 1966, Paraskevaidis 1976, Jeffery 1976:237–243, Kontis 1978 (major study), Rösler 1980:26–36, Boruhovič 1981, Manfredini 1981, Aloni 1983, Burnett 1983:107–120, Green 1989 (witty and concise account of the history of Lesbos), Axiotis 1992 (vast field research in Lesbos), Mason 1993, Kurke 1994, Spencer 1995 (Spencer reviews and draws on much important bibliography on early Lesbos), Spencer 2000, Mason 2001. For religion in Lesbos, and especially Mytilene, see Shields 1917; cf. Kontis 1978:405–436, Page 1955: 161–169, and Treu 1980:142ff. For more recent discoveries, with special reference to Mytilene, see the annual reports by C. and H. Williams in *Échos du Monde Classique/Classical Views* 1986–1991 (especially Williams and Williams 1986 and 1991), Ruscillo 1993, Cole 1994:210–211, Spencer 1995:296–299, Sherwood 1997, Jordan and Curbera 1998; cf. Williams 1994 and 1995. Much of the material of the excavations conducted by H. Williams has not yet been studied in any detail; for comparative material from Korinthos, see Bookidis 1990, 1993, Bookidis et al. 1999, Bookidis and Stroud 1997. New information about early Lesbian history and saga has emerged from papyrus fragments (P.Oxy. 3711), perhaps from a commentary on Alkaios, ingeniously edited by Haslam (1986).

[224] Mason 1993:228 and n16, 230 (for the authoritativeness of the thalassocracy list of Eusebios, mentioned by Mason 1993, see also the opposite view adopted by Jeffery 1976:252–253). I do not agree with Mason (1993:229) that Dion Khrysostomos (45.13) alludes to an early attempt of Mytilene at *sunoikismos*. His arguments that such an attempt would explain how Sappho's Eressian origin did not prevent her from participating in the public life of Mytilene, why Leskhes was considered sometimes Mytilenean and sometimes Pyrrhaean by different sources, and the kind of status that Alkaios had in Pyrrha when he was excluded from Mytilenean politics (schol. Alkaios fr. 114 V) are not convincing. Dion's testimony probably refers to the Mytilenean revolt of 428/7 BC from the Athenian alliance.

[225] For further evidence, see Shields 1917:xii–xiii, Spencer 1995:301, and Spencer 2000. For grey ware amphoras found at Gordion, see Lawall 1997.

[226] For a list of Mytilenean colonial settlements, see Shields 1917:x–xi. Cf. Mason 1993:228.

the *khôra* and the city center of Mytilene were characterized by a comparative lack of monumental construction, such as the complexes of towers and enclosures or monumentally built cult places regularly found in the other cities of central and western Lesbos. These elaborate constructions may suggest that in the other city-states of archaic Lesbos the more affluent families strove to display their status and wealth symbolically, as well as to demarcate the borders of their city's territory.[227] On the contrary, from the excavations conducted so far, it seems that at Mytilene the richer and politically strong members of society did not invest their income in erecting monumental buildings that would emphasize their dominating role. As can also be inferred from Mytilene's involvement in the establishment of the pan-Greek Hellenion at Naukratis (the only Aeolic city that contributed to its foundation), its role in the Ionian Revolt, and the great interest it showed in retaining the area of Sigeion in the Troad (a fact that led to its well-known dispute with Athens), this city-state in the southeast of Lesbos had actively invested in foreign interests and ventures.[228]

All this was not unknown in other Greek cities and especially in Athens. Herodotos, our earliest source, does not mention the reasons for Kharaxos' journey to Egypt. A later writer like Strabon or his sources could have inferred that Kharaxos went to Naukratis to trade Lesbian wine, the supreme quality of which was celebrated in sympotic spaces.[229] One wonders whether such a detail about wine trade would have been provided in any of Sappho's songs. Being from Mytilene and associated with a courtesan and her professional milieu, Kharaxos could have aptly been assumed to be a *wine* trader. Furthermore, Athenaios, a Naucratite himself, claimed that Rhodopis and Dorikha were different persons.[230] We do not know the basis of his argument. However, we should pay attention to the fact that he does not refer to the detail about wine trade either. Athenaios' account is more restrained and argumentatively selective than Strabon's, which includes a fairy tale–like story about Rhodopis and her sandal.[231] The name of Rhodopis had the gripping power to assimi-

---

[227] For details about the monumental constructions of the other cities of central and western Lesbos compared to the modest structural remains found in Mytilene, see Spencer 2000.
[228] Spencer 2000.
[229] For Lesbian wine , see n. 192. Cf. Clinkenbeard 1982, 1986, and Schaus and Spencer 1994.
[230] Cf. Braun 1982:43, who argues that Dorikha is different from Rhodopis, and Wehrli 1967/1969: vol. 9, 80. On the critical methods of Athenaios, see the discussions included in section three of Braund and Wilkins 2000.
[231] Being familiar with Herodotos' narrative, Athenaios does not make mention of the anecdotal story associating a courtesan with the building of the pyramid. However, he further rejects the identification of Dorikha with Rhodopis, as reflected in the version of the story that Herodotos decided to recount. Athenaios also had access to the *Aithiopia* by Poseidippos, where Dorikha

late diverse stories. She was associated with different figures like Aisopos and masters like Iadmon. It is interesting that in a later version of the story of Rhodopis, Iadmon was presented as coming from Mytilene, not from Samos.[232] She even assimilated the figure of the early Egyptian queen Nitokris, also discussed by Herodotos (2.100). According to the third-century BC Egyptian writer Manetho, Nitokris, an exceptionally beautiful woman with "red cheeks," was said to have built the third pyramid of Giza—the same pyramid attributed to Rhodopis, another "rosy-cheeked" woman of extraordinary charm.[233]

Given the available sources about Rhodopis and Dorikha, it would be safer to argue that in the context of much talking and singing about Rhodopis in men's meeting places and sympotic contexts (to which κλεινή, ἀοίδιμος, and περιλεσχήνευτος point in Herodotos' narrative), Sappho's Dorikha, probably represented by the poet as a harmful lover for Kharaxos, was assimilated into the culturally vibrant figure of Rhodopis. The widely circulated, dazzling stories about Rhodopis, whose name eventually even created a proverb,[234] had become part of the cultural filters through which Dorikha was viewed and understood. Dorikha was identified with Rhodopis and, like Nitokris, was associated with the building of the pyramid.[235] I suggest that Dorikha's involvement with Kharaxos became a further asset for Rhodopis' wealth and career, as represented by the stories that Herodotos chose to narrate in order to substantiate his point about the incorrectness of another story to which "some Greeks" gave currency.

---

was *often* (πολλάκις) referred to (Athenaios 13.596c). As the text of Athenaios stands, his lost quotation of Kratinos' reference to the περιβόητοι ὀβελίσκοι of Rhodopis (the source that Athenaios cites in the context of his argument against Herodotos) seems to be contrasted to Poseidippos as a source about Dorikha (εἰς δὲ τὴν Δωρίχαν...). On Poseidippos' *Aithiopia*, see Angiò 1999 and Sider 2004:31.

[232] See Sappho testimonium 254d V. Concerning Rhodopis and Aisopos, I would further adduce a story provided by Pliny the Elder. In his extensive discussion of the nature of stones (*Natural History* 36) he includes a section on pyramids in Egypt (36.16.75). Toward the end of his account of pyramids, Pliny remarks (36.17.82): *haec sunt pyramidum miracula, supremumque illud, ne quis regum opes miretur, minimam ex iis, sed laudatissimam, a Rhodopide meretricula factam*. In this context Pliny adds an interesting version about the famous courtesan; Rhodopis was once not only the fellow-slave of Aisopos but also his *contubernalis* (36.17.82).

[233] Manetho *FGrH* 609 F2, F3a–b. On this assimilation, see Hall 1904, van de Walle 1934, Coche-Zivie 1972. Cf. Gera 1997:102.

[234] See *incerti poetae comici [com. adesp.]* fr. 489 K-A and the sources quoted by Kassel and Austin.

[235] Note how Strabon introduces his discussion (17.1.33 = 3.379 Kramer): λέγεται δὲ τῆς ἑταίρας τάφος γεγονὼς ὑπὸ τῶν ἐραστῶν. The matrix of the story was about "the *hetaira* and the building of a pyramid paid by her lovers." This is also reflected in the versions provided by the historian Diodoros (1.64.14); cf. the story about Kheops' daughter narrated by Herodotos (see above). It was to this story pattern that the name of Rhodopis was attached.

## Reperformance, Genre, and Textual Plasticity: The Anatomy of Improvisation

As in every context of communicative exchange, during the performance of an archaic song the participants—performer(s) and audience—interacted on the basis of what linguistic anthropologists have termed "contextualization cues."[236] It is such cues, I argued in Chapter Three, that allowed different classical Greek audiences to associate specific songs of Sappho with diverse discursive contexts.[237] The indexical and semantic doublelayeredness of a song led to different kinds of reception in different performative contexts. More important, a number of Sappho's songs were characterized by genre inter-discursivity:[238] different genre textures were embedded in a single song and, as a result, the imagery of a song could be viewed by different audiences as related to different systems of communication conditions. The concept of interdiscursivity goes beyond Tsvetan Todorov's understanding of genre classification in terms of formative associations with specific verbal discourses that lead to fixed "institutionalized" genre categories.[239] Instead of this somewhat restrictive view of genre as an institution, interdiscursivity foregrounds the dynamic and ever-redefined activation of different textures of sociocultural semantics—not necessarily verbal ones—involved in the production and consumption of archaic Greek songs and poetic compositions. Especially in the predominantly oral societies of archaic Greece, the act of song-making and performance was often a highly interactive occasion conditioned not as much by alleged fixed genre categories as by the manipulation of modes of signification across different domains of experience and sociocultural communication.

More than literary theory, a linguistic-anthropological approach to archaic Greek song-making may offer insights into the exploration of the function of what is conventionally described by scholars as "genre" and "genre laws" in traditional, primarily oral societies.[240] Recent discussions of

[236] Duranti and Goodwin 1992:5–7; Gumperz 1992 (cf. Gumperz's 1982 foundational work).
[237] See Chapter Three, pp. 245–262, 277–284.
[238] The concept of interdiscursivity with regard to ritual and socioaesthetic modes of signification has been proposed and developed in Yatromanolakis and Roilos 2003. For the approach to genre discussed here and genre interdiscursivity, see Yatromanolakis 2003a, 2007b, 2007e. Interdiscursivity should not be confused with such concepts as *Kreuzung der Gattungen* or, more recently, intertextuality.
[239] Todorov 1990.
[240] In his discussion of traditional oral literature among Native Americans, Franz Boas had already pointed to (albeit in a rather inchoate and unsystematic manner) the problematic character of genre classification and the methodological value of studying genre "concepts...in the native mind" (Boas 1940:455).

genre in the fields of linguistic anthropology as well as in social and cultural anthropology and ethnomusicology have shifted the focus of research in indigenous oral traditions from fixed categorizations to culturally defined principles of perceiving what we might want to call "genre markers"—that is, discursive aspects of the songs producing particular expectations and receptions of the performed "texts." To begin with, criteria of defining what genre may be differ from culture to culture or even from region to region within a broader cultural community. For instance, investigation of discourse genres among the Tenejapa Tzeital has suggested that at times even indigenous taxonomic criteria and categories are open to negotiation since they depend upon specific social and performative contexts or upon the perceptual priorities of specific individuals.[241] Similarly, Briggs and Bauman have studied how the relations of a specific text to a formative model of a genre are embedded in wider sociocultural dynamics. Genres, they argue, always "leak" since they are open to a number of discursive negotiations, redefinitions, and reorderings.[242] A specific "text" should thus be viewed as a flexible discursive entity that transgresses the boundaries of restraining genre categories and is potentially open to several modifications, dependent on specific performative environments.

The middle Indian female festival tradition *bhojalî* offers an illuminating case of the intricate embeddedness of genre categories within broader frameworks of sociocultural dynamics. By contrast to established, Western-centric taxonomic conceptualizations, the perception, performance, and reception of indigenous genres and individual songs in the region of Chhattisgarh are conditioned by specific contexts and local social dynamics. Gender constitutes

---

[241] Stross 1974; comparable is the considerable degree of disagreement about genre taxonomies among the Chamula Indians of Mexico (see Gossen 1974a:52–55 and cf. Gossen 1974b). A thought-provoking case in point is genre classification in Chinese song cultures. The history of the scholarly study and taxonomy of Chinese "folksong" sheds light on the broader sociopolitical dynamics implicated in the construction and manipulation of genre categories in certain societies and historical periods. Specific genres and song traditions are promoted at the expense of others, thus being transformed into cultural capital exploited by institutionalized agencies of political power. It has been documented that in China in the post-1949 period, the so-called "grass-roots musical genres" (regional operas) were seen as invested with legitimate class associations and therefore promoted to elevated art forms (Lau 1995/1996: 136). Related to this approach to genre classification is the taxonomic system prevailing in established Chinese anthologies of "folksongs," in which songs are classified according to their geographical distribution (Tuohy 1999). Instructive are the debates concerning the terminological spectrum of the overarching genre of *hua'er*, which seems to refer to "folksong" as a whole. However, the diversity of the criteria employed across different regions of China for the identification of songs believed to belong to this genre indicates that genre boundaries and taxonomic practices are often open to negotiation and manipulation on the part of a number of different agencies: local singers and regional ethnic groups (Tuohy 1999); cf. also Jones 1992.

[242] Briggs and Bauman 1992; cf. Bauman et. al. 1987.

339

a principal defining factor in the identification of the discursive markers that elicit an audience's response to a particular song. Rather than being perceived as fixed autonomous categories, "genres" in this Indian region are understood as discursive systems that "belong," as Flueckiger puts it, to particular social agents and to specific performative contexts. In the Phuljhar periphery, the ritual of *bhojalî* is enacted by unmarried pubescent girls who form ritual friendships while in the region of Raipur, the *same* female festival tradition is celebrated by married women, who become possessed by the goddess they worship.[243] In Phuljhar, the songs associated with the ritual of *bhojalî* are often performed along with *homo*, a nonritual genre of "play." Indicative of the context-sensitive conceptualization of genre and the plasticity of the functional and aesthetic value of traditional poetry in this part of India is the fact that songs are often referred to with the same terminology as that describing the ritual at which they are performed. For instance, *bhojalî* is employed in connection not only with the customary context of the establishment of ritually sanctioned friendships among unmarried women but also with a number of specific aspects of this celebration, including the worshipped goddess, the ritual friendship itself, as well as the songs performed in this specific traditional framework.[244]

More relevant to my present investigation of the plasticity of archaic song culture is the fact that in middle India the same group of traditional *bhojalî* songs is subjected to different interpretations according to the specific symbolic values promoted in different regional and sociocultural contexts. In Raipur, where *bhojalî* songs are primarily performed by married women, it is the idea of fertility that defines the symbolic reception of the performed "texts." In contrast, in Phuljhar, the songs and their hermeneutics are situated within the broader receptorial frame of ritual friendships among young, unmarried women between the ages of eleven and fifteen or sixteen. In this region, the symbolic meaning of the same group of songs is marked by the relations of companionship ritually forged between these young female performers.

Comparable is also the case of the songs performed during the festival of *dâlkhâî* in Phuljhar villages. Flueckiger reports that the last traditional performances of this festival enacted by pubescent girls took place in the early 1980s, where a small group of girls between the ages of eight and fourteen would dance and sing *dâlkhâî gît* (songs). The only male participants were the low-caste musicians who accompanied the dancing and singing of the girls.

---

[243] Flueckiger 1996:26–49.
[244] Flueckiger 1996:28.

In the original context of the festival, which allowed reversals of established social and gender hierarchies, *dâlkhâî* songs were received and interpreted in terms of the ritual liberty that characterized that rite of passage. When, however, the same songs entered different, male performative environments, they were subjected to different criteria of moral and aesthetic propriety that reflected male preconceptions about female sexuality and its potential endangering power, requiring restraint. Hence the transformation of *dâlkhâî gît* from ritually acceptable performances into *barî* (vulgar) songs in male performative contexts.[245]

Despite the conspicuous cultural and historical differences, the case of the Indian *bhojalî* songs may provide insights into the possible fluidity in the "classification" and reception of Sappho's songs in male sympotic contexts. Genre discourses as well as individual songs were in flux and subjected to a number of manipulations contingent upon specific performative and cultural dynamics. The different—each time—conditions of the performance of a specific "text" would involve modifications on a number of discursive and socioaesthetic levels.

In Chapter Three, I examined the contextual plasticity of a number of Sappho's songs. I shall here focus on the ways in which her "texts" offered opportunities to be "rewritten" in sympotic contexts.

We have already seen that four lines from Alkaios fragment 249 V were transmitted as a *skolion* in classical Athenian symposia.[246] This *skolion* is included in the collection of Attic *carmina convivalia* preserved in Athenaios.[247] The text of fragment 249 V provided by a papyrus from Oxyrhynchus presents

---

[245] Flueckiger 1996:50–76. That the symbolic communicative and genre value of a song in traditional, predominantly oral societies is often dependent upon concrete performative contexts is also clearly illustrated by a particular group of Greek songs that can be performed on totally antithetical ritual occasions, funerals and weddings. The contextual cues embedded within these songs allow their performance in these diametrically different contexts and their subsequent antithetical, albeit structurally parallel, reinterpretations and receptions by dissimilar audiences. For instance, symbolic allusions or explicit references to states of abrupt and painful separation or abduction permit the performance of the same identical song either as a proper ritual lament for a dead person or a wedding song lamenting the departure of the bride from her paternal (or, more accurately, maternal) home and her ritual integration into a foreign family, that of her husband. The contextualization cues and the double-layered images employed in a song are thus differently decodified according to the specific—each time—ritual context: at funerals they are perceived as allusions to the invincible power of Kharos and to his helpless female victim, whereas at weddings the same imagery is associated with the groom and his bride. Cf. especially Alexiou 2002a, Herzfeld 1981 and 1993, and Roilos 1998 and 2005:99–100.

[246] See Chapter Three, pp. 210 and 214.

[247] Athenaios 15.695a (= *carm. conv.* 891 *PMG*).

intriguing differences from that of the *skolion*.[248] These textual divergences might be accounted for as reflecting different stages in the oral transmission of the song. Comparable is the case of Alkaios fragment 141 V. In the *Wasps* 1232–1235, Philokleon quotes a version of Alkaios fragment 141.3–4 V:

ὤνθρωφ’, οὗτος ὁ μαιόμενος τὸ μέγα κράτος,  1232/1233

ἀντρέψεις ἔτι τὰν πόλιν· ἁ δ’ ἔχεται ῥοπᾶς.  1234/1235

> You, fellow, you who seek the great power,
> you'll turn the city upside down yet; its fate trembles in the
> balance.

The scholia on Aristophanes *Thesmophoriazousai* 162 provide the following text for Alkaios fragment 141.3 V (p. 265 Dübner):

ὤνηρ οὗτος ὁ μαιόμενος τὸ μέγα κράτος

> This fellow who seeks the great power.

Moreover, the scholia on *Wasps* 1232 preserve lines 3 and 4 of the fragment: †ὠνησαι† οὗτος ὁ μαιόμενος τὸ μέγα κράτος | †τρέψεις† τάχα τὴν πόλιν· ἁ δὲ ἔχεται ῥοπᾶς,[249] while a first-century AD papyrus fragment confirms the reading ὤνηρ for line 3.[250] This is how fragment 141.3–4 is printed by Voigt:

ᾤνηρ οὗτιος ὁ μαιόμενος τὸ μέγα κρέτος
ὀνͅτρέψͅει τάχα τὰν πόλιν· ἁ δ’ ἔχεται ῥόπας

Philokleon's version in the *Wasps* introduces the address "you, fellow" in the song, an address intended for Kleon. He also uses ἔτι ("yet") instead of τάχα ("soon") in his second line. In the context of the imaginary dinner-party he is reenacting with Bdelykleon, the political song of Alkaios seems most appropriate to be performed as a sympotic *skolion*, especially since *skolia* were often addressed or related to *hetairoi* and focused on sociopolitical themes and contemporary politics.[251] Although thus constructed by Aristophanes for the purposes of this imagined symposiastic scene, the version performed by Philokleon might reflect possible mechanisms of adaptation of other archaic compositions—reperformed as *skolia*—in the context of drinking-parties and related venues. The different versions of the Harmodios *skolion* support this

[248] P.Oxy. 2298 fr. 1. See p. 210.
[249] For textual variants in the scholia on *Wasps* 1232, see Koster 1978:194 and his comprehensive apparatus criticus.
[250] P.Oxy. 2295 fr. 2.
[251] See e.g. *carmina convivialia* 893–896, 906 *PMG*.

approach.[252] The performance of *skolia* involved the practice of "capping": they were often sung by symposiasts holding a twig of laurel or myrtle that was passed on to the next performer who would attempt to cap the previous song. Improvisation, an element of "performance genres that are not prescriptively notated,"[253] should have been part of the singing and recitation of *skolia*.[254] Recall that *Theognidea* 453–456 W starts with the address ὦνθρωπ(ε) and *Theognidea* 595–598 W with ἄνθρωπ(ε);[255] a large number of the compositions included in the *Theognidea* focused on sympotic life among *hetairoi* and were presumably performed, improvised, and reperformed on related occasions.[256]

Of particular relevance here is Praxilla fragment 750 *PMG* as compared with *carmen conviviale* 903 *PMG*. The fragment attributed to Praxilla reads as follows:

> ὑπὸ παντὶ λίθωι σκορπίον ὦ ἑταῖρε φυλάσσεο.

> Under every stone, my *hetairos*, look out for a scorpion.

The *skolion* preserved in the Attic collection of *skolia* in Athenaios offers a different version:

> ὑπὸ παντὶ λίθωι σκορπίος ὦ ἑταῖρ᾽ ὑποδύεται.
> φράζευ μή σε βάληι· τῶι δ᾽ ἀφανεῖ πᾶς ἕπεται δόλος.

> Under every stone, my *hetairos*, a scorpion lies hidden;
> watch out lest it sting you; the unseen is accompanied by
> every kind of trickery.

The two songs present striking similarities, as they exploit the same proverbial pronouncement.[257] However, the use of ὦ ἑταῖρε suggests that both of them

[252] Especially, *carmina convivialia* 893, 895, and 896 *PMG*.
[253] Sawyer 1999:121.
[254] Cf. Smyth 1900:civ; Vetta 1983b:119–120; Pellizer 1990:179.
[255] In his apparatus criticus on line 595, with regard to the address ἄνθρωπ(ε) West (1989/1992: vol. 1, 202) notes "fort. ὦνθρωπ᾽, cf. 453."
[256] On Simonides improvising (ἀπεσχεδίασε) an elegiac composition in the context of a dinner-party, see Simonides fr. eleg. 25 W (= Simonides 88 in Page 1981:301–302). See further *Homeric Hymn to Hermes* 4.54–56…θεὸς δ᾽ ὑπὸ καλὸν ἄειδεν | ἐξ αὐτοσχεδίης πειρώμενος, ἠΰτε κοῦροι | ἡβηταὶ θαλίηισι παραιβόλα κερτομέουσιν; note the emphasis on improvisation. For different versions of lines in the *Theognidea*, see the insightful discussion in Vetta 1980. Such versions probably point to improvisation. On the formation of the *Theognidea*, cf. G. Nagy's chapter in Figueira and Nagy 1985, E. Bowie's article in Most 1997, and Lane Fox 2000 (somewhat historicizing interpretation).
[257] For the proverb, see the sources collected in Praxilla fr. 750 *PMG*. Cf., further, Sophokles fr. 37 *TrGF*.

were part of the ever-expanding repertoire sung in sympotic contexts.[258] In such a context, it would be difficult for the reception of a song—a παροίνιον— by Praxilla to remain unaffected by the performance and reperformance of *skolia* that focused on exactly the same theme and displayed marked similarities in phrasing. A song like Praxilla fragment 750 *PMG* might be conducive, I argue, to the composition of multiforms transmitted anonymously and performed by *hetairoi* as *skolia*.

The address ὦ ἑταῖρε occurs both in Praxilla fragment 750 and in fragment 749 *PMG*, which was included in Praxilla's drinking-songs (παροίνια).[259] The latter fragment, as discussed in a previous section, was even ascribed by some to Sappho.[260] It is in the light of these references to *hetairoi*, I propose, that the textual transmission of Sappho fragment 2 V should be examined:

```
..ανοθεν κατιου[σ | –                                         1ᵃ
†δευρυμμεκρητεσιπ[.]ρ[     ] |.† ναῦον                          1
ἄγνον ὄππ[αι        ] | χάριεν μὲν ἄλσος
μαλί[αν], | βῶμοι δ' ἔ<ν>ι θυμιάμε-
   νοι [λι]|βανώτω<ι>·                                         4
ἐν δ' ὕδωρ ψῦχρον⌋ | κελάδει δι' ὔσδων
μαλίνων, | βρόδοισι δὲ παῖς ὀ χῶρος
ἐσκί|αστ', αἰθυσσομένων δὲ φύλλων |
   κῶμα †καταιριον·                                            8
ἐν δὲ λείμων | ἰππόβοτος τέθαλε
†τωτ…(.)ριν|νοισ† ἄνθεσιν, αἰ <δ'> ἄηται
μέλλι|χα πν[έο]ισιν [
   [            ]                                              12
ἔνθα δὴ σὺ †συ.αν† | ἔλοισα Κύπρι
χρυσίαισιν ἐν κυ|λίκεσσιν ἄβρως
<ὀ>μ<με>μεί|χμενον θαλίαισι | νέκταρ
οἰνοχόεισα                                                    16
```

[Hither…from Crete] to…holy temple,
where is a graceful grove
of apple trees—and altars
   smoking with frankincense.

---

[258] In his discussion of Attic *skolia*, Athenaios (15.693f–694a) stresses their antiquity and reports that Praxilla was admired for her *skolia*.

[259] On the use of ἑταῖρε in a composition that follows Sappho fr. 58c (= fr. 58.11–22 V) in P.Colon. inv. 21351 and 21376, see below, n. 341.

[260] See pp. 215–216.

In it cool water babbles through apple
boughs and all the place is shadowed
with roses, and from quivering leaves
    enchanted sleep comes down.
And there in a meadow, where horses browse,
blooms with flowers [of spring?], and breezes
blow softly [
    [     ]
there, Kypris, take...
pouring delicately in golden cups
nectar that is mingled with
our festivities.[261]

This fragment, as printed in Voigt's edition, might be deemed a somewhat ten-
tative, albeit critically established, version of how the corrupt text written on
the third-century BC ostrakon that preserves it should be understood. Debate
continues about different readings of the fragment.[262] Here I shall not focus on
the complicated textual problems that it presents. I shall only point out that
the conjecture ἐπ[ὶ τόνδ]ε ναῦον ("to *this* temple") is not compelling, given the
paleographic uncertainties of line 1. As the fragment stands, there is no deictic
[τόνδ]ε. Some scholars deem the hypothetical supplement τόνδ[ε necessary
for their argument that the song is a cult hymn and the "temple" mentioned
is a real one.[263] This idea supports the reconstruction of the so-called circle of
Sappho as a religious or initiatory group of girls under the leadership of the
poet. However, it should be observed that there is nothing in the fragment to
suggest that the landscape described is not imaginary.[264]

In Sappho 2 V, the singing voice summons Aphrodite to appear at a de-
lightful grove and join the "audience" in their festivities. A large number of
critics have argued that the song did not end with line 16. Denys Page, among
other researchers, held that the composition continued beyond this line and
that "we should rather expect Sappho to proceed to give some reason for her
invocation of the goddess."[265] What "we expect" or "do not expect" may have
little to do with the complexities of the poetics of archaic Greek song-making,

---

[261] Lobel and Page print οἰνοχόαισον instead of οἰνοχόεισα in line 16.

[262] For the textual problems, see, among other studies, Page 1955:35–39; Nicosia 1976:83–110;
Malnati 1993; Ferrari 2000 and 2003:64–66 (less convincing reconstruction); Pintaudi 2000; and
Yatromanolakis 2003a:52–55.

[263] For the methodology lying behind such analyses, see Yatromanolakis 2003a.

[264] For Sappho fr. 2 V as an imaginary space, see, from different perspectives, McEvilley 1972:326–
333, Winkler 1990:186, and Yatromanolakis 2003a:53–55.

[265] Page 1955:39.

since this line of argumentation can easily lead, and has often led, to a large-scale "rewriting" of the fragments of Sappho.[266] For all that, Athenaios, another significant source for the text of the last four lines of Sappho fragment 2 V, provides an "Attic version" for these lines:[267] ἐλθέ, Κύπρι,| χρυσίαισιν ἐν κυλίκεσσιν ἀβρῶς | συμμεμιγμένον θαλίαισι νέκταρ | οἰνοχοοῦσα ("Come, Kypris, pouring delicately in golden cups nectar that is mingled with our festivities").[268] Athenaios' text does not end with οἰνοχοοῦσα, but continues with the deictic phrase τούτοισι τοῖς ἐταίροις ἐμοῖς γε καὶ σοῖς.[269] His quotation of the last four lines of fragment 2 V occurs in the context of his broader discussion of ἐκπώματα ("drinking-cups") and modes of drinking. The phrase "for these companions of mine and yours" might well have been part of Sappho's song.[270] And Sappho fragment 160 V would defend this idea.[271]

Here I would not be interested in arguing that the phrase was part of the original song. What is more relevant to my discussion is that this stanza (13–16) provided audiences with contextualization cues closely related to sympotic discourses. These contextualization cues would be understood in the context of classical Athenian male gatherings as markedly symposiastic. The phrase "for these companions of mine and yours" might be viewed as part of the Athenian performative transmission of Sappho's songs.[272] Sappho referred in her poetry to *hetairai* and to her own *hetairai* ("companions"), and Praxilla composed, or was credited with, drinking-songs in which *hetairoi* were addressed. One of these songs (Praxilla fr. 749 *PMG*) was believed in later times

---

[266] See Chapter One. For this line of reasoning applied to the fragmentary songs of Sappho, see, more recently, West 2005 and all the "rewriting" he proposes for the poems preserved on three early Ptolemaic papyrus fragments (Gronewald and Daniel 2004a and 2004b). Numerous conjectural supplements and emendations will be similarly proposed in regard to these fragments in future publications.

[267] For Athenaios and other authors this was the usual practice in quoting the texts of Sappho and Alkaios.

[268] Athenaios 11. 463e and see Kaibel's apparatus criticus (Kaibel 1887/1890:vol. 3, 9–10).

[269] Cf. Kaibel's apparatus criticus for J. Schweighäuser's emendation τε, instead of the γε provided by cod. A (Kaibel 1887/1890:vol. 3, 10).

[270] For different restorations see Kaibel 1887/1890:vol. 3, 10. Following earlier views, Nicosia 1976:95–100 (cf. Ferrari 2000:41 and 2003:64, 66) does not believe that τούτοισι τοῖς ἐταίροις ἐμοῖς γε καὶ σοῖς may be an adaptation of a reference of the song to "companions." To support this idea, Nicosia adduces as parallel a passage in Athenaios 9.366a where the Homeric μῦθοι δὲ καὶ ἠῶθέν περ ἔσονται (*Odyssey* 4.214) is followed by ἐμοί τε καὶ σοί, ὦ Τιμόκρατες, a phrase that certainly refers to the participants in the discussion presented by Athenaios. However, his argument is not persuasive; see *Odyssey* 4.215. He also adduces Athenaios 10.446a (a quite different case of quotation). Among other scholars, Page 1955:39 suggests that τούτοισι τοῖς ἐταίροις ἐμοῖς γε καὶ σοῖς in Athenaios 11. 463e is an adaptation of some words from Sappho's original song.

[271] On the use of *hetairai* in this fragment (ἐταίραις), see Chapter Three, pp. 249–250.

[272] Yatromanolakis 2003a:53.

to be a composition of Sappho, a fact suggesting that at a certain stage in the transmission and reception of her poetry Sappho was viewed as a composer of *skolia* addressed to *hetairoi*. As in the case of fragment 94 V examined in Chapter Three, the "symposiastic" discourse embedded in fragment 2 V facilitated the reception of the song in male performative contexts. Further, I would argue that during their performative transmission a number of Sappho's songs were characterized by relative textual plasticity—that is, by a tendency to be assimilated into and adapted to different discursive modalities. The deictic phrase τούτοισι τοῖς ἑταίροις ἐμοῖς γε καὶ σοῖς, which might reflect something of the original composition—the presence of "participants" in the performative space of the song—reflects possible mechanisms of adapting it to symposiastic circumstances.

The reception of Sappho fragment 2 V should be viewed in terms of the three visual discursive idioms that I explored in Chapter Three: a male discourse directly connected with *sympotic* occasions, in the broadest sense of the term; a discourse related to female musical gatherings as these are refracted in fifth-century Attic representations produced by diverse craftsmen; and a visual discursive modality closely associated with the institution of marriage and wedding rituals. Especially during the early reception of Sappho and in the context of oral transmission, certain of her songs and their genre discourses offered opportunities to be slightly adapted and diversely perceived. Comparative ethnographic material indicates the possible validity of this line of inquiry. A composition like Sappho fragment 1 V could be "read" and even "rewritten" differently by diverse audiences. In lines 19–24, Aphrodite, whose voice is quoted by the poetic subject, speaks directly to "Psappho:"

<div style="text-align:center">

τίς σ᾽, ὦ
Ψά.πφ᾽, ˌἀδίκησι;          20
καˌὶ γ.ὰρ αἰ φεύγει, ταχέως διώξει,
αἰ δὲ δῶρα μὴ δέκετ᾽, ἀλλὰ δώσει,
αἰ δὲ μὴ φίλει, ταχέως φιλήσει
κωὐκ ἐθέλοισα.          24

</div>

Who wrongs
you, Psapph(o)?
for if she flees, soon she'll be pursuing;
if she does not accept gifts, she'll be giving them;
if she does not love, soon she will love
even against her will.

347

Of longstanding debate is whether in line 24 the original reading was κωὖκ
ἐθέλοισα ("[she will love] even against her will") or κωὖκ ἐθέλοισαν.[273] In
the former case, the gender of the person who will soon pursue and love is
certainly female.[274] In the latter case, κωὖκ ἐθέλοισαν refers to "Psappho,"
and the gender of the person who wrongs her remains ambivalent: it could,
in principle, be either female or male ("[s/he will love you] even if you do not
want").[275] The majority of critical editors and literary critics have endorsed
and argued in favor of κωὖκ ἐθέλοισα.[276] The question here is not whether
Sappho was explicit or perhaps intentionally ambiguous. Diverse performers
and audiences could have "rewritten" this line of the song in view of the
cultural idioms investigated in Chapters Two and Three.

## Textual Plasticity and Dialogues

In the early third century BC, Hermesianax included in a catalogue of love
narratives related to poets and philosophers the ardent story of Alkaios and
Anakreon, who were enamored of the nightingale Sappho (fr. 7. 47–56 CA):[277]

> Λέσβιος Ἀλκαῖος δὲ πόσους ἀνεδέξατο κώμους
>   Σαπφοῦς φορμίζων ἱμερόεντα πόθον,
> γιγνώσκεις· ὁ δ᾽ ἀοιδὸς ἀηδόνος ἠράσαθ᾽, ὕμνων
>   Τήϊον ἀλγύνων ἄνδρα πολυφραδίῃ.          50
> Καὶ γὰρ τὴν ὁ μελιχρὸς ἐφημίλλητ᾽ Ἀνακρείων
>   στελλομένην πολλαῖς ἄμμιγα Λεσβιάσιν·
> φοίτα δ᾽ ἄλλοτε μὲν λείπων Σάμον, ἄλλοτε δ᾽ αὐτὴν

[273] For the readings provided by the manuscripts, see Voigt 1971:33. Discussions of this issue
have been numerous: see Voigt's apparatus criticus; cf. Tzamali 1996:82–83. Knox 1939:194n3
suggested κωὖ σε θέλοισαν. See also Gerber 1993:76–79, 86–87. Note that the genre discourses
of Sappho fr. 31 V could have been viewed and exploited in the context of the "game [or perfor-
mative practice] of *eikasia*" at sympotic gatherings.
[274] For incisive analyses of Sappho fr. 1 V, see Koniaris 1965 (with references to previous ap-
proaches), Giacomelli 1980 (with further references to earlier studies), and Nagy 1996a:87–103.
[275] This is Most's interpretation (Most 1995:32), who believes that there was "ambiguity" in
Sappho's original song. Note that his suggestion aims at reconstructing the original reading in
fragment 1.24 V; according to him, ambiguity in her compositions helped Sappho's popularity
in later times. Most (1995) also finds ambiguity in Sappho fr. 31 and 16 V.
[276] Page 1955:3 and 11 prints κωὖκ ἐθέλοισα (as in Lobel and Page 1955:2) and maintains that "I
leave οὐκ ἐθέλοισα in the text, without the least confidence in it."
[277] As transmitted, the text presents a number of problems and interpretive conundrums; see
Powell's apparatus (Powell 1925:102). See also Hermesianax fr. 2. 47–56 in the second volume
of E. Diehl's *Anthologia Lyrica Graeca* (Leipzig 1925:217–218). Cf. Kobiliri 1998:132–152, who,
however, does not discuss satisfactorily the textual problems or emendations that have been
proposed; for the whole fragment, cf. also the notes in Couat 1931:89–94.

οἰνηρῇ δειρῇ κεκλιμένην πατρίδα
Λέσβον ἐς εὔοινον· τὸ δὲ Μύσιον εἴσιδε Λεκτὸν      55
πολλάκις Αἰολικοῦ κύματος ἀντιπέρας.

And you know in how many komastic revels the Lesbian
   Alkaios
participated,[278] as he sang to the lyre of his yearning desire
for Sappho; the bard loved that nightingale and,
   by the eloquence of his songs, caused distress to the man of
   Teos.
For the honey-voiced Anakreon contended for Sappho,
   who was surrounded by, mingled with, many Lesbian
   women;
and sometimes he would leave Samos, sometimes
   his own fatherland that lies on the vine-rich hill,
and visit wine-abounding Lesbos; and often he gazed upon Mysian
   Lekton[279]
   across the Aeolian wave.

This catalogue formed part of the third book of Hermesianax's *Leontion*, a poetic composition in elegiac couplets (apparently inspired by his mistress Leontion)[280] which, as late as 1995, was confidently defined by experts as "surely the silliest surviving product of its age."[281]

In the extensive fragment that has been preserved by Athenaios, Hermesianax starts with mythical bards like Orpheus and moves to imaginary and wittily composed love narratives involving Hesiod and the Ascraean Ἠοίη, Homer and Penelope, and Mimnermos and Nanno. He further recounts love stories related to Sophokles, Hermesianax's contemporary Philitas, and even Pythagoras and Sokrates.[282] In the narrative about Mimnermos, the idea of rivalry is introduced (fr. 7. 35–40 CA) and is developed fully in the story associated with Sappho. Anakreon contended with Alkaios for her love and made frequent visits to Lesbos (lines 53–55). It is significant that Anakreon—or his sympotic song-making—is represented as often traveling from wine-producing

---

[278] Or, "how many ensembles of komasts he greeted."
[279] The text of the second half of the line is problematic: see Powell 1925:102; cf. Kobiliri 1998:149–150.
[280] Athenaios 13.597a. Leontion might possibly have been a fictional mistress for Hermesianax.
[281] Cameron 1995:318; cf. Cameron 1995:319.
[282] On Hermesianax's—and, more general, the Hellenistic—antiquarian interest in the lives of poets, see Ellenberger 1907 and especially Bing 1993. On the relation of Hermesianax's *Leontion* with earlier poetic traditions, see also Couat 1931:84–103.

Teos to Lesbos, an island abounding in and renowned for its wine.[283] I suggest
that the narrative adroitly exploits elements of the Dionysiac spaces of *sympo-
sion* and *kômos*. Further, I would place emphasis on the context provided by Her-
mesianax with regard to Alkaios' singing of his desire for Sappho: it is during
komastic revels (κώμους) that Alkaios performed his serenades. Note that a song
of Alkaios started with the komastic entreaty "receive me, the reveler, receive
me, I beg you, I beg," employing discursive elements of a *paraklausithuron*.[284]
Anakreon's compositions, too, included images of *kômoi*.[285] Competitive aspects
in singing are suggested by ἀλγύνων ἄνδρα πολυφραδίη in line 50:[286] Herme-
sianax highlights the preeminent skills of the Lesbian ἀοιδός. More impor-
tant, the context of komastic revel in association with the singing of Alkaios
recalls the juxtaposition of the image of Dionysos holding a *kantharos* and vine
branches with that of the performer Alkaios on the Munich *kalathos-psykter*.[287]

Concerning line 52, Sappho is represented as surrounded by, almost en-
wrapped with, many Lesbian women. Whether ἄμμιγα contains an erotic allu-
sion remains a matter of conjecture.[288] Scholars have been eager to rewrite the
meaning of the line and its possible allusion to the original context of Sappho's
poetry.[289] What is certain is that while Anakreon traveled widely in both insular

---

[283] See the discussion above, pp. 329, 336. Kobiliri (1998:146) assumes that "the point here is that as
Sappho did not want Anacreon, he could at least drink wine as a consolation" (cf. Giangrande
1977/1978:112), but this is not borne out by the narrative.

[284] Alkaios fr. 374 V Δέξαι με κωμάσδοντα, δέξαι, λίσσομαί σε, λίσσομαι.

[285] Anakreon frs. 373.3 ψάλλω πηκτίδα τῆι φίληι κωμάζων †παιδὶ ἁβρῆι† and 442 *PMG* κωμάζει
†δὲ ὡς ἂν δεῖ† Διόνυσος.

[286] The narrative does not indicate what the results of Alkaios' *kômoi* were with regard to Sappho.
For the image of Anakreon gazing upon Lekton across the Aeolian sea, cf. the images exploited
in Sappho fr. 96 V. Anakreon fr. 377 *PMG* referred to the Mysians. It is worth pointing out
that the whole narrative is followed by a love narrative about Sophokles, who is described as
μελιχρός in Simias 5.5 G-P; the first word in this story (Hermesianax fr. 7. 57 *CA*) is Ἀτθίς, here
an adjective, but in Sappho the name of one of her female companions (frs. 49, 96, 90d. 15, 130
V; cf. perhaps Sappho frs. 8.3, 90e.2 V and S476.3 *SLG*). Hermesianax's narrative about Alkaios,
Sappho, and Anakreon is in intriguing intertextual dialogue with their songs.

[287] See Chapter Two, pp. 73–77.

[288] In the 1996 Supplement of LSJ, the marked meaning "promiscuously, confusedly" of ἀνάμιγα
that occurred in the main lexicon is replaced by the more general "so as to be mingled to-
gether." On ἄμμιγα, see also Gow and Page 1965:vol. 2, 515 (on Simias 5.6 G-P) and cf. *Anthologia
Palatina* 7.12.6, Theaitetos 5.3 G-P, Theokritos 21.3 G-P. On Hermesianax fr. 7.51–56, cf. Powell
1925:105.

[289] It has been speculated that Hermesianax presents Sappho as homosexual: Giangrande 1977/
1978:112, followed by Kobiliri 1998:142. I do not agree with their interpretation of στελλομένην
in line 52. However, Couat 1931:92 (adopting C. P. Gulick's rendering "[Sappho] whose beauty
was supreme among the many women of Lesbos") equally "rewrites" the reference to Sappho.
The text of this line is not easy to translate. Note that Poseidippos employs in his epigram 17
G-P περιστέλλουσα and σύγχρους for Rhodopis.

and mainland Greece, chronology would hardly allow him to visit Sappho in Lesbos. Yet it is not only Hermesianax who thought of her as conversing with the Teian poet.[290] A little earlier (perhaps) than the third century, the Peripatetic philosophers/writers Khamaileon (*c.* 350–*c.* 280 BC) and Klearkhos of Soloi (*c.* 340–250 BC) felt inclined to juxtapose the poetry of Sappho and Anakreon.[291] According to Athenaios,[292] Khamaileon reported that Anakreon fragment 358 *PMG* about the girl from Lesbos was addressed to Sappho,[293] and that Sappho replied to Anakreon with another song (= *fragmentum adespotum* 953 *PMG*). I shall return to Khamaileon later in this chapter.

Fanciful dialogues among poets were an essential means of fictionalization in Greek antiquity. We find this kind of dialogue in diverse traditional cultures the world over. For example, in India, the well-known poet Kalidasa (fifth century AD) was presented as conversing with Vidya or Vijjaka, a seventh-century woman poet. It even seems that an attested poetic dialogue between Sappho and Alkaios (Sappho fragment 137 V) might have been fabricated.[294] A male figure bashfully initiates it:[295]

> θέλω τί τ᾽ εἴπην, ἀλλά με κωλύει           1
> αἴδως…

> I want to tell you something, but I am prevented
> by shame…

and [Sappho] advises him not to speak such words:

> αἰ δ᾽ ἦχες ἔσλων ἵμερον ἢ κάλων           3
> καὶ μή τί τ᾽ εἴπην γλῶσσ᾽ ἐκύκα κάκον,
> αἴδως †κέν σε οὐκ† ἦχεν ὄππατ᾽,
> ἀλλ᾽ ἔλεγες †περὶ τῶ δικαίω†[296]

---

[290] Athenaios, who after quoting the whole of Hermesianax fr. 7 *CA* (that is 98 lines) discussed *only* the narrative about Sappho and Anakreon (13. 599c), believed that Hermesianax was joking about Anakreon's love for her (13. 599d).

[291] The former in his treatise *On Sappho* (fr. 26 Wehrli), and the latter in his *Erôtika* (fr. 33 Wehrli). On Diphilos' *Sappho*, see above, p. 298.

[292] Athenaios 13.599c–d.

[293] For this fragment, see Chapter Three, pp. 173–183.

[294] Cf., from different perspectives, Bowra 1961:225–226 and Rösler 1980:93–94.

[295] The text is quoted by Aristotle in his *Rhetoric* 1367a. 8–14 Kassel (1976:43).

[296] Cf. the interpretation of Stephanos in his scholia on Aristotle *Rhetoric* 1367a.8, p. 280, 30–35 Rabe = Anecdota Graeca Par. 1.266.25–31 Cramer εἴτε ὁ Ἀλκαῖος ὁ ποιητὴς ἤρα κόρης τινὸς ἢ ἄλλος τις ἤρα, παράγει οὖν ὅμως ἡ Σαπφὼ διάλογον· καὶ λέγει ὁ ἐρῶν πρὸς τὴν ἐρωμένην ᾽θέλω τι εἰπεῖν πρὸς σέ, ἀλλὰ ἐντρέπομαι, αἰδοῦμαι, αἰσχύνομαι᾽, εἶτ᾽ αὖθις ἀμοιβαδὶς ἡ κόρη λέγει πρὸς ἐκεῖνον ᾽ἀλλ᾽ ἐὰν ἦς ἀγαθὸς καὶ ὃ ἔμελλες πρὸς μὲ εἰπεῖν ἦν ἀγαθόν, οὐκ ἂν ἡδοῦ καὶ

But if you desired things good or beautiful,
and your tongue were not concocting something bad to say,
shame would not seize your eyes,
but you would speak about what you claim [?].

If one compares this scenario to the poetic exchange between Anakreon and Sappho mentioned by Khamaileon, their similarities are pronounced, *mutatis mutandis*. In the second case the source is Aristotle, in the first the Peripatetic Khamaileon. Note that Khamaileon argues that *others* had suggested (λέγειν τινάς φησιν) that idea with regard to Anakreon fragment 358 *PMG*. Aristotle states that "Sappho composed the following lines, when Alkaios said: 'I wish to tell you…'."[297] In other words, Alkaios is represented as the composer of a song to which Sappho responded. While we might argue that the lines must be ascribed to one poet, most probably Sappho,[298] and that one should not go so far as to set aside lines 3–6 as spurious with Maas and Voigt,[299] there is yet no reason to give Aristotle credit for being, or trying to be, accurate in identifying the speakers in the dialogue. Had Sappho introduced either Alkaios' or her name in the song?[300] If either were true, would that entail that the dialogue might refer to an actual event? In this regard, we observe that a fragmentary song of Sappho similarly presents the speaking "I" addressing a male figure and advising him to choose a younger woman:[301]

ἀλλ' ἔων φίλος ἄμμιν λέχος ἄρνυσο νεώτερον·
οὐ γὰρ τλάσομ' ἔγω σύν <τ'> οἴκην ἔσσα γεραιτέρα

---

ᾐσχύνου οὔτως, ἀλλὰ μετὰ παρρησίας ἔλεγες ἂν βλέπων πρὸς μὲ ἀνερυθριάστως.' Of course, Stephanos may not have had the whole text of the poem at his disposal, while commenting on Aristotle's passage. But the fact that he did not follow Aristotle's interpretation may equally suggest that he was not influenced by the stories about the two poets that appear to have been in fashion at the time of Aristotle.

[297] καὶ Σαπφὼ πεποίηκεν, εἰπόντος τοῦ Ἀλκαίου. This phrase has caused much speculation: see, among other scholars, Page 1955:106–109 and Bowra 1961:224–225.

[298] Cf. Scholia anon. on Aristotle *Rhetoric* 1367a.8, p. 51, 22–31 Rabe πεποίηκε γὰρ ἡ Σαπφὼ λέγοντα τὸν Ἀλκαῖον, Stephanos on Aristotle *Rhetoric* 1367a.8, p. 280, 30–35 Rabe παράγει… ἡ Σαπφὼ διάλογον, and Anna Komnene, *Alexias* 15.9 (Reinsch and Kambylis 2001:vol. 1, 489) τὰ μὲν οὖν τοῦ τέρατος τούτου ταύτῃ ἐχέτω· ἠβουλόμην δὲ καὶ πᾶσαν τὴν τῶν Βογομίλων διηγήσασθαι αἵρεσιν, ἀλλά με κωλύει καὶ αἰδώς, ὥς πού φησιν ἡ καλὴ Σαπφώ, ὅτι συγγραφεὺς ἔγωγε γυνὴ καὶ τῆς πορφύρας τὸ τιμιώτατον καὶ τῶν Ἀλεξίου πρώτιστον βλάστημα, τά τε εἰς ἀκοὴν πολλῶν ἐρχόμενα σιγῆς ἄξια βούλομαι μὲν γράφειν, ἵνα τὸ πλῆρες τῆς τῶν Βογομίλων παραστήσω αἱρέσεως, ἀλλ' ἵνα μὴ τὴν γλῶτταν μολύνω τὴν ἐμαυτῆς, παρίημι ταῦτα.

[299] Maas 1920, followed by Voigt (1971:134). But see Treu 1984:231.

[300] The opposite is most frequently held for Alkaios on the basis of Alkaios fr. 384 V. However, this is a very thorny fragment. See Chapter Three, pp. 168–171.

[301] Sappho fr. 121 V (on line 2, see Maas 1929).

But if you are a friend, take the bed of a younger woman;
for I shall not bring myself to live with you while I am the older
one.

## Reconstructive Images

The history of the modern scholarly reception of Sappho fragment 137 V
has not been sufficiently explored. Although I shall not investigate it here in
detail, it is intriguing that in this case again the tendency of researchers to
"rewrite" the fragments attributed to archaic song-makers has been partic-
ularly marked. Early in the nineteenth century the dialogic lines quoted by
Aristotle were considered an invention of his contemporaries.[302] This approach
would attract contemporary researchers, too. Later, Bergk printed lines 1–2 as
Alkaios fragment 55.2 and lines 3–6 as Sappho fragment 28 in his edition.[303]
Following taxonomic principles that have remained influential in most recent
scholarship,[304] Bergk also placed his Alkaios fragment 55 in his category of
*Erôtika*[305] and attached to "I want to say something…" an extra introductory
line: Ἰόπλοκ' ἄγνα μελλιχόμειδε Σάπφοι.[306] The latter purported address to
Sappho was deemed by many scholars a fitting opening line for a song that
Alkaios composed for her. Anna Komnene's reference to the first two lines of
Sappho fragment 137 V as a composition written by Sappho was thought of as
erroneous.[307] This kind of reconstruction of the poetics of Alkaios and Sappho
and of the original context of the poetic dialogue in early sixth-century Lesbos
informed the argumentation of later discussions.[308] Writing archaic cultures—
genres, original contexts, cultural ideologies—on the basis of the objectivity
that textual criticism apparently presupposes, often without acknowledging
the tentative character of our approaches to culture, has been and still is one
of the most enduring paradigms in scholarship.[309]

[302] Welcker 1828:294–295.
[303] Bergk 1882:171 (Alkaios) and 98–99 (Sappho). In earlier editions of his *Poetae Lyrici Graeci*, Bergk
had adopted the same practice: see Bergk 1843:584 (Alkaios fr. 54.2 in this edition, under the
category *Erôtika*) and 607 (Sappho fr. 32 in this edition); Bergk 1867:948 (Alkaios fr. 55.2 Bergk)
and 887 (Sappho fr. 28 Bergk).
[304] See Yatromanolakis 2003a. Cf., further, Yatromanolakis 2007a.
[305] Such genre categories are repeated by Crusius in *RE*, s.v. Alkaios, col. 1501 and numerous later
scholars.
[306] On this fragmentary line, see discussion in Chapter Three, pp. 168–171.
[307] See Bergk 1882:171. For Anna Komnene's reference, see above, n. 298.
[308] E.g. Page 1955:106–107. Page's scholarly analysis includes detailed historicizing reconstruc-
tions of what Sappho did with regard to Alkaios' poem.
[309] See Chapter One.

If we go back to Aristotle's information and attempt to view it in its broader Peripatetic context, doubts about its reliability emerge. These doubts make us suspect that it was again "others" who had earlier circulated the story—a story perhaps triggered by, but not directly stemming from, vase-paintings depicting Alkaios performing with Sappho, such as that of the fifth-century *kalathos-psykter* of Munich.[310] In fact, Aristotle visited Lesbos and "spent much time studying the habits of the marine life—starfish, sea-urchins, gobies, above all oysters."[311] Along with his biological investigations on Lesbos, Aristotle was apparently interested in learning about the sociopolitical history of Mytilene[312] and thus might have heard local narratives about its most important protagonists: Pittakos, Alkaios, eminent Lesbian families of nobles, and several other figures. During his sojourn there, he could have had the opportunity to listen to compositions of Alkaios and Sappho. Probably while at Assos, but certainly later on in Athens, he was associated with Theophrastos, who was from Eressos, another major city of Lesbos.[313] One of Aristotle's pupils, Phainias of Eressos, was similarly well acquainted with the older Lesbian culture. The Peripatetic Khamaileon wrote treatises on Sappho and Anakreon in which his interest in biographical approaches to their poetry is traceable.[314] Finally, another pupil of Aristotle, Dikaiarkhos, wrote a treatise περὶ Ἀλκαίου.[315] The early Peripatetics took a strong interest in the life and *oeuvre* of lyric poets, without being immune to local stories and common-talk about them.[316] The case of Khamaileon's view about Anakreon and Sappho attests to the appeal of imagined performative poetic dialogues to such writers.

---

[310] See discussion in Chapter Two, pp. 77–78.

[311] Green 1989:59, who refers to Aristotle *On the Generation of Animals* 3.11.763b and *History of Animals* 9.37.621b; see Green 1989:279n103 (and the bibliography there cited). See also the remarks of Nussbaum 1996:165: "While at Assos, and afterwards at Mytilene on Lesbos, he did the biological research on which his later scientific writings are based. (The treatises refer frequently to place-names and local species of that area). His observations, especially in marine biology, were unprecedented in their detail and accuracy."

[312] See Aristotle *Politics* 1285a.35–1285b.1 (=Alkaios fr. 348 and testimonium 470 V), where he quotes Alkaios to elucidate political events in Mytilene; also Alkaios testimonia 471 (= Aristotle fr. 75 Rose) and 472 V (= Aristotle *Politics* 1311b.26–30). See, also, references to Aristotle in papyrus fragments of commentaries on Alkaios: fr. 306A a.4–5 (alongside the names of Dikaiarkhos, Aristotle's pupil, and Aristarkhos), and S265 fr. 4. 3 *SLG*.

[313] On Theophrastos as traveler, see Maxwell-Stuart 1996.

[314] For these treatises, see Wehrli 1967/1969:vol. 9, 79–80, 84, Giordano 1990:151–154, 174–175, Porro 1994:11–12. For other treatises of Khamaileon on archaic and classical poets, see Wehrli 1967/1969:vol. 9, 54–62. Of particular relevance here is his discussion of Alkman (fr. 25 Wehrli).

[315] For Dikaiarkhos' work on Alkaios, see Wehrli 1967/1969: vol. 1, 73–74; cf. Porro 1994:7–10.

[316] See Woodbury 1967:161, Momigliano 1971:70, Fairweather 1974, Arrighetti 1987:141–159 (with references to further studies), Giordano 1990.

Doubts about Khamaileon's reports (on Sappho at least) are probably raised by a late second- or early third-century AD papyrus fragment from a commentary on Sappho,[317] whose author seems to refer to Khamaileon as having gone wrong in one of his assertions about Sappho. Aristotle himself was attracted to biographies of and anecdotes about poets. Should we, therefore, trust Aristotle's testimony about the poetic dialogue of Alkaios and Sappho?[318] It is more probable, I believe, that the conversing *personae* of a song by Sappho were at a certain point given historical names. A dialogic song, or a dialogue embedded in the broader plot of a song, could perhaps have been even slightly modified so that it might meet the requirements of an exchange between two songmakers. And a likely context for the dissemination of such a poetic dialogue, performed as a kind of *skolion*, is in the earlier performance traditions that conditioned the gradual shaping of the performative personae of the two poets.[319]

## Closing Stages

All this brings us to a significant case of textual plasticity with regard to the reception of the song-making of Sappho as well as to the markedness of the shaping of her figure. This informant provides a crucial link to the complexities of the socioaesthetic idioms and discursive practices investigated throughout this book, and suggests how the performative trafficability of the figure of Sappho was rewritten by ancient audiences.

In his treatise *On Sappho*, Khamaileon maintains that "some say" that the following lines were addressed to Sappho by Anakreon (καὶ λέγειν τινάς φησιν εἰς αὐτὴν πεποιῆσθαι ὑπὸ Ἀνακρέοντος τάδε):[320]

σφαίρῃ δηῦτέ με πορφυρῇ

[317] P.Oxy. 1800 fr. 1. col ii. 28–30 (edited by Hunt 1922b = Khamaileon fr. 27 Wehrli). For a discussion of lines 28–30 of the papyrus fragment in question—those referring to Khamaileon, see Montanari 1989. I agree with Montanari that Edmonds's supplements of the lines (1928a:430) are improbable.

[318] Cf. the story attributed to Aristotle about an "exchange" between Polykrates and Anakreon (Stobaios 4.31c.91): Ἐκ τῶν Ἀριστοτέλους Χρειῶν. Ἀνακρέων ὁ μελοποιὸς λαβὼν τάλαντον χρυσίου παρὰ Πολυκράτους τοῦ τυράννου, ἀπέδωκεν εἰπὼν 'μισῶ δωρεάν, ἥ τις ἀναγκάζει ἀγρυπνεῖν' (cf. Stobaios 4.31c.78). A treatise on Συμπόσιον ἢ περὶ μέθης is attributed to Aristotle (frs. 99–111 Rose); on the fragments of Aristotle, see the excellent discussion of Wilpert (1960). On the biographical interests of Aristotle, cf. Huxley 1974. On anecdotes, see Dover 1988b.

[319] Note that, apart from this fragment, Aristotle quotes Alkaios fr. 348 V, "one of Alkaios' *skolia*," as he points out (Aristotle *Politics* 1285a.35–1285b.1).

[320] Khamaileon fr. 26 Wehrli (Wehrli prints ὁ Ἑρμεσιάναξ instead of ὁ Ἑρμησιάναξ). Anakreon fr. 358 *PMG* has been examined in Chapter Three; I quote it here for the sake of my argument.

βάλλων χρυσοκόμης Ἔρως
νήνι ποικιλοσαμβάλῳ
συμπαίζειν προκαλεῖται·
ἡ δ’, ἐστὶν γὰρ ἀπ’ εὐκτίτου          5
Λέσβου, τὴν μὲν ἐμὴν κόμην,
λευκὴ γάρ, καταμέμφεται,
πρὸς δ’ ἄλλην τινὰ χάσκει.

Once again golden-haired Eros,
striking me with a purple ball,
challenges me to play with
a girl with embroidered sandals.
But she, for she is from
well-built Lesbos, blames
my hair, because it is white,
and she is gaping at another.

Moreover, Khamaileon reports that Sappho in turn composed the following
song and addressed it to Anakreon, although we are not told whether it was
again some others who had circulated this idea before him:[321]

κεῖνον, ὦ χρυσόθρονε Μοῦσ’, ἔνισπες
ὕμνον, ἐκ τᾶς καλλιγύναικος ἐσθλᾶς
Τήιος χώρας ὃν ἄειδε τερπνῶς
πρέσβυς ἀγαυός.

You uttered that song, O golden-throned Muse,
which the illustrious old Teian man
from the fine land of beautiful women
sang delightfully.

The latter song has received almost no attention by scholars, since it has been
deemed spurious and classified as a *fragmentum adespotum*. However, for the
cultural economy that conditioned the multilayered shaping of Sappho the
song is most intriguing.

As I argued in the previous chapters, the figure of Sappho in the classical
period should be viewed as a *texture* in dialogue with other broader cultural
*textures*. In the particular case of Khamaileon's report, a song is composed
and attached to her figure, while the performative and deictic context of

---

[321] *Fragmentum adespotum* 953 PMG. See Athenaios 13.599d (= Khamaileon fr. 26 Wehrli) καὶ τὴν
Σαπφὼ δὲ πρὸς αὐτὸν ταῦτά φησιν [sc. Khamaileon] εἰπεῖν.

another song by Anakreon is adapted so that "Sappho's song" may tally with Anakreon's. I suggest that the textual and contextual plasticity of Sappho, often facilitated by the oral transmission of her poetry in diverse discursive contexts, is implicated here in an intricate hermeneutics of *vraisemblance* and a mechanism of cultural coinage that contributed to the assimilation of her figure into a considerably marked cognitive model.

The composition of Anakreon is, as we have seen, about a young woman from Lesbos. By the time of Khamaileon, the same composition was viewed by "some" as being addressed to Sappho,[322] who, as Khamaileon reports, replied to Anakreon's song. The Peripatetic writer invites us to see "Sappho's stanza" as a kind of dialogic response to the verses of Anakreon.[323] This poetic exchange presupposes an (imagined) performance context, which is not specified.[324] "Sappho's song" was certainly composed after Anakreon's, at a time when his and Sappho's poetry was performed or discussed in similar discursive contexts. Apart from rhythmical affinities that might have been perceivable during performance,[325] three correspondences occur between *fragmentum*

[322] In his discussion of Anakreon fr. 358 *PMG*, Urios-Aparisi 1993:52 mistakenly assumes that "perhaps what Hermesianax thought when giving this interpretation is that ἄλλην in l. 8 refers to Sappho herself, as Muse of inspiration of a Lesbian woman who would play, sing music and behave according to the traditional features of her island." Urios-Aparisi 1993:52 and 70 similarly misreads Athenaios, who, as Urios-Aparisi believes, quotes the poem to criticize "Hermesianax's view that it was dedicated to Sappho." Endorsing the paradigm of comedy (see above), Wehrli 1967/1969: vol. 9, 80 briefly examines Khamaileon fr. 26 in terms of a speculative reconstruction of Diphilos' *Sappho* as well as other comedies, and refers to the influence of oral transmission.

[323] On the structure of the "Sapphic stanza," see Voigt 1971:15.

[324] Cf. Khamaileon fr. 25 Wehrli (= Athenaios 13. 600f–601a). According to Khamaileon, Arkhytas *ho harmonikos* reported that Alkman led the way in erotic songs and was the first to make public a licentious song, since that was his way of life with regard to women. Arkhytas' discussion indicates how a poet of songs for choruses of young women was viewed as composer of erotic, even licentious songs by early informants. Note that Alkman was also thought of as a composer of wedding songs (Leonidas of Tarentum 57.1 G-P)—an idea that shows, I argue, how interdiscursivity of genres in his songs was perceived. In view of my investigations in Chapter Three, I further suggest that Arkhytas' discussion should be deemed part of the discursive practices that also conditioned the reception of the songs of Sappho. On the performance of Alkman's songs in juxtaposition to the performance of Gnesippos' ἀείσματα, see Chapter Three, p. 226, and Eupolis fr. 148 K-A. In Khamaileon fr. 25 Wehrli, Alkman fr. 59a *PMG* is quoted, a song that included discursive images comparable to those occurring in fragments of Sappho. Moreover, in Khamaileon fr. 25 Wehrli it is reported that Alkman fell in love with "the poetess" Megalostrate, "who was able to attract lovers to her by her conversation," and that he addressed a song to this "blessed maiden" (μάκαιρα παρσένων "blessed among maidens;" Alkman fr. 59b.2 *PMG*).

[325] Note that the meter of Anakreon's composition heavily draws on aeolic cola ("aeolic" because they first occur in the songs of Alkaios and Sappho): the first three lines are glyconics (x x -ᴗ ᴗ -ᴗ -), while the last one is a pherecratean (x x - ᴗ ᴗ - - ).

*adespotum* 953 *PMG* and Anakreon fragment 358 *PMG*. First, the reference in the latter to the place of origin of the young female figure is capped by Τήιος in "Sappho's composition." Second, ἐκ τᾶς καλλιγύναικος ἐσθλᾶς...χώρας further responds to ἀπ᾽ εὐκτίτου Λέσβου and places emphasis on the land of "beautiful women"—an emphasis that, I argue, is significant in the case of this poetic dialogue. Third, in Anakreon fragment 358 *PMG*, the poetic voice refers to his λευκὴ κόμη ("white hair") and in her reply, Sappho describes Anakreon as an "old man."[326] By creatively employing markedly poetic words like ἔνισπες ("you uttered," "you spoke"),[327] καλλιγύναικος ἐσθλᾶς ("[from] the fine [land] of beautiful women"), χρυσόθρονε ("golden-throned"), and ἀγαυός ("illustrious," often used of heroes, kings, and divine figures in the Homeric epics), the composer(s) of Sappho's song attempted to retain some degree of *vraisemblance*: synchronically and diachronically this song represents the *writing* of Sappho—both in terms of compositional features and with regard to the cultural writing of her figure.

To contextualize *fragmentum adespotum* 953 *PMG* further, we should explore it in the light of the song written on the scroll that Sappho gazes at on the Athens *hydria*. In this representation, ΣΑΠΠΩΣ identifies the seated figure and is placed near her book roll.[328] The line "...with airy words I begin [my song]" on the vase is "Sappho's." I suggest that attributing newly composed songs, even sympotic *skolia*,[329] to Sappho was an important aspect of her early reception, and "Sappho's song" quoted by Khamaileon might be viewed as part of the same process. Not unlike the composition on the Athens *hydria*, "Sappho's reply" has the air of poetic loftiness. Her stanza addresses a golden-throned Muse, a female deity, and focuses on the delightful song sung by the old man from the fine land of beautiful women. The song uttered by the Muse is the composition performed by Anakreon. This composition, according to an idea circulated by "some" (as Khamaileon reports), is addressed to Sappho. It represents a *mythopractical* performance of the "female Lesbian culture:"[330] the young woman from Lesbos is gaping after a female object of desire. Therefore, by the time of Khamaileon the different socioaesthetic idioms and ideological filters investigated in Chapters Two and Three had produced a marked discourse about female Lesbian eroticism. All the rich and multidirectional

---

[326] Compare also ἄειδε τερπνῶς in *fragmentum adespotum* 953.4 *PMG* with Anakreon fr. 402c.2 *PMG* χαρίεντα μὲν γὰρ ἄιδω, χαρίεντα δ᾽ οἶδα λέξαι; and cf. Sappho fr. 1.1 V and *fragmentum adespotum* 953.1 *PMG*.

[327] Cf. *Odyssey* 1.1 and *Iliad* 2.761; see LSJ s.v. *ἐνέπω and cf. Giordano 1990:152. For the other poetic words, see LSJ s.vv. and Diehl 1936:214 (apparatus criticus).

[328] On the Athens red-figure *hydria*, see Chapter Two, pp. 154–163.

[329] See Chapter Three, pp. 215–216.

[330] On mythopraxis, see Chapter One, pp. 42–48.

future of the figure of Sappho and the local female societies of Lesbos has already been fully adumbrated.

The late classical and Hellenistic periods saw an intense circulation and proliferation of representations of Sappho. Mostly deprived of eroticism, she became the tenth member of the ensemble of the nine Muses,[331] an idea that will later be applied to other figures too.[332] It is important that the Hellenistic association of Sappho with the Muses was decisively conducive to the notion that she was involved in the teaching of young female students.[333] In the same period, a second Sappho was created—this time, a Sappho who was not a poet but a courtesan who fell in love with Phaon.[334] This courtesan was eventually defined as a ψάλτρια ("harpist") who threw herself from the cliff of Leukatas for love of the Mytilenean Phaon.[335] Creating a second Sappho was related to a cultural practice also attested for other poets.[336] In the first century BC the erudite scholar Didymos investigated, among other topics, whether Anakreon was given more to drunkenness or to lustfulness and whether Sappho was a prostitute.[337] Earlier on, her poems were edited in Alexandria,[338] while we hear that even earlier the citizens of Mytilene honored her.[339] Also during

[331] For the relevant epigrams, see Page 1981:173 (for the dating of the epigrams ascribed to "Plato," cf. Page 1981:126) and Yatromanolakis 1999a:182.

[332] See Peek 1955:no. 1767 (on Herodes) and *Anthologia "Palatina"* 16.283 (on the *orkhêstris* Rodokleia).

[333] Yatromanolakis 2007a.

[334] Nymphodoros *FGrH* 572 F6 (= Athenaios 13.596e). According to Athenaios, this idea goes back to the geographer and paradoxographer Nymphodoros of Syracuse (date uncertain: fourth or third century BC?). Athenaios mentions that καὶ ἡ ἐξ Ἐρέσου δὲ τῆς ἑταίρας....Σαπφὼ τοῦ καλοῦ Φάωνος ἐρασθεῖσα περιβόητος ἦν, ὥς φησι Νύμφις ἐν Περίπλῳ Ἀσίας. In his *Index scriptorum* (1887/1890: vol. 3, 643, s.v. NYMPHIS), Kaibel rightly observed that in this passage the reference should be to Nymphodoros, and not to Nymphis (it was the former who wrote the *Periploi*, see *FGrH* 572 F4–8). Regarding the lacuna of the sentence, Kaibel suggested in his apparatus criticus the emendation καὶ ἡ ἐξ Ἐρέσου δὲ τῆς <ποιητρίας ὁμώνυμος> ἑταίρα Σαπφώ. Cf. Edmonds (1928a: 150) καὶ ἡ ἐξ Ἐρέσου δὲ τῆς <ἑτέρας Σαπφοῦς ὁμώνυμος> ἑταίρα. See also Jacoby's apparatus criticus in Nymphodoros *FGrH* 572 F6.

[335] Suda s.v. Sappho (Σ 108, iv 323 Adler). In Suda s.v. Sappho (Σ 107, iv 322 Adler) the "first" Sappho is from Eressos, while in Suda s.v. Sappho (Σ 108, iv 323 Adler) the "second" Sappho is from Mytilene. For the "second" Sappho, see also Aelian *Historical Miscellany* 12.19. For the late association of Λεσβία with τριβάς, see Cassio 1983.

[336] For other cases, see Tsantsanoglou 1973b.

[337] Seneca *Epistles to Lucilius* 88.37 (p. 321 Reynolds).

[338] See Yatromanolakis 1999a. For Sappho in the canon of the nine lyricists, see Pfeiffer 1968:205–207, Page 1981:340–343, Davies 1991:1–3, and Barbantani 1993.

[339] Aristotle *Rhetoric* 1398b.10–16 Kassel; see Chapter Three, p. 166. In his wide-ranging study of the cult of poets in ancient Greece, Clay 2004:150–151 believes that there was a cult of Sappho on Lesbos; the evidence (mainly Aristotle *Rhetoric* 1398b.10–16 Kassel) he adduces is thin. The difference between Lesbos and other areas with regard to their reception of Sappho must have been pronounced. On the early Hellenistic poet Nossis (Gow and Page 1965:vol. 1, 151–154 and vol. 2, 434–443) and Sappho, see Skinner 1989, 1991, Bowman 1998, Gutzwiller 1998:74–88, and

Chapter 4

the Hellenistic period, Sappho's poems were transmitted in collections, as is indicated by a list of the first lines of songs by Alkaios, Sappho, and probably Anakreon (P.Mich. inv. 3498$^r$ = S286 SLG).[340] Such collections, I suggest, must have further contributed to genre associations.[341]

For all that, the intricate prehistory of the reception of Sappho was in its concluding stages by the early Hellenistic period. All the mythopractical mechanisms, metonymic webs of signification, and discursive idioms associ-

---

Skinner 2002. In Anthologia Palatina 9.189, another intriguing representation of Sappho appears (cf. Page 1981:337–338 for the possible dating of the epigram); for beauty contests in Lesbos and elsewhere, see Welcker 1816:57–58, Nilsson 1906:57, Nilsson 1919, Graf 1985:60–61, Jackson 1995:100–108, and Yatromanolakis 2007a. For Nossis and Erinna in Herodas, see Yatromanolakis 2007a.

[340] Yatromanolakis 1999a:191. For other incipits-lists, see Parsons 1987:65–66. Concerning P.Mich. inv. 3498$^r$, Campbell 1982:200–201 claims that it is a second century AD papyrus. Based on a photograph of the papyrus, I agree with Page 1974:96 that it should probably be dated to the second century BC. As Dr. Nikolaos Litinas confirms after an examination of the original papyrus in Michigan, different features of the particular hand are characteristic of the second century BC (cf. Turner and Parsons 1987:82–83, no. 45, dated to c. 160 BC and Seider 1967:no. 8).

[341] In early Ptolemaic papyrus fragments (P. Colon. inv. 21351 and 21376, edited by Gronewald and Daniel 2004a, 2004b, and 2005), three poems that seem to focus on a similar general theme provide marked signs of a thematically arranged collection of songs by Sappho. The first eight lines come probably from a poem by Sappho (fr. 58b; I call "fr. 58a" the first nine lines preserved in P.Oxy.1787 fr. 1.1–9, that is, fr. 58.1–10 V), as meter and dialect suggest (note that in Hunt 1922a:28–29, fragment 58a consists of 9 lines; I have examined the original papyrus and confirmed that Hunt was right, while Lobel 1925:26 was not correct in thinking that there are traces of an additional line at the beginning of P.Oxy. 1787 fr. 1; unfortunately Voigt 1971:77–78 follows Lobel 1925:26). The main, twelve-line fragment (fr. 58c = fr. 58.11–22), parts of which are also preserved in P. Oxy. 1787 fr. 1.11–22 (a third-century AD papyrus edited by Hunt 1922a), is followed in the early-third-century BC Cologne papyrus fragments by thirteen lines written in a different hand and composed in language and meter that seem to disqualify them from being part of a poem by Sappho. However, the first two lines of this thirteen-line fragment make it likely that it is in intertextual dialogue with Sappho fr. 1.1–2 V (ψιθυροπλόκε δόλιε μύθων αὐτουργ[(έ) | ἐπίβουλε παῖ...). It is intriguing that in line three of this third composition the address ἑταῖρε occurs. The terminus ante quem for this poem is apparently the third century BC. Gronewald and Daniel 2005:7–8 hold that its date is the fifth century or possibly later. In light of my broader approach and analyses in this book and particularly of the arguments advanced in this chapter with regard to Praxilla's paroinia, improvisation in symposia, performative versions of the Theognidea and Alkaios, the skolion attributed to Sappho, and Sappho fragment 2 V, I would suggest that in the Cologne "anthology" of melic texts the third composition might represent a poem attributed at an earlier period to Sappho in the context of performances and reperformances of her songs in Attic symposia. On the possibly performative function of such collections, see Yatromanolakis 1999a:188–191. I would further argue that fragment 58c (= fr. 58.11–22 V) might perhaps be a performative version of a longer song (see Chapter Three, pp. 203–204])—a composition that included lines 23–26 of fragment 58 V (= fr. 58d, the so-called ἀβροσύνα poem). I proposed this idea at a lecture at Harvard University in February 2005. See, further, Yatromanolakis 2007a.

360

ated with and, in certain cases, emanating from the shaping of her figure and the performative transmission of her songs were foregrounded in the cultural economies of diverse local communities and city-states. These dynamic traditions—traditions in flux—were exploited in turn by other epochal communities, obsessed depressingly, ambivalently, or confidently with the song-making of the Lesbian *poiêtria*,[342] markedly the only composer from classical antiquity who defined a gender in more modern times. The late classical and early Hellenistic periods witnessed a transition from the earlier identity of Sappho as a texture in dialogue with broader and sanctioned sociocultural textures to a configuration of a crystallized, multilayered *eikôn*, in the literal, literary, and rhetorical sense (metaphor) of the ancient Greek world—however contested this complex *eikôn* often was in later centuries.[343] Although Sappho continued to be assimilated into diverse social schemata, a number of metonymic identities had been attached to her, which defied consistent narrativization, despite efforts of later biographers and writers prone to construct linear narratives.[344]

I began this book with the observation that the history of the early (or later) ancient reception of the female aesthetic cultures of archaic Lesbos had not been written. This may now be accounted for as a prefiguration for the challenge of any enterprise to write about the cultural economy of a figure who in the early stages of the shaping of her identity resisted unifying and unidirectional representation. Diverse investigations of the early and late stages of her reception may prove instrumental in our rewriting of her original *contexts*.

---

[342] See Galenos 4.771 Kühn οὕτω δὲ καὶ τὴν ἐπιθυμητικὴν αὐτῇ δύναμιν ὁ Πλάτων ὑπάρχειν ἔλεγεν, ἣν [τε] δὴ κοινῶς ἐπιθυμητικήν, οὐκ ἰδίως ὀνομάζειν ἔθος αὐτῷ. πλείους μὲν γὰρ εἶναι <καὶ> ταύτης τῆς ψυχῆς ἐπιθυμίας φησί, πλείους δὲ καὶ τῆς θυμοειδοῦς, πολὺ δὲ πλείους καὶ ποικιλωτέρας τῆς τρίτης, ἣν δι' αὐτὸ τοῦτο κατ' ἐξοχὴν ὠνόμασεν ἐπιθυμητικὴν εἰωθότων οὕτως τῶν ἀνθρώπων ἐνίοτε τὰ πρωτεύοντα τῶν ἐν τῷ γένει τῷ τοῦ γένους ὅλου προσαγορεύειν ὀνόματι, καθάπερ ὅταν εἴπωσιν ὑπὸ μὲν τοῦ ποιητοῦ λελέχθαι τόδε τὸ ἔπος, ὑπὸ δὲ τῆς ποιητρίας τόδε· πάντες γὰρ ἀκούομεν Ὅμηρον <μὲν> λέγεσθαι ποιητήν, Σαπφὼ δὲ ποιήτριαν.

[343] On *eikôn* in the sense of "simile" and its close association with metaphor, see McCall 1969:24–53.

[344] In contrast to other archaic and classical song-makers, she is among the rare cases for which the Suda provides two different entries.

# 5

## In Search of Sappho's Companions: Anthropological Fieldwork on Socioaesthetic Cultures

THE POSTCARD ON THE COVER OF THE BOOK depicts a privileged view of a central street of Mytilene at the beginning of the twentieth century. One of the major Greek Orthodox monuments of the city, the elaborate church of St. Therapon, most prominent in Mytilene until today, dominates the left background of the picture, the right front of which is occupied by an eclectic mixture of random local passersby. Rather than a historical "document" of the life and sociocultural economies of Mytilene at a specific historical period, this image may be viewed as an aestheticized "monument"—a metonymic, anthropologically intriguing illustration of the discursive mechanisms involved in the rewriting and circulation of foreign societies among privileged consumers of cultural capitals. Characteristically, the French caption at the bottom of the picture (*Une rue de Mételin*) undertakes to rewrite the snapshot of the photographed indigenous life in the *lingua franca* of European cultural colonialism at the beginning of the twentieth century. This rendering entails a discursive transference of the multilayered—but here inevitably fragmented—local culture into a hegemonizing artistic crystallization intended for consumption by European admirers of (ancient, medieval, and contemporary) Greece's perplexing, albeit often idealized, alterity. From this perspective, this postcard captures some of the discursive processes implicated in any attempt to convey, interpret, and naturalize the otherness of foreign, past or present, cultures.

"Rewriting" is inherent in cultural or literary historical accounts and hermeneutics, despite the fact that only rarely is its almost omnipresent function explicitly recognized in the study of Greek antiquity. It is this unwillingness to accept rewriting as an intrinsic constituent of any analytical process that often gives rise to lasting essentialized ideological or methodological approaches. In classical philology—defined as the study of texts in their *original* context,

viewed always to a certain degree through the lenses of the textual work of Alexandrian Greek scholars—these approaches resist being superseded by newer paradigms, themselves methodological models not invulnerable to large-scale revision and modification. Practices of rewriting and monumentalizing Greek antiquity into sometimes unnecessarily confident reconstructions of archaic realities have been explored in different parts of this book. My analysis has attempted to shift the research focus from a "corrective" approach to ancient Greek evidence to the intricacy of the cultural practices that shaped the synchronic receptorial filters through which the song-making and figure of Sappho entered visual, literary, and wider sociocultural discursive domains of archaic, classical, and early Hellenistic antiquity. Moving beyond the polar hermeneutic schema of original authorial past vs. authoritative interpretive present, an anthropological approach to ancient cultural informants advocates the urgency of investigating Sappho *in the making*, especially in the early and pivotal stages of her reception. By focusing on the densely layered loci of these stages of the shaping of Sappho and other archaic and classical songmakers, my investigation has aspired to eschew the hermeneutic linearity of historicizing approaches that attempt to reconstruct in aggressive detail the original context or intentions of her poetry while leaving aside the synchronic discursivity of ancient informants who mediate between the past of her authorial voice and the present of their recontextualizing practices.

The theoretic methodology proposed in this book attempts to demonstrate several main arguments. If we return to the current sporadic outlines of *the* ancient reception of Sappho—viewed as a unified conglomeration of miscellaneous images from distant periods susceptible to modern narrativization—we run the risk of casting into schematic oblivion the richness, cultural vibrancy, and, more importantly, the interdiscursivity of existing sources—ancient Greek, Roman, and medieval. As one looks more closely at this material, which, despite contrary current assumption, has not yet been thoroughly collected, it appears persistently more extensive and more eloquent as an articulation of the *pluralities* of what ancient informants defined as "the songs of Sappho." Reconstructing the original, late seventh- and early sixth-century *contexts* of the compositions of Sappho—the search for her companions—must continue being practiced as fervently as before. However, in current reconstructions of her original context, a marked tendency exists to look askance in the wrong places. Throughout this work, I argue that only through a plurality of investigations into the linguistic and cultural anthropology of sources and their broader sociopolitical discursive textures can scholarly advances be made with regard to how Sappho and her archaic world of social action might

be viewed and written about in modern times. Once we shift our research focus to nexuses of synchronic ancient discursive idioms, mythopractical associations, and syntagmatic metonymies closely connected with the shaping and representation of her figure, the picture becomes more complex and our results concerning the original realities lurking behind the textual fragments of Sappho more historically grounded. Interesting questions surrounding late seventh-century Sappho remain: Was she perhaps a chorus leader in, or a poet for, archaic *khoroi* of young girls, a socioreligious initiator of some sort? Was her performative medium choral or monodic (a rather schematic understanding of performance in view of the arguments advanced in Chapter Four with regard to how we might want to conceptualize genre in archaic and classical Greece?)[1] And did she possibly represent a tamed version of male symposiastic poets like Alkaios or a coeval companion of women from Lesbos and the coast of Asia Minor? These questions must be based, I contend, on anthropologically oriented investigations into the socioaesthetic cultures that defined the agency of individual ancient discourses, which point both to Sappho's original cultural context on Lesbos and to their need to rewrite it.

This brings us to a related argument. It has most often been assumed that no classical sources exist regarding the reception of Sappho. Our sources, the reasoning goes, are predominantly Hellenistic, with the exception of the allegedly numerous late classical comedies about the poet that exercised almost exclusive influence on later successive biographical readings of her poems. The prehistory of this Hellenistic flourishing of representations of Sappho has not been a scholarly concern whereas sporadic intuitive ideas about the late archaic and classical periods of her reception have remained influential, even regarding the question of homoeroticism in her compositions. However, if her songs and figure were scanned by early classical male audiences as indeed largely associated with a desire for sexual pleasure, we may perhaps not expect to find unambiguous references to female homoeroticism in Sappho's poetry by classical authors, especially in Attic contexts. In extant classical literary sources there is no explicit mention.[2] And this is not confined to the songs

---

[1] Cf. further Yatromanolakis 2003a, 2007b, 2007e.

[2] Although what we expect or do not expect may have nothing to do with ancient realities and idealities, we should not underestimate the relative scarcity of preserved material from the archaic, classical, and Hellenistic periods. It is interesting how easily the current state of sources can lead us to reach overconfident conclusions about the reception of "homoeroticism" in Sappho's poetry by classical writers, and then apply these conclusions to all early readers and audiences of her songs, as the following case indicates: "The interpretation of Sappho's poems is complicated by the fact that no writer of the Classical period found their homoeroticism sufficiently remarkable to warrant mention (although a red-figure Attic

of Sappho. Female same-sex relationships as such are distinctly unpopular in the literature of that period.³ Kenneth Dover has ingeniously suggested that in the case of Attic comedy and art, this fact can be accounted for as a kind of cultural taboo imposed on the playwrights and craftsmen by the male anxiety of an androcentric society.⁴ The only serious objection to this idea is the representation of scenes involving female homoeroticism or, as we might prefer to describe it as, *female sexual fluidity* in classical vase-paintings.⁵ Even so, as I have argued with regard to early and late classical informants, Sappho's songs were scanned by male audiences as analogous to songs that celebrated homoerotic male *erôs* between *erastês* and *erômenos.*⁶ Therefore, one may need to formulate the whole question quite differently. The prehistory, visual or textual, of the Hellenistic representations of Sappho suggests hitherto unnoticed ways in which such issues can be approached.

Furthermore, the paradigms of comedy and the so-called biographical tradition should be approached from a less static and more sociopolitical synchronic ancient perspective. It is my contention that biographical tradition and ancient fictionalizing tendencies were characterized by more pronounced fluidity and interdiscursivity than what is normally assumed. A "corrective" approach to this tradition—the view that by undermining its fictions about the lives of poets we achieve a sort of entrance to the original ancient realities

---

hydria, attributed to the Polygnotus group, from about 440 BC portrays Sappho in what may be a female homoerotic setting [Beazley, *ARV*² 1060, no. 145])....So either Sappho's earlier readers and auditors saw nothing homoerotic in her poems or they saw nothing remarkable in Sappho's homoeroticism" (Halperin 2003:722). On the Athens *hydria*, see Chapter Two (pp. 143–163): the representation on this *hydria* has nothing to do with female homoeroticism. What may be worth pondering in Halperin's sweeping statement is that some elite male audiences, long familiar with the phenomenon of pederasty, saw little or nothing remarkable in Sappho's "homoeroticism," since they conceived it as being potentially comparable. For the culturally constructed concepts of heterosexuality and homosexuality, see Halperin's earlier most interesting discussion (1990:41–53).

³ Cf. Dover 1989:172. Dover 1980:118 claims that Plato *Symposion* 191e5 "is the only surviving passage from classical Attic literature which acknowledges the existence of female homosexuality," but Plato *Laws* 636c is overlooked. Dover's 1980 statement is adopted by a number of scholars; see e.g. duBois 1995:91: "Lesbian sex like that celebrated in Sappho's poetry in the centuries before [i.e., Plato *Symposion* 191e] is not described, except in this briefest allowance for it, in the classical age, even in the works of Aristophanes, which are very explicit about many other imaginable forms of sexual behavior."

⁴ Dover 1989:172–173, 182; cf. duBois 1995:91: "Lesbian sex may also be unmentionable, except in some abstract sense, because it represents a threat to phallic sexuality" (and see duBois 1995:14).

⁵ See Koch-Harnack 1989:143–158 and Kilmer 1993b:26–30; cf. Chapter Two, n. 195.

⁶ See Chapter Two, with regard to the Bochum *kalyx-krater*, Chapter Three, and Chapter Four—concerning Epikrates *Antilais* fr. 4 K–A.

that defined their works—needs to be complemented or even undermined by a more wide-ranging, when possible, recontextualization of the cultural economies that shaped biographies as well as other kinds of ancient fictionalizing modalities. The same is true of the very late representations of Sappho being performed in dinner parties—images that in current scholarship are taken as *evidence* for late archaic and early classical realities.

I have suggested that we should think of ancient reception from an anthropological vantage-point and conduct fieldwork on metonymic nexuses of signification and complex discursive idioms conducive to the early crystallization and even expansion of cognitive frames and mental spaces. By tracing the ways in which the almost rhetorical (due to the use of schemata) and aestheticized *vraisemblance* of such visually and textually articulated frames and spaces engaged in dialogue with synchronic communicative systems and performance contexts, we may achieve a more anthropologically grounded investigation of ideological tensions. It was these tensions that eventually defined the unobtrusive, almost naturalized, cultural currencies in the overall process of receptorial scanning of musical performances by ancient female and male audiences. Our only guide to such cultural currencies is the diversity of papyrological, epigraphical, archaeological, and further textual informants.

# Abbreviations and Bibliography

For the fragments of Sappho and Alkaios I cite Voigt's critical edition [= V]. For the other melic poets I use Page's *Poetae Melici Graeci* [= *PMG*], while for Alkman, Stesikhoros, and Ibykos I refer to Davies 1991 when necessary. For the elegiac and iambic poets, I cite West's edition [= W]. For Pindar I use Snell and Maehler [= S-M] and Maehler [= M]; for Bakkhylides, I refer to Maehler 2003. Page's *Supplementum Lyricis Graecis* [= *SLG*] provides further melic fragments, but needs to be revised and supplemented in the light of the publication of new papyrus fragments. When there is no Oxford Classical Texts edition of a specific ancient Greek or Latin text, I have made a systematic effort to refer to the editor whose text or numbering I have adopted.

| | |
|---|---|
| *ABV* | See Beazley 1956 |
| *Add.* | Carpenter, T. H., with T. Mannack and M. Mendonça, *Beazley Addenda*, second ed., Oxford 1989 |
| *ARV* | See Beazley 1963 |
| *CA* | See Powell 1925 |
| *CEG* | P. A. Hansen, *Carmina Epigraphica Graeca saeculorum VIII–V a.Chr.n.*, Berlin 1983 and *Carmina Epigraphica Graeca saeculi IV a.Chr.n.*, Berlin 1989 |
| *CVA* | *Corpus Vasorum Antiquorum* |
| D-K | H. Diels and W. Kranz, *Die Fragmente der Vorsokratiker*, sixth ed., Berlin 1951–1952 |
| *FGrH* | F. Jacoby, *Die Fragmente der griechischen Historiker*, Berlin 1923–(Leiden 1954–) |
| Gigon | O. Gigon, *Aristotelis Opera. Volumen tertium: Librorum deperditorum fragmenta*, Berlin 1987 |
| G-P | See Gow-Page 1965 |
| *IG* | *Inscriptiones Graecae*, Berlin 1873– |
| Jan | K. von Jan, *Musici Scriptores Graeci*, Leipzig 1895 and *Musici Scriptores Graeci: Supplementum*, Leipzig 1899 |
| K-A | R. Kassel and C. Austin, *Poetae Comici Graeci*, 8 vols., Berlin 1983– |
| *LGPN* | P. M. Frazer, E. Matthews, et al. (eds.), *A Lexicon of Greek Personal Names*, vols. I, II, IIIA, IIIB, IV, Oxford 1987–2005 |

*Abbreviations and Bibliography*

| | |
|---|---|
| *LIMC* | *Lexicon Iconographicum Mythologiae Classicae*, vols. 1–8, Zurich 1981–1997 |
| L-P | See Lobel and Page 1955 |
| LSJ | H. G. Liddell, R. Scott and H. S. Jones, *A Greek-English Lexicon*, ninth ed. with a revised supplement, Oxford 1996 |
| M | H. Maehler, *Pindari Carmina. Pars II: Fragmenta*, Leipzig 1989 |
| M-W | See Merkelbach and West 1967 |
| *Para.* | J. D. Beazley, *Paralipomena*, Oxford 1971 |
| *PMG* | See Page 1962 |
| P.Oxy. | *The Oxyrhynchus Papyri*, London 1898– |
| *RE* | Pauly-Wissowa, *Real-Encyclopädie der classischen Altertumswissenschaft*, Stuttgart 1894–1980 |
| Rose | V. Rose, *Aristotelis qui ferebantur librorum fragmenta*, Leipzig 1886 (repr. 1967) |
| *SEG* | *Supplementum Epigraphicum Graecum*, Leiden 1923– |
| *SH* | H. Lloyd-Jones and P. J. Parsons, *Supplementum Hellenisticum*, Berlin 1983 |
| *SIL* | W. Dittenberger, *Sylloge Inscriptionum Graecarum*, 4 vols., third ed., Leipzig 1915–1924 (Hildesheim 1960) |
| *SLG* | See Page 1974 |
| S-M | B. Snell and H. Maehler, *Pindari Carmina. Pars I: Epinicia*, eighth ed., Leipzig 1987 |
| Stephanis | I. E. Stephanis, Διονυσιακοὶ Τεχνῖται. Συμβολὲς στὴν Προσωπογραφία τοῦ Θεάτρου καὶ τῆς Μουσικῆς τῶν Ἀρχαίων Ἑλλήνων, Herakleion 1988 |
| *SVF* | H. F. A. von Arnim, *Stoicorum Veterum Fragmenta*, 4 vols., Leipzig 1903–1924 |
| *TrGF* | B. Snell, R. Kannicht and S. Radt, *Tragicorum Graecorum Fragmenta*, 5 vols. (vol. 1, second ed. 1986), Göttingen |
| V | See Voigt 1971 |
| W | See West 1989/1992 |
| Wehrli | See Wehrli 1967/1969 |

## Journals

| | |
|---|---|
| *AA* | *Archäologischer Anzeiger* |
| *AK* | *Antike Kunst* |
| *AM* | *Mitteilungen des Deutschen Archäologischen Instituts, Athenische Abteilung* |
| *APap* | *Analecta Papyrologica* |

370

| APF | *Archiv für Papyrusforschung und verwandte Gebiete* |
|---|---|
| ARAnthr | *Annual Review of Anthropology* |
| CAnthr | *Cultural Anthropology* |
| Ethn | *Ethnomusicology* |
| H | *Hellenika, Ἑλληνικά* |
| HSCP | *Harvard Studies in Classical Philology* |
| JdI | *Jahrbuch des Deutschen Archäologischen Instituts* |
| JLA | *Journal of Linguistic Anthropology* |
| RA | *Revue Archéologique* |
| RM | *Mitteilungen des Deutschen Archäologischen Instituts, Römische Abteilung* |
| S/C | *Σύγκριση/Comparaison* |
| ZPE | *Zeitschrift für Papyrologie und Epigraphik* |

Adams, J. N. 1982. *The Latin Sexual Vocabulary*. London.

Adam Veleni, P. 1999. "Ἐπιγραφικὲς μαρτυρίες ἀπὸ τὰ Βρασνὰ νομοῦ Θεσσαλονίκης." *Πρακτικὰ Στ´ Διεθνοῦς Συμποσίου γιὰ τὴν Ἀρχαία Μακεδονία*, 1–14. Thessalonike.

———. 2002. "Una nuova epigrafe musicale." *Kleos* 7: 211–215.

Adorno, T. W. 2002. "On Popular Music." Id., *Essays on Music*, selected and edited by R. Leppert, trans. S. H. Gillespie, 437–469. Berkeley and Los Angeles.

Adrados, F. R. 1999. *History of the Graeco-Latin Fable, vol. 1: Introduction and from the Origins to the Hellenistic Age*, trans. L. A. Ray, revised ed. by F. R. Adrados and G.-J. van Dijk. Leiden.

———. 2003. *History of the Graeco-Latin Fable, vol. 3: Inventory and Documentation of the Graeco-Latin Fable*, trans. L. A. Ray and F. Rojas del Canto, supplemented ed. by F. R. Adrados and G.-J van Dijk. Leiden.

Albertoni, M. 1977. "Una singolare iscrizione su vaso attico." *Atti della Accademia nazionale dei Lincei* 32: 231–232.

Albizzati, C. 1925/1939. *Vasi antichi dipinti del Vaticano*. Rome.

Alexiou, M. 2002a. *The Ritual Lament in Greek Tradition*, second ed. revised by D. Yatromanolakis and P. Roilos (first ed. Cambridge 1974). Lanham, MD.

———. 2002b. *After Antiquity: Greek Language, Myth, and Metaphor*. Ithaca, NY.

Alexiou, M., and P. Dronke. 1971. "The Lament of Jephtha's Daughter: Themes, Traditions, Originality." *Studi Medievali* 12.2: 819–863.

Aloni, A. 1983. "Eteria e tiaso: I gruppi aristocratici di Lesbo tra economia e ideologia." *Dialoghi di Archeologia* ser. 3, n. 1: 21–35 [= id., "Lotta politica e pratica religiosa nella Lesbo di Saffo e Alceo." *Atti del Centro Ricerche e Documentazione sull' Antichità Classica* 11 (1980/1981): 213–232 (same version without footnotes)].

———. 1997. *Saffo: Frammenti*. Florence.

———. 2000. "Anacreonte a Atene." *ZPE* 130: 81–94.

———. 2001. "What Is That Man Doing in Sappho, fr. 31V.?," *Iambic Ideas: Essays on a Poetic Tradition from Archaic Greece to the Late Roman Empire* (eds. A. Carvarzere et al.) 29–40. Lanham, MD.

———. forth. "A proposito di Sim. 22 W² e Ael. Arist. 31.2 K." *Eikasmos.*

Alpers, S. 1984. *The Art of Describing: Dutch Art in the Seventeenth Century.* Chicago.

Aly, W. 1920. "Sappho." *RE* 2 A (1920). coll. 2357–2385.

Andersen, Ø. 1987. "Mündlichkeit und Schriftlichkeit im frühen Griechentum." *Antike und Abendland.* 23: 29–44.

———. 1989. "The Significance of Writing in Early Greece—A Critical Appraisal." *Literacy and Society* (eds. K. Schousboe and M. T. Larsen) 73–90. Copenhagen.

Andreadis, H. 2001. *Sappho in Early Modern England: Female Same-Sex Literary Erotics, 1550–1714.* Chicago.

Andrews, E. 1990. *Markedness Theory: The Union of Asymmetry and Semiosis in Language.* Durham.

Angiò, F. 1999. "Posidippo di Pella, l' *ep.* XVII Gow-Page e l'Αἰθιοπία." *Museum Helveticum* 56: 150–158.

Angiolillo, S. 1997. *Arte e cultura nell' Atene di Pisistrato e dei Pisistratidi: Ὁ ἐπὶ Κρόνου βίος.* Bari.

Arafat, K., and C. Morgan. 1989. "Pots and Potters in Athens and Corinth: A Review." *Oxford Journal of Archaeology* 8:311–346.

———. 1994. "Athens, Etruria and the Heuneburg: Mutual Misconceptions in the Study of Greek-Barbarian Relations." *Classical Greece: Ancient Histories and Modern Archaeologies* (ed. I. Morris) 108–134. Cambridge.

Arnott, W. G. 1996a. *Alexis. The Fragments: A Commentary.* Cambridge.

———. 1996b. *Menander, volume II.* Cambridge, MA.

Arom, S. 1991. *African Polyphony and Polyrhythm: Musical Structure and Methodology.* Cambridge and Paris.

Arrighetti, G. 1987. *Poeti, eruditi e biografi: Momenti della riflessione dei Greci sulla letteratura.* Pisa.

Asad, T. 1986. "The Concept of Cultural Translation in British Social Anthropology." In Clifford and Marcus 1986: 141–64.

Aujac, G., and M. Lebel. 1981. *Denys d'Halicarnasse: Opuscules rhétoriques, vol. 3: La composition stylistique.* Paris.

Austin, C., and G. Bastianini. 2002. *Posidippi Pellaei quae supersunt omnia.* Milan.

Avagianou, A. 1991. *Sacred Marriage in the Rituals of Greek Religion.* Bern.

Axel, B. K. 2002. *From the Margins: Historical Anthropology and Its Futures.* Durham, NC.

Axiotis, M. 1992. Περπατῶντας τὴ Λέσβο. 2 vols. Mytilene.

Bader, F. 1989. *La langue des dieux, ou, L'hermétisme des poètes indo-européens.* Pisa.

Bagordo, A. 2003. *Reminiszenzen früher Lyrik bei den attischen Tragikern: Beiträge zur Anspielungstechnik und poetischen Tradition.* Munich.

Bain, D. M. 1982. "κατωνάκην τὸν χοῖρον ἀποτετιλμένας" (Aristophanes, *Ekklesiazousai* 724)." *Liverpool Classical Monthly* 7.1: 7–10.

———. 1991. "Six Greek Verbs of Sexual Congress (βινῶ, κινῶ, πυγίζω, ληκῶ, οἴφω, λαικάζω)." *Classical Quarterly* 41:51–77.

Bakhtin, M. M. 1986. *Speech Genres and Other Late Essays*, trans. V. W. McGee, eds. C. Emerson and M. Holquist. Austin, TX.

Barbantani, S. 1993. "I poeti lirici del canone alessandrino nell' epigrammatistica." *Aevum Antiquum* 6:5–97.

Barker, A. 1984. *Greek Musical Writings, vol. I: The Musician and His Art*. Cambridge.

———. 1988. "Che cos' era la 'mágadis'?" In Gentili and Pretagostini 1988:96–107.

———. 1989. *Greek Musical Writings, vol. II: Harmonic and Acoustic Theory*. Cambridge.

Barkhuizen, J. H. and G. H. Els 1983. "On Sappho, fr. 16 (L.P.)." *Acta Classica* 26: 23–32.

Barner, W. 1967. *Neuere Alkaios-Papyri aus Oxyrhynchos*. Hildesheim.

Barnes, J. 1705. *Anacreon Teius, poeta lyricus: summa cura et diligentia . . . emendatus*. Cambridge.

Barrett, W. S. 1964. *Euripides: Hippolytos*, edited with introduction and commentary. Oxford.

Barthel-Calvet, A.-S. 2000. *Le rhythme dans l' oeuvre et la pensée de Xenakis*. EHESS, Paris.

Barthes, R. 1977a. *Image, Music, Text*, trans. S. Heath. New York.

———. 1977b. "The Photographic Message" and "Rhetoric of the Image." In Barthes 1977a:15–31, 32–51.

Bascoul, J.-M.-F. 1911. *Ἡ ἀγνὰ Σαπφώ. La chaste Sappho de Lesbos et le mouvement féministe à Athènes au IVe siècle av. J.-C.* Paris.

———. 1913. *La chaste Sappho de Lesbos et Stesichore*. Paris.

Battezzato, L. 2003. "Song, Performance, and Text in the New Posidippus." *ZPE* 145:31–43.

Battistella, E.L. 1996. *The Logic of Markedness*. New York and Oxford.

Baudrillard, J. 1979. *De la seduction*. Paris.

Bauer, P. O. 1963. "Sapphos Verbannung." *Gymnasium* 70: 1–10.

Bauman, R. 1992. "Contextualization, Tradition, and the Dialogue of Genres: Icelandic Legends of the *kraftaskáld*." In Duranti and Goodwin 1992:127–145.

Bauman, R., and J. Sherzer (eds.). 1974. *Explorations in the Ethnography of Speaking*. Cambridge [second ed., with new introduction, Cambridge 1989].

Bauman, R., et. al. 1987. *Performance, Speech Community, and Genre*. Working Papers and Proceedings of the Center for Psychological Studies, 11. Chicago, IL.

Baurain, C., et al. (eds.). 1991. *Phoinikeia Grammata: Lire et écrire en Méditerranée*. Namur.

Baurain-Rebillard, L. 1998 [2002]. "Des peintres linguistes?" *Métis* 13:75–105.

Baxandall, M. 1985. *Patterns of Intention: On the Historical Explanation of Pictures*. New Haven, CT.

Bažant, J. 1981. *Studies on the Use and Decoration of Athenian Vases.* Prague.

Baziotopoulou-Valavani, E. 1994. "Ἀνασκαφὲς σὲ ἀθηναϊκὰ κεραμικὰ ἐργαστήρια τῶν ἀρχαϊκῶν καὶ κλασσικῶν χρόνων." *The Archaeology of Athens and Attica under the Democracy: Proceedings of an International Conference Celebrating 2500 Years since the Birth of Democracy in Greece, Athens, December 1992* (eds. W. D. E. Coulson et al.) 45–54. Oxford.

Beaton, R. 1980. "Modes and Roads: Factors of Change and Continuity in Greek Musical Tradition." *Annual of the British School at Athens* 75:1–11.

Beazley, J. D. 1922. "Citharoedus." *Journal of Hellenic Studies* 42:70–98.

———. 1928. *Greek Vases in Poland.* Oxford.

———. 1932. "Little-Master Cups." *Journal of Hellenic Studies* 52:167–204.

———. 1933. *Campana Fragments in Florence.* Oxford.

———. 1948. "Hymn to Hermes." *American Journal of Archaeology* 52:336–340.

———. 1950. "Some Inscriptions on Vases: V." *American Journal of Archaeology* 54: 310–322.

———. 1953. "Brygan Symposia." *Studies presented to D. M. Robinson* (eds. G. R. Mylonas and D. Raymond), vol. 2:74–83. Saint Louis, MO.

———. 1954. *Attic Vase Paintings in the Museum of Fine Arts, Boston.* L. D. Caskey and J. D. Beazley. Part II: Text, Nos. 66-113. Oxford.

———. 1956. *(ABV) Attic Black-figure Vase-painters.* Oxford.

———. 1961. "An Amphora by the Berlin Painter." *AK* 4:49–67.

———. 1963. *(ARV) Attic Red-figure Vase-painters.* 3 vols., second ed. Oxford.

———. 1974a. *The Kleophrades Painter.* Mainz.

———. 1974b. *The Berlin Painter.* Mainz.

Beck, F. A. G. 1975. *Album of Greek Education: The Greeks at School and at Play.* Sydney.

Beck, W. 1991 [1987]. "ἔπος." In *Lexikon des frühgriechischen Epos.* vol. 2: B–Λ, 657–663. Göttingen.

Bélis, A. 1984. "Un nouveau document musical." *Bulletin de Correspondance Hellénique* 108:99–109.

———. 1992. "À propos de la coupe CA 482 du Louvre." *Bulletin de Correspondance Hellénique* 116:53–59.

Bell, J. M. 1978. "Κίμβιξ καὶ σοφός: Simonides in the Anecdotal Tradition." *Quaderni Urbinati di Cultura Classica* 28:29–86.

Bell, M. 1995. "The Motya Charioteer and Pindar's Isthmian 2." *Memoirs of the American Academy in Rome* 40:1–42.

Ben-Amos, D. 1976. "Analytical Categories and Ethnic Genres." *Folklore Genres* (ed. D. Ben-Amos) 215–242. Austin, TX.

Benardete, S. 1969. *Herodotean Inquiries.* The Hague.

Bennett, C. 1994. "Concerning 'Sappho Schoolmistress.'" *Transactions of the American Philological Association* 124:345–347.

Bennett, T. 1985. "Texts in History: The Determinations of Readings and Their Texts." *The Journal of the Midwest Modern Language Association* 18.1:1–16.

Bentz, M. and C. Reusser (eds.). 2004. *Attische Vasen in etruskischem Kontext: Funde aus Häusern und Heiligtümern.* Munich.

Bérard, C. 1974. *Anodoi: Essai sur l' imagerie des passages chthoniens.* Neuchâtel.

———. 1983. "Iconographie–Iconologie–Iconologique." *Etudes de lettres. Revue de la Faculté des Lettres. Université de Lausanne* 1983:5–37.

———. 1989. "The Order of Women." In Bérard et al. 1989:88–107.

Bérard, C. et al. (eds.). 1987. *Images et société en Grèce ancienne: L'iconographie comme méthode d'analyse. Actes du Colloque international, Lausanne 8-11 février 1984.* Lausanne.

Bérard, C. et al. 1989. *A City of Images: Iconography and Society in Ancient Greece.* trans. D. Lyons, Princeton, NJ.

Bérard, F., et al. (eds.). 2000. *Guide de l'épigraphiste: Bibliographie choisie des épigraphies antiques et médiévales,* third ed. Paris.

Bergamin, M. 2005. *Aenigmata Symposii: La fondazione dell'enigmistica come genere poetico.* Florence.

Bergk, T. 1843. *Poetae Lyrici Graeci.* 1 vol., first ed. Leipzig.

———. 1867. *Poetae Lyrici Graeci.* vol. 3, third ed. Leipzig.

———. 1882. *Poetae Lyrici Graeci.* vol. 3, fourth ed. Leipzig.

Bernabé, A. 1987. *Poetarum Epicorum Graecorum: Testimonia et Fragmenta.* Pars I. Leipzig.

Bernard, P. 1985. "Les rhytons de Nisa. I. Poétesses grecques." *Journal des Savants* 25–118.

Bessi, B. 1997. "La musica del simposio: Fonti letterarie e rappresentazioni vascolari." *Annali di archeologia e storia antica* (Istituto Universitario Orientale, Napoli), n.s. 4:137–152.

Bethe, E. 1931. *Pollucis Onomasticon.* fasc. 2: Lib. VI-X continens. Leipzig.

Biehl, W. 1975. *Euripides: Orestes.* Leipzig.

Bierl, A. 2001. *Der Chor in der Alten Komödie: Ritual und Performativität (unter besonderer Berücksichtigung von Aristophanes' Thesmophoriazusen und der Phalloslieder fr. 851 PMG).* Munich.

———. 2003. "'Ich aber (sage), das Schönste ist, was einer liebt!': Eine pragmatische Deutung von Sappho Fr. 16 LP/V." *Quaderni Urbinati di Cultura Classica* n.s. 74:91–124.

Bietti Sestieri, A. M. 1992. *The Iron Age Community of Osteria dell' Osa: A Study of Socio-political Development in Central Tyrrhenian Italy.* Cambridge.

Biffi, N. 1997. "Le storie diverse della cortigiana Rhodopis." *Giornale Italiano di Filologia* 49: 51–60.

Bing, P. 1988. *The Well-Read Muse: Present and Past in Callimachus and the Hellenistic Poets.* Göttingen.

———. 1993. "The *Bios*-Tradition and Poets' Lives in Hellenistic Poetry." *Nomodeiktes:*

375

*Greek Studies in Honor of M. Ostwald* (eds. R. M. Rosen and J. Farrell) 619–631. Ann Arbor, MI.

Blackburn, S. H., et al. (eds.). 1989. *Oral Epics in India*. Berkeley and Los Angeles.

Blacking, J. 1973. *How Musical is Man?* Seattle, WA.

Blank, P. 1995. "Comparing Sappho to Philaenis: John Donne's 'Homopoetics.'" *Publications of the Modern Language Association of America* 110, n. 3:358–368.

Blass, F. 1902. "Die Berliner Fragmente der Sappho." *Hermes* 37:456–479.

Blech, M. 1982. *Studien zum Kranz bei den Griechen*. Berlin.

Blok, J. 2001. "Virtual Voices: Toward a Choreography of Women's Speech in Classical Athens." *Making Silence Speak: Women's Voices in Greek Literature and Society* (eds. A. Lardinois and L. McClure) 95–116. Princeton, NJ.

Blok, J. and P. Mason (eds.). 1987. *Sexual Asymmetry: Studies in Ancient Society*. Amsterdam.

Blomfield, C. J. 1814. "Sapphonis Fragmenta." *Museum Criticum; or, Cambridge Classical Researches* I: 1–31.

Blümel, W. 1982. *Die aiolischen Dialekte. Phonologie und Morphologie der inschriftlichen Texte aus generativer Sicht*. Göttingen.

Boardman, J. 1975. *Athenian Red Figure Vases: The Archaic Period*. London.

———. 1976. "A Curious Eye Cup." *AA*: 281–290.

———. 1980. *The Greeks Overseas: Their Early Colonies and Trade*. New and enlarged ed. London [fourth edition 1999].

———. 1986. "Part Two" of D. C. Kurtz and J. Boardman, "Booners." *Greek Vases in the J. Paul Getty Museum* 3 [Occasional Papers on Antiquities 2] 35–70. Malibu, CA.

———. 1989. *Athenian Red Figure Vases: The Classical Period*. London.

———. 1992. "*Kaloi* and Other Names on Euphronios' Vases." *Euphronios. Atti del Seminario Internazionale di Studi, Arezzo 27-28 Maggio 1990* (eds. M. Cygielman et al.) 45–50. Florence.

———. 2001. *The History of Greek Vases: Potters, Painters and Pictures*. London.

Boas, F. 1940. *Race, Language, and Culture*. New York.

Boissonade, J. Fr. 1831. Ἀνέκδοτα: *Anecdota Graeca, e codicibus regiis*, vol. 3. Paris.

Bookidis, N. 1990. "Ritual Dining in the Sanctuary of Demeter and Kore at Corinth: Some Questions." In Murray 1990:86–94.

———. 1993. "Ritual Dining at Corinth." *Greek Sanctuaries: New Approaches* (eds. N. Marinatos and R. Hägg) 45–61. London and New York.

Bookidis, N. et al. 1999. "Dining in the Sanctuary of Demeter and Kore at Corinth." *Hesperia* 68:1–54.

Bookidis, N., and R. S. Stroud. 1997. *The Sanctuary of Demeter and Kore: Topography and Architecture* [Corinth XVIII, part III]. Princeton, NJ.

Borgeaud, P. et al. 1999. *La mythologie du matriarcat. L' atelier de Johann Jakob Bachofen*. Geneva.

Borofsky, R. 1997. "Cook, Lono, Obeyesekere, and Sahlins." *Current Anthropology* 38.2:255–282.

Boruhović, V. 1981. "Zur Geschichte des sozialpolitischen Kampfes auf Lesbos (Ende des 7.–Anfang des 6. Jh. v.u.Z.)." *Klio* 63:247–259.

Bosnakis, D. 2004. "Zwei Dichterinnen aus Kos: Ein neues inschriftliches Zeugnis über das öffentliche Auftreten von Frauen." *The Hellenistic Polis of Kos: State, Economy and Culture. Proceedings of an International Seminar organized by the Department of Archaeology and Ancient History, Uppsala University, 11-13 May, 2000* (ed. K. Höghammar) 99–108. Uppsala.

Boss, M. 1997. "Preliminary Sketches on Attic Red-figured Vases of the Early Fifth Century B.C." In Oakley et al. 1997:345–351.

Bourdieu, P. 1977. *Outline of a Theory of Practice,* trans. R. Nice. Cambridge.

———. 1984. *Distinction: A Social Critique of the Judgement of Taste,* trans. R. Nice. Cambridge, MA.

———. 1990. *The Logic of Practice,* trans. R. Nice. Stanford, CA.

Bowie, A. M. 1981. *The Poetic Dialect of Sappho and Alcaeus.* Salem, NH.

———. 1997. "Thinking with Drinking: Wine and the Symposium in Aristophanes." *Journal of Hellenic Studies* 117:1–21.

Bowman, L. 1998. "Nossis, Sappho and Hellenistic Poetry." *Ramus* 27: 39–59.

Bowra, C. M. 1961. *Greek Lyric Poetry: From Alcman to Simonides,* second revised ed. Oxford.

———. 1970a. "Xenophanes on the Luxury of Colophon." Id., *On Greek Margins* 109–121. Oxford.

———. 1970b. "Asius and the Old-fashioned Samians." Id., *On Greek Margins* 122–133. Oxford.

Brandenburg, H. 1966. *Studien zur Mitra: Beiträge zur Waffen- und Trachtgeschichte der Antike.* Münster.

Braun, T. F. R. G. 1982. "The Greeks in Egypt." *The Cambridge Ancient History,* vol. III, part 3: *The Expansion of the Greek World, Eighth to Sixth Centuries B.C.* (eds. J. Boardman and N. G. L. Hammond) Second ed. 32–56. Cambridge.

Braund, D. and J. Wilkins (eds.). 2000. *Athenaeus and His World: Reading Greek Culture in the Roman Empire.* Exeter.

Brelich, A. 1969. *Paides e Parthenoi.* Rome.

Bremmer, J. 1980. "An Enigmatic Indo-European Rite: Paederasty." *Arethusa* 13: 279–298.

Bremmer, J. N. 1994. *Greek Religion. Greece & Rome* New Surveys in the Classics No. 24. Oxford.

———. 1996. "Initiation." *The Oxford Classical Dictionary,* third ed. (eds. S. Hornblower and A. Spawforth) 758–759 [= third revised ed. 2003]. Oxford.

Briggs, C. L., and R. Bauman. 1992. "Genre, Intertextuality, and Social Power." *Journal of Linguistic Anthropology* 2.2:131–172.

Broger, A. 1996. *Das Epitheton bei Sappho und Alkaios: Eine sprachwissenschaftliche Unter-suchung.* Innsbruck.

Brooten, B. J. 1996. *Love between Women: Early Christian Responses to Female Homoeroticism.* Chicago.

Brown, C. 1983. "From Rags to Riches: Anacreon's Artemon." *Phoenix* 37:1–15.

Browning, R. 1960. "An Unnoticed Fragment of Sappho?" *Classical Review* 10:192–193.

Brumfield, A. C. 1981. *The Attic Festivals of Demeter and Their Relation to the Agricultural Year.* New York.

———. 1996. "Aporreta: Verbal and Ritual Obscenity in the Cults of Ancient Women." *Proceedings of the Third International Seminar on Ancient Greek Cult, organized by the Swedish Institute at Athens, 16-18 October 1992* (ed. R.Hägg) 67–74. Stockholm.

Brunet, P. 1998. *L'égal des dieux: Cent versions d' un poème de Sappho.* Paris.

———. 2003. "Sappho au *Banquet des Savants.*" *Colloque La poésie grecque antique* (eds. J.Jouanna and J. Leclant) 63–76. Paris.

Brusini, S. 1996. "L' Anacreonte Borghese: una nuova proposta di lettura." *Rivista di Ar-cheologia* 20: 59–74.

Bryant, M. 1983. *Riddles: Ancient and Modern.* London.

Bryson, N. 1983. *Vision and Painting: The Logic of the Gaze.* New Haven, CT.

——— 1991. "Semiology and Visual Interpretation." *Visual Theory: Painting and Interpreta-tion* (eds. N. Bryson et al.) 61–73. New York.

Buffière, F. 1980. *Éros adolescent: la pédérastie dans la Grèce antique.* Paris.

Buitron-Oliver, D. 1995. *Douris: A Master-Painter of Athenian Red-figure Vases.* Mainz.

Bundy, E. L. 1986. *Studia Pindarica* [first published as *Studia Pindarica I* and *II* in the *University of California Publications in Classical Philology* 18, nos. 1 and 2 (1962)]. Berkeley and Los Angeles.

Burke, P. 1987. *The Historical Anthropology of Early Modern Italy: Essays on Perception and Communication.* Cambridge.

Burkert, W. 1992. *The Orientalizing Revolution: Near Eastern Influence on Greek Culture in the Early Archaic Age,* trans. M. E. Pinder and W. Burkert. Cambridge, MA.

Burn, L. 1985. "Honey-pots: Three White-ground Cups by the Sotades Painter." *AK* 28: 93–105.

———. 1987. *The Meidias Painter.* Oxford.

Burnett, A. P. 1983. *Three Archaic Poets: Archilochus, Alcaeus, Sappho.* London.

Burnyeat, M. 1997. "Postscript on Silent Reading." *Classical Quarterly* 47:74–76.

Burzachechi, M. 1962. "Oggetti parlanti nelle epigrafi greche." *Epigraphica* 24:3–54.

Butor, M. 1969. *Les mots dans la peinture.* Geneva.

Cairns, F. 1972. *Generic Composition in Greek and Roman Poetry.* Edinburgh.

Calame, C. 1974. "Réflexions sur les genres littéraires en Grèce archaïque." *Quaderni Ur-binati di Cultura Classica* 17: 113–128.

———. 1977. *Les Choeurs de jeunes filles en Grèce archaïque. I. Morphologie, fonction religieuse et sociale*. Rome.

———. 1989. "Entre rapports de parenté et relations civiques: Aphrodite l' hétaïre au banquet politique des *hetaîroi*." *Aux sources de la puissance: sociabilité et parenté*, Actes du Colloque de Rouen 12–13 novembre 1987, 101–111. Rouen.

———. 1997. *Choruses of Young Women in Ancient Greece: Their Morphology, Religious Role, and Social Function*, second ed., trans. D. Collins and J. Orion. Lanham, MD.

———. 1999. "Indigenous and Modern Perspectives on Tribal Initiation Rite: Education according to Plato." *Rites of Passage in Ancient Greece: Literature, Religion, Society* (ed. M. W. Padilla) 278–312. Lewisburg, PA.

———. 2001. *Choruses of Young Women in Ancient Greece: Their Morphology, Religious Role, and Social Function*. New and revised ed., trans. D. Collins and J. Orion. Lanham, MD.

Calder, W. M. 1986. "F. G. Welcker's *Sapphobild* and Its Reception in Wilamowitz." *Friedrich Gottlieb Welcker. Werk und Wirkung* (eds. W. M. Calder et al.) 131–156. Stuttgart.

Cameron, A. 1993. *The Greek Anthology: From Meleager to Planudes*. Oxford.

———. 1995. *Callimachus and His Critics*. Princeton, NJ.

Campbell, D. A. 1982. *Greek Lyric I*. Cambridge, MA.

———. 1992. *Greek Lyric IV*. Cambridge, MA.

———. 1993. *Greek Lyric V*. Cambridge, MA.

Campbell, M. 1973/1974. "Anacr. fr. 358 P." *Museum Criticum* 8/9:168–169.

Campbell, S. J. 2004. *The Cabinet of Eros: Renaissance Mythological Painting and the Studiolo of Isabella d' Este*. New Haven, CT.

Cantarella, E. 1992. *Bisexuality in the Ancient World*, trans. C. Ó Cuilleanáin. New Haven, CT.

Carbone, G. 1993. "Le donne di Lesbo nel lessico svetoniano delle ingiurie (A proposito di Anacr. fr. 13 Gent.)." *Quaderni Urbinati di Cultura Classica* 44:71–76.

Carey, C. 2003. "Praxilla." *The Oxford Classical Dictionary*. Third ed. revised (eds. S. Hornblower and A. Spawforth) 1242. Oxford.

Carson, A. 1986. *Eros the Bittersweet: An Essay*. Princeton, NJ.

———. 2002. *If Not, Winter: Fragments of Sappho*. New York.

Cartledge, P. 1981. "Spartan Wives: Liberation or Licence?" *Classical Quarterly* 31:84–105.

———. 1994. "The Greeks and Anthropology." *Anthropology Today* 10.3:3–6.

———. 1996. "Classical Studies." *Encyclopedia of Social and Cultural Anthropology* (eds. A. Barnard and J. Spencer) 100–102. London.

Casadio, V. 1996. *I "dubbi" di Archiloco*. Pisa.

Casaubon, I. and J. Dalechamps 1597. Ἀθηναίου Δειπνοσοφιστῶν βιβλία πεντεκαίδεκα. *Athenaei Deipnosophistarum libri quindecim: I. Casaubonus recensuit . . . ; addita est I. Dalechampii Latina interpretatio*. Heidelberg.

Cassio, A. C. 1983. "Post-Classical Λέσβιαι." *Classical Quarterly* 33:296–297.

Càssola, F. 1975. *Inni omerici.* Milan.

Castaldo, D. 1993. *Immagini della musica nella Grecia antica: Iconografia musicale nelle ceramiche attiche e magnogreche del Museo Civico Archeologico di Bologna.* Bologna.

Castoriadis, C. 1987. *The Imaginary Institution of Society,* trans. Kathleen Blamey. Cambridge, MA.

Cataudella, Q. 1927. "Derivazioni di Saffo in Gregorio Nazianzeno." *Bollettino di Filologia Classica* 34:282–284 [reprinted in his *Intorno ai lirici greci,* Rome 1972, 66–69].

———. 1965. "Saffo e i Bizantini." *Revue des Études Grecques* 78:66–69 [reprinted in *Intorno ai lirici greci,* Rome 1972, 79–82].

———. 1973. "Recupero di un' antica scrittrice greca." *Giornale Italiano di Filologia* 4:253–263.

Cavalier, O. (ed.). 1996. *Silence et fureur: La femme et le mariage en Grèce. Les antiquités grecques du Musée Calvet.* Avignon.

Cavallini, E. 1986. *Prezenza di Saffo e Alceo nella poesia greca fino ad Aristofane.* Ferrara.

——— (ed.). 2004. *Samo: Storia, Letteratura, Scienza (Ravenna, 14-16 novembre 2002).* Pisa and Rome.

Cavallo, G., and H. Maehler 1987. *Greek Bookhands of the Early Byzantine Period, A.D. 300-800.* London.

Chadwick, J. 1990. "The Descent of the Greek Epic." *Journal of Hellenic Studies* 110:174–177.

Chantraine, P. 1948/1953. *Grammaire homérique.* 2 vols. Paris.

———. 1968/1980. *Dictionnaire étymologique de la langue grecque: histoire des mots.* Paris [new ed. 1999].

Chantry, M. 1999. *Scholia in Aristophanem. Pars III, fasc. Iª: Scholia Vetera in Aristophanis Ranas.* Groningen.

———. 2001. *Scholia in Aristophanem. Pars III, fasc. Iᵇ: Scholia Recentiora in Aristophanis Ranas.* Groningen.

Charitonides, S. I. 1966. "Ἡ ἰδιομορφία τοῦ λεσβιακοῦ πολιτισμοῦ στὴν ἀρχαϊκὴ ἐποχή." *Lesbiaka* 5:161–168.

Christidis, D. A. 1985. "Σαπφικά." *Η* 36:3–11.

Christin, A.-M. 1995. *L'image écrite ou la déraison graphique.* Paris.

Clark, E. 2004. *History, Theory, Text: Historians and the Linguistic Turn.* Cambridge, MA.

Clay, D. 2004. *Archilochos Heros: The Cult of Poets in the Greek Polis.* Cambridge, MA.

Clay, J. S. 1999. "*Iliad* 24.649 and the Semantics of *ΚΕΡΤΟΜΕΩ.*" *Classical Quarterly* 49:618–621.

Clifford, J. 1986. "On Ethnographic Allegory." In Clifford and Marcus 1986:98–121.

———. 1988. *The Predicament of Culture: Twentieth-Century Ethnography, Literature, and Art.* Cambridge, MA.

Clifford, J. T., and G. E. Marcus (eds.). 1986. *Writing Culture: The Poetics and Politics of Ethnography.* Berkeley and Los Angeles, CA.

Clinkenbeard, B. G. 1982. "Lesbian Wine and Storage Amphoras: A Progress Report on Identification." *Hesperia* 51:248–268.

———. 1986. "Lesbian and Thasian Wine Amphoras: Questions Concerning Colla-boration." *Recherches sur les amphores grecques: Actes du colloque international organisé par le Centre National de la Recherche Scientifique, l' Université de Rennes II et l'École française d'Athènes (Athènes, 10-12 Septembre 1984)* (eds. J.-Y. Empereur and Y. Garlan) 353–362. Athens.

Cobet, J. 1988. "Herodot und mündliche Überlieferung." *Vergangenheit in mündlicher Überlieferung* (eds. J. von Ungern-Sternberg and H. Reinau) 226–233. Stuttgart.

Coche-Zivie, C. 1972. "Nitocris, Rhodopis et la troisième pyramide de Giza." *Bulletin de l'Institut français d' archéologie orientale* 72:115–138.

Cohen, B. 1991. "The Literate Potter: A Tradition of Incised Signatures on Attic Vases." *Metropolitan Museum Journal* 26:49–95.

———. (ed.). 2000. *Not the Classical Ideal: Athens and the Construction of the Other in Greek Art.* Leiden.

———. 2001. "Ethnic Identity in Democratic Athens and the Visual Vocabulary of Male Costume." *Ancient Perceptions of Greek Ethnicity* (ed. I. Malkin) 235–274. Cambridge, MA.

Cohen, B., and H. A. Shapiro. 2002. "The Use and Abuse of Athenian Vases." *Essays in Honor of Dietrich von Bothmer* (eds. A. J. Clark et al.) 83–90. Amsterdam.

Cohen, R. 2003. *500 Cantigas d' amigo: Critical edition.* Porto.

Coldstream, J. N. 1968. *Greek Geometric Pottery: A Survey of Ten Local Styles and Their Chrono-logy.* London.

Cole, S. G. 1994. "Demeter in the Ancient Greek City and Its Countryside." *Placing the Gods: Sanctuaries and Sacred Space in Ancient Greece* (eds. S. E. Alcock and R. Os-borne) 199–216. Oxford.

Collecott, D. 1999. *H. D. and Sapphic Modernism, 1910-1950.* Cambridge.

Comaroff, J., and J. L. Comaroff. 1992. *Ethnography and the Historical Imagination.* Boulder, CO.

Conca, F. 1994. *Il romanzo bizantino del XII secolo: Teodoro Prodromo, Niceta Eugeniano, Eustazio Macrembolita, Costantino Manasse.* Torino.

Contiades-Tsitsoni, E. 1990. *Hymenaios und Epithalamion: Das Hochzeitslied in der früh-griechischen Lyrik.* Stuttgart.

Cook, B. F. 1987. *Greek Inscriptions.* Berkeley and Los Angeles, CA.

Cooper, F., and S. Morris. 1990. "Dining in Round Buildings." In Murray 1990:66–85.

Coote, M. P. 1977. "Women's Songs in Serbo-Croatian." *Journal of American Folklore* 90: 331–338.

———. 1992. "On the Composition of Women's Songs." *Oral Tradition* 7:332–348.

Costanza S. 1976. "Su alcune risonanze classiche nel carme I 2, 10 di Gregorio di Nazi-anzo." *Sileno* 2:203–219.

———. 1980. "Un motivo saffico in Teodoro Besto e in Simeone Metafraste (Sappho, fr. 96 V. 6–9; Teodoro, BHG³, 624, 4; Simeone BHG³, 620, 4)." *Orpheus* n.s. 1:106–114.

Couat, A. 1931. *Alexandrian Poetry under the First Three Ptolemies,* with a supplementary chapter by E. Cahen, trans. J. Loeb. London.

Cougny, E. 1890. *Epigrammatum Anthologia Palatina cum Planudeis et appendice nova epigrammatum veterum ex libris et marmoribus ductorum,* vol. 3. Paris.

Coulson, W. D. E. 1996. *Ancient Naukratis, vol. II: The Survey at Naukratis and Environs. Part I: The Survey at Naukratis,* with the assistance of I. Leventi. Oxford.

Courby, F. 1922. *Les vases grecs à reliefs.* Paris.

Crapanzano, V. 1986. "Hermes' Dilemma: The Making of Subversion in Ethnographic Description." In Clifford and Marcus 1986:51–76.

———. 1992. *Hermes' Dilemma and Hamlet's Desire: On the Epistemology of Interpretation.* Cambridge, MA.

———. 2004. *Imaginative Horizons: An Essay in Literary-Philosophical Anthropology.* Chicago, IL.

Crusius, O. 1907. Review of *Berliner Klassikertexte* vol. V. *Literarisches Centralblatt für Deutschland* 58: 1309–1310.

———. 1926. *Die Mimiamben des Herondas,* revised ed. R. Herzog. Leipzig.

Csapo, E. 2000. "From Aristophanes to Menander? Genre Transformation in Greek Comedy." *Matrices of Genre: Authors, Canons, and Society* (eds. M. Depew and D. Obbink) 115–133. Cambridge, MA.

Csapo, E., and M. C. Miller. 1991. "The 'Kottabos-toast' and an Inscribed Red-figured Cup." *Hesperia* 60:367–382.

Culler, J. 1975. *Structuralist Poetics: Structuralism, Linguistics, and the Study of Literature.* Ithaca, NY.

Cummings, M. S. 2001. "The Early Greek Paraclausithyron and Gnesippus." *Scholia* 10: 38–53.

Cunningham, I. C. 1971. *Herodas Mimiambi,* edited with introduction, commentary, and appendices. Oxford.

Cyrino, M. 1996. "Anakreon and Erôs Damalês." *Classical World* 89:371–382.

Dale, A. M. 1968. *The Lyric Metres of Greek Drama,* second ed. Cambridge.

Darbo-Peschanski, C. 1987. *Le discours du particulier: Essai sur l'enquête hérodotéenne,* Preface P. Veyne. Paris.

Davidson, J. F. 1987. "Anacreon, Homer, and the Young Woman from Lesbos." *Mnemosyne* 40:132–137.

Davidson, J. N. 1997. *Courtesans and Fishcakes: The Consuming Passions of Classical Athens.* London.

———. 2000. "Gnesippus Paigniagraphos: The Comic Poets and the Erotic Mime." *The Rivals of Aristophanes: Studies in Athenian Old Comedy* (eds. D. Harvey and J. Wilkins) 41–64. London.

Davies, M. 1991. *Poetarum Melicorum Graecorum Fragmenta,* vol. 1: *Alcman, Stesichorus, Ibycus,* post D. L. Page edidit M. Davies. Oxford.

Davison, J. A. 1968. "Anacreon fr. 5 Diehl." Id., *From Archilochus to Pindar,* 247–255. London.

De Certeau, 1986. *Heterologies: Discourses on the Other.* Minneapolis, MN.

Debord, G. 1988. *Commentaires sur la société du spectacle.* Paris.

———. 1994. *The Society of the Spectacle,* trans. D. Nicholson-Smith. New York.

Deferrari, R. J. 1969. *Lucian's Atticism: The Morphology of the Verb.* Amsterdam [orig. publ. 1916].

Dehler, J. 1999. *Fragments of Desire: Sapphic Fictions in Works by H. D., Judy Grahn, and Monique Wittig.* Frankfurt am Main.

DeJean, J. 1989. *Fictions of Sappho, 1546-1937.* Chicago, IL.

de la Genière, J. 1987. "Rituali funebri e produzione di vasi." *Tarquinia: Ricerche, scavi e prospettive* (eds. M. B. Jovino and C. C.Treré) 203–208. Milan.

———. 1988. "Les acheteurs des cratères corinthiens." *Bulletin de Correspondance Hellénique* 112:83–90.

———. 1999. "Quelques réflexions sur les clients de la céramique attique." *Céramique et peinture grecques: Modes d' emploi. Actes du colloque international, École du Louvre, 26-28 avril 1995* (eds. M.-C. Villanueva Puig et al.) 411–424. Paris.

Delavaud-Roux, M.-H. 1995. "L' énigme des danseurs barbus au parasol et les vases 'des Lénéennes.'" *Revue Archéologique* 227–263.

de Man, P. 1982. "Introduction." In Jauss 1982: vii–xxv.

Denniston, J. D. 1954. *The Greek Particles,* second ed. Oxford.

Derderian, K. 2001. *Leaving Words to Remember: Greek Mourning and the Advent of Literacy.* Leiden.

Derrida, J. 1978a. *Writing and Difference,* trans. A. Bass. Chicago, IL.

———. 1978b. *La vérité en peinture.* Paris.

———. 1991. *Donner le temps: 1. La fausse monnaie.* Paris.

des Bouvrie Thorsen, S. 1978. "The Interpretation of Sappho's Fragment 16 L.-P." *SO* 53: 5–23.

Detienne, M. 1979. *Dionysos Slain,* trans. M. Muellner and L. Muellner. Baltimore, MD.

——— (ed.). 1988. *Les savoirs de l'écriture: en Grèce ancienne.* Lille.

———. 1991. "Pour une anthropologie *avec* les Grecs." In A. Bonnard, *Civilisation grecque,* VII–XIV. Lausanne.

———. 1996. *The Masters of Truth in Archaic Greece,* trans. J. Lloyd. New York.

———. 2000. *Comparer l'incomparable.* Paris.

———. 2001. "Back to the Village: A Tropism of Hellenists?" *History of Religions* 41.2:99–113.

———. 2003. *Comment être autochtone: Du pur Athénien au Français raciné.* Paris.

Detienne, M., and J.-P. Vernant 1974. *Les ruses de l'intelligence: La mètis des Grecs.* Paris.

Devine, A. M., and L. D. Stephens 1991. "Dionysius of Halicarnassus, *De Compositione Verborum* XI: Reconstructing the Phonetics of the Greek Accent." *Transactions of the American Philological Association* 121:229–286.

———. 1994. *The Prosody of Greek Speech.* New York and Oxford.

De Vries, K. 1973. "East Meets West at Dinner." *Expedition* 15:32–39.

———. 1997. "The 'Frigid Eromenoi' and Their Wooers Revisited: A Closer Look at Greek Homosexuality in Vase Painting." *Queer Representations: Reading Lives, Reading Cultures* (ed. M. Duberman) 14–24. New York.

———. 2000. "The Nearly Other: The Attic Vision of Phrygians and Lydians." In Cohen 2000:338–363.

Diehl, E. 1925. *Anthologia Lyrica Graeca,* vol. 1. Leipzig.

———. 1936. *Anthologia Lyrica Graeca,* vol. 1, second ed. Leipzig.

———. 1942. *Anthologia Lyrica Graeca. Supplementum: Addenda et corrigenda fasciculorum I–VI editionis alterius.* Leipzig.

Diggle, J. 1991. *The Textual Tradition of Euripides' Orestes.* Oxford.

———. 1994. *Euripidis Fabulae,* vol. 3. Oxford.

———2004. *Theophrastus: Characters,* edited with introduction, translation, and commentary. Cambridge.

Dilts, M. R. 1971. *Heraclidis Lembi Exerpta Politiarum.* Durham, NC.

———. 1974. *Claudii Aeliani Varia Historia.* Leipzig.

Dirks, N. 1987. *The Hollow Crown: Ethnohistory of an Indian Kingdom.* Cambridge.

———. 1996. "Is Vice Versa? Historical Anthropologies and Anthropological Histories." *The Historic Turn in the Human Sciences* (ed. T. J. McDonald) 17–51. Ann Arbor, MI.

Dobrov, G. W., and E. Urios-Aparisi. 1995. "The Maculate Music: Gender, Genre, and the *Chiron* of Pherecrates." *Beyond Aristophanes: Transition and Diversity in Greek Comedy* (ed. G. W. Dobrov) 139–174. Atlanta, GA.

Dörrie, H. 1975. *P. Ovidius Naso: Der Brief der Sappho an Phaon.* Munich.

Domingo-Forasté, D. 1994. *Claudii Aeliani Epistulae et Fragmenta.* Stuttgart and Leipzig.

Dornseiff, F. 1921. *Pindars Stil.* Berlin.

Dougherty, C., and L. Kurke (eds.). 1993. *Cultural Poetics in Archaic Greece.* Cambridge and New York.

——— (eds.). 2003. *The Cultures within Ancient Greek Culture: Contact, Conflict, Collaboration.* Cambridge.

Douglas, M. forth. *Thinking in Circles: An Essay on Ring Composition.* New Haven, CT.

Dover, K. J. 1980. *Plato. Symposium.* Cambridge.

———. 1987. "The Poetry of Archilochus." Id., *Greek and the Greeks. Collected Papers,* vol. I: *Language, Poetry, Drama,* 97–121 [orig. publ. in *Archiloque,* Geneva 1964, 181–222]. Oxford.

———. 1988a. "Greek Homosexuality and Initiation." Id., *The Greeks and Their Legacy: Collected Papers*, vol. II: *Prose Literature, History, Society, Transmission, Influence*, 115–134. Oxford.

———. 1988b. "Anecdotes, Gossip and Scandal." Id., *The Greeks and Their Legacy: Collected Papers*, vol. II, 45–52. Oxford.

———. 1989. *Greek Homosexuality*, updated with a new postscript. Cambridge, MA (orig. publ. 1978).

———. 1993. *Aristophanes. Frogs*, edited with introduction and commentary. Oxford.

———. 2002. "Two Women of Samos." *The Sleep of Reason: Erotic Experience and Sexual Ethics in Ancient Greece and Rome* (eds. M. C. Nussbaum and J. Sihvola) 222–228. Chicago, IL.

duBois, P. 1995. *Sappho Is Burning*. Chicago, IL.

Dunbabin, T. J. 1948. *The Western Greeks: The History of Sicily and South Italy from the Foundation of the Greek Colonies to 480 B.C.* Oxford.

Dunbar, N. 1995. *Aristophanes. Birds*, edited with introduction and commentary. Oxford.

Durand, J.-L., and F. Lissarrague. 1980. "Un lieu d'image? L'espace du loutérion." *Hephaistos* 2:89–106.

Duranti, A. 1997. *Linguistic Anthropology*. Cambridge.

Duranti, A., and C. Goodwin (eds.). 1992. *Rethinking Context: Language as an Interactive Phenomenon*. Cambridge.

———. 1992a. "Rethinking Context: An Introduction." In Duranti and Goodwin 1992: 1–42.

Düring, I. 1957. *Aristotle in the Ancient Biographical Tradition*. Göteborg.

Easterling, P. E. 1977. "Literary Tradition and the Transformations of Cupid." *Didaskalos* 5:318–337.

———. 1995. "Menander: Loss and Survival." *Stage Directions: Essays in Ancient Drama in Honour of E. W. Handley* [*Bulletin of the Institute of Classical Studies* Supplement 66] (ed. A. Griffiths) 153–160. London.

Écarnot, C. 2002. *L'écriture de Monique Wittig: À la couleur de Sappho*. Paris.

Edelstein, L., and I. G. Kidd. 1989. *Posidonius. I: The Fragments*, second ed. Cambridge.

Edmonds, J. M. 1922. "Sappho's Book as Depicted on an Attic Vase." *Classical Quarterly* 16:1–14.

———. 1928a. *Lyra Graec*, vol. 1, revised and augmented ed. London.

———. 1928b. *Sappho Revocata*. London.

———. 1931. *Lyra Graeca*, vol. 2, revised and augmented ed. London.

———. 1940. *Lyra Graeca*, vol. 3, revised ed. London.

Edmunds, L. 2001. "Sappho Fr. 31 V: Performance and Reading." *Annali dell' Università di Ferrara. Sezione Lettere* n.s. 2:3–23.

Ellenberger, O. 1907. *Quaestiones Hermesianacteae*. Diss. Giessen.

Evans, J. A. S. 1991. *Herodotus, Explorer of the Past: Three Essays.* Princeton, NJ.

Fabbro, E. 1992. "Sul riuso di carmi d' autore nei simposi attici (*Carm. conv.* 8 P. e Alc. fr. 249 V.)." *Quaderni Urbinati di Cultura Classica* n.s. 41:29–38.

———. 1995. *Carmina Convivalia Attica.* Rome.

Fabian, J. 1983. *Time and the Other: How Anthropology Makes Its Object.* New York. [Second ed., with foreword M. Bunzl, New York 2002].

Fairweather, J. 1974. "Fiction in the Biographies of Ancient Writers." *Ancient Society* 5: 234–255.

Fauconnier, G. 1984. *Espaces mentaux: aspects de la construction du sens dans les langues naturelles.* Paris.

———. 1997. *Mappings in Thought and Language.* Cambridge.

Fauconnier, G., and E. Sweetser (eds.). 1996. *Spaces, Worlds, and Grammar.* Chicago, IL.

Fehling, D. 1989. *Herodotus and His "Sources": Citation, Invention, and Narrative Art,* revised ed., trans. J. G. Howie [orig. German ed. 1971]. Leeds.

Fehr, B. 1971. *Orientalische und griechische Gelage.* Bonn.

———. 2003. "What Has Dionysos to Do with the Symposion?" *Symposium: Banquet et représentations en Grèce et à Rome* (eds. C. Orfanos and J.-C. Carrière). In *Pallas: Revue d'études antiques* 61: 23–37.

Feld, S. 1974. "Linguistic Models in Ethnomusicology." *Ethn* 18:197–217.

———. 1984a. "Communication, Music, and Speech about Music." *Yearbook for Traditional Music* 16:1–18.

———. 1984b. "Sound Structure as Social Structure." *Ethn* 28:383–409.

———. 1990. *Sound and Sentiment: Birds, Weeping, Poetics, and Song in Kaluli Expression,* second ed. Philadelphia, PA.

———. 1998. "They Repeatedly Lick Their Own Things." *Critical Inquiry* 24:445–472 [reprinted in L. Berlant (ed.), *Intimacy,* Chicago, 165–192].

Feld, S., and D. Brenneis. 2004. "Doing Anthropology in Sound." *American Ethnologist* 31: 461–474.

Feld, S., and A. A. Fox. 1994. "Music and Language." *Annual Review of Anthropology* 23: 25–53.

Feld, S., and B. B. Schieffelin. 1996. "Hard Words: A Functional Basis for Kaluli Discourse." *The Matrix of Language: Contemporary Linguistic Anthropology* (eds. D. Brenneis and R. K. S. Macaulay) 56–73. Boulder, CO.

Fernández-Galiano, E. 1987. *Posidipo de Pela.* Madrid.

Ferrari, F. 2000. "Due note al testo del fr. 2 di Saffo." *APap* 12:37–44.

———. 2003. "Il pubblico di Saffo." *Studi Italiani di Filologia Classica* ser. 4, vol. 1:42–89.

Ferrari, G. 2002. *Figures of Speech: Men and Maidens in Ancient Greece.* Chicago, IL.

Ferrari, W. 1940. "Due note su ἁγνός." *Studi Italiani di Filologia Classica* 17:33–53.

Ferri, S. 1938. "Sui vasi greci con epigrafi 'acclamatorie.'" *Rendiconti della Regia Accademia dei Lincei,* cl. sci. mor., series VI, vol. 14:93–179.

Festa, N. 1902. *Palaephati Peri apiston. Heracliti qui fertur libellus Peri apiston*, in *Mythographi Graeci* vol. III.2. Leipzig.

Figueira, T. J., and G. Nagy (eds.). 1985. *Theognis of Megara: Poetry and the Polis*. Baltimore, MD.

Fineman, J. 1981. "The Structure of Allegorical Desire." *Allegory and Representation* (ed. S. Greenblatt) 26–60. Baltimore, MD.

Finley, M. I. 1975. "Anthropology and Classics." Id., *The Use and Abuse of History*, 102–119. London.

Finnegan, R. 1977. *Oral Poetry: Its Nature, Significance and Social Context*. Cambridge. [Reprint with a new preface by the author, Bloomington and Indianapolis, IN. 1992.]

———. 1988. *Literacy and Orality: Studies in the Technology of Communication*. Oxford.

Fisher, H. G. 1986. *L' écriture et l' art de l' Egypte ancienne*. Paris 1986.

Fisher, N. 2000. "Symposiasts, Fish-Eaters and Flatterers: Social Mobility and Moral Concerns in Old Comedy." *The Rivals of Aristophanes: Studies in Athenian Old Comedy* (eds. D. Harvey and J. Wilkins) 355–396. London.

———. 2001. *Aeschines: Against Timarchos*. Oxford.

Flint, E. R. 1989. *An Investigation of Real Time as Evidenced by the Structural and Formal Multiplicities in Iannis Xenakis' Psappha*. Ph.D. diss., University of Maryland College Park.

———. 2001. "The Experience of Time and *Psappha*." In Solomos 2001:163–172.

Flower, H. I. 1991. "Herodotus and Delphic Traditions about Croesus." *Georgica: Greek Studies in Honour of G. Cawkwell* (eds. M. A. Flower and M. Toher) 57–77. London.

Flueckiger, J. B. 1996. *Gender and Genre in the Folklore of Middle India*. Ithaca, NY.

Foley, J. M. 1988. *The Theory of Oral Composition: History and Methodology*. Bloomington and Indianapolis, IN.

———. 1991. *Immanent Art: From Structure to Meaning in Traditional Oral Epic*. Bloomington and Indianapolis, IN.

———. 1995. *The Singer of Tales in Performance*. Bloomington and Indianapolis, IN.

———. 2002. *How to Read an Oral Poem*. Urbana, IL.

Ford, A. 2002. *The Origins of Criticism: Literary Culture and Poetic Theory in Classical Greece*. Princeton, NJ.

Fornaro, S. 1991. "Immagini di Saffo." *Rose di Pieria* (ed. F. De Martino) 139–161. Bari.

Fortenbaugh, W. W., P. M. Huby, R. W. Sharples, and D. Gutas. 1992. *Theophrastus of Eresus: Sources for His Life, Writings, Thought, and Influence*, 2 vols. Leiden.

Foucault, M. 1966. "Les suivantes." Id., *Les mots et les choses: une archéologie des sciences humaines*, 19–31. Paris.

———. 1969. *L'archéologie du savoir*. Paris.

———. 1981. "The Order of Discourse." *Untying the Text: A Poststructuralist Reader* (ed. R. Young) 48–78. New York.

———. 1983. *This Is Not a Pipe*, trans. and ed. J. Harkness. Berkeley and Los Angeles, CA.

———. 1984. *Histoire de la sexualité*, vol. 2: *L'Usage des plaisirs*. Paris.

Fowler, R. L. 1987. *The Nature of Early Greek Lyric: Three Preliminary Studies*. Toronto and Buffalo, NY.

Fränkel, H. 1928. Review of Lobel 1925 and 1927. *Göttingische gelehrte Anzeigen* 1928:258–278.

———. 1975. *Early Greek Poetry and Philosophy*, trans. M. Hadas and J. Willis. New York.

Frel, J. 1996. "La céramique et la splendeur des courtisanes." *Rivista di Archeologia* 20:38–53.

Freud, S. 1962. *The Standard Edition of the Complete Psychological Works of Sigmund Freud*, vol.3: *(1893-1899) Early Psycho-Analytic Publications*, trans. J. Strachey in collaboration with Anna Freud. London.

———. 1964. *The Standard Edition of the Complete Psychological Works of Sigmund Freud*, vol. 23: *(1937-1939) Moses and Monotheism, An Outline of Psycho-Analysis, and Other Works*. London.

———. 1965. *The Interpretation of Dreams*, trans. and ed. J. Strachey. London.

Fried, M. 1980. *Absorption and Theatricality*. Berkeley and Los Angeles, CA.

Frisk, H. 1960/1972. *Griechisches etymologisches Wörterbuch*. Heidelberg.

Froning, H. 1982. *Katalog der griechischen und italischen Vasen: Museum Folkwang Essen*. Essen.

———. 1988. "Anfänge der kontinuierenden Bilderzählung in der griechischen Kunst." *JdI* 103:169–199.

Frontisi-Ducroux, F. 1998 [2002]. "Kalé: le féminin facultative." *Métis* 13:173–185.

Frontisi-Ducroux, F., and F. Lissarrague. 1990. "From Ambiguity to Ambivalence: A Dionysiac Excursion through the 'Anakreontic' Vases." *Before Sexuality: The Construction of Erotic Experience in the Ancient Greek World* (eds. D. M. Halperin et al.) 211–256. Princeton, NJ.

Fusco, F. 1969/1970. "Il panegirico di Michele Italico per Giovanni Comneno." Ἐπετηρὶς τῆς Ἑταιρείας Βυζαντινῶν Σπουδῶν 37:146–169.

Gal, S. 1992. "Language, Gender, and Power: An Anthropological Perspective." *Locating Power: Proceedings of the Second Berkeley Women and Language Conference* (eds. K. Hall et al.) vol. 1, 153–161. Berkeley, CA.

———. 1995. "Language, Gender, and Power." *Gender Arti-culated: Language and the Socially Constructed Self* (eds. K. Hall and M. Bucholtz) 169–182. New York.

Galiano, M. F. 1984. "Le poète dans le monde archaïque, sa personnalité et son rôle: Sappho." *Actes du VIIᵉ Congrès de la Fédération Internationale des Associations d' Études Classiques*, vol. 1, 131–148. Budapest.

Gallavotti, C. 1948. *Storia e poesia di Lesbo nel VII-VI secolo a. C.: Alceo di Mitilene*. Bari.

———. 1962. *Saffo e Alceo: Testimonianze e frammenti*, vol. I, third revised ed. Naples [second ed. 1956].

Gallop, J. 1985. *Reading Lacan.* Ithaca, NY.

Gardner, E. A. 1888. *Naukratis.* Part II. London.

Garzya, A. 1971. "Per la fortuna di Saffo a Bisanzio." *Jahrbuch der Österreichischen Byzantinistik* 20:1–5 [reprinted in his *Storia e interpretazione di testi bizantini,* London 1974, ch. XV, 1–5].

Gautier, P. 1972. *Michel Italikos: Lettres et discours.* Paris.

Gavrilov, A. K. 1997. "Techniques of Reading in Classical Antiquity." *Classical Quarterly* 47:56–73.

Geddes, A. G. 1987. "Rags and Riches: The Costume of Athenian Men in the Fifth Century." *Classical Quarterly* 37:307–331.

Geertz, C. 1973. *The Interpretation of Cultures.* New York.

———. 1983. *Local Knowledge: Further Essays in Interpretive Anthropology.* New York.

———. 1988. *Works and Lives: The Anthropologist as Author.* Stanford, CA.

———. 1999. "History and Anthropology." *History and Histories within the Human Sciences* (eds. R. Cohen and M. S. Roth). Charlottesville, VA.

Geissler, P. 1969. *Chronologie der altattischen Komödie,* second ed. Berlin.

Gentili, B. 1958. *Anacreonte: Introduzione, testo critico, traduzione, studio sui frammenti papiracei.* Rome.

———. 1966. "La veneranda Saffo." *Quaderni Urbinati di Cultura Classica* 2:37–62.

———. 1973. "La ragazza di Lesbo." *Quaderni Urbinati di Cultura Classica* 16:124–128.

———. 1982. "Archiloco e la funzione politica della poesia del biasimo." *Quaderni Urbinati di Cultura Classica* n.s. 11:7–28.

———. 1988. *Poetry and Its Public in Ancient Greece: From Homer to the Fifth Century,* trans. A. T. Cole. Baltimore.

Gentili, B., and R. Pretagostini (eds.). 1988. *La Musica in Grecia.* Rome.

Gera, D. 1997. *Warrior Women: The Anonymous* Tractatus de Mulieribus. Leiden.

Gerber, D. E. 1993. "Greek Lyric Poetry since 1920. Part I: General, Lesbian Poets." *Lustrum* 35:7–179.

———. 1999. *Greek Elegiac Poetry: From the Seventh to the Fifth Centuries BC.* Cambridge, MA.

Gernet, L. 1968. *Anthropologie de la Grèce antique,* Preface J.-P. Vernant. Paris.

Giacomelli, A. 1980. "The Justice of Aphrodite in Sappho fr. 1." *Transactions of the American Philological Association* 110:135–142.

Giangrande, G. 1968. "Sympotic Literature and Epigram." *L'épigramme grecque,* 91–174. Geneva.

———. 1973. "Anacreon and the Lesbian Girl." *Quaderni Urbinati di Cultura Classica* 16: 129–133.

———. 1976. "On Anacreon's Poetry." *Quaderni Urbinati di Cultura Classica* 21:43–46.

———. 1977/1978. "Textual and Interpretative Problems in Hermesianax." Ἐπιστημονικὴ Ἐπετηρὶς τῆς Φιλοσοφικῆς Σχολῆς τοῦ Πανεπιστημίου Ἀθηνῶν, 98–121.

———. 1980. "Sappho and the ὄλισβος." *Emerita* 48:249–250.

———. 1981. "Anacreon and the *fellatrix* from Lesbos." *Museum Philologum Londiniense* 4: 15–18.

———. 1983. "A che serviva l' 'olisbos' di Saffo?" *Labeo* 29:154–155.

Giannini, P. 1973. "Espressioni formulari nell' elegia greca arcaica." *Quaderni Urbinati di Cultura Classica* 16:7–78.

Gigante, M. 1977a. "Anecdoton Pseudo-Sapphicum." *Rivista di Cultura Classica e Medioevale* 19:421.

———. 1977b. "La cultura letteraria." *Locri Epizefirii: Atti del XVI Convegno di Studi sulla Magna Grecia, Taranto 1976*, 617–697. Naples.

Giordano, D. 1990. *Chamaeleontis Heracleotae Fragmenta*, second ed. Bologna.

Göbel, M. 1915. *Ethnica, I: De Graecarum civitatum proprietatibus proverbio notatis*. Diss. Breslau.

Götte, E. 1957. *Frauengemachbilder in der Vasenmalerei des fünften Jahrhunderts.* Munich.

Goldhill, S. 1987. "The Dance of the Veils: Reading Five Fragments of Anacreon." *Eranos* 85: 9–18.

Gombrich, E. H. 1985. "Image and Word in Twentieth-Century Art." *Word and Image* 6: 213–241.

Gomme, A. W. 1945. *A Historical Commentary on Thucydides*, vol. I. Oxford.

———. 1957. "Interpretations of Some Poems of Alkaios and Sappho." *Journal of Hellenic Studies* 77:255–266.

———. 1958. "A Reply." *Journal of Hellenic Studies* 78:85–86.

Goodman, N. 1976. *Languages of Art: An Approach to a Theory of Symbols*, second ed. Indianapolis.

Goody, J. 1992. "Oral Culture." *Folklore, Cultural Performances, and Popular Entertainments* (ed. R. Bauman) 12–19. New York and Oxford.

Gossen, G. H. 1974a. "To Speak with a Heated Heart: Chamula Canons of Style and Good Performance." In Bauman and Sherzer 1974:389–413.

———. 1974b. *Chamulas in the World of the Sun: Time and Space in a Maya Oral Tradition.* Cambridge, MA.

Gostoli, A. 1990. *Terpander.* Rome.

Goulaki Voutira, A. 1991. "Observations on Domestic Music Making in Vase Paintings of the Fifth Century B.C." *Imago Musicae* 8:73–94.

Gow, A. S. F. 1952. *Theocritus*, edited with a translation and commentary, 2 vols, second ed. Cambridge.

———. 1965. *Machon: The Fragments.* Cambridge.

Gow, A. S. F., and D. L. Page. 1965. *The Greek Anthology: Hellenistic Epigrams*, 2 vols. Cambridge.

———. 1968. *The Greek Anthology: The Garland of Philip and Some Contemporary Epigrams*, 2 vols. Cambridge.

Graf, F. 1985. *Nordionische Kulte: Religionsgeschichtliche und epigraphische Untersuchungen zu den Kulten von Chios, Erythrai, Klazomenai und Phokaia.* Rome.

———. 2003. "Initiation: A Concept with a Troubled History." *Initiation in Ancient Rituals and Narratives: New Critical Perspectives* (eds. D. B. D. Todd and C. A. Faraone) 3–24. London and New York.

Graziosi, B. 2002. *Inventing Homer: The Early Reception of Epic.* Cambridge.

Green, J. R., and E. W. Handley. 2001. "The Rover's Return: A Literary Quotation on a Pot in Corinth." *Hesperia* 70:367–371.

Green, P. 1989. "Lesbos and the Genius Loci." Id., *Classical Bearings: Interpreting Ancient History and Culture,* 45–62 and 274–280 (an earlier version was published *as Lesbos and the Cities of Asia Minor,* The Dougherty Foundation Lecture 1984). London.

Green, R. 1961. "The Caputi Hydria." *Journal of Hellenic Studies* 81:73–75.

Greene, E. (ed.). 1996 [1997]. *Re-Reading Sappho: Reception and Transmission.* Berkeley and Los Angeles, CA.

Greifenhagen, A. 1967. "Smikros, Lieblingsinschrift und Malersignatur: Zwei attische Vasen in Berlin." *Jahrbuch der Berliner Museen* 9:5–25.

———. 1976. *Alte Zeichnungen nach unbekannten griechischen Vasen.* Munich.

Grillet, B. 1975. *Les femmes et les fards dans l' antiquité grecque.* Lyon.

Gronewald, M. 1974. "Fragmente aus einem Sapphokommentar: Pap. Colon. inv. 5860." *ZPE* 14:114–118.

Gronewald, M., and R. W. Daniel. 2004a. "Ein neuer Sappho-Papyrus." *ZPE* 147:1–8.

———. 2004b. "Nachtrag zum neuen Sappho-Papyrus." *ZPE* 149:1–4.

———. 2005. "Lyrischer Text (Sappho-Papyrus)." *ZPE* 154:7–12.

Guarino, A. 1981. "Professorenerotismus." *Labeo* 27:439–440.

Gubar, S. 1984. "Sapphistries." *Signs* 10:43–62.

Gumperz, J. J. 1982. *Discourse Strategies.* Cambridge.

———. 1992. "Contextualization and Understanding." In Duranti and Goodwin 1992: 230–252.

Gutzwiller, K. J. 1998. *Poetic Garlands: Hellenistic Epigrams in Context.* Berkeley and Los Angeles, CA.

Guy, R. 1987. "Dourian Literacy." In C. Bérard et al. 1987:223–225.

Hägg, T. 1985. "Metiochus at Polycrates' Court." *Eranos* 83:92–102.

Hägg, T., and B. Utas. 2003. *The Virgin and Her Lover: Fragments of an Ancient Greek Novel and a Persian Epic Poem.* Leiden.

Hague, R. H. 1983. "Ancient Greek Wedding Songs: The Tradition of Praise." *Journal of Folklore Research* 20:131–143.

Hall, E. 2000. "Female Figures and Metapoetry in Old Comedy." *The Rivals of Aristophanes: Studies in Athenian Old Comedy* (eds. D. Harvey and J. Wilkins) 407–418. London.

Hall, H. R. 1904. "Nitokris-Rhodopis." *Journal of Hellenic Studies* 24:208–213.

Hallett, J. P. 1979. "Sappho and Her Social Context: Sense and Sensuality." *Signs* 4:447–464.

———. 1989. "Female Homoeroticism and the Denial of Roman Reality in Latin Literature." *Yale Journal of Criticism* 3:209–227.

Halperin, D. M. 1990. *One Hundred Years of Homosexuality: And Other Essays on Greek Love.* New York.

———. 2003. "Homosexuality." *The Oxford Classical Dictionary,* third ed. revised (eds. S. Hornblower and A. Spawforth) 720–723. Oxford.

Hamm, E.-M. [= E.-M. Voigt]. 1957. *Grammatik zu Sappho und Alkaios.* Berlin.

Hammer, D. 2004. "Ideology, the Symposium, and Archaic Politics." *American Journal of Philology* 125:479–512.

Hanks, W. 1987. "Discourse Genres in a Theory of Practice." *American Ethnologist* 14.4:668–692.

Hannah, P. A. 2001. "ΤΟΝ ΑΘΕΝΕΘΕΝ ΑΘΛΟΝ. A Case Study in the History of a Label." *Speaking Volumes: Orality and Literacy in the Greek and Roman World* (ed. J. Watson) 161–184. Leiden.

Hannestad, L. 1984. "Slaves and the Fountain House Theme." *Ancient Greek and Related Pottery: Proceedings of the International Vase Symposium in Amsterdam 12-15 April 1984* (ed. H.A.G. Brijder) 252–255. Amsterdam.

Hansen, M. H. 1990. "The Political Powers of the People's Court in Fourth-Century Athens." *The Greek City from Homer to Alexander* (eds. O. Murray and S. Price) 215–243. Oxford.

Harris, W. V. 1989. *Ancient Literacy.* Cambridge, MA.

Hartog, F. 1988. *The Mirror of Herodotus: The Representation of the Other in the Writing of History,* trans. J. Lloyd. Berkeley and Los Angeles, CA.

Hartwig, P. 1893. *Die griechischen Meisterschalen.* Stuttgart and Berlin.

Harvey, A. E. 1955. "The Classification of Greek Lyric Poetry." *Classical Quarterly* 5:157–175.

———. 1957. "Homeric Epithets in Greek Lyric Poetry." *Classical Quarterly* 7:206–223.

Harvey, D. 1988. "Painted Ladies: Fact, Fiction and Fantasy." *Proceedings of the 3rd Symposium on Ancient Greek and Related Pottery. Copenhagen, August 31-September 4 1987* (eds. J. Christiansen and T. Melander) 242–254. Copenhagen.

Haslam, M. W. 1986. "[P.Oxy.] 3711. *Lesbiaca* (Commentary on Alcaeus?)." *The Oxyrhynchus Papyri,* vol. LIII, 112–125. London.

Haspels, C. H. E. 1936. *Attic Black-figured Lekythoi.* Paris.

Hausrath, A., and H. Hunger. 1970. *Corpus Fabularum Aesopicarum,* vol. 1: *Fabulae Aesopicae soluta oratione conscriptae.* Leipzig.

Head, B. V. 1911. *Historia Numorum: A Manual of Greek Numismatics,* second ed., assisted by G. F. Hill, G. MacDonald, and W. Wroth. Oxford.

Headlam, W. 1922. *Herodas: The Mimes and Fragments,* edited by A. D. Knox. Cambridge.

Heidegger, M. 1988. *The Basic Problems of Phenomenology*, revised ed., trans. A. Hofstadter. Bloomington, IN.

Henderson, J. 1991. *The Maculate Muse: Obscene Language in Attic Comedy*, second edition. New York and Oxford (orig. publ. 1975).

———. 2000. "Pherekrates and the Women of Old Comedy." *The Rivals of Aristophanes: Studies in Athenian Old Comedy* (eds. D. Harvey and J. Wilkins) 135–150. London.

Henrichs, A. 1972. *Die Phoinikika des Lollianos: Fragmente eines neuen griechischen Romans.* Bonn.

Henry, M. M. 1985. *Menander's Courtesans and the Greek Comic Tradition.* Frankfurt am Main and Bern.

———. 1995. *Prisoner of History: Aspasia of Miletus and Her Biographical Tradition.* New York and Oxford.

Herbig, R. 1929. "Griechische Harfen." *AM* 54:164–193.

Herdt, G. H. 1981. *Guardians of the Flutes: Idioms of Masculinity.* New York.

Herington, J. 1985. *Poetry into Drama: Early Tragedy and the Greek Poetic Tradition.* Berkeley and Los Angeles.

Hermann, G. 1816. *Elementa Doctrinae Metricae.* Leipzig.

———. 1831. "Über die Behandlung der griechischen Dichter bei den Engländern nebst Bemerkungen über Homer und die Fragmente der Sappho." *Wiener Jahrbücher* 54:217–70 (=id., *Opuscula*, vol. VI, Leipzig 1835, 70–141).

Herter, H. 1957. "Dirne." In *Reallexikon für Antike und Christentum*, vol. 3, 1154–1213. Stuttgart.

———. 1960. "Die Soziologie der antiken Prostitution im Lichte des heidnischen und christlichen Schrifttums." *Jahrbuch für Antike und Christentum* 3:70–111.

Herzfeld, M. 1981. "Performative Categories and Symbols of Passage in Rural Greece." *Journal of American Folklore* 94:44–57.

———. 1993. "In Defiance of Destiny: The Management of Time and Gender at a Cretan Funeral." *American Ethnologist* 20:241–255.

Herzog, R. 1912. *Die Umschrift der älteren griechischen Literatur in das ionische Alphabet.* Basel.

Higgins, R. A., and R. P. Winnington-Ingram. 1965. "Lute-players in Greek Art." *Journal of Hellenic Studies* 85:62–71.

Hodot, R. 1990. *Le Dialecte Éolien d'Asie: La Langue des Inscriptions, VIIe s. a.C.–IVe s. p.C.* Paris.

———. 1997. "Autour du corpus épigraphique du lesbien, 1986–1995." *Katà diálekton: Atti del III Colloquio Internazionale di Dialettologia Greca. Annali dell' Istituto Universitario Orientale di Napoli*, sez. filol.-letterar. 19 [1997] (ed. A.C. Cassio) 383–399.

Höckmann, U., and D. Kreikenbom (eds.). 2001. *Naukratis: Die Beziehungen zu Ostgriechenland, Ägypten und Zypern in archaischer Zeit. Akten der Table Ronde in Mainz, 25–27 November 1999*, Möhnesee.

Hoesch, N. 1990a. "Das Kottabosspiel." In Vierneisel and Kaeser 1990:272–275.

———. 1990b. "Männer in Luxurgewand." In Vierneisel and Kaeser 1990:276–279.

Hoffmann, H. 1977. *Sexual and Asexual Pursuit: A Structuralist Approach to Greek Vase Painting.* London.

———. 1988. "Why Did the Greeks Need Imagery? An Anthropological Approach to the Study of Greek Vase Painting." *Hephaistos* 9:143–162.

———. 1994. "The Riddle of the Sphinx: A Case Study in Athenian Immortality Symbolism." *Classical Greece: Ancient Histories and Modern Archaeologies* (ed. I. Morris) 71–80. Cambridge.

———. 1997. *Sotades: Symbols of Immortality on Greek Vases.* Oxford.

Hoffmann, H., and F. Hewicker. 1961. *Kunst des Altertums in Hamburg.* Mainz.

Hogarth, D. G., et al. 1898/1899. "Excavations at Naukratis." *Annual of the British School at Athens* 5:26–97.

———. 1905. "Naukratis. 1903." *Journal of Hellenic Studies* 25:105–136.

Holland, D., et al. [W. Lachicotte, D. Skinner, and C. Cain]. 1998. *Identity and Agency in Cultural Worlds.* Cambridge, MA.

Hooker, J. T. 1977. *The Language and Text of the Lesbian Poets.* Innsbruck.

Hornblower, S. 1991. *A Commentary on Thucydides,* vol. I. Oxford.

———. 2002. "Herodotus and His Sources of Information." *Brill's Companion to Herodotus* (eds. E. J. Bakker et al.) 373–386. Leiden.

Hornbostel, W., et al. 1977. *Kunst der Antike: Schätze aus norddeutschem Privatbesitz.* Mainz.

———. 1980. *Aus Gräbern und Heiligtümern: Die Antikensammlung W. Kropatscheck.* Mainz.

Hornbostel, W., and L. Stege. 1986. *Aus der Glanzzeit Athens: Meisterwerke griechischer Vasenkunst in Privatbesitz.* Hamburg.

How, W. W., and J. Wells. 1928. *A Commentary on Herodotus,* 2 vols. Oxford.

Huber, I. 2001. *Die Ikonographie der Trauer in der griechischen Kunst.* Mannheim.

Hubert, C. 1938. *Plutarchi Moralia,* vol. 4. Leipzig.

Humphreys, S. C. 1978. *Anthropology and the Greeks.* London.

———. 2004. *The Strangeness of Gods: Historical Perspectives on the Interpretation of Athenian Religion.* Oxford.

Hunt, A. S. 1914a. "[P.Oxy.] 1231. Sappho, Book i." In B. P. Grenfell and A. S. Hunt, *The Oxyrhynchus Papyri,* part X, 20–43. London.

———. 1914b. "[P.Oxy.] 1232. "Sappho, Book ii." In B. P. Grenfell and A. S. Hunt, *The Oxyrhynchus Papyri,* part X, 44–50. London.

———. 1922a. "[P.Oxy.] 1787. Sappho, Book iv." In B. P. Grenfell and A. S. Hunt, *The Oxyrhynchus Papyri,* part XV, 26–46. London.

———. 1922b. "[P.Oxy.] 1800. Miscellaneous Biographies." In B. P. Grenfell and A. S. Hunt, *The Oxyrhynchus Papyri,* part XV, 137–150. London.

Hunter, V. 1981. "Classics and Anthopology." *Phoenix* 35:145–155.

———. 1982. *Past and Process in Herodotus and Thucydides.* Princeton, NJ.

Hurwit, J. M. 1990. "The Words in the Image: Orality, Literacy, and Early Greek Art." *Word and Image* 6:180–197.

Hutchinson, G. O. 2001. *Greek Lyric Poetry: A Commentary on Selected Larger Pieces.* Oxford.

Huxley, G. 1974. "Aristotle's Interest in Biography." *Greek, Roman and Byzantine Studies* 15:203–213.

Immerwahr, H. R. 1964. "Book Rolls on Attic Vases." *Classical, Mediaeval, and Renaissance Studies in Honor of B. L. Ullman* (ed. C. Henderson, Jr.) vol. 1, 17–48. Rome.

———. 1965. "Inscriptions on the Anacreon Krater in Copenhagen." *American Journal of Archaeology* 69:152–154.

———. 1973. "More Book Rolls on Attic Vases." *AK* 16:143–147.

———. 1990. *Attic Script: A Survey.* Oxford.

Iser, W. 1974. *The Implied Reader: Patterns of Communication in Prose Fiction from Bunyan to Beckett.* Baltimore, MD.

———. 1978. *The Act of Reading: A Theory of Aesthetic Response.* Baltimore, MD.

Jackson, S. 1995. *Myrsilus of Methymna: Hellenistic Paradoxographer.* Amsterdam.

Jacobsthal, P. 1912. *Göttinger Vasen, nebst einer Abhandlung Συμποσιακά.* Berlin.

Jacoby, F. 1904. *Das Marmor Parium.* Berlin.

Jakobson, R. 1952. "Studies in Comparative Slavic Metrics." *Oxford Slavonic Papers* 3:21–66 (reprinted as "Slavic Epic Verse: Studies in Comparative Slavic Metrics," id., *Selected Writings*, vol. 4: *Slavic Epic Studies.* The Hague 1966, 414–463).

———. 1987 [1960]. "Linguistics and Poetics." Id., *Language in Literature* (eds. K. Pomorska and S. Rudy) 62–94. Cambridge, MA.

Janko, R. 2000. *Philodemus: On Poems, Book 1,* edited with introduction, translation, and commentary. Oxford.

Jauss, H. R. 1982. *Toward an Aesthetic of Reception.* Minneapolis, MN.

Jay, P., and C. Lewis. 1996. *Sappho through English Poetry.* London.

Jeffery, L. H. 1976. *Archaic Greece: The City-states, c. 700–500 B.C.* New York.

———. 1990. *The Local Scripts of Archaic Greece,* revised edition with supplement by A. W. Johnston. Oxford.

Jocelyn, H. D. 1980. "A Greek Indecency and Its Students: λαικάζειν." *Proceedings of the Cambridge Philological Society* n.s. 26:12–66.

Johnson, W. 2000. "Toward a Sociology of Reading in Classical Antiquity." *American Journal of Philology* 121:593–627.

Johnston, A. W., and A. K. Andriomenou. 1989. "A Geometric Graffito from Eretria." *Annual of the British School at Athens* 84:217–220.

Jones, A. F. 1992. *Like a Knife: Ideology and Genre in Contemporary Chinese Popular Music.* Ithaca, NY.

Jordan, D. R., and J. B. Curbera. 1998. "Curse Tablets from Mytilene." *Phoenix* 52:31–41.

Jorro, F. A. 1985/1993. *Diccionario Micénico.* 2 vols. Madrid.

Jurenka, H. 1902. "Die neuen Bruchstücke der Sappho und des Alkaios." *Zeitschrift für die Österreichischen Gymnasien* 53:289–298.

Just, R. 1989. *Women in Athenian Law and Life.* London and New York.

Kaibel, G. 1887/1890. *Athenaei Naucratitae Dipnosophistarum libri XV,* 3 vols. Leipzig.

Kaimio, M. 1977. *Characterization of Sound in Early Greek Literature.* Helsinki.

Kakridis, J. Th. 1966. "Zu Sappho 44 LP." *Wiener Studien* 79:21–26 (repr. in id., Μελέτες καὶ Ἄρθρα. Thessalonike 1971, 33–38).

Kalb, D., and H. Tak. 2005. *Critical Junctions: Anthropology and History beyond the Cultural Turn.* New York.

Kanowski, M. G. 1984. *Containers of Classical Greece: A Handbook of Shapes.* St. Lucia.

Kapparis, K. 1999. *Apollodoros: 'Against Neaira' [D. 59],* edited with introduction, translation and commentary. Berlin.

Karadagli, T. 1981. *Fabel und Ainos: Studien zur griechischen Fabel.* Königstein/Ts.

Karla, G. A. 2001. *Vita Aesopi: Überlieferung, Sprache und Edition einer frühbyzantinischen Fassung des Äsopromans.* Wiesbaden.

Karp, I. 1980. "Beer Drinking and Social Experience in an African Society: An Essay in Formal Sociology." *Explorations in African Systems of Thought* (eds. I. Karp and C. S. Bird) 83–119. Bloomington, IN.

Kassel, R. 1976. *Aristotelis Ars Rhetorica.* Berlin.

Katz, M. A. 1995. "Ideology and 'the Status of Women' in Ancient Greece." *Women in Antiquity: New Assessments* (eds. R. Hawley and B. Levick) 21–43. London.

Kauffmann-Samara, A. 1982. "Ἐπιγραφὲς στὰ μελανόμορφα ἀγγεῖα τοῦ 6ου αἰ. π.Χ." Ἀρχαιολογία 5:53–64.

———. 1988. "'Mère' et enfant sur les lébétès nuptiaux à figures rouges attiques du Ve s. av. J.C." *Proceedings of the 3rd Symposium on Ancient Greek and Related Pottery. Copenhagen, August 31–September 4 1987* (eds. J. Christiansen and T. Melander) 286–299. Copenhagen.

———. 1996. "Paroles et musiques de mariage en Grèce antique: Sources écrites et images peintes." In Cavalier 1996:435–448.

———. 1997. "'Οὐκ ἀπόμουσον τὸ γυναικῶν' (Εὐριπ. Μήδ. 1089). Γυναῖκες μουσικοὶ στὰ ἀττικὰ ἀγγεῖα τοῦ 5ου αἰ. π.Χ." In Oakley et al. 1997:285–295.

———. 2003. "Des femmes et des oiseaux. La perdrix dans le gynécée." In Schmaltz and Söldner 2003:90–92.

Kazazis, J. N. 1978. *Herodotos' Stories and History: A Proppian Analysis of His Narrative Technique.* Diss. University of Illinois at Urbana-Champaign.

Kehrberg, I. 1982. "The Potter-Painter's Wife: Some Additional Thoughts on the Caputi Hydria." *Hephaistos* 4:25–35.

Kemke, J. 1884. *Philodemi de musica librorum quae exstant.* Leipzig.

Kemp, J. A. 1966. "Professional Musicians in Ancient Greece." *Greece and Rome* ser. 2, vol. 13:213–222.

Kenner, H. 1970. *Das Phänomen der verkehrten Welt in der griechisch-römischen Antike.* Bonn.

Kidd, I. G. 1988. *Posidonius. II: The Commentary.* Cambridge.

Kilmer, M. F. 1982. "Genital Phobia and Depilation." *Journal of Hellenic Studies* 102:104–112.

———. 1993a. "In Search of the Wild Kalos-Name." *Échos du Monde Classique/Classical Views* 37:173–199.

———. 1993b. *Greek Erotica on Attic Red-figure Vases.* London.

Kilmer, M. F., and R. Develin. 2001. "Sophilos' Vase Inscriptions and Cultural Literacy in Archaic Athens." *Phoenix* 55:9–43.

Kleingünther, A. 1933. *Πρῶτος Εὑρετής: Untersuchungen zur Geschichte einer Fragestellung.* Leipzig.

Kluckhohn, C. 1961. *Anthropology and the Classics.* Providence, RI.

Knigge, U. 1990. *Ὁ Κεραμεικὸς τῆς Ἀθήνας: Ἱστορία-Μνημεῖα-Ἀνασκαφές.* Athens.

Knox, A. D. 1939. "On Editing Hipponax: A Palinode?" *Studi Italiani di Filologia Classica* 15: 193–196.

Knox, B. M. W. 1968. "Silent Reading in Antiquity." *Greek, Roman and Byzantine Studies* 9: 421–435.

Knox, P. E. 1995. *Ovid Heroides: Select Epistles.* Cambridge.

Kobiliri, P. 1998. *A Stylistic Commentary on Hermesianax.* Amsterdam.

Koch-Harnack, G. 1989. *Erotische Symbole: Lotosblüte und gemeinsamer Mantel auf antiken Vasen.* Berlin.

Koller, H. 1956. "Die Parodie." *Glotta* 35:17–32.

Körte, A., and A. Thierfelder. 1957/1959. *Menandri quae supersunt,* 2 vols. Leipzig.

Koniaris, G. L. 1965. "On Sappho, Fr. 1 (Lobel-Page)." *Philologus* 109:30–38.

———. 1967. "On Sappho, Fr. 16 (L.P.)." *Hermes* 95:257–268.

———. 1995. *Maximus Tyrius: Philosophumena-Διαλέξεις.* Berlin.

Kontis, I. D. 1978. *Λέσβος καὶ ἡ Μικρασιατική της περιοχή.* Athens.

Kopidakis, M. 1995. "Σαπφὼ Φαρμακολύτρια." In Ἀντὶ χρυσέων. Ἀφιέρωμα στὸν Ζήσιμο Λορεντζάτο, 333–346. Athens.

Kordatos, G. K. 1945. *Ἡ Σαπφὼ καὶ οἱ Κοινωνικοὶ Ἀγῶνες στὴ Λέσβο.* Athens.

Koster, W. J. W. 1964. "Sappho apud Gregorium Nazianzenum." *Mnemosyne* ser. 4, 17: 374.

———. 1978. *Scholia in Aristophanem. Pars II, fasc. I: Scholia vetera et recentiora in Aristophanis Vespas.* Groningen.

Kowerski, L. M. 2005. *Simonides on the Persian Wars: A Study of the Elegiac Verses of the "New Simonides."* New York.

Kraemer, R. S. 1992. *Her Share of the Blessing: Women's Religions among Pagans, Jews, and Christians in the Graeco-Roman World.* New York and Oxford.

Kramer, B. 1978. "60. Sappho (?)/61. Fragmente aus einem Sapphokommentar." In B. Kramer and D. Hagedorn, *Kölner Papyri (P.Köln)*, Band 2, Opladen, 40–44.

Krech, S. 1991. "The State of Ethnohistory." *ARAnthr* 20:345–375.

Kretschmer, P. 1894. *Die griechischen Vaseninschriften*. Gütersloh.

Krischer, T. 1974. "Die logischen Formen der Priamel." *Grazer Beiträge* 2:79–91.

Kroeber, A. L., and C. Kluckhohn. 1952. *Culture: A Critical Review of Concepts and Definitions*. Cambridge, MA.

Kroll, W. 1925. "Lesbische Liebe." In *RE* 12 (1925):2100–2102.

Kugelmeier, C. 1996. *Reflexe früher und zeitgenössischer Lyrik in der Alten attischen Komödie*. Stuttgart.

Kuhn, T. 1962. *The Structure of Scientific Revolutions*. Chicago, IL [third ed. 1996].

Kullmann, W., and M. Reichel (eds.). 1990. *Der Übergang von der Mündlichkeit zur Literatur bei den Griechen*. Tübingen.

Kunisch, N. 1971. *Antike Kunst aus Wuppertaler Privatbesitz*. Wuppertal.

———. 1972. *Antiken der Sammlung Julius C. und Margot Funcke*. Bochum.

———. 1980. *Antiken der Sammlung Julius C. und Margot Funcke: Die zweite Stiftung*. Bochum.

———. 1984. "Bilder griechischer Musikanten in den Kunstsammlungen der Ruhr-Universität Bochum." *Jahrbuch 1984 der Ruhr-Universität Bochum* 3–30

———. 1997. *Makron*. Mainz.

Kunisch, N., et al. 1989. *Symposion: Griechische Vasen aus dem Antikenmuseum der Ruhr-Universität Bochum*. Köln.

Kuper, A. 2000. *Culture: The Anthropologists' Account*. Cambridge, MA.

Kurke, L. 1992. "The Politics of ἁβροσύνη in Archaic Greece." *Classical Antiquity* 11:91–120.

———. 1994. "Crisis and Decorum in Sixth-Century Lesbos: Reading Alkaios Otherwise." *Quaderni Urbinati di Cultura Classica* n.s. 47:67–92.

———. 1999. *Coins, Bodies, Games, and Gold: The Politics of Meaning in Archaic Greece*. Princeton, NJ.

Kurtz, D. C. (ed.). 1983. *The Berlin Painter*, text by D. C. Kurtz and drawings by J. D. Beazley. Oxford.

———. (ed.). 1989. *Greek Vases: Lectures by J. D. Beazley*. Oxford.

Kyriakidou-Nestoros, A. 1978. Ἡ Θεωρία τῆς Ἑλληνικῆς Λαογραφίας: Κριτικὴ Ἀνάλυση. Athens.

Labarbe, J. 1982. "Un curieux phénomène littéraire: l' anacréontisme." *Bulletin de la Classe des Lettres et des Sciences Morales et Politiques de l' Académie royale de Belgique* 68:146–181.

Lafitau, J. F. 1997. *Customs of the American Indians Compared with the Customs of Primitive Times*, 2 vols., trans. and eds. W. Fenton and E. Moore. Toronto.

Lakoff, G. 1987. *Women, Fire, and Dangerous Things: What Categories Reveal about the Mind*. Chicago, IL.

Lambrinoudakis, B. K. 1981. "Ἀνασκαφὴ Νάξου." *Πρακτικὰ τῆς ἐν Ἀθήναις Ἀρχαιολογικῆς Ἑταιρείας* 137:293–295.

Lanata, G. 1960. "L'ostracon fiorentino con versi di Saffo. Note paleografiche ed esegetiche." *Studi Italiani di Filologia Classica* n.s. 32:64–90.

Lane Fox, R. 2000. "Theognis: An Alternative to Democracy." *Alternatives to Athens: Varieties of Political Organization and Community in Ancient Greece* (eds. R. Brock and S. Hodkinson) 35–51. Oxford.

Lang, M. L. 1984. *Herodotean Narrative and Discourse.* Cambridge, MA.

Lardinois, A. 1989. "Lesbian Sappho and Sappho of Lesbos." *From Sappho to de Sade: Moments in the History of Sexuality* (ed. J. N. Bremmer) 15–35. London.

———. 1994. "Subject and Circumstance in Sappho's Poetry." *Transactions of the American Philological Association* 124:57–84.

———. 1996. "Who Sang Sappho's Songs?," *Reading Sappho: Contemporary Approaches* (ed. E. Greene) 150–172. Berkeley and Los Angeles, CA.

———. 2001. "Keening Sappho: Female Speech Genres in Sappho's Poetry." *Making Silence Speak: Women's Voices in Greek Literature and Society* (eds. A. Lardinois and L. McClure) 75–92. Princeton, NJ.

Latacz, J. 1990. "Die Funktion des Symposions für die entstehende griechische Literatur." In Kullmann and Reichel 1990:227–264.

Lateiner, D. 1989. *The Historical Method of Herodotus.* Toronto.

Latour, B., and S. Woolgar. 1979. *Laboratory Life: The Social Construction of Scientific Facts.* Beverly Hills, CA and London.

Lau, F. 1995/1996. "Individuality and Political Discourse in Solo *Dizi* Compositions." *Asian Music* 27.1:133–152.

Lawall, M. L. 1997. "Gordion: The Imported Transport Amphoras, 600–400 B.C." Paper given at the 98th Annual Conference of the Archaeological Institute of America [Session "Anatolia in the First Millennium B.C."], abstract in *American Journal of Archaeology* 101:361.

Layton, E. (Zeniou). 1994. *The Sixteenth-Century Greek Book in Italy.* Venice.

Leach, E. 1961. "Two Essays Concerning the Symbolic Representation of Time." Id., *Rethinking Anthropology*, 124–136. London.

———. 1976. *Culture and Communication: The Logic by Which Symbols are Connected.* Cambridge.

Lefkowitz, M. R. 1981. *The Lives of the Greek Poets.* Baltimore, MD.

Lenaiou, E. [pseudonym of C. Charitonides]. 1935. *ΑΠΟΡΡΗΤΑ.* Thessalonike.

Levine, M. M. 1995. "The Gendered Grammar of Ancient Mediterranean Hair." *Off with Her Head!: The Denial of Women's Identity in Myth, Religion, and Culture* (eds. H. Eilberg-Schwartz and W. Doniger) 76–130. Berkeley and Los Angeles, CA.

Lewis, S. 1997. "Shifting Images: Athenian Women in Etruria." *Gender and Ethnicity in Ancient Italy* (eds. T. Cornell and K. Lomas) 141–154. London.

———. 1998/1999. "Slaves as Viewers and Users of Athenian Pottery." *Hephaistos* 16/17: 71–90.

———. 2002. *The Athenian Woman: An Iconographic Handbook.* London.

Lezzi-Hafter, A. 1988. *Der Eretria-Maler: Werke und Weggefährten,* 2 vols. Mainz am Rhein.

Liberman, G. 1988. "Alcée 384 LP, Voigt." *Revue de Philologie* ser. 3, 62:291–298.

———. 1995. "A propos du fragment 58 Lobel-Page, Voigt de Sappho." *ZPE* 108:45–46.

———. 1999. *Alcée: Fragments.* 2 vols. Paris.

Licht, H. [pseudonym of P. Brandt]. 1931. *Sexual Life in Ancient Greece,* trans. J. H. Freese. London.

Lidov, J. B. 1993. "The Second Stanza of Sappho 31: Another Look." *American Journal of Philology* 114:503–535.

———. 2002. "Sappho, Herodotus, and the *Hetaira*." *Classical Philology* 97:203–237.

Lightfoot, J. L. 1999. *Parthenius of Nicaea: The Poetical Fragments and the Erôtika Pathêmata,* edited with introduction and commentary. Oxford.

Lilja, S. 1972. *The Treatment of Odours in the Poetry of Antiquity.* Helsinki.

Lincoln, B. 2003. "The Initiatory Paradigm in Anthropology, Folklore, and History of Religions." *Initiation in Ancient Rituals and Narratives: New Critical Perspectives* (eds. D. B. Todd and C. A. Faraone) 241–254. London and New York.

Lipking, L. 1988. "Sappho Descending: Abandonment through the Ages." Id., *Abandoned Women and Poetic Tradition.* 57–96. Chicago, IL.

Lissarrague, F. 1985. "Paroles d'images: Remarques sur le fonctionnement de l' écriture dans l'imagerie attique." *Écritures II* (ed. A.-M. Christin) 71–93. Paris.

———. 1990. *The Aesthetics of the Greek Banquet: Images of Wine and Ritual,* trans. A. Szegedy-Maszak. Princeton, NJ.

———. 1992a. "Graphein: écrire et dessiner." *L' image en jeu: De l' antiquité à Paul Klee* (eds. C. Bron and E. Kassapoglou) 189–203. Lausanne.

———. 1992b. "Figures of Women." *A History of Women in the West: I. From Ancient Goddesses to Christian Saints* (ed. P. Schmitt-Pantel) trans. A. Goldhammer, 139–229. Cambridge, MA.

———. 1994. "*Epiktetos egraphsen*: The Writing on the Cup." *Art and Text in Ancient Greek Culture* (eds. S. Goldhill and R. Osborne) 12–27. Cambridge.

———. 1998. "Satyres chez les femmes." In P. Veyne, F. Lissarrague and F. Frontisi-Ducroux, 179–198. Paris.

———. 1999. "Publicity and Performance: *Kalos* Inscriptions in Attic Vase-painting." *Performance Culture and Athenian Democracy* (eds. S. Goldhill and R. Osborne) 359–373. Cambridge.

———. 2000. "Aesop, Between Man and Beast: Ancient Portraits and Illustrations." In Cohen 2000:132–149.

Lissarrague, F., and A. Schnapp. 1981. "Imagerie des Grecs ou Grèce des imagiers?" *Le Temps de la Réflexion* 2:275–297.

Liventhal, V. 1985. "What Goes On among the Women? The Setting of Some Attic Vase Paintings of the Fifth Century B.C." *Analecta Romana Instituti Danici* 14:37–52.

Lloyd, A. B. 1988. *Herodotus, Book II,* vol. 3. Leiden.

Lloyd, G. E. R. 1983. *Science, Folklore and Ideology.* Cambridge.

———. 1990. *Demystifying Mentalities.* Cambridge.

———. 2002. *The Ambitions of Curiosity: Understanding the World in Ancient Greece and China.* Cambridge.

Lobel, E. 1925. Σαπφοῦς μέλη. *The Fragments of the Lyrical Poems of Sappho.* Oxford.

———. 1927. Ἀλκαίου μέλη. *The Fragments of the Lyrical Poems of Alcaeus.* Oxford.

———. 1951a. "[P.Oxy.] 2291. Sappho?" In id., *The Oxyrhynchus Papyri,* part XXI, 10–14. London.

———. 1951b. "[P.Oxy.] 2292. Commentary on Sappho." In id., *The Oxyrhynchus Papyri,* part XXI, 15. London.

Lobel, E., and D. Page. 1955. *Poetarum Lesbiorum Fragmenta.* Oxford (corrected ed. 1963).

Lombardo, M. 1983. "*Habrosyne e habra* nel mondo greco arcaico." *Forme di contatto e processi di transformazione nelle società antiche. Atti del convegno di Cortona (24–30 maggio 1981)* 1077–1103. Pisa and Rome.

Loraux, N. 1990. *Les mères en deuil.* Paris.

———. 1996. "Back to the Greeks? Chronique d'une expédition lointaine en terre connue." In Revel and Wachtel 1996:275–297.

———. 2002. *The Mourning Voice: An Essay on Greek Tragedy,* trans. E. T. Rawlings. Ithaca, NY.

Lord, A. B. 1960. *The Singer of Tales.* Cambridge, MA. [ed. with new introduction by S. Mitchell and G. Nagy, Cambridge, MA. 2000].

———. 1991. *Epic Singers and Oral Tradition.* Ithaca, NY.

———. 1995. *The Singer Resumes the Tale,* edited by M. L. Lord. Ithaca, NY.

Lowe, N. J. 1998. "Thesmophoria and Haloa: Myth, Physics and Mysteries." *The Sacred and the Feminine in Ancient Greece* (eds. S. Blundell et al.) 149–173. London.

Luppe, W. 1974. "Nochmals zu Philainis, Pap.Oxy. 2891." *ZPE* 13:281–282.

———. 1998. "Zum Philainis-Papyrus (P.Oxy. 2891)." *ZPE* 123:87–88.

Lyotard, J.-F. 1993. *Libidinal Economy,* trans. I. H. Grant. Bloomington and Indianapolis, IN.

Maas, M., and J. M. Snyder. 1989. *Stringed Instruments of Ancient Greece.* New Haven, CT.

Maas, P. 1912. "Gnesippos." *RE* 7.2:1479–1481.

———. 1920. "Ährenlese." *Sokrates* 8:20–26.

———. 1929. "Sappho fr. 75 Bergk." *Zeitschrift für vergleichende Sprachwissenschaft auf dem Gebiete der indogermanischen Sprachen* 56:137–138.

Mace, S. T. 1993. "Amour, Encore! The Development of δηὖτε in Archaic Lyric." *Greek, Roman and Byzantine Studies* 34:335–364.

Maehler, H. 2003. *Bacchylides. Carmina cum fragmentis,* eleventh ed., Munich.

Malnati, A. 1993. "Revisione dell' ostrakon fiorentino di Saffo." *APap* 5:21–22.

Manakidou, E. 1992/1993. "Athenerinnen in schwarzfigurigen Brunnenhausszenen." *Hephaistos* 11/12:51–91.

Mandilaras, B. G. 1986. *Oἱ Μῖμοι τοῦ Ἡρώνδα*, second ed. Athens.

———. 2003. *Isocrates: Opera Omnia.* 3 vols. Munich and Leipzig.

Manfredini, M. 1981. "La guerra per il Sigeo nella tradizione storiografica antica." *Scritti in ricordo di Giorgio Buratti,* 249–269. Pisa.

Manfrini-Aragno, I. 1992. "Femmes à la fontaine: réalité et imaginaire." *L' image en jeu: De l'antiquité à Paul Klee* (eds. C. Bron and E. Kassapoglou) 127–148. Lausanne.

Maquet, J. 1986. *The Aesthetic Experience: An Anthropologist Looks at the Visual Arts.* New Haven, CT.

Marcovich, M. 1975. "How to Flatter Women: P.Oxy. 2891." *Classical Philology* 70:123–124.

———. 1983. "Anacreon, 358 *PMG* (ap. Athen. XIII. 599C)." *American Journal of Philology* 104: 372–383.

Marcus, G. E., and M. J. Fischer. 1986. *Anthropology as Cultural Critique: An Experimental Moment in the Human Sciences.* Chicago [second ed., with new introduction, Chicago 1999].

Marett, R. R. 1908. *Anthropology and the Classics.* Oxford.

Marks, E. 1978. "Lesbian Intertextuality." *Homosexualities and French Literature: Cultural Contexts/Critical Texts* (eds. G. Stambolian and E. Marks) 353–377. Ithaca, NY.

Marolles, M. de. 1680. *Les quinze livres des Deipnosophistes d'Athénée, de la ville de Naucrate d'Egypte, ecrivain d'une érudition consommée & presque le plus sçavant des Grecs: ouvrage delicieux, agreablement diversifié & rempli de narrations sçavantes sur toutes sortes de matieres & de sujets; traduit pour la première fois en françois, sans l'avoir jamais esté en quelque langue vulgaire que ce soit sur le Grec original, après les versions latines de Natalis Comes de Padoüe & de Iacques d'Alechamp de Caën.* Paris.

Martin, J. 1931. *Symposion: Die Geschichte einer literarischen Form.* Paderborn.

Martin, R. P. 1989. *The Language of Heroes: Speech and Performance in the Iliad.* Ithaca, NY.

———. 1993. "The Seven Sages as Performers of Wisdom." In Dougherty and Kurke 1993: 108–128.

———. 2001. "Just Like a Woman: Enigmas of the Lyric Voice." *Making Silence Speak: Women's Voices in Greek Literature and Society* (eds. A. Lardinois and L. McClure) 55–74. Princeton, NJ.

———. 2003. "The Pipes Are Brawling: Conceptualizing Musical Performance in Athens." In Dougherty and Kurke 2003:153–180.

Martindale, C. 1993. *Redeeming the Text: Latin Poetry and the Hermeneutics of Reception.* Cambridge.

Martos Montiel, J. F. 1996. *Desde Lesbos con amor: Homosexualidad femenina en la antigüedad.* Madrid.

Mason, H. J. 1993. "Mytilene and Methymna: Quarrels, Borders, and Topography." *Échos du Monde Classique/Classical Views* n.s. 12:225–250.

———. 2001. "*Lesbia Oikodomia*: Aristotle, Masonry, and the Cities of Lesbos." *Mouseion* ser. 3, vol. 1:31–53.

Mastronarde, D. J. 1988. *Euripides: Phoenissae.* Leipzig.

———. 1994. *Euripides: Phoenissae,* edited with introduction and commentary. Cambridge.

Matheson, S. B. 1995. *Polygnotos and Vase Painting in Classical Athens.* Madison, WI.

Mathiesen, T. J. 1999. *Apollo's Lyre: Greek Music and Music Theory in Antiquity and the Middle Ages.* Lincoln, NE.

Maxwell-Stuart, P. G. 1996. "Theophrastus the Traveller." *Parola del Passato.* 51:241–267.

Mazal, O. 1967. *Der Roman des Konstantinos Manasses: Überlieferung, Rekonstruktion, Textausgabe der Fragmente.* Vienna.

Mazzarino, S. 1943. "Per la storia di Lesbo nel VI° secolo A.C. (A proposito dei nuovi frammenti di Saffo e Alceo)." *Athenaeum* n.s. 21:38–78.

———. 1947. *Fra oriente e occidente: Ricerche di storia greca arcaica.* Florence.

McCall, M. H. 1969. *Ancient Rhetorical Theories of Simile and Comparison.* Cambridge, MA.

McClure, L. K. 2003. *Courtesans at Table: Gender and Greek Literary Culture in Athenaeus.* New York.

McEvilley, T. 1972. "Sappho, Fragment Two." *Phoenix.* 26:323–333.

McNiven, T. J. 2000. "Behaving Like an Other: Telltale Gestures in Athenian Vase Painting." In Cohen 2000:71–97.

Meillet, A. 1923. *Les origines indo-européennes des mètres grecs.* Paris.

Meineke, A. 1839. *Historia Critica Comicorum Graecorum.* Berlin.

———. 1840. *Fragmenta Comicorum Graecorum, vol. 3: Fragmenta Poetarum Comoediae Mediae.* Berlin.

———. 1847. *Fragmenta Comicorum Graecorum,* vol. 1, editio minor. Berlin.

Merkelbach, R. 1957. "Sappho und ihr Kreis." *Philologus* 101:1–29.

———. 1972. "φαυσώ?" *ZPE* 9:284.

———. 1973. "Verzeichnis von Gedichtanfängen." *ZPE* 12:86.

Merkelbach, R., and M. L. West. 1967. *Fragmenta Hesiodea.* Oxford.

Metzler, D. 1987. "Einfluss der Pantomime auf die Vasenbilder des 6. und 5. Jhds. v. Chr." In Bérard et al. 1987:73–77.

Michaelides, S. 1981. Ἐγκυκλοπαιδεία τῆς Ἀρχαίας Ἑλληνικῆς Μουσικῆς. Athens (=*The Music of Ancient Greece: An Encyclopedia,* London 1978).

Mihalopoulos, C. 2001. *Images of Women and Concepts of Popular Culture in Classica Athens, 450–400 B.C.* Diss. University of Southern California.

Miller, M. C. 1991. "Foreigners at the Greek Symposium?" In Slater 1991:59–81.

———. 1992. "The Parasol: An Oriental Status-Symbol in Late Archaic and Classical Athens." *Journal of Hellenic Studies* 112:91–105.

———. 1997. *Athens and Persia in the Fifth Century BC: A Study in Cultural Receptivity.* Cambridge.

———. 1999. "Reexamining Transvestism in Archaic and Classical Athens: The Zewadski Stamnos." *American Journal of Archaeology* 103:223-253.

Millis, B. 2001. "A Comment on 'The Rover's Return.'" *Illinois Classical Studies* 26:127.

Miner, J. 2003. "Courtesan, Concubine, Whore: Apollodorus' Deliberate Use of Terms for Prostitutes." *American Journal of Philology* 124:19-37.

Mingazzini, P. 1950/1951. "Sulla pretesa funzione oracolare del kottabos." *Archäologischer Anzeiger* 65/66:35-47.

Mitchell, A. G. 2004. "Humour in Greek Vase-Painting." *RA* 3-32.

Mitchell, W. J. T. 1986. *Iconology: Image, Text, Ideology.* Chicago, IL.

———. 1994. *Picture Theory: Essays on Verbal and Visual Representation.* Chicago, IL.

Möller, A. 2000. *Naukratis: Trade in Archaic Greece.* Oxford.

Momigliano, A. 1971. *The Development of Greek Biography: Four Lectures.* Cambridge, MA. [expanded ed. 1993].

Montanari, F. 1989. "Cameleonte. 3T *De Sappho.*" *Corpus dei papiri filosofici greci e latini: Testi e lessico nei papiri di cultura greca e latina,* vol. 1*, 406-409. Florence.

Mora, E. 1966. *Sappho: Histoire d' un poète et traduction intégrale de l'oeuvre.* Paris.

Morales, H. 1998. "A Discourse of Desire." *Times Literary Supplement,* May 29, 1998:12.

Moravcsik, G. 1964. "Sapphos Fortleben in Byzanz." *Acta Antiqua Academiae Scientiarum Hungaricae* 12:473-479 [reprinted in his *Studia Byzantina,* Budapest 1967, 408-413].

Moret, J.-M. 1979. "Un ancêtre du phylactère: le pilier inscrit des vases italiotes." *RA* fasc. 1:3-34.

Moretti, A. F. 1995. "Revisione di alcuni papiri greci letterari editi tra i *P.Mil.Vogl.*" *APap* 7:19-30.

Morgenthau, J. C. 1886. *Über den Zusammenhang der Bilder auf griechischen Vasen.* Diss. Leipzig.

Morris, I. 1993. Review of Powell 1991. *Classical Philology* 88:71-77.

Mossman, J. 1997. "Plutarch's *Dinner of the Seven Wise Men* and Its Place in *Symposion* Literature." *Plutarch and His Intellectual World: Essays on Plutarch* (ed. J. Mossman) 119-140. London.

Most, G. W. 1985. *The Measures of Praise: Structure and Function in Pindar's Second Pythian and Seventh Nemean Odes.* Göttingen.

———. 1995. "Reflecting Sappho." *Bulletin of the Institute of Classical Studies* 40:15-38.

——— (ed.). 1997. *Collecting Fragments/Fragmente sammeln.* Göttingen.

Muellner, L. C. 1976. *Meaning of Homeric EYXOMAI through Its Formulas.* Innsbruck.

———. 1996. *The Anger of Achilles: Mênis in Greek Epic.* Ithaca, NY.

Murra, J. V., N. Wachtel, and J. Revel (eds.) 1986. *Anthropological History of Andean Polities.* Cambridge and Paris.

Murray, O. 1983a. "Symposion and Männerbund." *Concilium Eirene: Proceedings of the 16th International Eirene Conference* (eds. P. Oliva and A. Frolikóvá) 47–52. Prague.

———. 1983b. "The Greek Symposium in History." *Tria Corda: Scritti in onore di A. Momigliano* (ed. E. Gabba) 257–272. Como.

———. 1983c. "The Symposium as Social Organisation." *The Greek Renaissance of the Eighth Century B.C.: Tradition and Innovation* (eds. R. Hägg and N. Marinatos) 195–199. Stockholm.

———. 1987. "Herodotus and Oral History." *Achaemenid History II. The Greek Sources* (eds. H. Sancisi-Weerdenburg and A. Kuhrt) 93–115. Leiden.

——— (ed.). 1990. *Sympotica: A Symposium on the Symposion.* Oxford.

———. 1993. *Early Greece,* second ed. London.

———. 1994. "Nestor's Cup and the Origins of the Greek *symposion.*" *Annali dell'Istituto Universitario Orientale di Napoli. Sezione di archeologia e storia antica* n.s. 1 (1994) [APOIKIA. *I più antichi insediamenti greci in occidente: funzioni e modi dell' organizzazione politica e sociale. Scritti in onore di G. Buchner]* 47–54.

Murray, O., and M. Tecuşan (eds.). 1995. *In vino veritas.* London.

Mure, W. 1854. *A Critical History of the Language and Literature of Ancient Greece,* second ed., vol. 3. London.

Nagy, G. 1973/1990b. "Phaethon, Sappho's Phaon, and the White Rock of Leucas." *HSCP* 77:137–177 (= rewritten form in id., *Greek Mythology and Poetics,* Ithaca, NY, 1990: 223–262).

———. 1974. *Comparative Studies in Greek and Indic Meter.* Cambridge, MA.

———. 1990. *Pindar's Homer: The Lyric Possession of an Epic Past.* Baltimore, MD.

———. 1996a. *Poetry as Performance: Homer and Beyond.* Cambridge.

———. 1996b. *Homeric Questions.* Austin, TX.

———. 1999. *The Best of the Achaeans: Concepts of the Hero in Archaic Greek Poetry,* revised ed. (first ed. Baltimore 1979). Baltimore, MD.

———. 2003. *Homeric Responses.* Austin, TX.

———. 2004a. *Homer's Text and Language.* Urbana, IL.

———. 2004b. "L'aède épique en auteur: La tradition des *Vies d' Homère.*" *Identités d'auteur dans l'Antiquité et la tradition européenne* (eds. C. Calame and R. Chartier) 41–67. Grenoble.

———. 2005. Review of D. Boedeker and D. Sider (eds.), *The New Simonides: Contexts of Praise and Desire.* Oxford 2001. *Classical Review* 55:407–409.

Neer, R. T. 2002. *Style and Politics in Athenian Vase-Painting: The Craft of Democracy, ca. 530–460 B.C.E.* Cambridge.

Neils, J. 2000. "Others Within the Other: An Intimate Look at Hetairai and Maenads." In Cohen 2000:203–226.

Nelson, M. 2000. "A Note on the ὄλισβος." *Glotta* 76:75–82.

Nesselrath, H.-G. 1990. *Die attische Mittlere Komödie: Ihre Stellung in der antiken Literaturkritik und Literaturgeschichte.* Berlin.

———. 2000. "Eupolis and the Periodization of Athenian Comedy." *The Rivals of Aristophanes: Studies in Athenian Old Comedy* (eds. D. Harvey and J. Wilkins) 233–246. London.

Nettl, B. 1964. *Theory and Method in Ethnomusicology.* New York.

Neubecker, A. J. 1986. *Philodemus. Über die Musik IV. Buch: Text, Übersetzung und Kommentar* [*La Scuola di Epicuro* 4]. Naples.

———. 1994. *Altgriechische Musik,* second ed. Darmstadt [first ed. 1977].

Neue, C. F. 1827. *Sapphonis Mytilenaeae Fragmenta. Specimen operae in omnibus artis Graecorum lyricae reliquiis excepto Pindaro collocandae.* Berlin.

Nickau, K. 1974. "Planudes und Moschopulos als Zeugen für Sappho (fr. 2, 5–6 L.-P.= Voigt)." *ZPE* 14:15–17.

Nicosia, S. 1976 [1977]. *Tradizione testuale diretta e indiretta dei poeti di Lesbo.* Rome.

Nilsson, M. P. 1906. *Griechische Feste von religiöser Bedeutung, mit Ausschluss der Attischen.* Leipzig.

———. 1919. "Kallisteia." *RE* 10:col.1674.

Nimis, S. 1984. "Fussnoten: Das Fundament der Wissenschaft." *Arethusa* 17:105–134.

Nixon, L. 1995. "The Cults of Demeter and Kore." *Women in Antiquity: New Assessments* (eds. R. Hawley and B. Levick) 75–96. London.

Notopoulos, J. A. 1966. "Archilochus, the Aoidos." *Transactions of the American Philological Association* 97:311–315.

Nussbaum, M. C. 1996. "Aristotle." *The Oxford Classical Dictionary,* third edition (eds. S. Hornblower and A. Spawforth) 165–169 [=third revised ed. 2003]. Oxford.

O'Higgins, D. M. 2001. "Women's Cultic Jocking and Mockery." *Making Silence Speak: Women's Voices in Greek Literature and Society* (eds. A. Lardinois and L. McClure) 137–160. Princeton, NJ.

O'Sullivan, J. N. 1981. "Asius and the Samians' Hairstyle." *Greek, Roman, and Byzantine Studies* 22:329–333.

Oakley, J. H. 2004. *Picturing Death in Classical Athens: The Evidence of the White Lekythoi.* Cambridge.

Oakley, J. H., and R. H. Sinos. 1993. *The Wedding in Ancient Athens.* Madison, WI.

Oakley, J. H., et al. (eds.). 1997. *Athenian Potters and Painters: The Conference Proceedings.* Oxford.

Obeyesekere, G. 1992. *The Apotheosis of Captain Cook: European Mythmaking in the Pacific.* Princeton, NJ.

Ohl, R. T. 1928. *The Enigmas of Symphosius.* Diss. University of Pennsylvania. Philadelphia, PA.

Ohlert, K. 1912. *Rätsel und Rätselspiele der alten Griechen.* Berlin.

Ohly-Dumm, M. 1985. "Tripod-Pyxis from the Sanctuary of Aphaia on Aegina." *The Amasis Painter and His World: Vase-Painting in Sixth-Century B.C. Athens* (ed. D. von Bothmer) 236–238. New York and Malibu.

Osborne, R. 1997. "Law, the Democratic Citizen and the Representation of Women in Classical Athens." *Past and Present* 155:3–33.

———. 1998. "Early Greek Colonization? The Nature of Greek Settlement in the West." *Archaic Greece: New Approaches and New Evidence* (eds. N. Fisher and H. van Wees) 251–269. London.

———. 2004. "Workshops and the Iconography and Distribution of Athenian Red-figure Pottery: A Case Study." *Greek Art in View: Essays in Honour of B. Sparkes* (eds. S. Keay and S. Moser) 78–94. Oxford.

Page, D. L. 1955. *Sappho and Alcaeus: An Introduction to the Study of Ancient Lesbian Poetry.* Oxford.

———. 1958. "ΔΕΔΥΚΕ ΜΕΝ Ά ΣΕΛΑΝΑ." *Journal of Hellenic Studies* 78:84–85.

———. 1962. *Poetae Melici Graeci.* Oxford.

———. 1963. "Archilochus and the Oral Tradition." *Archiloque [Entretiens sur l'Antiquité Classique. Fondation Hardt,* vol. 10] 117–163. Geneva.

———. 1974. *Supplementum Lyricis Graecis: Poetarum Lyricorum Graecorum Fragmenta quae recens innotuerunt.* Oxford.

———. 1975. *Epigrammata Graeca.* Oxford.

———. 1981. *Further Greek Epigrams,* revised and prepared for publication by R. D. Dawe and J. Diggle. Cambridge.

Panvini, R., and F. Giudice (eds.). 2003. *Ta Attika: Veder greco a Gela. Ceramiche attiche figurate dall'antica colonia.* Rome.

Papademetriou, I.-Th. 1987. *Αἰσώπεια καὶ Αἰσωπικά.* Athens.

———. 1997. *Aesop as an Archetypal Hero.* Athens.

Papadopoulos, J. K. 1996. "The Original Kerameikos of Athens and the Siting of the Classical Agora." *Greek, Roman, and Byzantine Studies* 37:107–128.

Papaspyridi-Karouzou, S. 1942/1943. "Anacréon à Athènes." *BCH* 66/67:248–254.

Papathomopoulos, M. 1999a. *Ὁ Βίος τοῦ Αἰσώπου: Ἡ παραλλαγὴ W.* Edited with introduction, translation, and commentary. Athens.

———. 1999b. *Πέντε Δημώδεις Μεταφράσεις τοῦ Βίου τοῦ Αἰσώπου.* Athens.

Paquette, D. 1984. *L'instrument de musique dans la céramique de la Grèce antique: Études d'Organologie.* Paris.

Paraskevaidis, M. 1976. "Lesbos." *The Princeton Encyclopedia of Classical Sites* (eds. R. Stillwell et al.) 502–503. Princeton, NJ.

Parassoglou, G. M. (ed.). 1993. *Ἀνδρόνικος Νούκιος, Γεώργιος Αἰτωλός: Αἰσώπου Μῦθοι.* Athens.

Pardini, A. 1991. "Riesame della tradizione e nuove scelte editoriali: *Carm. conv.* 891, 1; *Pervig. Ven.* 46; Aug. *In Rom.* 64 (72), 6." *Orpheus* 12:555–562.

Parisinou, E. 2000. *The Light of the Gods: The Role of Light in Archaic and Classical Greek Cult.* London.

Parke, H. W. 1977. *Festivals of the Athenians.* Ithaca, NY.

Parker, H. N. 1992. "Love's Body Anatomized: The Ancient Erotic Handbooks and the Rhetoric of Sexuality." *Pornography and Representation in Greece and Rome* (ed. A. Richlin ) 90–111. Oxford and New York.

———. 1993. "Sappho Schoolmistress." *Transactions of the American Philological Association* 123:309–351.

———. 2005. "Sappho's Public World." *Women Poets in Ancient Greece and Rome* (ed. E. Greene) 3–24. Norman.

Parker, L. P. E. 2001. "*Consilium et Ratio*? Papyrus A of Bacchylides and Alexandrian Metrical Scholarship." *Classical Quarterly* 51:23–52.

Parker, R. 1987. "Myths of Early Athens." *Interpretations of Greek Mythology* (ed. J. Bremmer) 187–214. London.

Parry, M. 1971a. *The Making of Homeric Verse: The Collected Papers of Milman Parry*, ed. A. Parry. Oxford.

———. 1971b. "Studies in the Epic Technique of Oral Verse-Making. II. The Homeric Language as the Language of an Oral Poetry." In id., 1971a, 325–364 [orig. publ. 1932].

———. 1971c. "The Traces of the Digamma in Ionic and Lesbian Greek." In id., 1971a, 391–403 [orig. publ. 1934].

Parsons, P. J. 1987. "[P.Oxy.] 3724. List of Epigrams." *The Oxyrhynchus Papyri*, vol. LIV, 65–82. London.

———. 1992. "[P.Oxy.] 3965. Simonides, *Elegies*." *The Oxyrhynchus Papyri*, vol. LIX, 4–49. London.

———. 2001. "'These Fragments We Have Shored Against Our Ruin.'" *The New Simonides: Contexts of Praise and Desire* (eds. D. Boedeker and D. Sider) 55–64. Oxford and New York.

Patrucco, R. 1972. *Lo Sport nella Grecia antica*. Florence.

Pauw, J. C. de 1732. *Anacreontis Teii Odae et Fragmenta, Graece et Latine, cum notis*. Trajectum ad Rhenum [Utrecht].

Pavlidis, I. I. 1885. Σαπφὼ ἡ Μυτιληναία. Leipzig.

Peek, W. 1955. *Griechische Vers-Inschriften: Grab-Epigramme*. Berlin.

Pelliccia, H. 1991. "Anacreon 13 (358 *PMG*)." *Classical Philology* 86:30–36.

———. 1995. "Ambiguity against Ambiguity: Anacreon 13 Again." *Illinois Classical Studies* 20:23–34.

Pellizer, E. 1990. "Outlines of a Morphology of Sympotic Entertainment." In Murray 1990: 177–184.

Peredolskaya, A. A. 1967. *Krasnofigurnye atticheskie vasy v Ėrmitazhe: Katalog*. Leningrad.

Perry, B. E. 1952. *Aesopica: A Series of Texts Relating to Aesop or Ascribed to Him or Closely Connected with the Literary Tradition That Bears His Name*, collected and edited, in part translated from Oriental languages, with a commentary and historical essay. Urbana, IL.

————. 1967. *The Ancient Romances: A Literary-Historical Account of Their Origins.* Berkeley and Los Angeles, CA.

Peruzzi, E. 1992. "Cultura greca a Gabii nel secolo VIII." *Parola del Passato* 47:459–468.

Pesenti, G. 1922. "'Sapphica Musa' I. (P.Oxy. 1231, 1)." *Aegyptus* 3:49–54.

Peschel, I. 1987. *Die Hetäre bei Symposion und Komos in der attisch-rotfigurigen Vasenmalerei des 6.-4. Jahrhunderts v. Chr.* Frankfurt am Main.

Petersen, L. H. 1997. "Divided Consciousness and Female Companionship: Reconstructing Female Subjectivity on Greek Vases." *Arethusa* 30:35–74.

Petrie, W. M. F., et al. (C. Smith, E. Gardner, and B. V. Head). 1886. *Naukratis,* part I. London.

Pettigrew, T. F. 1981. "Extending the Stereotype Concept." *Cognitive Processes in Stereotyping and Intergroup Behavior* (ed. D. L. Hamilton) 303–331. Hillsdale, NJ.

Pfeiffer, R. 1968. *History of Classical Scholarship: From the Beginnings to the End of the Hellenistic Age.* Oxford.

Pfeijffer, I. L. 1999. *Three Aeginetan Odes of Pindar: A Commentary on* Nemean V, Nemean III, *and* Pythian VIII. Leiden

————. 2000. "Playing Ball with Homer: An Interpretation of Anacreon 358 *PMG.*" *Mnemosyne* 53:164–184.

Philaretos, G. N. 1907. Δεῖπνα καὶ Συμπόσια τῶν Ἀρχαίων Ἑλλήνων. Athens.

Philippart, H. 1933. "Deux vases attiques inédits du Castello Sforzesco, à Milan." *RA* ser. VI, vol. 1:154–162.

Picard, C. 1948. "Art et littérature: Sur trois exégèses." *Revue des Études Grecques* 61:337–357.

Pickard-Cambridge, A. 1988. *The Dramatic Festivals of Athens,* second ed. revised by J. Gould and D. M. Lewis, reissued with supplement and corrections. Oxford.

Pieters, J. T. M. F. 1946. *Cratinus: Bijdrage tot de geschiedenis der vroeg-attische comedie.* Leiden.

Pintaudi, R. 2000. "Ermeneutica *per epistulas:* L' ostrakon fiorentino di Saffo (*PSI* XIII 1300)." *APap* 12:45–62.

Pirenne-Delforge, V. 1994. *L' Aphrodite grecque: Contribution à l' étude de ses cultes et de sa personalité dans le panthéon archaïque et classique.* Athens and Liège.

Plehn, S. L. 1849. Τὰ Λεσβιακά, ἤτοι Ἱστορία τῆς νήσου Λέσβου, trans. into Greek and revised by E. Georgiades (orig. publ. in Latin, 1826). Athens.

Pöhlmann, E. 1960. *Griechische Musikfragmente. Ein Weg zur altgriechischen Musik.* Nuremberg.

————. 1970. *Denkmäler altgriechischer Musik. Sammlung, Übertragung und Erläuterung aller Fragmente und Fälschungen.* Nuremberg.

————. 1976. "Die Notenschrift in der Überlieferung der griechischen Bühnenmusik." *Würzburger Jahrbücher für die Altertumswissenschaft,* n.s. 2:53–73.

———. 1994. *Einführung in die Überlieferungsgeschichte und in die Textkritik der antiken Litera-tur, Band I: Altertum.* Darmstadt.

———. 2000. *Δρᾶμα καὶ Μουσικὴ στὴν Ἀρχαιότητα.* Athens.

Pöhlmann, E., and M. L. West. 2001. *Documents of Ancient Greek Music: The Extant Melodies and Fragments,* edited and transcribed with commentary. Oxford.

Politou-Marmarinou, E. 1982. "Ποίηση καὶ Γλῶσσα," in *Μνήμη Γ.Ι. Κουρμούλη* [1988]: 211–242 [also published independently in 1982]. Athens.

Pontani, F. 2001. "Le cadavre adoré: Sappho à Byzance?" *Byzantion* 71:233–250.

Porro, A. 1994. *Vetera Alcaica: L' esegesi di Alceo dagli Alessandrini all' età imperiale.* Milan.

Powell, B. B. 1991. *Homer and the Origin of the Greek Alphabet.* Cambridge.

———. 2002. *Writing and the Origins of Greek Literature.* Cambridge.

Powell, J. U. 1925. *Collectanea Alexandrina: Reliquiae Minores Poetarum Graecorum Aetatis Ptolemaicae, 323–146 A.C.* Oxford.

Pozzi, G. 1981. *La parola dipinta.* Milan.

Pratt, L. 1995. "The Seal of Theognis, Writing, and Oral Poetry." *AJPh* 116:171–184.

Presta, A. 1959. "Leggende e novelle sibaritiche." *Almanacco Calabrese* 9:49–71.

Price, S. D. 1990. "Anacreontic Vases Reconsidered." *Greek, Roman, and Byzantine Studies* 31:133–175.

Prins, G. 2001. "Oral History." *New Perspectives on Historical Writing* (ed. P. Burke), second ed., 120–156. University Park, PA.

Prins, Y. 1999. *Victorian Sappho.* Princeton, NJ.

———. 2005. "Sappho Recomposed: A Song Cycle by Granville and Helen Bantock." *The Figure of Music in Nineteenth-Century British Poetry* (ed. P. Weliver) 230–258. Alder-shot.

Probonas, G. K. 1978. *Λεξικὸ τῆς Μυκηναϊκῆς Ἑλληνικῆς,* vol. I. Athens.

Pucci, P. 1980. "The Language of the Muses." *Classical Mythology in Twentieth-Century Thought and Literature: Proceedings of the Comparative Literature Symposium, Texas Tech University,* vol. XI (eds. W. M. Aycock and T. M. Klein) 163–186. Lubbock, TX.

Pütz, B. 2003. *The Symposium and Komos in Aristophanes.* Stuttgart.

Purcell, N. 1990. "Mobility and the *Polis.*" *The Greek City from Homer to Alexander* (eds. O. Murray and S. Price) 29–58. Oxford.

Queyrel, A. 1988. "Les Muses à l'école: Images de quelques vases du peintre de Calliope." *AK* 31:90–102.

———. 1992. "Mousa, Mousai." *LIMC* 6:657–681.

Rabinowitz, N. S. 2002. "Excavating Women's Homoeroticism in Ancient Greece: The Evidence from Attic Vase Paintings." *Among Women: From the Homosocial to the Homoerotic in the Ancient World* (eds. N. S. Rabinowitz and L. Auanger) 106–166. Austin, TX.

Race, W. H. 1982. *The Classical Priamel from Homer to Boethius.* Leiden.

Radcliffe-Brown, A. R. 1958. *Method in Social Anthropology.* Chicago, IL.

Rea, J. R. 1968. "[P.Oxy.] 2659. List of Comic Poets and their Plays." *The Oxyrhynchus Papyri*, vol. XXXIII, 70–76. London.

Reardon, B. P. (ed.). 1989. *Collected Ancient Greek Novels*. Berkeley and Los Angeles.

Rebillard, L. 1991. "Exékias apprend à écrire. Diffusion de l' écriture chez les artisans du céramique au VIᵉ s. av. J.-C." In Baurain et al. 1991:549–564.

Redfield, J. 1991. "Classics and Anthropology." *Arion* ser. 3, vol. 1.2:5–23.

Reeder, E. D. (ed.). 1995. *Pandora: Women in Classical Greece*. Princeton, NJ.

Reinsberg, C. 1993. *Ehe, Hetärentum und Knabenliebe im antiken Griechenland*. Munich (orig. publ. 1989).

Reinsch, D. R., and A. Kambylis. 2001. *Annae Comnenae Alexias*, 2 vols. Berlin.

Reitzenstein, R. 1893. *Epigramm und Skolion: Ein Beitrag zur Geschichte der alexandrinischen Dichtung*. Giessen.

Renehan, R. 1984. "Anacreon Fragment 13 Page." *Classical Philology* 79:28–32.

———. 1993. "On the Interpretation of a Poem of Anacreon." *Illinois Classical Studies* 18: 39–47.

Reusser, C. 2002. *Vasen für Etrurien: Verbreitung und Funktionen attischer Keramik im Etrurien des 6. und 5. Jahrhunderts vor Christus*. Zurich.

Revel, J., and N. Wachtel (eds.). 1996. *Une École pour les Sciences sociales: De la VIe section à l'École des Hautes Études en Sciences Sociales*. Foreword M. Augé. Paris.

Reynolds, M. 2000. *The Sappho Companion*. London.

———. 2003. *The Sappho History*. Basingstoke, Hampshire.

Richter, G. M. A. 1965. *The Portraits of the Greeks*, vol. 1. London.

Richter, G. M. A., and M. J. Milne. 1935. *Shapes and Names of Athenian Vases*. New York.

Richter, G. M. A., and R. R. R. Smith. 1984. *The Portraits of the Greeks*, abridged and revised ed. by R. R. R. Smith. Ithaca, NY.

Ridgway, B. S. 1987. "Ancient Greek Women and Art: The Material Evidence." *American Journal of Archaeology* 91:399–409.

———. 1998. "An Issue of Methodology: Anakreon, Perikles, Xanthippos." *American Journal of Archaeology* 102:717–738.

Riffaterre, M. 1990. *Fictional Truth*. Baltimore.

Riginos, A. S. 1976. *Platonica: The Anecdotes Concerning the Life and Writings of Plato*. Leiden.

Rigolot, F. 1983. "Louise Labé et la rédecouverte de Sappho." *Nouvelle revue du seizième siècle* 1:19–31.

Rilke, R. M. 1984. *Rainer Maria Rilke: New Poems [1907]*, bilingual edition trans. by E. Snow. New York.

Rissman, L. 1983. *Love as War: Homeric Allusion in the Poetry of Sappho*. Königstein/Ts.

Roberts, H. D. 1974. *Ancient Greek Stringed Instruments, 700-200 B.C.* Ph.D. diss. University of Reading.

———. 1980. "The Technique of Playing Ancient Greek Instruments of the Lyre Type." *Music and Civilisation, British Museum Yearbook* 4 (ed. T. C. Mitchell) 43–76. London.

Robertson, M. 1987. "The State of Attic Vase-Painting in the Mid-Sixth Century." *Papers on the Amasis Painter and His World. Colloquium Sponsored by the Getty Center for the History of Art and the Humanities and Symposium Sponsored by the J. Paul Getty Museum*, 13–28. Malibu, CA.

———. 1992. *The Art of Vase-painting in Classical Athens*. Cambridge.

Robertson, N. 2003. "Aesop's Encounter with Isis and the Muses, and the Origins of the *Life of Aesop*." *Poetry, Theory, Praxis. The Social Life of Myth, Word, and Image in Ancient Greece: Essays in Honour of W. J. Slater* (eds. E. Csapo and M. C. Miller) 247–266. Oxford.

Robinson, D. M. 1924. *Sappho and Her Influence*. Boston, MA.

Robinson, D. M., and E. J. Fluck. 1937. *A Study of the Greek Love-names*. Baltimore, MD.

Rodríguez Somolinos, H. 1992. *Estudios sobre el léxico de Safo y Alceo*. Diss. Madrid.

———. 1994. "Notas léxicas a Safo y Alceo." *Emerita* 62:109–123.

———. 1997. "Les *hapax legomena* des poètes lesbiens: L'apport des papyrus." *Akten des 21. Internationalen Papyrologenkongresses, Berlin, 13.-19.8.1995, APF, Beiheft 3* (eds. B. Kramer et al.) 847–857. Stuttgart.

———. 1998. *El léxico de los poetas lesbios*. Madrid.

Rösler, W. 1975. "Ein Gedicht und sein Publikum. Überlegungen zu Sappho Fr. 44 Lobel-Page." *Hermes* 103:275–285.

———. 1980. *Dichter und Gruppe: Eine Untersuchung zu den Bedingungen und zur historischen Funktion früher griechischer Lyrik am Beispiel Alkaios*. Munich.

———. 1983. "Über Deixis und einige Aspekte mündlichen und schriftlichen Stils in antiker Lyrik." *Würzburger Jahrbücher für die Altertumswissenschaft* n.s. 9:7–28.

———. 1984. "Die Alkaios-Überlieferung im 6. und 5. Jahrhundert." *Proceedings of the VII$^{th}$ Congress of the International Federation of the Societies of Classical Studies I* (ed. J. Harmatta) 187–190. Budapest

———. 1990a. "*Mnemosyne* in the *Symposion*." In Murray 1990:230–237.

———. 1990b. "Realitätsbezug und Imagination in Sapphos Gedicht ΦΑΙΝΕΤΑΙ ΜΟΙ ΚΗΝΟΣ." In Kullmann and Reichel 1990:271–287.

———. 1992. "Homoerotik und Initiation: Über Sappho." *Homoerotische Lyrik: 6. Kolloquium der Forschungsstelle für europäische Lyrik des Mittelalters an der Universität Mannheim* (T. Stemmler) 43–54. Tübingen.

———. 1997. "Trasmissione culturale tra oralità e scrittura." *I Greci. Storia, culura, arte, società. 2. Una storia greca. II. Definizione* (ed. S. Settis) 707–723. Torino.

———. 2004. "Presentazione." In G. F. Nieddu, *La scrittura 'madre delle Muse':Agli esordi di un nuovo modello di comunicazione culturale*. Amsterdam.

Roilos, P. 1998. "Ὁ Νεκρὸς ὡς Δέντρο στὰ Ἑλληνικὰ Μοιρολόγια. Ἡ Μεταφορὰ στὴν Παραδοσιακὴ Προφορικὴ Ποίηση Τελετουργικοῦ Χαρακτῆρα." *H* 48:61–85.

———. 2000. "*Amphoteroglossia*: The Role of Rhetoric in the Medieval Greek Learned Novel." *Der Roman im Byzanz der Komnenenzeit* (eds. P. Agapitos and D. R. Reinsch) 109–126. Frankfurt am Main.

———. 2002. "Orality and Performativity in the *Erotokritos*." *Cretan Studies* 7:213–230.

———. 2005. *Amphoteroglossia: A Poetics of the Twelfth-Century Medieval Greek Novel.* Cambridge, MA.

———. 2006. "Ekphrasis and Ritual Poetics." *Literatur und Religion* (ed. A. Bierl) forth.

———. forth. "Orality, Ritual, and the Dialectics of Performance." *Oral Literature: Theoretical and Comparative Perspectives* (ed. K. Reichl). Berlin.

Roilos, P., and D. Yatromanolakis. 2002. "Bibliographical Supplement." In Alexiou 2002: 261–272.

Roilos, P., and D. Yatromanolakis. forth. *Interdiscursivity and Ritual: Explorations in Patterns of Signification in Greek Literature and Societies.* Munich.

Rosati, G. 1996. "Sabinus, the *Heroides* and the Poet-Nightingale: Some Observations on the Authenticity of the *Epistula Sapphus*." *Classical Quarterly* 46:207–216.

Rosén, H. B. 1987. *Herodoti Historiae: Vol. I.* Leipzig.

Rosenmeyer, P. A. 1992. *The Poetics of Imitation: Anacreon and the Anacreontic Tradition.* Cambridge.

———. 1997. "Her Master's Voice: Sappho's Dialogue with Homer." *Materiali e Discussioni* 39:123–149.

———. 2004. "Girls at Play in Early Greek Poetry." *American Journal of Philology* 125:163–178.

Rosivach, V. J. 1987. "Autochthony and the Athenians." *Classical Quarterly* 37:294–306.

Rossi, L. E. 1993. "Lirica arcaica e scoli simposiali (Alc. 249, 6–9 V. e *carm. conv.* 891 P.)." *Tradizione e innovazione nella cultura greca da Omero all'età ellenistica. Scritti in onore di B. Gentili* (ed. R. Pretagostini) vol. 1, 237–246. Rome.

Rotroff, S. I., and J. H. Oakley. 1992. *Debris from a Public Dining Place in the Athenian Agora* (*Hesperia Supplement* 25). Princeton, NJ.

Rüdiger, H. 1933. *Sappho: Ihr Ruf und Ruhm bei der Nachwelt.* Leipzig.

Ruscillo, D. 1993. "Faunal Remains from the Acropolis Site, Mytilene." *Échos du Monde Classique/Classical Views* n.s. 12:201–210.

Russell, D. A., and N. G. Wilson. 1981. *Menander Rhetor*, edited with translation and commentary. Oxford.

Russo, J. 1973. "Reading the Greek Lyric Poets (Monodists)." *Arion* n.s. 1:707–730.

———. 1997. "Prose Genres for the Performance of Traditional Wisdom in Ancient Greece: Proverb, Maxim, Apothegm." *Poet, Public, and Performance in Ancient Greece* (eds. L. Edmunds and R. W. Wallace) 49–64. Baltimore, MD.

Rutter, N. K. 1970. "Sybaris-Legend and Reality." *Greece and Rome* 17:168–176.

Saake, H. 1972. *Sapphostudien: Forschungsgeschichtliche, biographische und literarästhetische Untersuchungen.* Paderborn.

Sabetai, V. 1993. *The Washing Painter.* Diss. University of Cincinnati.

413

———. 1997. "Aspects of Nuptial and Genre Imagery in Fifth-century Athens: Issues of Interpretation and Methodology." In Oakley et al. 1997:319–335.

Sahlins, M. 1981. *Historical Metaphors and Mythical Realities: Structure in the Early History of the Sandwich Islands Kingdom.* Ann Arbor, MI.

———. 1985. *Islands of History.* Chicago, IL.

———. 1995. *How "Natives" Think: About Captain Cook, for Example.* Chicago, IL.

———. 2004. *Apologies to Thucydides: Understanding History as Culture and vice versa.* Chicago, IL.

Sakellariou, M. B. 1958. *La migration grecque en Ionie.* Athens.

Salskov Roberts, H. 2002. "Anakreon in the Pictorial Arts." *Noctes Atticae: 34 Articles on Graeco-Roman Antiquity and Its Nachleben: Studies Presented to J. Mejer on His Sixtieth Birthday* (eds. B. Amden et al.) 241–253. Copenhagen.

Sartori, K. 1893. *Studien aus dem Gebiete der griechischen Privataltertümer. I: Das Kottabos-Spiel der alten Griechen.* Diss. Munich.

Sawyer, R. K. 1999. "Improvisation." *Language Matters in Anthropology* (ed. A. Duranti), *Journal of Linguistic Anthropology* 9.1–2:121–123.

Sbordone, F. 1976. Φιλοδήμου Περὶ ποιημάτων. *Tractatus tres.* [*Ricerche sui papiri ercolanesi*, vol. 2]. Naples.

Schadewaldt, W. 1950. *Sappho: Welt und Dichtung.* Potsdam.

Schäfer, A. 1997. *Unterhaltung beim griechischen Symposion: Darbietungen, Spiele und Wettkämpfe von homerischer bis in spätklassische Zeit.* Mainz am Rhein.

Schauenburg, K. 1975. "ΕΥΡΥΜΕΔΩΝ ΕΙΜΙ." *AM* 90:97–121.

Schaus, G. P., and N. Spencer. 1994. "Notes on the Topography of Eresos." *American Journal of Archaeology* 98:411–430.

Schefold, K. 1997. *Die Bildnisse der antiken Dichter, Redner und Denker.* Basel.

Schefold, K., and F. Jung. 1989. *Die Sagen von den Argonauten, von Theben und Troia in der klassischen und hellenistischen Kunst.* Munich.

Scheibler, I. 1983. *Griechische Töpferkunst: Herstellung, Handel und Gebrauch der antiken Tongefäße.* Munich.

———. 1992. Ἑλληνικὴ Κεραμεικὴ: Παραγωγή, Ἐμπόριο καὶ Χρήση τῶν Ἀρχαίων Ἑλληνικῶν Ἀγγείων, revised and augmented ed., trans. E. Manakidou. Athens.

Schenkl, H., and G. Downey. 1965. *Themistii Orationes quae supersunt*, vol. 1. Leipzig.

Schmaltz, B., and M. Söldner (eds.). 2003. *Griechische Keramik im kulturellen Kontext: Akten des Internationalen Vasen-Symposions in Kiel vom 24.–28.9.2001 veranstaltet durch das Archäologische Institut der Christian-Albrechts-Universität zu Kiel.* Münster.

Schmitt-Pantel, P. 1992. *La cité au banquet: Histoire des repas publics dans les cités grecques,* Rome.

Schmitt-Pantel, P., and F. Thelamon. 1983. "Image et histoire: Illustration ou document." *Image et céramique grecque: Actes du Colloque de Rouen, 25–26 novembre 1982* (eds. F. Lissarrague and F. Thelamon) 9–20. Rouen.

Schnapp, A. 1988. "Why Did the Greeks Need Images?" *Proceedings of the 3rd Symposium on Ancient Greek and Related Pottery. Copenhagen, August 31–September 4 1987* (eds. J. Christiansen and T. Melander) 568–574. Copenhagen.

Schneider, K. 1922. "Kottabos." *RE* 11.2:1528–1541.

Scholz, B. 2003. "Akrobatinnen in Attika und Unteritalien." In Schmaltz and Söldner 2003: 99–101.

Schott, P. 1905. *Posidippi Epigrammata collecta et illustrata.* Diss. Berlin.

Schrenk, L. P. 1994. "Sappho Frag. 44 and the 'Iliad'." *Hermes* 122:144–150.

Schubart, W. 1902. "Neue Bruchstücke der Sappho und des Alkaios." *Sitzungsberichte der königlich preußischen Akademie der Wißenschaften zu Berlin* 10:195–209.

———. 1907. "Sappho. P. [Berol.] 9722." *Berliner Klassikertexte 5.2: Lyrische und Dramatische Fragmente* (eds. W. Schubart and U. von Wilamowitz-Moellendorff) 10–18. Berlin.

Schultz, W. 1909/1912. *Rätsel aus dem hellenistischen Kulturkreise,* vol. 1: *Die Rätselüberlieferung* and vol. 2: *Erläuterungen zur Rätselüberlieferung.* Leipzig.

Schwartz, E. 1887. *Scholia in Euripidem,* vol. 1: *Scholia in Hecubam, Orestem, Phoenissas.* Berlin.

Seebass, T. 1991. "The Power of Music in Greek Vase Painting: Reflections on the Visualization of *rhythmos* (order) and *epaoidê* (enchanting song)." *Imago Musicae* 8:11–37.

Seeger, A. 1979. "What Can We Learn When They Sing? Vocal Genres of the Suyá Indians of Central Brazil." *Ethnomusicology* 23:373–394.

———. 1987. *Why Suyá Sing? A Musical Anthropology of an Amazonian People.* Cambridge [new ed. Urbana and Chicago, IL 2004].

Segal, C. 1974. "Eros and Incantation: Sappho and Oral Poetry." *Arethusa* 7:139–160.

Seider, R. 1967. *Paläographie der griechischen Papyri,* vol. I. Stuttgart.

Ševčenko, I. 1951. "A New Fragment of Sappho?" *Annals of the Ukrainian Academy of Arts and Sciences in the U.S.* 1.2:150–152.

Sevinç, N. 1996. "A New Sarcophagus of Polyxena from the Salvage Excavations at Gümüsçay." *Studia Troica* 6:251–264.

Sgourou, M. 1997. "Λέβητες γαμικοί. Ὁ γάμος καὶ ἡ ἀττικὴ κεραμεικὴ παραγωγὴ τῶν κλασσικῶν χρόνων." In Oakley et al. 1997:71–83.

Shapiro, H. A. 1981. "Courtship Scenes in Attic Vase-Painting." *American Journal of Archaeology* 85:133–143.

———. 1983a. "Epilykos Kalos." *Hesperia* 52:305–311.

———. 1983b. "Amazons, Thracians, and Scythians." *Greek, Roman, and Byzantine Studies* 24:105–114.

———. 1987. "Kalos-Inscriptions with Patronymic." *ZPE* 68:107–118.

———. 1989. *Art and Cult under the Tyrants in Athens.* Mainz am Rhein.

——. 1992. "Eros in Love: Pederasty and Pornography in Greece." *Pornography and Representation in Greece and Rome* (ed. A. Richlin) 53–72. Oxford and New York.

——. 1993. *Personifications in Greek Art: The Representation of Abstract Concepts, 600–400 B.C.* Zurich.

——. 1995a. "Literacy and Social Status of Archaic Attic Vase-Painters." *Revista do Museu de Arqueologia e Etnologia* 5:211–222.

——. 1995b. *Art and Cult under the Tyrants in Athens: Supplement.* Mainz am Rhein.

——. 1997. "Correlating Shape and Subject: The Case of the Archaic Pelike." In Oakley et al. 1997:63–70.

——. 2000a. "Modest Athletes and Liberated Women: Etruscans on Attic Black-figure Vases." In Cohen 2000:315–337.

——. 2000b. "Leagros and Euphronios: Painting Pederasty in Athens." *Greek Love Reconsidered* (ed. T. K. Hubbard) 12–32. New York.

——. 2003. "Brief Encounters: Women and Men at the Fountain House." In Schmaltz and Söldner 2003:96–98.

Sherwood, K. D. 1997. "Multiculturalism in Microcosm: The Evidence of the Terracotta Figurines from the Hellenistic Sanctuary of Demeter Thesmophoros at Mytilene." Paper given in the 98th Annual Conference of the Archaeological Institute of America [Session "Anatolia in the First Millennium B.C."], abstract in *American Journal of Archaeology* 101:362–363.

Shields, E. L. 1917. *The Cults of Lesbos.* Ph.D. diss. The Johns Hopkins University.

Shipp, G. P. 1977. "Linguistic Notes (λαικάζω, πόσις, ῥηχίη, ψάρ and ψήρ, rex)." *Antichthon* 11:1–9.

Shostak, M. 1981. *Nisa: The Life and Words of a !Kung Woman.* Cambridge, MA.

Sider, D. 1997. *The Epigrams of Philodemos: Introduction, Text, and Commentary.* New York and Oxford.

——. 2004. "Posidippus Old and New." *Labored in Papyrus Leaves: Perspectives on an Epigram Collection Attributed to Posidippus (P.Mil.Vogl. VIII 309)* (eds. B. Acosta-Hughes et al.) 29–41. Cambridge, MA.

Sidwell, K. 2000. "From Old to Middle to New? Aristotle's *Poetics* and the History of Athenian Comedy." *The Rivals of Aristophanes: Studies in Athenian Old Comedy* (eds. D. Harvey and J. Wilkins) 247–258. London.

Sifakis, G. M. 1967. "Singing Dolphin Riders." *Bulletin of the Institute of Classical Studies* 14:36–37.

Simon, E. 1972. Review of *CVA Germany* vol. 24 and vol. 29: *Gotha, Schlossmuseum,* ed. E. Rohde, Berlin 1964 and 1968, in *Gnomon* 44:420–423.

——. 1981. *Die griechischen Vasen,* second ed., Munich [first ed. 1976]

Sissa, G. 1997. "Philology, Anthropology, Comparison: The French Experience." *Classical Philology* 92:167–171.

Skinner, M. B. 1989. "Sapphic Nossis." *Arethusa* 22:5–18.

———. 1991. "Nossis *Thêlyglôssos*: The Private Text and the Public Book." *Women's History and Ancient History* (ed. S. B. Pomeroy) 20–47. Chapel Hill, NC.

———. 2002. "Aphrodite Garlanded: *Erôs* and Poetic Creativity in Sappho and Nossis." *Among Women: From the Homosocial to the Homoerotic in the Ancient World* (eds. N. S. Rabinowitz and L. Auanger) 60–81. Austin, TX.

Slater, N. W. 1999. "The Vase as Ventriloquist: *Kalos*-Inscriptions and the Culture of Fame." *Signs of Orality: The Oral Tradition and Its Influence in the Greek and Roman World* (ed. E. A. Mackay) 143–161. Leiden.

Slater, W. J. (ed.). 1991. *Dining in a Classical Context*. Ann Arbor, MI.

Slings, S. R. 1994. "Sappho, fr. 94, 10." *ZPE* 102:8.

———. 2000a. "Literature in Athens, 566–510 BC." *Peisistratos and the Tyranny: A Reappraisal of the Evidence* (ed. H. Sancisi-Weerdenburg) 57–77. Amsterdam.

———. 2000b. *Symposium: Speech and Ideology. Two Hermeneutical Issues in Early Greek Lyric, with Special Reference to Mimnermus*. Amsterdam.

Small, J. P. 2003. *The Parallel Worlds of Classical Art and Text*. Cambridge.

Smith, A. C. 1999. "Eurymedon and the Evolution of Political Personifications in the Early Classical Period." *Journal of Hellenic Studies* 119:128–141.

Smith, J. D. 1977. "The Singer or the Song? A Reassessment of Lord's 'Oral Theory.'" *Man* n.s. 12:141–153.

———. 1991. *The Epic of Pābūjī: A Study, Transcription and Translation*. Cambridge.

Smith, T. J. 1998. "Dances, Drinks, and Dedications: The Archaic Komos in Laconia." *Sparta in Laconia: The Archaeology of a City and Its Countryside* (eds. W. G. Cavanagh and S. E. C. Walker) 75–81. Athens.

———. 2000. "Dancing Spaces and Dining Places: Archaic Komasts at the Symposion." *Periplous: Papers in Classical Art and Archaeology Presented to J. Boardman* (eds. G. R. Tsetskhladze et al.) 309–319. London.

Smyth, H. W. 1900. *Greek Melic Poets*. London.

Snodgrass, A. 1998. *Homer and the Artists: Text and Picture in Early Greek Art*. Cambridge.

———. 2000. "The Uses of Writing on Early Greek Painted Pottery." *Word and Image in Ancient Greece* (eds. N. K. Rutter and B. A. Sparkes) 22–34. Edinburgh.

Snyder, J. M. 1972. "The *Barbitos* in the Classical Period." *Classical Journal* 67:331–340.

———. 1974. "Aristophanes' Agathon as Anacreon." *Hermes* 102:244–246.

———. 1995. *Sappho*. New York and Philadelphia.

———. 1997a. "Sappho in Attic Vase Painting." *Naked Truths: Women, Sexuality, and Gender in Classical Art and Archaeology* (eds. A. O. Koloski-Ostrow and C. L. Lyons) 108–119. London and New York.

———. 1997b. *Lesbian Desire in the Lyrics of Sappho*. New York.

———. 1998. "Sappho and Other Women Musicians in Attic Vase Painting." *Hearing the Past: Essays in Historical Ethnomusicology and the Archaeology of Sound* (ed. A. Buckley) 165–190. Liège.

Solomos, M. (ed.). 2001. *Présences de Iannis Xenakis/Presences of Iannis Xenakis*. Paris.

Sommerstein, A. H. 1994. *Aristophanes: Thesmophoriazusae*. Warminster.

———. 1998. *Aristophanes: Ecclesiazusae*. Warminster.

Sourvinou-Inwood, C. 1979. *Theseus as Son and Stepson: A Tentative Illustration of Greek Mythological Mentality*. London.

———. 1988. *Studies in Girl's Transitions: Aspects of the Arkteia and Age Representation in Attic Iconography*. Athens.

———. 1991. *'Reading' Greek Culture: Texts and Images, Rituals and Myths*. Oxford.

———. 1995a. *'Reading' Greek Death: To the End of the Classical Period*. Oxford.

———. 1995b. "Male and Female, Public and Private, Ancient and Modern." In Reeder 1995:111–120.

———. 2002. "Greek Perceptions of Ethnicity and the Ethnicity of the Macedonians." *Identità e prassi storica nel Mediterraneo Greco* (ed. L. Moscati Castelnuovo) 173–203. Milan.

———. 2003. "Herodotus (and others) on Pelasgians: Some Perceptions of Ethnicity." *Herodotus and His World* (eds. P. Derow and R. Parker) 103–144. Oxford.

———. 2005. *Hylas, the Nymphs, Dionysos and Others: Myth, Ritual, Ethnicity*. Stockholm.

Sparkes, B. A. 1960. "Kottabos: An Athenian After-Dinner Game." *Archaeology* 13:202–207.

———. 1996. *The Red and the Black: Studies in Greek Pottery*. London.

Speier, H. 1932. "Zweifiguren-Gruppen im fünften und vierten Jahrhundert vor Christus." *RM* 47:1–94.

Spencer, N. 1995. "Early Lesbos between East and West: A 'Grey Area' of Aegean Archaeology." *Annual of the British School at Athens* 90:269–306.

———. 2000. "Exchange and Stasis in Archaic Mytilene." *Alternatives to Athens: Varieties of Political Organization and Community in Ancient Greece* (eds. R. Brock and S. Hodkinson) 68–81. Oxford.

Spivey, N. 1991. "Greek Vases in Etruria." *Looking at Greek Vases* (eds. T. Rasmussen and N. Spivey) 131–150. Cambridge.

Spyropoulos, E. 1975. "Μάγνης ὁ κωμικὸς καὶ ἡ θέση του στὴν ἱστορία τῆς ἀρχαίας ἀττικῆς κωμωδίας"." *H* 28:247–274.

Stähler, K (ed.). 1984. *Griechische Vasen aus westfälischen Sammlungen*. Münster

Stansbury-O' Donnell, M. D. 1999. *Pictorial Narrative in Ancient Greek Art*. Cambridge.

Starr, C. G. 1978. "An Evening with the Flute-Girls." *Parola del Passato* 33:401–410.

Stehle, E. 1990. "Sappho's Gaze: Fantasies of a Goddess and a Young Man." *differences* 2:88–125.

———. 1997. *Performance and Gender in Ancient Greece: Nondramatic Poetry in Its Setting*. Princeton, NJ.

Stein, J. 1981. *The Iconography of Sappho, 1775-1875*. Ph.D. diss. University of Pennsylvania, Philadelphia.

Steiner, A. 1993. "The Meaning of Repetition: Visual Redundancy on Archaic Athenian Vases." *Jahrbuch des Deutschen Archäologischen Instituts* 108:197–219.

———. 1997. "Illustrious Repetitions: Visual Redundancy in Exekias and His Followers." In Oakley et al. 1997:157–169.

Steiner, D. T. 1994. *The Tyrant's Writ: Myths and Images of Writing in Ancient Greece*. Princeton, NJ.

Steinhart, M. 2003. "Literate and Wealthy Women in Archaic Greece: Some Thoughts on the 'Telesstas' Hydria." *Poetry, Theory, Praxis. The Social Life of Myth, Word, and Image in Ancient Greece: Essays in Honour of W.J. Slater* (eds. E. Csapo and M. C. Miller) 204–231. Oxford.

Steinrück, M. 2000. "Neues zu Sappho." *ZPE* 131:10–12.

Stephens, S. A. 2002. "Commenting on Fragments." *The Classical Commentary: Histories, Practices, Theory* (eds. R. K. Gibson and C. S. Kraus) 67–88. Leiden.

Stephens, S. A., and J. J. Winkler. 1995. *Ancient Greek Novels: The Fragments*. Princeton, NJ.

Stissi, V. 1999. "Production, Circulation, and Consumption of Archaic Greek Pottery (Sixth and Early Fifth Centuries BC)." *The Complex Past of Pottery: Production, Circulation, and Consumption of Mycenaean and Greek Pottery (Sixteenth to Early Fifth Centuries BC). Proceedings of the ARCHON International Conference, Amsterdam, 8–9 November 1996* (eds. J. P. Crielaard et al.) 83–113. Amsterdam.

Stocking, G. 1968. *Race, Culture, and Evolution: Essays in the History of Anthropology*. New York.

Stoddart, S., and J. Whitley. 1988. "The Social Context of Literacy in Archaic Greece and Etruria." *Antiquity* 62:761–772.

Storey, I. C. 2003. *Eupolis: Poet of Old Comedy*. Oxford.

Stross, B. 1974. "Speaking of Speaking: Tenejapa Tzeltal Metalinguistics." In Bauman and Sherzer 1974:213–239.

Sultan, N. 1988. "New Light on the Function of 'Borrowed Notes' in Ancient Greek Music: A Look at Islamic Parallels." *Journal of Musicology* 6:387–398.

Sutton, R. F. 1981. *The Interaction between Men and Women Portrayed on Attic Red-figure Pottery*. Diss. University of North Carolina, Chapel Hill.

———. 1992. "Pornography and Persuasion on Attic Pottery." *Pornography and Representation in Greece and Rome* (ed. A. Richlin) 3–35. Oxford and New York.

———. 1997/1998. "Nuptial Eros: The Visual Discourse of Marriage in Classical Athens." *Journal of the Walters Art Gallery* 55/56:27–48.

Svenbro, J. 1984a. *La parola e il marmo: Alle origini della poetica greca*, revised and corrected ed., trans. P. Rosati. Turin.

———. 1984b. "La stratégie de l'amour: Modèle de la guerre et théorie de l'amour dans la poésie de Sappho." *Quaderni di Storia* 19:57–79.

———. 1993. *Phrasikleia: An Anthropology of Reading in Ancient Greece*, trans. J. Lloyd. Ithaca, NY.

Swain, S. 2004. "Bilingualism and Biculturalism in Antonine Rome: Apuleius, Fronto,

and Gellius." *The Worlds of Aulus Gellius* (eds. L. Holford-Strevens and A. Vardi) 3–40. Oxford.

Taillardat, J. 1965. *Les images d'Aristophane: Études de langue et de style*, second ed. Paris.

———. 1967. *Suétone ΠΕΡΙ ΒΛΑΣΦΗΜΙΩΝ. ΠΕΡΙ ΠΑΙΔΙΩΝ (Extraits Byzantins)*. Paris.

Talcott, L. 1936. "Vases and Kalos-Names from an Agora Well." *Hesperia* 5:333–354.

Tambiah, S. 1985. *Culture, Thought, and Social Action: An Anthropological Perspective.* Cambridge, MA.

Tarrant, R. J. 1981. "The Authenticity of the Letter of Sappho to Phaon (*Heroides* XV)." *HSCP* 85:133–153.

———. 1983. "Ovid." *Texts and Transmission: A Survey of the Latin Classics* (ed. L.D. Reynolds) 257–284. Oxford.

Teodorsson, S.-T. 1989/1996. *A Commentary on Plutarch's Table Talks*, 3 vols. Göteborg.

Terzaghi, N. 1939. *Synesii Cyrenensis Hymni et Opuscula,* vol. I. Rome.

Theander, C. 1943. "Lesbiaca." *Eranos* 41:139–168.

Thomas, R. 1989. *Oral Tradition and Written Record in Classical Athens.* Cambridge.

———. 1992. *Literacy and Orality in Ancient Greece.* Cambridge.

———. 1993. "Performance and Written Publication in Herodotus and the Sophistic Generation." *Vermittlung und Tradierung von Wissen in der griechischen Kultur* (eds. W. Kullmann and J. Althoff) 225–244. Tübingen.

———. 1995. "The Place of the Poet in Archaic Society." *The Greek World* (ed. A. Powell) 104–112. London.

———. 2000. *Herodotus in Context: Ethnography, Science and the Art of Persuasion.* Cambridge.

Thompson, H. A. 1984. "The Athenian Vase Painters and their Neighbours." *Pots and Potters: Current Approaches in Ceramic Archaeology* (ed. P.M. Price) 7–19. Los Angeles, CA.

Threatte, L. 1980. *The Grammar of Attic Inscriptions*, vol. I: *Phonology.* Berlin.

———. 1996. *The Grammar of Attic Inscriptions*, vol. II: *Morphology.* Berlin.

Tibiletti Bruno, M. G. 1969. "Un confronto greco-anatolico." *Athenaeum* 47:303–312.

Todorov, T. 1990. "The Origin of Genres." Id., *Genres in Discourse*, trans. C. Porter. 13–26. Cambridge.

Tomić, O. M. 1989. *Markedness in Synchrony and Diachrony.* Berlin and New York.

Tomory, P. 1989. "The Fortunes of Sappho: 1770–1850." *Rediscovering Hellenism: The Hellenic Inheritance and the English Imagination* (ed. G. W. Clarke) 121–135. Cambridge.

Treu, M. 1980. *Alkaios. Lieder*, third ed. Munich (first ed. 1952, second ed. 1963).

———. 1984. *Sappho. Lieder*, seventh ed. Munich (first ed. 1954; second ed. 1958, fourth ed. 1968).

Truitt, P. 1969. "Attic White-ground Pyxis and Phiale, ca. 450 B.C." *Boston Museum Bulletin* 67:72–92.

Trypanis, C. A. 1951. "The Epigrams of Anacreon on Hermae." *Classical Quarterly* 45:31–34.

Tsantsanoglou, K. 1973a. "The Memoirs of a Lady from Samos." *ZPE* 12.2:183–195.

———. 1973b. "Δύο Ἀλκμᾶνες; (P.Oxy. 2802)." *H* 26:107–112.

Tsiaphaki, D. S. 1998. *Ἡ Θράκη στὴν ἀττικὴ εἰκονογραφία τοῦ 5ου αἰῶνα π.Χ.: Προσεγγίσεις στὶς σχέσεις Ἀθήνας καὶ Θράκης.* Komotene.

Tsolakis, E. Th. 1967. *Συμβολὴ στὴ μελέτη τοῦ ποιητικοῦ ἔργου τοῦ Κωνσταντίνου Μανασσῆ καὶ Κριτικὴ Ἔκδοση τοῦ μυθιστορήματός του "Τὰ κατ᾽ Ἀρίστανδρον καὶ Καλλιθέαν."* Thessalonike.

Tuohy, S. 1999. "The Social Life of Genre: The Dynamics of Folksong in China." *Asian Music* 30:39–86.

Turner, E. G. 1977. *Athenian Books in the Fifth and Fourth Centuries B.C.,* second ed. London.

Turner, E. G., and P. J. Parsons. 1987. *Greek Manuscripts of the Ancient World,* second ed. revised and enlarged by P. J. Parsons. London.

Tylor, E. B. 1871. *Primitive Culture,* vol. 1. London.

Tzachou-Alexandri, O. (ed.). 1989. *Mind and Body: Athletic Contests in Ancient Greece. National Archaeological Museum 15th May 1989–15th January 1990.* Athens.

Tzamali, E. 1996. *Syntax und Stil bei Sappho.* Dettelbach.

Ucciardello, G. 2001. "Sapph. frr. 88 e 159 V. in POxy. LXIV 4411." *ZPE* 136:167–168.

Urios-Aparisi, E. 1993. "Anacreon: Love and Poetry (on 358 *PMG,* 13 Gent.)." *Quaderni Urbinati di Cultura Classica* 44:51–70.

Usener, H., and L. Radermacher. 1929. *Dionysii Halicarnasei quae exstant,* vol. VI. Leipzig.

Usher, S. 1985. *Dionysius of Halicarnassus: The Critical Essays,* vol. 2. Cambridge, MA.

Ussher, R. G. 1973. *Aristophanes: Ecclesiazusae,* edited with introduction and commentary. Oxford.

van de Walle, B. 1934. "La 'quatrième pyramide' de Gizeh et la légende de Rhodopis." *Antiquité Classique* 3:303–312.

van der Weiden, M. J. H. 1991. *The Dithyrambs of Pindar: Introduction, Text and Commentary.* Amsterdam.

van Dijk, G.-J. 1997. *Αἶνοι, λόγοι, μῦθοι. Fables in Archaic, Classical, and Hellenistic Greek Literature, with a Study of the Theory and Terminology of the Genre.* Leiden.

Vansina, J. 1965. *Oral Tradition: A Study in Historical Methodology,* trans. H. M. Wright. Chicago, IL.

———. 1985. *Oral Tradition as History.* Madison, WI.

Vazaki, A. 2003. *Mousike Gyne: Die musisch-literarische Erziehung und Bildung von Frauen im Athen der klassischen Zeit.* Möhnesee.

Venit, M. S. 1988a. "The Caputi Hydria and Working Women in Classical Athens." *Classical World* 81:265–272.

———. 1988b. *Greek Painted Pottery from Naukratis in Egyptian Museums.* Winona Lake, IN.

Vérilhac, A.-M., and C. Vial. 1998. *Le mariage grec du VIᵉ siècle av. J.-C. à l'époque d'Auguste.* Athens.

Vermeule, E. 1965. "Fragments of a Symposion by Euphronios." *AK* 8:34–39.

Versnel, H. S. 1987. "Wife and Helpmate: Women of Ancient Athens in Anthropological Perspective." In Blok and Mason 1987:59–86.

———. 1990. *Inconsistencies in Greek and Roman Religion I: Ter Unus. Isis, Dionysos, Hermes—Three studies in henotheism.* Leiden.

———. 1993. *Inconsistencies in Greek and Roman Religion II: Transition and Reversal in Myth and Ritual.* Leiden.

Vetta, M. 1980. *Theognis. Elegiarum liber secundus.* Rome.

———. 1982. "Il P.Oxy. 2506 fr. 77 e la poesia pederotica di Alceo." *Quaderni Urbinati di Cultura Classica* n.s. 10:7–20.

——— (ed.). 1983a. *Poesia e simposio nella Grecia antica: Guida storica e critica.* Rome and Bari.

———. 1983b. "Un capitolo di storia di poesia simposiale (per l'esegesi di Aristofane *Vespe* 1222-1248." In Vetta 1983a:117–131.

———. 1992. "Il simposio: La monodia e il giambo." *Lo spazio letterario della Grecia antica* (eds. G. Cambiano et al.) 1:177–218. Rome.

———. 1996. "Convivialità pubblica e poesia per simposio in Grecia." *Quaderni Urbinati di Cultural Classica* n.s. 54:197–209.

Vidan, A. 2003. *Embroidered with Gold, Strung with Pearls: The Traditional Ballads of Bosnian Women.* Cambridge, MA.

Vierneisel, K., and B. Kaeser (eds.). 1990. *Kunst der Schale. Kultur des Trinkens.* Munich.

Voigt, E.-M. 1971. *Sappho et Alcaeus.* Amsterdam.

Vološinov, V. N. 1973. *Marxism and the Philosophy of Language*, trans. L. Matejka and I. R. Titunik. New York.

von Reden, S. 1997. "Money, Law, and Exchange: Coinage in the Greek Polis." *Journal of Hellenic Studies* 117:154–176.

Wachter, R. 1991. "The Inscriptions on the François Vase." *Museum Helveticum* 48:86–113.

———. 2001. *Non-Attic Greek Vase Inscriptions.* Oxford.

Walker, J. 2000. *Rhetoric and Poetics in Antiquity.* Oxford.

Wallace, R. W. 2003. "An Early Fifth-Century Athenian Revolution in Aulos Music." *HSCP* 101:73–92.

Wankel, H. 1991. "Demosthenes 51,12 und die partielle Atimie." *ZPE* 85:37–39.

Wannagat, D. 2001. "'*Eurymedon eimi*'–Zeichen von ethnischer, sozialer und physischer Differenz in der Vasenmalerei des 5. Jahrhunderts v. Chr." *Konstruktionen von Wirklichkeit: Bilder im Griechenland des 5. und 4. Jahrhunderts v. Chr.* (eds. R. von den Hoff and S. Schmidt) 51–71. Stuttgart.

Watkins, C. 1995. *How to Kill a Dragon: Aspects of Indo-European Poetics.* Oxford and New York.

Weber-Lehmann, C. 2003. "Musik um Adonis. Beobachtungen zur Rechteckkithara auf apulischen Vasen." In Schmaltz and Söldner 2003:160–166.

Webster, T. B. L. 1972. *Potter and Patron in Classical Athens.* London.

Wehrli, F. 1967/1969. *Die Schule des Aristoteles: Texte und Kommentar.* 10 vols., second ed. Basel.

Welcker, F. G. 1816. *Sappho von einem herrschenden Vorurtheil befreyt* [later version in *Kleine Schriften. Zweyter Theil*, Bonn 1845, 80–144]. Göttingen.

———. 1828. Review of Neue 1827. *Jahrbücher für Philologie und Pädagogik* 6:389–433.

———. 1857. "Ueber die beiden Oden der Sappho." *Museum für Philologie* 11:226–259.

Wells, C. M. 1973. "The Greek Lyric Poets' 'Again.'" *Échos du Monde Classique/Classical Views* 17:1–11.

West, M. L. 1970a. "Burning Sappho." *Maia* 22:307–330.

———. 1970b. "Melica." *Classical Quarterly* 20:205–215.

———. 1973. "Greek Poetry, 2000–700 B.C." *Classical Quarterly* 23:179–192.

———. 1976. "The Asigmatic Atlas." *ZPE* 22:41–42.

———. 1982. *Greek Metre.* Oxford.

———. 1988. "The Rise of the Greek Epic." *Journal of Hellenic Studies* 108:151–172.

———. 1989/1992. *Iambi et Elegi Graeci ante Alexandrum cantati.* 2 vols., second revised ed. Oxford.

———. 1990. "Notes on Sappho and Alcaeus." *ZPE* 80:1–8.

———. 1992a. *Ancient Greek Music.* Oxford.

———. 1992b. "The Descent of the Greek Epic: A Reply." *Journal of Hellenic Studies* 112:173–175.

———. 1993a. *Carmina Anacreontea,* editio correctior editionis primae (1984). Leipzig.

———. 1993b. *Greek Lyric Poetry: The Poems and Fragments of the Greek Iambic, Elegiac, and Melic Poets (excluding Pindar and Bacchylides) down to 450 BC,* trans. with introduction and notes. Oxford.

———. 1997. "When Is a Harp a Panpipe? The Meanings of πηκτίς." *Classical Quarterly* 47:48–55.

———. 2002. "The View from Lesbos." *Epea pteroenta: Beiträge zur Homerforschung. Festschrift für Wolfgang Kullmann zum 75. Geburtstag* (eds. M. Reichel and A. Rengakos) 207–219. Stuttgart.

———. 2005. "The New Sappho." *ZPE* 151:1–9.

White, H. 1978. *Tropics of Discourse: Essays in Cultural Criticism.* Baltimore, MD.

———. 1987. *The Content of the Form: Narrative Discourse and Historical Representation.* Baltimore, MD.

———. 1999. *Figural Realism: Studies in the Mimesis Effect.* Baltimore, MD.

Whitley, J. 1997. "Cretan Laws and Cretan Literacy." *American Journal of Archaeology* 101:635–661.

Wiechers, A. 1961. *Aesop in Delphi*. Meisenheim am Glan.

Wigodsky, M. 1962. "Anacreon and the Girl from Lesbos." *Classical Philology* 57:109.

Wilamowitz-Moellendorff, U. von. 1900. *Die Textgeschichte der griechischen Lyriker*. Berlin.

———. 1913. *Sappho und Simonides: Untersuchungen über griechische Lyriker*. Berlin.

———. 1921. *Griechische Verskunst*. Berlin.

Williams, C., and H. Williams. 1986. " Ἀνασκαφὲς στὴν Μυτιλήνη κατὰ τὸ 1986." *Lesbiaka* 9:223–232.

———. 1991. "Excavations at Mytilene, 1990." *Échos du Monde Classique/Classical Views* n.s. 10:175–191.

Williams, D. 1993. "Women on Athenian Vases: Problems of Interpretation." *Images of Women in Antiquity*, revised ed. (eds. A. Cameron and A. Kuhrt) 92–106. Detroit, MI.

———. 1995. "Potter, Painter, and Purchaser." *Culture et Cité. L'avènement d'Athènes à l'époque archaïque* (eds. A. Verbanck-Piérard and D. Viviers) 139–160. Brusells.

Williams, H. 1994. "Secret Rites of Lesbos." *Archaeology* 47:34–40.

———. 1995. "Investigations at Mytilene, 1994." *Échos du Monde Classique/Classical Views* n.s. 14:95–100.

Williams, R. 1983. *Keywords: A Vocabulary of Culture and Society*. London.

Williams, R. T. 1961. "An Attic Red-figure Kalathos." *AK* 4:27–29.

Willink, C. W. 1986. *Euripides' Orestes*, with introduction and commentary. Oxford.

Wilpert, P. 1960. "The Fragments of Aristotle's Lost Writings." *Aristotle and Plato in the Mid-fourth Century: Papers of the Symposium Aristotelicum Held at Oxford in August 1957* (eds. I. Düring and G. E. L. Owen) 257–264. Göteborg.

Wilson, L. H. 1996. *Sappho's Sweetbitter Songs: Configurations of Female and Male in Ancient Greek Lyric*. London.

Wilson, N. G. 1987. "Variant Readings with Poor Support in the Manuscript Tradition." *Revue d'histoire des textes* 17:1–13.

———. 1996. *Scholars of Byzantium*, revised ed., Cambridge, MA.

———. 1997. *Aelian: Historical Miscellany*. Cambridge, MA.

Wilson, P. 2003. "The Sound of Cultural Conflict: Kritias and the Culture of *Mousikê* in Athens." In Dougherty and Kurke 2003:181–206.

Winkler, J. J. 1990. *The Constraints of Desire: The Anthropology of Sex and Gender in Ancient Greece*. New York.

———. 1991. "Sappho and the Crack of Dawn (fragment 58 L-P)." *Journal of Homosexuality* 20:227–233.

Wirth, P. 1963. "Neue Spuren eines Sapphobruchstücks." *Hermes* 91:115–117.

Wood, E. 1994. "Sapphonics." *Queering the Pitch: The New Gay and Lesbian Musicology* (eds. P. Brett et al.) 27–66. New York.

Woodbury, L. 1967. "Helen and the Palinode." *Phoenix* 21:157–176.

424

————. 1979. "Gold Hair and Grey, or the Game of Love: Anacreon fr. 13: 358 *PMG*, 13 Gentili." *Transactions of the American Philological Association* 109:277–287.

Wroth, W. 1964. *A Catalogue of the Greek Coins in the British Museum: Catalogue of the Greek Coins of Troas, Aeolis, and Lesbos* (original ed. London 1894). Bologna.

Wyatt, W. F. 1992. "Homer's Linguistic Forebears." *Journal of Hellenic Studies* 112:167–173.

Yatromanolakis, D. 1998. "Simonides fr. eleg. 22 W²: To Sing or to Mourn?" *ZPE* 120:1–11 [repr. in *Greek Literature, vol. 3: Greek Literature in the Archaic Period: The Emergence of Authorship* (ed. G. Nagy) New York 2002].

————. 1999a. "Alexandrian Sappho Revisited." *HSCP* 99:179–195.

————. 1999b. "When Two Fragments Meet: Sapph. fr. 22 V." *ZPE* 128:23–24.

————. 2000. "Healing Sounds: Music and Medicine in Greek Antiquity." *Proceedings of the Theoretical and Diagnostic Histopathology Conference.* Alexandroupolis, keynote lecture abstract.

————. 2001a. "Visualizing Poetry: An Early Representation of Sappho." *Classical Philology* 96:159–168.

————. 2001b. "To Sing or to Mourn?: A Reappraisal of Simonides 22 W²." *The New Simonides: Contexts of Praise and Desire* (eds. D. Boedeker and D. Sider) 208–225. Oxford and New York.

————. 2002. " Ἑτερογλωσσικοὶ Διάλογοι καὶ Ἀνα-σύνθεση στὴ Σαπφώ τοῦ Ὀδυσσέα Ἐλύτη." *S/C* 13:60–72.

————. 2003a. "Ritual Poetics in Archaic Lesbos: Contextualizing Genre in Sappho." In D. Yatromanolakis and P. Roilos 2003:43–59.

————. 2003b. "Palimpsests of Sappho in Nineteenth- and Twentieth-Century Greece." *Modern Greek Literature: Critical Essays* (eds. G. Nagy et al.) 171–189. New York and London.

————. 2004a. "Exploring Lyric Tropes." *S/C* 15:70–79.

————. 2004b. "Fragments, Brackets, and Poetics: On Anne Carson's *If Not, Winter.*" *International Journal of the Classical Tradition* 11:266–272.

————. 2005. "Contrapuntal Inscriptions." *ZPE* 152:16–30.

————. 2006a. "Ancient Poetry as Modernist Bricolage." *Festschrift I.-Th. Papademetriou.* Stuttgart, forth.

————. 2006b. "A Lyric *Epos.*" *H* 56:381–388.

————. 2007a. *Fragments of Sappho: A Commentary.* Cambridge, MA, forth.

————. 2007b. "Ancient Greek Popular Song." *The Cambridge Companion to Greek Lyric* (ed. F. Budelmann), forth.

————. 2007c. "Alkaios and Sappho." *The Cambridge Companion to Greek Lyric* (ed. F. Budelmann), forth.

————. 2007d. "An Anthropology of Archaic Greek Genres." *Anthropology and Classics* (ed. M. Detienne), forth.

————. 2007e. "Genre Categories and Interdiscursivity of Genres in Alkaios and Archaic Greece." *S/C* forth.

Yatromanolakis, D., and P. Roilos. 2003. *Towards a Ritual Poetics*. Athens.

———. 2005a. Πρὸς μία Τελετουργικὴ Ποιητική. Preface M. Detienne, trans. E. Skouras. Athens.

——— (eds.). 2005b. *Greek Ritual Poetics*. Cambridge, MA.

Yoken, D. W. 1985. *Iannis Xenakis' Psappha: A Performance Analysis*. San Diego, CA.

Younger, J. G. 1998. *Music in the Aegean Bronze Age*. Jonsered.

Yunis, H. (ed.). 2003. *Written Texts and the Rise of Literate Culture in Ancient Greece*. Cambridge.

Zachariadou, O., D. Kyriakou, and E. Baziotopoulou. 1992. "Ateliers de potiers à l'angle des rues Lenormant et de Constantinople (rapport préliminaire)." *Les ateliers de potiers dans le monde grec aux époques géométrique, archaïque et classique. Actes de la Table Ronde, Athènes, octobre 1987* (eds. F. Blondé and J. Y. Perreault) 53–56. Athens and Paris.

Zaidman, L. B. 1992. "Pandora's Daughters and Rituals in Grecian Cities." *A History of Women in the West, vol. I: From Ancient Goddesses to Christian Saints* (ed. P. Schmitt Pantel) trans. A. Goldhammer, 338–376. Cambridge, MA.

Zanker, P. 1995. *The Mask of Socrates: The Image of the Intellectual in Antiquity*, trans. A. Shapiro. Berkeley and Los Angeles.

Zumthor, P. 1990. *Oral Poetry*, trans. K. Murphy-Judy. Minneapolis, MN.

Zuntz, G. 1939. "De Sapphus Carminibus ε̄ 3, ε̄ 4, ε̄ 5." *Mnemosyne* ser. 3, 7:81–114.

———. 1951. "On the Etymology of the Name Sappho." *Museum Helveticum* 8:12–35.

# INDEX OF SUBJECTS

# INDEX OF NAMES



# Index of Names



Porcius Licinus 84

Porphyrios 224

Poseidippos 304, 317, 326–329, 334, 336–337, 350

Poseidonios 235

Pratinas 235

Praxilla 215–216, 219, 292, 343–344, 346–347, 360

Pythermos 219

Quintus Catulus 84

Radcliffe-Brown, A. R. 45n121

Ravel, M. 16

Rhodopis 18, 309, 312–337, 350
and vase paintings 322–323

Rilke, R. M. 78

Roilos, P. 23, 36, 47n126, 279, 288, 301, 338

Sabouroff Painter 115

Sahlins, M. 37, 43n118, 45, 45n121, 46, 46n123–124

Salpe 194, 236

Sappho
ancient editions 159
Alexandrian edition of, 11, 216, 278, 281
and Alkaios 73–81, 167–171, 224
and blame poetry 332–334
and comedy (*see also* comedy) 293–312, 357, 365
and homoeroticism (*see also* pederasty) 21, 173–178, 220, 224, *passim*
and male audience/performers (*see also* men) 227–286, 346–348
and ritual 210–211, 238–239, 241, 247, 345
and symposia (*see also* men) 88–103, 258–286, 344–348, 360, *passim*
as texture 258–259, 357–358, *passim*
Athenian performative transmission of, 346–347
contextual plasticity 259–286
dialogue in, 7
*epithalamians* 11, 211–212
father of, 300
fr. 58 V 16, 203–204, 360
husband of, 294 (biography)
in vase paintings 51–164
metapoetic discourse in, 218–219
modern reception of, 4–5, 19, 78, 159, *passim*
semantic doublelayeredness 245–259, 278–286
textual plasticity 338–358
time in, 281–282
transmission of, 7–10, 21, 207–224, 225, 261, 272, 287–361, *passim*
Sappho Painter 66, 71
Sartre, J.-P. 12n44, 15
Seneca 359
Shostak, M. 37–42, 172
Simonides 118, 127, 206, 215, 225–226, 301, 319, 343
Skalkotas, N. 15
Skamandronymos 300
Smikros 102
Sokrates 86–88, 226, 349
Solon 85–88, 126, 310, 319, 328
Sopatros 235
Sophilos 99
Sophokles 231, 256, 343
Sophron 190
Sotades Painter 52, 66
Sphinx 307–308
Stephanos 351

438

# INDEX OF GREEK TERMS

CPSIA information can be obtained
at www.ICGtesting.com
Printed in the USA
LVHW081032281022
731813LV00012B/213